Realms
of
Heroism

INDIAN PAINTINGS AT

THE BROOKLYN MUSEUM

Amy G. Poster

with Sheila R. Canby,
Pramod Chandra,
and Joan M. Cummins

The Brooklyn Museum
IN ASSOCIATION WITH HUDSON HILLS PRESS, NEW YORK

FIRST EDITION

© 1994 by The Brooklyn Museum

Vice Director for Publications: *Elaine Koss*

Copy Editor: *Joanna Ekman*

All rights reserved under International and Pan-American Copyright Conventions.

Published in the United States by Hudson Hills Press, Inc., Suite 1308, 230 Fifth Avenue, New York, NY 10001-7704.

Editor and Publisher: *Paul Anbinder*

Copy Editor: *Irene Gordon*

Proofreader: *Lydia Edwards*

Indexer: *Karla J. Knight*

Designer: *Betty Binns*

Composition: *U.S. Lithograph, typographers*

Manufactured in Japan by Dai Nippon Printing Company

Distributed in the United States, its territories and possessions, Canada, Mexico, and Central and South America by National Book Network.

Distributed in the United Kingdom and Eire by Art Books International Ltd.

Exclusive representation in Asia, Australia, and New Zealand by EM International.

Library of Congress Cataloguing-in-Publication Data

Brooklyn Museum.
 Realms of Heroism: Indian paintings at The Brooklyn Museum / Amy G. Poster, with Sheila R. Canby, Pramod Chandra, and Joan M. Cummins. — 1st ed.
 p. cm.
 Includes bibliographical references and index.
 ISBN 0-87273-131-6
 1. Miniature painting, Indic—Catalogues. 2. Miniature painting, Mogul—Catalogues. 3. Miniature painting—New York—Brooklyn—Catalogues. 4. Brooklyn Museum—Catalogues. I. Poster, Amy G., 1946– . II. Title.
ND 1337.15B76 1994
751.7′7′09540747423—dc20 94-12261
 CIP

COVER ILLUSTRATION: Artist unknown, *Arghan Div bringing the weapon chest to Hamza,* folio from the *Hamza-nama,* 1562–77, opaque watercolor and gold on cotton cloth (cat. no. 22)

Realms
of
Heroism

INDIAN PAINTINGS AT
THE BROOKLYN MUSEUM

Contents

Colorplates

All works are by unknown artists, except as otherwise indicated.
The **boldface** number to the left of the entry indicates the catalogue number.

Foreword

R. STEWART CULIN, first Curator of Ethnology, acquired the first Indian miniature paintings for The Brooklyn Museum on an expedition to India in 1913–14. A decade later, his tireless pursuit brought the Museum several *Hamza-nama* pages, four of which remain among the most important acquisitions in the collection. This volume thus reflects an enthusiasm that was initiated more than seventy-five years ago. I am especially pleased that this important contribution to scholarship in the field of Indian art appears at a time when interest in India's rich cultural heritage is particularly strong in America.

Under the direction of Amy G. Poster, first as Associate Curator and then as Curator of Asian Art, we have witnessed the ongoing evolution and growth of the Museum's holdings in this area. The desire to publish the collection dates back almost twenty years; however, such an impressive project could finally be realized only by means of a grant from the National Endowment for the Arts within its Utilization of Collections program. Over a period beginning in 1973, the Endowment provided funds that allowed Mrs. Poster, who has directed the expansion of the Museum's holdings, to research the collection, with the collaboration of Dr. Sheila R. Canby, formerly Associate Curator of Islamic Art at the

Museum (presently Assistant Keeper, Department of Oriental Antiquities, The British Museum, London) and author of the entries on Mughal and Deccani painting. Endowment support enabled both scholars to examine many important collections here and abroad and also provided funds for the translation of much documentary material. Matching funds from the Andrew W. Mellon Foundation also enabled the curatorial assistants and interns acknowledged below to take an active part in the development of this project. Our thanks are gratefully extended to all those who contributed their time and knowledge to the fulfillment of this commitment.

A special declaration of gratitude is extended to the J. Aron Charitable Foundation, and to its president, Peter A. Aron, for its extraordinary support over an extended period of time toward the publication of this catalogue, and to the Christian Humann Foundation, as well, for its generous support of this endeavor. Support for this catalogue was also provided by the Andrew W. Mellon Foundation.

We look on this volume not as a finale, but as the first in a series of publications on our Indian art collections.

ROBERT T. BUCK

Director
The Brooklyn Museum

Acknowledgments

A PROJECT OF THE SCOPE presented here is not accomplished without the knowledge, enthusiasm, and aid of many individuals and institutions. It is with heartfelt pleasure that we express our thanks to the South Asian art specialists, colleagues, collectors, and donors who stood ready to share their expertise:

In Germany, Dr. Joachim Bautze, Berlin. In Great Britain: Channel Islands: Dr. Simon Digby; London: Dr. Mildred Archer, India Office Library; Dr. Jeremiah P. Losty, Keeper, Department of Oriental Manuscripts and Printed Books, The British Library; Dr. Michael Rogers and Dr. Wladimir Zwalf, formerly Keepers, Department of Oriental Art, The British Museum; Dr. W. G. Archer (deceased) and Mr. Robert Skelton, formerly Keepers, Ms. Rosemary Crill, Mr. John Guy, Ms. Susan Stronge, Indian Section, Victoria & Albert Museum; Simon M. W. Ray and Michael Spink, Spink & Sons, Ltd.; and Mr. Edmund DeUnger, Dr. Linda York Leach, Ms. Betty Tyers, Dr. Mark Zebrowski; Oxford: Mr. Andrew Topsfield, Curator of Indian Art, Ashmolean Museum. In Ireland: Dr. David James, formerly Chester Beatty Library, Dublin.

In Hong Kong, Mr. S. W. Muirhead. In India: Ahmedabad, Dr. Shridhar Andhare, L. D. Museum; Bombay: Ms. Usha Bhatia and Mr. Karl K. Khandalavala, Lalit Kala Akademi; Hyderabad: Mr. Jagdish Mittal, Jagdish and Kamala Mittal Museum of Indian Art; Jodhpur: Dr. Naval Krishna, Curator, Mehrangarh Museum Trust; Mysore: Dr. S. P. Tewari, Superintending Epigraphist, Archaeological Survey of India; New Delhi: Mr. Chote Bharany; Patna: Mr. G. K. Kanoria (deceased) and Mr. Vinod Kanoria; Varanasi: Dr. Anand Krishna, Banaras Hindu University. In Pakistan: Dr. Brijan N. Goswamy, Punjab University, Chandigarh.

In the United States: Ann Arbor: Dr. Walter Spink; Beverly Hills: Dr. Catherine Glynn Benkaim, formerly Associate Curator of Indian Art, Los Angeles County Museum of Art, and Mr. Ralph Benkaim; Boston: Dr. Jan Fontein and Dr. James Watt, formerly Curators of Asiatic Art, Museum of Fine Arts; Burlington: Dr. John Seyller, Professor of Art, University of Vermont; Cambridge: Dr. Pramod Chandra, George P. Bickford Professor of Indian and South Asian Art, Mr. Scott Redford and Mr. Stuart Cary Welch, Fogg Art Museum, Harvard University; Charlottesville: Professor Daniel J. Ehnbom, University of Virginia; Los Angeles: Dr. Pratapaditya Pal, Senior Curator of Indian Art, Los Angeles County Museum of Art; Madison: Professor V. Narayana Rao, University of Wisconsin; Menlo Park: Dr. Gursharan Sidhu; New York City: Dr. Vishakha N. Desai, Director, The Asia Society Galleries (formerly Assistant Curator of Indian Art, Museum of Fine Arts, Boston); Mr. Steven M. Kossak, Department of Far Eastern Art, Ms. Marie L. Swietochowski and Ms. Caroline Kane, Department of Islamic Art, The Metropolitan Museum of Art; Mr. Carlton Rochell, Sotheby's; Dr. Barbara Stoler Miller (deceased), Milbank Professor, Columbia University; and Ms. Wendy Findlay, Mr. Terence McInerney, Dr. Elizabeth Rosen, Mr. Paul F. Walter, and Mrs. Doris Wiener; Philadelphia: Dr. Alvin O. Bellak; Dr. Stella Kramrisch (deceased), Curator of Indian Art, Philadelphia Museum of Art; Richmond: Dr. Joseph M. Dye III, Curator of Asiatic Art, Virginia Museum of Fine Arts; San Diego: Edwin S. Binney, 3rd (deceased); Dr. Ellen S. Smart, Curator of Indian and Islamic Art, San Diego Museum of Art; Washington, D.C.: Dr. Milo Cleveland Beach, Director, Freer Gallery of Art and Arthur M. Sackler Gallery, Smithsonian Institution.

Special recognition must be accorded those former curators of the Oriental Art Department (now the Asian Art Department) who first recognized the importance of the painting collection and systematically provided invaluable information, particularly R. Stewart Culin, Laurance P. Roberts, Lois Katz, and Dr. Stanislaw Czuma.

Many members of the Museum staff have participated in this project over the years it was in gestation. In addition to the cooperation of Dr. Canby, members of the Asian Art Department staff, particularly Layla S. Diba, Associate Curator of Islamic Art, Research Assistants Joan Cummins, whose essay on the Museum's Indian drawings appears in the Appendix and who patiently compiled the Glossary, and

Dr. Usha Ramamrutham deserve special commendation. The contributions of the interns Dale Hudson, Sonali Mitra, and Nancy Wu, who participated in summer volunteer projects coordinating and researching works for this presentation, have been significant. Among more recent participants who have contributed their individual talents are Marjan Adib and interns Allison Beecher, Sarah Brooks, Sarah Jillings, and Hillary Veeder. We are grateful to Elaine Koss, Vice Director for Publications, and Joanna Ekman, Editorial Associate, and Antoinette Owen, John Derow, and Rachel Danzig, Paper Conservators, for expert advice. William Lyall, Patricia Bazelon, Patty Wallace, and Faith Goodin of the Photography Department have sensitively presented the photographic records of the paintings. Roy R. Eddey, Deputy Director, and Dr. Linda S. Ferber, Chief Curator, have been generous in their advice on many aspects of this work. Ann Thompson is to be blessed for her patient typing and retyping of the manuscript, as is Jorin Burr for helping in the later stages of its production. Rena Zurofsky, formerly Vice Director for Marketing, was instrumental in bringing our project to the attention of our publisher, Paul Anbinder, Editor and Publisher, Hudson Hills Press. Joanna Ekman proofread the manuscript and followed it through to publication.

Dr. Nadine Berardi, Edwin Bryant, Sonali Mitra, Dr. Allan Shapiro, under the direction of Dr. Barbara Stoler Miller, and Maryam Ekhtiar, Marjan Adib, and Dr. S. P. Tewari have provided translations of inscriptions and identifications of many of the subjects of the paintings. The color transparencies of Phillip Pocock and John Listopad reveal the intrinsic quality of the individual paintings; a set photographed by John Listopad will be made available to scholars and college students by the American Committee for South Asian Art Slide Series, University of Michigan.

We extend our appreciation here to Elizabeth Knight, editor and publisher of *Orientations,* for granting permission to reprint Dr. Chandra's essay on the *Qissa-i Amir Hamza,* which appeared in the July 1989 issue of that magazine in slightly different form.

Finally, much of this volume has been revised and rewritten on numerous Saturdays and Sundays spent in the Museum in the company of Irene Gordon, who has so ably edited this catalogue, and my husband, Robert L. Poster, who, with great good nature, spent hours in the Museum's Art Reference Library searching out the documents needed for our references and developed an uncanny ability for finding the proper bibliographical data for the most recondite literature when he would have preferred visiting art galleries or watching a football game. I thank them and hope those days were as satisfying to them as, in retrospect, they have been for me.

AMY G. POSTER
Curator of Asian Art

Introduction

Indian art is almost invariably a religious art, and the painting of India has been, at least in its origins, no exception. Wall painting predates the tradition of Indian miniature painting, which began as an art of manuscript illumination and developed to a point where the illustration began to occupy the entire page and its subject matter included secular as well as religious matter. The paintings that prompted this study—whose sometimes delicate, sometimes primitive, colors and compositions have lately become extremely popular in the West—are most commonly referred to as Indian miniatures, but while many of the paintings illustrated in this volume are small by the standards of Western oil painting, such works are by no means always small. The *Hamza-nama* pages (cat. nos. 22–25) are certainly no smaller than many Titian portraits, and many of the paintings in the palace at Udaipur, which remain accessible to tourists visiting today, are larger still.

The study of Indian painting has evolved from a concentration on styles to a more recent emphasis on text and context. The aim of this introduction is to familiarize the reader with the broad outlines of Indian miniature painting and to sketch its development (and that of the scholarship in the field) by isolating the historical, social, and religious circumstances that affected it and by indicating some outstanding highlights. The paintings in the collection of The Brooklyn Museum will be considered in light of that development and with regard to today's scholarship, and attention will be drawn to areas in the study of Indian painting that have prompted endless questions—some that have now been answered but many that remain enigmatic.

This introduction will treat briefly of the artists who painted these works, the techniques used to paint them, and the principal themes and subjects of these paintings before discussing their history and the development of their style.

Artists

While painters worked under the patronage of royalty, priests, and the wealthy merchant community, they were not necessarily attached to particular workshops for life and often migrated between states and patrons. They were not limited by either their religious affiliation or that of their patron. There is evidence that, at least in the later periods, skillful painters altered styles to suit the particular ateliers to which they were attached at the time. John Seyller is the first scholar to document that artists of the Akbar period (1556–1605) produced works in a variety of styles that reflected the commissions they received (Seyller 1987, pp. 247–77). There is no reason to believe that this was not the case during other periods.

On the other hand, the virtuosity of the artist in India has been likened to that of a performer—whose ingenuity stems from a new manipulation of the "established canon of imagery" (Lowry 1988, pp. 46–47)—rather than to the skill of a "creator" of a new vision, in the modern Western sense. While there are certainly signed Indian paintings, including several reproduced in this catalogue, in general the artist worked anonymously as a craftsman and a member of an atelier, rather than as an individual creative genius. Thus, the great majority of Indian paintings in The Brooklyn Museum are the products of anonymous craftsmen.

Technique of Indian miniature painting

Traditional Indian painting is basically a watercolor technique often characterized by a burnished surface. Preliminary sketches are drawn in ink and sanguine. In pre-Mughal Jain paintings we often find color applied to sheets of gold leaf (cat. no. 1). Two approaches to the application of pigments thus date even from pre-Mughal times: the outline filled in with flat opaque colors; and a rapidly applied pigment burnished between each applied layer to create an opacity.

Except for the *Hamza-nama* (cat. nos. 22—25) and other works on cloth, most paintings from the fifteenth century on were executed on paper, which, particularly in Mughal painting, was primed with translucent lead white. Brushes were generally of squirrel hair.

For color Mughal artists used minerals or earths or ochers in mineral salts. In early Mughal paintings, insect and vegetable colors were rarely used, except carmine and indigo. The zinc white used in early Mughal paintings was imported, purportedly from Kashgarh, whereas kaolin was the pigment commonly used for white in Rajput, Nepali, and probably later Mughal paintings. Black was composed of lampblack, which was, as in the case of almost all pigments, mixed with gum arabic. India yellow (a color with the ability to fluoresce) was made from the urine of cows that had ingested mango leaves (the method is described in detail in M. Chandra 1949b). The pigments and techniques used are discussed at length in Johnson 1972, pp. 139—46.

Text and image: epics and other common themes

Since many Indian paintings are illustrations of religious texts and poetry, images are usually closely tied to the narrative of a text. The Sanskrit literary scholar Barbara Stoler Miller (1971) has demonstrated how the painting conforms to the text in her study of the fifteenth-century *Chaurapanchasika,* in which several regional recensions of a text relate to different painting compositions and motifs. The most common subjects of paintings made for the Rajput (that is, the indigenous Hindu) rulers of Northern India, which are well represented in Brooklyn's collection, are episodes from the life of Krishna, the *nayikas* of contemporary Hindi poetry, such Hindu epics as the *Ramayana* and the *Bhagavata Purana,* folk stories of legendary figures, and

The relationship of text to image with reference to the Hindu epics can be examined in several versions of the *Mahabharata,* a subject often regarded as less popular in painting but well represented in Brooklyn's collection. A Persian version, the *Razm-nama,* for example, is known in two Mughal sets. One scene from a 1598—99 *Razm-nama* painted by a Muslim artist with the text given in Avadhi script on a contiguous page is shown in catalogue number 28. In a Pahari version painted in a large horizontal format in the Kangra style (cat. no. 232), several scenes of the narrative are incorporated into one image; no text accompanies the image, but labels identifying the figures are given. In a South Indian version of 1670, the painting appears to be secondary to the text that surrounds the square image (cat. no. 248). A Paithan folk image (cat. no. 251) without accompanying text was intended to be used by a reciter in a performance of the epic.

Depictions of musical modes in *Ragamala* paintings are standardized in texts, compositions, and iconographies. Bundi, seat of the Hara Rajputs, and Kota, for example, follow the model of the famous "Chunar *Ragamala*" painted in 1591 at Chunar, near Benares (Beach 1974, figs. 1 and 3; Victoria & Albert Museum 1990, p. 133, pl. 114), believed to be the earliest known formulation of this iconography and to have been produced in Chunar by artists trained at Akbar's court (Skelton 1982, p. 56). At least ten later *Ragamala* series were derived from this common iconographical program and composition, which remained virtually unchanged over two hundred years. An exemplary Bundi image adhering to the Chunar *Ragamala* formula is *Kamoda Ragini* (cat. no. 124), depicting the heroine seated in a bower awaiting her lover. One unusual illustration from the Bundi-Kota group is a *Desakhya Ragini* (cat. no. 127) showing three male figures performing acrobatic feats suspended from an organically rendered banyan tree instead of the usual exercise post. The *Ragamala* compositions of Rajasthan are similarly expanded in versions executed in the Punjab Hills to include new variations on the familiar themes.

The *nayikas* portrayed in Rajasthani painting are rich in metaphor and nuance, and follow closely the language of their inscriptions. The themes of the months *(Baramasa)* are depicted as scenes of love associated with the seasons. These are usually painted in sets of twelve leaves, corresponding to the twelve months. Although the rainy and summer seasons are most conducive to illustration, a study of the winter month Pausha (cat. no. 104) effectively conveys the lonely woman huddled with her attendant around a brazier.

A contemporary Hindi treatise on love, the *Rasikapriya,* composed in the late sixteenth century by Keshavadasa, is frequently depicted in Rajasthani paintings. While it systematically enumerates the different types and situations of love, heroes and heroines, their messengers, and features of poetry, its sets of classifications are worked into fine poetry in the context of the Radha-Krishna legends. Brooklyn's collection includes independent pages from numerous dispersed series illustrating this treatise. A Bikaner *Rasikapriya* page in the collection (cat. no. 120) exemplifies how closely the artist followed the text.

The *Gita Govinda,* a Sanskrit devotional poem of the twelfth century, was an important subject for miniature painting throughout northern India. In two pages from an early-eighteenth-century series painted at Mewar (cat. nos. 166 and 167), the divine lovers Krishna and Radha are depicted in an idealized landscape of bowers of arched cypresses and blossoming trees, a literary metaphor for the intertwined lovers.

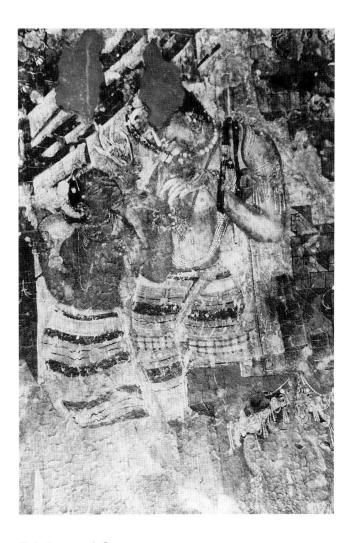

The tradition of painting related to Jain ritual continued in India well into the eighteenth century. The later period of Jain art is represented in the Museum's collection by several large-scale paintings on cotton, including a representation of a pilgrimage center (cat. no. 151) and two cosmic diagrams used to demonstrate the various levels of worldly and spiritual experience (cat. nos. 187 and 188). There is also a fragment painted in the Mewar style of the traditional monk's invitation *(Vijnaptipatra),* a long document painted in scroll format (cat. no. 170).

Portraiture

Indian painting was primarily an art composed for the royal-warrior caste (as opposed to Indian temple arts, which were strictly regulated by the priestly caste). An interest in portraiture was not evidenced by these patrons until the arrival of the Mughal conquerors in the sixteenth century. The Rajput courts quickly emulated their Mughal rivals, and later Rajput princes often commissioned portraits, such as catalogue number 132, which belongs to a group of posthumous portraits of Bundi rulers commissioned at Uniara, circa 1780–90.

A wide variety of historical portraits reveals the sometimes subtle modes of representation through which Indian rulers reasserted their own power and achievement. The figure's royal status may be conveyed by an aureole behind his head and royal emblems that indicate his rank; the latter are included in a portrait of the Mughal emperor Jahangir holding a falcon (cat. no. 36). Rajput portraiture reflects a Mughal-influenced interest in recording important persons and scenes of court festivities, religious festivals, and other activities such as *darbar,* worship, and the hunt (see Desai 1985, pp. xv–xviii). Two exemplary Rajput works in the collection are a portrait of Rao Sujan Singh on horseback (cat. no. 118) and Maharao Ram Singh of Kota portrayed in his battle regalia preparing for the ritual reenactment of Durga Killing the Buffalo Demon (cat. no. 134).

Origins and format

From very early times, Indian painting was a narrative medium in which visual images of a religious character depicted the idealized divine world and events from the stories of the Buddha, Vishnu, and Shiva on the walls of Buddhist and Hindu places of worship. The wall paintings at the Buddhist site at Ajanta, executed largely during the fifth century A.D., convey a sense of intimacy in their *Jataka* scenes (narrating the previous lives of the Buddha) (see fig. 1). Wall paintings also survive at Ellora and Sittanavasal, dated to the eighth century. Thereafter there is a vacuum, a period of some two centuries from which nothing of this quality has been found (or to which nothing has so far been attributed).

Thus, on the basis of present evidence, the painting tradition later found in manuscript illumination can be continuously traced back only as far as the tenth or eleventh century, though it is certain that manuscript production is more ancient (see Pal and Meech 1988, p. 33). Religious manuscripts of this period were executed on palm leaves in a long horizontal format. Paper, in this same shape, was introduced only in the thirteenth century. It did not supplant the palm leaf until the beginning of the fifteenth century, and the tradition of writing and illuminating palm-leaf

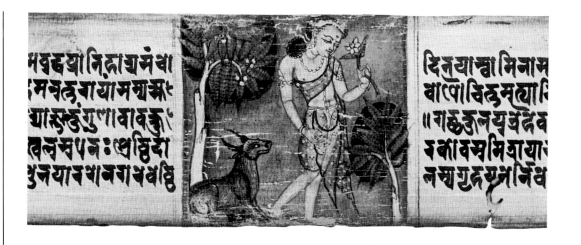

Figure 2

Folio from a Gandavyuha manuscript (detail)

Nepal, 12th century

Opaque watercolor on palm leaf

Sheet 2 x 21⅝ in. (5 x 54.6 cm)

The Brooklyn Museum

Gift of the Ernest Erickson Foundation, Inc., 86.227.137

books actually continues today in certain areas. Buddhist palm-leaf painting from Eastern India and Nepal of the eleventh through twelfth centuries in the Pala tradition (see fig. 2) does have a naturalistic and modeled style reminiscent of the Ajanta mural tradition, but it presents a distinctive palette, format, and iconography. For some reason, probably the loss of patronage brought on by the decline of Buddhism in India after the thirteenth century, this style seems to have died out in Eastern India, though it survived in Nepal and Tibet. The lack of continuity of the older styles—the gap between Ajanta and Pala period painting, as well as the demise of Pala-style painting in the thirteenth century—is one of the many intriguing questions that present themselves to students of this genre.

It would appear that the precursor of the corpus of Rajput paintings known and collected in the West was a much stiffer and more linear painting tradition practiced in Western India, characterized by outlines enclosing areas of flat color rather than by the naturalistic and modeled shapes that are so remarkable in the earlier murals, palm-leaf manuscripts, and illuminated book covers (for an example of a book cover, see Lerner 1984, pp. 86–89).

The work produced after the thirteenth century reveals a mature tradition in the illustration of both religious and secular texts. In many early manuscripts, the pages were not bound into books as we know them but were loose, or held together by cords strung through holes in the pages, as had been the case in earlier palm-leaf manuscripts. Paintings in manuscripts or albums, which generally comprised only a small part of the page, were meant to be seen not only in relation to the text, but also as an independent sequence of images.

Schools of Indian painting and their development

PRE-MUGHAL PAINTING

In the early sixteenth century, the Mughals, a Central Asian dynasty descended from Timur (Tamerlane), invaded northern India. These invaders were highly cultured princes, and under their patronage there developed in India a painting style that is identified as "Mughal." This is the style best known in the West, particularly the extraordinary paintings created for the early Mughal emperors in India. The degree to which Mughal painting reacted to and influenced indigenous Indian traditions is one of the subjects that has long preoccupied scholars in this field. Earlier scholars of Indian painting assumed that Mughal influence was extensive and deep, but several significant indigenous painting traditions already existed when the Mughal rulers came to India. It is therefore useful to summarize the various regional traditions the Mughal invaders would have found when they arrived in India, when Babur conquered Sultan Ibrahim Lodi at Panipat in 1526 and occupied Delhi and Agra.

The pre-Mughal Hindu and Jain painting tradition had evolved over the previous four or five centuries. This illustrative, formulaic style had its roots in religious canonical texts such as the *Chitrasutra* of the *Vishnudharmottara,* a fifth- to seventh-century Hindu compendium of rules governing the arts, and the Jain *Kalpasutra* (The Book of Ritual). It is commonly referred to as the "Jain" style (because more Jain manuscripts of this period have survived than Hindu) or as the "Western Indian" style (because Gujarat was the most prolific center of these paintings, although the style did flourish in other parts of northern India as well as Rajasthan and Malwa). The style becomes increasingly linear, without modeling, and is characterized by the direct application of pure color. A dated palm-leaf manuscript of A.D. 1060 in the Jain Trust, Jaisalmer, contains depictions of elephants and the deities Kamadeva and Shri (Doshi 1985, pp. 33–34). The elephants are rendered with a plasticity reminiscent of Ajanta,

whereas the deities are drawn with taut angular outlines indicating expressive energy (ibid., p. 33) and exaggerated proportions and facial features. Icons are frontal; other images are shown in three-quarter view.

"Western Indian" paintings of the medieval period (fourteenth to sixteenth century) also reflect Persianate influence to some extent, portraying certain stock figures of foreigners as subjects of the contemporary ruling Muslim dynasty (Lodi). From the late fourteenth century on, manuscript illustrations of the *Kalakacharya-katha,* a classic Jain text relating the adventures of three monks named Kalaka (cat. no. 1), follow the customary convention of representing the foreign Sahi king as a distinctive stereotype, always in a long foreign costume, with a Mongol facial type, and shown in three-quarter view, in contrast to the indigenous figural type that is used here to represent the divinities.

Before the sixteenth century, paintings were generally painted in a horizontal format, in imitation of palm-leaf manuscripts. During the lengthy medieval period, Jain manuscripts, many of which bear dates, do not seem to have undergone any radical stylistic changes. The painting tradition appears to have been a long, conservative one, in which the representation of the Tirthankara subject in an iconic manner continued to follow the strict tenets of the Jain faith dominant in this area of India. A *Kalpasutra* dated 1465 and painted at Jaunpur, in Uttar Pradesh (cat. no. 15), represents the continuity of the Western Indian style in areas distant from the center of the Jain painting tradition.

How do we characterize the style of Jain painting? The earliest securely dated *Kalpasutra* on paper is set at 1411 (Beach 1992, p. 8). In these early pages relating the life of Mahavira, one of the twenty-four Jain Tirthankaras, and other *jinas* (Jain saints), yellow is a predominant color (later replaced with gold), and gold and silver are frequently used for the text. Stylized figure types with heads in profile and a protruding farther eye, and such colors as carmine, orange-yellow, and ultramarine blue predominate in early Jain paintings. In later illustrated Jain manuscripts, scenes are often more elaborate and border decoration more profusely ornate. The limited modeling of figures that had survived from earlier tradition has by now disappeared; figures are flatly rendered, and there is little interest in landscape—backgrounds are mere fields of color, often sheets of gold leaf to which pigment is applied.

In addition to the 1465 Jaunpur page, the Brooklyn collection is rich in Jain *Kalpasutra* pages of the fifteenth and sixteenth centuries. Ninety-nine leaves of a 1472 *Kalpasutra* (cat. no. 3) and numerous isolated pages that convey the common tight, controlled style elude definitive attribution. The colophons have become separated from these isolated pages, leaving their origin, date, or patronage unknown.

Painting in pre-Mughal India was not confined to Jain subjects or areas, as can be seen from a number of fifteenth- and sixteenth-century manuscripts that may or may not have been painted prior to the arrival of the Mughals but nevertheless reflect an artistic tradition rooted in pre-Mughal times that developed quite independently of the arrival of the Mughal conquerors in India. The leaf from a 1525–40 *Bhagavata Purana* series, a Hindu text devoted to the life and exploits of the god Krishna (cat. no. 18), belongs to an important group of sixteenth-century North Indian Hindu manuscripts that points to the existence of more than one indigenous pre-Mughal style. Like the 1465 Jaunpur manuscript, the set to which this leaf belongs was probably painted in Uttar Pradesh. It impresses with its bold colors, absence of the Jainesque protruding eye, and inventive compositions conveying vigor and energy. The *Bhagavata* series consists of several distinct stylistic groups, each corresponding to known sets of illustrated texts executed over a period of time. In this context, the Brooklyn *Bhagavata* page displays a composition similar to pages from the 1450 *Balagopala-stuti* (Khandalavala 1982, fig. 183) and the *Gita Govinda* series of about 1520 now in the Prince of Wales Museum of Western India, Bombay. The figure types in the *Bhagavata* series are physiognomically indigenous; the horizontal format and the duplication of figures in the composition indicate a continuing narrative. The arrangement of Krishna and *gopis* seated in a row, as in the Brooklyn page, also shows strong stylistic affinities to a *Chaurapanchasika* series of circa 1525–50 (N. C. Mehta Collection, Ahmedabad). The style of that series is associated with several contemporaneous works called the "*Chaurapanchasika* group," in the rhythmic fantail arrangement of the *gopis'* saris, their ornaments, the bold and lively patterns of costumes and textiles, the profile and physiognomy of the figures, the monochrome ground, and the flat, two-dimensional composition. Such paintings from the series of *Bhagavata Purana* manuscripts can be considered significant documents of an amalgamation of styles, which in the early sixteenth century seems to have produced a new and vibrant painting style.

The reigns of the independent sultans of Delhi, Malwa (at Mandu), and Bengal were also periods of royal patronage that produced a number of significant manuscripts, dating from the fourteenth century through the first half of the sixteenth, primarily depicting such popular Muslim subjects as the *Khamsa* of Nizami, the *Shah-nama* of Firdawsi, and the *Chandayana.* Isolated pages from these early-sixteenth-century Sultanate manuscripts are represented in the Brooklyn collection. A leaf (cat. no. 17) from *Chandayana* manuscript (most of whose pages are now in the Prince of Wales Museum of Western India, Bombay), with its swirling clouds, formalized spraylike trees from which no leaves protrude beyond the outline, and a background punctuated with tiny floral designs, is typical of the Sultanate style as first described by Khandalavala (1951, pp. 6 and 14).

While the Sultanate illuminations are thought to presage the Deccani style of painting of the later sixteenth century, B. N. Goswamy, in discussing a newly discovered *Shah-nama* of about 1425–50 painted in Malwa, notes stylistic and iconographic ties to North Indian workshops and the anticipation of the Rajput style, although he does not indicate if this is one style or a generic Rajput style, and if it is one style, of which school (Goswamy 1988, pp. 6–8).

The term Sultanate is used generally, since few of these paintings can yet be attributed to particular patrons or to particular sultanates. However, identification can be based on a number of factors: on the predominant artistic tradition, the Shirazi style (Melikian-Chirvani 1969), and Middle Eastern Islamic types of architecture, costume, and treatment of figures on the one hand; and on "indigenous" stylistic elements on the other, such as the Tughluq mausoleum dome type (Fraad and Ettinghausen 1971, p. 54), the Tughluq script recognized by J. Losty in the border of a dispersed fourteenth-century Koranic manuscript in which the text is Arabic with interlinear Persian notations (Losty 1986, p. 10), and attributions of Sultanate manuscripts to local artists working for Muslim patrons (Goswamy op. cit., pp. 20–27). There are known works in variants of this style produced for Muslim patrons at Mandu, Jaunpur, in Bengal and the Deccan, and similar works have recently been attributed to Delhi (Goswamy op. cit., p. 8). To further complicate the mix of painting styles the Mughals found in India, it might also be noted that there already existed an independent tradition of Muslim painting in the Deccan (discussed below) as well as independent South Indian styles under the patronage of various Hindu kingdoms.

MUGHAL PAINTING

The period of Mughal rule in North India set the stage for unification of many of the diverse elements in Indian painting under this new patronage. In 1526 Babur invaded India and established the Mughal empire. In 1530 he was succeeded by his son Humayun, who was driven into exile in 1540 by Sher Shah Sur but returned to the throne at Delhi in 1555. It is known that, during his exile in the Safavid court of Shah Tahmasp in Persia (1542–55), Humayun employed Iranian artists, among them Mir Sayyid 'Ali and 'Abd as-Samad, who then came to India with him on his brief return to the throne.

The imperial atelier *(tasvir khana)* was established under the supervision of these artists, and Indian artists were hired by the affluent court. Paintings commissioned for the new rulers vividly demonstrate Persian elements, but at the same time, Indian styles were also of major importance. Artists often accompanied the emperors on imperial expeditions in order to record events, making Mughal painting a reflection of the changing fortunes of the empire, its attitudes regarding life and nature, and the philosophy of the court.

While early Mughal painting displays marked Safavid influence in style and detail, as represented in its quintessential achievement in Safavid painting, Shah Tahmasp's *Shah-nama,* of circa 1525, there evolved under Emperor Akbar (r. 1556–1605) a purely Mughal style that combined Persian elegance, precision, and harmony with the dynamism and natural vibrancy of the indigenous pre-Mughal tradition, together with such European influences as vanishing-point perspective and shading. Any study of the achievements of Emperor Akbar must note as a high point his patronage of the arts. In the *Akbar-nama,* two manuscripts of which are known to have survived (unfortunately, the Brooklyn collection does not include a page from these important manuscripts), artists are listed with anecdotes of their lives, as recorded by the court chronicler, Abu'l Fazl. Under Akbar's supervision, numerous Persian and Indian texts were copied with profuse illustrations that synthesize Persian technical virtuosity, Indian idealism, and the naturalism of European prints and pictures brought to the court by foreign merchants and missionaries. During his reign, new subjects entered the repertory. Animal and bird studies based on Safavid prototypes reveal a keen observation of nature and life in intricate detail.

The earliest evidence of this eclectic style is demonstrated in the "full-bodied and individualized figures, three-dimensional landscapes, carefully observed trees and vegetation, and bold and thickly applied colors" of the Cleveland *Tuti-nama* of circa 1560–65 (P. Chandra 1976, p. 28). The manuscript, now largely held by the Cleveland Museum of Art, represents the period before the total merger of Mughal and indigenous styles in early Mughal painting. It was first analyzed by P. Chandra (1976, vol. 1) and later discussed by Beach, who emphasized the variety of styles exhibited in the illustrations (1987, p. 15). Recent scholarship has suggested that it may be a Sultanate manuscript that was overpainted in the subsequent period (Seyller 1992, pp. 283–318).

Perhaps the greatest manuscript commissioned by Akbar is the *Qissa-i-Amir Hamza,* or *Hamza-nama,* four of whose striking folios are among the glories of the Brooklyn collection (cat. nos. 22–25). The manuscript, which presents an epic account of the exploits of Amir Hamza, the uncle of the Prophet Muhammad, is a monumental work and is among the earliest Mughal illuminated manuscripts whose patronage is established. The large paintings on cotton in this widely dispersed group, which are remarkable for their iconographic invention and dramatic expression, were executed under the direction of Mir Sayyid 'Ali and 'Abd as-Samad between circa 1562 and 1577 (P. Chandra 1976, pp. 62–72). Characterized by modeled human forms and bold colors, the paintings have a "restless," charged rhythm.

The dramatic visual narrative is most striking for its setting within the exquisite and meticulously painted detail of textile patterns, wall surfaces, tiles, and other decorative elements. For the first time in Indian manuscript painting, facial expression is individualized and personal traits can be read. These paintings mark the birth of the new and vital tradition of the Mughal school.

Throughout his reign, Akbar made the translation of established Sanskrit religious texts and the production of illustrated histories into official artistic projects. In 1582 he ordered the translation of the Hindu epic *Mahabharata* (in the Persian version, the *Razm-nama*). One splendid illustrated copy, the most lavish version of those known today, was completed by 1586, as noted by Akbar's adviser, Abu'l Fazl, in his preface to the work. In addition to this imperial copy, now in the Maharaja Man Singh II Museum, Jaipur, two slightly later subimperial illustrated copies of the manuscript exist, one dated 1598–99 and another dated 1616. An illustration from the 1598–99 *Razm-nama* (cat. no. 28), ascribed to the artist Mohan, demonstrates that artists trained in the Mughal court atelier were available to work for subroyal Mughal or other patrons producing compositions detailed with figures and objects of Akbar's own period.

The tranquil phases of Mughal history find expression in illustrations of religious and secular texts, portraiture, and themes depicting nature and the musical modes. Under Emperor Jahangir (r. 1605–27) new subjects expanded Akbari interests while the production of illustrated manuscripts declined in favor of individual album leaves. A naturalist, as were his predecessors Babur and Humayun, Jahangir commissioned individual paintings of aspects of nature, portraits, and animal studies, decorated with illuminated margins *(hashiya)* and then compiled into elaborate albums (for a later example of a fragment of a border, see cat. no. 40). Portraiture gained prominence, and one marvels at the individuality achieved in these finely executed works produced by master artists who concentrated on specificity and verisimilitude. A skillful study of Jahangir with a falcon, isolated against a monochromatic background, is one of the earliest portraits in the collection (cat. no. 36). Considered to represent Jahangir early in his reign, the study has been attributed to Manohar, a Hindu painter in the emperor's court and son of the artist Basawan (Basavana).

The collection includes both drawings and finished Mughal portraits. Conforming to standard portrait compositions, several studies of Mughal courtiers in the collection (cat. nos. 39, 40, 43) show isolated figures frozen in formal stance against the blank paper ground, their features sensitively executed with tinted brushwork.

The paintings produced during the reign of Shah Jahan (1628–58) are noted for their refinement and meticulous execution. Two illuminated calligraphic folios in the collection (with calligraphy by Persian scribes) exemplify the elaborate border style of the period (cat. nos. 37 and 38). An element of stiffness permeates such finished works of the era, which demonstrate the decline of the spontaneity and flow of the earlier period.

Emperor Aurangzeb's reign (1658–1707) was turbulent, marked by political chaos and cultural stagnation in the Mughal court. He embarked on a long period of military conquest east and south of the capital, and finally captured the Deccani capitals of Bijapur (1686) and Golconda (1687). Imperial patronage of art in the court at Delhi declined, encouraging artists to seek employment elsewhere, in local courts and provinces.

Thus, from the mid-seventeenth century on, both court style and subject matter developed in Mughal spheres of influence outside Delhi. After the sack of the city by Nadir Shah in 1739, the Mughals' central authority collapsed, providing the opportunity for patrons in the provinces to attract Mughal artists (Losty 1982, p. 110). At the provincial capitals of Oudh, Lucknow, and Faizabad, in the Deccan (at Hyderabad), and in Bengal (at Murshidabad), divergent styles emerged that combined local idioms and traditional Mughal features to produce hybrid styles. The specific subject matter of earlier Mughal painting was transformed into more generalized subjects; the prince was now portrayed in a passive role, in which he is entertained, and ladies of the court are given new prominence (Binney 1972, p. 121). By the eighteenth century, details became conventions and perspectives were simplified. An individual style may have evolved within each of the provincial regions, but scholarship has not yet identified the precise characteristics that would differentiate each school. Every region was influenced by Deccani artists, and each in turn influenced artists of other schools, such as those in the Punjab Hills (Binney, ibid., p. 122). It is conceivable that individual artists, such as Mir Kalan Khan in Oudh, might be credited with developing a style that permeated the period and all these centers; for an example of the artist's work, see Desai 1985, cat. no. 101.

The art of miniature painting and textual illustration reached a zenith of organized refinement under the Mughals. Artistic traditions were transmitted from generation to generation, and as members of the administration, outstanding artists were rewarded handsomely. Workshops were organized in a systematic manner with papermakers, leatherworkers, gilders, painters, scribes, and apprentices who maintained and prepared supplies. Projects were directed by master artists and individual pictures were assigned among the various craftsmen. As the painting tradition dispersed into the local areas outside the capital, this systematic division of labor appears to have vanished.

DECCANI PAINTING

Painting in the Deccan (an area extending across India from the east coast to the west beginning roughly in the north at the latitude of Aurangabad and ending in the south at the latitude of Vijayanagar) apparently flourished before, during, and after the Mughal incursions. The rulers of the Deccan plateau were Muslim, like the Mughals, yet there all resemblances cease. While the Mughals were Sunnis and turned to Eastern Iran and Central Asia for inspiration, the Deccani Sultans were Shi'as and looked to Safavid culture, as well as the Arab world generally, for their models (Zebrowski 1983, pp. 8–9), an approach encouraged by the thriving sea trade that existed among the Deccan and Turkish, Persian, and Arab populations.

Despite evidence of pre-Mughal workshops in the Deccan (1347–1537) and of the continuous production of painting in Deccani centers from the period of the sixteenth century through at least the eighteenth, relatively little is known about Deccani painting and comparatively few examples are known. The most comprehensive study of this school, if it can be viewed as a school, which essays a broad overview and analysis of the known Deccani oeuvre (some two hundred works) is that by Mark Zebrowski published in 1983. The author succinctly summarizes the problems attached to any understanding of these paintings:

First, what exactly are the characteristics of the Deccani schools, which so many researchers have tried to reconstruct during the past five decades? Secondly, who were these mysterious sultans who boldly pitched their tents in the centre of peninsular India, only to disappear abruptly after two centuries, leaving little trace except for a few ruined cities and two hundred great paintings, now scattered among collections in Asia, Europe, and America? These questions are still difficult to answer precisely because the Deccani sultans lacked the customary Islamic passion for historical record. As they commissioned fewer histories than their Mughal contemporaries, much less is known about the Deccan than about northern India. Moreover, Deccani paintings are rarely dated or inscribed with the names of artists or patrons, as Mughal and Rajasthani pictures often are (Zebrowski 1983, p. 8).

In broad outline, the Deccan was dominated by three kingdoms: Ahmadnagar, whose high period occurred in the late sixteenth century; Bijapur, late sixteenth century through late seventeenth century; and Golconda (near present-day Hyderabad), early sixteenth century through late seventeenth century. These were succeeded by a Mughal hegemony that lasted through the first quarter of the eighteenth century. In Hyderabad and in the provincial centers of the Deccan, painting continued to be produced through the eighteenth and into the nineteenth century.

Given the problems confronting Deccani studies and the paucity of material, it is not surprising that the Brooklyn collection is not rich in early Deccani paintings. The Museum has no example of sixteenth-century Ahmadnagar painting. However, the collection does contain examples of Deccani production that can help explicate the development of the style. One of the idiosyncratic contributions of Deccani painting was the technique of "marbling," a method probably originating in Iran or Turkey but frequently executed in the Deccan, particularly at Bijapur. A superb example is the study of a stalling elephant with two riders (cat. no. 58), which can be attributed to mid-seventeenth-century Bijapur.

Some of the earliest identifiable Deccani pictures are from Golconda, the capital of the Qutb Shah rulers from the beginning of the sixteenth century until the Mughal conquest of 1687. The Museum's sole example, an unsigned study of a bird perched on a rock accompanied by poppies, a butterfly, and a dragonfly (cat. no. 59), has been dated circa 1650 to 1670 on the basis of its similarity to works by the Safavid master Riza 'Abbasi (c. 1565–1635), revealing continued contact with the Islamic world. Other paintings in the collection are typical of later seventeenth-century work and post-Mughal production in Hyderabad (see cat. nos. 61–65).

Zebrowski has noted that in the eighteenth century, "Deccani artists suddenly rediscover the female body, creating an idealized world of princesses and courtesans" (1983, p. 245). Two works in the collection (cat. nos. 66 and 67) reflect this interest. A problematic aspect of Deccani painting of the period has been caused by geography: the northern limits of the Deccan abut Malwa, a Central Indian area noted for its seventeenth-century Rajasthani painting style, and certain paintings that immediately suggest a Malwa origin have been ascribed to the Deccan (Zebrowski 1983, col. pl. III, pls. 24 and 31). Deccani paintings cannot be distinguished by their subject matter since certain traditional non-Muslim subjects fascinated Deccani artists. The *Ragamalas* portrayed in catalogue numbers 68–71 and the Krishna scenes in three pages from a *Bhagavata Purana* series (cat. no. 72) may have been produced for Persian viewers.

In 1959 the Museum was given a group of late Deccani paintings and calligraphies mounted on album leaves, said to have come from the collection of the Nizam of Hyderabad (cat. nos. 73–100). The works fall into five categories: portraits of Mughal and Deccani rulers and nobles; compositions deriving from *Ragamala* scenes; paintings with a multitude of figures; a portrait of a saint; and fanciful calligraphic pictures. Within each category the works display stylistic uniformity, but unfortunately none of the works is of great artistic merit. In fact, the portraits and *Ragamala* scenes exemplify the wooden lifelessness of later nineteenth-century Hyderabad painting, as if they were all copies of copies of original works.

Nevertheless, the portraits are of historical interest, for they are inscribed with the names of the sitters, often Indian notables of whom we possess few or no other portraits. While the portraits may not all be by the same hand, they have all been rendered in virtually the same style. All but two of the figures stand or sit in a simple landscape or on a terrace before pale blue or green skies rimmed with a bank of dark blue clouds. With one exception the paintings all date to the last quarter of the nineteenth century. Jagdish Mittal has noted (1963, p. 54) that Hyderabad paintings of this period were executed on handmade or machine-made paper attached to sheets of newspaper pasted together, called *waslis*.

RAJASTHANI AND CENTRAL INDIAN PAINTING

Several scholars, among them W. G. Archer and Edwin Binney, 3rd (1968), have produced systematic descriptions of Rajasthani works, identifying and dating regional schools and uncovering new manuscripts. As a result, we now know that a chronology of Rajasthani painting based on dated manuscripts and stylistic analysis must begin with the earliest attributable works produced outside the Rajasthan realms, such as the 1450 *Balagopala-stuti* manuscripts, a *Bhagavata Purana* (cat. no. 18) produced in North India about 1525–40, and the Prince of Wales Museum *Gita Govinda* produced in Western India in the mid-sixteenth century, all of which are noted above in the discussion of Pre-Mughal painting. These multi-paged manuscripts do not represent a fusion of the Western Indian and the Mughal styles, but are a unique innovation within the pre-Mughal traditions noted above.

A key factor in the evolution of the Rajasthani and Central Indian painting styles may have been the revival of Vaishnavism (worship of Vishnu) in the Hindu religious tradition and the emergence of the Bhakti (devotion) cult in the sixteenth century, which had an impact on religious life and affected manuscript production. In his search for a geographic origin of the *Gita Govinda* and *Bhagavata Purana* manuscripts, Skelton has suggested that since the Bhakti movement was centered in the region of Mathura and Vrindavan in Uttar Pradesh, where patrons, authors, and craftsmen congregated, the *Bhagavata Purana* series, at least, may have been produced there (public lecture, The Pierpont Morgan Library, New York, 1978). However, reliable evidence is lacking, and Bhaktiism probably was practiced at more than one center.

The heyday of Rajasthani painting was long after the production of these early manuscripts. A factor underlying the Rajasthani court tradition in the later sixteenth and seventeenth centuries was the reduction of patronage within the Mughal court. Poets, artists, and artisans employed at these courts brought their own traditions and conventions and helped to shape the emerging cultural values of the Rajput

and Gujarati leaders: "It was not until Gujarat and Rajasthan felt the full impact of Mughal painting that we see a really new outlook and the old style gradually dies out" (Khandalavala 1951, p. 5). How and to what extent the Mughal artistic influences reacted with the native traditions to produce the flowering of painting that occurred in Rajasthan and Central India over the next century is one of the most interesting and controversial questions in the field of Indian painting. Certainly, by the Jahangir and Shah Jahan periods of Mughal rule, the Rajput courts of Mewar and Bikaner were important centers of painting, where a confluence of earlier and new traditions resulted in a burgeoning of painting production, as demonstrated by the famous 1605 *Ragamala* pages produced at Chawand, in Mewar, the 1628 Mewar series, and other well-known series.

Not all schools of Rajput painting are a direct continuation of the pre-Mughal Rajasthani tradition, and the schools are often grouped into those that are tied to the Mughal tradition and those that continue the pre-Mughal Rajasthani tradition. Certain of the Rajasthani court inventories, diaries, and collections give powerful evidence of Mughal court influences. On the other hand, a fascinating aspect of the history of this genre is that as time passed, the influence of the Mughal style waned in many centers of painting and elements of the indigenous pre-Mughal styles reasserted themselves, so that by the eighteenth and nineteenth centuries, painters in many Rajput centers seemed to manifest few if any elements of Mughal influence. The Rajasthani schools represented in the Museum's collection are here grouped by kingdoms, to designate the local styles.

Amber/Jaipur

Amber had capitulated to Akbar as early as 1562; in 1727/28 Sawai Jai Singh (r. 1700–1744) moved the court from Amber to the new town of Jaipur. No independent style of painting developed in Jaipur in the seventeenth century, possibly because of its close ties to the Mughal court and its proximity to the Mughal capitals of Delhi and Agra. The Museum's collection includes two pages representing the Amber style (cat. nos. 101 and 102), which appear closely related to a 1709 *Ragamala* series painted for Jai Singh (Beach 1992, p. 184); here is a case where recent scholarship (Andhare 1972 and Beach 1992) has enabled us to revise past attributions on the basis of the colophon, as these paintings for many years were thought to have been painted at Bikaner. Like most Rajput rulers, those of Jaipur patronized an existing tradition of illustration of mythological stories and religious texts; a nineteenth-century scene of devotions to a Nagadevata serpent god (cat. no. 106) is typical. The Jaipur rulers also paid special attention to secular portraiture (see App. D25, a portrait of Raja Pratap Singh). Jaipur painting is characterized by a Mughal style, though often very static; the frequent use of gold leaf in filigree to

denote intricate textile patterns (see cat. no. 106); and a possible Western influence, derived from engravings, revealed by the incorporation of perspective and landscape elements into local idioms (see cat. nos. 109 and 110).

Bikaner

Painting at Bikaner also reflected that state's close Mughal ties and the presence of a large number of Muslim artists residing there in the seventeenth century. Some of these artists accompanied the Bikaner rulers when they joined with the Mughals in their Deccan campaigns (c. 1630s) and may thus have been exposed to the Deccani painting tradition. A posthumous portrait of Rao Chattar Sal of Bundi (r. 1631–58) (cat. no. 112), one of several extant studies of this ruler, provides us with an exemplary Bikaner modification of the Mughal style.

Paintings from Bikaner differ distinctly from the norm of traditional Rajasthani paintings. While a hallmark of Rajasthani work is the use of bold and vibrant colors, in paintings from Bikaner figures appear to float in landscape or, sometimes, stark desert settings defined by cool pastel colors. This may reflect the palette of the artists from the Mughal courts, as may the delicate drawing and subtlety of expression that characterize Bikaner painting of the seventeenth and eighteenth centuries. Eighteenth-century Bikaner work is well represented in the Brooklyn collection by several *Ragamala* pages and portraits of Bikaner noblemen. Our understanding of Bikaner painting is enhanced by Naval Krishna's studies of the court inventories, which provide documentation on the subject matter, patronage, and execution of extant works (Krishna 1985 and personal communication). A splendid early-eighteenth-century version of *Vaikuntha Darshana* (Vishnu and Lakshmi enthroned; cat. no. 117) reiterates the dream of Raja Karan Singh (r. 1631–74) set down by his court painter Ali Raza and copied here with more attenuated figures but the same minutely detailed gold and jeweled ornamentation.

Bundi and Kota

The courts of Bundi and Kota were in close proximity to each other, so it comes as no surprise that the paintings from these states show similar styles of composition and imagery. Mughal influence was assimilated into the classical Indian tradition by Bundi painters even before the seventeenth century. Throughout Bundi's history, paintings featuring romantic subjects and *Ragamalas* were rendered with an element of delicacy and poetic lyricism in the depiction of both figures and landscapes. The *Ragamala* format and iconography associated with this region is based on a series painted at Chunar in 1591. Beach (1974, pp. 6–10) defines the stylistic practice as a conventionalization of figures within the composition, while palette and details of clothing or setting may change.

A period of political turmoil in Bundi and Kota that began in the mid-1700s and lasted through the nineteenth century is reflected in a change in artistic style and subject matter, when pictures of hunts and animals in a rugged, rocky, and heavily forested setting became popular themes.

A nineteenth-century portrait of Ram Singh of Kota (r. 1827–66) presents the ruler dressed in battle regalia. As pointed out by Bautze (cat. no. 134), the ruler is preparing for a ritual reenactment of Durga's slaughter of the Buffalo Demon. The static poses of priests in the worship of Shri Nathaji exemplify the Kota style of the 1870s (cat. no. 135).

Subschools such as the *thikanas* Uniara and Raghugarh (in Central India) were offshoots of the Bundi and Kota schools, and utilize similar compositions and figure types.

Kishangarh

The state of Kishangarh, founded about 1609, was closely tied to the Mughal court. That Mughal influence flourished in the courts there from this period and throughout the eighteenth century is evident in Kishangarh paintings. Sawant Singh (r. 1748–57) was a principal patron of Kishangarh painting. Until his death in 1764, painting in this court largely revolved around his devotional poetry to Krishna. Alongside representations of court genre scenes, the chief theme of Kishangarh paintings became the allegorical portrayal of romantic love. Ladies of the harem and rulers were often shown in the palace and in lush landscapes rendered as the divine lovers Krishna and Radha, whose love was seen as the union of the devotee with god (as in cat. no. 136, in which Sawant Singh's likeness can be seen in the portrayal of Krishna). Figures in the paintings have elegant elongated torsos in arched postures, receding foreheads, sharp noses and chins, long almond-shaped eyes, and arched eyebrows. Kishangarh paintings are characterized by striking detail work and stylized facial features.

Malwa/Bundelkand/Datia

The so-called Malwa group is the most conservative of the Rajput styles. Although the Malwa region is located in Narsingarh state, the geographic center of India, the painting style is related to the schools of the contiguous Rajasthan area, particularly that of Mewar—a similarity that prompts scholars to associate the Central Indian Malwa school with Rajasthani painting traditions. The southern boundaries of Malwa abut on the area known for the Western Indian painting tradition. Malwa painting in the seventeenth century presents an amalgam of current modes that have been reduced to a distinct style characterized by broad expanses of bold pure color, simple architectural and landscape elements with a limited repertory of detail, and relatively few figures, often depicted in profile, seldom over-

lapping. The termination of paintings in the Malwa style after the early eighteenth century remains an enigma, but one may look to Bundelkand and Datia for a continuation of the style.

Among the earliest royal paintings associated with Malwa are the pre-Mughal pages from the *Ni'mat-nama,* a treatise on cooking of about 1500–1505 in a distinctively Indianized Persian style, and the copy of circa 1502 of the *Bustan* by the thirteenth-century Iranian poet Sadi, both painted at Mandu in the Sultanate period. W. G. Archer (*Central Indian Painting,* London, 1958) and Ebeling (1973, p. 90 and fig. 1) cite a *Bhairavi Ragini* of about 1550 attributed to Malwa, in which the pre-Mughal *Chaurapanchasika* elements (fishtail drapery, boldly patterned textiles, and wide-eyed gaze of the figures) predominate.

By the second quarter of the seventeenth century the Malwa style shed all foreign components, and a pure style with pictorial motifs incorporating distinct Western Indian and *Chaurapanchasika* elements emerged. Malwa paintings of the seventeenth century are characterized by more pronounced "expanses of unmodulated color" (Dye 1984, p. 365), in which the red and blue color fields are independent of the figures and their setting. There appears to be an almost mathematical formula in which the number of figures and pictorial elements is reduced in ratio to the color ground. The earliest dated Malwa paintings are from a *Rasikapriya* series of 1634, the colophon of which is in the National Museum, New Delhi. Several examples from this *Rasikapriya* series are in the Brooklyn collection, among them a folio from the introductory section that depicts Krishna tied to a mortar next to a tree in which the faces of Manigriva and Nalakubara appear (cat. no. 140). Originally thought to be from a contemporaneous *Bhagavata Purana* series, the page is identified as a depiction of the *rasa karuna* (compassion); in the introductory passages of the *Rasikapriya,* Krishna's exploits are used as a metaphor for emotions demonstrated in the love theme that follows.

Possibly owing to political instability in the following century or because of the influence of the Mughal painting style (Leach 1986, p. 159), there are no extant eighteenth- and nineteenth-century Malwa paintings. Central Indian paintings from Bundelkand and Datia demonstrate a continuation of the Malwa tradition as distinct from other Rajasthani schools. Their format and composition are often similar to the standard Malwa type, although there is a proliferation of details and the palette includes pastel colors in non-Malwa combinations. The figural types in these eighteenth-century paintings, unlike those of the Rajasthani schools of the period, have not yet been studied as a distinct group.

Marwar/Jodhpur

Like the paintings of Bikaner, those of the desert kingdom of Marwar in western Rajasthan (whose court eventually came to be located at Jodhpur, where it remains today) reflect an eccentricity in style. The Museum's Jodhpur holdings provide a range of portraits that are a good representation of this style. The portrait of Maharaja Bakhat Singh is an example of static official portraiture in the mid-eighteenth century (cat. no. 152). The late-nineteenth-century portrait of Maharaja Jaswant Singh of Marwar (r. 1873–95), on the other hand, is a personal statement on the part of the sitter who commissioned it (cat. no. 153). It is not in the Jodhpur tradition, but betrays British influence in the raja's surrounding himself with the trappings of Western portrait photography.

Mewar/Udaipur/Nathadwara

Fiercely independent, the rulers of the state of Mewar withstood the military onslaughts of the Mughals. While by 1576 every other Rajput kingdom had succumbed to the armies of Akbar, Mewar's rulers continued to resist, and though they temporarily abandoned their capital at Udaipur, their resistance to the Mughals continued until 1614. Rana Pratap Singh's secure alternate capital, Chawand, bordering on Malwa, is mentioned in the colophon of a dated *Ragamala* series (1605) by the Muslim painter Nasiruddin, executed in the reign of Rana Amar Singh I (1597–1620). The works in this so-called Chawand series are the earliest Mewar paintings known. Their style is a mixture of *Chaurapanchasika* and Mughal elements. (For an example in an American collection, see Leach 1986, cat. no. 89.)

In 1615 Mewar did capitulate to the Mughals, but the rulers were given certain political privileges and were not considered vassals of the emperor. Few paintings fall into the period between 1615 and 1628, when history records Mewar's closer ties to the Mughals, including support for the Mughal campaign to Ranakpur in 1621 and the asylum given to Prince Khurram in 1623. However, the Brooklyn collection has a pair of double-sided pages from a dispersed *Bhagavata Purana* attributed to 1610–50 (cat. nos. 154 and 155). Andhare (1987) poses the question of the relationship of the Mewar style and the Mughal style of the Jahangir period, and suggests that early Mewar painting was influenced by Mughal artists outside the Jahangir court (working in the so-called Popular Mughal style). The Brooklyn leaves would seem to indicate that he is correct.

Mewar painting came into its own during the reign of Maharana Jagat Singh I (r. 1628–52) with innovative manuscripts on the Krishna theme, many attributed to individual artists. The 1628 *Ragamala,* 1629 *Gita Govinda,* 1648 *Bhagavata Purana,* and 1649–50 *Ramayana* series ascribed to the Muslim artist Sahibdin are among the glories of Indian painting (for an example of this style, see cat. no. 155). The collection's most distinctive Mewar paintings, which date from the seventeenth century, include a page from a *Gita Govinda* series

of about 1650–60 (cat. no. 157) and three leaves from a *Rasikapriya* series of circa 1660–90 (cat. nos. 162–64). In the eighteenth and early nineteenth centuries, large-scale historical scenes representing court festivals at Udaipur, then the capital of Mewar, are most commonly associated with Mewar production. This period is well researched on the basis of inscriptions that identify the subjects (Andhare 1987 and Topsfield 1980 and 1990).

Southern Rajasthani schools, including Sirohi and Gujarat

In Gujarat as well as Rajasthan, the so-called Western Indian style evolved into the Rajasthani style. Here, too, Mughal influences played a role, but since later paintings from Gujarat and Southern Rajasthan have not been systematically studied, most paintings attributed to the regions are grouped because of affinities in the stylized treatment of physiognomy and costume, and their palette favoring bright opaque colors, especially orange, pink, and yellow. A frontispiece from a *Bhagavata Purana* series painted in the first half of the seventeenth century known as the Tula Ram series (cat. no. 182) was first presented as evidence of Mughal influence in Gujarat in the period (Goetz 1953), even though the subject matter is purely Hindu.

The paintings of Gujarat in this period are also stylized and often folkish. They are characterized by the frequent use of brightly colored and simplified floral meanders in wide borders; particularly notable is the early-seventeenth-century border surrounding a fragment depicting polo players (see cat. no. 180). Some of the figures in the late Gujarat works appear stiffly executed, with figures arranged as if floating in space and decorative elements, such as flowering plants, interspersed with elements of the narrative (see cat. nos. 183 and 184).

Dark green landscape elements accented with mauve overpainting distinguish a late-seventeenth-century depiction of *Nata Ragini* (cat. no. 176), here attributed to a Southern Rajasthan artist but sharing characteristics with northern Deccani works of the period. Even though elements of the figures' costumes are rendered in copious detail, they cannot be tied to any specific artist, style, or patron.

PAINTING OF THE PUNJAB HILLS

The Museum's collection of paintings frequently referred to as "Pahari" from the states of the Punjab Hills (north and generally west of Delhi, in the areas leading to the Himalayan range) presents a cross-section of the historical, geographical, and stylistic range of work from this area. While these kingdoms were ruled by Rajput princes similar in outlook and interests to their counterparts in Rajasthan to the south, they seem to have been less affected, perhaps because of their geographical isolation, by Mughal domination and to have had closer ties to one another than are found among the states of Rajasthan or Central India.

Scholars have long noted two distinct trends in the production of this area: the intense colors and exaggerated physiognomies of the seventeenth-century and early-eighteenth-century work produced in Kulu, Basohli, Mankot, and Chamba; and the fine draftsmanship and subtle coloration (evidently Mughal-influenced) of the eighteenth-century Kangra, Guler, and Bilaspur schools. In 1973 W. G. Archer's monumental history of painting from the Punjab Hills was published, which set every then-known document in its historical and artistic context. Because at that time no painting from this region was known to have predated the seventeenth century, however, theories on the origin of the earlier style developed in a vacuum. Catalogues and writings on early Pahari painting still assume an extensive Mughal influence in the development of the early Pahari style generally, and in the early development of painting at Basohli in particular—an idea that has been given some credence by the Mughal-inspired ornamental details of textiles and adornments found in such Basohli paintings as the representation of Siddha Lakshmi with Kali in catalogue number 191.

In recent decades, however, new documents have been discovered and the ancestral collections of Himachal Pradesh have been located, helping to bring the date of the earliest Pahari paintings, with a marked pre-Mughal style, back at least to the mid-sixteenth century. In particular, the discovery of an illustrated *Devi Mahatmya* manuscript, now in the Simla Museum, apparently painted in the Kangra area in the period 1560–70 in a North Indian style related to that of the *Chaurapanchasika* series, suggests the existence of a much earlier and broader-based painting tradition in the Hill States than has previously been supposed (see Ohri 1991 for a discussion of these early manuscripts).

The Basohli page depicting the isolated figures of the goddess Siddha Lakshmi and Kali (cat. no. 191), from a dispersed Devi series, considered to be one of the earliest and most celebrated seventeenth-century Pahari series known, provides an important foundation for the Museum's Punjab Hills collection. The intense colors and ferocious expressions and gestures, contrasted with the Mughal-inspired ornamental details of the textile patterns and adornments, typify the mannerisms of early Basohli painting and express perfectly the ardent religious beliefs of the Basohli patrons of the mid-seventeenth century.

The cult of Devi and the worship of Shiva were long associated with Basohli. The Basohli ruler Sangram Pal (r. 1635–73) is said to have adopted Vaishnavism during his reign and is credited with having commissioned an extraordinary illustrated version of the *Rasamanjari,* dated 1660–70. The *Rasamanjari* paintings convey the same expressive passion as the Devi Siddha Lakshmi page, but they describe a poetic theme with Krishna as the central figure.

The assertive energy of the figures in both series is highlighted by their boldly colored images shown isolated against a jarring monochromatic background. The squarish format is typical of tantric paintings of this period (see W. G. Archer 1973, vol. 2, p. 16; Goswamy 1986, p. 198; and Pal 1983, pp. 99–101). Other technical conventions associated with early Pahari painting at Basohli are burnished surfaces highlighted by pricked details in the applied gold and silver and the treatment of jewelry, such as the raised dots of white paint to indicate pearls and the shiny emerald beetle-wing cases applied as details of jeweled ornament.

Here, too, recent scholarship has to be considered. B. N. Goswamy and Eberhard Fischer have amassed evidence that early painting was not entirely centered at Basohli and, in their attempt to focus our attention on certain "master artists" rather than on the characteristics of traditional Pahari schools, have suggested that both the so-called Basohli Devi series and the contemporaneous "Early" *Rasamanjari* series were painted by the same Nurpur artist. Although these suggestions are provocative and may well be proven correct by additional evidence, at the moment we have chosen to regard the Nurpur attribution as an interesting speculation while retaining the traditional Basohli captions, since the artist of these two stylistically comparable series is not named on any colophon or other document.

Later Pahari painting, in contrast, is less intense, reflecting more direct Mughal influence. The choice of texts for illustration expanded to include several great devotional poems and epics, such as the *Gita Govinda, Ramayana,* and *Bhagavata Purana.* Union with God is celebrated in Jayadeva's popular song the *Gita Govinda,* exalting the love of Krishna and his consort Radha, an important subject of miniature painting throughout northern India. In a page from the "Lumbagraon *Gita Govinda*" series painted at Kangra in the 1820s, the separated lovers play out their longing in a lush forest scene made brilliant by a white sweep of moonlight (cat. no. 226). Painting activity at Kangra during the period of Sansar Chand (r. 1775–1823) is well represented in the collection, with exemplary works demonstrating the typically romantic subject matter: two pages from a large *Ramayana* series, a skillfully painted starry night scene (cat. no. 215) and an image of Ravana's abduction of Rama's wife, Sita (cat. no. 216); a *nayika* with two rabbits, here identified as *Dhanashri Ragini* (cat. no. 218); and a painting of Radha reproaching Krishna, here identified as *Khandita Nayika* (cat. no. 223).

The popularity of the *Ramayana* in Pahari painting at the beginning of the eighteenth century is demonstrated by the number of illustrated series devoted to that subject. A large series painted at Mankot about 1700–1710 is represented in the collection by a portrayal of Rama, the hero of the epic, seated upon an outcropping of rocks with his brother Lakshmana and Sugriva, the king of Kishkindha (cat.

no. 241). This style can be compared to that of the contemporaneous "Shangri *Ramayana*" series, in which the bold, squarish faces of the monkeys and figures isolated on one plane against a green or yellow ground are the dominant features (see cat. nos. 212 and 213). The so-called Shangri *Ramayana* is thought to have belonged to the Maharaja of Shangri, a branch of the Kulu royal family, and hence is commonly given a Kulu attribution. However, no other work from Kulu in this period is known. Goswamy and Fischer have suggested for various reasons an attribution to a part of the Jammu kingdom called Bahu (Goswamy and Fischer 1992, pp. 76–79), and because comparable painting styles are known from Jammu in the late seventeenth century, a Jammu attribution seems more plausible than the traditional one. The reader will thus find the Shangri *Ramayana* folios located in the Jammu section of the catalogue.

The later enigmatic Punjab Hill school paintings include a Chamba Durga in a folkish style (cat. no. 202) and numerous royal portraits that exhibit a range of style and approach. The earliest is a portrait here tentatively identified as Raja Mahipat Dev of Mankot, circa 1720 (cat. no. 242). Also noteworthy are portraits of Ajmer Chand of Kahlur (Bilaspur) of about 1730 (cat. no. 196) and Sansar Chand of Kangra of 1800–1810 (cat. no. 222), each typifying the stylized approaches to the sitter in Punjab Hill schools. Since women were confined to separate quarters, few identifiable female rulers were portrayed, which makes the Museum's study of Rani Vantu of Mandi (c. 1750) especially noteworthy (cat. no. 238).

All the portraits are idealized, identifiable largely by inscription. The royal figures are not shown as martial leaders, but as dignified courtiers, engaged in courtly pastimes. In these paintings we see *darbar* scenes and public rituals with attendants or isolated figures; patrons sometimes re-create the milieu of the divinities to whom they devote their worship and patronage. An intriguing subject identified as Baj Bahadur of Kumaon (cat. no. 204), here attributed to a Garhwal artist of the mid-eighteenth century, suggests an area yet to be investigated—the connection between the Hill States and the Rajput courts north of Almora. Garhwal and Kumaon were warring rivals for almost one hundred years, beginning in the early seventeenth century. With the possible exception of Nainsukh's portraits of the Jammu courtiers, Pahari portraits generally do not convey psychological insight or individualized personality. Instead, they represent symbolic aspects of a sitter's rule by means of their composition, motifs, and such details as jewelry, costume, textiles, and ornament that convey the rich texture and wealth of the court.

COMPANY SCHOOL PAINTING

The eighteenth century saw the disintegration of the Mughal empire and with it the growing sway of the East India Company. The defeat of the French at Arcot in 1751 by Company troops led by Robert Clive effectively set the stage for British ascendancy over all India, which was, fundamentally, consolidated over the ensuing century. The British, at first present largely in eastern India in the provinces of Bengal, Bihar, and Murshidabad, not only collected paintings, but also, far more significantly, commissioned new works, largely by Mughal artists (Binney 1972, p. 123). Subject matter naturally expanded to suit the new patrons, and even the paintings commissioned by local princely patrons gradually reflected a similar Europeanizing influence. It is not surprising that the most comprehensive collections of this material, notably the Impey and Johnson collections, are housed in the India Office Library in London (Falk and M. Archer 1981).

Scholars have detailed modifications in technique introduced to suit British patronage, such as the use of lighter washes of watercolor (Losty 1986, p. 66). Styles also changed, as shown in a few notable examples of the Company school, named for the East India Company patrons. A study of a white lily by an anonymous Calcutta artist was part of a series of botanical subjects commissioned by James Nathaniel Rind (cat. no. 246). In addition to naturalist subjects, artists portrayed the residents and their retinues. A pair of unattributed portraits painted on small ivory tablets dating to the nineteenth century depict male and female European sitters (see cat. nos. 244 and 245). An idiosyncratic portrait of the Maharaja of Marwar (cat. no. 153) reflects the contemporary princely taste for Europeanized goods. The British preference for the three-quarter view in portraiture (which triumphed over the profile) and the influence of portrait photography are the underpinnings of this exceptional psychological and cultural study (which has been placed in the Rajasthani section of this catalogue because it was made for a Marwar ruler).

OTHER SCHOOLS

Other schools are represented in the Museum's collection by a single or few examples. Folk paintings of Paithan in Maharashtra are shown by a page from a *Mahabharata* series in the collection (cat. no. 251). The Paithan paintings date from recent times—the late nineteenth century at the earliest—and were used to illustrate a recitation of the epic. In these works the heroes are depicted in the same scale as attendants, animals, and vegetation, in pale colors within black outline.

In Orissa the subject matter is the same as elsewhere in India, but the works are distinctively stylized. There the tradition of palm-leaf manuscript painting continues even today and can be seen in two leaves from an illustrated treatise on love (cat. no. 252).

This continuity, as we have seen, has been a hallmark of the Indian painting tradition—a tradition that was not immune to foreign influences but nevertheless evolved slowly over the five hundred years covered by this catalogue. Many of the works presented here conform to contemporaneous Iranian or earlier Indian models and at the same time subtly depart from them. Subject matter, patronage, and use, as well as local idioms, palettes, and interpretations, contribute to the breadth of this tradition. Even when paintings are inscribed or dated, it is difficult, without documentation, to attribute these works definitively, but our understanding should become more complete as catalogues of comprehensive collections such as that of The Brooklyn Museum become better known and independent pages and folios can be placed in context, as in the original manuscripts.

Map of India

Sites indicated are referred to in the text.

History of the Collection

Although Indian miniature painting has existed for several hundred years in numerous regional styles throughout the subcontinent, only in this century have these paintings been sought after by collectors of "art," and only late in this century in the West has there been a real corpus of collectors outside of museums. The collection of The Brooklyn Museum reflects the varying degrees of American interest in Indian culture throughout the past century; though eclectic, it is, as a result, quite representative of the history of collecting in this field.

The Indian collection was initiated in 1909 when, under the guidance of curators, trustees, and collectors, the Department of Ethnology at what was then the Brooklyn Institute of Arts and Sciences set out to acquire works in all mediums and schools on the institution's first expedition to Asia. This campaign was conducted by the first curator of the department, R. Stewart Culin (1858–1929), who began his tenure at Brooklyn in 1903 by undertaking the first of a series of trips to the American Southwest to collect artifacts of Native American cultures. In 1909 he began what would become a series of expeditions to Japan, China, and India to build the Museum's existing but sparse Asian collections. At the time, non-Western art was generally collected for its "ethnographic" interest, and what eventually became the Asian Art Department was just a section of the Department of Ethnology. (As late as 1929–34, Tassilo Adam occupied the position of Associate Curator of Ethnology as well as that of Curator of Eastern and Near Eastern Art.)

An ethnologist and student of the world's religions, Culin focused not only on the art of each geographic region but also on religious objects and on artifacts of everyday use. His expedition to the East took place more than a dozen years before the publication in America of the first major study of Indian miniature painting (Coomaraswamy 1926). Culin's aim was to establish the foundation for a general collection. Along with miniature paintings—largely of the late eighteenth and nineteenth centuries, purchased in Lucknow and catalogued as Delhi school, which was largely what was available in India at the time, at least to Western collectors—he amassed at least eight hundred Indian objects, artifacts, and archival materials. He collected in a systematic fashion, and his filed reports, which contain day-by-day accounts of his travels, purchases, and meetings with dealers, collectors, and ordinary people, along with information on the history, manufacture, and use of the objects he collected, constitute an important document of collecting in the field at that period.[1]

1. These, and his equally fascinating and instructive reports of his trips to the American Southwest, are in The Brooklyn Museum Archives, Culin Archival Collection Expedition Reports.

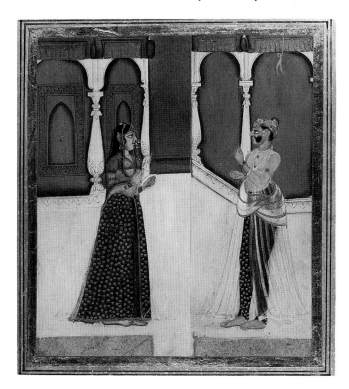

Figure 3

Standing couple

India, Datia

Ink and color on paper

10 x 7⅜ in. (25.4 x 18.7 cm)

Museum Expedition 1914, Museum Collection Fund, and Museum Special Fund, 14.576

Figure 4

Wall hanging (kalamkari)

India, Madras region (Publicat?)

Circa 1610–20

Cotton; drawn and painted resist and mordants, dyed

Overall: 9 ft. ¼ in. x 3 ft. 1¾ in. (275 x 96 cm)

Museum Expedition 1914, Museum Collection Fund, and Museum Special Fund, 14.719.2

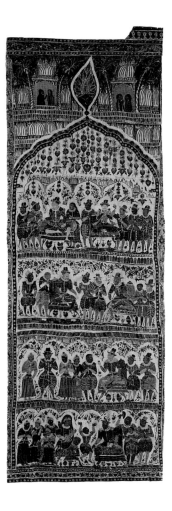

The Delhi school paintings (fig. 3 and acc. nos. 14.36– 14.538, 14.576), now attributed to the Provincial Mughal or Datia/Bundelkand schools, are items now relatively common and easily available, but the expedition yielded as well The Brooklyn Museum Hanging (fig. 4), a curtain comprising seven mordant-printed and dyed wall hangings produced on the Coromandel Coast in the first quarter of the seventeenth century (Gittinger 1982, pp. 80–108).

In 1923 and 1924 Culin made what was perhaps to be his greatest addition to the Museum's Indian painting collection by acquiring nine folios of the *Hamza-nama*. Commissioned by the Mughal Emperor Akbar and painted during the years 1562–77, the series originally consisted of as many as fourteen hundred paintings on cotton, all illustrating the mythical exploits of Muhammad's uncle Amir Hamza (see pp. 61–69). In 1739 the paintings, or at least some of them, were appropriated by the Iranian ruler Nadir Shah after his successful sack of Delhi. The series was eventually broken up, some portions remaining in India and others reaching Iran. In 1912 Riza Khan Monif, a general in the

Iranian army who ultimately settled in New York, acquired from the Shah of Iran's sister an album, bound in red leather and stamped with the seal of the royal Iranian library, containing twenty-six paintings from the series. He sold two of them in Paris, but in 1923, after his death, the remaining twenty-four paintings were put up for auction,[2] at which most failed to sell. Culin apparently acquired his nine paintings in two lots: five from the Anderson Galleries (predecessor of Parke Bernet Galleries) and four from Monif's son, the Persian art dealer H.K. Monif. The prices ranged from $150 to about $300 per page. Museum correspondence reveals that Culin subsequently wanted to purchase more but was thwarted by his superiors, who felt that he had already bought enough in one narrow area and should turn his attention elsewhere. Culin also acquired an entire rest house from a Jain temple at Ahmedabad, as well as several Jain cosmological diagrams (cat. nos. 187 and 188).

In Culin's time, only a few American museums showed any interest in the art of India, among them the Museum of Fine Arts, Boston, the Metropolitan Museum of Art, New York, and the Cleveland Museum of Art. From the 1920s until the late 1950s, the views of most American collectors, curators, and dealers were, not surprisingly, formed by the writings of the pioneers in the field, the most influential of whom in America was the scholar Dr. Ananda K. Coomaraswamy (1877–1947), who served as Curator of Indian Art at the Museum of Fine Arts from 1917 to 1947.

Coomaraswamy's interest in Indian painting was more than merely scholarly, as is evident from his personal collection, from which Laurance P. Roberts, Brooklyn's Curator of Eastern Art (1936–42), purchased in 1936 the first paintings from Rajasthan and the Punjab Hills to enter the collection (cat. nos. 147, 161, 199, 201, 202, 207, 217, 222–24), as well as four other paintings. The British scholar Percy Brown described the atmosphere that had prevailed since the turn of the century, which was surely current when Culin and Coomaraswamy began their tenures at their respective museums:

Less than twenty years ago the West had settled down to the comfortable feeling that there was no such art as painting in India. The few publications on Indian art previous to that time distinctly state that the country is deficient in pictorial art. The acceptance of this dictum simplified matters, and made what little there was of this subject comparatively easy. It is true, a certain number of decoratively coloured miniatures had at different times been obtained from India, but these were usually catalogued as Persian, and actually sometimes as Chinese. (P. Brown 1918, p. 5)

2. There is some suggestion in the Museum Archives that Monif may have sold four of the paintings in Paris, leaving only twenty-two for the sale in New York.

In his series of catalogues of Boston's collection of miniature paintings, Coomaraswamy identified specific themes from Hindu mythology and literature and also recognized the symbolic use of color and images in these works (Coomaraswamy 1926 and 1930). In America during the 1920s and 1930s, his influence was stronger than that of any other individual. His taste and ideas, and particularly his interest in paintings from the indigenous (or Rajput) traditions of India as well as those of her Mughal conquerors, were not limited to his acquisitions for Boston. The correspondence files and accession records of the 1930s at The Brooklyn Museum provide significant evidence of Coomaraswamy's connection with the institution. His influence was present too in the great (now dispersed) collection of the art dealer Nasli M. Heeramaneck, New York (Heeramaneck 1935–36).

It is common knowledge that in the period 1936–38, through a process of deacquisition, the Museum lost five of the nine great *Hamza-nama* folios in exchange for other oriental antiquities. The curator at the time, the distinguished scholar Laurance P. Roberts, believed that nine were five too many *Hamzas* to exhibit. He actively offered pages for exchange and did trade one page to the University of Pennsylvania Art Museum (now in the Philadelphia Museum of Art) for what he described as "a Chinese figurine or so," and the remaining four to the dealer Nasli Heeramaneck, three in exchange for four miniatures from India dating from the sixteenth through eighteenth centuries (cat. nos. 46, 138, 210, and App. D76) and the fourth for an eighteenth-century Rajasthani textile, now considered to be of indifferent quality. A *Hamza-nama* page in the collection of the Art Institute of Chicago and another in the collection of the Cincinnati Art Museum both were among the group of four exchanged with Heeramaneck.

When the dealer H.K. Monif sought to purchase from among the remaining pages, he was told, "I am afraid that I have no more Hamza Namahs, save the four on exhibition, and since they must remain there, I will not be able to exchange any" (letter of Laurence P. Roberts to Mr. H.K. Monif, January 31, 1939, The Brooklyn Museum Archives). By today's standards, these exchanges were hardly advantageous to the institution. Mr. Roberts, however, was not disenchanted with Indian painting; Museum records show that in 1936 the very same meeting that approved the deaccessioning of the *Hamzas* authorized $400 for "the purchase of two Jain miniatures from Mr. N.N. [*sic*] Heeramaneck," and in that same year Roberts also acquired for $1,000 fourteen Indian miniatures from Dr. Coomaraswamy. The records show that "of this lot five are purchased and the remaining nine (9) are to be given to the Museum contingent on purchase."[3]

nine (9) are to be given to the Museum contingent on purchase."[3]

Coomaraswamy and other scholars of the pre–World War II generation were generally concerned with the explication of subject matter, and only secondarily with the identification of regional or local styles. The period of collecting and scholarship following the war focused on distinguishing and classifying various styles under such terms as Rajput (or Rajasthani) and Punjab Hills (or Pahari), among others. In the United States until well after World War II, Pahari paintings (from the Punjab Hills of northwest India) were viewed as an extension of the Mughal "court art" tradition, and it became fashionable to collect late-eighteenth-century paintings of the Pahari schools of Guler, Kangra, or Basohli, which were seen as graceful interpretations of the Mughal style, as well as sympathetic treatments of the nuances of love themes, a trait of Pahari paintings of this period (for example, cat. no. 223, one of the paintings acquired from Coomaraswamy in 1936).

From 1940 to 1958, the Museum paid little attention to its collection of Indian miniatures; only three outstanding works (cat. nos. 45, 140, 197) and a handful of minor works (for example, cat. nos. 38, 42, 49, 57, 64, 103) were acquired during this period. The years 1959–67 were equally somnolent, except for the gifts arranged by Roy R. Neuberger of two groups of Hyderabadi miniatures (then thought to be Mughal) from the distinguished lawyer James S. Hays (cat. nos. 73–83, 91–93, 96–98, 100) and from Philip P. Weisberg (cat. nos. 84–90, 94, 95, 99). Until 1967, the Museum apparently did not purchase any Indian paintings.

The world outside, however, was not at a standstill. In 1952 W.G. Archer published the first of his many books on Pahari painting, *Indian Paintings in the Punjab Hills,* in which he identified several of the local centers of the style represented in the collection of the Victoria & Albert Museum. Although the encyclopedic, handsomely illustrated work of 1958, *Pahari Miniature Painting,* by the noted Bombay lawyer, collector, and scholar Karl Khandalavala brought together all the known information on the full range of schools in the Punjab Hills, and other scholars in India, such as Moti Chandra, Jagdish Mittal, and Anand Krishna published extensively, Archer remained the most influential author among Western art historians. The exhibition of the

3. While Coomaraswamy's combination of sale and donation is familiar in today's museum world, Roberts's observation that the four remaining *Hamza* pages were all on view is in marked contrast to current museum practices; conservation considerations require rotation of such paintings as the *Hamza-nama* pages. Were Mr. Roberts today desirous of having two *Hamza* pages on view at all times, he would probably be constrained to keep the additional pages on hand for rotation purposes.

Archers' own collection of Pahari paintings that toured the United States in 1958 proved to be a most effective instrument in popularizing Pahari painting in America.

In light of Archer's analysis and the growing body of scholarship in the 1960s and 1970s, classification of some of the Museum's earlier acquisitions had to be reconsidered, among them a Pahari *Ragamala* page purchased in 1936 from Coomaraswamy (cat. no. 199), now dated to about 1750 as from Bilaspur, and a remarkable page depicting Durga defeating the demon Raktabij, a gift from Coomaraswamy acquired that same year as folk Pahari, which is now seen as an early-nineteenth-century work of the Chamba school (cat. no. 202). The only painting from the Punjab Hills region acquired by the Museum since its *Hamza* exchange and its initial purchases and gifts from Coomaraswamy in the mid-thirties, a magnificent portrayal of the boar avatar of the god Vishnu (cat. no. 197), was reattributed to the Hill state of Bilaspur almost thirty years after its acquisition.

It was in the 1970s that American scholars, too, began to publish and analyze earlier documents and chronicles in search of a definitive means of classifying the different schools of Indian miniature painting. New manuscripts, often with important colophons and inscriptions, were discovered, affecting scholarship as well as collecting. A series of excellent exhibitions with catalogues by Edwin Binney, 3rd (known as a collector but also a scholar), Stuart Cary Welch (known as a scholar but also a collector), and Milo Cleveland Beach, together with the known collecting activities of such public figures as John Kenneth Galbraith and Jacqueline Kennedy Onassis, thrust the subject into prominence. All this activity stimulated further interest among a new group of collectors, making the late 1970s and the early 1980s a lively and exciting time for curators and collectors in the field. Perhaps as a result, a new generation of younger scholars in this country, in Europe, and in India, increasingly able, in the case of Western scholars, to read firsthand inscriptions and original source material, has been making new discoveries and revising our views.

The Brooklyn Museum has been part of these activities, as is evident in its recent acquisitions. Whereas the 1960s saw a few painting acquisitions (eleven paintings, mostly from Rajasthan, and five loans, which later became gifts, from various schools), the 1970s saw almost forty paintings added to the collection, and the 1980s more than one hundred. The groundwork for this growing activity had been laid during the tenures of Lois Katz (Associate Curator in charge of the Department 1961–70) and Stanislaw Czuma (Curator 1970–71), both of whom were keenly interested in Indian art. Ms. Katz had actively assisted in the acquisitions of Ernest Erickson and Paul E. Manheim, both trustees of the Museum, several of whose paintings later entered the collection (for example, cat. nos. 40, 194, and 195), and instigated the first Brooklyn Museum–sponsored members' tour of India.

A turning point for The Brooklyn Museum's collection occurred in 1978 with the exhibition *Visions of Courtly India: The Archer Collection of Pahari Miniatures.* This presentation, which was the second group of miniature paintings selected for a tour from the personal collection of Mr. and Mrs. W.G. Archer, spurred a renewed interest at The Brooklyn Museum in its own holdings. The late 1970s and the decade of the eighties were years when it was still possible to purchase major paintings at prices that, if not low, were still reasonable in comparison with those in other schools of painting. A few purchases of key works in areas less well represented in the collection, made possible by the Museum and/or by the Oriental Art Council, run the gamut of what has been on the market—Company school, Pahari, Rajasthani, Deccani, even Mughal paintings, although in this last area the escalating prices have severely limited acquisitions. Members of the Asian Art Department made major efforts to find specific works of exceptional quality to fill the lacunae and place them in the hands of its friends when, as usually occurred, the Museum's own purse could not afford such purchases.

Commencing with the gift of the 1525–40 *Bhagavata Purana* page (cat. no. 18) by Peter and Wendy Findlay in 1980, the Museum has thus been able to add to its collection pages from major manuscripts or even series, thanks largely to the generosity of this small group of donors. Among these choice items are the *Dipaka Raga* (cat. no. 115, Gift of Charlene and S. Sanford Kornblum), *Maharaja Jaswant Singh of Marwar* (cat. no. 153, Gift of Mr. and Mrs. Robert L. Poster), a page from a seventeenth-century Basohli *Devi* series (cat. no. 191, Gift of Mr. and Mrs. Robert L. Poster in honor of Dr. Bertram H. Schaffner), the Company school botanical study (cat. no. 246, Purchased with funds given by Mr. and Mrs. Willard G. Clark), and the *Stalling Elephant* (cat. no. 58, Promised Gift of Dr. Bertram H. Schaffner). A review of the accession numbers in this catalogue shows that approximately half the paintings illustrated were acquired since 1978, a record that should be encouraging to those who, after reading this volume, feel the stirrings of an aspiration to collect. As of this writing, The Brooklyn Museum collection of Indian painting consists of more than two hundred fifty items. It is a rich assemblage of painting styles that range from the fifteenth through nineteenth centuries, all of which represent important phases in the history and development of Indian painting.

Since 1978 monumental studies on the schools of Rajasthan, Central India, and Pahari painting, as well as investigations of individual painters, manuscripts, and sources in situ have added to our knowledge. Especially in the case of Rajasthani painting, but also in other fields, postwar scholarship has largely taken the form of exhibition catalogues. Of late, however, younger scholars have been publishing independent scholarly works as well, a healthy sign of the growing maturity of Indian painting scholarship. The

Museum has not only benefited from this recent scholarship, but it has also contributed to this activity. Four lecture programs have brought scholars, collectors, and the general museum audience together in public forums: in 1978, an exhibition and a lecture by Barbara Stoler Miller in honor of her translation of the *Gita Govinda, Love Song of the Dark Lord* (1977); in 1978, a series concerned with Pahari painting; in 1981, an examination of topics related to botanical subjects in Indian painting; in 1982, sessions devoted to the subject of the goddess in Indian art. Between 1980 and 1990, the Asian Art Department presented seven exhibits in the permanent galleries, which examined the collection from thematic, regional, and technical standpoints.

The catalogue presented here is a direct result of this burgeoning scholarly activity, and joins the catalogues of the Indian painting collections of other American museums. It reflects recent research in the area of themes, the recognition of schools and centers of production, the establishment of dates, the identification of groups of painters, and the attribution of individual works. To accomplish this, the Museum has had the good fortune of being able to enlist the expert aid of colleagues in the field, among them Joachim Bautze, Pramod Chandra, Vishakha N. Desai, Saryu Doshi, Daniel Ehnbom, Catherine Glynn, B.N. Goswamy, Naval Krishna, Barbara Stoler Miller, John Seyller, Gursharan Sidhu, and Robert Skelton, to ensure correct identifications and proper translations and, in short, to take care that all scholarly apparatus is in place.

AMY G. POSTER

Indian Paintings at
The Brooklyn Museum

Note to the Catalogue

In dimensions given in catalogue entries, height precedes width. Brief inscriptions giving information such as title, artist or attribution, and date are given in caption at the head of the entry. They are rendered in English, with original language and type of script indicated. When an extended text has been translated, the translation is given in the body of the entry. The translation follows the original, preserving any apparent errors or inconsistencies, which may reflect local dialect. Full citations for abbreviated bibliographical references are found in the Bibliography.

Definitions of words that appear in italic may be found in the Glossary, which also includes explanations of Indian epics, religions, and so forth. Definitions of words referring to items of dress, rituals, class, and the like set in Roman type appear in Webster's Third New International Dictionary. Sanskrit terms without diacritical marks observe the system found in that same volume. Translations of place names and other geographical terms generally follow the spelling given in the historical atlas of South Asia edited by Joseph E. Schwartzberg (Schwartzberg 1978; see Bibliography).

In the rendering of dates:

A.H. The era *anno Hegirae,* reckoned from A.D. 622, the year of Muhammad's flight from Mecca.

V.S. The era *Vikram samvat,* generally used in northern India, reckoned from 57 B.C.

Contributors to the Catalogue

MA Marjan Adib
JKB Joachim K. Bautze
NB Nadine Berardi
SRC Sheila R. Canby
JC Joan Cummins
LSD Layla S. Diba
ME Maryam Ekhtiar
SM Sonali Mitra
AGP Amy G. Poster
UR Usha Ramamrutham
JS John Seyller

Pre-Mughal Painting

WESTERN INDIAN PAINTING

1 Artist unknown

Leaf from a dispersed Jain manuscript of the Kalakacharya-katha

Western India, Gujarat
Circa 1450–75
Opaque watercolor and gold on paper
Image
Recto 4⅜ x 3 in. (11.1 x 7.6 cm)
Verso 4⅜ x 2⅞ in. (11.1 x 7.3 cm)
Sheet 4⅜ x 10½ in. (11.1 x 26.7 cm)
A. Augustus Healy Fund, 36.235

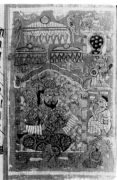

On the recto, shown against a red field superimposed on a gold ground, the figures of the scene are depicted in compartmentalized areas. At the left, a richly costumed Sahi king holding a scepter sits on an elaborate throne supported by stylized lions and surmounted by three parasols ornamented with parrots. His Mongolian appearance is emphasized by his prominent beard and queue. In about one-fifth of the remaining space on the right, which is divided into compartments, Kalaka (second from the bottom) is shown with a warrior above and an attendant Sahi below. Although he is the hero of the narrative, Kalaka is represented as a diminutive seated figure, holding the bowl brought to him by the overlord's messenger.

Whereas the Sahi warriors are depicted in the same frontal manner as the main figure, Kalaka is shown in typical profile with the protruding "farther eye." The Sahi's costume is treated as elaborate textiles, patterned with large gold and green rosettes enclosed in gold circles on a red ground. Around his shoulders is a close-fitting cape ornamented with red-on-gold scroll designs that, like epaulets, extend beyond the garment. The attire of the attendant is rendered in a simple checkered pattern. Kalaka's monastic robe leaves his right shoulder bare. The offending Sahi understands that he cannot expect mercy and must take his own life with the sword. When the deed is completed, the messenger will return to his master with the severed head in the bowl. (For similar treatments of the subject, see cat. no. 12, and Brown 1933, figs. 21, 22, 28, 33.)

In the bipartite illustration on the verso, in the scene in the upper register, Kalaka stands to the right of a flaming brick kiln, extending his right arm to turn the bricks to gold by his touch. He is distinguished by the same monastic garment, while the other figures appear in military garb. An equestrian figure to the right of Kalaka is the Sahi king, identified by a royal parasol above him. The scene in the lower register repeats the figure of the Sahi king on horseback to the right of three Sahi foot soldiers. Two of the figures hold shields and weapons, while the third carries gold bricks on his head. (For similar treatment of the subject, see Brown 1933, figs. 15, 29, 37.)

The use of both Persian and Indian figural styles is an interesting aspect of Jain manuscript illustration. In this example, the Sahi king shown on the recto is depicted in the

Persian style. Bearded and dressed in a costume of an emphatic geometricized floral pattern, he is seated frontally in a posture of royal ease, while the other figures exemplify the indigenous traits of Western Indian manuscripts.

Both sides of the leaf have wide margins above and below the text, which is written in Devanagari script. The numbers of the verses are indicated in red. In the center of each side is a red dot or stylized floret suggesting the placement of the string hole found in earlier palm-leaf manuscripts. The horizontal format of the page also refers to the traditional palm leaf used for writing canonical texts.

The page has been repaired and new margins added. AGP
Provenance Nasli M. Heeramaneck, New York.

2 Artist unknown

Leaf from a Jain Kalpasutra manuscript

Western India, Gujarat
Late 15th century
Opaque watercolor and gold on paper
Image 4⅛ x 2¾ in. (10.5 x 7 cm)
Sheet 4¼ x 10⅛ in. (10.8 x 25.7 cm)
Gift of Nasli M. Heeramaneck, 36.301

On the recto, a single Tirthankara, who apparently symbolizes the twenty-three Tirthankaras who preceded Mahavira, sits cross-legged on a throne under a pointed arch supported by columns. His right hand is raised in the gesture of teaching. His left hand lies in his lap. He is dressed in the

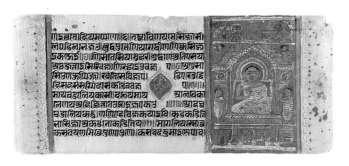

white robe of the Shvetambara monks, the color indicated by white dots on a gold ground. The outline of his body is visible through the robe. Standing on either side of the Tirthankara, beneath brackets that project from the tops of the columns, are monks in similar robes, their hands joined in adoration. Above them, a small figure is seated on each bracket.

The eight auspicious symbols (*ashtamangala*) regularly associated with the Tirthankaras are, reading from the upper left corner: "mirror (*dappana, darpana*), throne of distinction (*bhaddasana, bhadrasana*), powder vase (*vaddhamanaga, vardhamanaka*), full water vessel (*kalasha, kalsha*)"; reading from the lower left corner: "pair of fish (*matsyaugma*), the *sirivaccha* (*shrivatsa*) symbol, the *nandiyavatta* (*nandyavarta*) symbol, and the *sotthiya* (*svastika*) symbol" (Brown 1934, p. 12).

The figures, the architecture, and the symbols are painted in gold, with red, white, and black details. The background is blue. The central lozenge, which contains a full water vessel with two eyes, as depicted in the upper right corner, is shown in red and gold on a blue field. The vertical margins of the illustration and the left margin of the page are marked by gold borders, beyond which blue and red scroll designs extend outward toward the edges of the page spotted with red. The text is written in black ink with red verse markings.

The verso, which contains only text, is decorated with three lozenges, the two in the margins enclosing gaily caparisoned horses.

A similar scene is illustrated in Coomaraswamy 1926, Part 4, pl. IV, fol. 2, and pl. XV, fol. 2. Coomaraswamy views this figure as Mahavira, but W.N. Brown (1934, p. 12, fig. 4) identifies an almost identical scene as of Tirthankara. Further similar scenes are illustrated in Shah 1932, pl XIV.

The *Kalpasutra* is one of the canonical works of Jainism, an essentially Indian religion based on devotion to austerity. Along with the *Kalakacharya-katha* it was one of the favorite Jain texts chosen for illustration. Large numbers of these texts have been preserved, though works of distinguished quality are rare. AGP

Exhibitions The Art of Greater India, Los Angeles County Museum of Art, March 1–April 16, 1950, cat. no. 80; *Art in Asia and the West,* UNESCO exhibition, San Francisco Museum of Art, Civic Center, October 28–December 1, 1957, cat. no. 24c.

3 Artist unknown

Leaves from a Jain Kalpasutra manuscript

Western India, Gujarat. At Shripattana (Patana)
V.S. 1529/A.D. 1472
Opaque watercolor and ink on gold leaf on paper
Gift of Dr. Bertram H. Schaffner, 1994.11.9–107

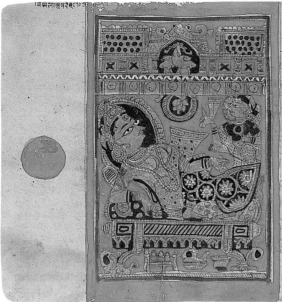

माद्रणी सयणिक्रं सिक्खडगारसउदीरमाणीपरि
मियासुव उगलकल्लाण सिबधनमंगल्ल मस्रि
रण चउदससमदाससुमिणा तिसलाखत्तियाणी
णदडणसिन्नाण पडिबुद्धा तेंडडा
गायवसहगादा यणंरयणिचण
समाणा लगवंसमहावीर दवाणंदासरम
रहणी एणालेधरसण्णाण करिडउतिसलाख
त्तियाणीण वासिहसण्णाण करिडसिगरहणासस
दरिण तेरयणिचणं सादवेतिसलाखत्तियाणी तं

१६

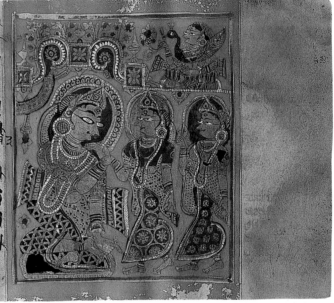

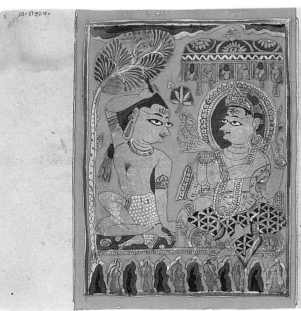

वरदवणसुक्काउ अहारमसमाणासादस्मी
व ताक्कासियासमाणा संएयाङग्डा णणुरर
दरेण अहिदतनिम्स अक्कडकिणियासु
रक्कात वह्याली संछझियामादस्मी
वं ताक्कासियाछडियासंएयाङ्क
गादवर अरदऊंगंडण नदयासुका
णं समणावमिडियाणं एगासयसादस्मीव
झाडरिचसदस्मा ताक्कासियासमाणावस
गसंएयाङ्कडा अरदऊंगंडण महासुबया

41

A

Trishala reclining

Recto

Image 4⅜ x 2⅞ in (11 x 7.4 cm)

Sheet 4⅜ x 10¼ (11 x 26 cm)

INSCRIPTION

In lower right margin, in gold pigment, in Devanagari script: *16.*

1994.11.23

In this elaborate scene, Queen Trishala, shown with an oval halo, reclines on a couch in her palace following the mystical visit of Harinegameshin. The narrative relates that Harinegameshin was ordered by the god Shakra (Indra) to transfer the embryo of Mahavira from the womb of Devananda, of the priestly Brahman caste, to that of Trishala, of the warrior Kshatriya caste. The queen's costume consists of a green choli, a long black skirt decorated with white and red flowers, and a gold patterned scarf. A female attendant stands to the right, and foods are arranged in several vessels in the foreground. The architectural setting is ornamented at the center with a pair of geese with intertwined necks. (For a similar treatment of the subject, see Brown 1933, p. 18, fig. 17.)

B

Trishala's grief

Recto

Image 4⁷⁄₁₆ x 3½ in. (12 x 9.1 cm)

Sheet 4⁷⁄₁₆ x 10¼ in. (12 x 26 cm)

INSCRIPTIONS

In Devanagari script

Recto, in upper left margin: *Trishala's grief.*

Verso, in lower right margin: *37.*

1994.11.45

The pregnant Queen Trishala, seated at left, is comforted by two female attendants who stand at the right. She is bedecked with jewelry and richly decorated garments. The three women are haloed and wear a distinctive triangular tiara. (For a comparable image of the subject, see Brown 1933, p. 29, fig. 53.)

C

Mahavira's renunciation

Image 4⅜ x 3¹⁄₁₆ in. (11 x 7.8 cm)

Sheet 4⅜ x 10¼ in. (11 x 26 cm)

INSCRIPTIONS

In Devanagari script

In top left margin: *Mahavira;* in lower right margin: *48.*

1994.11.56

At the left, the Tirthankara Mahavira, seated under the ashoka tree with his right leg crossed over his left ankle, takes hold of his queue. He looks over his left shoulder at Shakra, seated on a cushion under a decorated parasol at his right. Shakra is haloed and four-armed, holding offerings in his two upper hands and an elephant goad in his lower left hand. Below are mountain peaks. (For a comparable treatment of the subject, see Brown 1933, p. 34, fig. 73.)

The life of the savior Mahavira, the twenty-fourth Tirthankara, whose symbol is the lion, is the subject of this complete illustrated manuscript. Its ninety-nine leaves are on deposit in the Museum; fifty-six of them bear illustrations of fine quality. The text is in Prakriti. The colophon (the missing page, presently in a private collection) records the date as Samvat 1529. The format of each page conforms to a standardized canonical formula with small rigid figures drawn in rectangular compositions, as if icons.

Typical of the Western Indian painting style at its height during the fourteenth through sixteenth centuries, the Tirthankara is shown haloed, while the subordinate figures, such as the mother of the Savior (who is also haloed) and his devotees, who turn toward him, are shown with their bodies in profile and their heads in three-quarter view, with the typical feature of the "farther eye" projecting beyond the facial contour (suggesting a multiple viewpoint). Torsions of body and gestures are drawn schematically with a continuous angular contour line.

The garments are drawn in a stylized manner, as in the jutting triangular point of the cloth ends of the women's attire (noted by Kramrisch 1975, p. 401). The fabrics of clothing and cushions are decorated with elaborate geometric patterns, lending a festive accent to each page. The figures are framed by such abbreviated architectural or landscape elements as detailed columns, canopies, roofs, rocks, and trees. (For a discussion of the stylistic repertory and mode of Western Indian Jain painting, see Kramrisch 1975.)

The fine quality of drawing and painting in a variety of pigments, among them ultramarine blue and carmine accented with gold, is similar to a *Kalpasutra* manuscript in the Philadelphia Museum of Art that is dated to 1432, a series that Kramrisch describes as a quintessential example of the "self-assured overstatement" of the Western Indian style in "the last creative phase in the fifteenth century" (ibid., pp. 399 and 398). AGP

4 Artist unknown

Mahavira preaching at the Gunashilaka shrine

Leaf from a dispersed Jain manuscript of the *Kalpasutra*

Western India, Gujarat

15th century

Opaque watercolor and gold on paper

Image 3 x 3¼ in. (7.8 x 8.2 cm)

Sheet 4½ x 11⅜ in. (11.4 x 28.9 cm)

Gift of the Ernest Erickson Foundation, Inc., 86.227.48

INSCRIPTION

In lower right margin, in black ink, in Devanagari script, twice: *119.*

This *Kalpasutra* page is illustrated in the Western Indian style, which is characterized by flat, linear forms, sharp angular contours, and faces generally in profile with the farther eye protruding into space. The scene on this sheet depicts the Jain saint Mahavira seated on a spired throne with a face cloth in hand, preaching the *Samachari,* i.e., the "Rules for Monks at the Paryushana Season," the third part of the *Kalpasutra.* The panel, on the right side of the recto, is painted on a gold ground in white, blue, and black on the usual red field. Opposite Mahavira, on a lower seat, a monk receives instruction. In the row below, six figures seated on cushions are (from right to left): two laywomen (or goddesses), two nuns, and two laymen, figures who seem to constitute the *Sangha* (see Brown 1934, p. 63, figs. 150 and 151).

Our folio differs from a representation of the event in a similar, undated manuscript of the *Kalpasutra* in the Freer Gallery of Art, Washington, D.C. (ibid., p. 44), in which the scene is divided into two independent panels: Mahavira preaching to a monk as one picture (ibid., opp. p. 63, fig. 150), and three laymen, three laywomen, and two nuns in three separate registers of a second picture (ibid., fig. 151). AGP

Literature Katz 1963, cat. no. 120; Poster 1987, cat. no. 120.

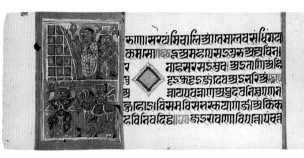

5 Artist unknown

Kalaka converts the bricks to gold

Leaf from a dispersed Jain manuscript of the *Kalakacharya-katha*

Western India, Gujarat

15th century

Opaque watercolor and gold on paper

Image 3¹⁵⁄₁₆ x 3⁹⁄₃₂ in. (10 x 8.4 cm)

Sheet 4½ x 11¼ in. (11.5 x 28.6 cm)

Gift of Martha M. Green, 1991.181.10

INSCRIPTIONS

In Devanagari script

Recto, in bottom right margin: *9.*

Verso, at upper left: *Powder.*

The illustration, on the verso, is at the left side of the page. In the upper left corner Kalaka, shown with an aureole behind his head, stands before a flaming brick kiln, "his right hand outstretched to sprinkle upon it the magic powder that converts the bricks to gold" (Brown 1933, p. 142). As in other representations of this episode from the *Kalakacharya-katha,* the figure standing behind him, who carries two gold bricks on his head, is a Shaka soldier, identified by his chain-mail armor. In the left corner of the lower register, a second Shaka soldier, here dressed in a dhoti, also carries two gold bricks on his head. At the right, a figure mounted on horseback completes the scene. The three figures shown with Kalaka are foreigners, identified not only by their armor but also by their Mongolian features.

For a similar treatment of the subject, see ibid., figs. 15, 29, 37.

For another illustration of this scene, see catalogue number 6. AGP

Provenance Paul E. Manheim, New York.

6 Artist unknown

Kalaka converts the bricks to gold

Leaf from a dispersed Jain manuscript of the *Kalakacharya-katha*
Western India, Gujarat
15th century
Opaque watercolor and gold on paper
Image 3¹⁵⁄₁₆ x 3⁹⁄₃₂ in. (10 x 8.4 cm)
Sheet 4½ x 11¼ in. (11.5 x 28.6 cm)
Gift of Martha M. Green, 1991.181.11

INSCRIPTIONS

In Sanskrit, in Devanagari script
Recto, at upper left: *Guru throwing the powder;* at lower right: *137.*

The subject and treatment of this episode, on the recto, are similar to those of catalogue number 5. However, in this illustration the bricks in the kiln are more numerous and are more elaborately ornamented. Also, the decorative elements of the garments of the Shaka soldiers and the outfit of the caparisoned horse are more ornately patterned.

Three dots on the verso indicate the traditional placement of the string holes in Jain manuscripts. AGP

Provenance Paul E. Manheim, New York.

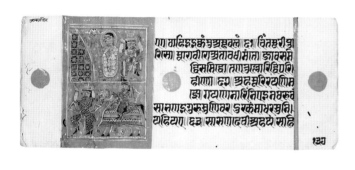

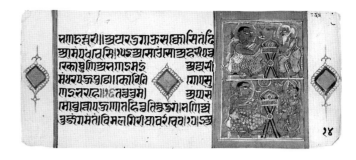

7 Artist unknown

Kalaka with Shakra disguised and revealed

Leaf from a dispersed Jain manuscript of the *Kalakacharya-katha*
Western India, Gujarat
15th century
Opaque watercolor and gold on paper
Image 3¹¹⁄₁₆ x 3⅛ in. (9.4 x 8 cm)
Sheet 4¼ x 10¼ in. (10.4 x 26.1 cm)
Gift of Martha M. Green, 1991.181.12

INSCRIPTIONS

Recto, in upper right margin, in black ink, in Sanskrit, in Devanagari script: *Kalaka;* in lower right margin, in Devanagari script: *14.*

The illustration, on the recto, is at the right side of the page. In the upper register, Kalaka, seated on a throne, is dressed in a dotted robe, a broom under his right arm and his ritual mouth cloth in his right hand. Shakra, one of the sixty-four Jain leaders, disguised here as an old Brahman, extends his hand before him to have his fortune told. In the lower register, Kalaka is again shown seated at the left, here dressed in a robe decorated with clustered dots. According to Brown (1933, p. 130), Kalaka "addresses Shakra, who now faces him in full regalia, two of his four arms upraised in a posture of worship. Between the two is the stand with the symbolic representation of Kalaka's absent *guru* (spiritual mentor)."

The two episodes concerning Shakra, here combined in one image, are represented on separate pages in other versions of the *Kalakacharya-katha* (see ibid., figs. 19, 20, 31, 32). AGP

Provenance Paul E. Manheim, New York.

8 Artist unknown

Kalaka with Shakra disguised and revealed

Leaf from a dispersed Jain manuscript of the *Kalakacharya-katha*
Western India, Gujarat
15th century
Opaque watercolor and gold on paper
Image 3¹¹⁄₁₆ x 2⅜ in. (9.4 x 6.1 cm)
Sheet 4½ x 11⅜ in. (11.5 x 28.9 cm)
Gift of Martha M. Green, 1991.181.13

INSCRIPTIONS
In black ink, in Sanskrit, in Devanagari script
Recto, in upper left margin: *Samyaghavara* (?); in lower right margin: *9.*

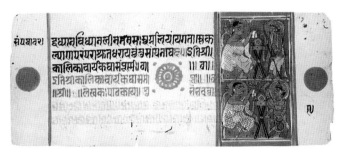

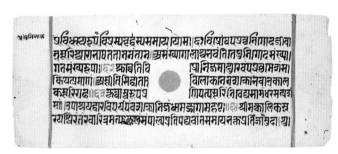

The illustration on the recto appears at the right of the page. The subject and treatment of this episode are similar to those of catalogue number 7. AGP

Provenance Paul E. Manheim, New York.

9 Artist unknown

Kalaka with Shakra disguised and revealed

Leaf from a dispersed Jain manuscript of the *Kalakacharya-katha*
Western India, Gujarat
15th century
Opaque watercolor and gold on paper
Image 3¹⁵⁄₁₆ x 2¾ in. (10 x 7 cm)
Sheet 4¼ x 10¼ in. (10.4 x 26.1 cm)
Gift of Martha M. Green, 1991.181.14

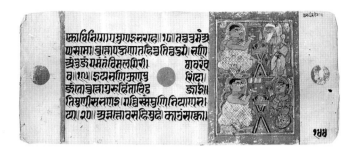

INSCRIPTIONS
In black ink, in Sanskrit, in Devanagari script
Recto, at upper right: *The Realm of the Guru Indra [Guru Indra Désaji];* at lower right: *177.*

The illustration on the recto appears at the right side of the page. The subject and treatment of this episode are similar to those of catalogue number 7. AGP

Provenance Paul E. Manheim, New York.

10 Artist unknown

The siege of Ujjain and the defeat of the magic She-Ass

Leaf from a dispersed Jain manuscript of the *Kalakacharya-katha*
Western India, Gujarat
15th century
Opaque watercolor and gold on paper
Image 4⅛ x 2⅝ in. (10.5 x 6.7 cm)
Sheet 4⁵⁄₁₆ x 10³⁄₁₆ in. (11 x 25.9 cm)
Gift of Martha M. Green, 1991.181.15

INSCRIPTIONS
Verso, in upper left margin, in black ink, in Devanagari script: *King Gadha;* in lower right margin, in Devanagari script: *8.*

The illustration on the recto is on the left side of the leaf. A semicircle emerging from the left margin forms the city wall of Ujjain, with a gate at the center. King Gardabhilla sits within, a brazier before him, "which he has used in effecting

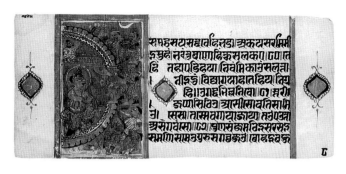

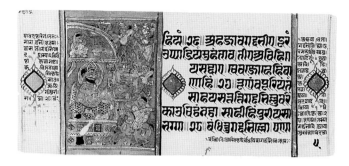

the magic" (Brown 1933, p. 128, fig. 16). The She-Ass is at the gateway, its mouth open, prepared to bray. Shown above the king is the captive nun Sarasvati, with two vessels before her. In order to repel the advances of Gardabhilla, she is fasting. Outside the city wall three Shaka archers on foot, dressed in armor and equipped with drawn bows, hold the city siege. Their attire and facial features indicate their Mongolian origin. In the lower right corner, Kalaka is shown with a drawn bow on a spotted horse.

The composition is enclosed by a cloud in the upper right corner and a flowered scroll at the bottom of the image.

For comparable images, see ibid., figs. 16 and 30.　AGP

Provenance　Paul E. Manheim, New York.

11　Artist unknown

The siege of Ujjain and the defeat of the magic She-Ass

Leaf from a dispersed Jain manuscript of the *Kalakacharya-katha*
Western India, Gujarat
15th century
Opaque watercolor and gold on paper
Image 4¹⁄₁₆ x 2¹³⁄₁₆ in. (10.3 x 6.7 cm)
Sheet 4½ x 10⅛ in. (11.5 x 25.7 cm)
Gift of Martha M. Green, 1991.181.16

INSCRIPTIONS

Verso, at bottom of leaf, in black ink, in Devanagari script: *Gardabhilla surrounded by the Sahis;* in lower right margin, in Devanagari script: *5.*

The illustration on the recto appears at the left side of the leaf. The subject and treatment of this episode are similar to those of catalogue number 10.　AGP

Provenance　Paul E. Manheim, New York.

12　Artist unknown

Kalaka and Sahi

Leaf from a dispersed Jain manuscript of the *Kalakacharya-katha*
Western India, Gujarat
15th century
Opaque watercolor and gold on paper
Image 3¾ x 2¾ in. (9.6 x 7 cm)
Sheet 4¼ x 10¼ in. (10.4 x 26.1 cm)
Gift of Martha M. Green, 1991.181.17

INSCRIPTIONS

Recto, at top right, in black ink, in Sanskrit, in Devanagari script: *shaki* [?]; at lower right, in Devanagari script: *5.*

The illustration, on the recto, is at the right side of the leaf. At the left, an elaborately costumed Sahi sits on a lion throne surmounted by two honorific parasols. His Mongolian appearance is emphasized by his mustache and decorated queue. Before him, in a niche surmounted by crossed military standards, Kalaka sits and preaches. He holds the ritual mouth cloth in his outstretched right hand, while the ritual broom is under his right arm. At the command of his angered overlord, the messenger seen at the lower right has brought the sword held by the Sahi (to take

his own life) and the bowl seen above the Sahi's left hand (to hold his severed head for presentation to the overlord).

The figures are painted in gold on a red ground highlighted with lapis lazuli blue. The three gold-ornamented, blue-bordered lozenges were intended to indicate hole and page numbers.

For similar treatments of the subject, see Brown 1933, figs. 21, 22, 28, 33. AGP

Provenance Paul E. Manheim, New York.

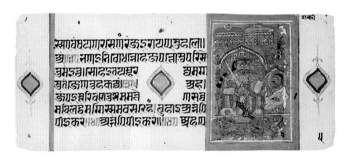

13 Artist unknown

Kalaka hears Gunakara preach; Kalaka exercises the horse

Leaf from a dispersed Jain manuscript of the *Kalakacharya-katha*
Western India, Gujarat
15th century
Opaque watercolor and gold on paper
Image 4⅛ x 2¾ in. (10.5 x 7 cm)
Sheet 4⅜ x 10¹⁄₁₆ in. (11.1 x 25.6 cm)
Gift of Martha M. Green, 1991.181.18

INSCRIPTIONS

Verso, in upper right margin, in black ink, in Sanskrit, in Devanagari script: *Kalaka. . .*; at the lower right corner, in Devanagari script: *1*.

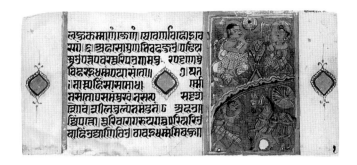

The illustration, on the recto, is on the right side of the leaf. In the upper register, Gunakara sits on an ornamented throne, his mouth cloth in hand, preaching to Kalaka, who sits opposite, his hands raised in a gesture of reverence. Between them is a stand on which there is the symbolic representation of Gunakara's absent guru. In the lower register, framed by a wavy ground line—identified as "clouds" by Brown (1933, p. 142) and possibly as hills by Saryu Doshi (personal communication)—Kalaka is shown leading his horse.

As in catalogue number 12, the blue ground dominates the field and the figures are painted in gold highlighted with white, red, green, and black. The horse is pink and red with gold trimmings. As in other *Kalakacharya-katha* pages, three ornamental, blue-bordered gold lozenges were intended to indicate the string hole and page numbers.

The episode shown here compares to the scenes in the *Kalakacharya-katha* described by Brown (1933, figs. 26 and 35). AGP

Provenance Paul E. Manheim, New York.

14 Artist unknown

Harinegameshin carrying the embryo

Fragment of a leaf from a dispersed *Kalpasutra*
Western India, Gujarat
16th century
Opaque watercolor on gold leaf on paper
Sheet 4 x 3 in. (10.2 x 7.6 cm)
Gift of the Ernest Erickson Foundation, Inc., 86.227.49

This fragment of a leaf from a dispersed *Kalpasutra* depicts Harinegameshin, an antelope-headed divinity who was instructed by Shakra (Indra) to exchange the embryo of the Jain saint Mahavira with another embryo so that the saint could be born to a noble family. Harinegameshin is seen here striding forth vigorously, carrying Mahavira's embryo in his right hand. The swift movement of the haloed, divine messenger is expressed by such features as the extended scarf ends, as well as the outspread arms and the triumphant stride alongside the peacock, which may serve as his vehicle (Brown 1934, pp. 15 and 18).

Although this fragment is not dated, it is similar to an illustration from a *Kalpasutra* manuscript dated Samvat 1577 (A.D. 520), in which Harinegameshin faces left with the embryo in his left hand and wears a dhoti that has a different pattern from the one seen here (Brown 1934, pl. 5, fig. 15). The pattern of the dhoti is similar to that worn by Indra in a *Kalpasutra* manuscript (ibid., pl. 4, fig. 11) formerly owned by the Heeramaneck Galleries, New York, and dated as "probably sixteenth century" (ibid., p. 3 and pl. 4, fig. 11).

Harinegameshin is usually represented as a hybrid with a human body and the head of either a horse or an antelope

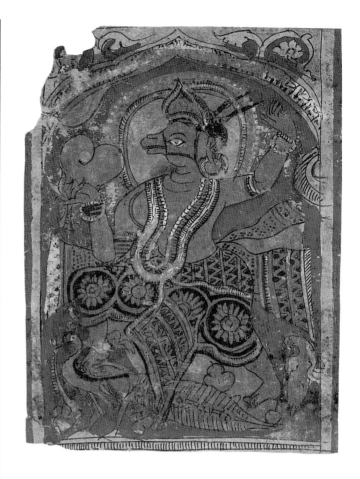

(ibid., p. 15). Here he is shown with the head of an antelope. His vehicle is a peacock (ibid., p. 15). He is a composite being, who becomes the commander of Indra's army (Doshi 1985, p. 106) and at the same time is associated with the procreation of children and the use of herbs (Brown, op. cit., p. 15). AGP

Literature Katz 1963, cat. no. 119; Poster 1987, cat. no. 121.

15 Artist unknown

Kalaka becomes a Jain monk; Kalaka abducts the nun

Two leaves from a dispersed Jain manuscript of the
Kalakacharya-katha
Uttar Pradesh, Jaunpur
Circa 1465
Opaque watercolor and gold on paper
A. Augustus Healy Fund, 36.236.1–.2

36.236.1
Verso (image) 4¼ x 2¾ in. (10.8 x 7.1 cm)
Sheet 4⅜ x 10½ in. (11.1 x 27.1 cm)

INSCRIPTION

Verso, in cartouche in lower right margin, in gold, in Devanagari script: *89.*

36.236.2
Sheet 4⅜ x 10⅝ in. (11.1 x 27.1 cm)

INSCRIPTION

Verso, in cartouche in lower right margin, in gold, in Devanagari script: *94.*

The illumination on the verso of the illustrated leaf contains a compartmentalized scene. At the top left in the upper register, Kalaka listens to the priest Gunakara. At the right, Kalaka exercises his horse accompanied by two soldiers from his retinue; in the next register, King Gardabhilla on horseback meets the nun Sarasvati, and in the lowest register he has her carried away. Both Kalaka and the king are dressed in dhotis and adorned with jewels and crowns. Kalaka, in the top register, is distinguished by a jeweled aureole. Below, the Jain master and the nun wear white monastic gowns. The text, which is part of the *Kalpasutra,* is written in gold against a crimson ground with richly decorated floral and geometric margins. The recto of this page, as well as the second leaf, have only text. For a translation of the text, see Brown 1933, pp. 52–54.

The leaf is attributed to the same workshop as a well-known illustrated *Kalpasutra* manuscript from Jaunpur dated 1465 now in the collection of Narasimhajini Polno Jhana Bhandara, Baroda (discussed at length in M. Chandra 1949; Khandalavala and M. Chandra 1962; and Doshi 1983 and 1985). Doshi observes that the face is evidently more square in shape than those of the Western Indian type, and the "farther eye" is now seen as projecting from but attached to the profile face (1983, p. 51, fig. 5).

The Jaunpur manuscript and our leaves are rendered in a stylistically consistent manner with figures depicted in profile with the projecting "farther eye," the same boldly patterned fabrics, and beading around crowns and halos. The range of colors, particularly the use of pink skin tones, is similar, and the richly decorated borders consist of repeated flowers borrowed from the designs and colors of tile decoration of local Muslim architecture. Even in the small format, the figures are drawn with a controlled flowing contour line. It is interesting to note that our two leaves, which belong to the *Kalakacharya-katha* text, are numbered 89 and 94 respectively. The fact that they illustrate early verses (numbers 6

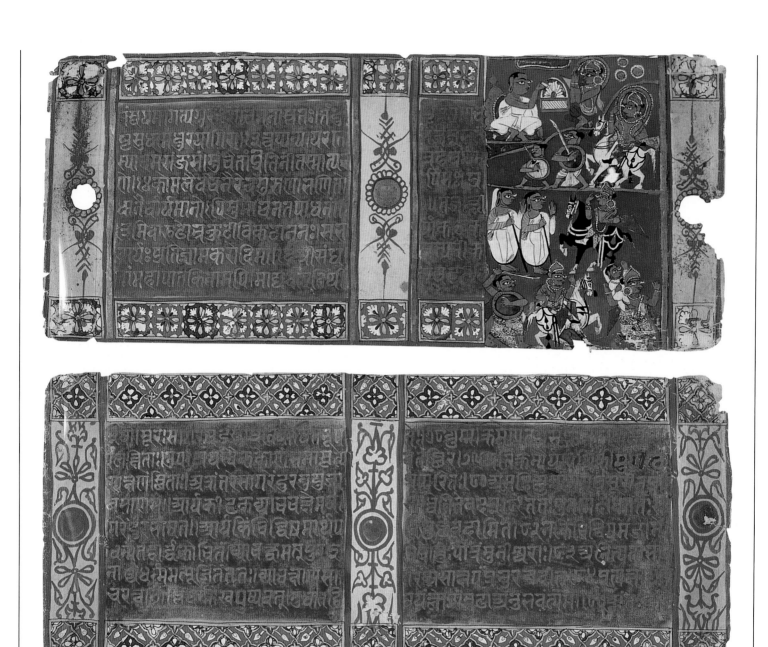

and 7 in the text) demonstrates convincingly that the set to which they belonged originally followed the *Kalpasutra*.

Losty (1982, p. 45) emphasizes the importance of the colophon in determining the relevance of this manuscript to important stylistic advances in this period, namely, that the scribe and illustrator noted there (reproduced in Khandalavala and M. Chandra 1962, p. 12) was not a Jain monk but a Bengali artist from the Hindu caste of *kayasthas* (professional scribes). AGP

Literature Roberts 1937, pp. 113–26, no. 3; Los Angeles 1950, cat. no. 79; UNESCO 1957, cat. no. 24b.

Provenance Nasli M. Heeramaneck, New York.

16 Artist unknown

Majnun and his father, Salim

Leaf from a *Khamsa* of Nizami
North India, Sultanate Period
Circa 1500
Opaque watercolor and ink on paper
Image 2 1/16 x 2 9/16 in. (5.25 x 6.5 cm)
Sheet 9 5/8 x 6 11/16 in. (24.4 x 17 cm)
Gift of Mr. and Mrs. J. Gordon Douglas III, 83.234.3

INSCRIPTION
Recto, in right margin, in black ink: *38*.

Majnun, in a loincloth, kneels beneath a tree with huge pink blossoms, on which a bird is perched, and talks with Salim, his father, who kneels to the right. The latter, trying to persuade his son to return to his senses, gestures to a bowl of rice, which Majnun refuses. Standing behind Salim, a servant in a patterned blue robe holds a tray of food. The artist has rendered the setting in a series of colored bands: red and white for the foreground, green for the background, and azure and royal blue for the sky. The Urdu text is written in four vertical columns.

Three other published leaves from this manuscript illustrate scenes from the *Iskandar-nama* of Nizami. However, the appearance of this leaf from the story of Layla and Majnun leads us to identify the manuscript as a full *Khamsa* (Five Poems) of the poet.

For other leaves from this manuscript, see Welch and Beach 1965, p. 115 and fig. 2; Sotheby's 1972, pp. 57–58, lots 179–81; Binney 1973, p. 20, cat. no. 5 (now San Diego Museum of Art); and Robinson 1976, pp. 173–74 and pl. 146, cat. no. III, 205, 206. SRC

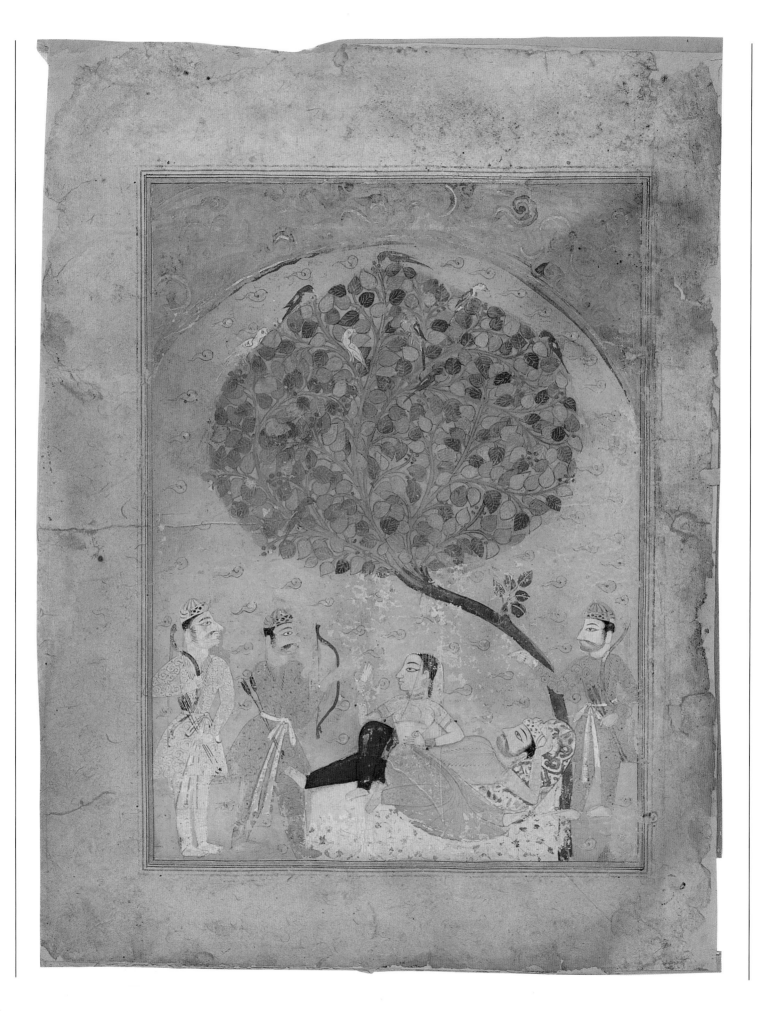

17 Artist unknown

Laurak and Chanda rest on their journey to a trysting place

Leaf from a *Chandayana* manuscript
Northern India or Mandu, Sultanate Period
First half of the 16th century
Opaque watercolor and gold on paper
Recto (image) 7⅜ x 5½ in. (18.8 x 14 cm)
Verso (image) 7⅜ x 5⅜ in. (18.8 x 13.3 cm)
Sheet 10 x 7¹¹⁄₁₆ in. (25.4 x 19.2 cm)
Gift of Mr. and Mrs. H. Peter Findlay, 78.198

As Laurak reclines against a red and white pillow, Chanda kneeling by his side looks back and gestures to the two soldiers at the left. A third archer stands at the right pointing at Chanda. Atop a curving trunk, a leafy tree populated with birds fills most of the space above the figures. The ground is pale coral, and above the high, curved horizon the sky is blue with banded gold clouds.

The *Chandayana* manuscript in the Prince of Wales Museum, Bombay, to which this and other dispersed leaves also belong, has been discussed frequently and at length in the last twenty-five years. Composed in Avadhi, a form of Eastern Hindi, by Mulla Da'ud in the late fourteenth century, the narrative centers on the romance of Laurak and Chanda, their elopement and subsequent adventures. Scholars agree generally on the dating of this manuscript to the first half of the sixteenth century, noting the combination of Persian Shirazi influence and that of the indigenous Indian, sixteenth-century *Chaurapanchasika* style of the Delhi-Agra region. Although Khandalavala and M. Chandra have suggested the provenance of the Prince of Wales manuscript to be Jaunpur or Northern India (1969, pp. 53–55), J. Losty (1982, p. 69) makes a case for its being from Mandu. He not only notes similarities of composition and

palette between the *Ni'mat-nama* of circa 1495–1505 (India Office Library, London) and the *Chandayana,* but also suggests that the style of both these manuscripts presages that of Deccani painting of the later sixteenth century.

For other leaves from this manuscript, see Archer 1960, pl. 12; Khandalavala and M. Chandra 1969, pp. 94–99, figs. 156–75, col. pl. 24; M. Chandra 1970, pls. 59–61; Binney 1973, cat. no. 6; P. Chandra 1976, pp. 48–49, pls. 106–11; Falk, Smart, and Skelton 1978, p. 17, cat. no. 2; Losty 1982, p. 69, cat. no. 45, col. pl. XVI; Ehnbom 1985, p. 26, cat. no. 3; Leach 1986, cat. no. 7.

SRC

18 Artist unknown

Krishna and the gopis

Leaf from a *Bhagavata Purana* series
Uttar Pradesh, Delhi-Agra region
Circa 1525–40
Opaque watercolor on paper
Image 5⅜ x 8⅞ in. (13.7 x 22.5 cm)
Sheet 6⅞ x 9⅛ in. (17.45 x 23.2 cm)
Gift of Mr. and Mrs. H. Peter Findlay, 80.41

INSCRIPTIONS
Recto, in top border, caption in Rajasthani dialect in Devanagari script: illegible; in another hand: *Hirabai.*

The *gopis* (cowherd wives) have searched desperately for Krishna, the divine lover. Here, to their evident pleasure, he has reappeared. Their aroused senses and the tension of the reunion are conveyed by the formulaic arrangement of the figures seated on a large black printed fabric. The crowned Krishna and the adoring *gopis* are isolated against the characteristic monochromatic red background heightened by the jewel-like pattern of the women's garments, their black pompon bangles, and their erect poses. The moonlit evening scene resembles a stage set with a lotus pool in the foreground and three trees in the background silhouetted against a dark blue sky.

The revival of the Krishna cult in Mathura during the late fifteenth century may be responsible for the emergence of a group of paintings relating the Krishna legends. The tenth book of the *Bhagavata Purana* is the standard Sanskrit canon of Krishna's exploits, including his triumphs over numerous challenges and, as shown here, his romantic dalliances with the *gopis.*

This series is part of an important group of sixteenth-century Indian manuscripts that establishes the existence of pre-Mughal styles. It is one of the earliest known series, a stylistic and iconographic prototype (see Ehnbom 1984) significant for the combination of indigenous Indian styles

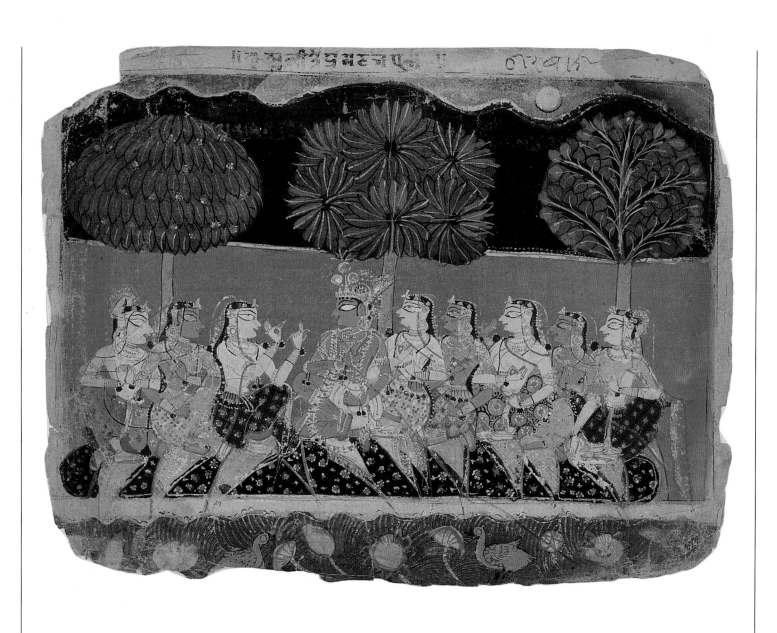

and many variations based on earlier foreign traditions: bold colors, vigorous movement, and inventive compositions that convey energy and excitement. One group from the series, to which our page belongs, displays compositions similar to those on the pages from a *Balagopala-stuti* (Khandalavala 1982, fig. 183) and the Prince of Wales *Gita Govinda* series of circa 1550 (Khandalavala 1953–54). The page also shows strong stylistic affinities to the *Chaurapanchasika* group of circa 1525 in the N. C. Mehta Collection, Ahmedabad (Khandalavala and M. Chandra 1969, pl. 20 and figs. 106–7), namely, the rhythm of the fantail arrangement of the *gopis'* saris, their ornaments, the energized patterns of the textiles, the profile and physiognomy of the figures, the monochrome ground, and the flat, two-dimensional composition. (For a more extensive publication of the illustrations of the *Chaurapanchasika,* see Shiveshkar 1967.)

Folios from this large undated series, inscribed on many of the pages with the names Sa Mitharama and Sa Nana (in all probability those of patrons or owners), are located in collections throughout the world. An attribution to the period around 1540 has been made on the basis of stylistic considerations by Khandalavala and Mittal (1974, pp. 28–32). For the date and provenance of the series, which have been debated in Indian art circles for many years, see Barrett and Gray 1963, pp. 63–72; Welch and Beach 1965, pl. 3b.; Archer and Binney 1968, cat. no. 1c; Khandalavala and Mittal, op. cit.; P. Chandra 1976, pls. 77 and 79; Losty 1982, cat. no. 36; Ehnbom 1985, p. 24, cat. nos. 1 and 2; S. C. Welch 1985, cat. nos. 225a–d; Goswamy 1986, cat. nos. 69 and 134; Leach 1986, cat. nos. 8i–iii. The revised dating of 1525–40 is presented in a recent analysis of this series by Ehnbom (1984).

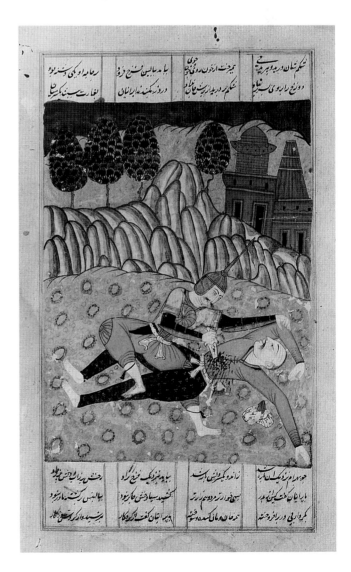

The text on the verso refers to a previous passage in the *Bhagavata Purana* (Bk. 10, Ch. 32, vv. 2–4 and first line of v. 5):

And in their very midst appeared Lord Krishna, the descendant of the King Sura, with his lotus-face beaming with a smile, wearing a yellow garment, adorned with a wreath of flowers, capable of fascinating the god of love [Cupid] himself [with his charm]. Seeing their beloved most Darling [has] arrived, all those women, though emaciated and weak at once sprang to their feet, with their eyes wide open with rapturous delight, even as the limbs of the body do on the return of the vital principle [*Prana*]. . . . (Trans. G. V. Tagare, *Bhagavata Purana,* pp. 1453–54) AGP

19 Artist unknown

Foroud slays a foe

Leaf from a dispersed *Shah-nama* series
Mughal School or Sultanate (Kashmir?)
Late 16th century
Opaque watercolor and gold on paper
Image 8⁵⁄₁₆ x 4⁷⁄₈ in. (21.1 x 12.4 cm)
Sheet 10⁵⁄₈ x 7¼ in. (27 x 18.4 cm)
Gift of Mr. and Mrs. Ed Wiener, 75.203.1

INSCRIPTION
Recto, in Arabic script: *125.*

Foroud, son of Siyavush, garbed in a gold helmet and armor, blue undershirt, and orange pants, plunges a knife into the belly of one of his numerous Iranian foes. The victim, in an orange shirt and blue flowered pants, lies outstretched with his arms thrown back. As is typical of the other miniatures in this dispersed manuscript (see cat. no. 20), the ex-

pressiveness of the men's faces is heightened by their bristly, long-haired mustaches and the liberal use of pink lines to denote wrinkles. The ground consists of four registers: the light blue foreground with ovoid forms representing rocks or grass; a middle ground of jutting banana-shaped mountains painted in startling gradations of fuchsia with four leafy trees growing from their peaks; a gold farther ground of mountains in which two buildings are located; and a dark blue sky above the high horizon.

The manuscript from which this leaf is detached is said to have been discovered near Delhi. Possibly it was produced in that region or farther north, at Lahore, as Stuart Cary Welch has suggested (1973, p. 87), or at Kashmir. While the *Shah-nama* itself is the Persian national epic and the depiction of such a murder scene is typical of Persian *Shah-nama* illustrations, this painting is stylistically at variance with even the most provincial sixteenth-century Persian work. Not only the palette, but also the architecture and regularly shaped trees point to Indian origin. Moreover, unlike Persian *Shah-nama* illustrations, this painting does not illustrate the text that surrounds it.

The chapter heading on the recto and the narrative on the verso, which bears the miniature, refer to the suicide of Foroud's mother, an event that occurred after Foroud's death.

For related Sultanate *Shah-nama* leaves, see S. C. Welch 1973, cat. no. 51; Binney 1973, cat. no. 8; Rijksprentenkabinet 1978, cat. no. 4, fig. 5. Unpublished leaves from the same manuscript are in the collections of Jeffrey Paley, New York; George Fitch; and the Los Angeles County Museum of Art. SRC

20 Artist unknown

Hum captures Afrasiyab

Leaf from a dispersed *Shah-nama* series
Mughal School or Sultanate (Kashmir?)
Late 16th century
Opaque watercolor, gold, and silver on paper
Image 8 x 4¹⁵/₁₆ in. (21.4 x 12.6 cm)
Sheet 10⅝ x 7³/₁₆ in. (27 x 18.1 cm)
Anonymous gift, 84.201.1

INSCRIPTION
Recto, at top, in border, in Arabic: *288.*

A young prince, his head enclosed in a turban, binds his bareheaded captive in a landscape of rocks close to a cave. In the distance, a palace is set against a gold horizon beneath a narrow strip of blue sky. The poetry framing the painting, from the Persian national epic, the *Shah-nama,* indicates that the scene depicted is from the episode of Hum and

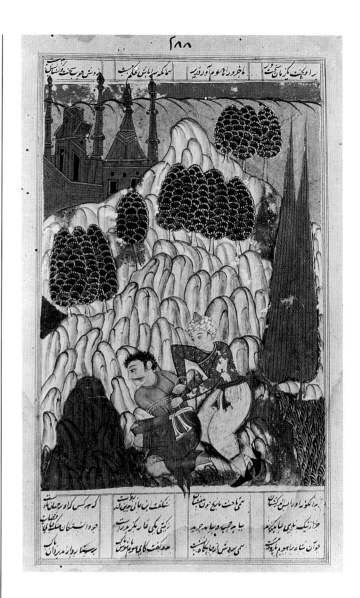

Afrasiyab. After having killed Hum's brother, Afrasiyab, the great-grandson of Fereidoun, takes refuge in a cave. Hum sets out in search of Afrasiyab and finds him hiding there. The painting represents Hum tying up Afrasiyab for committing this crime.

For another page from this series, see catalogue number 19. SRC

21 Artist unknown

Rustam rescues Bizhan from the dungeon

Leaf from a dispersed *Shah-nama* series
North India, Mughal School (?)
Late 16th century
Opaque watercolor, silver, and gold on paper
Image 6½ x 5⅝ in. (16.5 x 14.3 cm)
Sheet 12 x 7¾ in. (30.5 x 19.5 cm)
Gift of Dr. Bertram H. Schaffner, 84.267.2

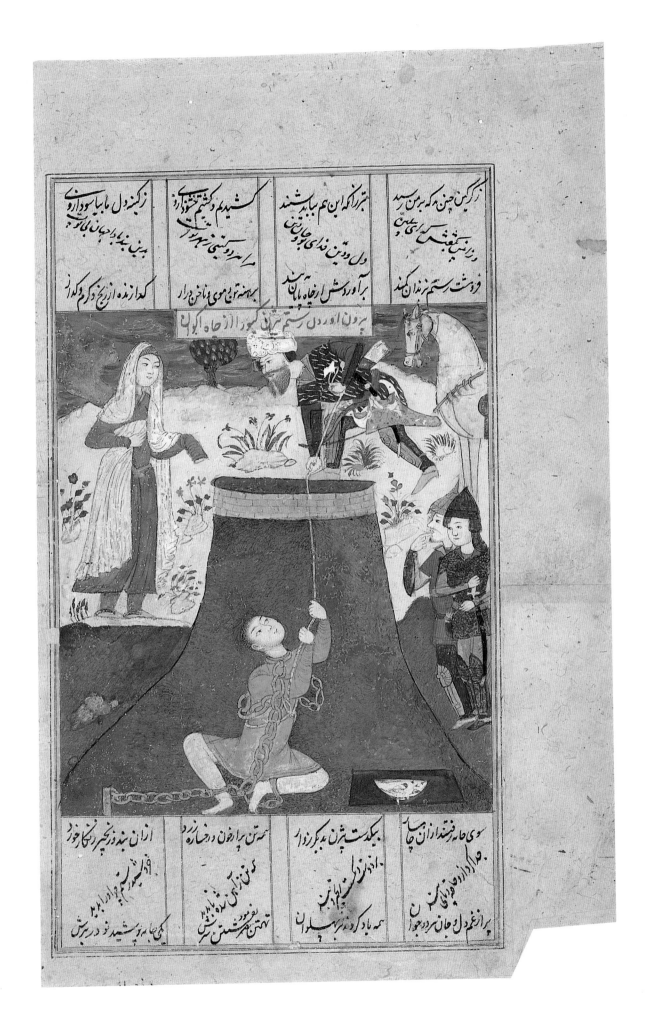

INSCRIPTIONS

Subtitles in red ink, in Persian, in nastaliq script.

Recto, at top center of image: *Rustam rescues Bizhan son of Giv from Akvan the Div's Pit.*

Verso, at top mid-center: *The difficulty of rescuing Bizhan from the pit.* (Trans. M. Ekhtiar)

Rustam, the hero of the great Persian epic, the *Shah-nama,* recognized by his animal-skin cap, armor, and animal-headed mace, is shown here at the top of the page using a rope to lift Bizhan from a dungeon in the wilderness, in which he had been imprisoned for his illicit romance with Manizhah, the daughter of King Afrasiyab. Manizhah, who had secretly fed crumbs of bread to her entombed lover in the pit, stands to the left, and two male attendants are present at the right.

This page is the sole known sheet from its series. The manuscript was not produced at one of the Sultanate kingdoms (Bengal, Gujarat, Delhi, or the Deccan), but probably belongs to a provincial Muslim center, perhaps in the vicinity of Lahore or Kabul. Except for the form of the dungeon or well that widens at its base, the composition is based on such earlier iconographic models as a folio depicting the same subject now in the Rietberg Museum, Zurich, attributed to the Shah Jahan period (Goswamy and Fischer 1987, p. 50). Even though very little in this page exemplifies the delicacy of works of the late Safavid style prior to the Mughals in northern India, a Persianate composition and trees and rocks in the Persian manner are portrayed here in the typically bold colors of Indian painting with disproportionately large flowers scattered throughout the landscape. AGP

Mughal Painting

The Brooklyn Museum Folios of the Qissa-i Amir Hamza (Hamza-nama)

PRAMOD CHANDRA

Of all the wonderful illustrated manuscripts produced by the atelier located at the court of the Mughal emperor Akbar (r. 1556–1605), the *Qissa-i Amir Hamza* (Romance of Amir Hamza), painted sometime around the years 1562–77, is unique, among the earliest, and surely the most highly treasured of Indian illustrated manuscripts, now as it was in earlier times.[1] Some even went so far as to place it on a par with the fabulous peacock throne of Shah Jahan: thus the Persian chronicler of Nadir Shah's sack of Delhi (1739), who recounts how the wazir of the Mughal empire begged Nadir Shah on behalf of the ruling king Muhammad Shah to take the peacock throne with all its encrusted jewels, including the Kuh-i nur, but to spare the manuscript. The Persian king spurned the request, though he is reported to have promised its return after due perusal, a promise that does not seem to have been kept, at least not fully.[2]

What actually happened is somewhat unclear, for portions of the manuscript have been found in India, but there is also no doubt that at least parts of it reached Iran and stayed there. For this we have the testimony of one Riza Khan Monif, apparently a general in the Iranian army who left his country to live in the West, ultimately in New York City. While in Iran in 1912 he is reported to have purchased an album containing twenty-six paintings from the *Qissa-i Amir Hamza,* which had been a gift from the Shah of Iran to his sister. The album was bound in red leather and was stamped with the seal of the royal Iranian library. General Monif appears to have sold two or four of the pictures in France, but the rest remained with him until his death, after which they were auctioned off, nine being acquired by The Brooklyn Museum in 1924.[3] Surprisingly, as late as 1949, when the importance and beauty of the *Qissa* as an outstanding example of the Mughal school was fully recognized among knowledgeable circles in the West, five of these paintings were deaccessioned and dispersed. Fortunately, four are still at the Museum. They are of very good quality; one, if not two of them can be placed among the very best of the manuscript.

The atelier of Akbar, with the strong encouragement of the emperor, can be credited with laying the foundations of the Mughal school of painting a little after the middle of the sixteenth century. The atelier was composed of a somewhat motley group of artists, among them, however, the great Iranian masters Mir Sayyid 'Ali and 'Abd as-Samad, who had worked earlier in the extremely refined if somewhat static decorative style prevalent in Iran, as well as a large group of native artists whose names and personalities remain largely undocumented in contemporary writings of a historical character. We know, however, that they were drawn from various parts of India and belonged to various local traditions of painting, some of which were of an order drastically different from the high Iranian manner.

It is the tension produced by the presence in one atelier of work of widely disparate character, a yearning for something unique, and also an atmosphere emphasizing things Indian promoted by the emperor himself that seem to have led to the emergence of a new Mughal style. This new style is best exemplified by such great masters as Dasavanta and Basavana, whose presence in the atelier in its earliest period is attested by their work in the *Tuti-nama* of the Cleveland Museum of Art.[4] Though adopting certain conventions of composition and ornament from Iranian work, their manner is as different from that style as it is from contemporary non-Mughal schools in India, being characterized by emphatic movement, a preference for modeled forms, and a vivid sense of color that gives it a unique flavor.

The *Qissa-i Amir Hamza* recounts legendary tales of Persian origin, filled with miracles and magic centering around the hero Hamza, whose identity was later merged with an uncle of the prophet Muhammad of the same name, which accounts in part for the pro-Islamic character with which they are tinged. These tales continue to be popular to the present day but in very widely varying versions, both in the Persian and the Urdu languages. Akbar himself had one Khwaja Ataullah rewrite them in everyday Persian in a new version, for his own pleasure, and so fond was he of these stories that not only did he listen to them avidly, but he also often recited them personally to the members of his household.[5]

The illustrated version of these marvelous tales prepared for Akbar was a gigantic undertaking, complete in fourteen volumes, each supposedly embellished with one hundred paintings, making a total of fourteen hundred. Each painting was approximately 26⅜ by 20⅛ inches (67 by 51 centimeters) and was on cotton cloth instead of paper. Although the paintings were done on the cloth itself, the text was written in nastaliq script on paper pasted to the cloth. Of the paintings, barely one-tenth, or about one hundred fifty, have survived, and it does not appear likely that many more will be discovered. Though much scholarly effort has been expended on the illustrations, a critical study and reconstruction of the text and other codicological aspects has not been successfully completed, though Glück made a valiant beginning. No doubt a great deal of further light will be shed on the manuscript and its illustrations once this is done.

The largest collection of paintings, numbering close to sixty, is in the Museum für Angewandte Kunst in Vienna; the Victoria & Albert Museum in London has the next largest group, twenty-seven in number. The latter were found in Kashmir, indicating that a group of Hamza paintings may have never left India for Iran, or at least found their way back into the country. One must keep in mind the fortuitous circumstances of their discovery in a humble curiosity shop located in one of the "picturesque wooden huts on the Hawa Kadal bridge across the Jhelum where some of them had been plastered to the lattice-windows in order to keep away the cold." [6] These would certainly have perished had they not been seen by Sir C. Purdon-Clarke, ultimately finding their way to the London museum.

The Brooklyn pictures luckily come from a royal album in Iran and are by contrast in a superb state of preservation. They are all in what earlier scholars would have called an Indianizing as opposed to a Persianizing manner, preferring a comparatively bold and broad presentation of the theme. The scene of Arghan Div bringing the weapon chest to Hamza (cat. no. 22) has been assigned by Sheila Canby to Book 12, folios 20r/21v.[7] The demon Arghan emerges from the water, here rendered by frothy, curling waves, presenting a seemingly ferocious aspect with spotted skin, flaming eyes, and mastodontine teeth projecting from a mouth with a rather frozen grimace. On the shore is Hamza, seated on a throne placed beneath a bright canopy secured by poles and ropes. His royal status is indicated by a row of attendants to the right carrying insignia, among them the yak-tail whisk waved over his head. A man kneels humbly before him, touching his feet. To the left is an attendant holding a naked sword over his shoulder as he leads three scantily clad and bareheaded prisoners with ropes around their necks. Below to the right, a man steps forward vigorously, gesticulating at the monster, and behind are other attendants, some of whom hold a finger to their lips in the gesture of wonder and amazement that occurs in Indian art from the sculptures at Bharhut of the second century B.C. onward. The rocks are

painted as a pile of soft-edged boulders, and the single tree with a massive trunk painted in rippling brushstrokes bears dense leaves and flowers. In quality this page seems to be of fairly standard character, with conventional grouping of figures and average workmanship. The text on the reverse makes reference to the demon carrying Hamza's armory on its head but does not explain other features of the painting. Here, as in the case of other illustrations, we do not find a direct relationship between the picture and the text on the reverse.

A painting of better quality involves the giant Zumurrud Shah (cat. no. 23), one of the principal antagonists of Hamza. Again the text on the reverse is not very helpful in interpreting the scene. What is evident though is that the enormous giant, whose figure dominates the composition, is quite grief stricken, his mouth open, teeth bared in anguish on the receipt of some very sorrowful tidings. He has put his arms gently around a man who bows to caress the luxuriant tresses of the giant's beard. Another man, turbanless, touches the giant's knee. Facing him are two lamenting men, one of them wiping his eye, the other tearing at his hair. A peasant wearing a triangular loincloth stands by a bull, an expression of concern on his features. To the right are several women in various states of dejection and grief. The elderly woman in the foreground tries to comfort a child who looks apprehensively at the giant. In the background, beyond the rocks, are caparisoned bulls with riders, one of whom is accompanied by a woman. Preceding them is a woman carrying a baby in a basket on her head.

In contrast to the Arghan Div scene, here the artist convincingly captures the weight of the sagging canopy with its fluttering fringe as well as the grieving expressions. The sturdy bulls, alert and cheerful, remind one of the ease with which the Indian artist constantly depicts animals. The women, all wearing Indian dress, are derived (and this is particularly evident when they are rendered in profile) from a contemporary non-Mughal Indian idiom, right down to such little details as the print on the blouse or the ivory wedge worn as an earring.

The painting that depicts the rescue of Sa'id-i Farrukh Nizhad from a castle (cat. no. 24), which has previously been identified as a fight between Tayus and Umrao of Chin, is once again largely unrelated to the text on the reverse. A few men have rushed into the courtyard of a palace that is all aglow with tiled decoration, light blue on the floor and pink, dark red, and blue elsewhere. Unlike Persian examples from which it is derived, even ornament is here impregnated with an inner movement, both laterally and in depth. The soldier at the gate to the left is slashing mightily at the neck of a guard; two others lie limp and dead on the ground, their lifeless faces showered by the blood pouring from their gaping wounds. Armed men hasten to rescue the manacled prisoners. A figure identified by Faridany-Akhavan (1989, p. 194) as Sa'id-i Farrukh Nizhad watches calmly as his

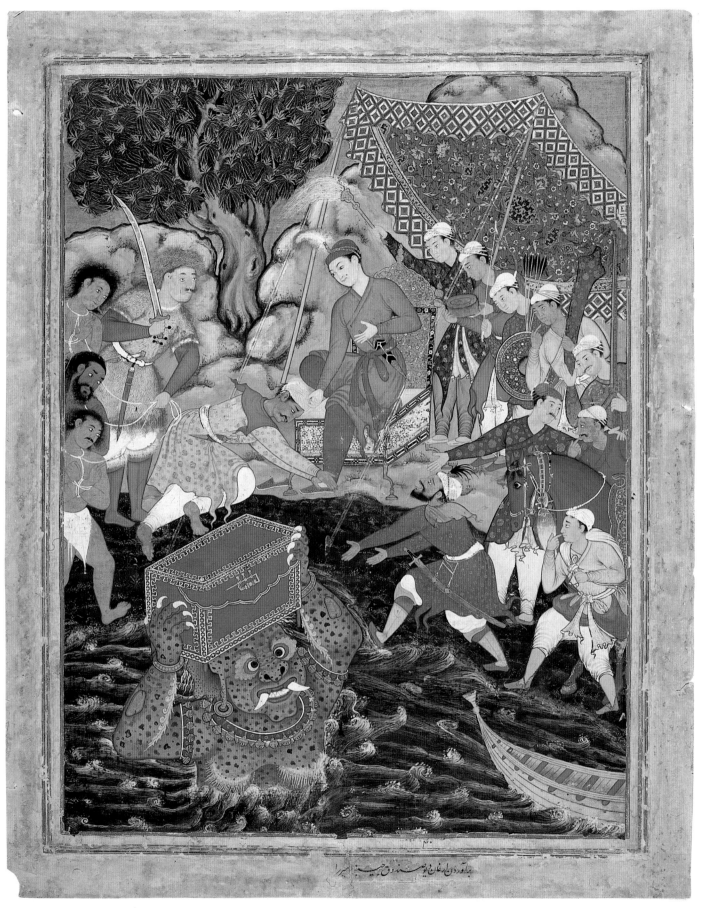

Catalogue number 22

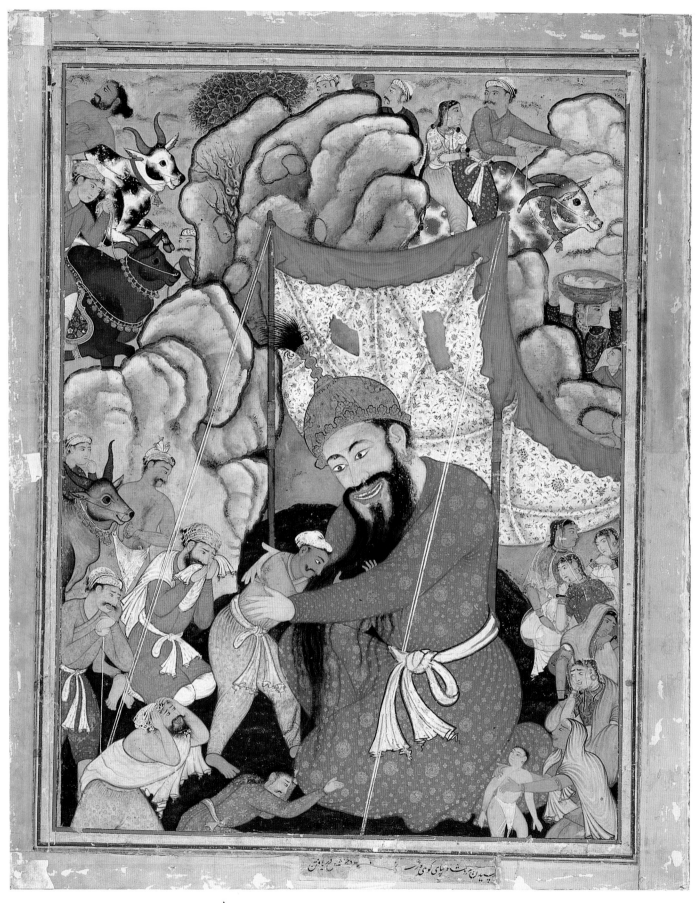

Catalogue number 23

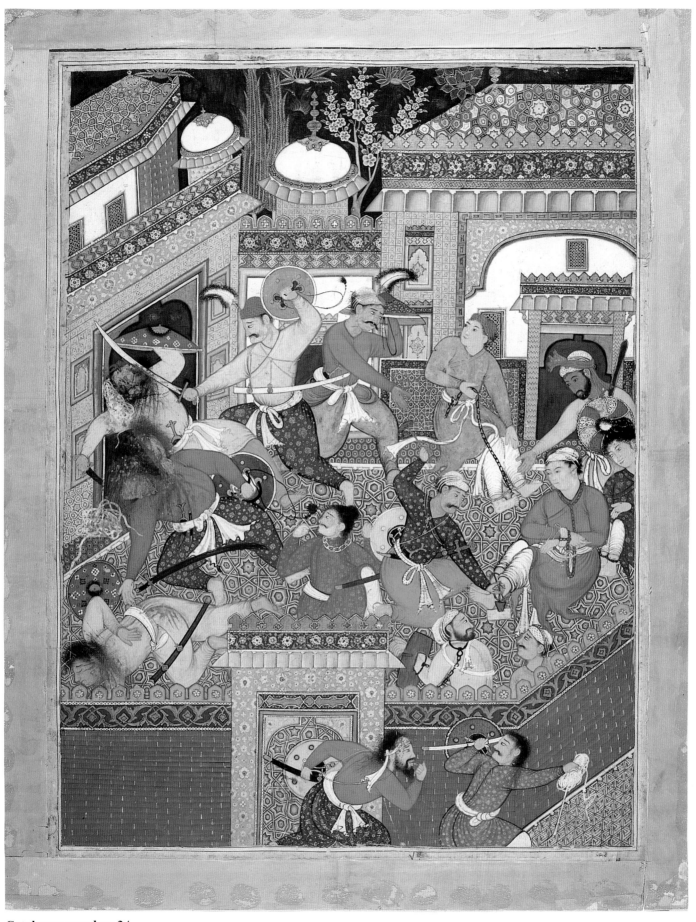

Catalogue number 24

chains are cut off with heavy blows of hammer on chisel. The prisoners themselves are both despondent and expectant.

The composition of the picture is remarkably accomplished. The attacking soldiers, the guards, and the prisoners are arranged skillfully in a rough circle, the gestures and movements of each figure smoothly merging from one to the other so that the total effect is that of a dance. The swinging rhythm is further accentuated by windswept scarves tied at the waist, fluttering pointed ends of the tunics, the sway of the scabbard, and even in tiny details. Particularly noteworthy is the leaping, lively black shoulder cord of the raised shield held by the soldier beheading the guard to the left that, in its flying loop, echoes the entire composition. In another telling detail, this lively rendering is made to contrast sharply with the slack, lifeless loop of the shield of the equally lifeless soldier lying dead on the ground. The high artistic imagination in evidence here suggests that we are dealing with the work of a fine master.

The last painting of the series presented here (cat. no. 25) has been identified by Sheila Canby as Book 11, folio 84r. It is one of a series of three that depict the entry of Amr and his companion, disguised respectively as a physician and his attendant, into the fort of Zumurrud Shah and his sorcerers. Once inside, the two interlopers proceed to drug the sorcerers and rescue their captives. In the immediate foreground, outside the massive palace gate flanked by two towers, is a large craggy hill beyond which are tiny figures of shepherds herding their flock; to the right, a traveler carrying a box slung on a pole walks past a large tree.

In contrast to this quiet mood, the scene inside the palace is one of utmost agitation. Amr, in disguise, attends to the sick and emaciated sorcerer whose thin and wasted body is emphasized by the massive robes in which he is swathed. Supported by a concerned attendant, he leans forward to have his pulse taken by the doctor. Figures in a state of great apprehension and nervous agitation can be seen all around. These include a shrieking woman who carries a child clinging frantically to her neck while she grasps another child by the wrist. Across the courtyard a young frightened woman has thrown herself on a much older woman lying on a bed, clutching her by the arm and the shoulder. The bed rocks violently, skillfully suggested by the wildly fluttering edges of the bed cover, reinforcing the tumultuous happenings all around. Among other sensitively observed figures is a man hastily tying another man's turban, preparatory to springing into action, while the man next to him has dozed off, supporting his head with his hand. Scattered on the floor are assorted bags containing medicaments. Adding to the noise and confusion is a servant pounding away in a large mortar, presumably preparing the prescribed medicine. At the right, the horse attended by grooms, tongue extended, one leg raised, impatiently reinforces the restless atmosphere.

The composition, with its figures arranged in a roughly circular pattern, is somewhat akin to that of catalogue number 24, but much more complex, with many more cross and counter rhythms, notably those set up by the folds of drapery that move with a swift life all their own. The sure and accomplished brushwork and the keen psychological insight are seldom surpassed in Mughal painting and betray the hand of a great master.

Adding to the piquancy is the mocking tone adopted toward the practice of medicine. The upheaval, verging on terror, at the arrival of the healing physician would seem rather unnatural; one would expect instead a calming effect on the patient and his family. But not according to ancient as well as modern Indian sayings, which regard a physician with the deepest suspicion: "Vaidyaraja namastubhya yamaraja sahodarah!"(Hail to you, king of physicians, veritable brother of Yama, god of death!) One must suspect that the artist had some such saying very much in mind as he painted this scene.

1. The date of the *Qissa-i Amir Hamza* was a vexing question, its beginnings being placed by some as early as the reign of Humayun, Akbar's father. The entire problem was throughly examined by this writer in his work on the Cleveland *Tuti-nama* manuscript (P. Chandra 1976, vol. 1, pp. 62–68). With the help of important new materials, the dates of the *Hamza-nama* were fixed as given here, with the hope that new evidence would clarify matters further. No serious argument has been advanced against this position since its publication.

2. Muhammad Kazim, quoted in Dickson and Welch 1981, p. 254, n. 12.

3. This information has been drawn from correspondence on file in The Brooklyn Museum, notably a letter dated October 10, 1924, from Stewart Culin, the curator responsible for the acquisition, to Heinrich Glück, whose extensive 1925 monograph on these miniatures in the present Museum für Angewandte Kunst in Vienna and in other collections remains the most important publication on the subject. I am deeply indebted to Ms. Amy Poster for kindly giving me access to these papers.

4. See P. Chandra 1976, vol. 1, p. 78.

5. *Maathir-ul-Umara,* vol. 1, p. 454.

6. Clarke 1921b, p. 3.

7. This information is taken from a draft list prepared by Dr. Sheila Canby that was passed on to me. It may not be entirely accurate, but it does give some approximate idea of the position of the Brooklyn folios in the manuscript as a whole. Codicological and textual work has also been done (see Faridany-Akhavan 1989).

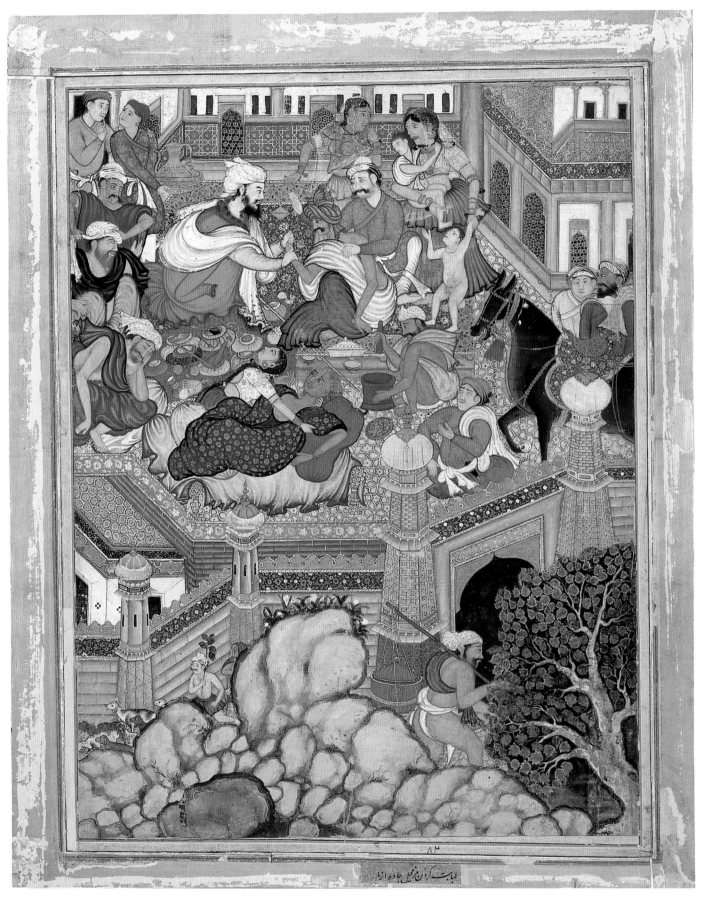

Catalogue number 25

22 Artist unknown

Arghan Div bringing the weapon chest to Hamza

Folio from the *Hamza-nama*
Mughal School, Akbar Period
1562–77
Opaque watercolor and gold on cotton cloth
Image 26⅜ x 20¹¹⁄₁₆ in. (67.5 x 52.5 cm)
Sheet 31⅛ x 24¹⁵⁄₁₆ in. (79.1 x 63.3 cm)
Museum Collection Fund, 24.47

Literature Culin 1924, vol. 2, p. 140; Glück 1925, p. 155; Khandalavala and M. Chandra 1969, pp. 70, 78, 111; P. Chandra 1989, p. 42, fig. 2.

23 Artist unknown

Zumurrud Shah in his tent

Folio from the *Hamza-nama*
Mughal School, Akbar Period
1562–77
Opaque watercolor and gold on cotton cloth
Image 26¾ x 20⅛ in. (68 x 51.1 cm)
Sheet 31 x 25 in. (78.8 x 63.5 cm)
Museum Collection Fund, 24.48

Literature Khandalavala and M. Chandra 1969, pp. 70, 78, 111; P. Chandra 1989, p. 41, fig. 1; Faridany-Akhavan 1989, p. 99 and pl. 22.

24 Artist unknown

Sanghar-i Balkhi and Lulu the spy slit the throats of the prison guards and free Sa'id-i Farrukh Nizhad

Folio from the *Hamza-nama*
Mughal School, Akbar Period
1562–77
Opaque watercolor and gold on cotton cloth
Image 26¹⁵⁄₁₆ x 20½ in. (68.5 x 52 cm)
Sheet 30⅞ x 24½ in. (78.4 x 62.3 cm)
Museum Collection Fund, 24.46

Literature Art News 1964, p. 29, pl. 2; Khandalavala and
M. Chandra 1969, pp. 70, 78, 111; P. Chandra 1989, p. 43,
fig. 3; Faridany-Akhavan 1989, p. 194 and pl. 67.

25 Artist unknown

Amr, disguised as Doctor Musmahil, treating sorcerers in a courtyard

Folio from the *Hamza-nama*
Mughal School, Akbar Period
1562–77
Opaque watercolor and gold on cotton cloth
Image 26¾ x 20⅝ in. (68 x 52.4 cm)
Sheet 31 x 25 in (78.8 x 63.5 cm)
Caroline H. Polhemus Fund, 24.49

Literature Comstock 1925, p. 348; Goetz 1930, pl. 47; Dimand
1933, pl. 35; idem, n.d., pl. 8; S. C. Welch 1964, p. 161, cat.
no. 2B; Beach 1981, p. 65, cat. no. 5B; Khandalavala 1983, pl. 1;
P. Chandra 1989, p. 45, fig. 4; Faridany-Akhavan 1989,
pp. 213–15 and pl. 76.

26 Artist unknown

Hunter and two cheetahs

Mughal School, Akbar Period
Circa 1565–70
Opaque watercolor on paper
Image 3¹⁄₁₆ x 8³⁄₁₆ in. (7.7 x 20.8 cm)
Sheet 6⁹⁄₁₆ x 10⁷⁄₈ in. (16.6 x 27.6 cm)
Gift of the Ernest Erickson Foundation, Inc., 86.227.167

This fragment of two joined pages contains an unidentified scene of a hunter holding a bow and arrow in his hand and carrying a quiver of arrows on his back. His body is thrust to his left while his head is turned back over his right shoulder toward two reclining cheetahs. He wears a jama over knee-length pants and ankle-high boots. His turban is cut off by the frame of the top border. The landscape is composed of a pair of entwined cypresses at the far left, tall grasses, poppies, and clumps of grasses. The whole is mounted on paper decorated with a stenciled floral design of palmette scrolls. An intermediary border is filled with twelve independent segments of an unrelated text in Urdu.

The character of this fragment anticipates the fully developed Akbar period style but befits the early Akbari amalgam of diverse modes. In style, scale, and such details as the entwined trees at the far left, it corresponds to the renderings one encounters in the pages from a *Tilasm and Zodiac* of circa 1570 in the Raza Library at Rampur cited by Beach (1987, figs. 49 and 50) as continuing the native Indian stylistic elements of the Cleveland *Tuti-nama* of circa 1550–60 (P. Chandra 1976). For another composition from the same series with an almost identical rendering of the figure type and bamboo grove, see Khandalavala and Mittal 1969, fig. 15. AGP

Literature Poster 1987, cat. no. 122.

Provenance Charles D. Kelekian Collection, New York.

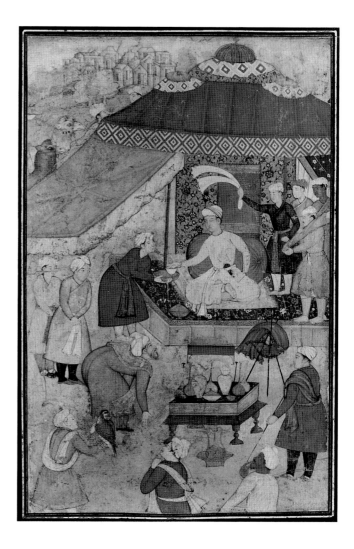

27 Artist unknown

Tent encampment

Mughal School, Akbar Period
Circa 1580–95
Opaque watercolor and gold on paper
Image 8½ x 5½ in. (21.6 x 14 cm)
Sheet 9¾ x 6⁵⁄₈ in. (24.8 x 16.8 cm)
Gift of the Ernest Erickson Foundation, Inc., 86.227.165

Attired in a green costume with a dagger in his sash, a prince surrounded by attendants at a temporary encampment sits cross-legged on a platform adorned with rugs and pillows while his attendant offers him a tray of food. Four attendants stand to his right, one of whom holds a sword case (*gur*) while another waves a cloth fly whisk or fan. In the left corner foreground, an attendant carries a hawk on his right

arm. To his right, two other attendants watch the scene, one with a finger pointing to his mouth in a gesture of amazement. In the lower center of the painting, a low table holds ewers and bowls. Behind it, to the right, a leather water bag and a shawl hang on a stand made of three spears near which a man stands at rest. The man to the left of the table bows low, while two attendants stand behind him with hands clasped in an attitude of obeisance. The center platform, covered with a floral carpet, is surmounted by a tent embellished with a translucent brick red wash. The bold red, white, and blue geometric lozenge design of the canopy decorations is typical of similar tents shown in paintings of the period.

In the left background beyond the tent, two men can be seen leading camels. Behind them in the distance are low hills and the outline of a town, possibly derived from European prints that were brought to the Mughal court in the last quarter of the sixteenth century.

The attendants surrounding the prince are depicted as stock, stereotypical figures, but the one who is bent from the waist and appears to be a messenger, is portrayed with great individuality.　AGP

Literature Poster 1987, cat. no. 123.

28　Mohan, Son of Banwari

Gautama is relieved to find that his son Chirakarin has not carried out his impulsive order to execute Ahalya

Leaf from a *Razm-nama* manuscript

Mughal School, Akbar Period

A.H. 1007 /A.D. 1598–99

Opaque watercolor on paper

Image 10 x 5¼ in. (25.4 x 13.35 cm)

Sheet 12 x 6¹³⁄₁₆ in. (30.5 x 17.3 cm)

Gift of Danielle and A. Richard Bertocci, 86.253

INSCRIPTIONS

Recto, in top margin: *314*; around the lower left corner, in Persian, in naskhi script: *When Gautama rishi arrived at his own house, his son Chirakarin fell at his feet and let the sword that his father had given him drop from his hands to the ground. His father had given [him] the order to kill his mother . . . [but] he showed compassion upon Chirakarin's delay in carrying out his mother's execution;* in center of lower border, in Persian, in naskhi script: *Mohan, son of Banwari.* (Trans. J. Seyller)

Like most of the illustrations in the 1598 *Razm-nama*, this full-page painting displaces all the text to one side of the leaf. Even without reference to the preceding text, however,

the subject of the painting can be identified by virtue of the titular inscription along the lower left corner of the image. This inscription, which must have been added immediately after the painting was completed, summarizes a minor anecdote from the *Shanti Parvan* (Book 12, section 258, verse 7) in which the calamity of precipitous action is averted by recourse to thoughtful delay. Enraged at the alleged infidelity of his wife, Ahalya, Gautama orders his son, Chirakarin, to kill his mother. Chirakarin recognizes the injustice of this ill-considered order and stalls until his father comes to his senses.

The encounter between the temperamental father and his wiser son occupies only a small portion of this exceptional composition. The remainder of the small courtyard is filled

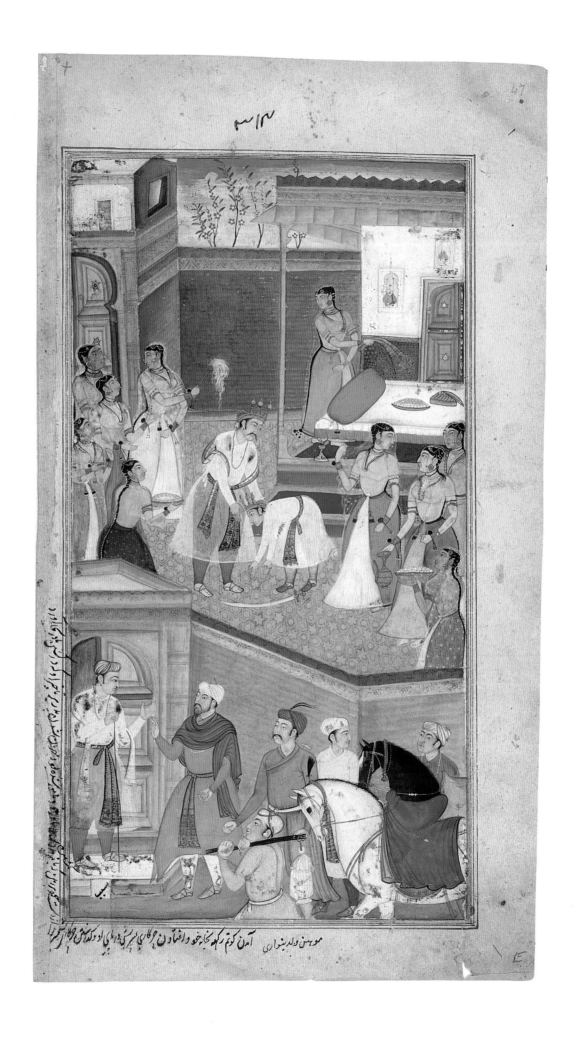

with a host of court ladies bearing food and fly whisks; outside the diagonally arranged palace wall, a number of men entreat a gatekeeper to admit them to the compound.

This illustration belongs to a dispersed manuscript of the *Razm-nama*, one of several copies of the Persian translation of the Hindu epic of the *Mahabharata*, made about the end of the sixteenth century. One section of this profusely illustrated manuscript has survived intact and provides a colophon dated A.H. 1007 / A.D. 1598—99. The ascription in the center of the lower border identifies the artist of the work as Mohan, son of Banwari, who contributed two other works to this *Razm-nama* manuscript (Seyller 1598, p. 58, no. 53, and p. 61, no. 127). The name Mohan appears on contemporary imperial and subimperial paintings, notably the 1604—10/11 British Library *Anwar-i Suhayli* and the 1597—1605 Freer *Ramayana*, but never again with the distinguishing patronymic that is a prominent feature of this particular manuscript.

The repetition of this common Indian name and the generally lower level of quality of painting in the 1598 *Razm-nama* have led to speculation that the manuscript was actually prepared for Abd al-Rahim (1556—1626), the patron of the Freer *Ramayana*, rather than for an imperial patron. This suggestion can be ruled out by the sheer number of artists active on the *Razm-nama* who contributed to other contemporary imperial manuscripts, including the 1582—86 *Razm-nama* now in the Maharaja Sawai Man Singh II Museum, Jaipur. It is likely that this Mohan continued in imperial employ, though it is also possible that he followed his father, who is probably the artist known as Banwari Khurd (the younger), to Abd al-Rahim's workshop after the completion of the *Ramayana* project. JS

Literature Czuma 1975, cat. no. 46; Beach 1981, p. 147, fig. 29; Seyller 1985, p. 59, no. 97.

Provenance George P. Bickford Collection, Cleveland; Sotheby & Co. 1921, lot 246a.

29 Artist unknown

Court scene

Mughal School
Late 16th century
Opaque watercolor on paper
Image 6 x 3¹⁵⁄₁₆ in. (15.2 x 10 cm)
Sheet 6¾ x 4⅜ in. (17.2 x 11.2 cm)
Anonymous gift, 80.309

In a palace courtyard, a prince, seated cross-legged on an octagonal throne, gestures to a woman who stands before him with a jeweled turban ornament in her hand. At the left

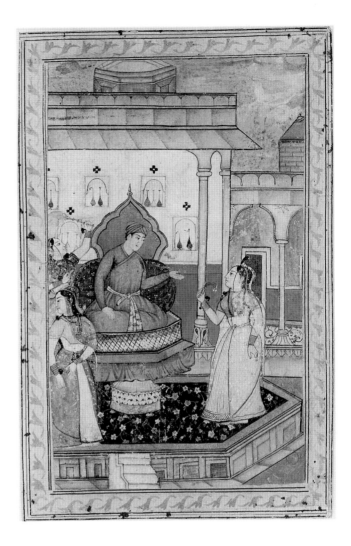

a woman fans the prince with a fly whisk while a third looks back over her shoulder. The throne rests on a round pedestal placed in the center of a floral carpet. The pale color scheme of pink and white marble, yellow, gold, and mauve garments, and pale blue sky contrasts with passages of red in the background and orange in the throne's skirt.

The palette, simple composition, and figural types suggest work outside the Mughal atelier, but this is debatable. The manuscript from which this painting comes has not been identified, and its text is concealed by the card to which the painting is glued.

For a related work, see Falk and Archer 1981, fig. 13viii.
 SRC

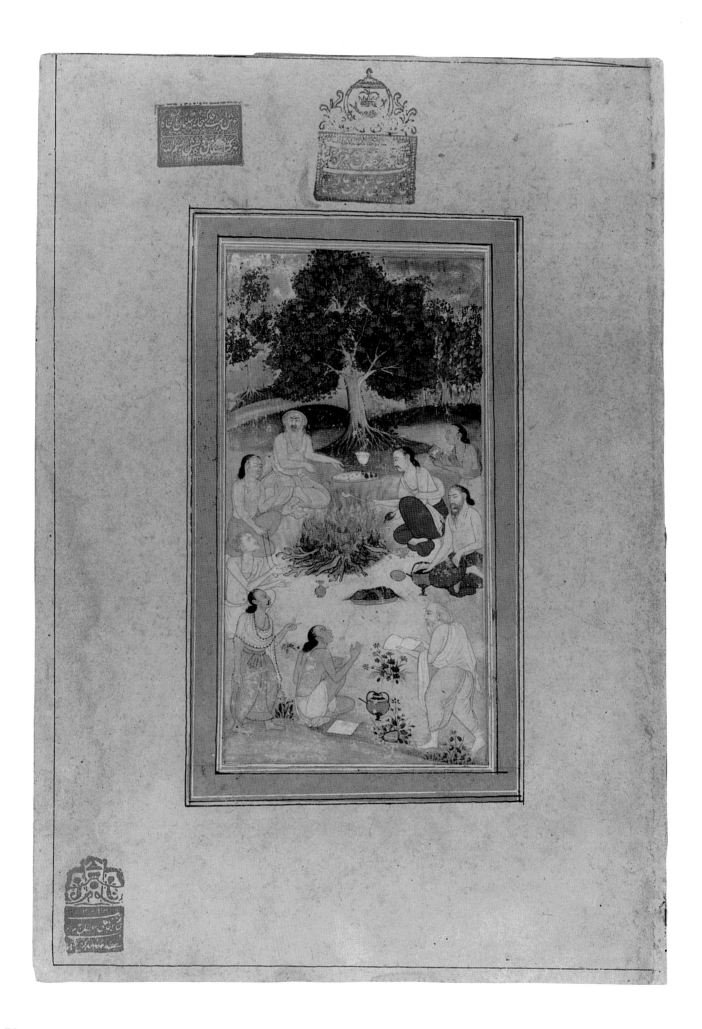

30 Artist unknown

Sadhus gathered around a fire

Mughal School
Circa 1600
Opaque watercolor on paper
Image 8¹³⁄₁₆ x 4¹¹⁄₁₆ in. (22.4 x 11.9 cm)
Sheet 15¹⁵⁄₁₆ x 11³⁄₁₆ in. (40.5 x 28.4 cm)
Obtained by exchange from N.M. Heeramaneck, 39.85

INSCRIPTIONS

Recto, in margins, three collectors' seals: top left: seal of the library of
Suleiyman Jah; top right: *To each book of mine like the design of Bismallah*;
lower left: *The pen of Majd Ali Shas, the king of the Times [A.H.] 1244*
[A.D. 1829]. (Trans. M. Adib)

Nine holy men are gathered around a fire into which one,
in a red dhoti, has poured a sacrifice from a hand-shaped
spoon. The bearded figure at his left wears a brown dhoti;
the others are clad in pale pink, white, and saffron dhotis.
All have *rudraksha* (prayer beads) around their necks and sev-
eral wear shawls. At the lower right a white-haired holy man

carries an open book toward a gesturing seated figure. The
other figures at the left all gesture toward the fire. The
bearded figure in the brown dhoti at left also appears to be
actively involved with the ritual as he holds his right hand on
the lid of a round, two-handled pot with small foot. Another
such pot sits in the foreground near the edge of a stream.
Nearer the fire are containers of food, bowls, and a small
spouted vessel, presumably for use in the ritual. The majes-
tic tree with exposed roots dominates the upper third of the
page. Behind it a similar tree can be seen in the distance.
The surface has been abraded and some areas are over-
painted. (For related pages, see Falk and Archer 1981,
no. 26; Beach 1978, cat. nos. 42 and 62.)

While many paintings of yogis or holy men were exe-
cuted in the period 1610–50, they begin to emerge in the
late sixteenth century. Many of the later paintings of yogis
incorporate the same compositional elements as are found
here, namely the fire burning in the center of a circle of
lightly clad or nude holy men set in a landscape before a
large tree.

John Seyller has identified this painting as a page from a
Razm-nama dating to circa 1600. Seyller describes this manu-
script as "similar to, but more refined than, the 1598
Razm-nama" and cites additional pages from the circa 1600
manuscript in the Bharat Kala Bhavan; the Bharata Itihasa
Sanshodhaka Mandala, Pune; the Birla Academy of Art and
Culture; the Free Library of Philadelphia; and the Museum
of Fine Arts, Boston (Seyller 1985, p. 65, n. 3).

On the verso, mounted on the album border, are four
lines of Persian poetry, in black ink, in nastaliq script:

I have heard that in the heavens there is a gilded inscrip-
tion which reads:
Ultimately [on the day of judgment] all is praiseworthy.
Do not think of wrath and do not despair, for all that
exists is under the protection of [God's] generosity.
[Signed at the lower left] The most humble Ali.
(Trans. M. Ekhtiar)

SRC

Provenance Luzac et Cie, Paris.

31 Artist unknown

A falconer and a gamekeeper

Mughal School
Circa 1600
Opaque watercolor on paper
Image 5½ x 3⅞ in. (14 x 9.9 cm)
Sheet 8¹¹⁄₁₆ x 7 in. (22.1 x 17.8 cm)
**Gift of the Executors of the Estate of Colonel Michael
Friedsam, 32.1324**

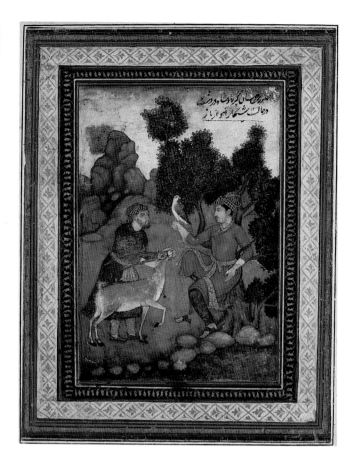

INSCRIPTION

In upper right corner, in Persian, in nastaliq script: *Picture of Jahangir Padshah in the desert hunting deer with a falcon.*

A man in a red jama holding a falcon in his right hand sits in a tree, his right foot tucked under his left leg, his left arm circling the slender branch of the tree. A man in brown leading a deer has approached him from the left. In the foreground an eddying stream is bordered by rocks, while in the background more craggy rocks jut into the slightly cloudy sky. The painting has been abraded in spots, especially the face and body of the man at the left, the deer, and the stream at the lower right. There are signs of light retouching at the edge of the jama and turbans.

Despite the inscription identifying the falconer as Jahangir, this painting may date to the late Akbar period, circa 1600. Such landscapes, with distant crags and swirling water, are found throughout the Akbar period. Moreover, Persian motifs, including figures seated in trees, find greater acceptance in Mughal painting of the early seventeenth century. Finally, although the falconer cannot be identified as Jahangir, he resembles Prince Khusrau, Jahangir's son, who would have been about fifteen years old at the time this was painted. Khusrau, a contender for the throne during Akbar's lifetime, was imprisoned for rebellion shortly after Jahangir's accession in 1605. Thus, one would expect to find portraits of Khusrau painted in the first years of the seventeenth century, while he still enjoyed the royal favor of Akbar.

For what seems to be a convention of the falconer's arm encircling the slender branch of a tree, see an Ottoman drawing of the second half of the sixteenth century in A. Welch and S. C. Welch 1982, p. 30, no. 5. For a related work in the collection of A. Chester Beatty, see Chester Beatty, pl. XI, no. 33, *Visit to a Saint.* SRC

32 Artist unknown

The execution of Mansur Hallaj, from the Warren Hastings Album

Mughal School, Akbar Period, probably at Allahabad
1600–1605
Opaque watercolor on paper
Image 7¼ x 4½ in. (18.5 x 11.4 cm)
Sheet 15¼ x 11³⁄₁₆ in. (38.8 x 28.5 cm)
A. Augustus Healy and Carll H. de Silver Funds, 69.48.2

INSCRIPTIONS

In rectangular text panel at top of page, in Persian, in nastaliq script: *As stone on the head of those who were coming toward him* (Trans. M. Adib); at top of outer border, in nastaliq script: *Mansur Hallaj.*

In this fine illustration, detached from a manuscript, the artist has depicted Mansur Hallaj in manacles being led to his death by hanging. Encircling the gallows, his supporters weep and gesticulate, to no avail. In the background, rocks and trees border a lake, and a group of buildings nestles into the hillside on its far shore. While the landscape elements have been rendered in earthy greens and browns, the jamas and sashes of the fourteen figures are painted in an array of reds, blues, saffrons, greens, and whites.

Mansur Hallaj cited in the border is the late-ninth–early-tenth-century mystic theologian who is best known for having declared, "I am the Truth," a statement perceived by the religious and political authorities of 'Abbasid Baghdad as highly inflammatory and heretical. Ultimately, after nine years of imprisonment, Hallaj was hanged, then decapitated and cremated.

On the basis of style and familiar Akbar elements—the distant townscape and flocks of birds, the tree and gibbet forming compositional anchors—the painting can be dated between 1600 and 1605. However, the identification of the artist and the original context of the miniature remain elusive. (For another version of this painting, see Ettinghausen 1961, pl. 8.)

Other early Mughal renderings of the death of Hallaj are known. One of these (Walters Art Gallery, Baltimore, W.684B), of 1602–3, depicts the execution of al-Hallaj from a *Divan* of Amir Hasan Dihlavi (1253–1328), where the martyr is shown being hoisted up the gallows by two

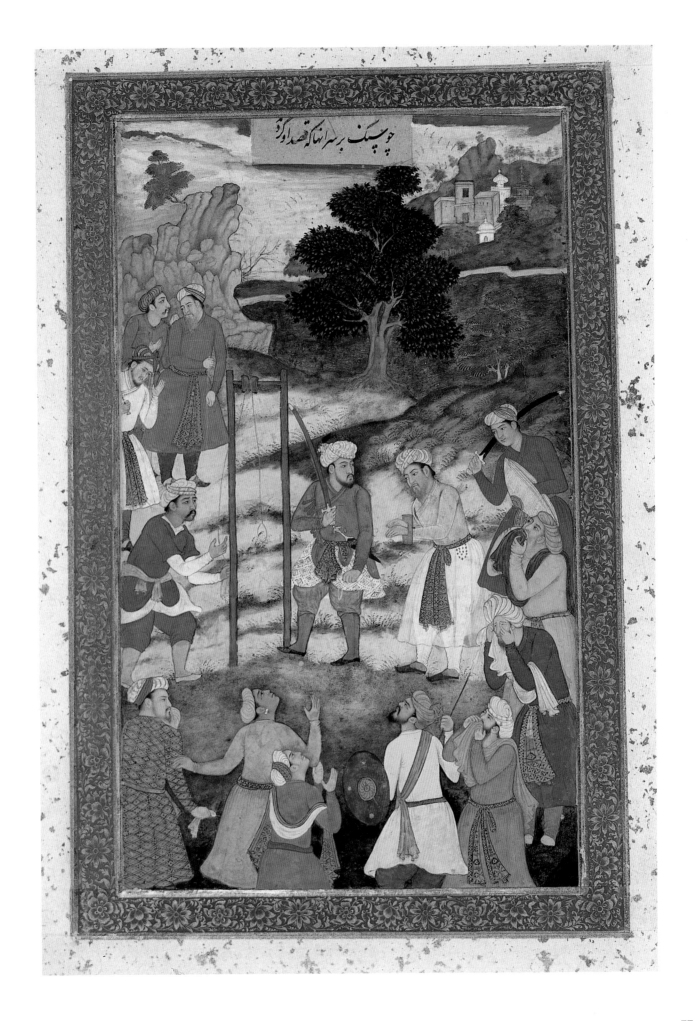

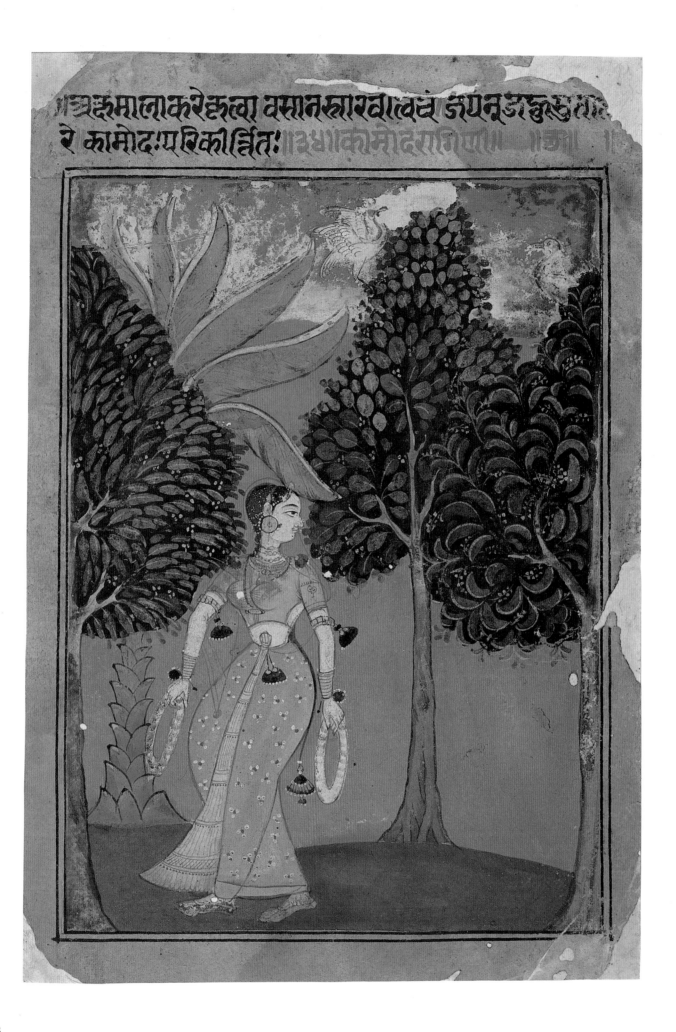

hangmen (Beach 1981, p. 41, where the scene is identified as an episode from the *Akbar-nama* and ascribed to Miskin). Another rendering (Chester Beatty Library, Dublin, MS 61[2]) depicts the burning of the body of Hallaj. In preparing the catalogue of the Indian paintings in the Beatty Library, Robert Skelton and Linda Leach have established (personal communication) that the page was detached from the *Nafahat al-Uns* (Breaths of Familiarity) of Jami copied in 1605 by the scribe Ambarin Qalam at Agra (now British Library, London, Or.1362).

In both style and size, our miniature is close enough to the paintings of al-Hallaj in Baltimore and Dublin not only to confirm a date of 1600–1605, but also to suggest that it illustrates another version of either Amir Hasan Dihlavi's *Divan* or Jami's *Nafahat al-Uns*. The place of production of the painting remains a question. As it is similar in style to the Baltimore and Dublin examples, an Allahabad provenance is likely.

John Seyller has identified the source of this painting as the *Nafahat al-Uns* manuscript copied for Akbar in Agra in 1605. Seventeen pages from the manuscript are in the British Library, with other pages in the Chester Beatty Library. Seyller notes that this painting would have been the seventh in the manuscript, which is described by Losty (1982, cat. no. 69). Seyller attributes this work to the artist Padarath (active circa 1585–1630).

Warren Hastings (1731–1818), Governor-General of Bengal from 1772 to 1785, was a bibliophile, scholar, educator, and one of the outstanding collectors of Indian miniature paintings (see Ehnbom 1985, pp. 11–12). SRC

Provenance Mr. and Mrs. Mehdi Mahboubian, New York; Sotheby & Co. 1968, lot 384; Sir Thomas Phillipps Collection, sold by Messrs. Farebrother, Clark, and Lye, August 22, 1853, lot 879; Warren Hastings Collection, Daylesford House, Oxfordshire, England.

33 Artist unknown

Kamoda Ragini

Page from a *Ragamala* series
Mughal School
Circa 1605–10
Opaque watercolor on paper
Image 6⁷⁄₁₆ x 4¹³⁄₁₆ in (16.4 x 12.2 cm)
Sheet 7¹⁵⁄₁₆ x 5½ in. (20.2 x 14 cm)
Anonymous gift, 79.187.1

A solitary woman walks through a grove looking back over her shoulder. Clad in a lavender skirt, orange bodice, and pale yellow scarf, and adorned with large gold earrings, nu-

merous bangles with black tassels, and several necklaces, she holds a garland in each hand. Above, a bird lands in a tree-top near his mate. Two lines of Devanagari script at the top identify the *ragini* as *Kamoda Ragini* and give the number 34. The iconography of *Kakubha Ragini*, also a solitary woman holding a garland in each hand, corresponds to the iconography of *Kamoda*.

Our page and the Binney *ragini* page (1973, cat. no. 33b; now San Diego Museum of Art) have been compared to pages from the contemporaneous dated Berlin *Ragamala* series (Waldschmidt 1975, fig. 109). Binney suggests that the *Ragamala* series from which this painting comes is not a product of the imperial atelier, but "may have been painted in some Rajput city or in a Mughal center for a Hindu patron." (See also P. Chandra 1960, pp. 25–41.) SRC

34 Artist unknown

Elephant hunt

Mughal School, Akbar Period
Circa 1600–1605
Opaque watercolor on paper, lacquered and mounted on leather
Sheet 10¹⁄₁₆ x 6⁷⁄₁₆ in. (26.1 x 16.4 cm)
Gift of Mr. and Mrs. Mehdi Mahboubian, 69.47

Before a rocky background a wild elephant on the right attacks a tame elephant mounted by two men at the left. In a tree at the right two men gesture toward the combat. In the center, another man runs away from the fight, while a horseman observes. At the left side of the page three adult elephants and one baby in a pool flee as two more wild elephants enter from the right. In the foreground two more men on elephants gesture toward the combat. (For other scenes of the Akbar period depicting elephants in combat, see Stchoukine 1929, pls. 17 and 18.)

The text, written in nastaliq script in panels, reads:

A large number of Indian animals [the equivalent of ten cities] were brought in from the frontiers of the Indian province [name illegible; Kali Qilti?].
The elephants are the tallest and fastest attainable. More and more of these wild elephants enter the area, about forty in number, they take over the whole locality. (Trans. M. Ekhtiar)

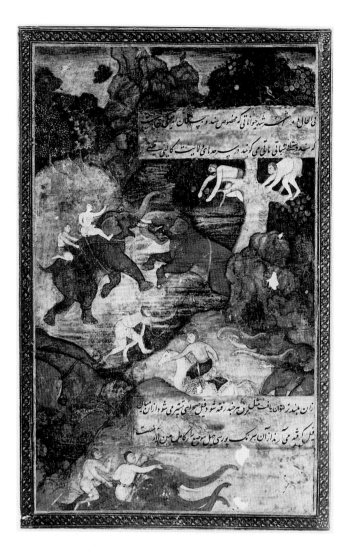

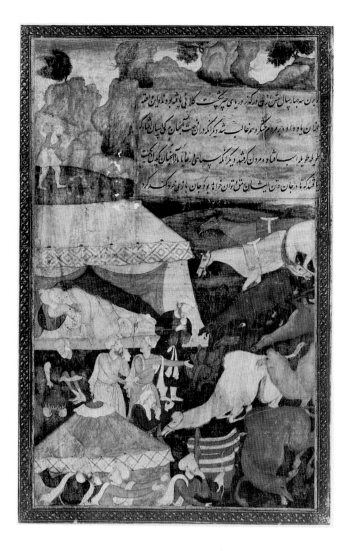

The page is now mounted as a book cover. For the companion piece, see catalogue number 35. SRC

Provenance Mr. and Mrs. Mehdi Mahboubian, New York.

35 Artist unknown

Poisoned horses and camels in an encampment

Mughal, Akbar Period
Circa 1600–1605
Opaque watercolor on paper, lacquered and mounted on leather
Sheet 10¹⁄₁₆ x 6⁷⁄₁₆ in (26.1 x 16.4 cm)
A. Augustus Healy and Carll H. de Silver Funds, 69.48.1

As a man sleeps in a tent at the center left, seven other men gesture and discuss with great animation the ailing horses and camels at the right. A man carrying a pot over a fire at the lower left and another tending a fagot in the left background go about their business unaware of the events taking place around them. In the background rocky hills are crowned by lone, windblown trees.

The Persian text in the panel at the top of the page reads:

And because three or four years ago in the sea of Khayr he was defeated greatly. This occasion is remembered and the . . . people were filled with fear that such a terrible death occurred [to them] where horses died stable by stable. This made the army and peasants so united that they decided that as long as they had spirit and energy they would sacrifice their lives. (Trans. M. Ekhtiar)

The scene would appear to depict the death of the horses mentioned in the text and the resistance by the people in the encampment to their own ruination. The artist has rendered this event most convincingly by contrasting the agitated gestures of most of the human figures with the collapsing, gagging, droopy-eyed animals.

In spite of the ruined state of this miniature, the careful brushwork and varied characterizations of the late Akbar period are still evident. Moreover, such elements as the lozenge-patterned flap of the tent, the high, rocky horizon, and genre touches unrelated to the story all typify early-seventeenth-century Mughal book painting.

Unfortunately, this painting and catalogue number 34, to which it is attached, were removed from their original manuscript and mounted as book covers.　SRC

Provenance　Mr. and Mrs. Mehdi Mahboubian, New York.

36　Attributed to Manohar

Portrait of Jahangir holding a falcon

Mughal School, Jahangir Period
Circa 1600–1610 (?)
Opaque watercolor and gold on paper
Sheet and image 5½ x 3⅜ in. (14 x 8.6 cm)
Gift of Mr. and Mrs. Robert L. Poster, 87.234.7

INSCRIPTION

Recto, at top center, in border, librarian's notation, in Persian, in nastaliq script: *Emperor Jahangir.*

Although most contemporary portraits of Jahangir (r. 1605–27) show him standing alone, with a halo encircling his head, this portrait, identified by inscription as the Emperor Jahangir, depicts him in middle age standing in a three-quarter pose observing a white falcon perched on his right hand. He is dressed in a deep blue robe tied with an elaborate gold brocade sash and wears an orange turban. The figure is isolated against a background of blue-green wash. The portrait has been mounted on an album page of a later date, with cream-colored, plain paper margins. Since he is shown here without an earring, our painting may depict him as he looked before 1615, when he had his ears pierced (Beach 1978, p. 158).

The painting is attributed to the artist Manohar, who is noted for his skill in rendering royal portraits as well as narrative scenes. A Hindu painter in the court of Jahangir and the son of Basawan, one of the greatest artists of the sixteenth century, he was active from circa 1580 to 1625. Manohar's earliest paintings are dated 1581 and 1582, and the existence of many of his signed works would indicate that he was a prolific artist. The attribution of our painting to Manohar has been endorsed by Beach and Lowry, who note that the facial features are sensitively rendered in a manner typical of Manohar's skillful early portraits (personal communications).

The attribution of our painting is based on the manner of painting and other stylistic features that are related to other known works. Jahangir's posture and stance, the treatment of such details as the textile design of the sash, and the dark outline enclosing the figure also appear in a stylistically related image painted by Manohar in the Kevorkian Album, Metropolitan Museum of Art, New York, depicting Prince Danyal, circa 1595 (McInerney 1991, fig. 7, and S. C. Welch 1987, p. 115, cat. no. 18). Another image of Jahangir, saluting his father, Akbar, stylistically similar, is in the Elvira and Gursharan Sidhu Collection, Menlo Park, California. McInerney has dated it to circa 1620 and attributed it to Manohar (op. cit., fig. 14 and p. 68, n. 27). The difficulty in attributing Manohar's works is complicated by disagreements regarding a number of paintings, including a portrait of Jahangir standing before his father, with a signature of Manohar, in the Ehrenfeld collection, San Francisco, which presents the figures in a similar pose (Ehnbom 1985, p. 58, cat. no. 21). However, comparison of the modeling and brushwork of the Danyal portrait with that of our painting suggests that ours is the work of another hand, and this viewpoint is also held by McInerney (op. cit., p. 68, n. 27).

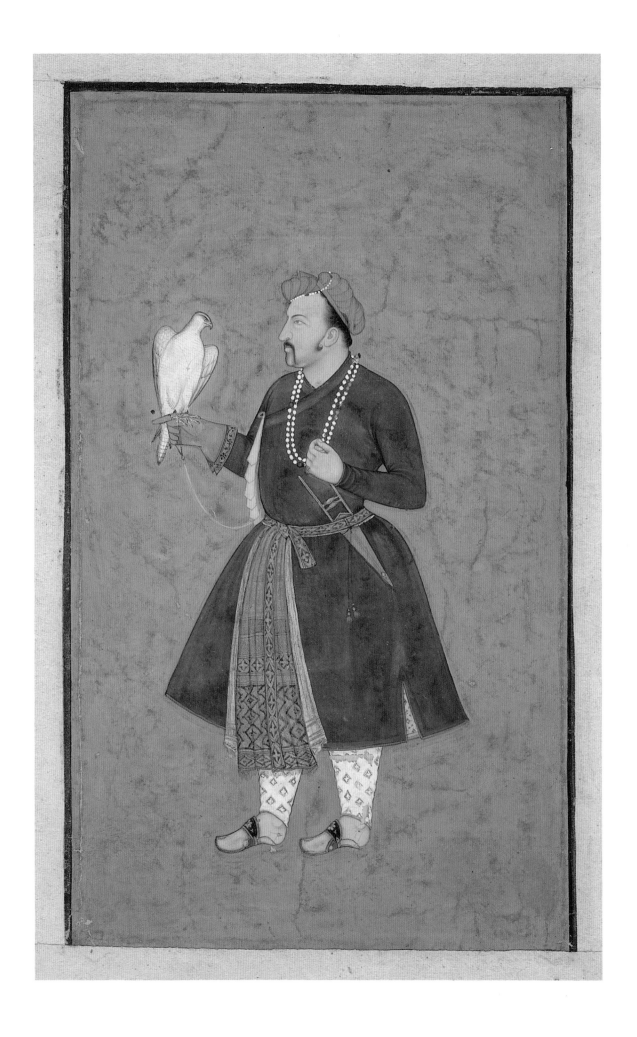

For a discussion of Manohar's career and for a list of his major paintings, including several other portraits of the Emperor Jahangir, see Das 1978, pp. 188–92; Lowry in Beach 1978, pp. 130–31; and McInerney 1991, pp. 54–68, who proposes (p. 54) that Manohar's career spans the years 1582 through circa 1620. In the most thorough study on Mahohar to date, McInerney introduces several issues regarding the later group portraits, including the possibility that bodies may well be stock figures produced by the method of pouncing, whereas the heads were painted by the artist.

A seven-line mystical poem in Persian in nastaliq script on the verso reads:

The good fortune you initiated has been revealed to us.
Your efforts overcome all obstacles.
You are the focal point [*giblah*] of hope and I am the seeker [of hope].
Your auspicious person responds to everyone's needs.
Praise to the Almighty God who brought forth the good fortune in amassing an abundance of prosperity and wealth in your Honor.
Pray to God, the essence of our service and servitude is the means to attain pride and glory.
With courtesy and reverence, the victory over all struggles and difficulties, is all due to your kind favors.
May your prosperity and rising fortune always shine. (Trans. M. Ekhtiar)

In the first four lines of his poem, the author compares his auspicious person to the gate of the Ka'bah.

For Warren Hastings, the earliest Western owner of the painting, see catalogue number 32. AGP

Provenance Terence McInerney, New York; Warren Hastings Collection, Daylesford House, Oxfordshire, and by descent through his family.

37 Artist unknown

Illuminated calligraphic page from a Mughal album

Calligraphy Iran, 16th–17th century
Margins India, 17th century
Opaque watercolor, gold, and ink on paper
Calligraphy panel 7¹³⁄₁₆ x 3¹³⁄₁₆ in. (19.8 x 9.7 cm)
Sheet 14⁷⁄₁₆ x 10 in. (36.7 x 25.4 cm)
Purchased with funds given by anonymous donors and the Helen B. Saunders Fund, 1991.185

Set against an illuminated background of polychrome floral arabesques and decorative triangular panels contained within a tripartite border, four silver-blue bands of clouds enclose two couplets from a Persian poem written at an angle in black ink in the graceful cursive nastaliq script developed to perfection by Persian calligraphers of the fifteenth and sixteenth centuries:

Your face is flushed [and] has become [like] a bright moon;
You have exalted your stature [and] have become the envy of the [tall] cypress;
The beauty of your face increases day by day;
Although you were beautiful yesterday, you are more beautiful today. (Trans. L.S. Diba and E. Yar-Shater)

In the small cloud at the lower left the calligrapher has signed, "the lowly scribe Ali." This "lowly" scribe may possibly be identified with 'Ali Haravi, one of the most famous sixteenth-century practitioners of this art, also known as Mir 'Ali and 'Ali al-Sultany al-Husainy (as in a similar folio reproduced in Lowry and Beach 1988, p. 290; for his biography, see Soucek 1985, pp. 864–65).

As with many great Mughal albums, the margins are as finely rendered as the central calligraphy. Here, a buff ground is delicately illuminated with a design of flowering plants and birds outlined in gold that is worthy of the French master of floral compositions Pierre-Joseph Redouté (1759–1840) and of the naturalist John James Audubon (1785–1851). Roses, poppies, carnations, irises, and other plants alternate with pairs of cockatoos, kingfishers, doves, parrots, cranes, and pigeons on a ground sprinkled with small tufts of grass and cloud bands in the Chinese style.

Both bird and plant life are naturalistically rendered and observed in a style typical of the aesthetic concerns of the seventeenth-century imperial Mughal painting ateliers. This veritable encyclopedia of Indian flora and fauna reflects the great appreciation the Mughal emperors and their contemporaries had for plant life and gardens, a taste inherited from their Timurid forebears. Their ancestor Babur recorded his admiration of the beauties of Bukhara's natural landscape (Beveridge 1921, p. 208), and no one had greater appreciation for the charms of Kashmir's wild flowers than Jahangir himself.

The style of the calligraphy and the marginal decoration of our example are consistent with those of other folios dispersed among a number of public and private collections, from what was perhaps the last great royal Mughal album, named by Beach (1978, pp. 76–77) the *Late Shah Jahan Album,* thus designated for its numerous portraits of Shah Jahan in his old age and other portraits that may be dated stylistically to the later years of his reign. The leaves of the album, consisting of more than one hundred, were split when it was dispersed in the early twentieth century (Lowry and Beach 1988, p. 292), and while many of the figural compositions have been identified (Beach, loc. cit.), the reconstruction of the original decorative and literary program of the album awaits full identification of the remaining calligraphic folios.

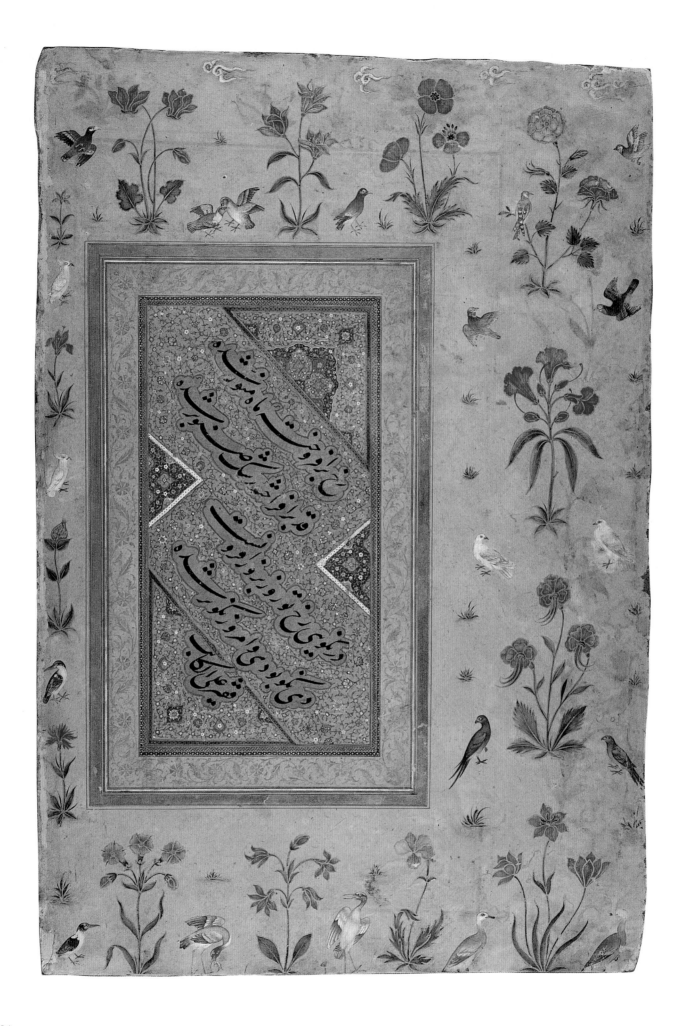

In the seventeenth century, royal Mughal patronage shifted from the production of illustrated manuscripts to the creation of sumptuous albums, in which painting and calligraphy were meant to be appreciated for their own sake. Such calligraphy admirably illustrates this important change in taste of Mughal collecting and connoisseurship.

Comparable calligraphies include examples in the collections of the Louvre Museum (*Arabesques* 1989, pp. 181–82, nos. 150 and 151); the Arthur M. Sackler Gallery, Smithsonian Institution (Lowry and Beach 1988, pp. 289–90, no. 341); and the Ehrenfeld collection (Ehnbom 1985, p. 68, cat. no. 26). LSD

38 Student of Muhammad Amir Salim Dehlawi

Illuminated page of calligraphy

Mughal School
A.H. 1009/A.D. 1631
Opaque watercolor and gold washes on paper
Image 6¹¹⁄₁₆ x 3⅝ in. (17 x 9.4 cm)
Sheet 11¾ x 7⅝ in. (30 x 19.4 cm)
A. Augustus Healy Fund, 45.5.1

Four lines of poetry written in nastaliq script are set into clouds in a typical diagonal format:

When shall I have time to come to you?
For your advice to make my wealth of knowledge richer,
For years I passed my time in drinking,
The rest I wish to spend in your service.

In the cloud tucked into the lower left corner, the calligrapher notes, "Written by a poor and sinful slave student of Seyyed Muhammad Amir Salim of Delhi, may his sins be forgiven." (Trans. M. Ekhtiar)

The texts in the two smaller clouds, written in Persian nastaliq script, read: "May God forgive his sins" (top right); "In the year 1009 of the Hejirah" (center right).

Interspersed among the clouds are small bird and animal studies executed in gold wash on a gold ground (which defy the modern camera). The margins between the inner and outer borders contain clusters of a variety of flowers precisely drawn in opaque colors with delicate outlines. The gold butterflies interspersed among the flowers are typical of the margins produced during the Shah Jahan period.

Robert Skelton (1972, p. 148 and pl. LXXXVI) has compared the formal arrangement of similar painted floral bands to carved marble panels of Shah Jahan's Diwan-i Khas in the Red Fort at Delhi (1636–37). AGP/ME

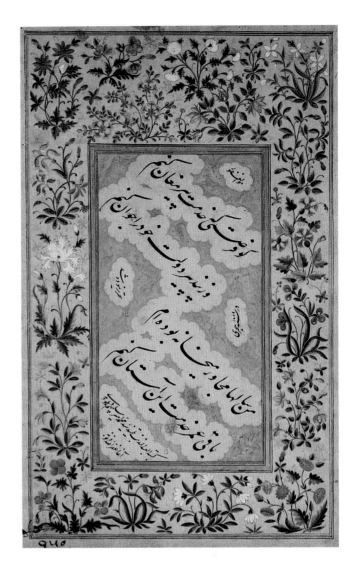

39 Artist unknown

Portrait of Kuka Azam Shah

Mughal School
Circa 1640
Ink and faint traces of color on paper
Image 5¾ x 3½ in. (14.5 x 9.6 cm)
Sheet 12⅜ x 8 in. (31.5 x 20.3 cm)
The Brooklyn Museum Collection, 37. 36

INSCRIPTION
In the lower left corner, in Persian, in nastaliq script: *Triumphant Prince Kuka Azam Shah.*

The subject of this portrait is a young bearded man, shown in profile facing our left. He wears a low turban, a jama fastened at the side with a full knee-length skirt, a sash, pajamas, and slippers. A sword is suspended from his waist, he carries a shield, and his right hand rests on a short double-

bladed sword (*katar*) tucked into his sash. There is no setting or background.

When Ettinghausen studied this work in the 1930s, he identified the inscription on the Museum's accession card as an honorific title, and not the sitter's actual name. As of now the person represented here remains unidentified.

For a series of comparable portraits, see Stchoukine 1929, pls. 48, 51, 54. AGP

Literature Roberts 1937, pp. 113–26.

Provenance F. R. Martin, Stockholm; Rudolf M. Riefstahl, New York.

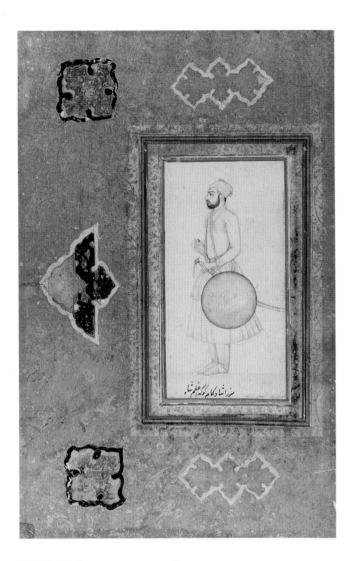

40 Artist unknown

Portraits of two scribes seated with books and writing table amid gold flowers

Fragment of a margin of a royal album page
Mughal School, Shah Jahan Period
Circa 1640–50
Watercolor and gold on paper
Sheet 2 x 9⅝ in. (5.1 x 24.4 cm)
Gift of the Ernest Erickson Foundation, Inc., 86.227.153

Illuminated borders (*hashiya*) appear frequently in royal album pages and are of fine quality, as demonstrated by this fragment. Two seated men, possibly painters or scribes, dressed in brown robes and white scarves and set amid clusters of golden flowers, are represented in other albums of the Shah Jahan period. The man on the left with an open book on the ground in front of him is reciting to the man seated in the center. At the far right is a low desk with a cup, pens, decorated manuscript pages, and a blue floral jar enclosed in a gold casing. The seated face-to-face arrangement of figures was common in portraits of the period and also a popular convention in marginal drawings.

In its understated elegance and refinement this unsigned work invites comparison with figure studies by other artists of the Jahangir and Shah Jahan courts. For similar marginal drawings from a slightly earlier album of the Jahangir period (early seventeenth century), now dispersed among the Muraqqa Gulshan in the Gulistan Library, Tehran, the Staatsbibliothek, Berlin, and a private collection in Tehran, see Beach 1978, p. 119, and Smart and Walker 1985, figs. 8a–d, which they compare to the work of Govardhan, a preeminent artist of the Mughal court.

For a study devoted entirely to such marginal drawings, see Kuhnel and Goetz 1926. AGP

Literature Poster 1987, cat. no. 125.

Provenance Charles D. Kelekian, New York.

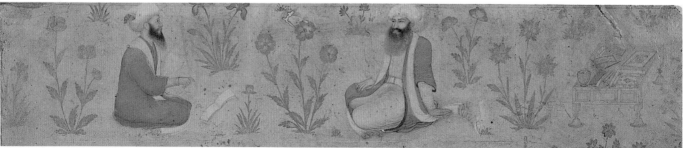

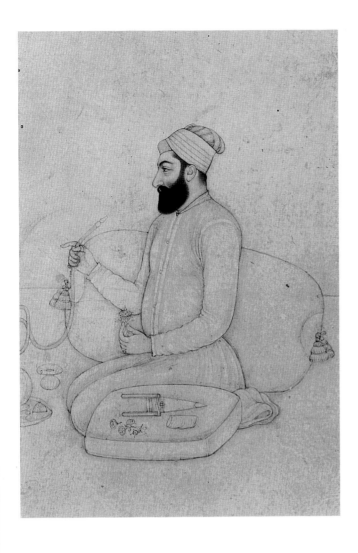

41 Hardas, Son of Anup Chatar

Portrait of Mirza Dakhani, Naubat Khan

Mughal School, Aurangzeb Period
Late 17th century
Color wash on paper
Sheet 7¼ x 4⅞ in. (18.4 x 12.4 cm)
Gift of the Ernest Erickson Foundation, Inc., 86.227.56

INSCRIPTIONS

Verso, at the top, in Persian, in nastaliq script: *Likeness of Mirza Dakhani who had become Naubat Khan, work of the artist Har Das son of Anup Chatar;* at left, in Devanagari script: *Likeness of Naubat Khan former name Mirza Dakhani. Padshah Aurangzeb [elevated him in favor?]. Formerly [he was] a Khanazad [born in imperial service] . . . soldier of good perception worthy of trust;* at right, in Devanagari script: *The painter Hardas son of Anupchitr [sic].* (Trans. R. Skelton) Both Devanagari inscriptions are headed by the auspicious *Shri.*

This fine drawing shows a bearded, seated man in profile. He is identified by two inscriptions on the reverse as Mirza Dakhani or Naubat Khan, while another gives the artist's name. It has not been possible to identify the sitter with any

Mughal nobleman, nor does any similar name occur in Ali (1985)—probably, according to Robert Skelton, since these names are only titles and not proper names. Skelton also notes: "There were two men called Naubat Khan who held rank under Shah Jahan. . . . One died in that reign and the other, named Jamshid, cannot be equated with any other known person. If Naubat Khan was the title of the functionary in charge of the ceremonial music, there must have been a number of office holders in the reigns of Shah Jahan and Aurangzeb. The title 'Mirza Dakhani' also tells us little. Perhaps he was from the Deccan. There was a Jamshid Bijapuri who held rank under Aurangzeb, but there is no evidence to suggest that this is him" (correspondence with the author, 1986).

Skelton proposes that the sitter was originally Mirza Dakhani and later, under Aurangzeb, became Naubat Khan. The English inscription, he observes, "is in the handwriting of Stanley Clarke, whose wrong date in the early 17th century seems to have led people astray, although he was correct in his other details. . . . The suggestion that he might be 'Abd ur Rahim has no foundation" (ibid.).

The figure holds the pipe of a hookah in one hand and a flower in the other. Various accoutrements are set around him as he rests against a large bolster. The face and turban are accentuated in polychromy.

For portraits by the artist Anup Chatar, circa 1640, see Falk and Archer 1981, nos. 70 and 73. AGP

Literature Coronation Darbar 1911, cat. no. C.104, where the subject is erroneously identified as Mirza Abd-ur-Rahim Khan, Khan Khanan and attributed to Hasham; Katz 1963, cat. no. 124, where he is identified as Abd-ur Rahim; Beach 1978, p. 130, where it is attributed to Mir Hashim; Poster 1987, cat. no. 124, where the subject and artist are studied anew.

42 Artist unknown

An emaciated horse

Mughal or Deccan
Mid-17th century
Colored ink on paper
Image 2⅞ x 3¹⁵⁄₁₆ in. (7.3 x 10 cm)
Sheet 2¹³⁄₁₆ x 4⁹⁄₁₆ in. (7.2 x 11.6 cm)
Gift of Mrs. George Dupont Pratt, 40.372

A starving pinkish brown horse is depicted walking through a landscape of leafy blue plants. His ribs stick out and all but a few hairs of his mane and tail have fallen out. On his neck

and front shoulder his coat has been reduced to stubble. His flattened ears, wrinkled nose, and loose lips accentuate his pathetic lot and contrast with his wide-open eye.

The subject of the starving horse was popular in sixteenth-century Iran, from where it apparently spread to Mughal India in the latter part of the century. Emaciated horses continued to be depicted frequently by seventeenth-century Mughal and Deccani artists. (For an outstanding Mughal version, see S.C. Welch 1976, pp. 36–37, cat. no. 87). Several marbled versions with and without riders are also known. (See Zebrowski 1983, figs. 104–6; and Weimann 1983, pp. 135–37).

According to Annemarie Schimmel, in Sufi poetry "a recurrent image [symbolizing] the *nafs*, the 'soul'—the lower self, the base instincts . . . is that of the restive horse or mule that has to be kept hungry and has to undergo constant mortification and training so that, eventually, it serves the purpose of bringing the rider to his goal" (Schimmel 1975, pp. 112–13). Although no rider is portrayed in this drawing, we may assume that the horse represents the *nafs*. SRC

43 Artist unknown

Portrait of Shah Jahan (?)

Mughal School

Late 17th century

Ink drawing with slight color on paper, mounted on gold-sprinkled border

Image 6 x 3¼ in. (15.25 x 8.3 cm)

Sheet 12 x 7⅞ in. (30.5 x 20 cm)

Gift of the Ernest Erickson Foundation, Inc., 86.227.164

INSCRIPTION

Lower left corner, in Persian: *Manohar 902* [circa A.D. 1666].

This formal portrait, in which modeling is achieved through subtle washes of ink, depicts an isolated standing figure of a

bearded nobleman facing toward his left. His right hand rests on his sword hilt; the blade, pointed downward, touches the ground between his feet. His left arm is flexed, the hand raised and cupped slightly, as if holding something. Flowers are interspersed in a row along the lower border, and birds are indicated in the upper edge.

Manohar, mentioned in the inscription, was a famous painter in the reign of the emperors Akbar and Jahangir, but this picture is obviously not by him. For a portrait attributed to this artist, see catalogue number 36. For an example of later Shah Jahan period portraiture, compare Sotheby's 1969, lot 148, *Portrait of Emp. Shah Jahan,* 1640–50, nastaliq calligraphy on reverse by Magbral-Din Muhammad al-Husaini dated A.H. 978/A.D. 1570–71.

The Persian script in the lower left corner, which spells "servant," is the introductory word of the text that continues on the next page. AGP

Literature Poster 1987, cat. no. 126.

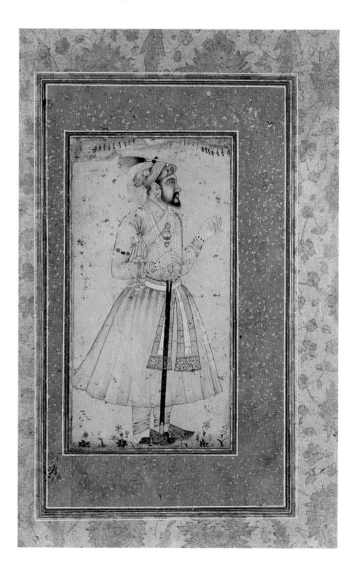

44 Artist unknown

Portrait of a prince

Mughal Style, Aurangzeb Period
Late 17th century
Opaque watercolor on paper
Image 5⅝ x 3¾ in. (14.25 x 9.5 cm)
Sheet 5¹³⁄₁₆ x 3¹⁵⁄₁₆ in (14.8 x 10 cm)
Gift of the Ernest Erickson Foundation, Inc., 86.227.139

The colors, costume details, and stylization of the clouds in this careful study of a young prince are typical of Aurangzeb period paintings of circa 1675. Holding a flower and standing facing his right, the prince wears a white patterned jama and yellow and gold boots. He is isolated against a background of pale washes of blue and green. The formal pose of three-quarter body with the face in profile follows a convention established in early-seventeenth-century Mughal portraiture. AGP

Literature Katz 1963, cat. no. 123; Poster 1987, cat. no. 127.

45 Artist unknown

Reception scene

Mughal School
Early 18th century (?)
Opaque watercolor on paper
Sheet 8⁹⁄₁₆ x 5½ in. (21.7 x 14 cm)
A. Augustus Healy Fund, 41.1175

A ruler in a purple robe, yellow and green boots, and orange shirt is seated outdoors on a throne under a canopy. With his left hand he offers a pearl and emerald turban ornament to the courtier who stands before him holding a letter. The nine other figures standing behind and in front of the ruler include the boy bearing the royal parasol, the arms bearer behind him, attendants with swords and shields, and a white-bearded elder. The courtiers stand before a gold balustrade on a brown ground under a green sky.

On the basis of such details as the Shah Jahani turban on one individual on the right, in contrast to the Persian headgear of the other figures, Wayne E. Begley has proposed that the scene may depict a specific event and not a general audience, perhaps an embassy sent by Shah Jahan to a Central Asian ruler. If this is indeed an event from Shah Jahan's life, Begley suggests a possible identification of the central figure as Nadar Muhammad Khan, a Central Asian ruler to whom

Shah Jahan sent ambassadors at the time of the Balkh campaign (communication with Amy Poster).

However, Robert Skelton is of a contrary opinion and proposes that the page is intended to represent the Sultan Bayazid before Timur, as seen in several Mughal versions (Mehta 1926, pl. 44, and Kuhnel 1922, fig. 111). Skelton also advances the possibility that the modeling of the figures may be the work of a Kashmiri artist (correspondence with Amy Poster, October 7, 1989).

A closely related drawing in the British Museum is inscribed with the name Timur (Tamerlane), founder of the Timurid dynasty and an ancestor of the Mughal emperors. Although certain figures and details in the drawing differ from those in this painting, notably the figures at the lower left and upper right, the similarity of the two is such that we

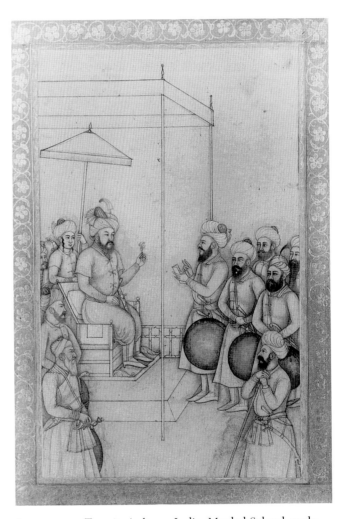

Anonymous. *Timur in Audience.* India, Mughal School, early 18th century. Ink and colors on paper. Image 8½ x 5⁵⁄₁₆ in. (21.7 x 13.5 cm). British Museum, London (BM 1920-9-17-013 [22]).

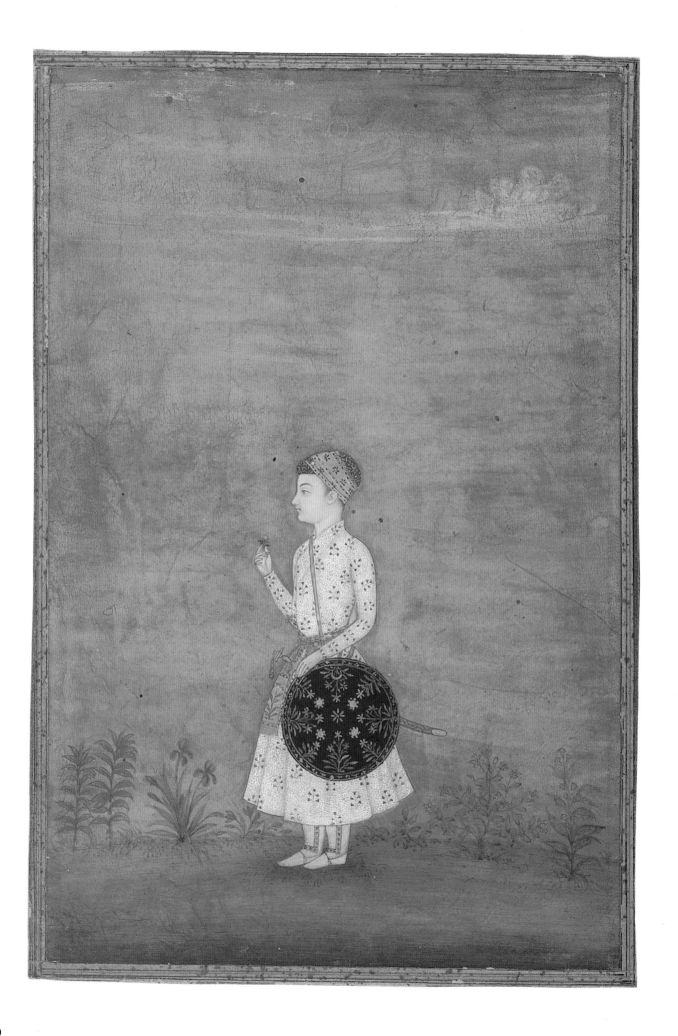

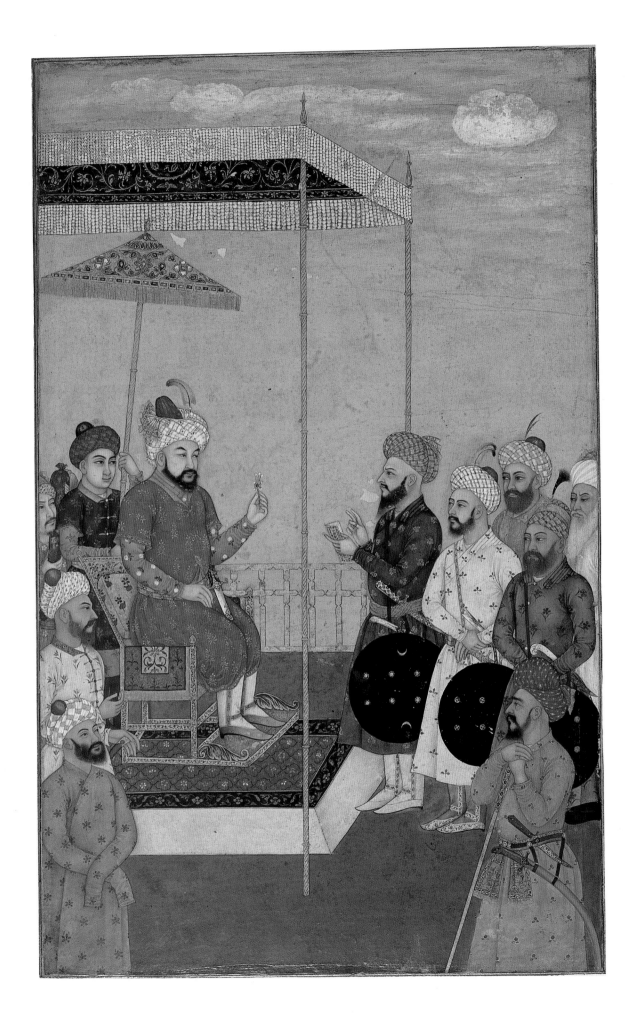

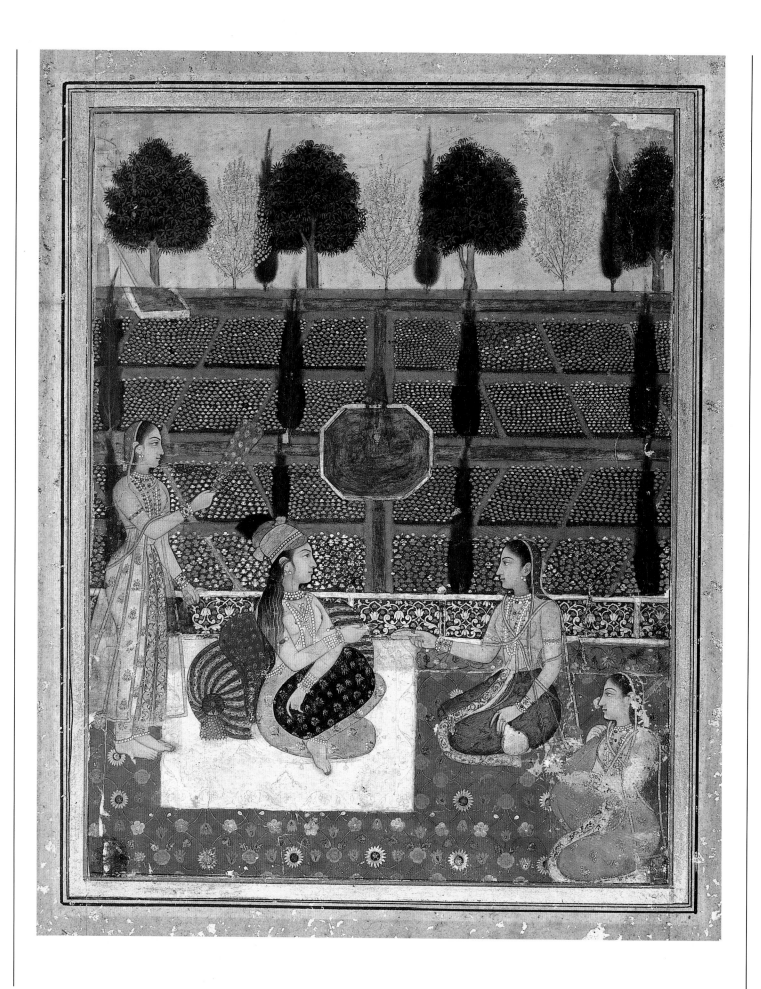

can assume the British Museum's work to be the preparatory drawing for our painting.

Portraits of the Mughal emperors and their ancestors enjoyed popularity from the earliest days of the empire in the sixteenth century until its demise in the nineteenth. Eventually such ancestor portraits were mass-produced as nostalgic expressions of the former splendor and glory of the Mughal empire. SRC/AGP

Provenance Nasli M. Heeramaneck, New York.

46 Artist unknown

Ladies on a terrace

Mughal School
Circa 1700–1710
Opaque watercolor on paper
Image 8³⁄₁₆ x 6⁷⁄₁₆ in. (20.8 x 16.4 cm)
Sheet 13¾ x 10¼ in. (34.95 x 26.05 cm)
Obtained by exchange with Nasli M. Heeramaneck, 36.231

A bejeweled Hindu woman and three of her attendants are on a terrace facing a formal garden. Left of center, she sits cross-legged on a white carpet with a pillow on her lap. Clad in a gold-flowered pajama, gold hat, strings of pearls and jewels, and with the ubiquitous red caste mark on her forehead, she leans against two more pillows. She extends a glass wine cup to her attendant, who offers her mistress a gold wine cup with her right hand while holding a wine bottle in her left. At the lower right, a female musician plays a stringed instrument, and at the left, an attendant waves a peacock-feather fly whisk. The ornate floral arabesque of the balustrade echoes the red, orange, blue, and white carpet of the terrace. The rhomboid flower beds of the garden are intersected by paths and watercourses that coalesce into an octagonal pool and fountain in the center. Cypresses and flowering and leafy deciduous trees alternate along the horizon. At the upper left, a tank and a building are visible.

Although single-figure and *Ragamala* paintings of women are found in sixteenth- and seventeenth-century Mughal painting, the depiction of two or more female figures on a terrace did not become popular until the eighteenth century. Because aristocratic wives were confined to the harem, their portraits are necessarily idealized. Apparently, the depiction of the calm and timeless lives of women in the Mughal court appealed to some artists of this period more than the chronicling of an empire where rigid convention had displaced the vigorous feats and aesthetic excellence of the previous century. SRC

Provenance Nasli M. Heeramaneck, New York.

47 Sukha Luhar

Emperor Alamgir II

Provincial Mughal
1756 (?)
Opaque watercolor on paper
Image 5¼ x 3⅛ in. (13.35 x 8 cm)
Sheet 7³⁄₁₆ x 5¼ in. (18.3 x 13.35 cm)
Anonymous gift, 78.256.5

INSCRIPTIONS

Verso, at top of page, in black ink, in Devanagari script: *Alamgir Sukha Luhar*; in red ink, in English script: *Mugal King as Rajput Style/Artist, painter Sukha Luhar/Date 1755 A.D./Mewar Style/Rare painting*; at bottom, in red ink, in English script: *EMPEROR-ALAMGIR.*

Dressed simply in a white jama and turban, the emperor has raised his right hand slightly with the palm upward as he kneels on a hexagonal gold throne with an orange brocade bolster, gold seat back, and parasol. A green and gold halo glistens behind his head. The ornate, leaf-shaped feet of the throne rest on a floral-patterned carpet. The background is a flat, rich blue. The stiff artificiality of this portrait typifies the stock representations of the Mughal emperors in the

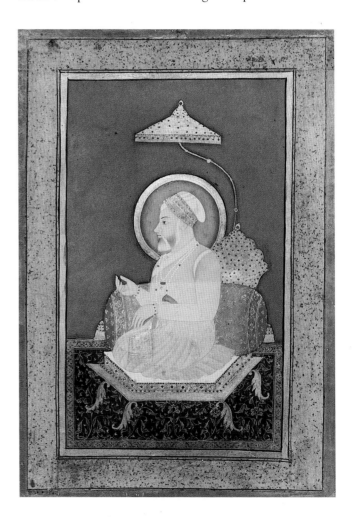

eighteenth and nineteenth centuries, at a time when the Mughal dynasty was waning.

An inscription on the verso, written in black ink in Devanagari script, names the artist as Sukha Luhar, gives a date of V.S. 1813 (A.D. 1756) and identifies the sitter as Alamgir. However, he should not be confused with the re-nowned Mughal emperor Alamgir I, also known as Aurangzeb, whose reign extended from 1658 to 1707. In-stead, this painting must be seen as a likeness of Alamgir II, who ruled from 1754 to 1759.

For similar works, see Titley 1977, p. 17, no. 36 (2), portrait of Alamgir II, Mughal, eighteenth century (British Museum, London, 1974-6-17-021); Sotheby's 1978b, lot 68. SRC

48 Artist unknown

Prince and his beloved in a garden

Provincial Mughal, Murshidabad (Bengal)
Circa 1760
Ink and opaque watercolor on paper
Image 5½ x 9⅝ in. (14 x 24.5 cm)
Sheet 12⅞ x 8½ in (32.8 x 21.6 cm)
Gift of Dr. Bertram H. Schaffner, 1989.179.5

In a courtyard a man in a white jama with a gold sash pre-sents a garland of flowers to a sari-clad woman standing in the doorway of her house. On the second floor another woman observes the scene from a window. The architecture is outlined sketchily, whereas the faces of all three figures and the garments have been well rendered in pink, gold, green, and white.

Although this composition does not conform to a known *Ragamala* type, it may well represent one. On the basis of the heavy shading of the faces, the picture has been assigned to Murshidabad, capital of Bengal, a thriving city in the eigh-teenth century. The figures' skin tone and other physiog-nomical details are quite distinct from those of the human images found in Mughal court painting. SRC

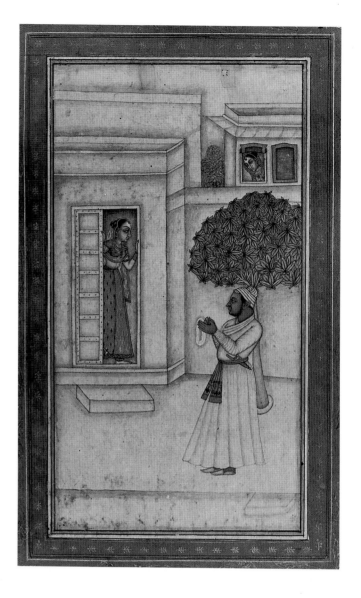

49 Artist unknown

Yogini in a landscape

Provincial Mughal, Lucknow
Circa 1760
Opaque watercolor on paper
Image 6⅞ x 3⁹⁄₁₆ in. (17.5 x 9.05 cm)
Sheet 11⅜ x 7⅞ in. (28.9 x 20 cm)
Gift of Mrs. George Dupont Pratt, 40.368

INSCRIPTION

Verso, four lines of Persian poetry, in nastaliq script: *Any attractive face who comes to you, the heavens want to take away, Go and give your heart to the one who will unconditionally always remain yours.*

A yogini, identified by her characteristic topknot, holds a blossom as she kneels in a landscape next to a small camp-fire before a thatched hut. Simply clad in a saffron robe and green shawl, she is nonetheless adorned with pearl neck-

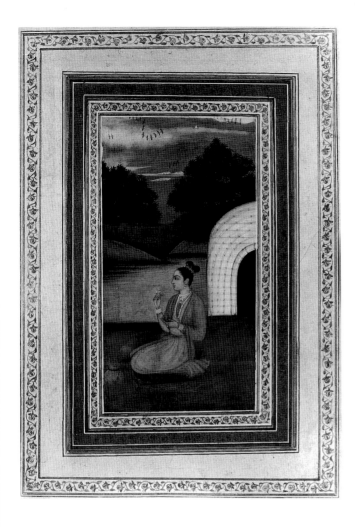

A prince is seated on a terrace, a female attendant behind him and three female musicians with their instruments before him. *Ragamala* sets were among the most popular subjects in the provincial Mughal regions throughout the eighteenth century. According to Losty, the "skies now tend to be full of multicolored clouds, echoing the vivid hues of the garments worn by the nobles and ladies against cold architectural backdrops, with solemn and formal rows of flowers and sometimes of sombre trees. Faces are heavily modeled, with shadows marked" (1982, p. 110). There are multiple floral borders.

A similar style is represented in a page depicting *Shri Raga* from Amber, dated 1709, in the Art Collection, Kankroli (Ebeling 1973, p. 238, fig. 178; and Waldschmidt 1975, p. 114, fig. 21). AGP

Literature Katz 1963, cat. no. 129.

Provenance Parish, Watson & Co., New York.

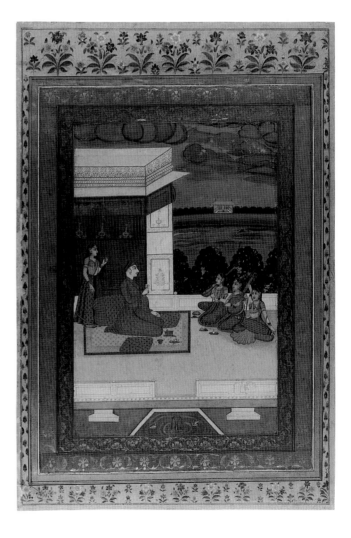

laces, rings, bracelets, and earrings. Around her are her satchel, staff, bowl, and kerchief. The palette of dusty and olive tones, the leafy trees, the lines of birds in the sky, and the delicate treatment of the figure all point to a provincial Mughal site such as Lucknow for the source of this painting. Further, the calm of the figure and the landscape recalls the style of the artist Hunhar II, who was active in Lucknow in the 1760s. (For Hunhar, see Falk and Archer 1981, cat. no. 177.) SRC

50 Artist unknown

Figures on a terrace

Provincial Mughal, Farrukhabad or Oudh
Circa 1760–75
Opaque watercolor and gold on paper
Image 12⅛ x 8³⁄₁₆ in. (30.9 x 20.8 cm)
Sheet 18¹⁵⁄₁₆ x 12⅞ in. (48.1 x 32.7 cm)
Gift of the Ernest Erickson Foundation, Inc., 86.227.54

51 Artist unknown

A woman is served fruit on a terrace

Provincial Mughal, Oudh (Lucknow)
Circa 1770
Opaque watercolor on paper
Image 8⅜ x 6 in. (21.2 x 15.2 cm)
Sheet 15⁹⁄₁₆ x 11³⁄₁₆ in. (39.5 x 28.5 cm)
Anonymous gift, 81.192.11

INSCRIPTIONS

Verso, below lower left corner of inner border, Arabic numeral: *36;* in nastaliq script: 4 lines, with false signature of Sultan 'Ali al-Mashhadi.

Although this painting was most likely produced in the provincial Mughal center of Lucknow, it owes much to the later work of the imperial school of Muhammad Shah (r. 1719–48) at Delhi. Under his weak and disastrous rule, paintings of women being entertained on terraces with a backdrop of sweeping river views predominate. Moreover, figures in European dress, as shown in this painting, were quite popular. Although the overall impression of this scene is one of stiffness, the artist has spared no detail in his depiction of

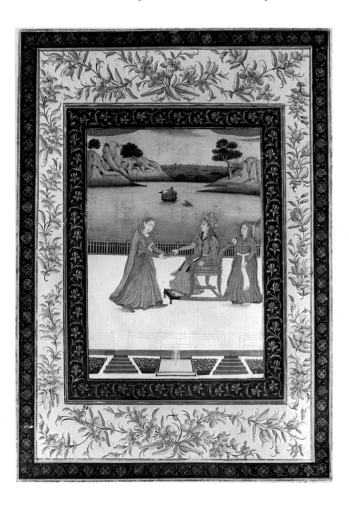

the sumptuously clad woman on a gold throne with her two attendants. The marriage of Indian and European elements is not without its amusing incongruities, as for example, the red-headed women clad in voluminous European dresses, capes, and jackets while the principal female is barefoot with delightfully hennaed toes. Beyond them, in the river, a very European-looking ship full of sailors is attacking a crocodile, while in the landscape beyond, a horseman hunts deer. The women are oblivious to this, staring as they do across the terrace or out at the viewer. The borders consist of a wide band of vegetal sprays between two narrower bands of gold arabesque on a dark blue ground.

A nearly identical painting is in the Johnson Album in the India Office Library, London; Falk and Archer assign it to the "style of Mir Kalan Khan," an artist who "appears to have come to Oudh from Delhi or the Deccan where he had been influenced by Dutch and Flemish landscape scenes. . . . A number of local artists modelled their work on this style" (Falk and Archer 1981, p. 136). Another similar painting was at Spink and Son (Ehnbom and Topsfield 1987, p. 37, cat. no. 14). Our painting appears to be the work of one of Mir Kalan Khan's followers, and its style is akin to that of Mihr Chand, a prolific Lucknow painter.

For similar work, see Sotheby's 1966, lot 4; Falk and Archer 1981, p. 138, no. 242, and p. 436 ill. SRC

52 Artist unknown

Intoxicated mystics and assorted subjects

Provincial Mughal, Oudh (Lucknow)
Circa 1775
Watercolor on paper with gold
Sheet 15¾ x 11½ in. (40 x 29.2 cm)
Anonymous gift, 84.183

INSCRIPTIONS

Lower left, near man on horseback lassoing man riding on elephant, in white pigment, in Persian, in nastaliq script: *Rustam the hero;* lower right corner, in gold pigment, in Persian, in nastaliq script: *The young Mirza Javan-Bakht and Shah 'Alam Padshah.* (Trans. M. Adib)

The scenes, taken from Muslim literary sources, depict Rustam lassoing Kabus (lower left) and (lower right) two royal hunters on an elephant, identified as Salim Mirza Javan-Bakht and Shah 'Alam Padshah, who are perhaps Aurangzeb and one of his princes. The lady in the howdah (upper right) may be one of the heroines of the Persian poet Nizami, and the elephant combat (top center) may derive from a prototype such as the *Akbar-nama* now in the Victoria

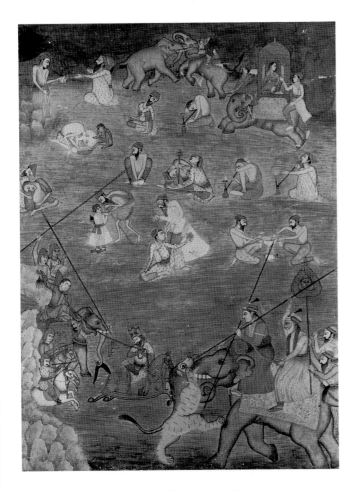

& Albert Museum (identified by Robert Skelton, personal correspondence, January 12, 1983). At the center, hashish-(*bhang*) or opium-eating rituals are illustrated. Figures are shown in various stages of intoxication and two are engaged in what may be one of the antinomian practices said to be part of ascetic ritual. The painting is a pastiche of themes modeled on the works of Mir Kalan Khan, a prominent artist at Oudh in eastern India, who is known mainly through later copies of his style.

One dominant technical feature of this painting is the heavy gray, stippled shading of the figures. The application of muted colors in thin washes is typical of the Mughal-influenced styles practiced at later capitals such as Oudh. This artist has employed an unusually limited palette, predominantly of light green and orange.

There is a wide range of opinion among scholars about the content of the painting, as well as the religious identity of the figures. Images of intoxicated ascetics are fairly common in Mughal painting, and although several of the central figures appear to be ascetics, whether they are Hindu or Muslim is unclear. Such subjects were frequently treated with ridicule or even disdain, with the ascetics presented as grotesque caricatures. The addition of the royal and heroic vignettes at the periphery complicates the reading of our painting. A close examination of the central figures reveals that several of the participants are dressed in aristocratic rather than ascetic attire, but their identity and possible connection with the outer figures are uncertain. SRC/AGP/JC

53 Artist unknown

Sohni swims to meet her lover Mahinwal

Provincial Mughal, Farrukhabad
Circa 1775–80
Opaque watercolor on paper
Image 9¹¹⁄₁₆ x 13⅞ in. (24.6 x 35.3 cm)
Sheet 10⅝ x 15⅛ in. (27 x 38.5 cm)
Gift of Dr. Bertram H. Schaffner, 77.208.2

In this version of a frequently illustrated Punjabi folk tale, Sohni, a village girl, swims across a river on an earthenware pot to meet her lover, Mahinwal. When Mahinwal, a Muslim merchant, fell in love with Sohni, her parents suspected his passion and married her off to a member of her own caste. Her secret nocturnal visits to Mahinwal came to an end when her sister-in-law replaced the pot she normally used as a buoy with an unfired one. As Sohni swam across the river, the pot dissolved and she drowned. Here the two principal figures are depicted in bright tones against a somber gray, green, and brown background. The preference for dark palettes is typical of late-eighteenth-century Mughal painting.

According to W.G. Archer and M.S. Randhawa, "the fakir smoking by his hut at the lower left prays to Khwaja Khizar, the river god, for Sohni's safety" (W.G. Archer 1973, vol. 1, p. 151). The buffaloes on the far side of the river are a reference to Mahinwal's name (literally, "buffalo-herder") and the occupation he chose in order to stay near his beloved.

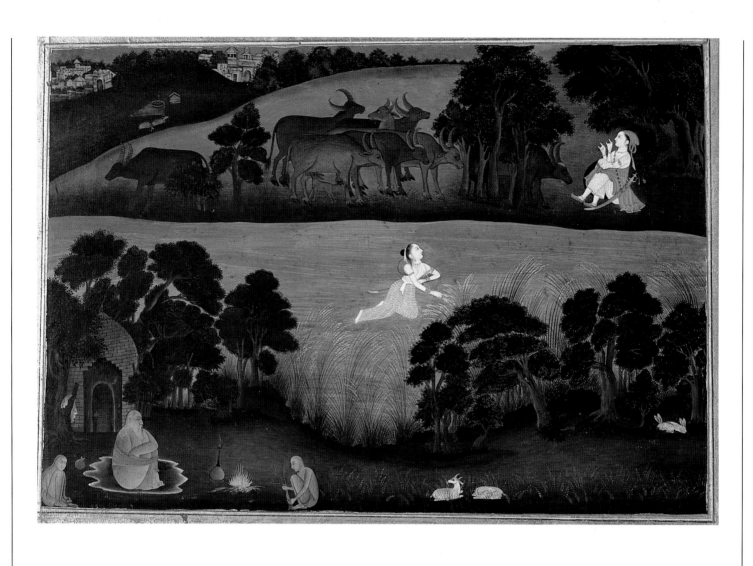

For an extremely close version of this painting in reverse, see Binney 1973, p. 128, cat. no. 105. Perhaps one of these paintings comes from a pounce of the other. The Binney page, now in the San Diego Museum of Art, and other versions of this subject in Farrukhabad painting are discussed in Binney 1977, pp. 118–23; Falk and Archer 1981, p. 444, pl. 335, in which the same scene is depicted in a vertical composition; and Markel 1988, pp. 99–114. AGP/SRC

Literature Markel 1988, fig. 6.

54 Artist unknown

An evening's music

Provincial Mughal
Late 18th century
Opaque watercolor and gold on paper
Image 9 x 6 in. (22.9 x 15.2 cm)
Sheet 12⅜ x 8⅞ in. (31.5 x 22.6 cm)
Gift of Mr. and Mrs. Alfred Siesel, 76.187

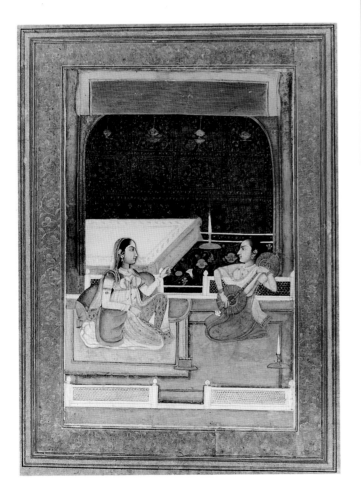

Colored walls of the room are decorated with gold floral sprays and painted ewers in three registers. The bright yellow bed at the left contrasts markedly with the dark walls and sets off the face of the woman who listens intently to the musician seated opposite her. Above, a rose-colored curtain with a green border has been rolled up to the lintel of the arched doorway.

This painting, harmonious and appealing in its own right, contains several features typical of the late eighteenth century. Night scenes of women on terraces enjoying music or other amusements were extremely popular in this period in provincial Mughal centers. Robert Skelton has attributed this work to a Jaipur artist working at the Mughal court (communication with Amy Poster). SRC

55 Artist unknown

A woman being led to her bedchamber

Provincial Mughal
Late 18th century
Opaque watercolor on paper
Image 9⁷⁄₁₆ x 6³⁄₁₆ in. (24 x 15.7 cm)
Sheet 18⁵⁄₁₆ x 12⁷⁄₁₆ in. (46.5 x 31.6 cm)
Gift of the Ernest Erickson Foundation, Inc., 86.227.55

A young woman, apparently intoxicated, is escorted to her bedchamber by four attendants, a musician carrying a *tanpura*, and the matron of the zennana (harem). The night scene consists of a pavilion on a terrace and a palace situated in distant hills.

The sensitive rendering of facial and other figural detail and the perspective of the pavilion interior contrast with the almost rudimentary execution of the landscape, a disparity that suggests a provincial attribution.

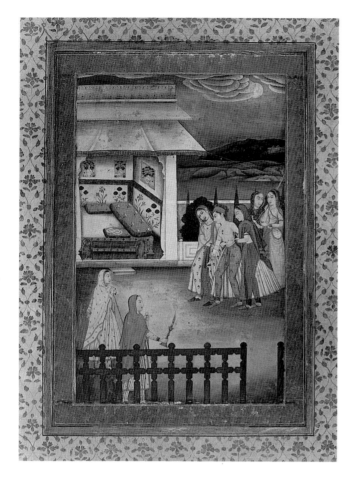

For almost identical figures, see Coomaraswamy 1916, vol. 2, pl. XX, and reference in vol. 1, p. 57. AGP

Literature Katz 1963, cat. no. 128.

Provenance Parish, Watson & Co., New York.

56 Artist unknown

Woman on a terrace

Mughal School, Delhi
Circa 1775
Opaque watercolor and gold on paper
Image 8¼ x 6¹³⁄₁₆ in. (21 x 17.3 cm)
Sheet 13¾ x 8⅝ in. (35 x 22 cm)
Gift of Mr. and Mrs. Peter P. Pessutti, 85.282.1

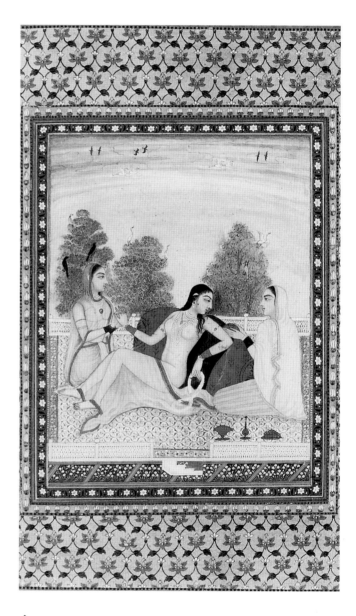

A nude woman draped in a transparent sari rests against a large bolster while two servants sitting on either side attend her. The location is a terrace covered by a gold-and-white carpet. A landscape is suggested beyond the tops of the three trees on the branches of which several birds nestle.

The fine drawing of the figures and repeated floral borders suggests an atelier of the Delhi school of the mid-to-late eighteenth century.

In the arrangement of the three figures, this painting is closely related to a page in the Bodleian Library, Oxford, Ouseley Ms. Add.171, fol. 15. UR

57 Artist unknown

A prince and his consort on a terrace

Provincial Mughal
Circa 1800
Opaque watercolor on paper
Image 8¾ x 5½ in. (22.2 x 14 cm)
Sheet 11¾ x 8⅜ in. (29.85 x 21.3 cm)
Gift of Mrs. George Dupont Pratt, 40.371

A prince leans against a bolster covered in gold cloth while he fondles his lady's breast. At the edge of the dais on which they sit, servant women cast sidelong glances in their direction. The scene takes place on a terrace next to a palace garden. The crescent moon in the sky and lighted candles in the foreground indicate that the time is evening.

Such compositions apparently gained currency during the reign of Jahangir (r. 1605–27). However, the prototype on which this early-nineteenth-century copy is based probably dates to the 1630s, during the reign of Shah Jahan. The thick application of paint and lax limbs support the dating of our painting to the turn of the nineteenth century.

For an early Mughal prototype, see Beach 1978, p. 99, no. 31. SRC

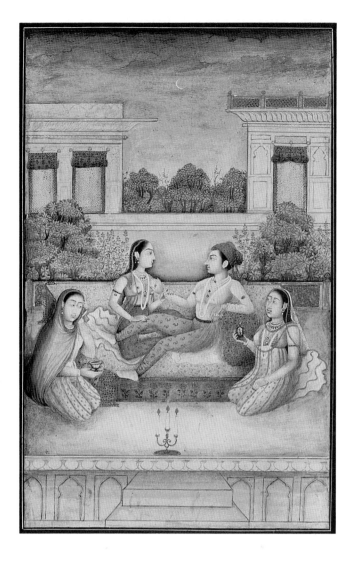

Deccani Painting

58 Artist unknown

Stalling elephant with two riders

Deccan, Bijapur
Mid-17th century
Ink, gold, and watercolor on paper
Sheet 6½ x 4⅞ in. (16.5 x 12.4 cm)
Promised gift of Dr. Bertram H. Schaffner, TL1986.371.4
INSCRIPTION
At left upper edge: illegible seal.

The mahout seated on the rear of the elephant sports a long mustache with fine shadowing of beard on his face; his right arm is extended and the index finger is hooked around the rope that holds the saddlecloth in place. The younger mahout, with delicate features, seated in front, leans over the elephant's head, a goad in his right hand and his left held against his forehead, indicating that he is directing the elephant to take a bow. This action is confirmed by the elephant's pose of forelegs outstretched and trunk raised. The animal is adorned with bells on chains suspended from long ropes across his body.

The scene is a tour de force of the marbler's art, representing a fleeting tradition in Deccani painting. According to the analysis by Christopher Weimann, the marbled areas of this painting were produced by means of four stencils, one for the figures' robes, one for the upper saddlecloth, one for the lower saddlecloth, and one for the elephant. Not only do the colors of each marbled passage vary, but also the direction of the marbling contrasts from section to section. As Weimann notes (1938, pp. 135–37), the patterns formed by the marbling heighten the sense of movement and define the contours of the elephant's body.

The tree and birds in the background, the figures' faces, and the bells, ropes, and shawls were all painted and highlighted with gold once the marbling was complete. While the riders' faces conform to mid-seventeenth-century Mughal norms, the evidence available on marbled paintings of the seventeenth century strongly supports an attribution of the group to a Deccani workshop, probably located at Bijapur. (For further discussion on Bijapuri marbling, see Zebrowski 1983, pp. 135–38.) SRC

Literature Weimann 1983, pp. 135–37.

59 Artist unknown

Finch, poppies, dragonfly, and bee

Deccan, Golconda
1650–70
Opaque watercolor and gold on paper
Image 7⅜ x 4 in. (18.7 x 10.2 cm)
Sheet 11½ x 7¾ in. (29.5 x 19 cm)
Ella C. Woodward Fund, 87.85

While Golconda artists maintained their own distinctive palette, they did not hesitate to borrow whole compositions from their Iranian counterparts of the late-sixteenth and seventeenth centuries. Thus, while this painting of a finch perched on a rock before flowering poppies may be viewed as an extension of the Mughal interest in nature, its inspiration actually lies in the bird and flower paintings of the Safavid artist Riza, his son Shafi' 'Abbasi, and Riza's student Mu'in Musavvir.

As the vogue for single-page paintings made for inclusion in albums became increasingly well established in early-seventeenth-century Iran, artists broadened their range of subjects. Riza, the leading artist at the court of Shah 'Abbas I, introduced the subject of a single bird perched on rocks, and he executed at least three versions of it during the 1620s (Canby 1981, p. 193; A. Welch 1973, p. 65, fig. 11). While the artist of our painting includes vegetation and a rocky cluster as in the works by Riza, he has omitted the wispy clouds and curving fronds so typical of Riza's paintings. In fact, the presence of insects and lack of clouds in our painting relate it to the work of Riza's son Shafi' 'Abbasi (Welch, op. cit., no. 58). Known for his textile designs as well as bird and flower paintings, Shafi' 'Abbasi worked in Isfahan in the mid-seventeenth century. Very possibly textiles based on his work, if not his paintings themselves, traveled to Golconda and influenced artists at the court of Sultan 'Abdullah Qutb Shah (r. 1626–72).

The intense purples and pinks and the contrasting cool green leaves and acid green feathers in this meticulously rendered painting bespeak a Deccani sensibility. The Deccani poppy, which is shown in all stages of flowering, and the dragonfly, which appears in the Deccan during the monsoon, are frequent motifs of Deccani painting. The marble-

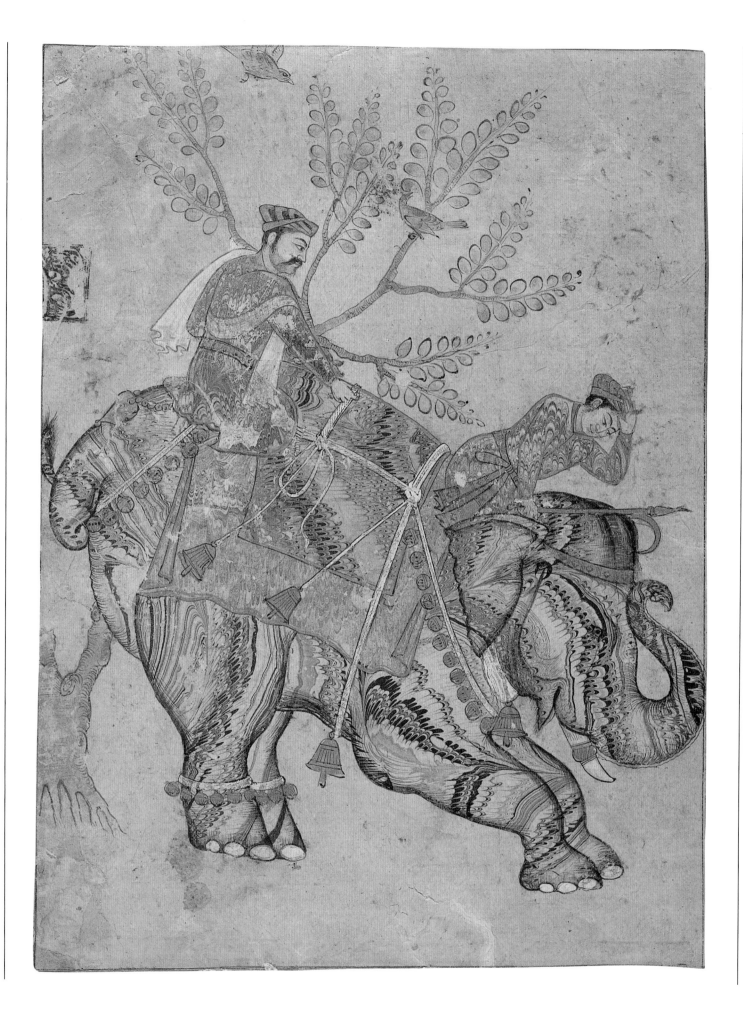

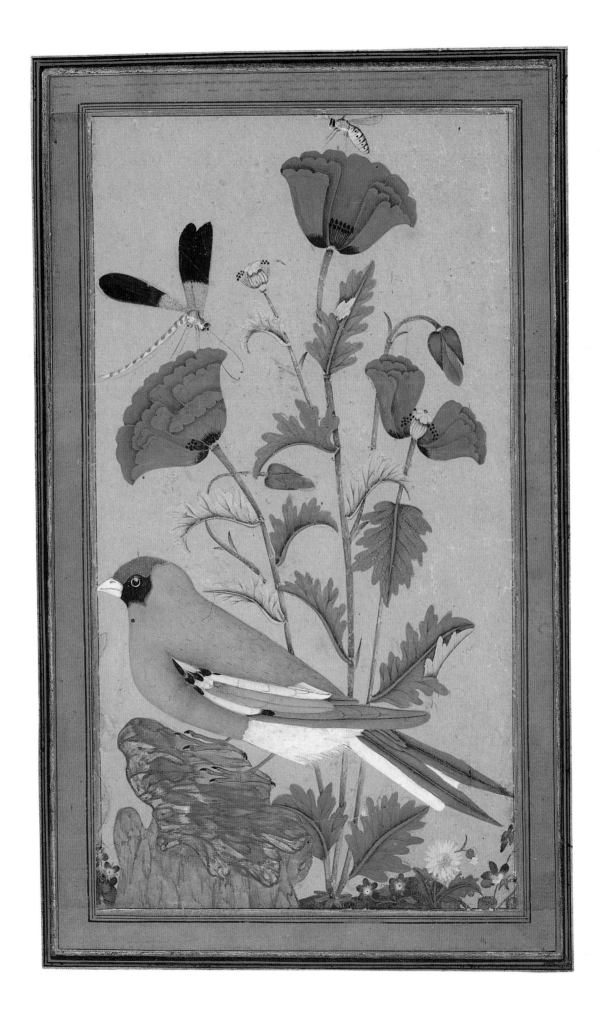

ized rock on which the finch perches is very close to the Deccani marbled-paper drawings.

A large number of similar bird or flower studies were produced for mid-seventeenth-century Mughal albums, such as the Dara Shikoh album in the India Office Library; see Falk and Archer 1981, p. 384, pls. 68f.23 and 68f.24, p. 390, pl. 68f.42, p. 391, pl. 68f.41v, p. 394, pls. 68f.49b, 68f.50, 68f.51b, and p. 398, pl. 68f.65b, attributed to the Mughal artist Muhammad Khan, circa 1630–35. SRC

60 Artist unknown

Layla visits Majnun in the grove

Deccan
17th century, with later additions
Opaque watercolor on paper
Image 6¾ x 4¾ in. (17.1 x 12.1 cm)
Sheet 9⅜ x 6 in. (23.8 x 15.2 cm)
The Brooklyn Museum Collection, X635.1

This miniature is pasted onto the original page to fit around the text. In this scene Majnun is depicted in his wilderness state. Driven to insanity by his love for Layla, Majnun, whose name is Arabic for "crazy one," has left human society. Befriended by wild animals in his exile, he composes poems to his beloved but unattainable Layla.

The upper section of the page depicts a flowering willow tree against a blue sky and a dark green hill with a high horizon line. The lower part shows Layla and Majnun in discourse in a conventional landscape of wine-colored rocks and a green meadow. The lovesick Majnun is seated under the tree at the left surrounded by pairs of tigers and deer. He is bearded and mustached, his hair is matted, and his body and hands are emaciated. He is clothed in a wine-colored loincloth. Layla kneels at the right and reads a love letter to him. She is dressed in a red and gold sari and wears a gold headdress and elaborate jewels on her arms, neck, and ears.

The Persian text in the panels relates the story of Layla and Majnun from the *Khamsa* of Nizami. The lovers faint when they see each other after years of painful separation (Behrouz 1984, p. 313) and are subsequently revived with perfume and rosewater by the old man Zayd. (For an illustration of this scene, see Lentz and Lowry 1989, p. 274, cat. no. 140.) Our painting depicts the lovers after they have been revived.

The repainting and condition of this miniature obscure the details and distract our attempt to attribute it correctly. Such elements as the parallel recumbent tigers, the deer seated transversely to each other, and the wispy tree at the top of the page conform to a certain extent to early Mughal conventions, while the female's pose, gown, and headdress appear to be later interpretations of the subject. These discrepancies in style and form may indicate repainting. SRC/ME

61 Artist unknown

Angel

Deccan
1675 or later
Opaque watercolor on paper
Image 3⅜ x 2¼ in. (8.6 x 5.7 cm)
Sheet 9¼ x 6⅜ in. (23.5 x 16.2 cm)
The Brooklyn Museum Collection, X623.4

This crudely painted, cut-down rendering of a haloed woman in a landscape is presumably based on a Western

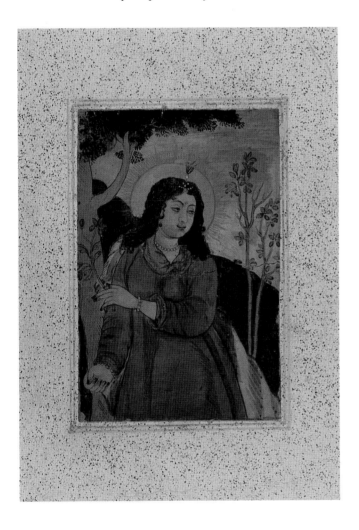

prototype. Clad in a blue robe with orange trim, the figure holds a flowering branch in her left hand and looks out across her left shoulder. In addition to her hennaed fingertips, she is adorned with a pearl earring, a single strand of pearls around her neck and each wrist, as well as a feather plume (*kalgi*) on her head, which consists of a single vertical feather fitted with pearls. Her round and fleshy face, framed by curly wisps of hair, is accentuated by her half-closed languorous eyelids. The pink and white form behind her may be either drapery or badly rendered wings, or part of the mountainous landscape, with radiating branches and leaves of a sparse tree on her left. European-inspired pictures enjoyed great popularity in the Deccan from the mid-seventeenth through the eighteenth century.

A note on the back of the painting, written by R. Stewart Culin, Curator of Ethnography at The Brooklyn Museum from 1903 to 1929, reads: "Miriam. Purchased in Jaipur, India Museum Expedition 1914." In the 1913–14 Expedition Report he noted: "I also bought myself a picture of the Virgin, apparently early Persian, for which I paid 10 rupees. . . . The picture the Mohammedan shop keeper designated as that of Miriam." Although items from Culin's estate entered the Museum's collection, as of this date no accession record has been found for this work. SRC/AGP

Provenance Jaipur Museum Collection.

62 Minuchihr

Portrait of Abu'l Hasan, last sultan of Golconda

Deccan, Hyderabad
Last quarter of the 17th century–early 18th century
Opaque watercolor and gold on paper
Image 8 x 5¼ in. (20.2 x 13.5 cm)
Sheet 11¾ x 7⅝ in. (29.8 x 19.5 cm)
Gift of the Ernest Erickson Foundation, Inc., 86.227.50

INSCRIPTION

In lower left corner, signature, in Persian, in nastaliq script: *A work of Minuchihr.*

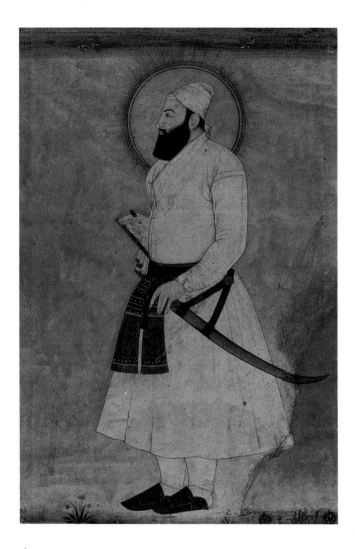

Abu'l Hasan, Tana Shah, the last sultan of the Qutb-Shahi Dynasty (1512–1687) of Golconda, is famous for his defense of Golconda for eight months in 1687 against the Mughal Emperor Aurangzeb (1658–1707). This study, probably painted at Hyderabad in the eighteenth century, shows him standing in profile tying on his sword. He wears a white turban and a long white jama tied with a gold sash. The nimbus with radiating gold lines behind his head is a convention of Deccani portraits of rulers, while the palette—violet-red, russet, black, green, gold, and white on a pale green background—is typical of later Deccani works. The artist's signature, in the lower left-hand corner, has

been identified. (For a portrait from the period of Abu'l Hasan's reign, see Zebrowski 1983, p. 190, fig. 156, which depicts a much more portly Abu'l Hasan.) AGP

Literature Coronation Darbar 1911, p. 119, no. 292; Katz 1963, cat. no. 125; Parke Bernet 1944, cat. no. 37.

Provenance Parke Bernet, New York; Sarkis Katchadourian, New York; Khwajah Mahmud Husain, Delhi.

63 Artist unknown

Page from an astrological treatise

Deccan, Hyderabad or Eastern Deccan
Circa 1750
Opaque watercolor on paper
Sheet 7¾ x 4½ in. (19.7 x 11.45 cm)
Museum Purchase, Restricted Funds, 71.120

In this depiction of a composite figure in a landscape, a constellation composed of the body of a spotted blue elephant with flames (or feathers) on its haunches, a human head, and gold-tipped bull's horns is shown strolling through a mythical Deccani landscape. Orange flowers border the foreground and purple lotuses are on either side of the beast. The distant background is dotted with red-roofed white buildings, purple and orange hillocks, and a variety of trees. The sky beyond is dark blue with a band of lighter blue clouds.

For other pages from this manuscript, see Binney 1973, no. 163; Wiener 1974, cat. no., 57; Maggs n.d.a, no. 45 and cover; and Rijksprentenkabinet 1978, cat. no. 44, pl. 17. SRC

Literature Maggs n.d.b, p. 12, fig. 14.

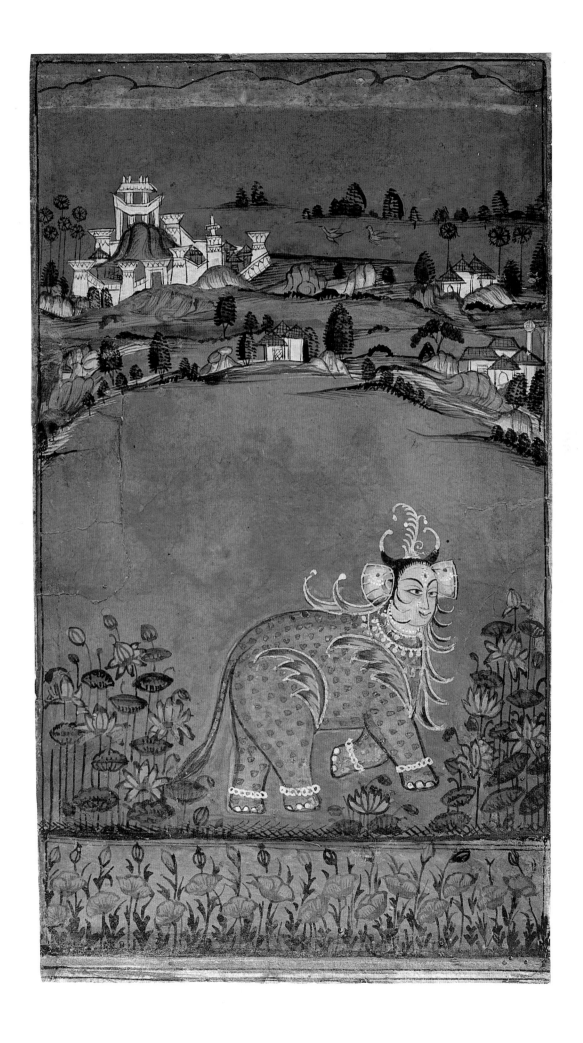

64 Artist unknown

Courtesan in a window

Deccan
18th century
Washes of watercolor, gold, and ink on paper
Image 5½ x 2⁹⁄₁₆ in. (14 x 6.5 cm)
Sheet 11⅞ x 8³⁄₁₆ in. (30.2 x 20.8 cm)
Gift of Mrs. George Dupont Pratt, 40.370

INSCRIPTIONS

Verso, poem in Persian, in nastaliq script: *If I could kiss you,/It would be all I would want from your person./You are my greatest passion and all else is vanity./The only thing I plead is to kiss you;* in lower left corner, signature, in Persian, in nastaliq script: *Written by Abd al-Nishaburi/May Lord pardon ́his sins.* (Trans. M. Ekhtiar)

A bejeweled courtesan shown in three-quarter length stares out from an arched window. Her black hair is covered with a net of pearls, rubies, emeralds, and gold ornaments. Numerous strings of pearls, jewels, and shells circle her neck and fall onto her transparent blouse. She holds a gold necklace in her right hand; her left rests on the window frame. Her skirt is pale green, her shawl a transparent wine-colored cloth with gold dots and borders.

The courtesan wears a circular ring with a mirror at the center framed with pearls on her index finger in the fashion of Hyderabad in the eighteenth and nineteenth centuries. The stiffness of line and lack of spontaneity in the rendering suggest that this portrait is an eighteenth-century copy of a seventeenth-century prototype. SRC

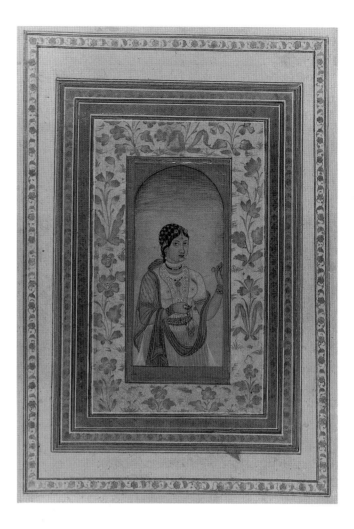

65 Artist unknown

Mandalika Ragini

Page from a dispersed *Ragamala* series
Southern Deccan
Mid-18th century
Opaque watercolor on paper
Image 10½ x 5⅜ in. (26.65 x 13.65 cm)
Sheet 12¼ x 7 in. (31.1 x 17.8 cm)
Gift of Dr. Farooq Jaffer, 79.266

A seated woman in a saffron and pink sari presents a vina to a female attendant who stands at the left. A second female attendant, rather awkwardly overlapped by the seated figure's carpet, stands at the right. The women are arranged on a terrace set between a flower garden in the foreground and a hilly landscape and dark blue sky in the background. The multiplicity and overlay of floral and geometric motifs in registers used by the artist—in the textiles, carpeting, architectural elements, and throughout the landscape— appear to be an attempt to create depth and perspective, but are more consistent with the flat surface typical of Deccani

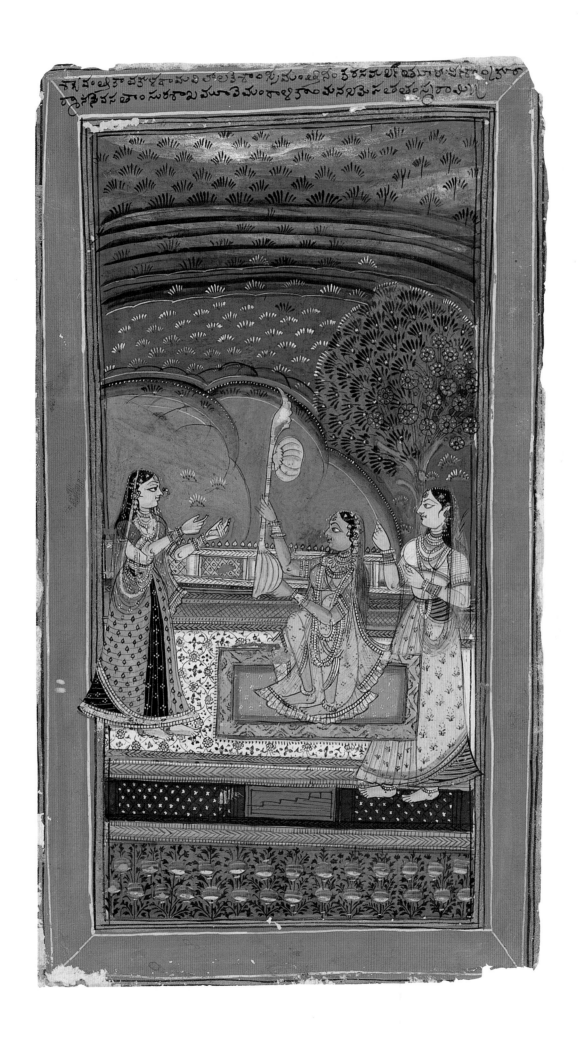

work. For comparable subjects from the same series, see Mittal 1963b, p. 58; Binney 1973, cat. no. 175a (now San Diego Museum of Art); Ehnbom 1985, p. 102, cat. no. 44; Bautze 1991, cat. nos. 27–28.

The Sanskrit text in the upper border, written in black ink in Telugu script, reads:

Forever I think of *Mandalika*. Her hair waves with garlands of syavantika and vakila flowers; she is an auspicious woman with a lovely vina in her hands, and she sits under the divine tree in tortoise position. (Trans. V. Narayana Rao)

The painting comes from a *Ragamala* series of which two paintings, still in the collection of the Raja of Wanparthy, have been published by J. Mittal (op. cit., pp. 58–59), who dates the group to circa 1750 and thus assumes the patron to have been Raja Sawai Venkat Reddy (r. 1746–63). Wanparthy was a small tributary of Hyderabad in which Telugu was spoken. While the general composition of this painting follows Hyderabadi models, the intense palette and strong treatment of forms relate the group to Southern Indian painting. SRC/AGP

Provenance Rameshwar Rao, Raja of Wanparthy.

66 Artist unknown

A lady receiving a messenger

Deccan, Hyderabad
Late 18th century
Opaque watercolor on paper
Image 8½ x 5 in. (21.6 x 12.7 cm)
Sheet 10 x 6¾ in. (25.4 x 17.2 cm)
Anonymous gift, 81.192.6

INSCRIPTION

Verso: In black ink, in Persian, in nastaliq script: *In the time of your just rule, O King, nobody has any complaints. May your world be always full of prosperity, and may The One Who Created Your World always protect you. Written by the lowly servant Amir Bavar Khabak.* (Trans. M. Adib)

A richly clad woman sits on a typical Hyderabad terrace attended by two servants and an old woman. One servant, in a red and gold sari, combs the lady's long black hair, while the other approaches her with a cup. The old woman in white leans forward to transmit a message. The setting—a white terrace with a fountain and garden in the foreground, canopy, pavilion, high wall, trees, and blue sky in the background—is standard for eighteenth- and nineteenth-century Hyderabad painting. Equally popular in late Hyderabad painting was the subject of the old woman who brings a message, memento, or advice concerning the lady's absent lover. The sensitive rendering of the subject of a young

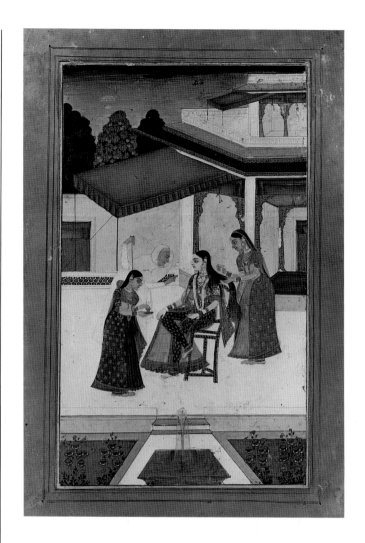

woman and her elderly confidante and chaperone is seen in catalogue number 219. The rich coloring and attention to detail in this painting support its late-eighteenth-century date.

For a later version of this scene and references, see catalogue number 95. SRC

67 Artist unknown

Two women in a landscape

Deccan
Mid-18th century
Opaque watercolor on paper
Image 6¹¹⁄₁₆ x 3¾ in. (17 x 9.5 cm)
Sheet 8¹¹⁄₁₆ x 5½ in. (22.1 x 13.95 cm)
Anonymous gift, 80.179

Two women stand facing one another in a landscape. The one at the left holds a gold bottle at her waist in her right hand and a cup in front of her in her left. She leans against a tree with arching boughs of sparse foliage, her left leg

crossed in front of her right, exposing her loosened sandal. Her companion faces her while tuning a *tanpura* (stringed instrument). Both women wear transparent dresses over colored pants. Diaphanous veils draped over their heads and shoulders gave the artist the opportunity to focus on the details of the figures' extraordinary long hair, which flows down to their knees. They are both heavily jeweled and sport the hair ornament (tikka). The ground on which they stand is dark green with a floral border. Behind them stretches an apple green background terminating in a dark blue sky with crenellated clouds. (For a similar study, see Mittal 1963, p. 50, no. 19.)

The clouds here vaguely recall those in a seventeenth-century work that has been attributed to Aurangabad. (Mittal, op. cit., p. 21, no. 9, offers a painting in a similar style.) However, the palette, treatment of landscape, and shading of the figures' faces are more closely related to mid-eighteenth-century Hyderabad style than to earlier painting of the Northern Deccan (see Zebrowski 1983, p. 250, fig. no. 222). SRC

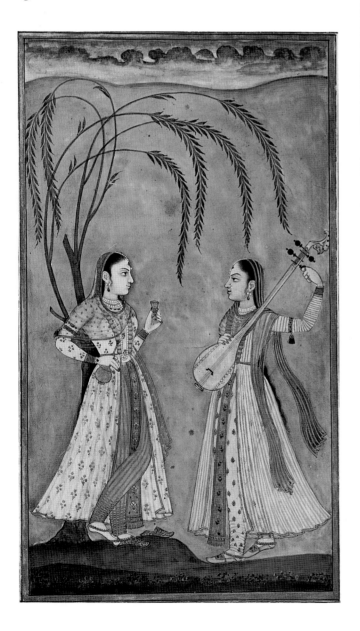

68 Artist unknown

Kedara Ragini

Page from a dispersed *Ragamala* series
Deccan
Circa 1800
Opaque watercolor on paper
Image 9½ x 5⅜ in. (24 x 14.3 cm)
Sheet 12 x 8¼ in. (30.5 x 21 cm)
The Brooklyn Museum Collection, X689.8

INSCRIPTIONS

Upper margin, twice in Persian, once in nastaliq script, once in Devanagari script: *Ragini Kedara;* lower margin, once in Persian: *36 Ragini Kedara.*

In a pavilion at a river's edge, a prince visits a female ascetic with a vina. Below, two men guard the door to the porch, and the prince's boatman sleepily awaits his master. The setting, a white building with turrets, balustrades, and floral

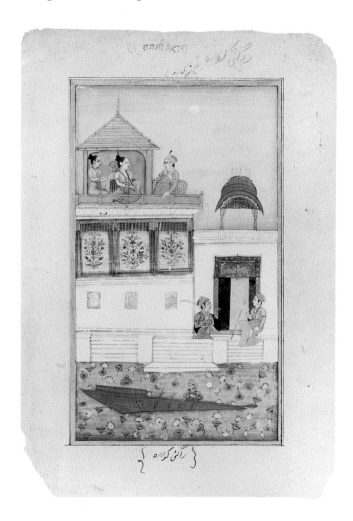

curtains, is typical of late-eighteenth- and early-nineteenth-century Hyderabad painting. The moonlit night, the ascetic, and her royal visitor all characterize *Kedara Ragini* scenes, particularly those of this period.

For other Hyderabad *Ragamala* paintings of the period, see Ebeling 1973, p. 119, col. pl. C47; Victoria & Albert Museum, London, I.S.73–1954, *Ragini Kedari Dipakki*, provincial Mughal, eighteenth century; and Falk and Archer 1981, p. 233, cat. no. 431 xii, *Kedara Ragini*.

For additional pages from this series, see catalogue numbers 69–71. SRC

69 Artist unknown

Dipaka Raga

Page from a dispersed *Ragamala* series
Deccan
Circa 1800
Opaque watercolor on paper
Image 9⅜ x 5¾ in. (23.7 x 14.5 cm)
Sheet 12 x 8¼ in. (30.3 x 21 cm)
The Brooklyn Museum Collection, X689.5

INSCRIPTIONS

Upper margin, twice in Persian, once in nastaliq script, once in Devanagari script: *Dipaka Raga;* lower margin, once in Persian: *25 Raga Dipaka.*

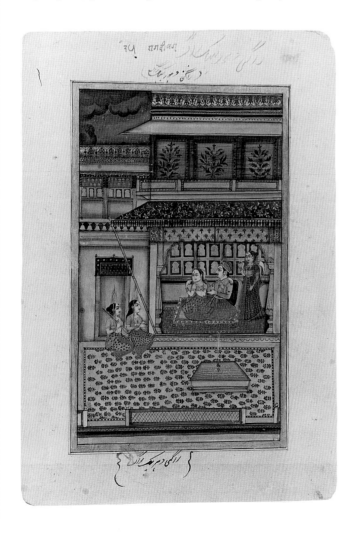

*D*ipaka Raga, rendered as a prince, and his consort embrace while sitting on a carpet in a pavilion. At the right a servant stands with a fly whisk, while two female musicians kneel at the left in a courtyard. The setting is replete with flowered gold and red brocade curtains and canopies and niches bordered in pink. A bright pink flowered carpet covers the courtyard and surrounds a fountain.

In a traditional rendering of *Dipaka Raga* flames emanate from all the figures and often illuminate the evening scene. The flames that spring from the heads of the prince, his consort, and the musicians, as well as the caressing couple and musical entertainment, identify this scene as *Dipaka Raga.*

For a later drawing, with additions, in which the male figure has flames emerging from his head and is fondling his consort, see Falk and Archer 1981, no. 431 ii.

For additional paintings from this series, see catalogue numbers 68, 70, and 71. SRC

70 Artist unknown

Kamodani Ragini

Page from a dispersed *Ragamala* series
Deccan
Circa 1800
Opaque watercolor on paper
Image 9¼ x 5⅝ in. (23.5 x 14.3 cm)
Sheet 12 x 8¼ in. (30.4 x 21 cm)
The Brooklyn Museum Collection, X689.7

INSCRIPTIONS

Upper margin, twice in Persian: *Ragini Kamodani;* once in Devanagari script: *33 Kamodi Ragini;* lower margin, once in Persian: *33 Kamodi Ragini.*

A woman dressed in a saffron sari sits on a floral carpet in a red pavilion high above a tank and a lush landscape. Egrets, doves, and fish enjoy the lotus-laden pool while a storm threatens the landscape behind the turret.

Despite the identification of this page as *Kamodani Ragini,* few of the characteristics of this *Ragamala* scene are present. (See, for example, cat. no. 33.) The figure's outstretched hand implies that she is rendering a song. *Kamod* represents a male or female ascetic worshiping a *Shivalingam* or Krishna statue, portrayed on the terrace of a palace, sometimes without an image, but shown with prayer beads. This example of a solitary female represents a different iconography of *Kamodani Ragini.*

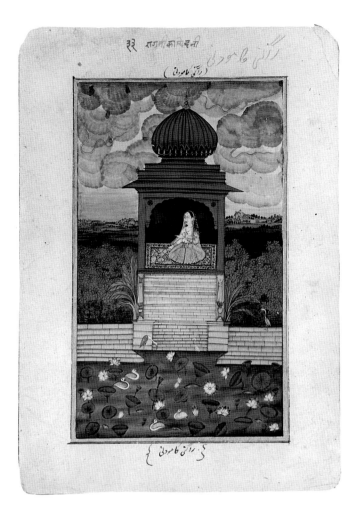

For additional pages from this series, see catalogue numbers 68, 69, and 71.　　SRC

71　Artist unknown

Desi Ragini

Page from a dispersed *Ragamala* series
Deccan
Circa 1800
Opaque watercolor and gold on paper
Image 9⅜ x 5⅝ in. (23.8 x 14.4 cm)
Sheet 12 x 8¼ in. (30.5 x 21 cm)
The Brooklyn Museum Collection, X689.6

INSCRIPTIONS
Upper margin, twice in Persian: *Ragini Desi;* once in Devanagari script: *30 Ragini Desi;* lower margin, once in Persian: *30 Ragini Desi.*

Although inscribed as "Desi," a generic term for a large group of *ragas,* this composition conforms to the description of *Desvarati Ragini,* a fair woman with her body twisted and arms upstretched, a sign of yearning. As with so many late Deccani paintings, this scene takes place on a terrace in a

garden complete with fountains, watercourses, a grand pavilion, and a thatched tent. *Desvarati Ragini* is accompanied by a servant woman with a fan and two female musicians.

For another rendering of *Desvarati Ragini,* from Hyderabad, see Falk and Archer 1981, p. 233, cat. no. 431 vi, *Desvarati Ragini.*

For additional pages from this series, see catalogue numbers 68–70.　　SRC

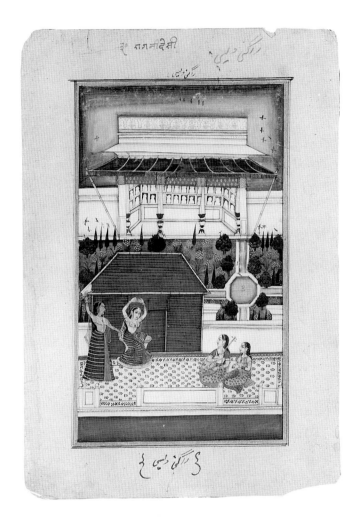

72　Artist unknown

Four pages from an unidentified Hindu manuscript

Deccan, possibly Shorapur or Hyderabad
19th century
Gifts of Dr. Andrew Dahl

The popular Hindu myths surrounding Krishna's exploits were translated into the various languages of the subcontinent. Several scholars who have examined the four pages reproduced here have suggested that they may well be part of an Urdu version of the *Bhagavata Purana,* but the verses are

not an exact transliteration of the Sanskrit text. Without the colophon page, which might have given the title, place, date, and perhaps the names of the artist and scribe of the manuscript, it is difficult to establish its origin or identify its subject matter with absolute certainty.

We have catalogued the pages as Deccani because certain features are typical of nineteenth-century Shorapur and Hyderabad painting, namely the vertical format of the page, the text panels framed by variegated rules, and the figures isolated against an unpainted ground, in the costumes of Maharashtra. Zebrowski describes Shorapur figures as "in rigid, South Indian poses" and dressed in Maratha costumes, including the long dhoti worn by men and the eight-foot saris worn by women (1983, pp. 274–75). Mittal (1963a, p. 54) notes the influence of Mysore and Tanjore, as well as Shorapur, in style, dress, and motifs that occur in Hyderabad paintings for Hindu patrons after the capture of Shorapur in 1858, when many artists migrated to Hyderabad. Mittal also observes the incorporation of forms from Nayak sculpture, specifically gold crowns, jewelry, and postures (ibid.).

The figures in our series are drawn with a very fine black line, while other details are freely drawn in color without any outline on an unpainted ground. The thin trunks of the trees support thick foliage at their tops. Modeled with juxtapositions of light and dark green, they are populated with birds and clusters of dots or star-shaped forms indicating blossoms. The artist has varied his technique in depicting the ground line, ranging from a continuous brushstroke to scrolling and dabbing of darker green on a lighter ground. Thinly painted areas of red, green, purple, brown, and yellow have been highlighted with gold to indicate crowns, jewelry, and borders of costumes.

A

Krishna subdues the serpent Aghasura

Opaque watercolor, gold, and silver on paper
Image 6⅜ x 4⅛ in. (16.2 x 10.5 cm)
Sheet 12⅞ x 7⅞ in. (32.7 x 20 cm)
80.115.8

As a variety of gods and demons watch, Krishna positions himself in the open jaws of the giant serpent demon Aghasura, who rises up in the center of the picture. At the right, the *devatas,* among them the four-headed Brahma, the ashen Shiva, Karttikeya, and Ganesha, observe Krishna's feat. At the left are four animal-faced demons.

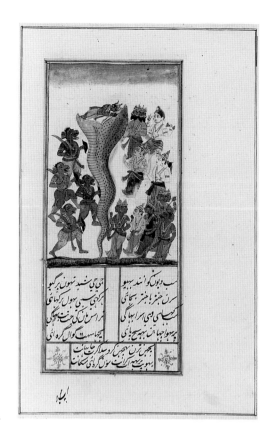

B

Krishna and devotees before a palace

Opaque watercolor and gold on paper
Image 9¾ x 6¼ in. (24.8 x 15.9 cm)
Sheet 12⅞ x 8⅜ in. (32.7 x 21.3 cm)
81.117.1

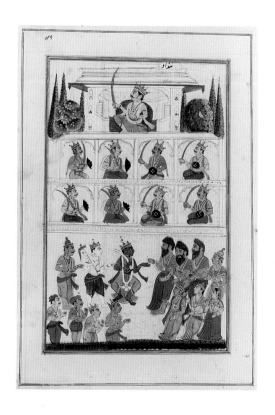

In top border, in Urdu, in nastaliq script: *Nanda.*

In the lowest register of this hieratic composition, Krishna speaks to three holy men while Balarama and attendants on the right and left observe. Above, in two rows of four niches, crowned warriors are portrayed with swords and shields, each in his own niche and each facing the center of the page. Above them, Nanda, ruler of Vrindavan and foster father of Krishna, is depicted as a larger figure holding a sword and seated on a carpet against a bolster in a chamber whose walls on either side are lined with bottles in recessed compartments. His pavilion is bordered by cypresses and flowering bushes in which birds perch.

C

Akrura speaks to the cowherds

Opaque watercolor and gold on paper
Image 3⅜ x 4¼ in. (8.6 x 10.8 cm)
Sheet 12⅞ x 8 in. (32.7 x 20.3 cm)
81.117.2

Under a spreading tree, Krishna's messenger, Akrura, wearing a gold crown, addresses the cowherds and *gopis* who kneel around him. A herd of ten cows of various colors occupies the center.

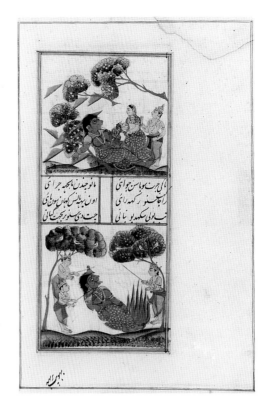

D

Krishna battles the demoness Putana

Opaque watercolor and gold on paper
Image (each) 4 x 4¼ in. (10.2 x 10.8 cm)
Sheet 12⅞ x 8 in. (32.7 x 20.3 cm)
81.117.3

On this page, two scenes relating Krishna's defeat of Putana are combined in one continuous narrative. In the upper register, the young Krishna approaches the black demoness Putana, who has uprooted the trees and the red-roofed huts. A woman in a sari is shown supporting the infant Krishna while a male attendant stands beside her. Below, two men, shouldering axes, strike Putana's head while another figure sets fire to the demoness's feet. The subduing and immolation of Putana by Krishna included several other incidents not depicted here, such as Krishna's suckling of the demoness, which renders her powerless. The artist has covered the outline of the houses in this picture with white paint.

SRC/AGP

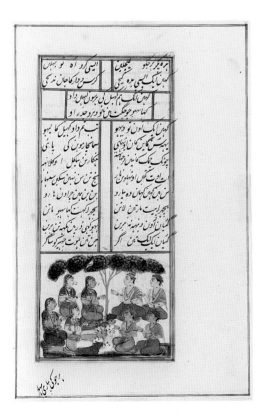

73 Artist unknown

Ruh Allah Khan

Deccan, Hyderabad
1875–1900
Opaque watercolor and gold on paper
Image 7⅞ x 5⁷⁄₁₆ in. (20 x 13.8 cm)
Sheet 19⅝ x 11⅞ in. (49.85 x 30.2 cm)
Gift of James S. Hays, 59.205.1

INSCRIPTION

At top of picture, in Persian, in gold nastaliq script: *Ruh Allah Khan.*

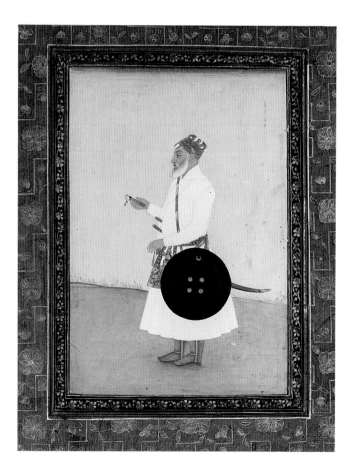

Ruh Allah Khan in a white jama, gold *patka* (sash), orange boots, and orange, white, and gold turban stands facing left. His black shield, suspended over his hip, and his sword indicate his identity as a "man of the sword." The gold oblong pouch in his right hand probably contains a knife. Under Aurangzeb (r. 1658–1707), Ruh Allah Khan held the office of Mir Bakshi, or paymaster-general. He died in 1692.

For other portraits of Ruh Allah Khan, see Titley 1977, p. 19, cat. no. 40(34) f. 35a, eighteenth-century Deccani portrait, in album compiled between A.H. 1176 and 1204/A.D. 1762 and 1790 for Hammat Yar Khan, British Museum, London, 1974-6-17-017; and Falk and Archer 1981, p. 98, cat. no. 134 i.

For the portrait on the verso of this page, see catalogue number 74. SRC

74 Artist unknown

Islam Khan Rumi

Deccan, Hyderabad
1875–1900
Opaque watercolor and gold on paper
Image 8⅛ x 5⅛ in. (20.7 x 13 cm)
Sheet 19⅝ x 11⅞ in. (49.85 x 30.2 cm)
Gift of James S. Hays, 59.205.2

INSCRIPTION

At top of picture, in Persian, in gold nastaliq script: *Islam Khan.*

Facing right, Islam Khan Rumi stands with a staff in his right hand and a sword in his left. His jama is apple green with orange trim. His turban and *patka* are predominantly orange and gold, his boots are pink, orange, and gold. Blue streaks of cloud are at the top of the page; both the ground and sky are green.

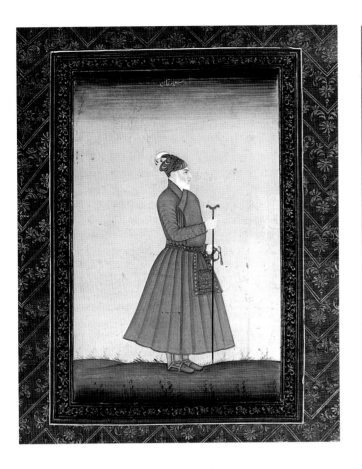

Islam Khan Rumi came to India from Basra in 1669. He served in the court of Aurangzeb and died in the battle of Bijapur on June 13, 1676 (Falk and Archer 1981, p. 93).

For other portraits of Islam Khan Rumi, see ibid., pp. 92–93, cat. nos. 107 and 108; Titley 1977, p. 163, no. 395 (28), lists "Islam Khan Rumi, i.e. Islam Khan, 'Abd al-Salam Mashhadi (d. 1648), vizier to Shahjahan," as Mughal, circa 1640, British Museum, London, 1920-9-17-813 (10).

For the portrait on the recto of this page, see catalogue number 73. SRC

75 Artist unknown

Raja Mahaji Sindhia

Deccan, Hyderabad
1875–1900
Opaque watercolor and gold on paper
Image 4⅞ x 3½ in. (12.4 x 8.9 cm)
Sheet 19¹¹⁄₁₆ x 11¾ in. (50 x 29.85 cm)
Gift of James S. Hays, 59.205.3

INSCRIPTION

In upper margin, in Persian, in gold nastaliq script: *Raja Mahaji Sindhia.*

Shown in three-quarter view against an orange bolster and a green ground, Raja Mahaji Sindhia stares blankly out of the window in which he is seated. Over his simple, white jama he wears an elaborate necklace of pearls, emeralds, and gold pendants. His dark face is adorned with a grand black mustache and the white Vaishnavite caste mark on his forehead. Above him is a rolled orange shade. The window is bordered in gold and set into a wall of reddish brown bricks.

According to R. C. Majumdar, "After the setback received at Panipat (1761) and the first Anglo-Maratha war (1774–82) Mahaji Sindhia became the king-maker at Delhi and directed imperial affairs until his death in 1794" (1936, p. 44). Despite being a Hindu prince of Gwalior, Mahaji Sindhia was instrumental in bringing the Mughal Emperor Shah 'Alam II to the throne in 1772.

For a possible likeness of Mahaji Sindhia of circa 1820, see Gascoigne 1971, p. 248. SRC

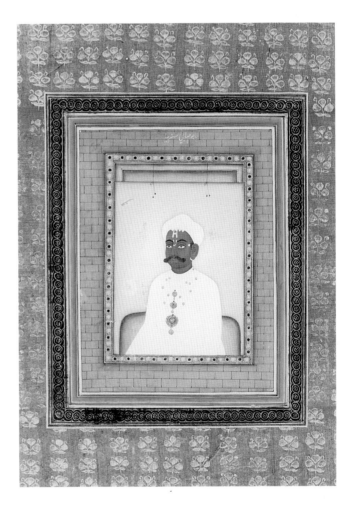

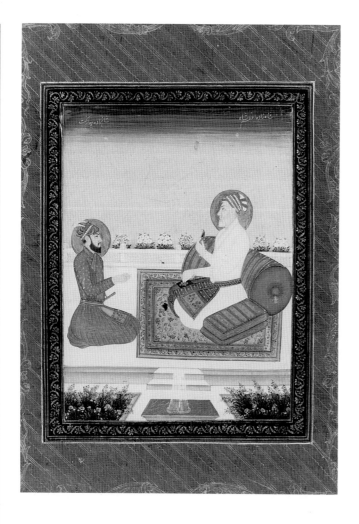

right a number of gold coins rest on a wine-colored cloth. With his right hand A'zam Shah has either picked up or is putting down a coin, while in his left hand he holds up a gold and ruby turban ornament. Bidarbakht, his hands open palmed, kneels before him. In his green jama, pink and gold *patka,* and gold and green turban, he is as expressionless as his companion.

A'zam Shah, the third son of Aurangzeb, spent his adult life fighting in his father's wars, particularly in the Deccan. Unlike his brothers, he succeeded in staying in his father's good graces and avoided prison or exile. He died in 1707, the same year as Aurangzeb. Bidarbakht, a general in Aurangzeb's army, was named Viceroy of Malwa in 1704; in 1706 he was transferred to Gujarat. Presumably, in this picture he is receiving recompense for one of his military feats.

Related works are listed in Titley 1977, p. 19, no. 40 (19) f.22a, portrait of "Bidarbakht (d. 1707), son of A'zam Shah and grandson of Aurangzeb. (Eighteenth century Mughal, overpainted)"; British Museum, London, 1974-6-17 017(41), and p. 165, no. 395 (90), "Mughal. c. 1705. Bidarbakht (d.1707) eldest son of A'zam Shah"; British Museum, London, 1920-9-17-0106 (2). For another portrait drawing of Bidarbakht, see Van Hasselt 1974, p. 62, no. 1755. SRC

77 Artist unknown

Akbar and one of his sons or grandsons

Deccan, Hyderabad
1875–1900
Opaque watercolor and gold on paper
Image 5¹⁄₁₆ x 3¾ in. (12.85 x 9.5 cm)
Sheet 19¾ x 11⅞ in (50.2 x 30.2 cm)
Gift of James S. Hays, 59.205.6

INSCRIPTION

At top of page, in Persian, in gold nastaliq script: *Akbar Shah Padishah.*

Akbar and a young boy are shown in a window that has been draped with a flowered gold cloth. Both figures are dressed in transparent white jamas and gold turbans. A gold halo frames the emperor's profile. Within the window the ground is green, and outside it is blue.

Painted more than two hundred fifty years after Akbar's death in 1605, this double portrait reveals none of the dynamism of his character. Moreover, without a specific inscription, the identity of the boy cannot be determined.

76 Artist unknown

Shahzadeh A'zam and Shahzadeh Bidarbakht

Deccan, Hyderabad
1875–1900
Opaque watercolor and gold on paper
Image 8 x 5¹⁵⁄₁₆ in. (20.3 x 15.1 cm)
Sheet 19⅝ x 11⅞ in. (49.95 x 30.2 cm)
Gift of James S. Hays, 59.205.5

INSCRIPTIONS

At top of page, above each figure, in Persian, in gold nastaliq script, left: *Shahzadeh Bidarbakht:* right: *Shahzadeh A'zam Shah.*

The two men face each other on a white terrace against a green sky with blue-streaked clouds above. A'zam Shah, dressed in a white jama, green and gold *patka,* and gold and white turban, kneels on a yellow and pink floral carpet, a large green bolster behind him. On the green pillow at his

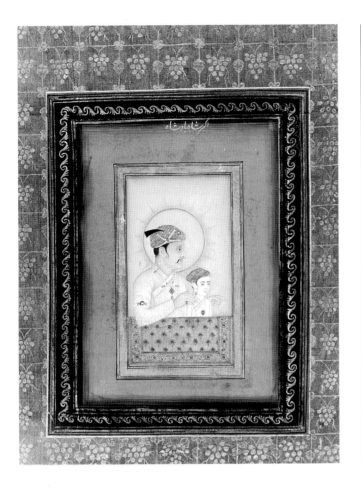

For comparison, see Titley 1977, p. 163, no. 395 (27), "Mughal, c. 1765. Akbar with Jahangir as a boy. (A copy, possibly by Mir Chand, of an earlier work)"; British Museum, London, 1920-9-17-013(9). SRC

78 Artist unknown

Shah Jahan with a falcon

Deccan, Hyderabad

1875–1900

Opaque watercolor and gold on paper

Image 7⅝ x 5 in. (19.35 x 12.7 cm)

Sheet 19¾ x 11⅞ in. (50.2 x 30.2 cm)

Gift of James S. Hays, 59.205.7

INSCRIPTION

At top of page, in Persian, in gold nastaliq script: *Shah Jahan.*

On a terrace in a garden, holding a falcon before him, Shah Jahan, the fifth Mughal emperor, is seated on a gold chair (which appears to be tilting backward), his feet resting on a footstool. Befitting his imperial rank, he is lavishly adorned with pearls and emeralds, a halo, and gold shoes and sashes. The fountain, flowers, and blue sky are all typical of late-nineteenth-century Hyderabad portraits.

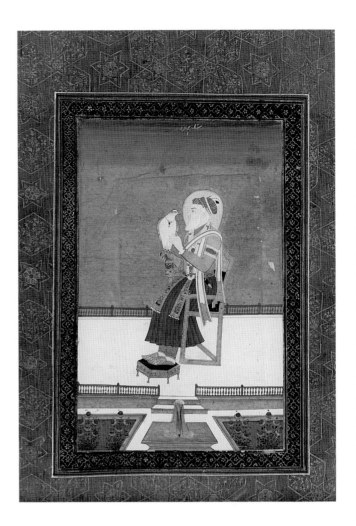

Best known as the patron of the Taj Mahal, Shah Jahan (r. 1627–58) also commissioned paintings and manuscripts of the highest quality. The ultimate inspiration for this late portrait may be a seventeenth-century portrait entitled *Shah Jahan Enthroned with His Son Dara Shikoh,* in which the emperor holds a falcon (see Binney 1973, p. 82, no. 56). SRC

79 Artist unknown

Shahzadeh Wala Jah

Deccan, Hyderabad

1875–1900

Opaque watercolor and gold on paper

Image 7⅞ x 4¾ in. (20 x 12.1 cm)

Sheet 19⅝ x 11¹³⁄₁₆ in. (49.8 x 30 cm)

Gift of James S. Hays, 59.205.8

INSCRIPTION

At top of page, in Persian, in gold nastaliq script: *Shahzadeh Wala Jah.*

The bearded prince Wala Jah (d. 1707?) stands facing left, holding his sheathed sword before him. He wears a pink jama, orange turban and boots, and gold *patka.* The ground

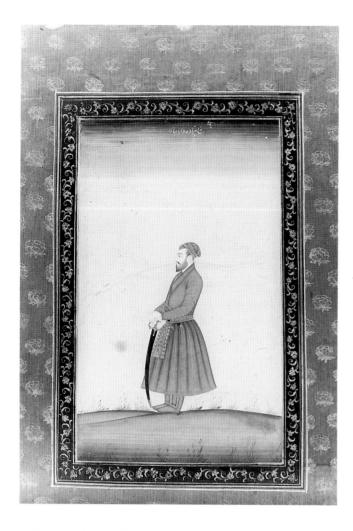

INSCRIPTION

At top of page, in Persian, in gold nastaliq script: *Hazrat Sultan Umar Shaykh Mirza ibn Sultan Abu Sa'id.*

Umar Shaykh Mirza kneels on a jewel-encrusted throne under a gold parasol on a terrace in a garden. Clad in a yellow jama, purple and gold coat, and orange and green turban, the bearded figure gestures with both hands as if he were speaking.

Umar Shaykh Mirza was the father of Babur and the great-great-grandson of Timur (Tamerlane). In 1469, upon the death of his father, Sultan Abu Sa'id Mirza, Umar Shaykh Mirza took control of the kingdom of Ferghana. He died in 1494. This portrait is clearly an imaginary likeness that derives from sixteenth- and seventeenth-century portraits of the ancestors of the Mughal emperors. The distinctive turban and parasol seen here characterize the earlier "portraits" as well.

For a similar, though earlier, portrait of Timur, see P. Brown 1924, pl. IV, fig. 1. Related portraits are listed in Titley 1977, p. 125, 271 (2): *Padshah-nama* of Muhammad Amin ibn Abu'l Husain Kazvini, "Mughal. Eighteenth century. . . . Portraits of Shahjahan's ancestors," British Library, London, Add. 20734, ff. 35–36; and idem, p. 128, 282 (1):

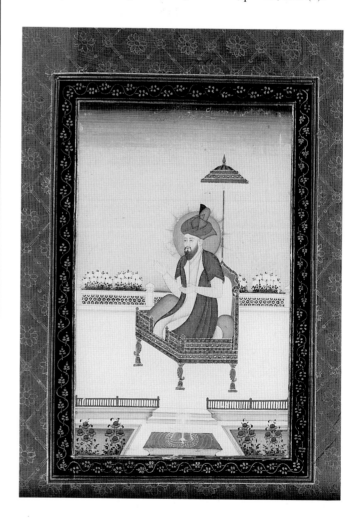

and sky are the standard apple green and pale green with blue streaks, respectively.

The prince portrayed here is most likely the ill-fated grandson of Aurangzeb, who joined his brother and father in a war of succession in 1707 and died at the Battle of Samogarh. Alternatively, he may be a member of the Walajah family, who were the *subedars,* or feudatories, of Arcot in the Deccan in the eighteenth and nineteenth centuries. The English East India Company enjoyed a close and profitable relationship with the Walajah nawabs in the late eighteenth century.

80 Artist unknown

Umar Shaykh Mirza

Deccan, Hyderabad
1875–1900
Opaque watercolor and gold on paper
Image 8⅛ x 5 in. (20.65 x 12.7 cm)
Sheet 19⅝ x 11¹³⁄₁₆ in. (49.8 x 30 cm)
Gift of James S. Hays, 59.205.9

'Amal-i Salih of Muhammad Salih Kanbu, "Mughal. Eighteenth century. . . . Portraits of Shahjahan's ancestors," British Library, London, Or. 2157, ff. 18b–19a. SRC

81 Artist unknown

Rafi' al-Daula Rafi' al-Shan Padshah ibn Bahadur Padshah

Deccan, Hyderabad
1875–1900
Opaque watercolor and gold on paper
Image 8⅚₆ x 5³⁄₁₆ in. (21.1 x 13.2 cm)
Sheet 19¾ x 11¹³⁄₁₆ in. (50.2 x 30 cm)
Gift of James S. Hays, 59.205.11

INSCRIPTION

At top of page, in Persian, in gold nastaliq script: *Rafi' al-Daula Rafi' al-Shan Padshah ibn Bahadur Padshah.*

The bearded figure is seated against crimson and green cushions on a hexagonal gold throne placed in the center of an octagonal terrace. A crudely rendered green halo accentu-

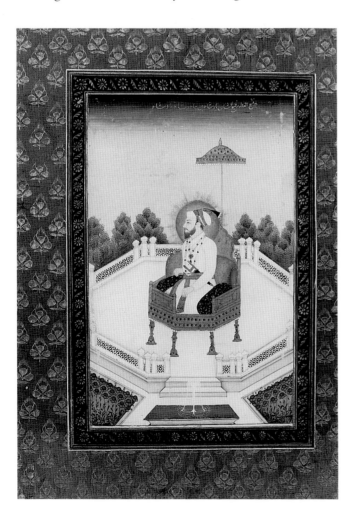

ates his profile and symbolizes his royal rank, as does the parasol above him.

Rafi' al-Daula, born Rafi' al-Shan, was the son of the Mughal emperor Bahadur Shah (d. 1712). He was made a puppet emperor by the British in June 1719; however, his reign was brief, since he died in September of the same year. For a portrait identified as Mughal, eighteenth century, see Titley 1977, p. 165, no. 395 (97). SRC

82 Artist unknown

Iraj Khan

Deccan, Hyderabad
1875–1900
Opaque watercolor and gold on paper
Image 9¼ x 5⅞ in. (23.5 x 15 cm)
Sheet 19⅝ x 11¹³⁄₁₆ in. (49.85 x 30 cm)
Gift of James S. Hays, 59.205.13

INSCRIPTION

At top right of page, in Persian, in gold nastaliq script: *Iraj Khan Pesar Qizilbash Khan.*

Of all the portraits in the Museum's Hyderabad group, this depiction of Iraj Khan boasts the most careful execution and most interesting composition. The figure stands on a terrace before a landscape of flowers, including outsize tulips, a flowering bush, a pear tree, and a hill rimmed with trees. Dressed in a transparent jama, orange pants, a pink, orange, and gold turban edged with pearls, and a gold *patka,* the bearded Khan holds his sword before him and gazes slightly suspiciously at the viewer. Although the technique employed in this picture does not vary greatly from that of the other nineteenth-century portraits, its prototype was probably a Golconda work of the late seventeenth century rather than a Mughal source.

Except for slight differences in background and flowers, a portrait with an extraordinary similarity of dimensions, composition, and middle ground appeared in a group of miniatures collected by Sir Casson Walker, British Financial Advisor to the Nizam of Hyderabad, circa 1870–1900. The painting was offered by Christie's (1977, lot 194, pl. 45), where it was attributed to Hyderabad, early eighteenth century. The subject was not identified.

Iraj Khan was the son of Qizilbash Khan, a minister under Shah Jahan. He served under Alamgir in a variety of posts in the Deccan.

For earlier portraits of Iraj Khan, see Ashraf 1963, p. 42, fig. 5; Binney 1973, no. 139b; Falk and Archer 1981, p. 226, no. 419. The work reproduced in M. Chandra 1962 (p. 25, pl. 2) is presumably the prototype for our portrait and the painting from the Walker collection. SRC

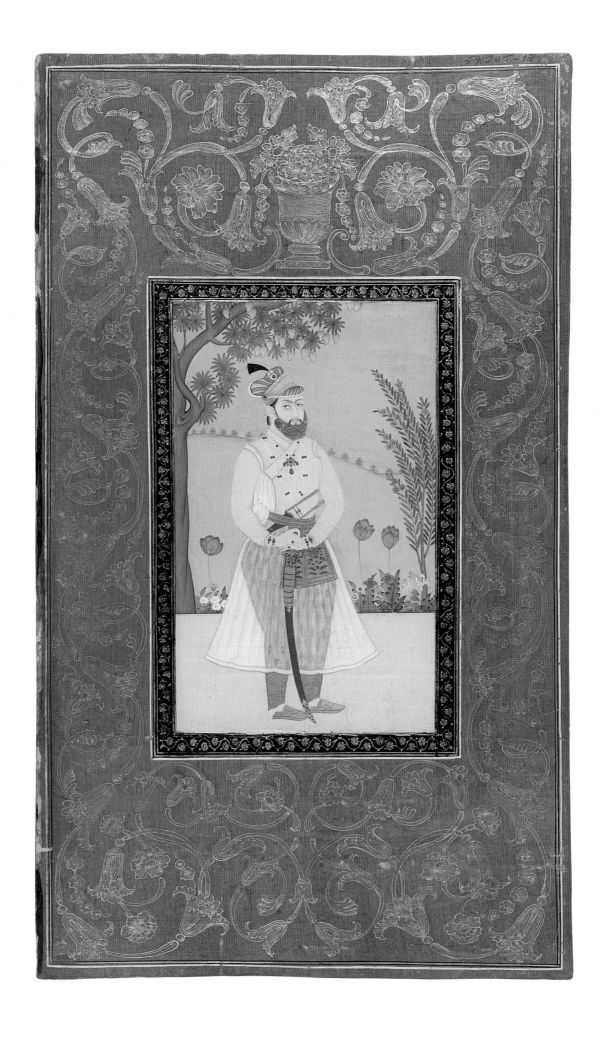

83 Artist unknown

Qamar al-Din Khan

Deccan, Hyderabad
1875–1900
Opaque watercolor and gold on paper
Image 6⅝ x 4⅛ in. (16.8 x 10.5 cm)
Sheet 19⅝ x 11¹³⁄₁₆ in. (49.85 x 30 cm)
Gift of James S. Hays, 59.205.14

INSCRIPTION
At top of page, in Persian, in gold nastaliq script: *Qamar al-Din Khan.*

In a bright yellow jama, green and white flowered coat with a fur collar, gold *patka,* and orange shoes and turban, Qamar al-Din Khan stands on a terrace facing right. He holds his

sword in his right hand and gestures with his left. Qamar al-Din Khan was the vizier and close companion of the Mughal emperor Muhammad Shah in the first half of the eighteenth century. SRC

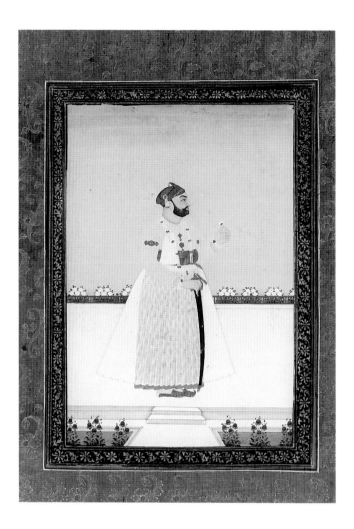

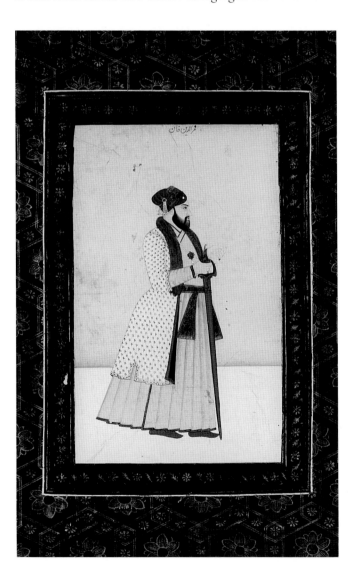

84 Artist unknown

Munir al-Mulk Bahadur

Deccan, Hyderabad
1875–1900
Opaque watercolor and gold on paper
Image 8 x 5½ in. (20.3 x 14 cm)
Sheet 19¹¹⁄₁₆ x 11¹³⁄₁₆ in. (50 x 30 cm)
Gift of Philip P. Weisberg, 59.206.1

INSCRIPTION
At top of page, in Persian, in gold nastaliq script: *Munir al-Mulk Bahadur.*

This substantial bearded figure stands on a terrace facing right, holding a flower in his left hand and a sword in his right. Munir al-Mulk, known as Aristu Jah, was appointed

Diwan, or prime minister, of the Nizam of Hyderabad, Asaf Jah III, in 1809. Despite his title, his arch-rival, Chandhu La'l, enjoyed greater influence with Sir Henry Russell, the British resident at Hyderabad. Ironically, the portrait of Chandhu La'l appears on the reverse of this page (see cat. no. 85).

Munir al-Mulk appears heavier in this portrait than in those from the second and third decades of the nineteenth century and thus may be shown here at a more advanced age. For earlier portraits, see Mittal 1963a, p. 50, no. 17; Zebrowski 1983, pp. 268–71, fig. nos. 247–49 and col. pl. XXIV. SRC

85 Artist unknown

Chandhu La'l

Deccan, Hyderabad
1875–1900
Opaque watercolor and gold on paper
Image 8⅛ x 5¾ in. (20.7 x 14.6 cm)
Sheet 19¹¹⁄₁₆ x 11¹³⁄₁₆ in. (50 x 30 cm)
Gift of Philip P. Weisberg, 59.206.2

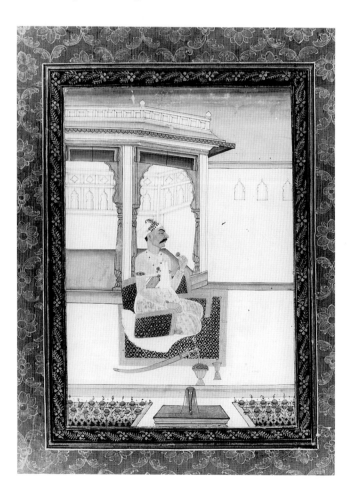

INSCRIPTION
At top of page, in Persian, in gold nastaliq script: *Raja Chandhu La'l.*

Chandhu La'l kneels on a carpet placed in a courtyard between a fountain and a porch with a pink floor. With his sword, sweets, and drinking cup at his right, he draws a pink flower to his nose and stares straight ahead. This crudely rendered portrait is nonetheless a faithful depiction of Chandhu La'l, the *peshkar,* or steward, for the Nizam of Hyderabad, Asaf Jah III, from 1808. Although Munir al-Mulk (cat. no. 84) held a higher office at the court of Hyderabad, Chandhu La'l cultivated British support and "rapidly became all-powerful, embittering both the nizam and Aristu Jah [Munir al-Mulk]" (Zebrowski 1983, p. 271).

For portraits of Chandhu La'l in other collections, see Mittal 1963a, p. 50, no. 17; Falk and Archer 1981, p. 237, no. 436ii; and Zebrowski 1983, p. 270, no. 249. SRC

86 Artist unknown

Muhammad Amin Khan Turani

Deccan, Hyderabad
1875–1900
Opaque watercolor and gold on paper
Image 8¼ x 5⁹⁄₁₆ in. (21 x 14.15 cm)
Sheet 19¹¹⁄₁₆ x 11¹³⁄₁₆ in. (50 x 30 cm)
Gift of Philip P. Weisberg, 59.206.3

INSCRIPTION
At top of page, in Persian, in gold nastaliq script: *Muhammad Amin Khan Turani.*

Before a beige sky with white clouds, the elderly bearded figure clad in a white jama and turban with a jeweled gold ornament and orange boots stands facing left. His status as a warrior is evident from the sword, *katar,* and shield suspended at his side.

Muhammad Amin Khan Turani (d. 1682) served as a military commander under Aurangzeb and later, in the 1670s, as governor of Afghanistan. When he lost a battle to the Pathans, he was stripped of his gubernatorial post but maintained his military rank. Under Muhammad Shah he became a vizier, or minister.

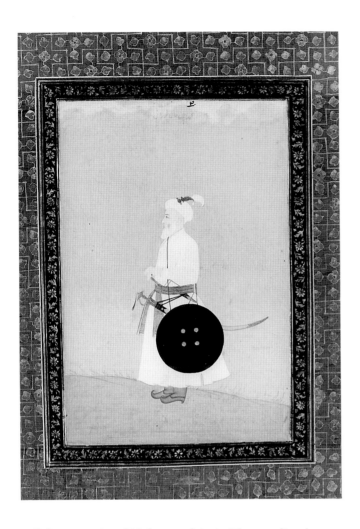

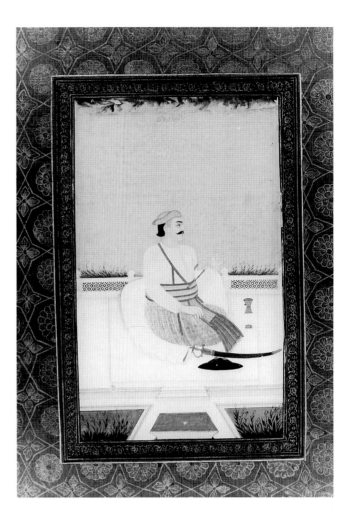

Other portraits of Muhammad Amin Khan are listed in Titley 1977, p. 13, 26 (24); p. 14, 29 (14) and (23); p. 15, 33 (10); p. 16, 34 (19); p. 19, 40 (29). SRC

87 Artist unknown

Niaz Bahadur Khan

Deccan, Hyderabad

1875–1900

Opaque watercolor and gold on paper

Image 8⅛ x 5 in. (20.6 x 12.7 cm)

Sheet 19¾ x 11⅞ in. (50.2 x 30.2 cm)

Gift of Philip P. Weisberg, 59.206.4

INSCRIPTION

At top of page, in Persian, in gold nastaliq script: *Niaz Bahadur Khan.*

The mustachioed figure on a terrace kneels against a white bolster. His sword, shield, cup, and pan (betel) box are placed around him. Resting his right hand on his knee, he lifts his left hand as if to take some pan. His distinctive yellow turban identifies him as coming from Kurnool, a Decanni *suba,* or petty kingdom, under the control of

a Pathan (Afghan) dynasty. Bahadur Khan ruled Kurnool from 1744 to 1751.

Another portrait of Niaz Bahadur Khan is listed in Titley 1977, p. 3, 9 (26), "'Ali 'Adilshah and Bahadur-Khan riding to Manikpur (1565)." SRC

88 Artist unknown

Sardar al-Daula (?)

Deccan, Hyderabad

1875–1900

Opaque watercolor and gold on paper

Image 7¼ x 4⅞ in. (18.4 x 12.35 cm)

Sheet 19¾ x 11⅞ in (50.2 x 30.2 cm)

Gift of Philip P. Weisberg, 59.206.5

INSCRIPTION

At top of page, in Persian, in gold nastaliq script: *Sardar al-Daula.*

The kneeling figure leans against a white bolster on a terrace. His turban is dark blue, as are his sash and the pants

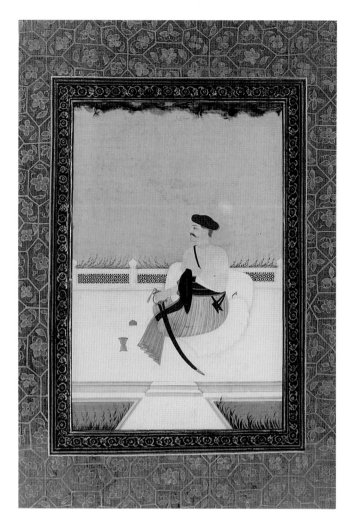

dressed in a short-sleeved gold brocade coat and an orange jama. His throne is placed on a terrace in a garden before a green and blue sky. His turban conforms to the fifteenth-century variety with its high red *kula,* feather, and voluminous folds.

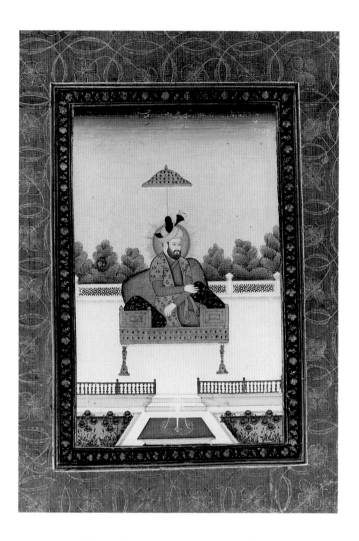

under his transparent jama. He holds his sword and shield, while before him lie his cup and pan box.

The identity of this figure is not certain, though his turban indicates his connection with Kurnool. SRC

89 Artist unknown

Miran Shah

Deccan, Hyderabad
1875–1900
Opaque watercolor and gold on paper
Image 8¼ x 5¹⁄₁₆ in. (20.8 x 12.8 cm)
Sheet 19⅝ x 11¾ in. (49.8 x 30 cm)
Gift of Philip P. Weisberg, 59.206.9

INSCRIPTION

At top of page, in Persian, in gold nastaliq script: *Jalal al-Din Hazrat Miran Shah Jahat Qur'an Sahib.*

As in the painting on the other side of this sheet, the sitter is shown kneeling on a gold throne with bolsters arrayed around him and a gold parasol above him. He is haloed and

Miran Shah was the son of Timur (Tamerlane) and the great-great-grandfather of Babur, founder of the Mughal dynasty. He was the father of Sultan Muhammad, whose portrait is on the reverse of this page (cat. no. 90). SRC

90 Artist unknown

Sultan Muhammad, son of Miran Shah

Deccan, Hyderabad
1875–1900
Opaque watercolor and gold on paper
Image 7⁵⁄₁₆ x 4⅛ in. (18.5 x 10.1 cm)
Sheet 19⅝ x 11¾ in. (49.8 x 30 cm)
Gift of Philip P. Weisberg, 59.206.10

INSCRIPTION

At top of page, in Persian, in gold nastaliq script: *Hazrat Sultan Muhammad Padshah ibn Miran Shah.*

The figure kneels on an elaborate, jewel-encrusted throne on a carpeted terrace. The garish carpet consists of a chartreuse ground of alternating cross and star designs with a bright pink floral border. Shown in a three-quarter view facing left, the figure gestures with his left hand and holds his sash in his right. He wears a yellow short-sleeved coat over a pink jama. His turban with its high *kula,* feathers, and broad folds typifies the late Mughal notion of the headdress of fifteenth-century pre-Mughal rulers.

Sultan Muhammad was the grandson of Timur (Tamerlane) and the great-grandfather of Babur, founder of the Mughal dynasty.　SRC

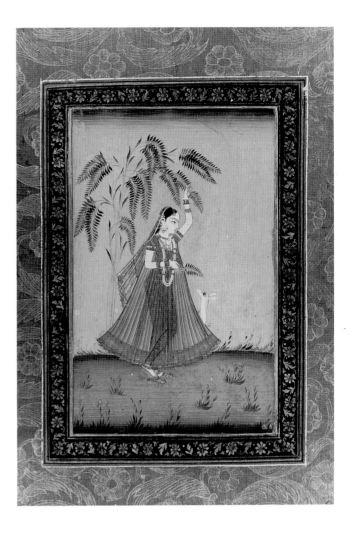

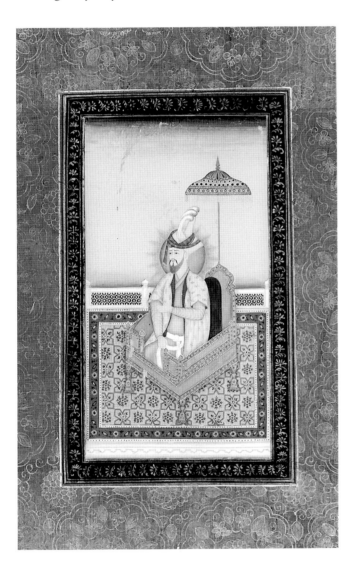

91　Artist unknown

Girl with a deer (Todi Ragini?)

Deccan, Hyderabad
1875–1900
Opaque watercolor and gold on paper
Image 6½ x 4⅛ in. (16.5 x 10.5 cm)
Sheet 19¹¹⁄₁₆ x 11¾ in. (50 x 30 cm)
Gift of James S. Hays, 59.205.4

A woman clad in a transparent pink and gold sari and red and gold pajama stands under a tree grasping one of its branches with her left hand. In her right hand, painted with henna, she holds a leafy spray from the tree. At her side and partly obscured by her skirt, a small deer gazes up at her. As in so many late Deccani paintings, the ground is apple green and the sky is pale green with blue streaks at the top.

Although the woman is not holding the customary vina, this painting could possibly depict *Todi Ragini:* "Poets have interpreted Todi as a lovesick woman, singing a lonely tune with deer as her only audience" (Ebeling 1973, p. 60).　SRC

92 Artist unknown

Standing woman

Deccan, Hyderabad
1875–1900
Opaque watercolor and gold on paper
Image 6⁵⁄₁₆ x 3¹⁵⁄₁₆ in. (16 x 10 cm)
Sheet 19¹¹⁄₁₆ x 11¾ in. (50 x 29.9 cm)
Gift of James S. Hays, 59.205.15

Against a brownish pink background streaked with blue at the top, a young woman stands facing right. Clad in a saffron and gold sari, she holds her transparent orange veil away from her head. Her jewelry consists of large pearl-and-emerald earrings, a double strand of pearls, and gold bracelets and anklets.

Because of the absence of iconographic attributes or inscriptions, the identity of this figure cannot be specified.

SRC

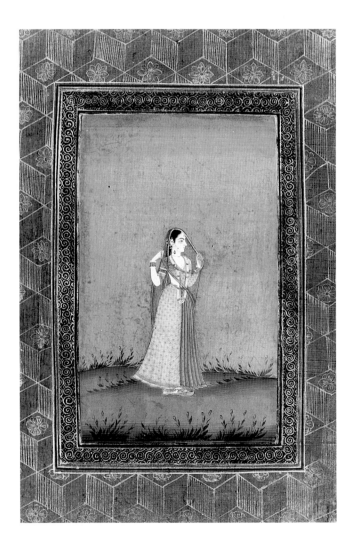

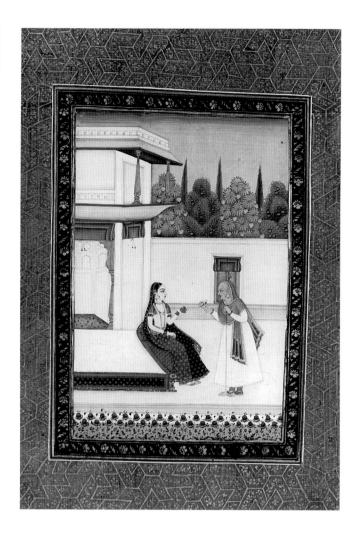

93 Artist unknown

A lady and her elderly servant

Deccan, Hyderabad
1875–1900
Opaque watercolor on paper
Image 8 x 5⅜ in. (20.3 x 13.7 cm)
Sheet 19¾ x 11⅞ in. (50.2 x 30.2 cm)
Gift of James S. Hays, 59.205.18

In a courtyard with a building and porch at the left, a seated lady receives a lotus and a chrysanthemum from her elderly servant. The latter is dressed in a pink shawl and white dress, while her mistress's attire consists of an orange and brown sari. Outside the high walls of the enclosure is a

dense, lush forest and blue sky. Rows of orange flowers fill the garden in the foreground.

Elderly servants, such as the one in this painting, often act as intercessors between women and their absent lovers. Presumably the flowers brought by the servant are intended to conjure up the absent loved one. This scene may possibly represent a *raga* or *ragini*, for example *Malasri* or *Patamanjari Ragini*.

For a comparable and even more poignant study of a lovesick female and her elderly servant, see Zebrowski 1983, p. 251, in the India Office Library, London. SRC

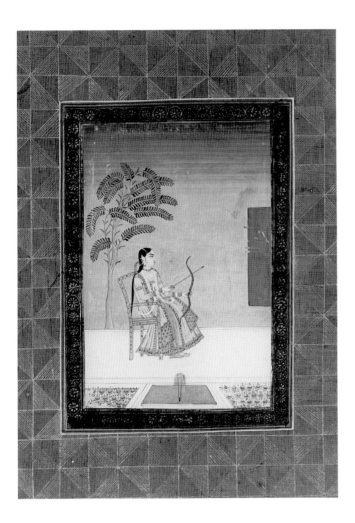

94 Artist unknown

A lady archer

Deccan, Hyderabad
1875–1900
Opaque watercolor and gold on paper
Image 6⅝ x 4½ in. (16.8 x 11.45 cm)
Sheet 19¾ x 11¾ in. (50.2 x 29.9 cm)
Gift of Philip P. Weisberg, 59.206.6

A lady dressed in a green and gold dress and seated on a jewel-encrusted gold throne prepares her bow and arrow to shoot at the target before her. Five arrows have already been shot into the rectangular, wooden target, which is apparently suspended in midair. The setting for this scene is typical of late Hyderabad painting: a white terrace with a fountain and garden in the foreground, a single tree with pink trunk and frondlike foliage, and a blue sky darkening toward the top of the page. SRC

95 Artist unknown

The Bismillah

Deccan, Hyderabad
1875–1900
Opaque watercolor and gold on paper
Image 8¹⁵⁄₁₆ x 7⅝ in. (22.75 x 19.35 cm)
Sheet 19⅝ x 11¹³⁄₁₆ in. (49.9 x 30 cm)
Gift of Philip P. Weisberg, 59.206.8

INSCRIPTION

Above, in upper border, in Persian, in black ink, in nastaliq script: *Tughva* [in this context, a calligraphic emblem] of *"In the name of God, the merciful, the compassionate."*

On a royal blue ground the Arabic phrase "Bismillah al-Rahman al-Rahim" is written four times: right side up, upside down, and the reverse of each of these. This is the opening phrase of all but one of the chapters of the *Qur'an*.

In the inscription, the page is referred to as a *tughra*, a type of calligraphic emblem that originated in Turkey in the sixteenth century and became popular in India in the nineteenth. Mirror writing in various cursive and squared scripts was a common practice in India, Turkey, and Iran in the eighteenth and nineteenth centuries. SRC

96 Artist unknown

Calligraphic face

Deccan, Hyderabad
1875–1900
Opaque watercolor on paper
Image 10 x 6½ in. (25.4 x 16.5 cm)
Sheet 19¹¹⁄₁₆ x 11⅞ in. (50 x 29.9 cm)
Gift of James S. Hays, 59.205.17

What appears at first to be an extremely odd face is in fact anthropomorphized calligraphy. A tentative reading of the words, written in mirror reverse, is "'Ali, Husain, Hassan," the names of the first three Shiite imams.

This type of figurative mirror writing enjoyed currency in nineteenth-century India, Iran, and Turkey. SRC

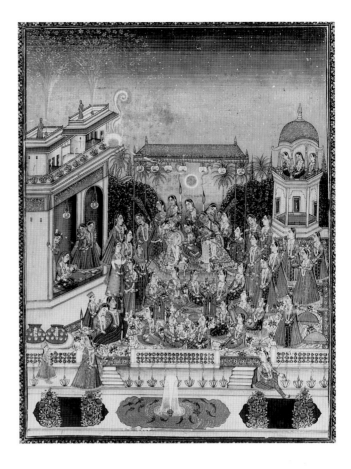

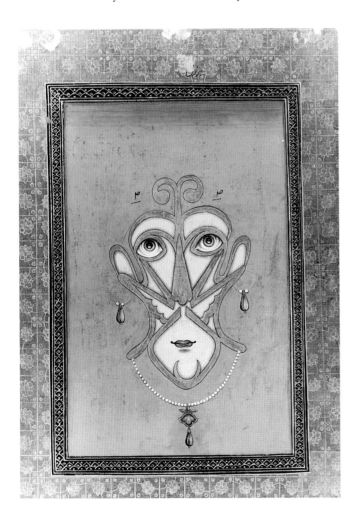

97 Artist unknown

The nuptials of Dara Shikoh

Deccan, Hyderabad
1875–1900
Opaque watercolor and gold on paper
Image 13⅜ x 10³⁄₁₆ in. (34 x 25.9 cm)
Sheet 19⅝ x 11¾ in. (49.8 x 29.8 cm)
Gift of James S. Hays, 59.205.10

INSCRIPTION
At top center, in Persian, in black ink, in nastaliq script: *Dar-al Shakooh*.

Under a canopy hung with lanterns are the prince Dara Shikoh, the eldest son and heir apparent of Shah Jahan, and his bride who, with head bent down and a veil of flowers covering her face, is being encouraged by her companions to look up at her groom. The couple sits before an open book surrounded by a multitude of women. In a pavilion at the left, one woman holds a baby while others observe the conviviality. The festive air is heightened by the gold fireworks exploding at the left and the flowered sticks held by the celebrants.

The presence of so many revelers, each a repetitive figure type, the elaborate details evident in the floral decorations, and the lamps further emphasize the celebratory occasion of the wedding. SRC

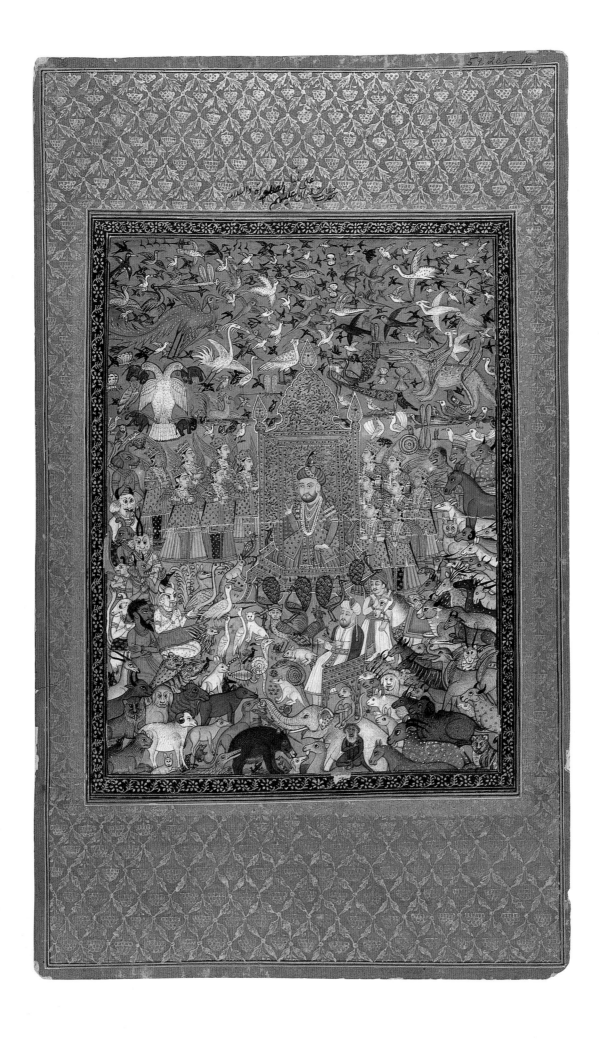

136

98 Artist unknown

King Solomon and his court

Deccan, Hyderabad
1875–1900
Opaque watercolor and gold on paper
Image 11⅜ x 8¾ in. (28.9 x 22.2 cm)
Sheet 19¹¹⁄₁₆ x 11⅞ in. (50 x 29.9 cm)
Gift of James S. Hays, 59.205.16

INSCRIPTION

On mount above picture, in Persian, in black ink, in nastaliq script: *Hazrat hanat Sulaiman 'Ali nababan [?] alaihim al-salwat wa al-salam.*

King Solomon is seated on a gold bejeweled throne smelling a flower in the midst of all manner of beasts and beings, both real and fantastic. Closest to the throne, rows of angels face him while peacocks fan their tails. In the foreground a turbaned figure, perhaps a saintly donor, is seated in front of his crudely painted servant. Despite the alternately garish and muddy palette, the array of animals enlivens this painting.

Depictions of the court of Solomon enjoyed great popularity in seventeenth-century Ottoman painting. The vogue appears to have spread from Turkey to the Deccan.

For this subject treated by a Turkish artist, see Binney 1979, p. 74, cat. no. 44; and a Deccani version based on a similar prototype, Sotheby's 1978b, lot 246. For another example, see Maggs 1978, cat. no. 15. SRC

99 Artist unknown

Yusuf and Zulaykha

Deccan, Hyderabad
1875–1900
Opaque watercolor and gold on paper
Image 8⅞ x 12⅞ in. (22.5 x 32.7 cm)
Sheet 11¾ x 19¹⁵⁄₁₆ in. (29.9 x 49.1 cm)
Gift of Philip P. Weisberg, 59.206.7

INSCRIPTION

In the margin at the right, in Persian, in nastaliq script: *His excellency, Saint Yusuf, praise and peace be upon him. Hazrat, Jainab, Yusuf, Aleihem al-salawat wa-al-salam.*

Before one of four city gates an outsize sultan greets Yusuf, whose head is set off by a flaming mandorla. This would seem to be the story of the appearance of the slave Yusuf before Zulaykha and her ladies-in-waiting, who had mocked her for being infatuated with him. Yet when he appeared, the ladies swooned at his beauty. (The couple is the equivalent of Joseph and Potiphar's wife in the Old Testament.) In this painting, male and female courtiers either pay homage to him or carry on with their work.

The topographical view of the palace quarter is a reinterpretation of a convention used in Central Indian and even Nepalese paintings of the nineteenth century to indicate a palace scene. The crowding of figures, shown in sizes that

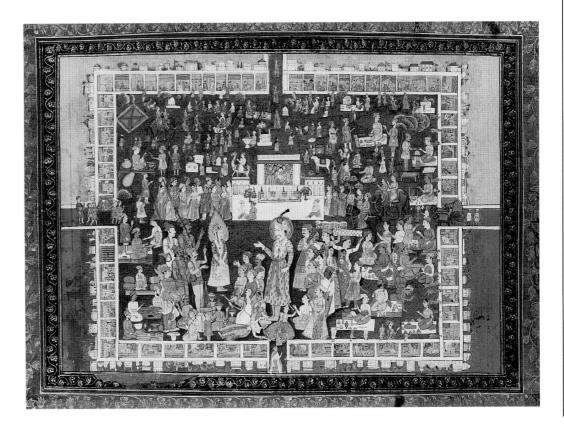

extend from large to miniature, conveys the rich variety of activity in the bazaar. Specific areas where foods, clothes, and objects are sold are rendered with extraordinary clarity, while even the minuscule figures in the background show such activities as monkey entertainers and figures in palanquins, on elephants, and with bullock carts (set in contemporaneous Hyderabad). In the center of the painting the sultan's white palace is visible, complete with its garden and harem.

This swarming activity is contained within a carefully rendered enframement of rectangles, each of which reveals figures pursuing their daily routines. The rigidity of these bands of carefully ruled blocks is relieved by a second border of minuscule buildings depicting the range of architectural styles and purposes in the busy town. Despite the oddities of scale and perspective, the artist has succeeded in illustrating the active, multifaceted character of traditional Indian life. SRC/AGP

100 Artist unknown

Saint Shams-i Tabriz

Deccan, Hyderabad
1875–1900
Opaque watercolor and gold on paper
Image 8⅜ x 5¹¹⁄₁₆ in. (21.3 x 14.5 cm)
Sheet 19¾ x 11¾ in. (50.2 x 29.9 cm)
Gift of James S. Hays, 59.205.12

INSCRIPTIONS

At left, above figure's halo, in Persian, in gold nastaliq script: *Shams-i Tabriz, Holy and Pure;* in top left corner, two lines in black ink, in Persian, in nastaliq script: *The deceased Saint Shams-i Tabriz, pleaser of God, chosen of God, and who endeavors to please Him. In his death God is with him and holy of God, pure of mind.*

On a green riverbank with rocky hills at the right and on the horizon, Shams-i Tabriz sits cross-legged waving a fish in his left hand and holding a red book in his right. In the stream before him fish leap and lotuses wave in the breeze.

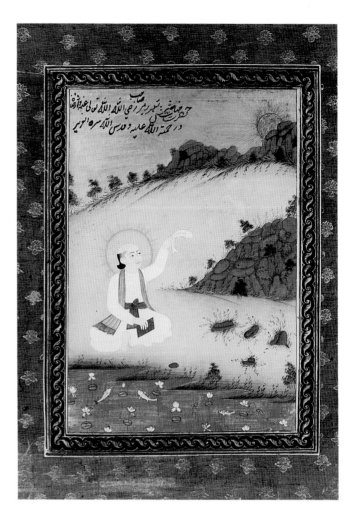

A golden sun sets, or rises, at the upper right, perhaps alluding to the saint's name, "Shams," which means sun. This type of picture commemorating a deceased saint falls squarely into one of the more popular categories of nineteenth-century Hyderabad painting.

The collection of the Victoria & Albert Museum, London, contains a nineteenth-century woodblock print inscribed, in English, "Shams Tabrizi (Multan Saint) Muhammedan. Cooking his fish by solar heat" (IM 2/166-1917), and another (IM 2/122-1917). SRC

Rajasthani Painting

101 Artist unknown

Bhairava Raga

Page from a dispersed *Ragamala* series
Rajasthan, Amber
1709 (?)
Opaque watercolor and silver, and beetle wing on paper
Image 10⅞ x 6⅝ in. (27.8 x 17 cm)
Sheet 16 x 11½ in. (40.3 x 29.4 cm)
Gift of the Ernest Erickson Foundation, Inc., 86.227.53

This painting depicts *Bhairava Raga,* iconographically represented as a manifestation of Shiva. The six lines of text at the top of the page in Braj, in Devanagari script, explain the *Bhairava (Bhairun) raga,* as originating from the mouth of Shiva:

It should be sung in the early morning of autumn. It has *Modaka* meter and *Dhaivata* as the dominant note. Shiva with the crescent moon on his forehead and snake bracelets is attended by the performing musicians. He is dressed in white and wears the garland of severed human heads. The heavenly river [Ganga] springs from his matted locks. The omniscient god, who personifies perfection, gazes at a single point with his three eyes. The five *raginis* are Bhairavi, Bairari, Madhimadhavi, Saindhavi, and Vangali. (Trans. S. Mitra)

Here, Shiva is shown as an ashen yogi dressed in white and seated on a tiger skin in a pavilion. He is flanked by two musicians at the right and a fan bearer at the left. He wears one necklace of severed heads and another with a green pendant, in which the iridescent green of the jewel is, in fact, beetle wing, which has been applied directly to the paper. He bears a third eye and the source of the Ganges springs from his head.

Andhare (1972, pp. 47–50) has reascribed this dated *Ragamala* series, formerly attributed to Bikaner, to Amber, on the basis of the colophon and the pictorial motifs and stylized conventions used in this set. The attribution of this page and the following page (cat. no. 102) is based on Andhare's postulate.

Other pages from this series are reproduced in Gangoly 1935, pl. L, figs. A and B; Goetz 1950, pp. 33–47, fig. 94; Ebeling 1973, p. 188; Czuma 1975, cat. no. 97; and Leach 1986, p. 167. Beach (1992, p. 184) concurs with the Amber attribution of the page in Leach 1986 but proposes that it is "from a second but uninscribed ragamala in identical style." AGP

Literature Katz 1963, cat. no. 127; Ebeling 1973, p. 188.

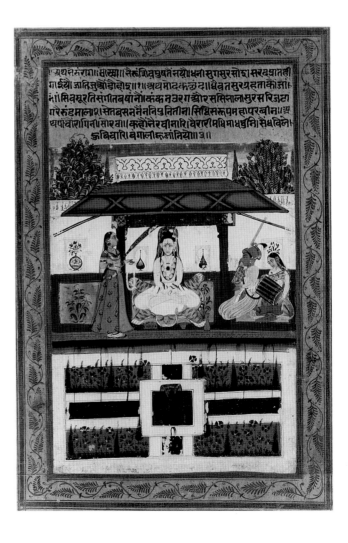

102 Artist unknown

Malkosa Raga

Page from a dispersed *Ragamala* series
Rajasthan, Amber
Circa 1700–1710
Opaque watercolor, gold, and silver on paper
Image 12½ x 8⅛ in. (31.7 x 20.8 cm)
Sheet 17⅛ x 12⅝ in. (43.5 x 32 cm)
Gift of Ashok K. Mehra, 84.263

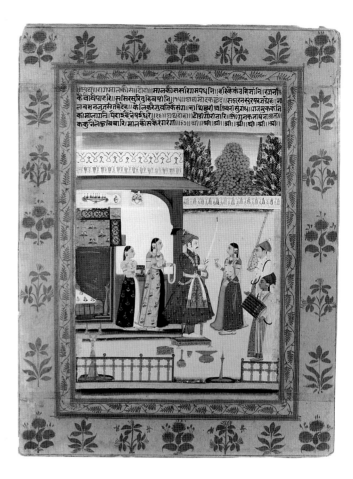

In *Ragamala* painting series, Malkosa's amorous play with his wives is accompanied with music. The five lines of text at the top of the illustration, in Braj, in Devanagari script, explain the meter, notes, and time at which *Malkosa Raga* is sung:

The meter is *Doha.* Of the sevenfold gamut of Indian musical notes, *sa, ri, ga, ma, pa, dha,* and *nie,* Malkosa is represented as the one that resembles the sound of a peacock. The preferable time is the last or fourth quarter of the night; the ideal season is cold. Now the *Modaka* meter: the musical notes of Malkosa must have *sadja* as one attired in red garments. He should be distinguished as the one sporting with young maidens, holding a stick in one hand and a perfume box in the other. He is adorned with a garland of "elephant pearls." This *raga* emerges in such a surrounding. Now *Doha* meter: among its female aspects are Todi, Gauri, Gunakali, Khambhavati, and Kakubha—all are within the realm of Malkosa. (Trans. S.P. Tewari)

The hero of this morning scene stands on a golden, upholstered platform and holds two attributes of his royal position: the fragant flower wand and a long gold sword in an orange scabbard. He is dressed in a gray-brown jama decorated with red flowers and green stems and a blue pajama with a gold floral motif, a gold turban with a large black plume, a white and gold sash, several strands of pearls crossing over his shoulders and chest, and various items of pearl jewelry including bracelets, earrings, and anklets.

The inscription identifies the three wives shown here as Todi, Gauri, and Kakubha, following Hanuman's system. They are dressed in long skirts, cholis, diaphanous scarves gathered at the waist and hanging the full length of the skirt, and elaborate arrangements of gem and pearl jewelry. They

hold a variety of objects: a cup, perhaps containing wine or pan (betel), a garland of white flowers, and a framed picture or album of paintings. The dark female drummer wears a yellow garment, green trousers, a brown hat, pearl jewelry, and a gold floral-patterned scarf that hangs oddly below the hemline of the yellow garment. The young boy playing the *tanpura* wears a turban similar to that of Malkosa, a white jama, a gold sash, and pearl jewelry. Several gold vessels and candelabra are depicted in the foreground.

A rolled "screen," richly patterned with gold and green areas of floral design, exposes the *raga*'s private chambers. The bed is rendered in unusually convincing perspective. A white pavilion occupying the left half of the page is ornamented with a red and blue parapet and a rich salmon pink overhanging roof held up by a gray, carved support. The courtyard, painted in the light green color typical of Bikaner painting, is demarcated by an orange balustrade in the foreground and a decorated wall in the background. Beyond the palace, several large trees are set against the morning sky. A wide border with silver botanical motifs surrounds the miniature.

The identification of this leaf is based on a comparison of iconography, composition, and classifications with other versions of the *Malkosa Raga,* which also belong to the Amber *Ragamala* tradition. Unlike the Raghugarh *Malakausika Raga* discussed below (cat. no. 123), *Malkosa Raga* frequently depicts a male with a flower wand, standing or seated, accepting pan. Two stylistically related *Ragamala* series, dated 1700 and 1709 respectively, have been attributed to Amber by Ebeling (1973, pp. 185–88) and Andhare (1972, pp. 47–50).

As noted in the identification of *Bhairava Raga* (cat. no. 101), Andhare's reattribution of the 1709 *Ragamala* series to Amber is convincing evidence for the identification of this page as an Amber work. Naval Krishna (personal communication, 1991) has suggested that the princely figure at the center appears to be taken from an Aurangabad prototype, while the female figures are in the Bikaner-Jaipur style. Furthermore, the closed position of the hands, rather than a palm-up position, is unusual for the set. The lack of common tree types may indicate retouching.

A painting from the same series with an identical architectural setting, furnishings, costumes, and facial features, as well as the same treatment of color, is published in Goetz 1950, p. 179, pl. 94. AGP

103 Artist unknown

Patamanjari Ragini

Page from a dispersed *Ragamala* series
Rajasthan, Jaipur
Early 18th century
Opaque watercolor and gold on paper
Image 9¹⁄₁₆ x 5¾ in. (23 x 14.6 cm)
Sheet 12 x 8⅞ in. (30.5 x 22.5 cm)
Acquired in exchange with Nasli Heeramaneck, 41.1024

INSCRIPTION
Verso, at top, in black ink, in nastaliq script: *Patmanjari ragini Hindul.*

Patamanjari Ragini represents the bereft woman whose attendants try unsuccessfully to console her. The painting expresses the story of abused love. As described in the text at the top of the sheet, Patamanjari, angry at her husband's response to someone else's love, and recalling his earlier warmth and affection, becomes agitated, grimaces, refuses to speak. Tears flow from her eyes like jewels falling from a broken necklace. Her well-wishing friends try to console her by counseling that her beloved will always be excited by her love. They swear in the names of Brahma and Shiva that they are correct, for the pleasure she has provided him will one day draw him closer. S.P. Tewari (personal communica-

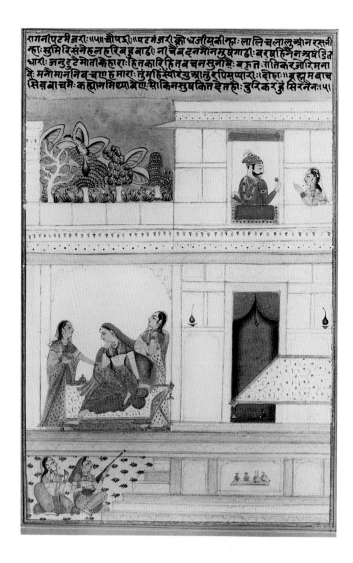

tion, 1991) has suggested that the scene at the upper right may represent the husband courting his new love.

This page relates in composition to the Amber leaves (cat. nos. 101 and 102) but is attributed to Jaipur on the basis of style, in which the female figures are portrayed without the definition of modeling, in costumes delicately rendered yet with detail of the textile design indicated with dots and color. The stylized foliage of trees and plantain bushes is rendered in the typical overlapping. (See Andhare 1972, p. 48, for a comparison with Jaipur-school paintings.) Our page may be compared with another, probably from the same series, in the Cleveland Museum of Art, which shares similar composition, architecture, and figures with delicate detailing (Leach 1986, cat. no. 63).

Other Jaipur *Ragamala* series are described in Ebeling (1973, p. 96 and col. pl. 40), particularly those produced during the reign of Maharaja Sawai Jai Singh II of Jaipur (r. 1699–1743). AGP

104 Artist unknown

The month of Pausha

Page from a *Baramasa* series
Rajasthan, Jaipur
Circa 1750
Opaque watercolor and gold on paper
Image 9¾ x 7⅛ in. (24.75 x 18.1 cm)
Sheet 13¾ x 10⅝ in. (34.9 x 27 cm)
Gift of Mr. and Mrs. H. Peter Findlay, 80.71.1

INSCRIPTIONS
In lower border, in black ink, in Sanskrit in Devanagari script, and in Persian in nastaliq script: *Pausha.*

This page from a *Baramasa* series represents the winter month Pausha of the lunar calendar, from mid-December to mid-January. Two women sit facing each other in a pavilion within a walled courtyard and enjoy the warmth of burning charcoal in a footed hexagonal brazier set on a circular tray to protect the rug. They wear patterned wool shawls over gold-patterned saris. The woman at the right may be the lady of the house, since she rests against a large bolster; a pillow covered with gold silk lies beside her. A female attendant stands outside the pavilion entrance. The blue sky streaked with white lines renders the feeling of winter's cold dusk hours.

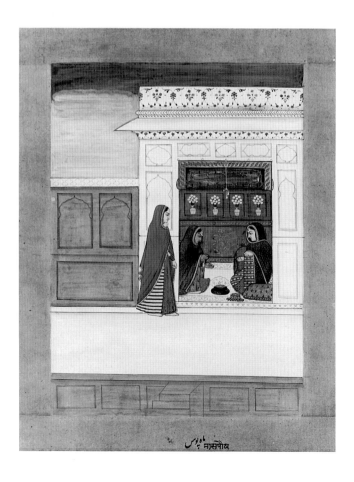

The architecture and setting are rendered in a combined Deccani-Rajasthani style. Notably, the detailed depiction of flowers in the pavilion architecture is comparable to Deccan painting of the same period (see Ebeling 1973, p. 55, fig. C-15), while the flowers flanked by the cypresses painted in gold in the lower section of the gray stone interior are a distinctive Rajasthan feature. On the other hand, the thin washes of salmon orange color for the sandstone outer walls and the blue and white sky are an unusual technical feature with conspicuous individual brushstrokes. This combination of Rajasthani features with Deccani or Mughal influence is known to have occurred in Jaipur painting during this period (see Ehnbom and Topsfield 1987, cat. nos. 26–29).

The Persian label in nastaliq script, a transliteration of the title, is placed with the Devanagari title beneath the image. This is a practice deliberately intended for a Persian-speaking owner, as noted in other leaves cited by Ebeling (1973, p. 146). AGP

105 Artist unknown

Lady with a black buck

Rajasthan, Jaipur (?)
Circa 1750
Opaque watercolor and gold on paper
Image 7 x 3⅞ in. (17.8 x 9.9 cm)
Sheet 8½ x 6¼ in. (21.6 x 15.9 cm)
Anonymous gift, 80.277.15

This finely detailed and finished study depicts a standing woman shown in three-quarter view facing left. She holds the collar of a black buck, whose fur is carefully rendered with hatching and cross-hatching. The animal wears a muzzle and a collar of bells. The woman is dressed in an intricately patterned red-orange and gold sari and gold slippers. A transparent shawl with plain gold borders covers her head and upper body and falls down her back. She wears long crossed garlands and strings of pearls and is richly adorned with earrings, bracelets, anklets, and hair ornaments. The figures are isolated on a white ground against a blue background over greenish underpainting. The multiple borders with gold filigree patterns are now unevenly cut. AGP
Provenance Jeffrey Paley, New York.

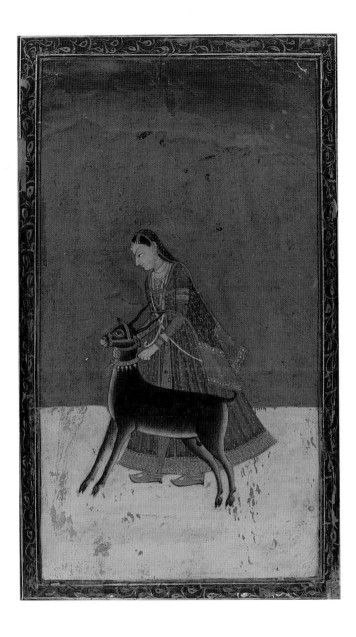

106 Artist unknown

Devotions to Nagadevata

Rajasthan, Jaipur
Circa 1790
Opaque watercolor and gold on paper
Image 8⅛ x 5¼ in. (20.65 x 13.35 cm)
Sheet 11³⁄₁₆ x 8¹⁄₁₆ in. (28.4 x 20.5 cm)
Anonymous gift, 79.186.2

In this painting, here tentatively identified as a devotional scene, a multiheaded, profusely bejeweled anthropomorphic snake god, Nagadevata (or Vasuki), holding a bejeweled staff, stands on a gold pedestal within a temple. Two snakes kiss his feet. He is flanked by a five-headed, ten-armed figure of the god Shiva, who stands to the left, and two *naginis* (wives of the Nagaraja) to the right. Four heavenly kings and a worshiper, gesturing with a bowl of flowers, stand in postures of reverence in the left foreground, while four devotees with musical instruments and four nude boys stand in similar poses opposite them. A table in the center holds some ritual objects.

The horse-headed figure at the lower right is possibly a heavenly musician *(kinnara),* who resides in the Himalayas. In Shaivite literature, animal-headed figures are referred to as *ganas* and are often depicted playing music. Here, the horse-headed figure is dressed as a Rajput king, while the other musicians wear the traditional garb of devotees. The ascetic with a lyre might be Narada, who is famous for playing the vina.

Typical of later Jaipur painting is the filigree pattern in gold enhanced by a shaded orange background that completes the scene. The highly burnished surface and pricked gold leaf in the unfiligreed areas of the painting give an effect of radiance or brilliance. Pierced holes at the left side of the leaf indicate that it was once bound in a volume. The outer edges of the border are discolored.

The symmetrical distribution of the figures, jewel-like painted surface, borders, and size compare to a Jaipur leaf of circa 1790 identified as "Arjuna's cosmic vision of the divine

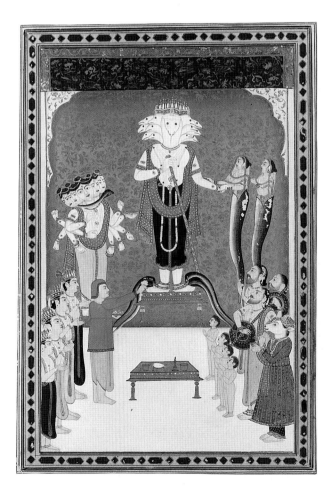

form of Krishna" (Colnaghi 1978, cat. no. 79, pp. 70–71, col. pl. 79). Another comparable work is published in Mookerjee 1966, pl. 3. AGP

107 Artist unknown

Gauri Ragini

Page from a dispersed *Ragamala* series
Rajasthan, probably Jaipur
First half of the 19th century
Opaque watercolor and gold on paper
Image 9¹⁄₁₆ x 5¹⁵⁄₁₆ in. (23 x 15.1 cm)
Sheet 10⁹⁄₁₆ x 7⁵⁄₁₆ in. (26.6 x 18.6 cm)
The Brooklyn Museum Collection, X689.1

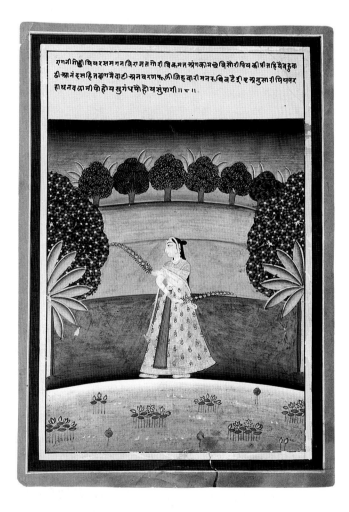

Gauri Ragini is represented as a woman strolling through a lush garden as she daydreams longingly of her husband. Dressed in an orange bodice (choli) and gold brocade sari that is drawn over her head and shoulders, she carries two long wands of mauve blossoms and green spiky leaves that repeat the colors of lotuses in the pool in the foreground. Her long hair, an opaque black, is tied in a knot at the back of her head. She wears crossed garlands of white flowers or pearl necklaces and is ornamented with bangles, anklets, rings, earrings, a forehead ornament, and hennaed palms and soles. The text, in a yellow band at the top of the page, in Devanagari script, describes the heated passion of *Gauri Ragini*.

The miniature swans in the pool and the playful birds and monkeys in the trees are delightful details of this painting in which the landscape, rendered as broad bands of striated color, is in pronounced contrast to the woman's extravagant ensemble. The horizontal brushstrokes complement the arched planes of color, providing depth and an unusual sense of volume to the scene. An orange line at the horizon may signify dawn or sunrise.

A Jaipur attribution has been considered here because of the treatment of the physiognomy of the figure and the juxtaposition of stylized plantain fronds behind flowering trees (see Andhare 1972, pp. 50–51).

For other examples of late Jaipur *Ragamala* paintings, see Ebeling 1973, pp. 125, 228, 268; and Findly 1981, pp. 62–65. AGP

108 Artist unknown

Kedari Ragini

Page from a dispersed *Ragamala* series
Rajasthan, Jaipur
First half of the 19th century
Opaque watercolor and gold on paper
Image 9⁹⁄₁₆ x 6¼ in. (24.3 x 15.85 cm)
Sheet 11¹⁄₁₆ x 7⁵⁄₁₆ in. (28.1 x 18.6 cm)
The Brooklyn Museum Collection, X689.2

INSCRIPTION
Verso, in black ink, in Devanagari script: *Ragini Kedari.*

In a moonlit night scene a young female with ashen skin dressed as an ascetic sits in a lakeside pavilion with two attendants. In a lotus pond in the foreground, a boatman wearing a red turban is seated in a boat decorated with an elephant-head finial. As in the preceding *Ragamala* page (cat. no. 107), small swans swim among the lotuses.

The varieties of representations of *Kedari Ragini* are intriguing, and our page offers an unusual variation of the theme. At the top of the page, in Devanagari script, the text reads:

On account of the anguish of separation from her beloved, the heroine has dressed herself like an ascetic: she is

marked by the separation as if smeared with ashes. She talks only of separation in conversation. Knowing her as a yogi, they will approach her either to learn yoga from her or to teach her yogi practices. She indirectly rejects these offers, addressing her ascetic friend aloud: "It is better now if I am relieved of this body since I cannot bear the agony of separation any longer by passing the entire night awake." (Trans. S.P. Tewari)

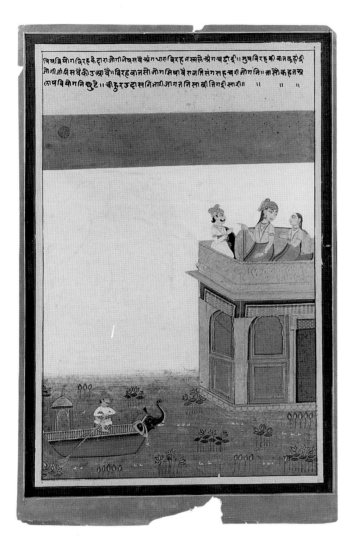

Although the word "kedara" means "a submerged field," the *Raga Kedara* or *Kedari* can refer to a lone ascetic playing a vina, a youth doing penance, or courtiers or ladies visiting an ascetic in a lakeside pavilion (see Ebeling 1973, p. 118, pl. C37, fig. 93, pp. 201, 270–71). Here, as suggested in Tewari's reading of the inscription, *Kedara* is not only a *raga* in separation. The verse suggests a pun on the word "yoga," which may mean both the practice of an ascetic and physical union with another person, thus testing her loyalty to her beloved in separation, marking the irony of the pun. AGP

109 Artist unknown

Krishna carried across the river

Rajasthan, Jaipur
First half of the 19th century
Opaque watercolor and gold on paper
Image 7⅛ x 5½ in. (18.5 x 14 cm)
Sheet 10⅝ x 7⁵⁄₁₆ in. (27 x 18.55 cm)
The Brooklyn Museum Collection, X689.4

In this unusual representation of the rescue of Krishna to Gokula, the scene is set in a dark night. The enormous serpent Vasuki protects the diminutive figure of Vasudeva, who carries the infant Krishna above his head as he crosses the Yamuna River. The scene is set in a dark night with a looming storm. To the right, Devaki holds the newborn baby while two kneeling guards sleep in front of the pavilion. In a palace at the top left, the god Vishnu is seated on a lotus throne, flanked by two female worshipers who pray for Krishna's safe delivery across the river. The lion at the left represents all the earthly dangers he encounters along the way, while the translucent and tenebrous monkey at the up-

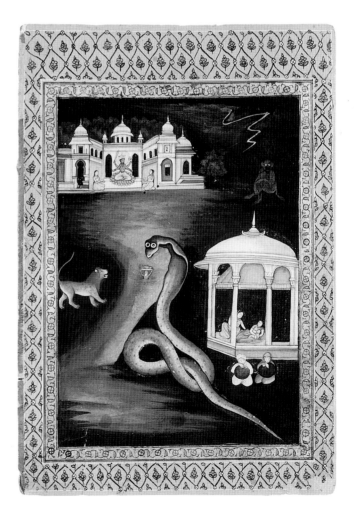

per right suggests the mood of dangers as in the *Abhisarika Nayika,* who is usually depicted crossing the wilderness in a stormy night.

The supernatural event celebrated by this scene is emphasized by the prominence of the serpent's eyes as well as those of the monkey, symbolizing that they are witness to the event. The painting has two floral borders, a narrower golden one and a wider intense orange one with flowers. Late Jaipur paintings have been identified by such stylistic conventions, particularly the minuscule scale of figures regardless of their role in the narrative and the careful use of perspective, specifically in the drawing of architectural elements (see W.G. Archer 1963, pp. 38–39). AGP

110 Artist unknown

Pushkar Lake

Rajasthan, Jaipur
Circa 1840–60
Opaque watercolor and washes on paper
Sheet 7⅞ x 12⅛ in. (19.8 x 33 cm)
Gift of Mr. and Mrs. Peter P. Pessutti, 85.282.2

INSCRIPTION

At top, center, in black ink, in Devanagari script: *Shri Pushkarji.*

The inscription identifies the landscape as Pushkar, the sacred lake in Rajasthan, situated seven miles to the northwest of Ajmer. One of the most important sacred waters in India, it is a major pilgrimage center and the site of an annual pil-

grim fair drawing thousands of devotees every autumn. It is also the site of the only temple in India dedicated to the worship of Brahma.

The lake, replete with pink lotus blooms, forms the central focus in the foreground of the picture. The notion of a full body of water is indicated by a half-submerged pavilion in the center. Rugged mountains enclose the lake on all sides; buildings dot the landscape, including two placed high atop mountains that have steps leading up to them. Bordering the lake is a semicircular arrangement of buildings on one side, with steps leading down into the water. No fewer than five temples, identified by their tall towers, are visible. Although pastel shades of brown and white predominate, green and blue have been used to accent the foliage. The concept of an oasis within a barren desert is manifest.

The composition is close to those in the murals in the Bhojan Shala of the Samod castle, north of Jaipur, which are datable to 1820–50. All these frescoes are unpublished and therefore it is not possible to date them and the painting more precisely. For further information on Pushkar, see Sarda 1911, pp. 136–46.

This type of topographical landscape painting is reminiscent of paintings, aquatints, and lithographs done by British and Indian artists in the nineteenth century as illustrations of travel books and as visual documentations of popular places.

A watermark is visible in the paper and reads STACEY WISE 184. UR/AGP/JB

drawn over her head. She is adorned with gold jewelry and black bangle bracelets with black tassels, a convention that appears often in Akbar-period miniature painting in both the Mughal and Rajput modes.

Although unidentified, this fragment may well be the left side of a page from a *Bhagavata Purana* series of circa 1590–1600 attributed to Bikaner, now dispersed but widely reproduced. As in other pages from this series, the figure is proportionately larger than the landscape elements; also, her ample figure, squarish head and physiognomy, costumes, ornaments, and gestures are similar to the female figures in other folios in the series (Goetz 1950, fig. 91). The jewelry—consisting of an oval amulet box suspended from a black cord below her breasts, a gold choker, a large circular earplug with a floral decoration, gold armlets, a gold necklace, wide gold wristbands, and the ubiquitous tassels at her wrists and waist—is also common in this series, as well as in such contemporaneous sets as the "Berlin 1605 *Ragamala*" (see Waldschmidt 1975, pp. 427–31).

A closely related painting depicting *Gauri Ragini* (in the Motichand Khajanchi Collection) is from a *Ragamala* series and is comparable in height to our example. Close parallels appear in the foliage and costumes of both paintings as well as in the hairstyle of the female figures. The Khajanchi catalogue attributes the leaf to the popular Mughal school (Khandalavala, Chandra, and Chandra 1960, p. 13a and frontispiece), suggesting that it was probably painted at Agra, or another center of Mughal painting such as Bikaner, since many court painters from Delhi were commissioned by local Rajput rulers. The flat bun and the ballooning veil at the back of the heads of the female figures in both pages are typical features in miniature paintings of the late Akbar and Jahangir schools. The red outlines of the figures is another common feature.

Naval Krishna has confirmed the attribution of this fragment and adds that the dangling pompons on the woman's wrists and waist and the serrated clouds are typical of the *Chaurapanchasika* group (personal communication, April 1991). AGP

Literature Poster 1987, p. 35, col. pl.

111 Artist unknown

Lady in the wilderness

Fragment of a page from a *Bhagavata Purana* series
Rajasthan, probably Bikaner
Circa 1590–1600
Opaque watercolor and gold on paper
Sheet 6⅝ x 4½ in. (16.8 x 11.4 cm)
Anonymous gift, 84.201.2

The scene depicts a solitary woman walking in a wilderness. She stands at the left and gestures with her arms outstretched toward a mango tree at the right, represented with light green leaves over a dark green ground, and vines with mauve-and-white flowers. These are key elements in the proposition that this fragment may be the left half of a horizontal page. The background is a light green wash separated from an arched blue band of horizon along the top of the page by a white cloud and a serrated black line. The woman wears a mauve bodice and a green skirt with an ankle-length transparent scarf gathered at the waist with a tassel and

112 Anonymous

Portrait of Rao Chattar Sal of Bundi

Rajasthan, Bikaner
Circa 1675
Opaque watercolor and gold on paper
Sheet 7⁵⁄₁₆ x 4¹¹⁄₁₆ in. (20.2 x 11.9 cm)
Anonymous gift, 82.227.1

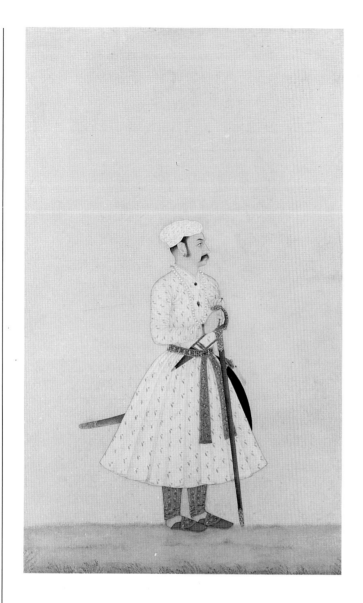

The Bundi ruler Rao Chattar Sal (r. 1631–58) stands facing the viewer's right attired in an elegantly pleated pale yellow *jama* patterned with red-and-green flowers. It is tied at the waist by a gold belt embossed with alternating rubies and emeralds, which holds his *katar*. Gold striped trousers, a long sash, slippers, and a brocaded white turban complete his outfit; jewelry and additional military regalia indicate his status: a *firangi* (long sword), whose tip emerges from behind his clothing at the left, a shield, and another sword. All the gold details are rendered with finely pricked gold leaf. With the exception of a band of sparse green landscape, the pale green background is undecorated. There are no borders.

This small portrait of the Bundi ruler is executed in a highly refined style that reflects the close relationship of Bikaner with the Mughal court. Joachim Bautze points out (1985, p. 107) that Chattar Sal (or Shatru Sal, as he is called in Bundi) died in the battle of Samugarh in April 1658 while he was in the service of the Mughal Prince Dara Shikoh. Naval Krishna has referred to another portrait of this ruler, which closely resembles this page and has been attributed to Ruknuddin, a disciple of Ali Riza (Paper, 79th Annual Conference of the College Art Association, Washington, D.C., 1991). The ruler is further discussed in many diaries in the Bikaner state archives. The style and date of the page are consistent with the depictions in an album of portraits of neighboring rulers painted at Bikaner in the third quarter of the seventeenth century.

A Bundi portrait now in the San Diego Museum of Art that was previously identified as Rao Chattar Sal (Archer and Binney 1968, cat. no. 12) has recently been recognized by Bautze (ibid.) as Bhao Singh, Chattar Sal's son. The San Diego portrait bears no similarity to the Bikaner rendering in either style or physiognomy. AGP

113 Ibrahim

Nayika awaits her lover

Page from a series illustrating the *Rasikapriya* of Keshavadasa
Rajasthan, Bikaner
1692
Opaque watercolor on paper
Image 7⅞ x 5½ in. (19.8 x 14 cm)
Sheet 9½ x 6¼ in. (24.2 x 15.5 cm)
Anonymous gift, 81.192.3

In this scene from a *Rasikapriya* series, a *nayika* is seated on a railed terrace under a white canopy supported by four gold posts. A kneeling attendant is at the right, while at the left, the heroine's lover (depicted here as Krishna) approaches from behind. The three figures are represented with deeply shaded faces in profile. The heroine wears a gold skirt; a transparent brown scarf with a gold border is drawn over her head. She is ornamented with gold-and-pearl jewelry inlaid with gemstones and a jeweled belt with a pearled tassel. Seated on a white carpet decorated with an overall meandering pattern of leaves and flowers, she leans against a mauve bolster; a gold casket and fruits are before her. The attendant, identified by her less elaborate costume, kneels with

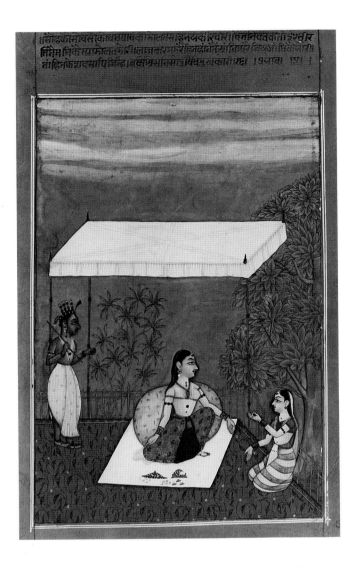

arms outstretched. Krishna, crowned and carrying a flute, wears a patterned yellow dhoti and is also ornamented with gold-and-pearl jewelry. The sky is a pale blue-green with clouds indicated by white and gold brushstrokes.

On the basis of both craftsmanship and the inscription on the verso, Naval Krishna has confirmed the attribution of this painting to Ibrahim, son of Ruknuddin, the master of the Bikaner court who was the supervisor of the atelier from 1680 to 1698 (personal communication, April 1991). Another painting by the artist, from the same series, is published in Chandra 1971, pl. 172.

The text in the top border of the recto, in Devanagari script, gives the classification of the *nayika* with attendant waiting for her lover.

For similar Bikaner paintings from a dated *Rasikapriya* series by this artist, see N. Krishna 1985, pl. XI, figs. 2 and 4. AGP

114 Murad (?)

Dhanyashari Ragini

Page from a dispersed *Ragamala* series
Rajasthan, Bikaner
Circa 1695
Opaque watercolor, gold, and silver on paper
Image 5⅞ x 4½ in. (15 x 11.6 cm)
Sheet 7⁵⁄₁₆ x 6 in. (18.5 x 15.4 cm)
Anonymous gift, 81.192.5

INSCRIPTIONS

Verso, inventory notation, in Sanskrit, in Devanagari script: *Ragini Dhanyashari—20 the work of Murad;* in fountain pen ink: *Samvat 1771;* in pencil: *1714.* Library stamp of H.H., the Maharaja of Bikaner.

In this page from a *Ragamala* series, the woman seated at left represents Dhanyashari, a form of love in separation. In keeping with tradition, she is shown sketching a portrait of her absent lover on a picture panel she holds in her left hand. An attendant kneels in front of her holding a parrot. Situated within a walled courtyard with treetops in the background, the figures sit in the center of the composition. The symmetry of the arrangement and other details of the painting, such as the pavilion, are similarly appropriate to the text. The cries of a peacock on the rooftop of the pavilion reiterate the emotion of solitude and loneliness. There are multiple borders.

Waldschmidt (1975, p. 264) cites a line from the text of *Samgitadamodara* that defines the *ragini:* "Dhanasri is a charming young woman, with a body dark like the blade of durva-grass, who—holding a picture panel in one of her hands—is about to paint the (far-off) lover, while her breasts are being washed by drops of tears falling down (from her eyes)." In this page, one figure is fair skinned while the heroine is dark; her green complexion is suitable to the definition of Dhanyashari.

Royal inventories (*bahis*) dated V.S. 1748, 1749, 1751, 1754, and 1756 are known to be available in the Bikaner State Archives, and those of other years may also be discovered. Naval Krishna, who has made an extensive study of these documents, suggests that the date V.S. 1771 [A.D. 1714] on the reverse of the painting is the date of a royal inventory, not that of its execution. He believes the leaf may be dated to circa 1695 (personal communication, 1991).

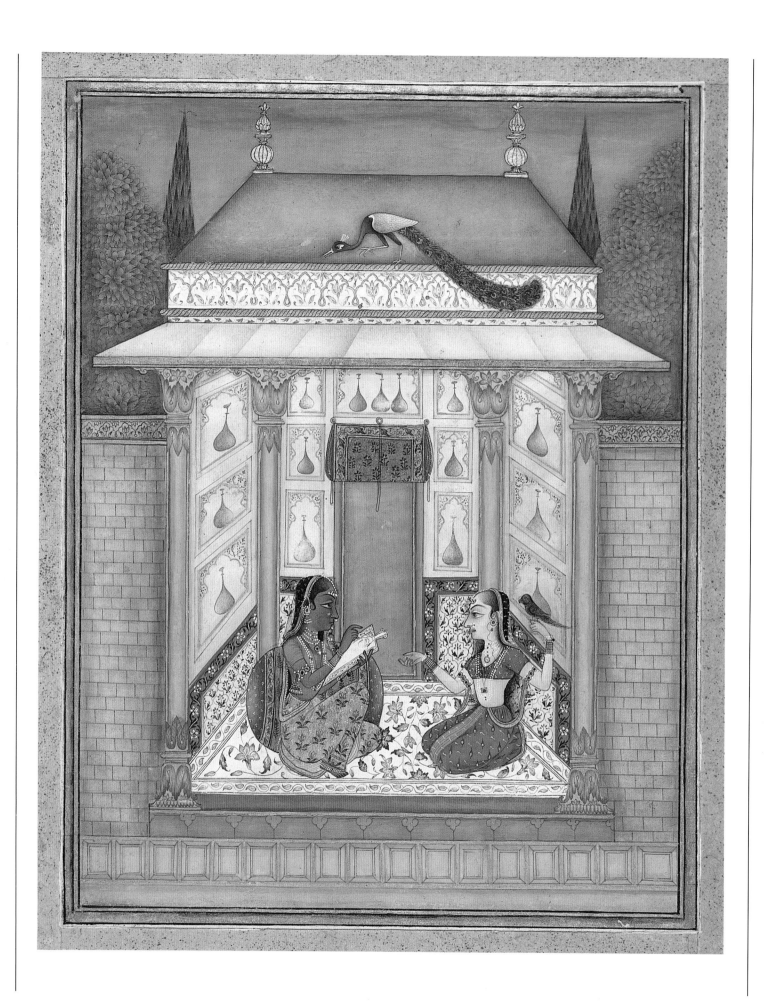

The foliage of the trees is indicated in distinctive patterns of leaves arranged in alternating bands of blue and green color. The modeling of the figures is achieved by a varied stippling that is in contrast to the flatness of the white marble pavilion. The textile furnishings are similar to the work in a contemporaneous *Bhagavata Purana* series from Bikaner. One page, which depicts the Death of Putana (Pal 1978, p. 96, cat. no. 25), is attributed by Naval Krishna to Abu, an artist of the Nuruddin group that painted the *Bhagavata Purana* series.

The shading of colors at the borders appears to be a Bikaner convention. This shading is not necessarily consistent with either the perspective or the naturalistic shadows but is a decorative element, as is the alternating blue and green striation in the foliage and the color and patterns of the richly decorated wall panels and textiles. The physiognomy and squat proportions of the figures bear close resemblance to other works by Murad. Because of the presence of other hands, Naval Krishna considers our painting to be from the atelier of Murad and not by Murad himself.

For other works by Murad, see Welch and Beach 1965, cat. no. 30, a page from a *Baramasa* series; and Colnaghi 1978, cat. no. 63. For further references, see Goetz 1950, fig. 88. AGP

115 Attributed to Muhammad, Son of Nur

Dipaka Raga

Rajasthan, Bikaner
Circa 1690–1700
Opaque watercolor, gold, and silver on paper
Image 6½ x 4¹⁵⁄₁₆ in. (16.5 x 12.4 cm)
Sheet 9⅞ x 7⅝ in. (25.2 x 19.5 cm)
Gift of Charlene and S. Sanford Kornblum, 1991.77

INSCRIPTION
Verso, in Sanskrit, in black ink, in Devanagari script: *Dipaka.*

In this exceptional representation of *Dipaka Raga,* the mood of passionate love is beautifully expressed, and the symbolic flame of *dipaka* is reiterated throughout in minute and glittering detail. The passionate hero embraces his beloved in a pavilion under a star-filled night sky. The woman wears a mauve choli, a silver skirt, a diaphanous golden veil with a white dotted pattern that covers her head and gathers at the front of her waist, pearl earrings and bracelets, a gold armband, and a wristband.

The hero is dressed in a deep-olive-colored jama patterned with gold-and-red flame-shaped designs, gold and blue striped pajamas, a crimson and blue sash, and a red and gold turban secured with a silver, armorlike band and decorated with a black plume, a flamelike ornament that affirms the fiery mood of the *Dipaka Raga.* Around his neck he wears two pearl necklaces with gold pendants and a garland made of white flowers. The archer's ring on his thumb suggests that he may be a warrior prince. The two figures rest against a large bolster. She gazes downward and pulls the veil with her right hand as if to cover her face, suggesting coyness. She is comforted by her lover, who holds her in his right arm; however, he eschews direct eye contact with her, staring above her head into the distance. The treatment of the architecture suggests perspective and a certain depth for the scene. The pavilion is depicted in somber tones of mauve, pink, orange, and green.

Waldschmidt (1975, p. 179) notes that the musical mode *Raga Dipaka* is "pregnant with the fire and the ardour of love" and derives its name from the Sanskrit *dipa,* which is generally translated as "lamp," "light," or "flame." The large mango tree and the flowering tree rising above the walls of the pavilion at the top of the painting situate the scene in the summer, the season with which *Dipaka* is associated. The star and moon augment the mood of *Dipaka,* which is usually conveyed by the presence of burning lamps.

A Bikaner *Dipaka* painting dated 1695 (San Diego Museum of Art, from the Collection of Edwin Binney, 3rd), with many of the same artistic conventions and a similar composition, is inscribed "Nur Muhammad." Although the setting of the painting is a courtyard rather than a pavilion, the relationship between the figures and repetition of the flame motif on the costumes are remarkably similar. This painting is attributed to the same artist, who, Naval Krishna has suggested, may be Muhammad, son of Nur (personal communication, April 1991).

For other Bikaner *Ragamalas,* see Sotheby 1970b, lots 12, 13–19, and Sotheby's 1973b, lot 243. AGP

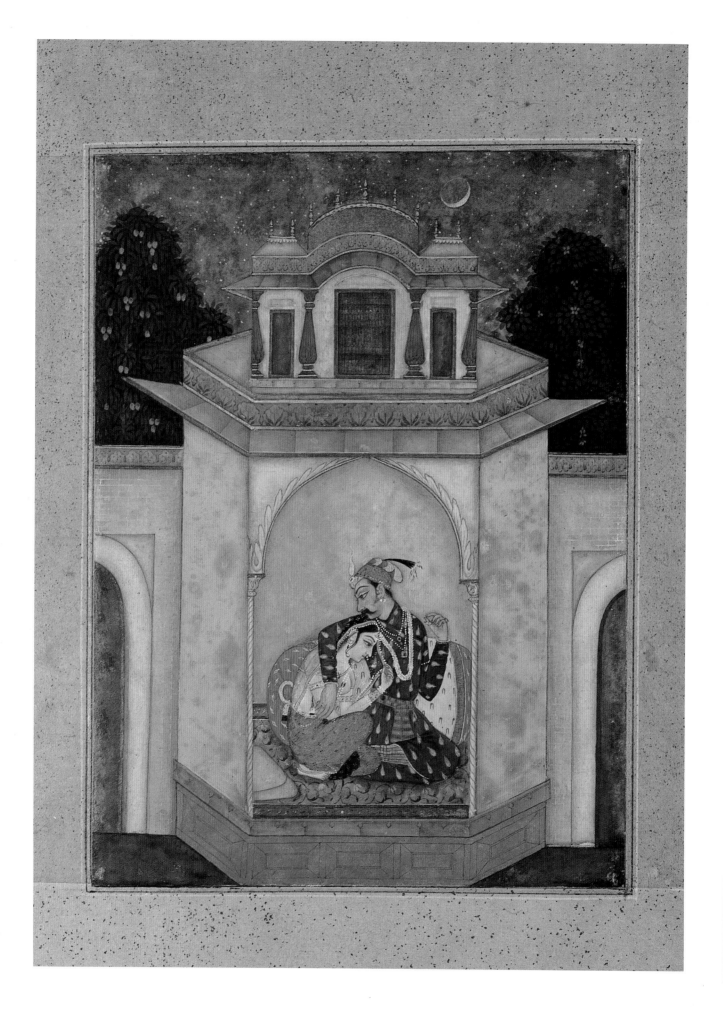

116 Artist unknown

Two women on a terrace

Rajasthan, Bikaner
Circa 1700 or later
Opaque watercolor and gold on paper
Image 6 x 5 in. (15.2 x 12.7 cm)
Sheet 8 x 7¾ in. (20.3 x 19.7 cm)
Anonymous gift, 78.260.4

Two richly attired noblewomen are seated on a carpet on a garden terrace enjoying wine. The principal lady, identified by her more elaborate pearl jewelry, is dark-skinned. She holds a small gold wine cup in her right hand. With her left arm she embraces her companion, who leans against a deep red brocade bolster with a pearled tassel and holds the neck of a blue glass wine bottle. Both are dressed in the long-

sleeved, ankle-length transparent outer garment identified by Waldschmidt as a *peshvaj,* a Mughal court garment worn over trousers and seen in Mughal paintings (1967, pp. 66–67, ills. 24 and 25). The long gold brocade sash and transparent orange shawl are traditional accompanying garments.

Various bottles, brass dishes, and platters are scattered around them. The terrace is otherwise bare, except for a row of red poppies at the upper border and a pale green background beyond. The painting is mounted on an orange paper flecked with gold and a lapis blue outer border.

Subjects with women engaged in drinking are popular in Bikaner painting and are repeated throughout the tradition. A close compositional parallel, dated 1666 and painted by Ruknuddin (Goetz 1950, pp. 106, 174, fig. 83), which shows a hostess and female companion on a terrace with attendants, is exemplary of the early versions of this subject, painted during the Karan Singh period, when Bikaner was involved in campaigns in the Deccan. Ruknuddin and other Muslim painters who accompanied the Bikaner rulers were influenced by Deccani style in their depiction of facial features, palette, and subject matter. The compositional elements, use of gilding, and modeling of features seen in this painting are descended from that tradition.

While Naval Krishna affirms that this painting is in the Bikaner style, he questions an eighteenth-century date because of the thickly applied gold paint and the shading of the figures, which is similar to that of paintings on ivory (personal communication, 1991). On the other hand, Andrew Topsfield has suggested that the inventory label, pasted on the reverse, written in red ink and independent of the calligraphy, conforms to a type found in the princely collection of Mewar (personal communication, 1991).

The relationship of the page to the text on the verso, with script that is round in form, remains unclear; perhaps the text is a later addition. AGP

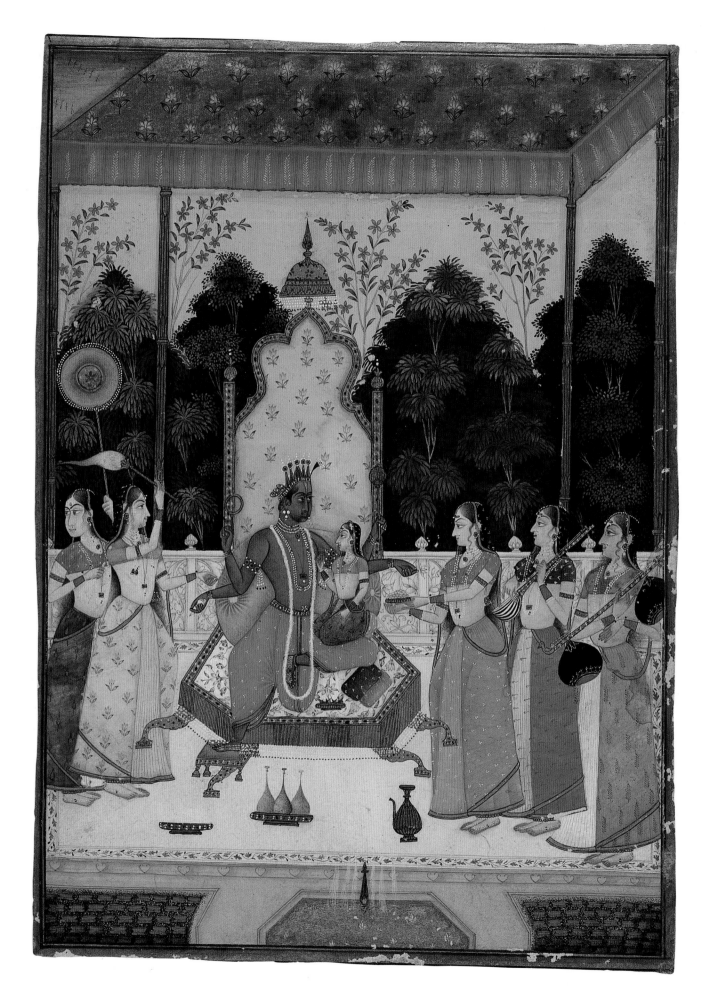

117 Attributed to Murad and Lupha

Vaikuntha Darshana

Rajasthan, Bikaner
Circa 1710–15
Opaque watercolor, gold, and silver on paper
Image 7⁷⁄₁₆ x 5⁵⁄₁₆ in. (18.9 x 13.5 cm)
Sheet 7¹¹⁄₁₆ x 5³⁄₈ in. (19.5 x 13.7 cm)
Designated Purchase Funds, 1990.134

Vishnu, the central figure, is seated on a jeweled throne with his consort Lakshmi on his lap. Deep blue in color, he is four-armed and carries his four attributes: discus, conch, mace, and lotus. He is bejeweled with a crown and ornaments of gold and pearls; a long garland and a lower garment in orange are his only attire. Both figures recline against a pink bolster. The high-arched throne is decorated with a tulip pattern against a yellow background. There are three female musicians on one side of the divine couple and two attendants on the other. The garden scene takes place on a terrace covered by a floral canopy. Dark green foliage, pink flowers, and scattered birds form the backdrop against a light green background, all typical of Bikaner painting. A hexagonal pool with a fountain and flower beds is in the foreground. The scene is composed in a vertical format.

Originally published as *Lakshmi Narayana* and attributed to Lupha (Ehnbom 1985, p. 144), the painting has been reidentified by Naval Krishna as *Vaikuntha Darshana,* an event that purportedly occurred in a dream of the Raja Karan Singh (r. 1631–74). The dream, of Vishnu and Lakshmi in their heavenly abode, was related by the maharaja to his chief court painter, Ali Riza, as noted in a colophon of his version of 1650 (reproduced in Khandalavala, Chandra, and Chandra 1960, cat. no. 83, col. pl. E.; and *Chhavi* 1971, col. pl. J). A similar image was reportedly commissioned for a golden casket, and later, subsequent court artists traditionally reiterated the dream in their works, as, for example, the rendering by Ruknuddin, dated 1678 (Colnaghi 1978, pl. 60), and another by Ustad Rashid, dated 1699 (Goetz 1950, fig. 79).

Naval Krishna has cited a comparable example by Murad in the J.P. Goenka Collection, Bombay, and a painting attributed to Lupha illustrated in the Khajanchi catalogue (Khandalavala, Chandra, and Chandra, op. cit., fig. 75). On the basis of the stylistic affinities of this page to the known works by these artists, Krishna has reattributed the painting as a joint work by Murad and Lupha, followers of Ibrahim (personal communication, 1991). As evident in this painting, the figures of these later artists are noticeably elongated, and the various patterns of goldwork in the throne and costumes are meticulously detailed. AGP

Literature Ehnbom 1985, p. 144, cat. no. 66.

Provenance Sotheby's 1989, lot 24; Dr. William Ehrenfeld, San Francisco.

118 Kasam, Son of Muhammad

Equestrian portrait of Maharaja Sujan Singh of Bikaner

Rajasthan, Bikaner
1747
Opaque watercolor, silver, and gold on paper
Image 8⁵⁄₈ x 5⁷⁄₈ in. (21.9 x 14.9 cm)
Sheet 11½ x 8⅛ in. (29.2 x 20.7 cm)
Gift of Mr. and Mrs. Carl L. Selden, 80.75

INSCRIPTION

Verso, inventory notation, partially erased, in Devanagari script: *Picture of Maharaja Shri 5 Shri Sujan Singh . . . work of Kasam, son of Muhammad, dated v.s. 1805.* (Trans N. Krishna) Library stamp of H.H., the Maharaja of Bikaner.

The ruler Rao Sujan Singh (r. 1700–1735), identified by the inscription on the reverse, is shown on horseback in ceremonial regalia attended by a chauri bearer on foot. He is elaborately dressed in a long white robe overlaid with a transparent yellow jama that flows down the length of his left side. He wears a long patterned belt and slippers. His orange and purple turban is ornamented with a plume, pearls, and other decorative elements. He is bejeweled with two bands of pearls on his left arm and bracelets at both wrists. He has Shaivite tilak marks and a long leather strap on his left shoulder, from which a long sword hangs at his side. The colorful wardrobe suggests that the king may be en route to a wedding or some religious festival. His fully caparisoned horse is beautifully modeled in black washes with shaded areas at the edges that are burnished to suggest a dark gray color. The horse's nostrils and mouth are indicated by a blue wash. The heavily shaded areas—especially the faces of the ruler and the horse—contrast with the opaque colorful details. The scene is simply composed with a background delineated only by a brown ground line dotted

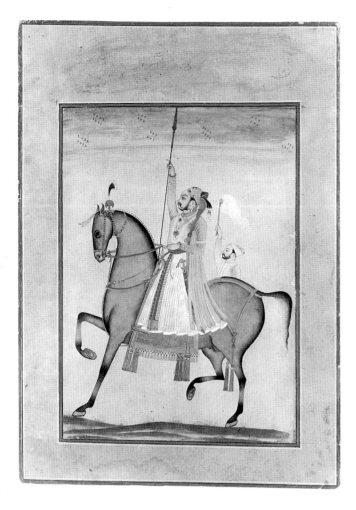

with foliage and a banded blue sky with gold clouds and groups of black birds, the last a typical Bikaner convention.

The nature of the inscription on the reverse has led Naval Krishna to identify the painting as a portrait of Raja Sujan Singh, most of whose portraits date to circa 1715–25. The 1964 inventory stamp of the Bikaner collection in purple-blue ink further establishes the source. Raja Sujan Singh, son of Anup Singh, was known to have been involved in many battles against his Rajput neighbors, especially Jodhpur. Although driven out early in his reign, he returned after the death of Aurangzeb when the Rajput kingdoms were declaring their sovereignty. For other portraits of this ruler, see Goetz 1950, p. 48, fig. 84; and Ehnbom 1985, pp. 150–51, cat. no. 69. AGP

119 Ustad Ahmad, Son of Ahmad Ali

Portrait of Thakur Sangram Singh

Rajasthan, Bikaner
Circa 1740–50
Opaque watercolor, gold, and silver on paper
Image 9¹⁄₁₆ x 5⁷⁄₈ in. (23 x 15 cm)
Sheet 12¼ x 8⁵⁄₁₆ in. (31.1 x 21.1 cm)
Gift of Patricia C. Jones, 86.187.1

INSCRIPTION

Verso, in Braj, in black ink, in Devanagari script: *Portrait of Thakur [baronet] Sangram Singh riding a chestnut horse by the master Ustad Ahmad, son of Ahmad Ali.* Library stamp (blotted out) of H.H., the Maharaja of Bikaner.

This portrait depicts Thakur Sangram Singh (of Uniara?) riding a chestnut horse. He wears a transparent white jama, an elaborate gold turban, and a long gold brocade *patka.* Six attendants, dressed in blue jamas and orange turbans and carrying guns and tapers, walk alongside, a pair in front and four in the rear. The high horizon is completed by a band of blue scalloped clouds; birds are indicated in horizontal brushstrokes in white, marking the sky. A green hilly land-scape with tufts of grass and rabbits completes the scene. One should perhaps note that the faces of the attendants are strikingly similar to that of the ruler.

Although politically allied to Jaipur throughout the eighteenth century, Uniara was a small Rajput state located close to Bundi and Kota. In the Uniara genealogy there are two rulers named Sangram, one who reigned 1690–1715 and another born in 1854 (Beach 1974, p. 54). This portrait fits a standard eighteenth-century type depicting local Rajput rulers commonly painted at Bikaner. AGP

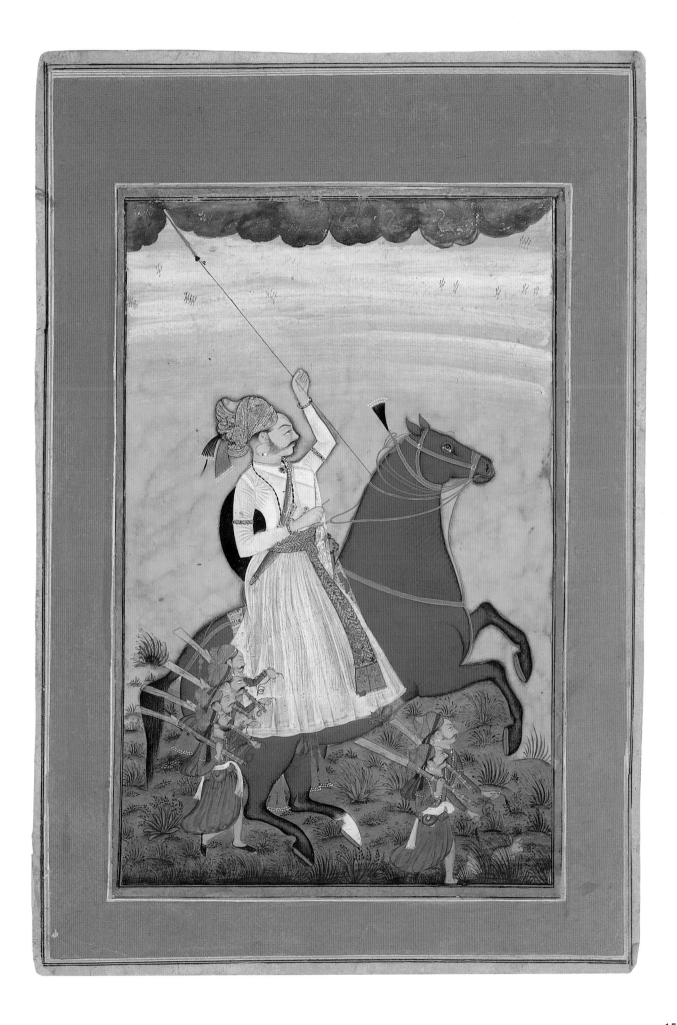

120 Kasam, Son of Ahmad

Radha manifesting the effect of love's separation from Krishna

Page from a *Rasikapriya* series of Keshavadasa
Rajasthan, Bikaner
1749
Opaque watercolor, gold, and silver on paper
Image 7⅝ x 4¹³⁄₁₆ in. (19.3 x 12.3 cm)
Sheet 10¼ x 7⁵⁄₁₆ in. (26.1 x 18.5 cm)
Anonymous gift, 81.192.4

INSCRIPTIONS

Recto, in top left margin, in Sanskrit, in black ink, in Devanagari script: *Radha Manifesting Love's Separation.*

Verso, at top of page, in black ink, in Devanagari script: *The work of Kasam, son of Ahmad, Samvat 1886* [A.D. 1749]/*Twelfth day of the bright half of the month of Kartik/A page of Rasikapriya.* (Trans. V. Desai)

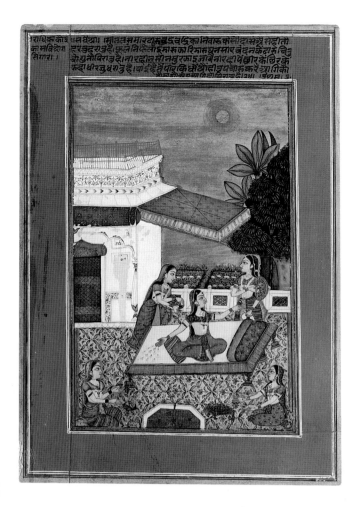

On a carpeted terrace a *nayika* (heroine) sits on a bed under a canopy accompanied by four attendants. The moon and starlit silvery sky indicate that the time is evening. A palace is seen at the left. The blossoming mango tree at the right indicates the summer season. The entire scene is enclosed in a red border with multiple gold, white, and black rules.

Nadine Berardi's unpublished study of this painting has provided us with a rare example of the close attention with which a painter might follow the text already inscribed on the page:

As if withdrawing the cool breeze and obstructing the moonlight, joy is erased.
Scattering the flowers and casting them away, brushing off the camphor, spilling out the sandal paste, the heart aches four times more intensely.
A fish out of water, fading, is restored only by water. Can it be sprinkled with milk? Does fortitude show fear?
Can so much pain inflicted, otherwise effect a cure? The fire which burned the body is the same fire by which it is cooled. (Trans. N. Berardi)

The painter has taken care to render all the details of the evocation. The attendant at the upper right withdraws a fan; a canopy shields Radha from the full moon; her right hand scatters flowers and her left reaches for a cloth held by the attendant, presumably to dust off the camphor. The attendant at the upper left holds a receptacle for sandal paste, while another at the lower left attends to the fish out of water by offering a small cup of milk. The attendant at the lower right extends her arms toward a sacrificial fire contained in a footed brazier.

The *chauguno* (fourfold increase of pain) is reflected by four attendants applying four different types of remedies and by Radha's action in instructing her attendants (*sakhi*) to stop the cool breezes, prevent the moon from shining, scatter flowers, and dust off the camphor, intensifying her pain fourfold. The sentiment in the second half of the verse, that a fish out of water, fading, can only be brought back to life with water, implies that other substances will not do; when Krishna is gone, only he can bring the heroine back to life. The painter expresses this sentiment by showing the fish struggling out of the fountain's little pool. The poet's final observation, that the fire that burns is the same one that cools the body, again refers to Krishna and is reflected in the juxtaposition of the fire and the pool in the painting, suggesting its potential for cooling.

It is not known whether the artist Kasam is related to Ustad Ahmad, who painted the equestrian portrait (cat. no. 119) of Thakur Sangram Singh (of Uniara). The detailed rendering of the figures and their garments as well as the distorted perspective in this painting are technical elements associated with the Bikaner school, evident in the work of other artists as well as Kasam.

Other leaves from the set are located in the Birla Academy of Art and Culture, Calcutta. AGP/NB

121 Artist unknown

Nata Ragini

Page from a dispersed *Ragamala* series
Rajasthan, Bikaner with influence of Jaipur
Circa 1800 or later
Opaque watercolor and gold on paper
Image 10 x 6⅞ in. (25.4 x 17.45 cm)
Sheet 12¼ x 9¼ in. (31.1 x 23.5 cm)
Anonymous gift, 85.220.3

At top left, a man on horseback with drawn sword advances toward an adversary dressed in yellow. In the center, the heroine on an elephant, accompanied by a male archer and a mahout firing a gun, charges a horseman. In the lower part of the painting, the adversary is now beheaded and a female figure carrying a sword holds a cup in which she catches blood from his throat. The presence of a male musician playing a *tanpura* in the upper left, though somewhat strange in this violent combat scene, is not altogether uncommon in the depiction of the *Nata Ragini*. (For an earlier painting of *Nata Ragini* with a warrior on horseback preceded by a male musician, see Ebeling 1973, p. 165, fig. 32.) The musician probably reminds the viewer that it is a *Ragamala* theme, set in a bloody battlefield.

At the upper right, a Shiva temple, recognizable by a trident with a flag, behind some lush green trees may represent an oasis in the desert state of Bikaner, where the painting originated. The setting is a pale green landscape with a high arched horizon line and a wide yellow margin at the top. The scene is set in a hilly terrain, suggested by the different horizontal registers. The monochromatic costumes and predominance of pale green in the background are typical of Bikaner painting in this period, yet here the artist has selected an unusual palette.

The text on the verso, in Devanagari script, describes *Nata Ragini* according to the standard version:

The first *ragini* is Nata and here is the description. *Chaupai.* The four-part verse. Nata is a variegated, refined *raga* who rides a caparisoned elephant, and holds swords in both hands. . . .1
His eyes are red and his physique is unparalleled. All his limbs as well as his costume are soaked in blood. Love in separation is burning like a fire within him, causing him to engage in valiant acts, like decapitating the enemy warrior. 2
The revered one, who is in the center of the combat, represents the image of a great warrior. He fought just as the great hero Arjuna fought in the great battle of the [Maha] Bharata and putting Indra [the king of gods] to shame and even the Shishodiyas. 3

End of verse.
Doha. Natanagari is engaged in a violent combat. (Trans. A. Shapiro)

Despite the consistent references to males in these verses, the picture shows a departure from this tradition in its inclusion of two female participants in the combat. The woman occupied with her bow and arrow in the howdah on the elephant's back is given more compositional emphasis than her two male companions. A decapitated figure often appears in depictions of the *Nata Ragini* as well as of the *Sindhu Ragini,* which is also represented by a tiered scene of fierce fighting. The *Nata Ragini* traditionally celebrates heroism and eagerness for battle (Waldschmidt 1975, pp. 103–4). Ebeling (op. cit., p. 149) cites the iconography of *Nata Ragini* in a provincial Mughal miniature, where the inscription specifically mentions arrows and sword blows decapitating the enemies while yoginis are filling skull goblets with streaming blood and drinking to their hearts' content.

For a comparable leaf showing a tripartite representation of *Nata Ragini,* see Ebeling 1973, p. 37, C6, identified as a leaf from an eighteenth-century Jaipur series, in the National Museum, New Delhi. In that page, too, a female is depicted in warrior's armor on the elephant. AGP

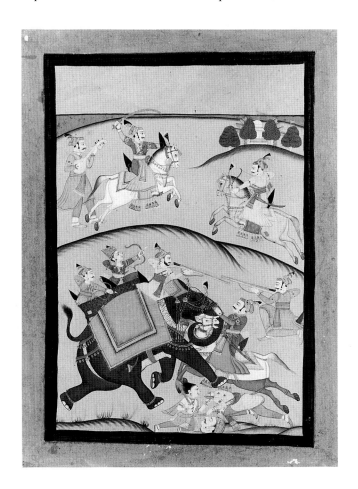

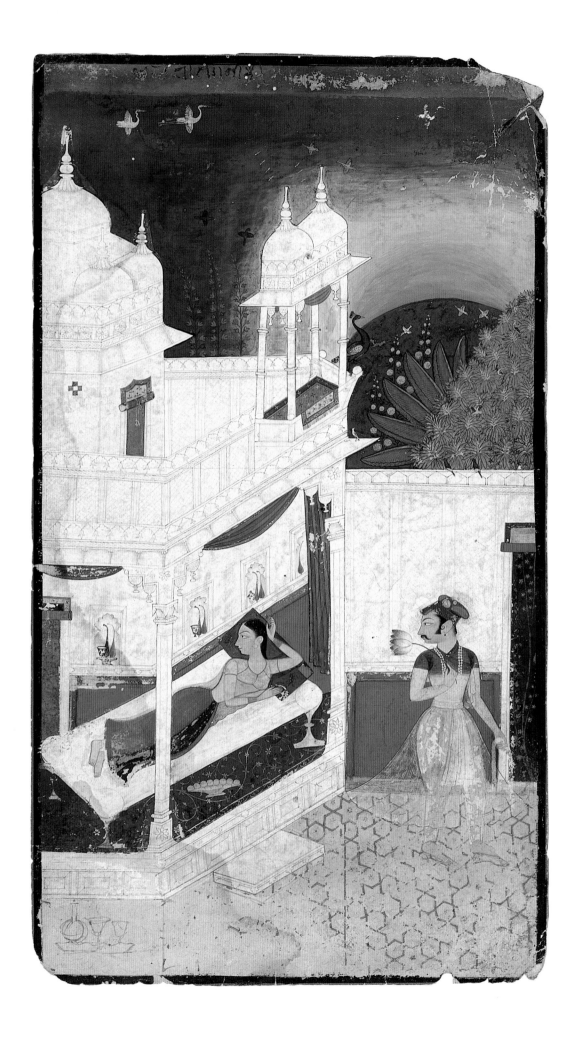

162

122 Artist unknown

Lalita Ragini

Page from a dispersed *Ragamala* series
Rajasthan, Bundi/Kota
Circa 1640
Opaque watercolor on paper
Image 11⅝ x 6⅝ in. (29.5 x 16.8 cm)
Sheet 11¹⁵⁄₁₆ x 6⁵⁄₁₆ in. (30.4 x 16.1 cm)
The Brooklyn Museum, by exchange, 39.86

INSCRIPTION

At top, in black ink, in Devanagari script: *Lalita Ragini.*

This painting, the earliest Bundi work in The Brooklyn Museum collection, depicts *Lalita Ragini,* the prince's departure at dawn from the chamber of his beloved. The prince wears a yellow pajama, a translucent white scarf, a shirt shaded brown at the top, and a crimson and orange turban. He holds a large lotus blossom in one hand and a white cloth in the other and glances back over his right shoulder at his beloved. The princess lies on a white bed, supported by an olive-colored pillow. Her gaze parallels that of her lover yet is more elusive, a gesture of contemplation rather than concentration. Wearing a simple yellow choli, a brown skirt, and a blue diaphanous scarf, she is, notably, without elaborate jeweled decoration, perhaps a naturalistic detail of a waking princess. The black outline of the eyes of both figures is typical of Bundi painting. A bowl of pink spherical fruit or molded food is set before the princess's bed. The blue underpainted outline of a tray containing three vessels is indicated at the lower left corner of the page.

The architectural setting is replete with intricate detail. Most striking are the six-pointed star pattern of the courtyard tiles, the floral design of the blue carpet, and the fine drawing of the parapets, column capitals, and domed pavilions. Beyond the courtyard, several trees and flowering creepers may be seen. The dominant curve of the green hill emphasizes the dramatic illustration of sunrise: the brilliant orange appears to illuminate the entire scene and slowly begins its conquest of the vestiges of the deep blue night sky. The interplay between complementary colors is repeated in the red and green elements of the architecture below. The pairs of birds occupying the sky are intriguing and metaphoric of the theme of the page. A solitary peacock is perched at the corner of the edifice.

A slightly later depiction of *Lalita Ragini,* circa 1660, in the San Diego Museum of Art (formerly Collection Edwin Binney, 3rd), though smaller in format, appears to have been taken from a common model (Ebeling 1973, p. 177, fig. 26), except, as noted by Bautze (personal communication, 1993), that the hero of our page is not in the usual act of putting his shawl on his shoulder. Nine examples of the Bundikalam *Lalita Ragini* are listed in Bautze 1987a, p. 225. One, of circa 1685 (Bautze 1991, p. 103, cat. no. 36), is from the same *Ragamala* series painted at Uniara as catalogue number 124. Bautze also cites (1987a) a painting in the Bundi Palace, datable to the mid-seventeenth century, that shares similarities in facial type and hairstyle with a reclining lady represented in a *Ragamala* series from the same region (fig. 51).

The text in the Brooklyn page is similar to that of another example of a Bundikalam *Lalita Ragini* (Bautze 1991, cat. no. 36). AGP/JKB

Literature Poster 1987, col. pl., p. 27.

Provenance Nasli M. Heeramaneck, New York.

123 Artist unknown

Malakausika Raga

Page from a dispersed *Ragamala* series
Rajasthan, Raghugarh (?)
Circa 1640–50
Opaque watercolor and gold on paper
Image 8 x 12¹⁄₁₆ in. (20.3 x 30.65 cm)
Sheet 9¾ x 14¹⁄₁₆ in. (24.8 x 35.7 cm)
Anonymous gift, 78.256.2

Malakausika, seated with his legs crossed on a mauve platform leaning against a blue bolster, turns to accept betel from a female figure at his right. He wears a white, semitransparent jama trimmed in gold over an orange pajama, a gold sash, an olive turban with gold ornaments, and gold-and-ruby items of jewelry. The women wear long skirts, cholis, and long transparent veils. A gold dot pattern has been added to their skirts, occasionally without respect for the volumetrics of the figures. The woman to the far left holds a brass container; the women at the right hold, respectively, a fly whisk and a wine vessel.

The Sanskrit text at the top of the sheet in Devanagari script notes that this is the seventh page, or the second *raga,* in the set. It describes the five constituents that characterize

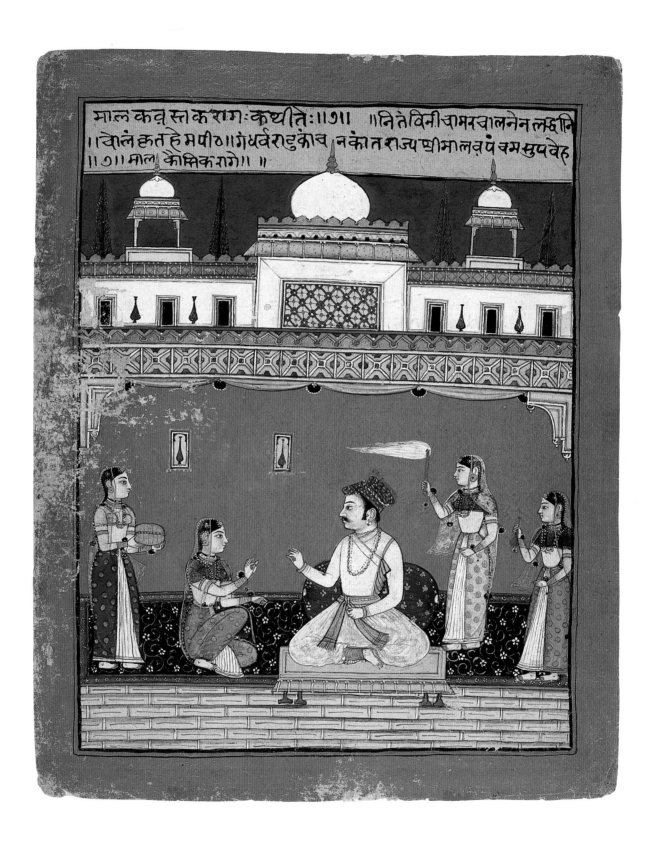

the *raga:* a lady waving a fly whisk, a king seated like the ruler of the Gandharvas, a golden throne represented by the royal bedcovers, the presence of women, and the kingdom represented by a palace.

The figures situated against an emphatic red background and the squared jaws and the facial features emphasized by shading are typical of this series. A balustrade and roof line indicate the transition from the interior scene to the exterior setting. The detail of the symmetrical arrangement of architectural components is consistent throughout the dispersed leaves of this set. Three white-domed pavilions with golden towers contrast with the deep blue sky. Four triangular trees are interspersed between the domes. The building is decorated with yellow, orange, and purple lines describing the windows and facade. The parapets, decorated with elaborate geometric patterns, are surmounted by gold crenellation. The decorative design located on the central domed pavilion may be a colorful representation of a reticulated screen panel.

Although previously identified as Mewar school of circa 1650–80, this *Ragamala* series is tentatively reassigned here to Raghugarh, circa 1640–50. (For a discussion of the Raghugarh attribution of this series, see Tandan 1982, pp. 68–69.) As yet no Raghugarh painting related to this series has been found. The particular iconography and style of this *Ragamala* group cannot be compared to any wall painting that would help us identify the place of origin, nor to a portrait of any ruler that has anything in common with this set. It must, therefore, be the product of one of the sub-schools, which cannot yet be ascertained. It is, in addition, difficult to determine the precise origin of the style. In the early Raghugarh compositions, such as the *Vasanta Ragini* in the G.K. Kanoria Collection, Patna (Barrett and Gray 1963, p. 144), the figures have especially large heads and the paintings have a squarer format, similar to the Bundi *Ragamala* group. However, the palette of yellow, mauve, orange, pink, and blue, and the highly burnished red background suggest Aurangabad influence (see Topsfield 1990, pp. 215–26, for a *Gita Govinda* in the Mewar-Deccani style). The shaded brickwork is another distinguishing characteristic of the series.

Other pages from this manuscript are reproduced in Wiener 1970, cat. no. 46; Wiener 1973, cover; Pal 1978, cat. no. 8; Tandan 1982, pp. 68–69, col. pls. XIII and XIV and figs. 40a–40c; Sotheby's 1992, p. 69, lot 31. Unpublished pages are in private collections in the United States, Germany, and India. AGP/JKB

124 Artist unknown

Kamoda Ragini

Page from a dispersed *Ragamala* series
Rajasthan, Bundi/Kota
Circa 1685
Opaque watercolor and gold on paper
Image 8³⁄₁₆ x 4¾ in. (20.7 x 12.2 cm)
Sheet 14³⁄₁₆ x 10⅛ in. (36.1 x 25.8 cm)
Anonymous gift, 78.256.1

INSCRIPTIONS
In black ink, in Devanagari script.

In upper border: *Kavitta [the name of the meter] has made her bed of garlands of flowers, and there are many flowers in her vicinity. She is trying to pluck flowers from their stems. . . . All her limbs are decorated with ornaments, her fair complexion is further enhanced by her heavy breasts. She listens to the pleasing tones of the* Ragini Kamodani [*alternately called* Kausmudi *or* Kaimoda] *which steals the heart of everyone.* (Trans. S. P. Tewari); at top of image, left: *27, Ragini of [Raga] Panchama;* right: *Kamoda Ragini, to be sung in the first quarter of the night.* (Trans. J. Bautze)

In this folio, *Kamoda Ragini* is represented as a female rather than as the customary male ascetic. In a forest beside a pond, the profusely ornamented princess sits on a bed of alternating bands of pink and yellow flower petals. She wears a sumptuous costume consisting of a gold embroidered sari, a yellow choli, an orange scarf tied at the waist, and over her head a magnificent transparent scarf, subtly striated and trimmed in gold bands accented with a floral motif. She is further adorned with countless articles of jewelry and polished nails on fingers and toes. She supports her weight with her left arm and gestures with the right. As in other depictions of this *ragini,* her gesture may be a prelude to picking a blossom from a tree or talking to a bird. Her skin is depicted in a soft shade of pale pink, and her hair is black.

The combination of the finely detailed foliage of the trees in the background and the stylized plants at the water's edge as well as the rhythmic juxtaposition of a deep green with orange and mauve tones lends a certain enchantment to the sylvan scene. The page is additionally animated by the playful ducks splashing about in the blue-black lake and the paired cranes sitting in the branches of a tree at the left. In a tree at the right a peacock pierces through the leaves above the princess; a second peacock has been partially abraded. The depiction of the plantain leaves is particularly remarkable in this finely drawn picture. A gold wash over an orange sky radiates in the distance like some cosmic miasma. The scene is outlined in a black rule and surrounded by a broad red border, which has suffered a large hole in the upper right as well as general water damage.

The execution of the series to which our page belongs must predate 1700, since *Panchama Raga,* mentioned in the inscription, changed places with another *raga* (*Megha*) only after 1700. Before 1700, *Megha* is a *Ragini* of *Shri Raga* and *Panchama* is the fifth, as his name already indicates. (For a discussion of this change, see Bautze 1987a, pp. 327–30.)

The composition of this series is based on a *Ragamala* series painted at Chunar in 1591, seen as the prototype for the Bundi style (Skelton 1981, pl. 9 and figs. 347–51). For a discussion of the Chunar *Ragamala,* see Skelton 1981, pp. 123–29; and Bautze 1987a, pp. 73–75 and p. 273, for a complete list of twelve different Bundikalam *Kamodinis,* including three previously unpublished examples.

For two other pages from this set, see Bautze 1991, catalogue numbers 31 and 32, and footnote 10 for a list of pages in other collections. JKB/AGP

Literature Bautze 1991, p. 95, n. 10.

125 Artist unknown

Couple seated under a tree

Rajasthan, possibly Bundi/Kota
Circa 1700
Opaque watercolor, gold, and silver on paper
Image 5¼ x 4⅛ in. (13.3 x 10.45 cm)
Sheet 5¾ x 4⁹⁄₁₆ in. (14.6 x 11.6 cm)
Anonymous gift, 80.277.13

A man is seated beneath a willow tree with a woman who attends him, fanning him as he eats. He is holding a *roti* in his left hand, an unusual gesture. Various snacks are arranged in small cups on a tray. A water jar, cup, and pan box (for betel) are nearby. The couple is seated on a white patterned carpet that covers the entire lower third of the picture, while the upper portion is a solid yellow-green. Two clusters of flowers are depicted, mysteriously sprouting in the "sky" and completely out of scale with the rest of the composition.

The style of painting is associated with a variant of the main Mewar, Bundi/Kota styles, probably from one of the *thikanas,* such as Raghugarh, a small state near Kota.

For a comparison with a *Ragamala* leaf in the Cleveland Museum of Art, see Leach 1986, cat. no. 69, which has a Raghugarh seal. AGP

Provenance Jeffrey Paley, New York.

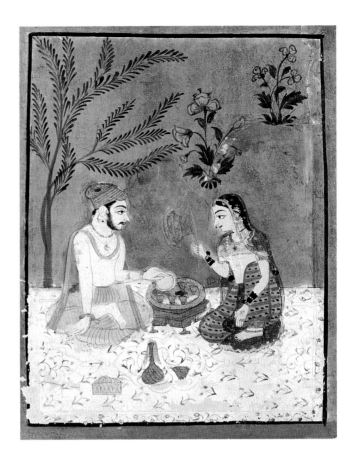

126 Artist unknown

Kakubha Ragini

Page from a dispersed *Ragamala* series
Rajasthan, Bundi/Kota
Circa 1727 (?)
Opaque watercolor on paper
Image 7¼ x 4⅝ in. (18.5 x 11.8 cm)
Sheet 10 x 7⅛ in. (25.9 x 18.3 cm)
The Brooklyn Museum Collection, X623.1

INSCRIPTIONS

In black ink, in Devanagari script

Recto, in upper border: *Kakumbha ragani 28.* (Trans. A. Shapiro)

Verso: *Samvat 1784* [A.D. 1727], *on the fourth, in the bright half of the month Chaitra [March–April]./Ragani Kaphi.* (Trans. J. Bautze)

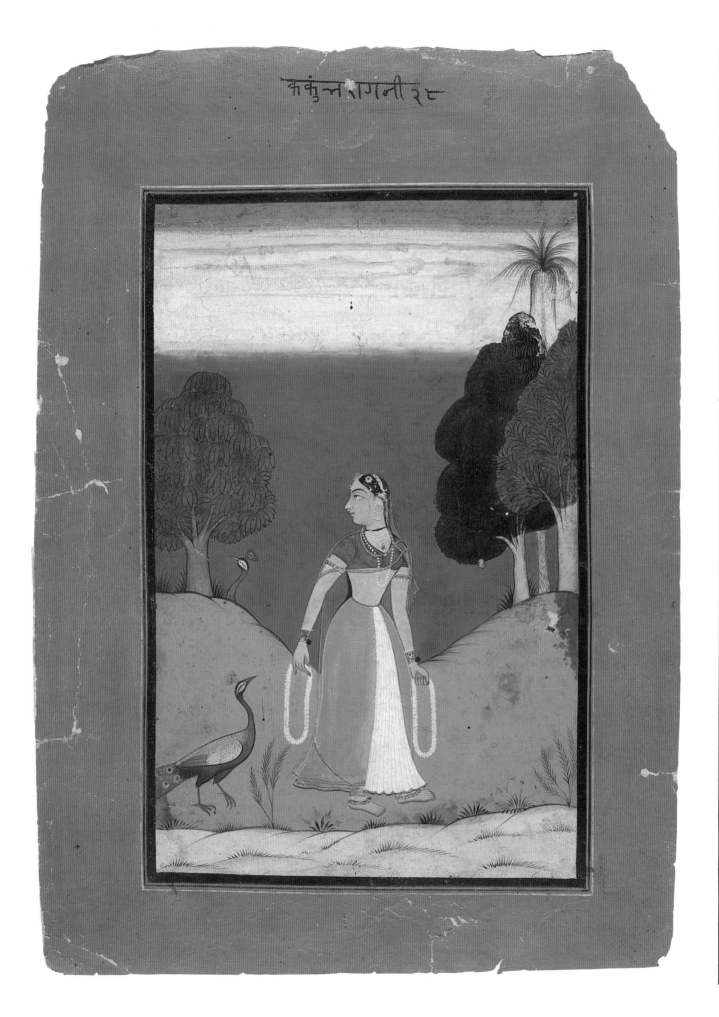

A woman holding a flower garland in each hand looks over her shoulder as she walks in a landscape. A peacock is at her right, while the head of another appears behind a hill in the background. Trees on either side frame a sky that is brownish red below and white changing to blue above. The woman wears a blue choli and a transparent white sari gathered at her waist in front, a long full orange-red skirt with gold borders, and rich jewelry, including a small black pompon on each wrist. A row of poppies is delicately indicated between the green background and the white ground line. The illustration is framed with black and red borders.

The *Ragamala* subject entitled Kakubha depicts a lonely woman dressed in yellow separated from her lover and refers to the cry of the cuckoo that is generally depicted in these scenes. The woman wanders in a mountainous wilderness with a garland of blossoms in each hand accompanied by two peacocks (see Waldschmidt 1975, pp. 275–76). Although the drawing of the figure of the heroine and various landscape elements corresponds to contemporaneous Bundi paintings, the ruddy colors used here are unusual. Various shades of green in the landscape enliven the arid atmosphere. The palm tree that extends into the white band of the sky at the upper right is an unexpected detail and may be a subsequent addition (see cat. no. 131 for a later example of this treatment). Bautze lists twelve published examples of *Kakubha Ragini* from Bundi/Kota, plus three previously unpublished examples of wall paintings (1987a, pp. 152–53, fig. 37; p. 175, fig. 96; pp. 285–86, fig. 143).

This painting may be earlier than the date given in the inscription, which may be a library inventory number. AGP

127 Artist unknown

Desakhya Ragini

Rajasthan, Bundi/Kota
Circa 1770–75
Opaque watercolor on paper
Image 6¹³⁄₁₆ x 4½ in. (17.3 x 11.5 cm)
Sheet 9³⁄₁₆ x 6½ in. (23.4 x 16.5 cm)
Frank L. Babbott Fund, 67.10

INSCRIPTION

Recto, at top, in silver, in Devanagari script: *Ragini Desakha of Raga Hindola, to be sung in the morning. 7.* (Trans. J. Bautze)

Desakhya or *Desakh Ragini* represents the heroic theme of *Ragamala* iconography in which the gymnastic competition of princes or heroes is depicted. In what is unquestionably one of the Museum's finest Rajasthani paintings, *Desakhya Ragini* is represented as three male acrobats performing physical feats. The central figure climbs a pole, in this case the bough of a banyan tree; the two flanking men exercise with weights held above their heads. The figures wear shorts and girdle cloths and are ornamented with earrings, necklaces, armlets, and bracelets. The banyan tree, on which the men have draped their clothes, provides the focus of a rich landscape setting. The scene is surrounded by wide red borders.

A large banyan tree has been substituted for the isolated practice post that traditionally occupies the center of this scene. Another example depicting three athletes in similar poses in the foreground and a large banyan tree in the background appeared in a Paris exhibition (see Galerie Marco Polo 1977, cat. no. 22), but no other representations present such a well-integrated study of landscape and figures as Brooklyn's page. Other examples of this subject from the Bundi/Kota *Ragamala* tradition are listed in Bautze 1987a, p. 247.

While maintaining the full range of the Bundi stylistic formula—modeling of the human bodies and shading via thin parallel lines, the Bundi profile, the lush landscape, etc.—the style of our painting stems from the same atelier as the Boston Bundi *Ragamala,* circa 1770 (see Bautze 1987a, pp. 86–87). For a discussion of the stylistic characteristics of the Boston *Ragamala* series and other Bundi paintings of this period, see Bautze 1991, pp. 106–7, and Beach 1974, pp. 34–35. JKB/AGP

Literature Bautze 1991, p. 110, n. 17.

Provenance H. Ampssler.

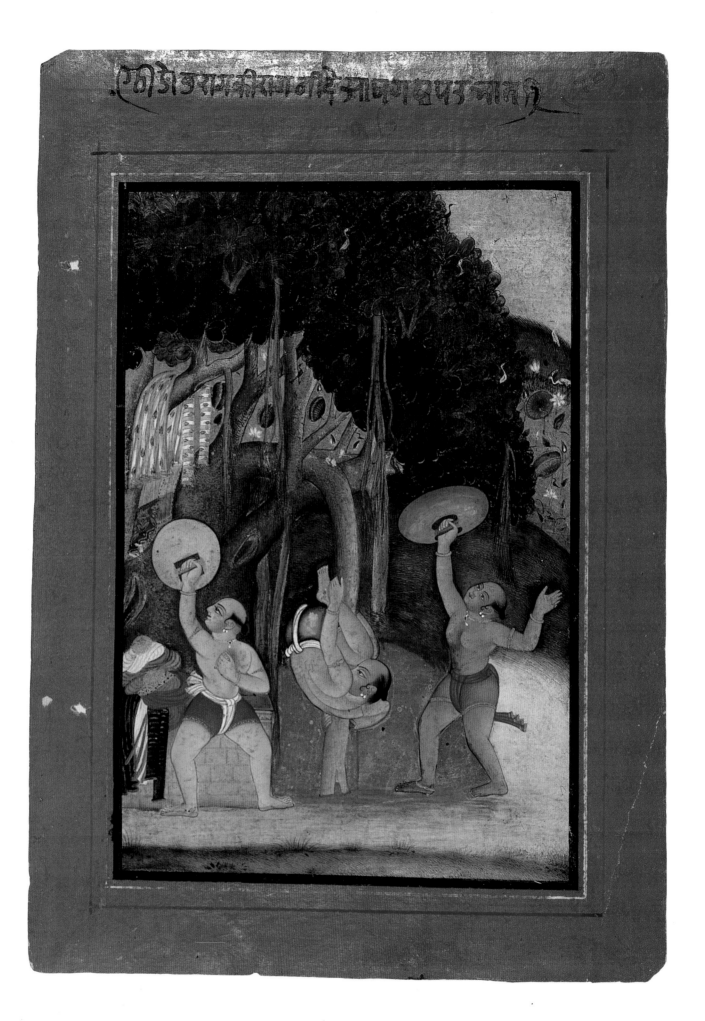

170

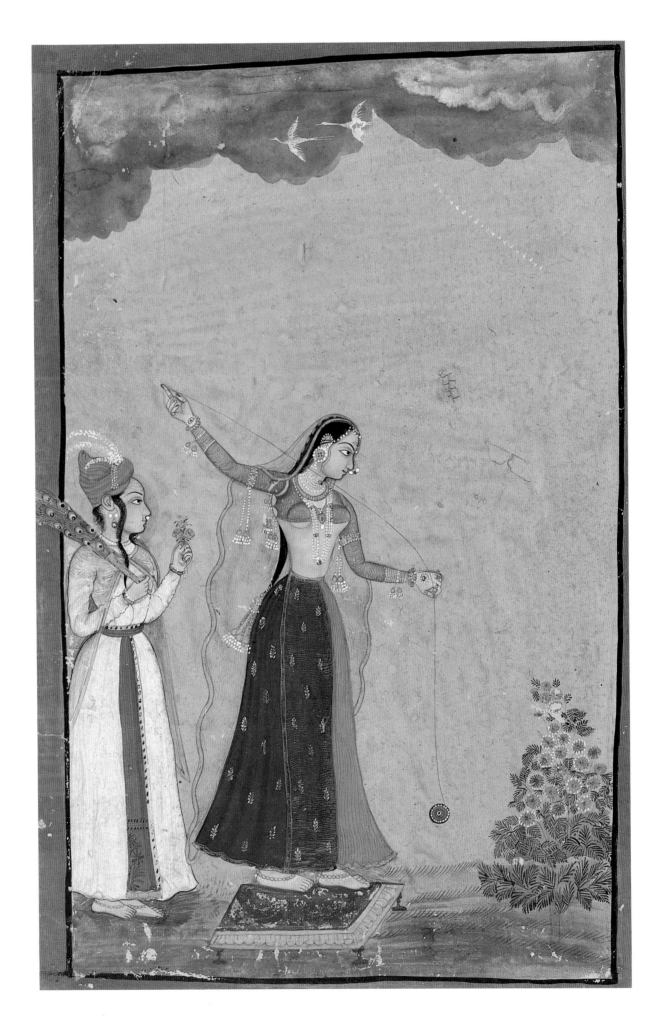

128 Artist unknown

Lady with a yo-yo

Rajasthan, Bundi/Kota (subschool, Raghugarh)
Circa 1770
Opaque watercolor and gold on paper
Image 8⅜ x 5¼ in. (21.3 x 13.35 cm)
Sheet 9¼ x 6³⁄₁₆ in. (23.5 x 15.75 cm)
Gift of Alan Kirschbaum, 80.268.1

An elegantly dressed lady stands on a low footed stool playing with a yo-yo, while an attendant dressed in white with a long red sash stands at the left holding a fan of peacock feathers and a spray of yellow blossoms. The player wears a red long-sleeved choli and a green sari with a transparent orange scarf tucked in at the waist. She is heavily adorned with jewelry consisting of pearl-and-gold ear plaques, pearl necklaces, a gold torque, armbands and bangles with long pendants of pearl tassels, bracelets, anklets, rings, and a nose ring. The elongated figures are depicted on a narrow band of grass with a small flowering tree at the right. The background is pale green, with clouds depicted as an uneven blue band with white and red washes across the top of the page. In the center amid the blue clouds, two white birds fly in the sky. The painting is framed with black rules and a red border.

The attribution to Raghugarh, a state situated in Central India (Malwa) near Kota, is made on the basis of the style. While painting at Raghugarh is not well documented, the Muslim type of turban worn by the attendant female, the elongated proportions of both figures (see Beach 1974, p. 46), and the reduced landscape elements (ibid., p. 47) are particular to paintings from that school. While related to Bundi/Kota styles of the period, Raghugarh painting contains these distinctive elements. AGP

Literature Poster 1987, col. pl. p. 35.

129 Artist unknown

Intoxicated woman at a window

Rajasthan, Bundi/Kota
Circa 1775
Opaque watercolor and gold on paper
Image 11¾ x 9⅝ in. (29.85 x 24.45 cm)
Sheet 13¾ x 11⅜ in. (35 x 28.9 cm)
Gift of Dr. and Mrs. Robert Walzer, 79.285

The woman leaning drowsily at a window with leaden eyelids conveys the subject of a woman alone with her wine and her thoughts in a poignantly beautiful manner. She is a courtesan, isolated against a striking monochromatic turquoise background, an unusual color in the Bundi/Kota palette. She is elaborately ornamented with meticulously detailed jewelry represented by pricked and painted gold and white to indicate pearl jewelry inlaid with rubies and emeralds. A cobalt blue shawl is wrapped about her shoulders and head; her left elbow rests against a horizontal brown bolster with gold striations and yellow end tassels. She holds a delicate, tiny wine cup in her right hand and a gilt mother-of-pearl wine flask in her left. Her reddened eyelids suggest the effect of drink. A richly colored textile is suspended over the windowsill. The border is silver-flecked.

The subject of the isolated figure at a window is popular in Rajasthani paintings, particularly those produced in Bundi and Kota from the mid-eighteenth century through the mid-nineteenth. As Beach has observed (1974, p. 38), this is a typical aspect of official portraiture, in which a nobleman or raja may be shown seated in the midst of a larger court scene looking out of a window. In our painting the figure is neither royal nor divine, or even the heroine we expect to find in such poetic subjects as *Ragamalas* or *Rasikapriyas*.

The Bundi style in this period is discussed by Beach (ibid., pp. 38–39), who notes the "masterful line, gradation of tone and muted softer hues," which, with the silver-flecked border, are features of many miniature paintings attributed to Bundi, including pages from a dispersed *Ragamala* series (see Pal 1967, cat. nos. 13, 34, 47).

For the theme of the intoxicated woman, frequently treated in Bundi/Kota painting, see Bautze 1987a, Appendix 4, and idem 1987b, cat. no. 31; he has also noted unpublished examples in the Bharat Kala Bhavan, Benares; British Library, London; Elvira and Gursharan Sidhu, Menlo Park; and Doris Wiener, New York (personal communication, 1992). AGP

Literature Poster 1987, col. pl. p. 25.

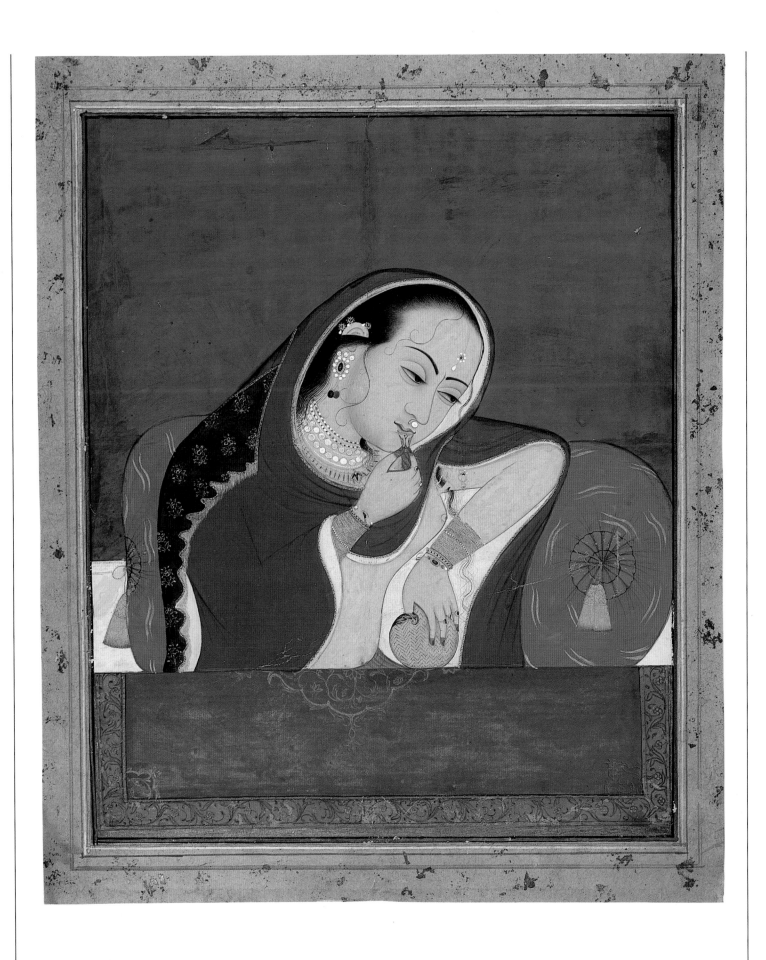

130 Artist unknown

Lovers on a moonlit night

Rajasthan, Bundi/Kota
Circa 1775
Opaque watercolor, gold, and silver on paper
Image 8⁷⁄₁₆ x 5 in. (21.45 x 12.7 cm)
Sheet 13³⁄₈ x 10¹¹⁄₁₆ in. (34 x 27.2 cm)
Gift of Mr. and Mrs. H. Peter Findlay, 80.71.4

This small study of a man caressing his beloved who lies on a bed is typical of the love-scene genre. The prince is dressed in a gray dhoti and a brilliant yellow, long jama open to the waist and flowing on the bed behind him. He is adorned with a golden turban and various necklaces, bracelets, earrings, and finger rings. The woman wears a green choli with long sleeves, gold-embroidered orange skirt, and a translucent yellow scarf with gold trim. They are situated within a gray and white room, surrounded by gilded vessels placed on the floor before them and in the niches behind them. The lady's attendant, shielded by a gray and orange curtain, watches from the doorway. She wears an orange choli and yellow skirt. A geometric pattern is visible through the atten-

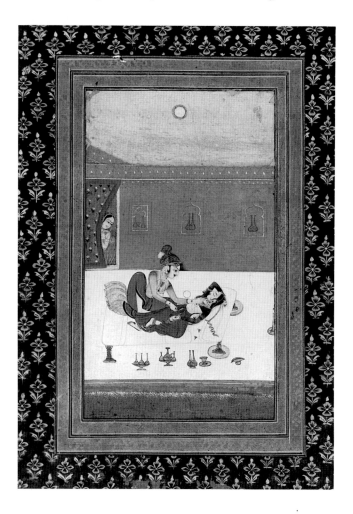

dant, indicating that the figure may have been added to the composition at a later time. A pale blue sky over-washed with white and a white and gold moon complete the scene.

The picture is enclosed within two embossed gold borders, a wide blue-green border of pink-and-mauve flowers with yellow stems and leaves, and a thin solid red border.

The woman looking from behind the curtain represents the viewer of the painting, a formula used in other paintings as well, though generally the lover is Krishna himself. A comparison is suggested to several unpublished Kota works, such as a drawing (dated to 1787) in the Los Angeles County Museum of Art; a portrait of the Diwan of Jhala Zalim Singh of Kota in a (private?) collection; a drawing in a German private collection; as well as a stylistically similar Kota painting (Bautze 1990c, fig. 13). AGP/JKB

Literature Wiener 1970, cat. no. 17.

131 Artist unknown

Bilavala Ragini

Rajasthan, Bundi/Kota
Circa 1770–90
Opaque watercolor and gold on paper
Image 9 x 5³⁄₈ in. (22.85 x 14.3 cm)
Sheet 12⁷⁄₈ x 7⁷⁄₈ in. (32.7 x 19.7 cm)
Gift of Emily M. Goldman, 1991.180.8

INSCRIPTION

Verso, at top, in black ink, in Devanagari script: *Ragini Bilavala [of] Raga Hindola.*

A woman is shown at her toilette with two female attendants, one of whom holds a mirror and the other, a musical instrument. The *ragini* wears an orange skirt, a gold choli with tassels, and a gold-trimmed diaphanous scarf. She sits on a golden dais; at her back is an orange and gray bolster. The bejeweled princess adopts a striking pose as she puts on her earring. Her attendant also wears an orange skirt and gold-trimmed scarf, but her choli is blue. She dutifully holds the mirror, a somber expression on her face. A smiling female musician plays a vina beside a reflecting pool in the foreground. The *ragini* and her attendants sit within a palace, the architecture arranged symmetrically around them. Notable decorative and architectural elements include the pale green parapets with meandering patterning in a darker green and the central dome with its two golden towers and curved base. Above them, the red triangular flags blow in the breezes.

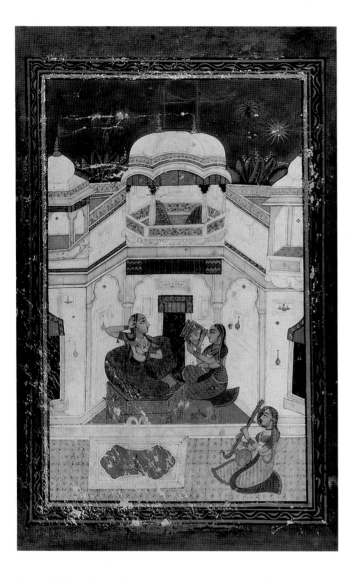

Beyond the palace, plantain trees, a cypress, and a coconut palm are visible. A golden sun radiates in the deep blue sky. The scene is enclosed within black and yellow rules, a black and gray patterned band, and a red border.

The poetry associated with the *Ragamala* theme (the woman putting the finishing touches to her ensemble in preparation for meeting her lover) is discussed at length in Waldschmidt (1975, pp. 135–41). The composition here, expressed in soft colors with simple ornamentation, relates to other representations of *Bilavala Ragini* (cited by Bautze 1987a, p. 252). For related wall paintings, see ibid., figs. 24, 79, 128. AGP/JKB

Provenance Paul E. Manheim, New York.

132 Artist unknown

Portrait of Rao Vir Singh

Rajasthan, Bundi/Kota (at Uniara)
Circa 1780–90
Opaque watercolor and gold on paper
Image 7 x 3⅞ in. (17.8 x 9.5 cm)
Sheet 12 x 9 in. (30.5 x 22.8 cm)
Anonymous gift, 84.201.10

INSCRIPTION
Verso, at top, in black ink, in Devanagari script: *Rao Vir Singh, son of Raghubir [?].*

The ruler is depicted in the full majesty of his regal position. The careful pleating of his long white jama and striped pajama presents an elegant foundation for the elaborate emblems that indicate his rank. His white turban is decorated with several gems and a large gold knob. The fabric of the raja's costume includes minute decorative details etched

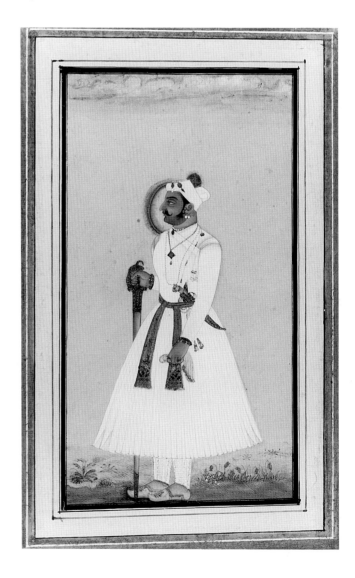

into the painted surface. He wears pink slippers, an embroidered gold sash, and numerous articles of gem-and-pearl-encrusted jewelry. A dagger with a jade animal-head hilt rests in its bejeweled scabbard at his left hip. His right hand grasps an enormous sword with a jeweled hilt in a red and pink scabbard; his left holds a translucent gold cloth, perhaps a handkerchief. The attention to these details is such that their heavily burnished surfaces often extend beyond their outlines into the mat finish of the larger areas of textile and atmosphere.

The figure's royal status is further conveyed by the aureole behind his face, in which concentric arcs of light blue, light green, and dark green are contained ultimately within a fiery gold circumference. The detail of the raja's refinement extends to his personal grooming, most notably the twin curls that decorate his mustache. His "hooked" nose, however, is perhaps his dominant facial feature. He stands in three-quarter view, turning his head slightly so that it may be depicted in strict profile. He is set against a flat background of a light green color often favored in Bundi/Kota portraits. Various grasses and flowering weeds are indicated in fine line drawings at the lower edge of the scene. The detail of the drawing and its coloration fade so as to indicate recession into space. The sky is indicated by a band of light blue-and-white cloudlike forms, accented with a gilded mist, that appear to hover and waver on the distant horizon.

Elements of Mughal portraiture of the late Shah Jahan period include this positioning of the principal figure in a sparse setting indicated only by a band of sky at the top and a band of grass at the bottom as well as the presentation of symbolic regalia and naturalist details. The light green background is an important element from Mughal portraiture of the Shah Jahan period. The page is bordered in bands of black, pink, and red.

This painting belongs to a group of posthumous portraits of Bundi rulers painted at Uniara, circa 1780–90, before the Jaipur style entered the Uniarakalam. The type of halo, archaic costume, and long jama suggest that the subject depicted here may well be a seventeenth-century ruler; the turban, sash, and sword of Vir Singh reflect an early-seventeenth-century fashion. The painters knew very well how to make their deceased rulers look archaic. The half halo, the plants in the landscape, and the treatment of the sky are indications that the painting is an Uniara copy of about 1780–90 of a late-seventeenth-century Kota portrait. In addition, the red border is typical of the material in the Bikaner royal collection; indeed, one of the most important early Bundi portraits that has survived in a Bikaner collection is in the same Bikaneri mount (see Bautze 1986, fig. 8).

Naval Krishna, on the other hand, has suggested that the painting may well be an early-nineteenth-century work representing the decline of the Bikaner school with a strong Jaipur influence. The pale green background, however, is closer in tone to the color preferred in earlier paintings (personal communication with Amy Poster, April 1991). JKB/AGP
Literature Christie's 1980b, lot 145, p. 73.

133 Artist unknown

Hindola Raga

Page from a dispersed *Ragamala* series
Rajasthan, Bundi/Kota
Circa 1830
Opaque watercolor and metallic paints on paper
Image 9½ x 5¹³⁄₁₆ in. (24.1 x 14.5 cm)
Sheet 10½ x 6⅞ in. (26.6 x 17.5 cm)
Anonymous gift, 81.192.2

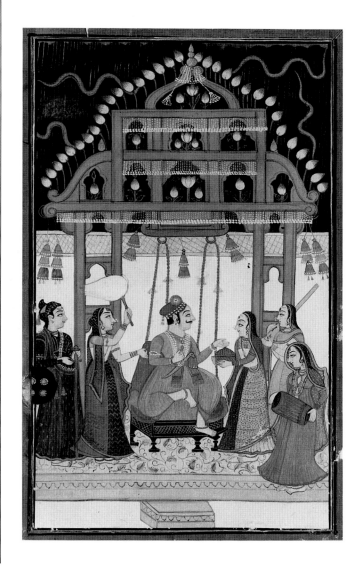

A prince is seated on an elaborate royal swing (*hindola*) receiving pan from a lady at his left. He is surrounded by four additional attendants: a woman bearing a chauri, two others playing a *tanpura* and a dolaki drum, and a man with a sword and shield. The figures are dressed in richly patterned garments of bright orange, deep green, pale mauve, and yellow. They occupy a terrace covered with a pale yellow floral-patterned carpet demarcated by a mauve border. A tall white wall rises behind them. Orange, yellow, and silver tassels and strings of pearls hang from the orange structural support for the *hindola*. The stormy evening sky of *Hindola Raga*, indicated by a curtain of silver lines representing raindrops and serpentine bolts of golden lightning against a black sky, is associated with the month of Shravana in the rainy season. It is further suggested by the numerous lotus blossoms above the swing.

The subject of this painting is related to the swing festival of Krishna, which takes place during the rainy season. In the Rajasthani tradition, *Hindola Raga* is often represented as a prince, with or without consort, surrounded by women (Ebeling 1973, p. 58). This painting combines the Bundi style at Uniara with an affinity for silver and opaque white decoration, sometimes used in early-nineteenth-century Jaipur paintings. AGP

134 Artist unknown

Maharaja Ram Singh of Kota

Rajasthan, Kota
1860s
Opaque watercolor and gold on paper
Image 9⅛ x 12¹³⁄₁₆ in. (23.2 x 32.6 cm)
Sheet 10½ x 14⅝ in. (26.7 x 37.2 cm)
Anonymous gift, 81.192.7

INSCRIPTIONS

Recto, in top border, center, in yellow pigment, in Devanagari script: *Shri Maharaja Raja Shri Maharao Ram Singhji. . . Shri Balaji. . .* (partially illegible); on shield, in white pigment, in Devanagari script: *Shri Sardhana Singhji Koelaka.*

The seated, haloed Maharaja Ram Singh of Kota (r. 1827–66) is portrayed in battle regalia for the formal ceremony of "Asoj sudi dasami," in which he will slay the buffalo from horseback. The Maharaja is shown in a formal garden with two attendants and a close friend, Sardhar Singh of Koela. The priest Balaji holding a gold staff stands at the right. The ruler sits on an Indo-European throne in full regalia: green pajama, a long pink jama with silver trim, a red sash with

gold trim, blue slippers, and silver armor. The armor is wonderfully painted with a gold intercrossing design and black dots on silver to suggest chain mail. He is further embellished with a gold crown encrusted with gemstones and pearls and topped with three black plumes, as well as twisted gold anklets, pearl and emerald necklaces, gold finger rings, and a long strand of blue beads (perhaps sapphires) that hang over his left shoulder. He holds a sword with a gold hilt in a green scabbard in his right hand and rests his left on a lacquered black shield embellished with gold. His aureole is a brilliant green outlined in a broad gold band with pricked white details. His eyes are light brown, and he wears the same black beard and mustache as his entourage. Sardhar Singh in an orange jama under a blue vest sits at the Maharaja's side. His arms rest on the rim of his black and gold shield held before him; the green scabbard of his sword protrudes from below. Both he and the Maharaja have yellow marks painted on their foreheads and necks.

Two attendants wave white fly whisks with golden handles behind the two seated figures. They are dressed in long jamas of white gauze over blue pajamas secured with orange sashes. One wears a red turban, the other a white one; both are adorned with gold and silver jewelry, and *katars* are tucked into their sashes.

At the right the priest awaits orders or is about to announce somebody. He has a full white beard and mustache and wears a jama like those of the attendants over a violet pajama, a red turban, and a red sash.

The figures are situated in a geometrically planned garden. Small orange, purple, mauve, yellow, and white flowers blossom at the edges of the brown sections of the inner garden. Beyond the garden, brightly colored and gilded plantain trees are interspersed with darker green trees against a gray-blue sky. The border consists of bands of blue, yellow, and red.

The period of Ram Singh is well represented in Kota paintings, since the raja was interested in documenting the events of his reign (Bautze 1988–89, pp. 316–50). The event represented here may well be the occasion of the festival of Dussera (Dasahara), when the maharaja invited a noble from Koela to assist in the ritual buffalo sacrifice.

Numerous dated portraits of the ruler engaged in various princely activities survive; see Binney 1968, pp. 34–35, cat. nos. 21 and 22; Beach 1974, pp. 40–41 and fig. 101; Topsfield 1980, cat. nos. 35 and 36; Desai 1985, pp. 116–21; Bautze 1990, pp. 71–91. JKB/AGP
Literature Poster 1987, col. pl., p. 26.

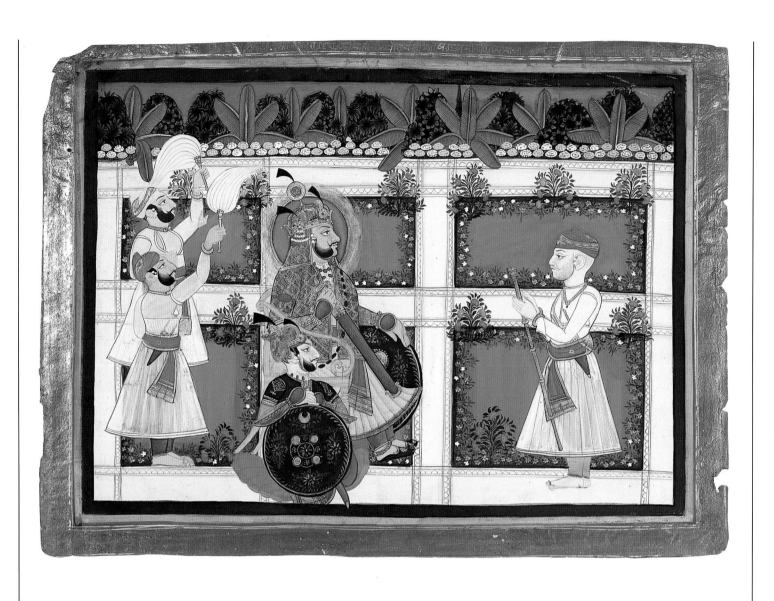

135 Artist unknown

Worship of Shri Nathaji

Rajasthan, Kota
Mid-19th century
Opaque watercolor, gold, and silver on paper
Image 11⅞ x 9¼ in. (30.3 x 23.5 cm)
Sheet 13⅛ x 10¼ in. (33.2 x 26.1 cm)
Gift of Dr. Bertram H. Schaffner, 1994.11.2

The central image of Shri Nathaji (Krishna), presented in a typical stiff frontal pose, is the focus of the scene. The left arm of the blue deity is raised, a single blossom held in his hand. His right arm is bent, with the hand clasping a full-blown lotus. His turban and torso are covered with garlands and long strands of pearls, bracelets, tassels, toe rings, and anklets. Such intricate details as silver finger- and toenails are also depicted. A pale scarf is draped over his right shoulder and fans out at his left waist. He stands on a footed stand before a gray stele carved with symbols of Krishna's

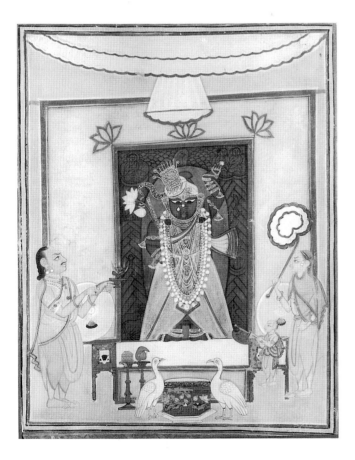

life: reading from right, and proceeding counterclockwise, a snake, aboriginals with bows, and a lion to represent Mount Govardhan, where this stele was found and first installed before it was brought to Sinhad (Nathadwara).

This central image of Krishna as Shri Nathaji is flanked by devotees, one carrying a lamp and two others holding fans. The figures of the male and female devotees are exact in all detail, both physiognomical and ornamental. The male priest standing at the left faces the central image, performing *arati* (ritual devotion) with a lamp of five flames held before him. He wears a saffron yellow dhoti and scarf, has Vaishnava tilak marks on his face, and is embellished with strings of pearls, armbands, and bangles. The female at the right holds a long-handled fan. She, too, is richly adorned and wears a saffron yellow sari. She is accompanied by a young child with a fan who stands beside her.

Low silver tables on either side of the central image support a *shalagrama* (at left) and a small decorated brass image of either Madanmohanji or Balakrishnaji (at right). There is a hexagonal silver casket decorated with lotuses flanked by two white aquatic birds seen in profile. A silver pedestal holds a gold casket (*banta*) at the left; another at the right, covered with a red cloth, supports a water jar *(jhari)* with water from the sacred Yamuna River. The white *pichhvai* (temple hanging) bordered with a silver band and decorated with three stylized lotuses indicates a specific event associated with Shri Nathaji's life; in this case, he seems to be dressed in the bridegrooms' Shringara, identifiable by his elaborate headdress. The *pichhvai* is draped from a redorange pole beneath a pleated canopy. The borders are orange.

Shri Nathaji carries a twofold meaning: Natha is the name of the husband of Shri (Lakshmi), as well as the Lord (Natha) of the town Nathadwara, a renowned Vaishnava pilgrimage center. This detailed presentation combines Europeanized elements and style with typical Kota treatment. For a more detailed description of the sect and the cult of Shri Nathaji, see Bautze 1987c, pp. 253–78.
JKB/AGP

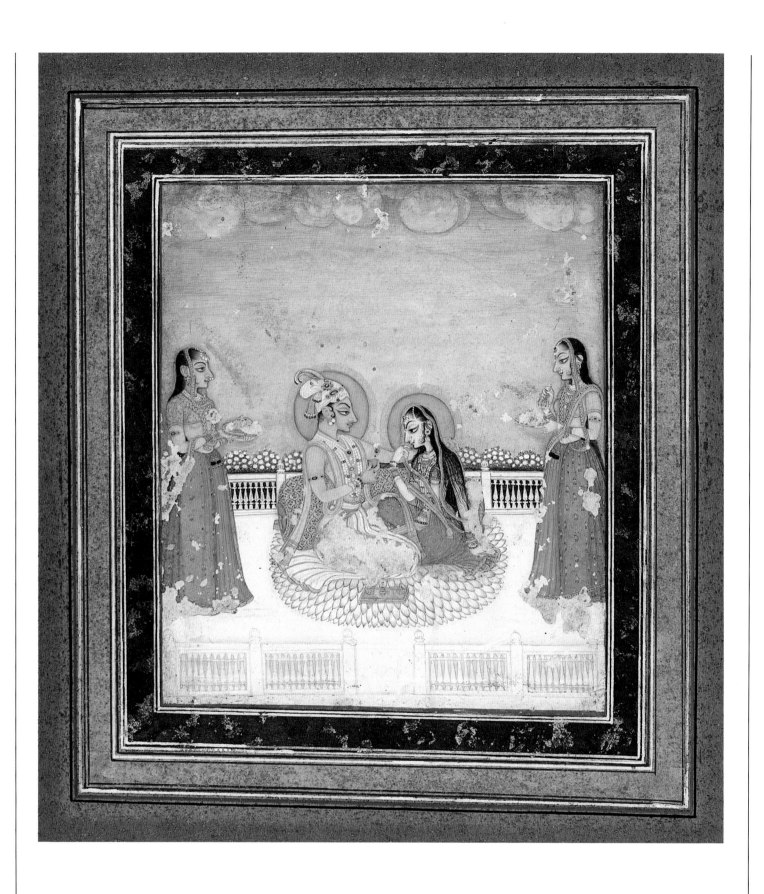

136 Artist unknown

Krishna and Radha seated on a terrace

Rajasthan, Kishangarh
Circa 1760–75
Opaque watercolor, gold, and silver on paper
Image 5 x 4⅜ in. (12.7 x 11.1 cm)
Sheet 13⅝ x 10¹³⁄₁₆ in. (34.6 x 27.5 cm)
Anonymous gift, 84.201.7

This exquisitely rendered painting is a typical Kishangarh study of Krishna and Radha portrayed as eternal lovers. Krishna, the Dark Lord, caresses his beloved with his left arm around her shoulder, urging her to sip from the cup he holds in his right hand. As in other Kishangarh portrayals of the divine lovers, in which the stylization of form is perfectly conceived, the "sharp-featured slender figures resemble each other under brows vaulting high above lowered lids that veil their emotion" (Kramrisch 1986, p. 173). Here, the nimbated couple are dressed in white and green, respectively, and are seated on a pink flower carpet arranged in a lotus shape, with a tray of small wine bottles set before them. Two handmaidens dressed in bodices and skirts flank the couple and offer refreshments. The scene is set on a stark white terrace. Behind the railing a row of white flowering bushes bloom; beyond is a pale blue sky with a row of matching blue clouds painted in circular brushstrokes with fine gold outlines indicated at the top. There are multiple borders.

The allegorical union of Krishna and Radha (see cat. no. 135) was a favorite subject in paintings for the Kishangarh rulers, devout followers of the Vallabhacharya sect who saw in this union their own union with god. A group of eighteenth-century paintings from the Kishangarh royal collection, including many of this subject, were discovered by Dickinson (see Dickinson and Khandalavala 1959, pl. XIII). Most notable are the paintings by Nihal Chand, the artist of the Kishangarh royal atelier in the mid-eighteenth century, credited with perfecting the Kishangarh style, which is noted for the exaggerated and elongated physical form seen here in the arched backs and elongated limbs and the distinctive facial features of the lovers, including their long almond-shaped eyes.

These stylized portrayals of Krishna and Radha are often said to be portraits of the ruler, poet (under the name Nagari Das), devout follower of Krishna, and patron Maharaja Sawant Singh (r. 1748–57) and his consort, the slave girl Bhani-Thani, in the role of the divine lovers (see Smart and Walker 1985, pp. 66–67; and Dickinson and Khandalavala 1959, pp. 8–9). Close inspection of this page reveals the artist's care in presenting sensuous detail and sensitively drawn elements, as for example, Krishna's scarf as it crosses over Radha's and curves around her knee, or her long hair falling loosely over her shoulders.

Comparable Krishna and Radha paintings in many different formats include examples in W.G. Archer 1957, p. 39; Randhawa and Galbraith 1968, p. 102, pl. 20; and Kramrisch 1986, cat. no. 75. AGP

Literature Lerner 1974, no. 27, ill.; Poster 1987, col. pl. p. 22.
Provenance Jeffrey Paley, New York.

137 Artist unknown

Prince hunting wild boar

Rajasthan, Kishangarh
Circa mid-18th century or later
Opaque watercolor and gold on paper
Sheet 7³⁄₁₆ x 8⅞ in. (18.25 x 22.55 cm)
Anonymous gift, 80.277.5

This hunt scene set in a barren wilderness depicts a prince riding a painted and elaborately caparisoned horse as he attacks a massive wild boar. The prince holds his long sword aloft in his right hand, ready to strike the beast a second time, although his first blow has sliced the boar almost in half.

Two strikingly similar Kishangarh compositions of a ruler on horseback killing a wild buffalo, both in the National Museum, New Delhi, offer telling comparisons (Dickinson and Khandalavala 1959, p. 15, fig. 2, and Goswamy 1986, cat. no. 143). In these two paintings, the princes are identified as Raj Singh of Kishangarh (r. 1706–48) and Raja Sahasmal (r. 1615–18), respectively. This page is remark-

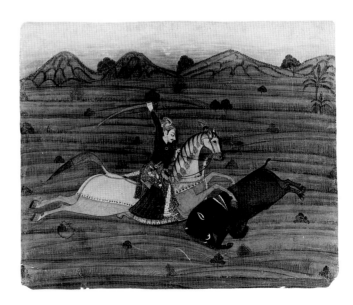

ably close to the painting of Raja Sahasmal, but certain details have been changed: the figure is more convincingly posed forward on his saddle with one arm wrapped around the horse's neck; his hold on the base of the reins and on his scabbard is more prominent. His horse pins the animal down under his front leg, while the horse in this page is shown in midgait. Landscape elements are more carefully rendered in the Delhi leaf, whereas the Brooklyn landscape is indicated in summary bands of green rendered with random brushwork and a gray sky painted over an opaque brown underlayer. Raj Singh's hunting episodes, on the other hand, which are frequently depicted in paintings, as exemplified by a dated example of 1694, reveal a style and subject comparable to Mughal hunt scenes of the Aurangzeb and Muhammad Shah periods when, according to Dickinson and Khandalavala, "the tendency to elongate figures came into vogue" (op. cit., p. 14).

It is ironic that this scene from Kishangarh, a state where painting was supposedly heavily influenced by Mughal prototypes, is so idiosyncratic, while the royal hunt scene from Mewar (cat. no. 171), a state that, more than any other Rajasthani state, resisted Mughal domination, is full of Mughal conventions. AGP

Literature Lerner 1974, cat. no. 26.

Provenance Jeffrey Paley, New York.

138 Artist unknown

Radha pining for her beloved

Page from a dated *Rasikapriya* series
Rajasthani School, Malwa
1634
Opaque watercolor and gold on paper
Sheet 7¹³⁄₁₆ x 6 in. (19.8 x 15.3 cm)
Image 7 x 5¼ in. (17.8 x 13.3 cm)
The Brooklyn Museum, by exchange, 36.232

This page from the dispersed 1634 *Rasikapriya* series depicts a female figure seated on a cushion, facing a monkey at the left, and a tree with foliage that consists of six stylized rosettes. Above it, a patch of blue sky is enclosed in a white undulating cloud. On the right is the ubiquitous Malwa pavilion-and-couch motif with a peacock on the roof. There are multiple monochrome borders.

The verse, entitled "Radha's fear and mental instability due to separation" (Ch. 11, v. 10), is written in Braj, in black ink, in Devanagari script in the band at the top of the page:

Hearing the sounds of peacocks and cuckoos, the separated heroine's heart aches and her mind is numbed; a cool and fragrant breeze now goes through her body and feels like cotton balls; she barely survived the full moon night by praying frequently to the sage Agatsya, but she cannot forget the pain and fear that lovely night caused her; but how will she survive in the morning and what will she do? (Trans. V. N. Desai)

Desai explains that "the verse is from the eleventh chapter of the *Rasikapriya* which explores the causes of separation of lovers and their subsequent physical and mental pleasure. This verse describes how the elements which once provided pleasure, now become the source of sorrow and fear. The condition is described through elaborate associations" (personal communication, 1992).

This *Rasikapriya* series remains the earliest dated Malwa paintings known; the colophon page—the page bearing the date—is in the National Museum, New Delhi. The series is widely dispersed, with other leaves located in the Metropolitan Museum of Art, New York; Albright-Knox Art Gallery, Buffalo; Virginia Museum of Fine Arts, Richmond; Cleveland Museum of Art (Leach 1986, cat. no. 81), among others.

For other pages in this series, see catalogue numbers 139–41. AGP

Exhibition "England's World of 1607," Virginia Museum of Fine Arts, Richmond, 1959.

Literature Roberts 1937, pp. 113–26.

Provenance Nasli M. Heeramaneck, New York.

॥राधि का कौ न ज न्रस्त॥ कोकिल के किन्तु लाह लउ लिउ ही
उर मैं मति की गति लुली॥ के सब सीत सुगंध समी रग ज्ञेउ डि धीर
ज ज्यौं तनु लुली॥ जो ख नि जो खनि कौ व वी जानु की जा मिनि प्रेक
जु यह

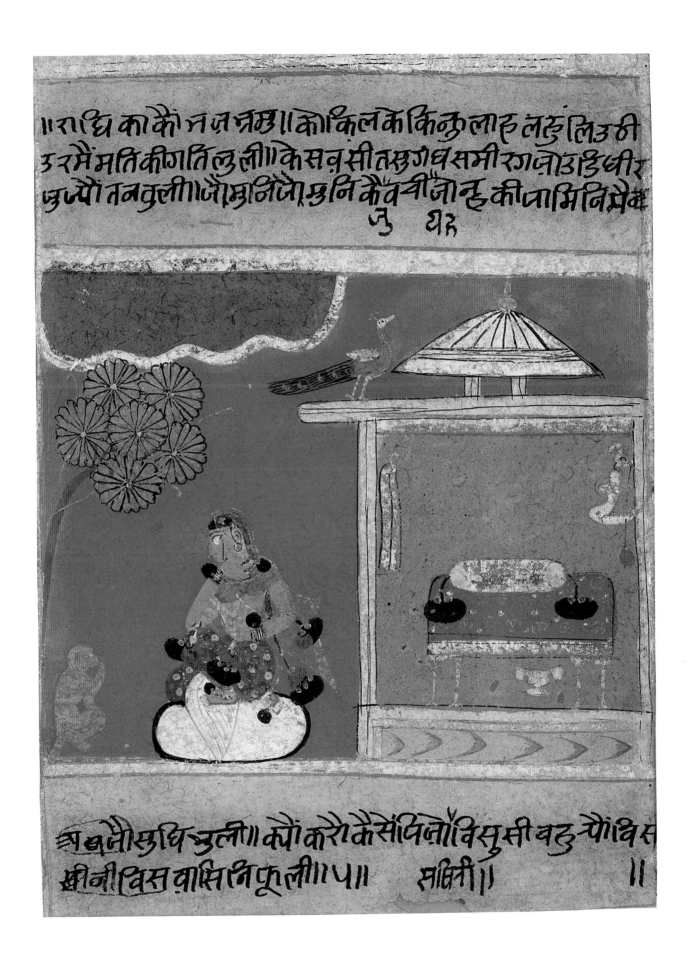

ब जौ औसधि ज्ञुली॥ कौ करौ कै संपि जौ विसु सी वड चौं वि स
खीनी विस वासि नि फूली॥ ५॥ सजिनी॥ ॥

139 Artist unknown

Krishna steals the gopis' clothes

Page from a dated *Rasikapriya* series
Rajasthani School, Malwa
1634
Opaque watercolor on paper
Sheet 7¾ x 6⅛ in. (19.8 x 15.5 cm)
Image 7 1/16 x 5½ in. (18 x 14 cm)
Gift of Nancy Anderson in honor of Dr. Bertram H. Schaffner, 82.73.1

INSCRIPTION

At top, in Braj, in black ink, in Devanagari script: *Stealing of clothes creates the sentiment of laughter.*

This page from the 1634 *Rasikapriya* shows two nude herdswomen *(gopis)* facing a tree at the right in whose branches Krishna, having stolen their garments, is seated. In a tree at the left, a cowherd displays the women's clothes. In a river below, four swimming *gopis,* still unaware of Krishna's pranks, are shown with heads and black hair indicated in summary forms. Traces exist of another figure at the right.

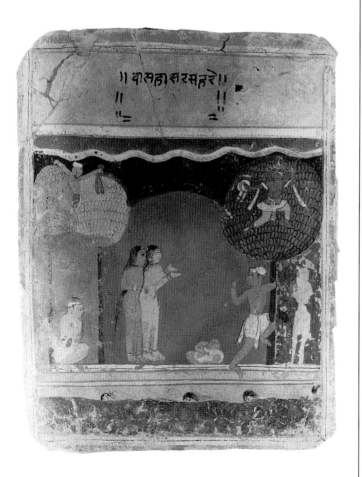

The episodes of Krishna's dalliances with the *gopis* are utilized in the opening passage of the *Rasikapriya* to describe the god's character. The inscription is taken from the second line of the second verse of the *Rasikapriya,* which describes how the various Krishna-related episodes refer to the nine *rasas* (sentiments). This serves as a description of Krishna's greatness and the author's gratitude to him (Vishakha N. Desai, personal communication, 1992). Krishna's stealing of the clothes of the *gopis* is thought to be an embodiment of the *hasya* (comic) sentiment.

For other pages in this series, see catalogue numbers 138, 140, and 141. AGP

140 Artist unknown

Yashoda ties Krishna to a mortar

Page from a dated *Rasikapriya* series
Rajasthani School, Malwa
1634
Opaque watercolor and gold on paper
Image 7¼ x 5 7/16 in. (18.3 x 13.8 cm)
Sheet 7¾ x 6 1/16 in. (19.5 x 15.3 cm)
Acquired in exchange, 42.407

INSCRIPTION

In top border, in Braj, in black ink, in Devanagari script: *Karunamaya [the compassionate one] is tied by his mother.* (Trans. S. P. Tewari)

Krishna has been tied to a mortar by his mother, Yashoda, as punishment for breaking a butter churn. Yashoda holds a cord tied to the wrists of Krishna (depicted here as a youth standing with his eyes raised, feigning innocence) and she turns to the female to the right who assumes the gesture of surprise. Krishna stands next to a tree in the upper branches of which the faces of Nalakubara and Manigriva appear. On the right is an open room. A peacock stands on the roof of the pavilion, and in the upper left, clouds are indicated by a white wavy line, a convention peculiar to Malwa, as in catalogue number 141.

As in the previous catalogue entry, this scene, symbolic of *rasa,* is part of the introductory passages of the *Rasikapriya.* Krishna's punishment by his mother, which surprisingly ends in the release of Manigriva and Nalakubara, is considered by the poet to embody the sentiment of *karuna* (compassion).

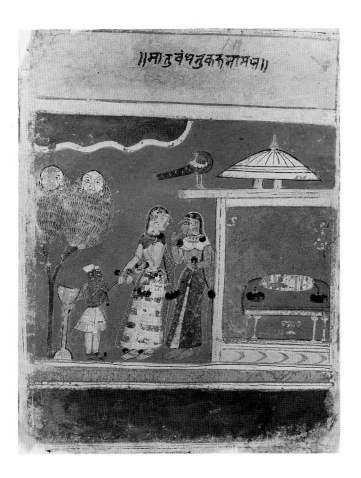

ing for her lover who has not yet arrived (Ch. 12, v. 5). While the two women converse at the left, a monkey scampers on the roof of the pavilion at the right, which houses a bed prepared for lovemaking.

The texts in the borders, in Braj, in black ink, in Devanagari script, read:

Top border: My lord Ghanashyama is like a forest of beauty; seeing his new charm every day, one's mind is filled with joy.
His body is like the house of fragrance.
Through him, one often forgets one's worries in the joy.
Before him, the nectar seems pale and even honey's sweetness wanes.
Lower border: What pleasure can you hope to gain by gazing shyly with your eyes toward him, if you do not open your mind and place it within the mind of your lover?
(Trans. V. N. Desai)

Dye (1980, pp. 25–32) has offered a detailed analysis of the pictorial elements of this particular page; he sees the complementary and contrasting gestures of the figures and the patterns and colors of the costumes that recur in the bedspread, which are repeated throughout this *Rasikapriya* series, as unifying elements in early Malwa painting. Desai has related the text to the images of the *Rasikapriya* (1984, p. 109, fig. 50). Her translation of the text here, for example, enables us to understand the effectiveness of the artist's presentation of the theme. AGP

Literature Katz 1963, cat. no. 121; Dye 1980, pp. 25–32; Desai 1984, p. 109.

Dye (1980, pp. 59–62, fig. 14) has proposed the idea that these leaves may have formed part of an independent *Krishna-Lila* series also dated 1634, but the inscriptions on these leaves do not seem to bear out such a theory. AGP

Exhibition "England's World of 1607," Virginia Museum of Fine Arts, Richmond, 1959.

Provenance Nasli M. Heeramaneck, New York.

141 Artist unknown

A maid's words to Radha

Page from a dated *Rasikapriya* series
Rajasthani School, Malwa
1634
Opaque watercolor on paper
Image 7 1/16 x 5 1/2 in. (17.9 x 14 cm)
Sheet 8 3/8 x 6 5/8 in. (21.3 x 16.8 cm)
Gift of the Ernest Erickson Foundation, Inc., 86.227.51

The fourth illustration from the 1634 *Rasikapriya* in the Museum's collection portrays a *sakhi* (confidante) trying to comfort, or bringing a message to, the longing Radha wait-

142 Artist unknown

Rama and Lakshmana receive envoys

Page from a dispersed *Ramayana* series
Rajasthani School, Malwa
Circa 1635–40
Opaque watercolor on paper
Sheet (only) 6 7/8 x 6 1/4 in. (17.5 x 15.9 cm)
Anonymous gift, 80.277.2

INSCRIPTION
Verso, at top, in black ink, in Devanagari script: *They went to the seashore.* (Trans. S. Mitra)

The gods Rama, with dark complexion, and Lakshmana wear, respectively, a yellow and a mauve dhoti. They are adorned, in addition, with pink headdresses, white sashes embroidered with flower motifs, earrings, bracelets, strands of pearls, and beads. Each holds a bow and arrow in his respective left and right hand and each has a quiver at the right hip. The brothers sit on white-cushioned stools supported by thin yellow legs. The pale beige monkeys and gray

आजनी कौबचनुराधिकासौं ॥ सोजा को सवकुवन में यौ द्रनस्
मुनितनई न ई राविवनेहेरतहेइ जोकिसैं दास सकल सुखाशु
कौ निवास करि विविध विलास हासत्रासु विसराई जो ऊपर
सुकेलु कुमउपर खुमी बुठा है पीजू पद्रू की विली वोडे दाकी

लिजराई जो वरी वीरां नै नलिखराजे छुषा कौ लौ जौ लौ पिज
मनमाऊ मन मालिन खराई जो ॥श॥ ॥ ॥

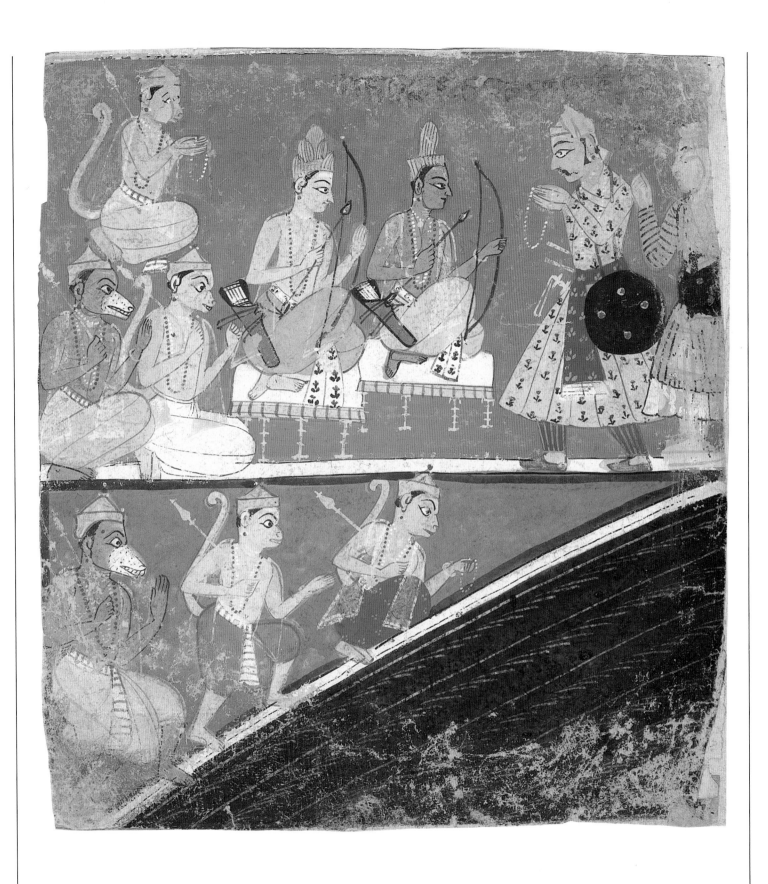

bears are nude to the waist and wear dhotis, diaphanous scarves, yellow hats, and various articles of jewelry. These figures, represented anthropomorphically, hold yellow staffs; two of the monkeys also hold rosaries of pearls. The messengers, however, are dressed formally in long, embroidered jamas, pajamas, scarves, turbans, and slippers. They are further distinguished by their mustaches, shields, and swords. The first messenger holds a rosary of pearls in his clasped hands in homage to the divine brothers.

The figures are somewhat elongated, especially the torsos of the seated figures. Thin pale lines define their forms, as in the definition of musculature, for example. The paint has been applied in flat planes of color with almost no shading. The arrangement of the figures throughout the composition and the repetition of formal elements (i.e., flat color and thin lines to define form) is typical of Malwa painting of this period. By comparison, the background setting is stylized and striated into broad areas of red, green, and blue. The sea, for example, is indicated by an arched form of deep blue with repeated registers of white lines to represent waves and a thick white band to represent the sandy shore.

Seventeenth-century Malwa painting depicting a wide variety of subjects, such as the *Ramayana,* continued to exhibit many of the same stylistic conventions. This page belongs to one of the best-known illustrated *Ramayana* series produced at Malwa before the mid-seventeenth century, but slightly later than the 1634 *Rasikapriya* (cat. nos. 138–41). Here, the monochromatic background areas separated by white bands and the abstract landscape elements provide a dramatic setting for the two episodes depicted, whereas in other series there are the usual early-seventeenth-century architectural structures, whether pavilions, fortifications, or more complex buildings (see Dye 1980, pp. 59–69).

Most of the pages of this series are located in the collection of the Bharat Kala Bhavan, Banaras (see Krishna 1963, pp. 16–17). For other pages from the same series in Western collections, see Welch and Beach 1965, cat. no. 12; Heeramaneck Collection 1966, p. 26, cat. no. 153 (now Los Angeles County Museum of Art); Archer and Binney 1968, no. 44 (now San Diego Museum of Art). Unpublished pages are in the collection of the Metropolitan Museum of Art, New York. AGP

Literature Lerner 1974, cat. no. 9.

Provenance Jeffrey Paley, New York.

143 Artist unknown

Lalita Ragini

Rajasthani School, Malwa
Circa 1650
Opaque watercolor and gold on paper
Image 6⅝ x 5⁵⁄₁₆ in. (16.7 x 13.5 cm)
Sheet 8½ x 5¾ in. (21.5 x 14.7 cm)
Anonymous gift, 80.277.3

INSCRIPTION

Verso, at top, in Braj, in black ink, in Devanagari script: *Lalita is a* ragini *of Bhairava. Doha [verse] . . . how can I tell my beloved with the gait of an elephant that I am leaving while she is sleeping?* (Trans. S. Mitra) Stamp of the State Picture Gallery of Datiya

This *Lalita Ragini* from a dispersed *Ragamala* series represents the hero leaving his slumbering mistress. At the left a prince parts from his beloved in the early morning, his sword over his right shoulder and a garland of flowers in his left hand. He is shown outside the pavilion in which his beloved lies sleeping. In the deep blue sky that surrounds the pavilion a morning sun shines above an arched horizon.

The male figure wears a transparent, ankle-length jama over a yellow pajama with a long red, geometrically patterned sash, and red slippers. A large dagger is tucked into the sash. On his head is a white turban; princely jewels of a pearl necklace, earrings, and an aigrette complete his costume. The underarms are indicated by an unusual feature of concentrated black dots. The female is dressed in similar simple yellow clothes under a transparent robe. Elaborate black tassels ornament her arms, waist, and ankles, and a large yellow bolster is placed under her head. The bed, cov-

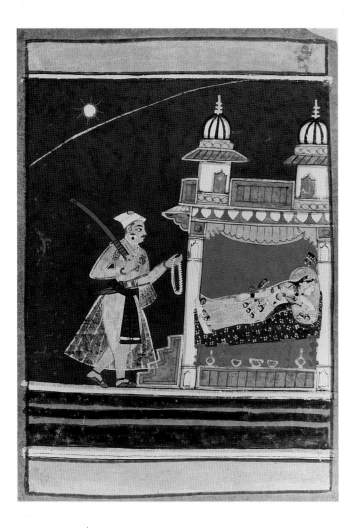

Love scenes

Rajasthani School, Malwa
1660–80
Opaque watercolor and gold on paper

A

Image 5⁵⁄₁₆ x 5³⁄₈ in. (13.5 x 13.6 cm)
Sheet 8 x 6⅛ in. (20.3 x 15.6 cm)
Anonymous gift, 84.201.3

A couple is shown lying in an embrace on a raised bed covered with a red cloth in a blue chamber. Except for their jewelry and his turban, the entwined figures are naked. Black tassels, typical of the Malwa tradition, enhance many objects in the scene: the drapery above, horse-head clothes hook, bolsters, and armlets. Gold ornamentation provides contrast with the black features of sky, tassels, and the lady's coiffure. The scene takes place in a white pavilion surmounted by a painted eave, a parapet decorated with interlaced floral pattern, and two turrets. A peacock, symbolic of love and the rainy season, is perched on the roof. Night is indicated by the black sky, which heightens the intensity of the pavilion scene. The large flowers at the left restate the love theme. The surrounds include a white margin with black rules, a yellow panel above, and a panel with a yellow meandering flower motif on a brown ground below.

This may be a page from a dispersed series of erotic subjects (see Pal 1978, cat. no. 10, for a leaf in the Paul F. Walter Collection). Malwa erotic scenes share many similar stylistic conventions, namely, the placement of a large flower or foliage to one side of the lovers' pavilion, a clothes hook within the pavilion in the form of a horse's head, the simple structure of the pavilion, and monochromatic backgrounds.

ered with a dark blue cloth patterned in a geometricized floral design, stands on green legs under a yellow canopy set against a solid red background. Bright yellow bands at the top and bottom are further enhanced by red and mauve outer borders. The alternating yellow, red, and white provide a resonant rhythm that is echoed in the minute pattern of the bedspread and such other outstanding details as the black-and-gold pompons. The pavilion itself is brightly colored in each of its discrete components; the two tall kiosks have eaves that are yellow and mauve, two colors that alternate throughout the architecture in the brackets, steps, and floor in contrast to the white structure.

A similar version of *Lalita Ragini,* painted at Malwa circa 1660, now in the Museum für Indische Kunst, Berlin, shows a hero carrying a sword and a garland, a woman whose embellishment contains the long tassels, and vessels on the floor beneath her bed. The inscription notes the origin of the folio as from the *Samgitadamodara* text (see Waldschmidt 1975, p. 227, fig. 73). AGP

Provenance Jeffrey Paley, New York.

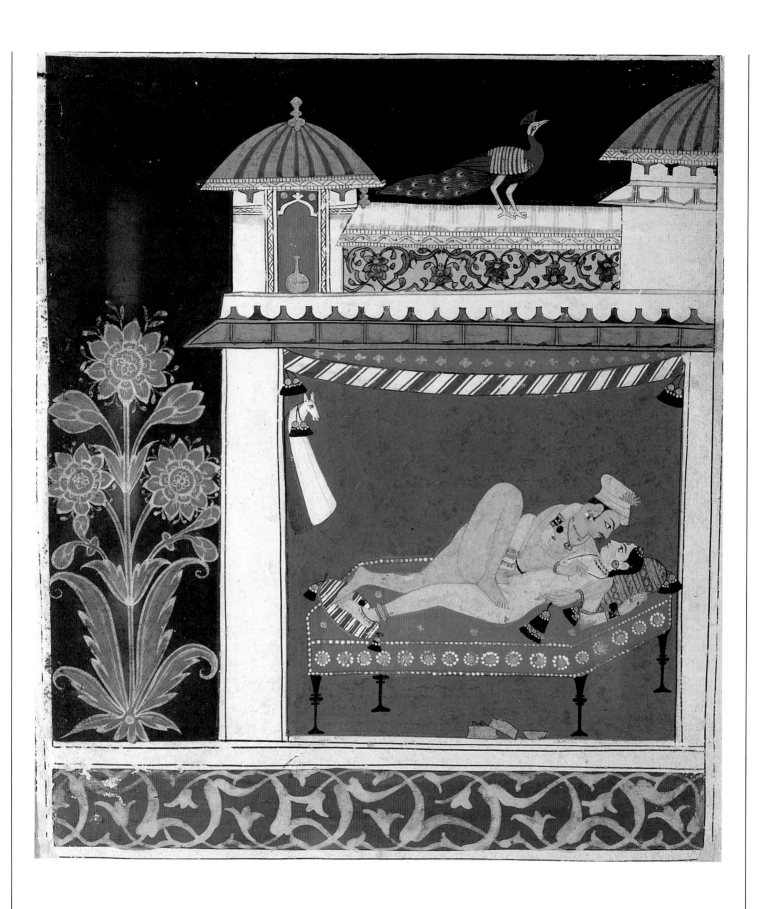

The decorative band of stylized flowers in the lower border of this painting compares to the one used in the *Amarushataka* series, a contemporaneous erotic album painted at Malwa (see Bautze 1991, pp. 31–32, 189–92, cat. nos. 79 and 80).

Literature Lerner 1974, cat. no. 10.

Provenance Jeffrey Paley, New York.

B

Image 5½ x 5½ in. (14 x 14 cm)
Sheet 8¼ x 6½ in. (20.9 x 16.6 cm)
Anonymous gift, 84.201.4

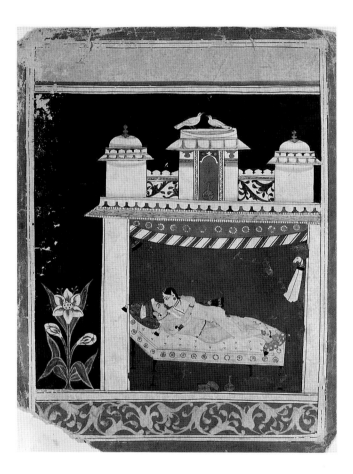

In this companion leaf, an embracing couple is shown on a yellow coverlet in a similar pavilion scene. The artist has provided the same general format: a pavilion at the right and a single flowering plant to the left silhouetted against a black sky framed by a yellow band at the top and a meandering floral motif at the bottom. The repetition of such details as the striped curtain, tassel ornamentation, gold vessels below the bed and in alcoves of the turrets, as well as the perspective of the furniture, suggest that both leaves are by the same hand. In this scene, however, the large plant has been replaced by a lily and a pair of white doves replaces the peacock. AGP

Literature Lerner 1974, cat. no. 10.

Provenance Jeffrey Paley, New York.

145 Artist unknown

Gauri Ragini

Rajasthani School, Malwa
Circa 1680
Opaque watercolor on paper
Sheet 7⅞ x 5½ in. (20 x 14 cm)
Gift of Emily Goldman, 1990.180.5

INSCRIPTION
Verso, at top, in black ink, in Devanagari script: *Gauri ragini.*

Gauri Ragini represents love in loss. The scene is set in a richly blooming vernal forest of stylized trees in various shades of green. The two figures in the central area are highlighted with a bright red color surmounted by an arched thin white line. Large rounded hills defined by gray, brown, and green shades, recede into the background. The rugged terrain is emphasized by dark blue streaks and tufts of grass and flowering weeds. The sky area is decorated with flowering creepers and birds in the treetops. A green parrot flying downward in the center provides an element that heightens the charm of this painting.

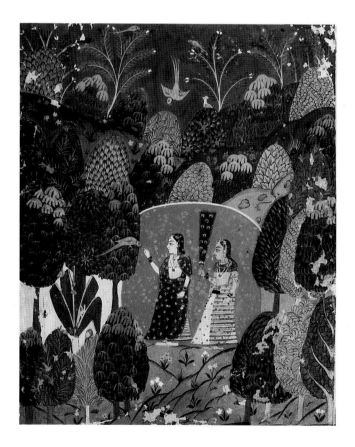

That there may have been some retouching in this painting is particularly suggested by the insertion at the left of a single banana tree against a light pink background. This detail may be a later addition, since the color of neither the tree's stem nor its leaves matches the overall color scheme, and this type of tree does not appear elsewhere in the painting.

The standard representation of *Gauri Ragini* (cat. no. 107, for example), shows a woman holding flower wands as she strolls in a rich forest setting. Here, however, in an unusual rendering of *Gauri Ragini,* the wife of *Malkosa Raga* is represented as a heroine longing for her husband and strolling through a forest with her companion (Ebeling 1973, pp. 46– 47). The organization of space and the lush landscape enveloping the two figures may relate to a Malwa *Ragamala* series of circa 1650 in the National Museum, New Delhi (Joseph M. Dye III, personal communication). However, the subdued palette in our painting, particularly the vegetation, may indicate repainting.

For leaves in a related florid style, see Ebeling 1973, pl. C5, *Bhairavi Ragini,* and pl. C54, *Sorath Ragini.* AGP

146 Artist unknown

Krishna and Balarama as children

Rajasthani School, Malwa
Circa 1690
Opaque watercolor and gold on paper
Image 6½ x 12⅞ in. (16.5 x 32.7 cm)
Sheet 7⅛ x 13⅝ in. (18.1 x 34.6 cm)
Anonymous gift, 80.277.4

INSCRIPTION
Recto, at top, in Sanskrit, in gold Devanagari script: *Eighth/24.*

This page from a dispersed *Bhagavata Purana* series depicts two consecutive scenes from the life of Krishna, in which, as the child Gopala, he frolics with his brother, Balarama, at the house of his foster-mother, Yashoda. The text on the verso in black ink in Devanagari script framed in a yellow border edged with narrow black rules relates part of the story:

In Yashoda's residence, Gopala is crawling. Watching him along with his elder brother Bala[rama] is considered to be of very good luck. (5) Again, within a few days, they are walking, following the calves with their tails in their hands. Seeing Shyama, the cloud-complexioned one, the peacock resting on the tree chirps with joy. (6) Praising their merits is an act of great fortune, and the joy [in doing so] is boundless. (Trans. S. Mitra)

The action begins at the left where Rohini and Yashoda, mother of Balarama and stepmother of Krishna, are seated on a bed watching the two infant boys crawling about. The upper body of the baby Krishna protrudes outside the pavilion, suggesting the babies' first exploration of their immediate surroundings. At the right, Yashoda and Rohini are again shown seated in a pavilion, while here the toddlers play with two calves, pulling their tails. The calves look cheerful at the touch of the toddlers, who are two divinities on earth in human form, born to play their special roles in world affairs. In this way the artist also indicates their future profession as cowherds. A flowering plantain and kadam trees with peacocks in their tops are shown at the center.

The change in time is skillfully suggested by the different colors of the costumes of the mothers and babies, their hand gestures, and such decorative elements as the bedspreads and the canopies of the pavilion.

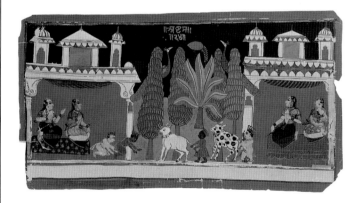

This page is from a well-known, widely dispersed series, many leaves of which are located in the Bharat Kala Bhavan, Banaras (A. Krishna 1963, col. pls. M and N). Krishna observes that successive episodes are frequently illustrated in one composition in this series. His description of the landscape elements of one of the illustrations compares closely to our page (ibid., p. 48). Other features of Malwa painting

present in this page include the black tassels, sometimes in double rows, the round ear plaque, and the conical shape of the ends of the dress of the children. The stylization of the veils worn by the mothers and their hieratic poses recall the Western Indian early-sixteenth-century *Chaurapanchasika* style of presenting figures in a stiff posture in which costume elements become formal motifs in themselves (see cat. no. 18 for a sixteenth-century *Bhagavata Purana* page exemplifying this style). AGP

Literature Lerner 1974, cat. no. 13.

Provenance Jeffrey Paley, New York.

147 Artist unknown

Devagandhara Ragini (?)

Rajasthan, Datia (?)
Late 18th century
Opaque watercolor and gold on paper
Image 9 x 6¹³⁄₁₆ in. (22.8 x 17.2 cm)
Sheet 14⅝ x 10½ in. (37.2 x 26.7 cm)
Gift of Ananda K. Coomaraswamy, 36.249

A solitary, ash-gray ascetic is depicted with a black beard and long hair tied into a topknot and secured with a jeweled hairpin. Seated with his legs crossed on a leopard skin spread on a mauve-colored terrace, he is dressed in a short green dhoti (pigment now flaked off) with an orange belt, and a gold and black striped scarf across his shoulders. In his left hand he holds a bunch of red flowers; his right hand rests on his right leg. In the foreground there are several vessels and a ladle.

Beyond the terrace, a large tree with a single bird nested in its thick foliage, an orange flag, and a gold-domed hexagonal pavilion with pointed *shikhara* are set against a blue sky. The empty interior of the shrine parallels the solitude of the ascetic. A wide band at the top is filled with blue comma-shaped clouds under a white wash interspersed with six scattered birds. The painting is surrounded by a border consisting of a narrow salmon-colored band and a broad dark blue margin with white rules, now torn on the left side. The paint has flaked in many places, and the blue on either side of the flowering tree in the lower right has possibly been retouched.

This uninscribed page has been tentatively identified as *Devagandhara Ragini. Devagandhara* is associated with an ascetic in the forest and is usually depicted with a beard, a piled coiffure, and sometimes with a rosary. Ebeling cites

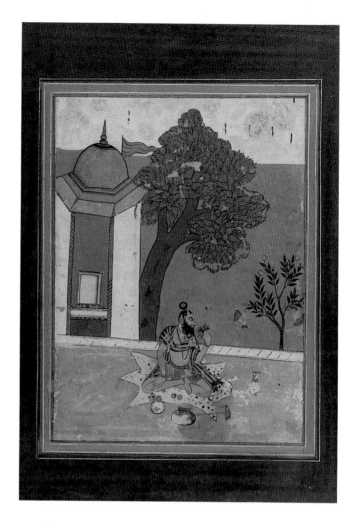

several comparable examples from other schools, among them an eighteenth-century Deccani page (1973, p. 267, fig. 284), in which the single male ascetic is seated on a terrace outside a temple, but with the additional attributes of radiant sun and Shiva's trident. A Jaipur *Devagandhara Ragini* also shows the ascetic seated by a temple with a hexagonal tower, attended by several figures and a ram in the foreground (ibid., p. 271, fig. 299). A verse concerning *Gandhari* has been translated: "With the usual top-knot, smeared with ashes, and—dressed in the reddish dhoti of the yogi—his body emaciated, and performing the eye-posture, the ascetic is said to be Gandhara Raga" (ibid., p. 122).

The attribution to Datia is tentative. The treatment of the figures, landscape elements, and architecture with contours emphasized by cross-hatching (as in the dome, window, and roof of the temple), the unusual palette of predominantly secondary colors, and the physiognomy of the sitter suggest a Datia attribution. AGP

148 Artist unknown

Devotional discourse

Rajasthani School, Datia
1750–75
Opaque watercolor and gold on paper
Image 7 x 7½ in. (17.8 x 19.2 cm)
Sheet 8¾ x 9³⁄₁₆ in. (22.2 x 23.4 cm)
Museum purchase, 35.1021

A group of women, seated and standing in a court before a white house with a pink roof and two doorways with green and orange screens rolled up, listen to a teacher, who holds a book inscribed "Shrirama Shrirama." The scene undoubtedly depicts a devotional discourse, and the teacher may be expounding the popular story of Rama. He is seated cross-legged away from the women of the harem, on a red mat with gold trim, before a door in the courtyard wall. Beyond the wall, a row of trees is visible. The sky is dark blue and the ground is yellow-green. In the foreground, a low black railing demarcates the courtyard. The women are dressed in colored skirts, cholis, and draped with *orhani;* some wear saris embellished with fine gold work. The religious teacher wears a white turban, a white scarf (*angavastar*) with gold edges, and a yellow dhoti tied as a *kachcha.* All are elaborately jeweled. On the ground before the teacher are several gilded vessels used for sprinkling holy water during the discourse, a mauve book stand, and a large green leaf.

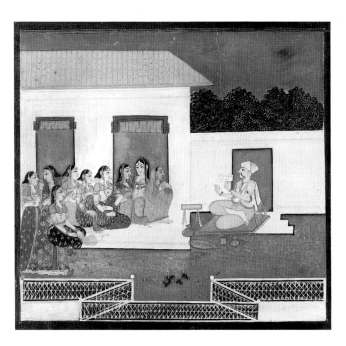

Perspective is indicated somewhat awkwardly in several areas, for example, the seated female in a dark green skirt who is oddly superimposed over the central section of the skirt of the woman standing behind her. The painting is surrounded by a broad black border sparsely flocked with gold. The border across the top has been cut and pasted back on again. The surface of the miniature has a thick, almost waxy varnishlike surface.

This painting may have been acquired by Stewart Culin during the 1914 Museum Expedition, but the inventory records are unclear. AGP

Provenance Museum Expedition, 1914 (?).

149 Artist unknown

An old man

Rajasthan, Marwar (?)
Circa 1730
Opaque watercolor on paper
Image 7 x 4⅞ in. (17.8 x 12.4 cm)
Sheet 9⅜ x 5⁷⁄₁₆ in. (23.8 x 13.8 cm)
Gift of the Executors of the Estate of Colonel Michael Friedsam, 32.1322

Dressed in a belted white robe and lavender turban, this elderly, mustachioed man carries a purple sack over his arm. The delicate treatment, in which both form and detail are defined by fine, pale colored lines, conveys a sense of dignity and nobility to this portrait. The foreground in which the figure stands is only slightly differentiated from the background by its darker green color. Gray clouds streak the sky that is visible above a high horizon. The painted surface has been abraded and scratched in areas, revealing an underpainting of yellow beneath the white jama. The scene is bordered in black, gold, orange, and blue rules and set into a pale brown page.

Although such simple, single-figure portraits remained popular in Mughal painting from the late sixteenth century through the nineteenth, the white dress and turban style are typical of eighteenth-century Rajasthan. This may well be a later copy executed in Rajasthan. Assigning it to Marwar is plausible, given the number of Marwar portraits of this date in Mughal style, but the classification remains tentative.

A notation in English on the reverse identifies the subject as a royal physician, but the name of the ruler is obscured.

AGP

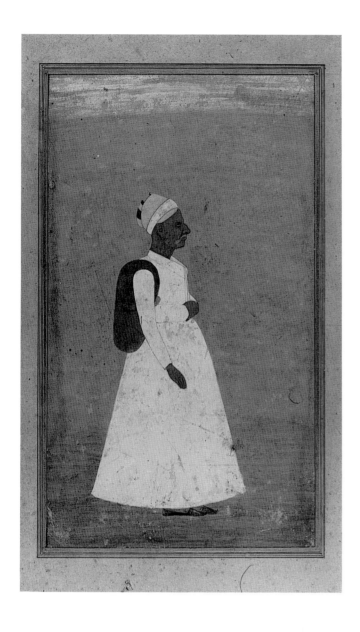

Like the other leaves from this Jain manuscript, the Brooklyn leaf contains illustrations on both sides of the sheet. The composition on the recto depicts several Jain devotional themes. A white temple occupies the upper right portion of the picture. Two men, one in a pink jama and the other in a yellow dhoti, raise their hands in gestures of reverence to the image of a seated Tirthankara in the temple's niche. Traces of gold suggest this detail may have been gilded originally. A reflecting pool before the figures captures the image of two white towers. In the distance beyond this scene, a woman may be seen seated in a doorway. Two red pendants, some trees, and houses are set against the dark blue background. At the left, a prince seated in a pavilion receives two men. The prince is dressed in a brown jama and turban (with traces of gold); he rests against a blue bolster and two smaller pillows while holding the stem of a single pink flower. Several small objects displayed on the white carpet before him are labeled *sarada* and *bida* (pan). The two figures facing him, seated on a large green carpet, hold shields and swords. The palace architecture includes onion domes and intricate lattice wall screens among its structural elements. Gold vessels are set out in one of the towers.

Below these scenes, the city wall is depicted. A guard stands at the gate, holding a long gold shaft in his right hand. He wears the same pink jama, gold-brown turban, long black sideburns, and drooping mustache as two of the figures above. A caparisoned elephant stands to the right of the gate; at the left are two horses, one enclosed in a long black blanket with red borders. The scene is framed in a border of red rules containing flowers with red petals, blue centers, and green stems.

The image on the reverse depicts a woman holding a young boy accompanied by two female servants and a young man. She wears a green choli, a long gold sari, and pearl jewelry. Both males wear long jamas and golden headdresses. The garments of the female attendants are similar to those of the central female, though less ornate. They fan the principal figures with a peacock-feather fly whisk and a large fan. The scene is set against a red ground framed within blue-and-white lattice screens and an ornate green carpet. The text below has been arranged to include the shape of a yellow tree. The flowered border is a variation of the motif that appears on the recto.

The Jain manuscript *Chandana Malayagiri Varta* is known from two illustrated versions, one dated 1684 (Khandalavala, Chandra, and Chandra 1960, p. 58, cat. no. 143) and another, dated 1745, probably a copy of the earlier version. Our leaf is from the later series, which has a colophon naming the artists, who are known only from this colophon, and the place where the manuscript was painted, Kishangarh.

150 Attributed to Karam Chandji and Mahata Chandji

Leaf from a Chandana Malayagiri Varta series

Rajasthan, Marwar/Jodhpur
1745
Opaque watercolor and gold on paper
Image (recto) 9⅝ x 6⅛ in. (24.45 x 15.6 cm)
Image (verso) 4¼ x 6 in. (10.9 x 15.2 cm)
Sheet 11⅜ x 7⅞ in. (28.9 x 20 cm)
Gift of Mr. and Mrs. Paul E. Manheim, 69.125.5

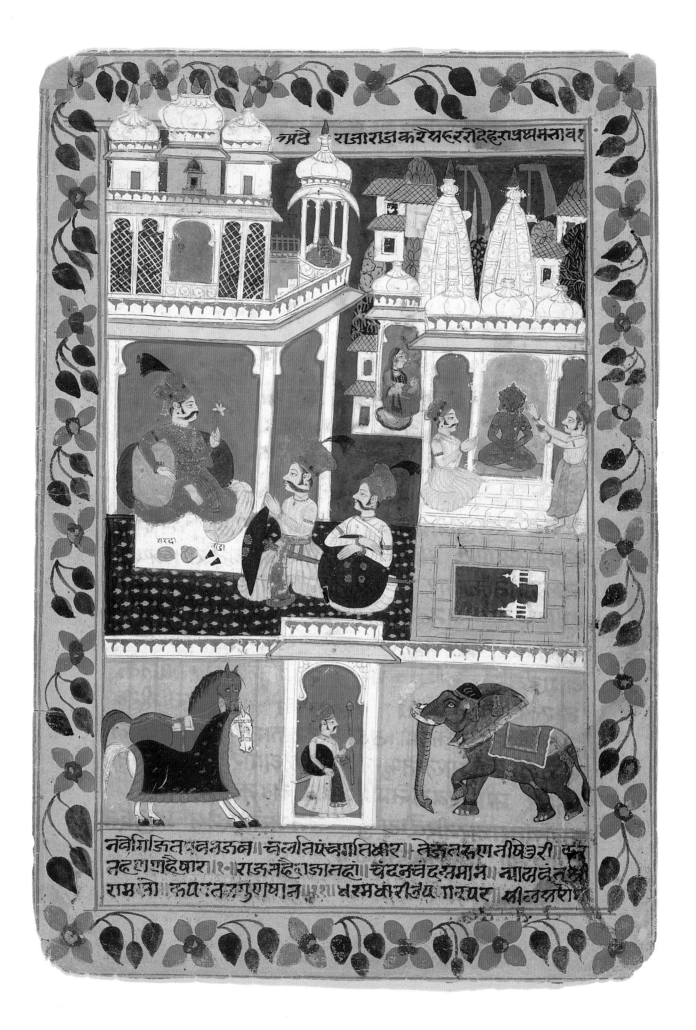

The leaf was originally attributed to a Mewar artist in Kishangarh; the attribution to Marwar has been made on the basis of stylistic comparisons with several *ramayana* leaves (see Leach 1986, pp. 182–85, cat. no. 70, and Kramrisch 1986, cat. nos. 69 and 70). Leach enumerates the relevant Marwari characteristics, such as the distinctive high turbans, long mustaches and sideburns of the male figures, as well as the predominance of dark green and red pigments. The floral border is typical of all the leaves in the manuscript.

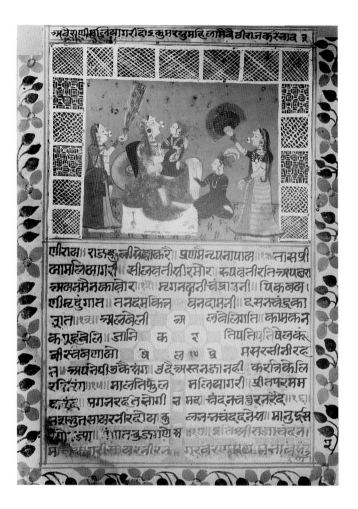

Other leaves from this series are located in the collections of the Philadelphia Museum of Art; George P. Bickford Collection, Cleveland (a double-sided leaf published in Czuma 1975, cat. no. 93); San Diego Museum of Art (formerly Collection of Edwin Binney, 3rd); and Doris Wiener Gallery. AGP

Literature Leach 1986, fig. 70(C); Poster 1987, col. pl., p. 37.

151 Artist unknown

Jain pilgrimage

Rajasthan, Jodhpur
Circa 1750 (?)
Opaque watercolor and gold on cotton
30⁵⁄₁₆ x 37¹³⁄₁₆ in. (77 x 96 cm)
The Brooklyn Museum Collection, 31.746

Large paintings on cotton often depict and commemorate the extensive pilgrimages of Jain monks or wealthy Jain patrons to various places of religious importance, possibly sites associated with the life of Mahavira or the other Tirthankaras. This work, painted in bright opaque colors (primarily red, pink, slate blue, green, yellow, brown, and white), has a yellow border with a green vine pattern of red flowers.

The composition is organized in two distinct sections, divided vertically down the center. Schwartzberg (1992, p. 442) explains that the unusual arrangement of the elements of the painting in two halves is intended to present two different perspectives. The left portion, when the piece is viewed horizontally, depicts the side of a purple mountain on which twenty Tirthankaras are arranged in irregular rows, with trees interspersed in the spaces. The Tirthankaras, who vary in size and color, are shown as objects of worship, seated in a meditative posture in domed niches or pavilions. The largest figure, shown at the top of the mountain, is painted white. The diminutive vehicle or animal associated with each Tirthankara stands before him. Stacks of auspicious pots represent donations.

The upper right side, when the painting is viewed as a vertical, shows a walled city and various scenes depicting activities of Jain pilgrims: in procession on horses, elephants, or camels, in carriages, or being carried in palanquins; receiving instruction from Jain preachers; in worship at small temples. Schwartzberg has identified these pilgrims as the patron of the work, pictured in ten different activities, and his retinue, which may suggest a continuous narrative (ibid.).

W.N. Brown suggested that the painting may represent Sammetashikhara (now Parasnath) in the Hazaribagh District, Bihar, and the other sites where twenty-four Tirthankaras attained *nirvana*:

. . .it commemorates a pilgrimage (or pilgrimages) of a pious Jain layman. This sort of pilgrimage is commonplace among the Jains, and may involve the expenditure of very large sums of money; for the pilgrim will take his relatives

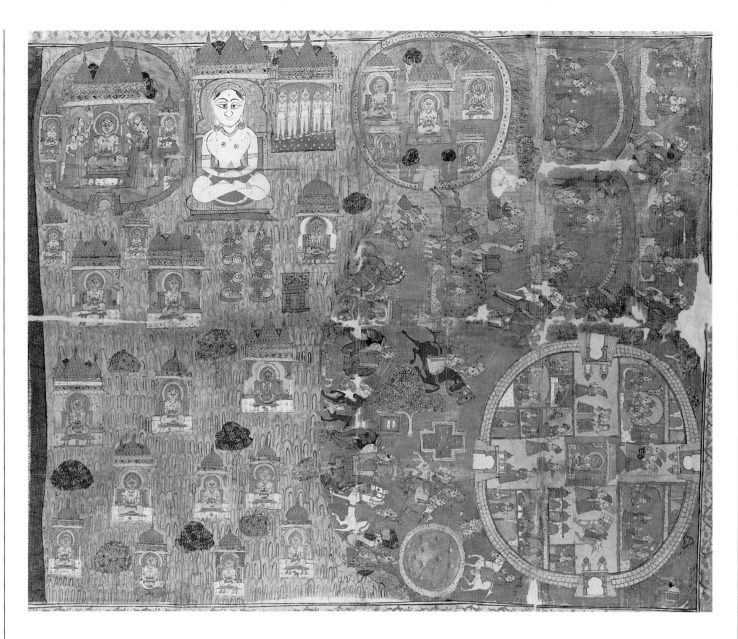

and friends, and feed them throughout the entire journey, and at the pilgrimage points will make offerings to the shrines. It would appear that the person whose pious works are celebrated here went to the places where all 24 of the Tirthankaras entered final nirvana. These places are only four in number: Mount Satrunjaya in the peninsula of Kathiawar, where the first Tirthanakara died; the village of Pava in Bihar, where the last Tirthankara (Mahavira) died; the town of Campapuri, where the 12th Tirthankara (Vasupujya) died; and Mount Sammetasikhara in Bihar, where the other 20 died.

At the left side of the scene are 22 of the Tirthankaras, 17 are seated and 5 are standing, among whom are probably the 20 who died on Mount Sammetasikhara (known today as Mount Parasnath). Parsva (the 23rd Tirthankara who gives the place its modern name) appears in the mid-dle not quite half-way down from the top, and is recogniz-able by the serpent-heads behind him. The others seem to have their cognizances beneath their thrones. . . . The largest figure is probably the Tirthankara to whom the pilgrimage-patron was particularly devoted; his color and cognizance would identify him. . . . Below him is a cross to represent his *samavasarana,* and a tree with footprints be-low it, probably representing the tree where enlighten-ment was obtained . . . (correspondence, 1940).

Ann Norton (correspondence, 1979) and Schwartzberg (op. cit.) add that Mahavira may be the central Jain saint rep-resented. As noted by Norton, the central figures in both the circular setting at the lower left and the circular four-gated city are gold, which is the color associated with Mahavira. She identifies the tree with the symbol of footprints as Pawa, the place where Mahavira was initiated. Schwartzberg (op.

cit., quoting Brown) notes that the journey is to the sites of the four great events in Mahavira's life: "birth, initiation, *samavasarana* [first preaching], and *nirvana.*" He also confirms that the Tirthankaras, other than Mahavira, would be associated with Mount Parasnath, viewed in the left half of the painting, where they attained *nirvana,* and that this is the site depicted in our painting.

This painting is similar in style to many miniatures illustrating *Kalpasutra* manuscripts and to a dated Jodhpur series of 1745 illustrating the *Chandana Malayagiri Varta* (see cat. no. 150). The floral border, landscape elements, animals, and figures, and especially the distinctive color scheme are typical of the style. Schwartzberg suggests that the iconography depicted is associated with the Shvetambara sect and, since certain details of the Jain ritual are incorrectly represented, the artist may not have been a Jain (op. cit.). AGP

Literature W.N. Brown 1947, pp. 69–72; Schwartzberg 1992, pp. 441–42, figs. 17.35 and 17.36.

152 Artist unknown

Portrait of Maharaja Bakhat Singh

Rajasthan, Jodhpur
Early 19th century
Opaque watercolor and gold on paper
Image 6⅝ x 4¼ in. (17.8 x 10.8 cm)
Sheet 8¹⁵⁄₁₆ x 6 in. (22.7 x 15.3 cm)
Gift of the Executors of the Estate of Colonel Michael Friedsam, 32.863

A Maharaja stands in three-quarter stance facing left. He wears a mauve ankle-length jama decorated with an overall leaf pattern in yellow, a yellow sash, yellow slippers, orange trousers, and an elaborate starched turban with a circular gold ornament. He carries the accoutrements of rank: the shield over his left shoulder and the *katar* in his right hand. His head is encircled by a green nimbus with a gold border. The figure is isolated against a light blue-green background; the ground line is noted with dark washes. The painting is mounted on reddish brown paper.

This rendering is an example of the official portraiture popular in Jodhpur circa 1800. Other portraits of Bakhat Singh are published in Coomaraswamy 1926, pl. CXVII; and Lewis 1969, fig. 42. AGP

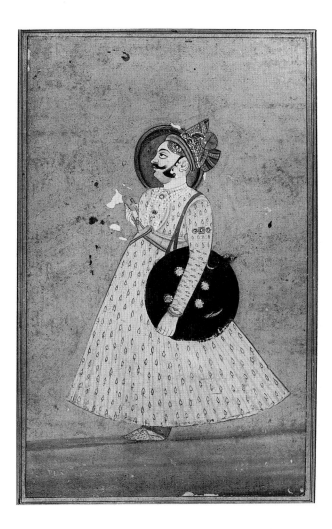

153 Attributed to Narsingh

Maharaja Jaswant Singh of Marwar

Rajasthan, Jodhpur
Circa 1880
Opaque watercolor on paper
Image 12¾ x 9½ in. (32.5 x 24.1 cm)
Sheet 15½ x 11⅝ in. (39.4 x 29.5 cm)
Gift of Mr. and Mrs. Robert L. Poster, 87.234.6

Maharaja Jaswant Singh ruled the state of Jodhpur from 1873 to 1895. In this portrait, he is seated on a chair of European design, his right arm resting on a round table draped with a fringed green cloth. The Maharaja's predilection for Western techniques in photography and portraiture are evident in this commissioned work. The complex psychological interplay of characteristics of the traditional Rajput warrior-ruler, as well as elements adopted from the British systems of colonial rule and constitutional monarchy, are suggested in the overall composition and in details. The

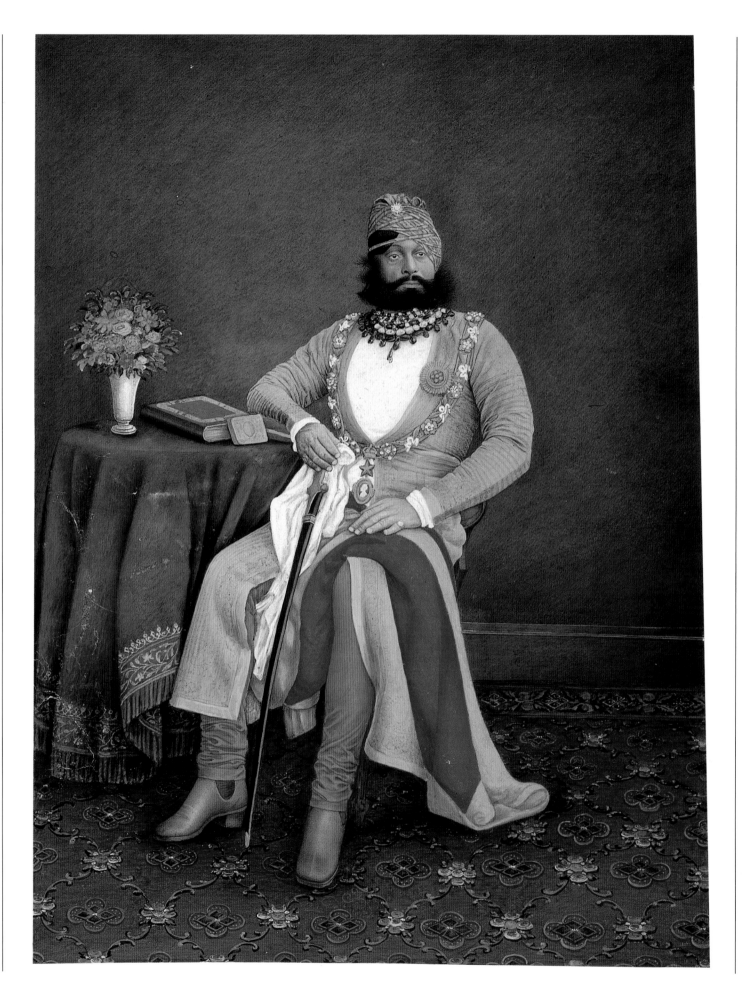

positioning of the figure, for example, denotes a significant departure from Indian portraits of only a century earlier (see cat. no. 152). Here the bearded prince wears leather riding boots, ocher jodhpur trousers, a violet jama, a white undergarment, a turban folded from two cloths (one golden, the other striped in pink and blue) that are twisted and secured with a white ornament. Two cloths are draped over his left knee and a sword is in his right hand.

The royal jewels and British decorations retain their local significances, yet in combination convey the political atmosphere of this transitional period. The furnishings of the room—the chair, carpet, and table—are Victorian in style. The floral arrangement and books further propose a conscious assimilation of foreign mythologies into Indian courtly life. The Maharaja wears the collar and badge of the British Order of the Star of India, a decoration bestowed on the highest order of ruling princes and chiefs of India. His turban, whiskers, clothing, and dazzling emerald and diamond necklace conform to Indian ideas of courtly grandeur. The artist's attention to modeling and recession in space suggests that he copied this portrait from a photograph, a practice that resulted in hyperrealistic likenesses of Indian potentates (see Worswick and Embree 1976, p. 117).

During his rule Maharaja Jaswant Singh adhered to the traditional values of Indian maharajas, whose active skills of hunting and fighting, suggested by his sword, paralleled their intellectual prowess, indicated by the books on the table.

AGP

Literature S.C. Welch 1978, p. 148, cat. no. 66; Desai 1985, p. 43, cat. no. 39, col. pl. p. 45.

154 Artist unknown

Leaf from a Bhagavata Purana series

Rajasthan, Mewar
Circa 1610–50
Opaque watercolor on paper
Image 7 x 13⅛ in. (17.7 x 33.3 cm)
Sheet 8⅛ x 14¾ in. (20.6 x 37.5 cm)
Gift of Dr. and Mrs. Richard Dickes, 83.164.1

INSCRIPTIONS

In Braj, in red pigment, in Devanagari script

Recto, above: *Here, Krishna suddenly grasped the topknot of Kamsa, threw him to the ground, and killed him. Whoever came in front of the two brothers they killed. The devatas began to shower them with flowers;* below: *The two wives of Kamsa stand with their hands pressed together in supplication as they cry.* (Trans. S. P. Tewari)

Verso, at top: *The two brothers prostrate themselves at the feet of their mother and father, Devaki and Vasudeva, offering obeisances. They place their heads at their [parents'] feet, who put their hands on their sons' heads;* above the heads of the parents: *Devaki; Vasudeva.* (Trans. E. F. Bryant)

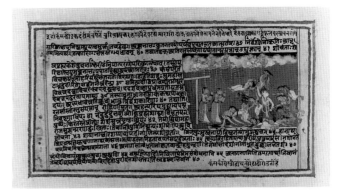

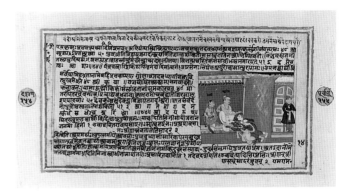

In this animated scene on the recto of a leaf from a *Bhagavata Purana* series, Krishna holds onto the unwound topknot of the evil Kamsa, while his brother, Balarama, throws off Kamsa's guards. Both divine warriors fight without weapons. Kamsa's crown and sword rest on the ground, alluding to the loss of his regal power. His weeping wives stand at the left. The women wear tassels, circular ear plugs, and a modified balloon-shaped veil over their long hair, all details indicative of an early-seventeenth-century date, as is the short transparent jama worn by the male figures. In the clouds above, divinities shower the figures with flowers. A red background emphasizes the dynamic action and symbolic victory of Krishna and Balarama.

On the reverse side of the leaf, Krishna and Balarama prostrate themselves before their parents, Devaki and Vasudeva, who are shown seated in the house where they were imprisoned by Kamsa. The two seated figures echo the *Chaurapanchasika* type and posture. Certain details of the prison pavilion resemble Mughal treatment, and the guard, who stands at an entrance at the right, is presented in a Mughal style of dress and pose.

Although the set from which this leaf comes has been widely dispersed, the only discussion of the series has been presented by Ehnbom (1985, pp. 112–13, cat. no. 49), who identifies another of the leaves as "Folio 32 from the *Uttardha* (latter half) of the tenth book of the *Bhagavata Purana*," and cites the stylistic treatment of "bold color, flat planes, vigorous yet simple compositions, and square-headed figure types," the keynote characteristic of the series. He also notes a stylistic awareness of Mughal painting of the early seventeenth century in "the refined line, softly shaded rocks, lessened angularity, and fluttering garments," and proposes that this "is probably the earliest illustrated *Bhagavata* that can be assigned to Mewar with any certainty."

Other pages from this set are reproduced in Hutchins 1980, pls. 20 and 22; Kramrisch 1986, pp. 69, 170–71, cat. no. 62 (a folio in the collection of Dr. Alvin O. Bellak, Philadelphia); Bautze 1991, pp. 44–45, cat. nos. 5–7. For another leaf from the series, see catalogue number 155. AGP

155 Artist unknown

Leaf from a Bhagavata Purana series

Rajasthan, Mewar
Circa 1610–50
Opaque watercolor on paper
Image 7 x 13⅛ in. (17.8 x 33.6 cm)
Sheet 8 x 15⅛ in. (20.3 x 38.3 cm)
Gift of Dr. and Mrs. Richard Dickes, 83.164.2

INSCRIPTIONS

In Braj, in red pigment, in Devanagari script

Recto, above: *When Krishna and Balarama were seated, Narada came and told them, "Your grandson has reached inside Shonitapura of Banasura, where a battle is taking place." After hearing this, Krishna and Baladeva sat in their chariot and marched to that place.* (Trans. S. P. Tewari)

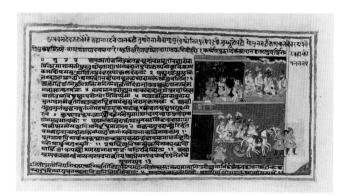

Verso: *After Banasura, Mahadeva [Shiva] came mounted on Nandi, Swami Karttikeya came mounted on his peacock. Of the trio, Krishna and Balarama are ahead of Aniruddha and the battle is going on;* in the margins, in light blue circles, left and right: *Section [of Tenth Book], folio 34.* (Trans. E. F. Bryant)

The subject illustrated on the recto concerns the sage Narada, who delivers a message that Krishna's grandson, Aniruddha, is imprisoned in Banasura's capital, Shonitapura, where there is a battle going on. The scenes of the narrative are divided into two registers. Above at the right, Krishna sits with his brother, Balarama, and his grandson, Pradyumna, facing the sage who delivers the message with the gesture of his outstretched hand, while the three wives sit in a nearby pavilion, supposedly worrying about the battle. Below, Krishna with Balarama and Pradyumna depart in a horse-drawn chariot accompanied by a charioteer and foot soldiers, one of whom protrudes into the border, a common feature in this series. Red, the predominant color in the background, highlights this departure episode.

The scene on the verso relates Krishna's kidnapping of Aniruddha and the ensuing battle. The crowded and lively activity depicts a bloody battle between the divine opponents: at the left, Krishna, Balarama, and Pradyumna stand on a chariot drawn by horses, aiming their arrows at Shiva, who is astride Nandi. Karttikeya, on his peacock, aims his spear at an animal-headed *gana* and another foot soldier. In the lower part of the composition, two figures, including a beheaded one who may be the charioteer, have fallen in the battle. Shiva's soldiers are all bare-bodied but with tassels hanging from their armlets, while Krishna's comrades are dressed in royal robes and crowns. Three of the Shaivaite figures are also distinguished by a projecting farther eye, a motif continued from the earlier Western Indian tradition.

A burnished solid red background has been used to enhance the figures in the narrative, while details of iconography and dress are meticulously rendered. A high horizon is indicated by a band of white cloud separating the scene from a dark blue sky.

For other pages in this series, see catalogue number 154. AGP

156 Artist unknown

Page from an unidentified series

Rajasthan, Mewar
Circa 1650
Opaque watercolor on paper
Image 6³⁄₁₆ x 4¹³⁄₁₆ in. (15.7 x 12.2 cm)
Sheet 6⁷⁄₈ x 5 in. (17.5 x 12.7 cm)
Gift of Martha M. Green, 1991.181.7

This small fragment from an unidentified manuscript divided into two registers illustrates scenes of devotion. In the upper scene, a prince sits enthroned with a small attendant and two female devotees. The prince wears a translucent

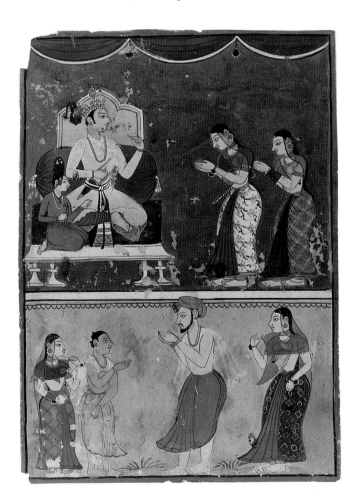

pink jama over red pajamas, a *katar* tucked into a black, white, and yellow sash, and several gold necklaces and bracelets. He sports long black sideburns and holds green pan (betel leaf) in his hands. He sits against a blue bolster on an elevated white dais with a yellow backrest. The diminutive attendant wears an orange jama and a strand of pearls. He lacks a headdress, but a brownish area of damage suggests a high topknot. The women wear cholis, patterned skirts, long diaphanous scarves, jewelry, and pompons. A dark green curtain above frames the scene.

In the lower portion of the page, four figures stand in a pale green-blue field. The men, nude to the waist, are dressed in dhotis, transparent scarves, and jewels. The larger male is bearded and wears a gray turban. The costumes of the women resemble those of the women in the upper scene.

The style of this unascribed painting, which may be a fragment of a larger page, suggests the work of the Sahibdin studio, whose attributed works include the 1628 *Ragamala,* the 1629 *Gita Govinda,* and a *Bhagavata Purana* of 1648 (see Topsfield 1981, pp. 231–38, and Losty 1982, p. 126). Sahibdin is noted for his depiction of figures in crowd scenes interspersed with foliage. Although this convention is not present here and the painting is not of the quality of other Sahibdin works, in the stylization of the figures and the cool palette, the work relates to the Mewar-Udaipur tradition. AGP

Provenance Paul E. Manheim, New York.

157 Artist unknown

Cupid disturbs Krishna's penance

Page from a *Gita Govinda* series
Rajasthan, Mewar
Circa 1650–60
Opaque watercolor and gold on paper
Image 6³⁄₄ x 8⁷⁄₈ in. (17.2 x 22.5 cm)
Sheet 7⁵⁄₈ x 9⁵⁄₈ in. (19.2 x 24.9 cm)
Gift of Mr. and Mrs. Robert L. Poster, 1990.186

In a continuous narrative, the bejeweled and crowned Krishna is depicted in two sequential scenes. At the right, he sits placidly on an outcropping of rock in a grove of trees, his flute beside him. His calm emotional state is further conveyed through elements of the surrounding landscape, the gentle sway of the trees and the calm flow of the river. At the left, Krishna bends to collect three "love-notes" that have been abandoned in his proximity. Here, his amorous excitement is echoed in the vigorous composition of dynamically

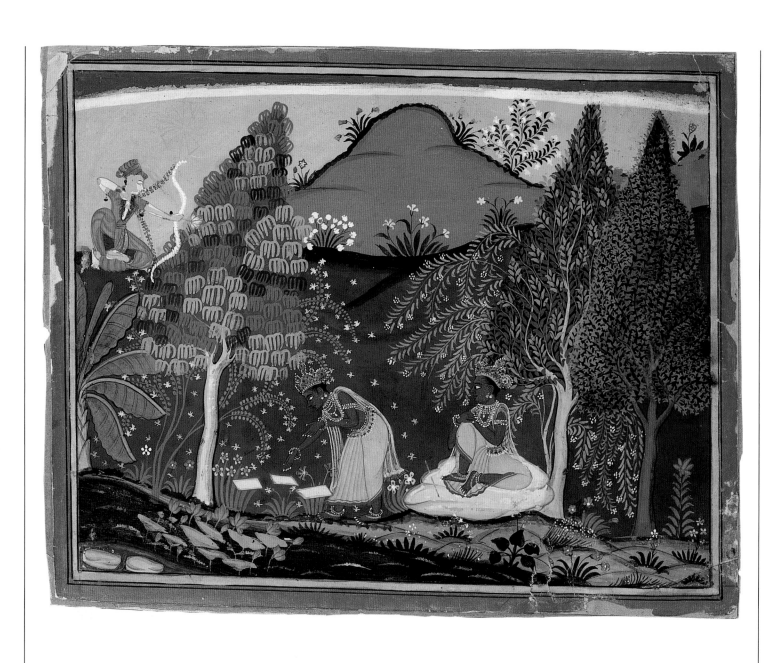

204

curved tree branches, flowers adrift in the breezes, and lotus blossoms springing forth from the active currents of the river. Silhouetted against a yellow sky on the left horizon, Kama, the god of love, focuses his glance at the seated Krishna and takes aim with his lotus arrow.

Although a common feature in this series is the use of color to indicate the symmetrical division of the picture into two scenes, for example, various tonalities exclusive to one scene or the other, here the colors are evenly dispersed throughout the page, despite the apparent depiction of two consecutive scenes. Another characteristic of this series is the solitary mountain that surmounts the scenes and rests below the high, slightly curved line of clouds. The foliage is depicted in the manner typical of mid-seventeenth-century Mewar painting, with the superpositioning of variegated leaves and the liberal distribution of star-shaped flowers across the page.

This series is presently dispersed, with pages located in the Prince of Wales Museum, Bombay, and various private collections. Other pages from the series are illustrated in M. Chandra 1957, pl. 6; Sotheby's 1963, lot no. 53; Sotheby's 1985, lot nos. 395 and 450. AGP

Provenance Sotheby's 1990, lot 87; Ramesh Kapoor, New York; Sotheby's 1985, lot 450; Doris Wiener, New York; Kumar Sangram Singh (library stamp of Nawalgarh on verso).

158 Artist unknown

Unidentified page from a dispersed Nayika series

Rajasthan, Mewar
Circa 1650–60
Opaque watercolor on paper
Image 8⅛ x 5⅝ in. (20.7 x 14.3 cm)
Sheet 8⅜ x 6 in. (21.3 x 15.2 cm)
Gift of the Ernest Erickson Foundation, Inc., 86.227.138

INSCRIPTIONS
Recto, in Braj, in black ink, in Devanagari script: *Pavilion;* in upper margin: 7.

A prince and princess sit on a bed placed in a pavilion set in a forest, while a female attendant sits beside a stream. The prince leans against a pink bolster. He holds a gold wineglass in his right hand, while reaching out to hold his beloved with his left. He wears orange pleated pajamas, a long diaphanous white jama, a gold turban and sash, and jewelry. The princess sits facing him, gesturing with her hands. She is dressed in an ocher-colored skirt, an orange choli, and a translucent scarf bordered in gold. They sit on a low white

bed strewn with red and green flowers under a red canopy supported by gold posts from which an orange and yellow curtain is suspended. The slippers of the amorous couple lie on the forest floor with several vessels of wine and fruit. The female attendant wears an ocher choli, green skirt, and orange scarf. The forest is represented with large flowering trees and plantains typical of Mewar painting of the period. A blue sky and white cloud band appear in the distance beyond a row of dark green mountains. The scene is bordered in yellow and red.

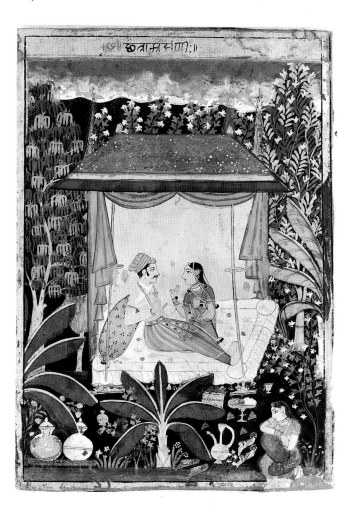

The great sets of seventeenth-century Mewar and Udaipur paintings, such as the 1628 Sahibdin *Ragamala* and the 1650 "Gem Palace" series in the National Museum, New Delhi, are noted for their exquisite quality, vibrant palette, and lush vegetation that integrate the settings and love themes. This page, in a slightly less refined and finished mode, is probably by a different hand from the one responsible for other groups, but certain elements do relate to that series, such as the stylized foliage and the wavy white cloud band at the horizon. A Mewar page in the collection of Dr. Alvin O. Bellak, Philadelphia, identified as *Abhisarika Nayika* and dated to circa 1630, demonstrates the same flowering trees, banana tree, and shrubs, all landscape elements that

give a sense of the atmosphere of the subject (Kramrisch 1986, cat. no. 61). There is also a direct stylistic relation to the Mewar *Gita Govinda* of circa 1650 (cat. no. 157). AGP

Literature Katz 1963, cat. no. 122.

159 Artist unknown

Page from a dispersed Bhagavata Purana series

Rajasthan, Mewar
Circa 1680
Opaque watercolor on paper
Image 8½ x 13½ in. (21.6 x 34.3 cm)
Sheet 9³⁄₁₆ x 14¼ in. (23.35 x 36.2 cm)
Gift of Dr. and Mrs. Robert Walzer, 84.206.1

The central section of this page from the same series as catalogue number 160 shows demons attacking the city of Mathura, represented as a walled pavilion from multiple vantage points. This central scene is flanked by two three-story pavilions: the one at the left is occupied by demons in awe of Krishna's power; in the one at the right, the infant Krishna is shown with his adoring parents.

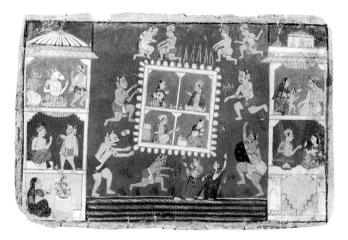

The text on the verso, written in Braj, in black ink with verse numbers indicated in red, in Devanagari script, reads:

. . . The Lord [Krishna] was conceived by Devaki. At the same time her co-wife also conceived and they both went through feelings of fear, joy, and sadness. . . .(1) For the welfare of Jadu lineage, the Almighty switched himself with Jogamaya. (2) He frightened and killed Mu[?]shtika,

Vrishvasura, Banasura, and the demoness Putana. (3) He went to Mathura, returning to his natural parents, who became very happy. (4) Their sadness was gone forever. The kings of Panchala, Koshala, Salva, and Vidarbha, along with the son of the demon Dhenuka, joined together to threaten Mathura. (5) Their joint attempt to burn the city was foiled by Hari [Krishna], the cloud-complexioned boy. . . . (6) Part 6. (Trans. S. Mitra)

AGP

160 Artist unknown

Page from a dispersed Bhagavata Purana series

Rajasthan, Mewar
Circa 1680
Opaque watercolor on paper
Image 8¼ x 13⅞ in. (21 x 35.2 cm)
Sheet 9¹⁄₁₆ x 14⅛ in. (23.05 x 35.9 cm)
Gift of Dr. and Mrs. Robert Walzer, 84.206.2

This page illustrates the effect of Krishna's enchanting flute playing. As described in the accompanying text, Krishna, depicted in the center of the third register from the top, is surrounded by an admiring audience—cows, cranes, swans, ascetics, cowherds, and young maidens (distributed in registers above and below the hero). In carriages spread in a horizontal blue band across the top of the page, the *devatas* and the gods in the heavens listen to the music and shower Krishna with flowers. In a three-story pavilion at the left, pairs of seated women are shown conversing.

The stylized trees with leaves or branches highlighted in yellow are a typical Mewar convention. Figures and objects in these scenes are silhouetted against a solid red, blue, or brown ground. For other pages from this series, attributed to Malwa, see Fussmann Collection 1992, pp. 160–63, cat. nos. 76–77.

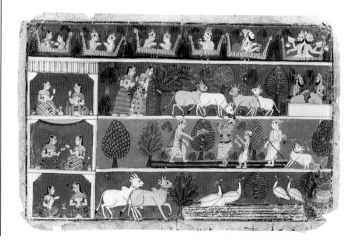

The text on the verso written in Braj, in black ink, in Devanagari script, reads:

Shri Krishna took the herd of cows to the forest. There the Beloved one played his flute while the boys of Vraja [Vrindavana] listened. (1) Praise be to the crowned god standing in a delicate threefold posture, immersing everyone's ears in his divine music and everyone's eyes in his unparalleled grace. (2) The scene of the Hari's delicate fingers playing the flute steals everyone's minds. (3) In the heavens, the gods listen to his music; on earth, the ascetics offering worship listen as well. The women engaged in casual conversation, mingled with laughter, forgot everything and became frozen like a painted image. (4) Along the banks of the river Yamuna, cows, oxen, deer, and peacocks stopped to listen to the flute. (5) Listening to the flute, even the forest dwellers mistook the moving water and the immobile stone as static and dynamic, respectively. (6) Seeing the son of Nanda [Nandalala Krishna] decorated with tilak, tulasi, and the garland of wild flowers, the inebriated swarms of bees and flocks of watercranes, birds, and swans surrounded him. (7) Listening to his tunes, Shiva, Shakra [Indra], and Brahma [Vidhi] lost their senses. Maidens of noble families, returning home, forgot the direction. (8) Such was the state of the maidens of Vraja, and the merits of Hari rai [Shri Krishna] have been recited. This page of this chapter is complete with the recitals of the merits of the Lord (9). Part 60. Chapter 34. (Trans. S. Mitra)

For another page from the same series, see catalogue number 159. AGP

161 Artist unknown

Belavala Ragini

Page from a dispersed *Ragamala* series
Rajasthan, Mewar
Circa 1680
Opaque watercolor and gold on paper
Image 14⁹⁄₁₆ x 8⁹⁄₁₆ in. (37.2 x 21.7 cm)
Sheet 14¹⁵⁄₁₆ x 11½ in. (37.7 x 29.3 cm)
A. A. Healy and Frank L. Babbott Funds, 36.253

This large-format *Ragamala* page epitomizes late-seventeenth-century Mewar painting. The central scene of the three registers depicted here shows a woman seated on a bed in a two-story pavilion. While one attendant holds a mirror before her and another holds a *morchal,* she arranges an earring. At the right two more attendants stand outside the building. The women are all elegantly dressed in saris and jewelry. Below, seen against a deep blue background, are four musicians seated on a pink carpet. To the left are a banana tree and a large flowering shrub. In the uppermost part of the composition, trees and birds are shown against a deep blue sky. To the left is the sun, painted in gold, with a human face.

Eight pages from the same series are located in the Museum of Fine Arts, Boston (see Pal 1967, pls. IV, VIII, XIV, XVII, XIX, XXIII, XXXVI, XXXIX). Other miniatures from this series are located in the collections of the British Museum, London (Stchoukine 1929, pl. LXVIII, and Gray 1949, pl. 4); Cleveland Museum of Art (Leach 1986, p. 228); Ralph and Catherine Benkaim, Beverly Hills; Everett and Ann McNear (McNear 1974, pl. 66). AGP

Literature Reiff 1959, p. 12, pl. 3; Lee 1960, cat. no. 17b.

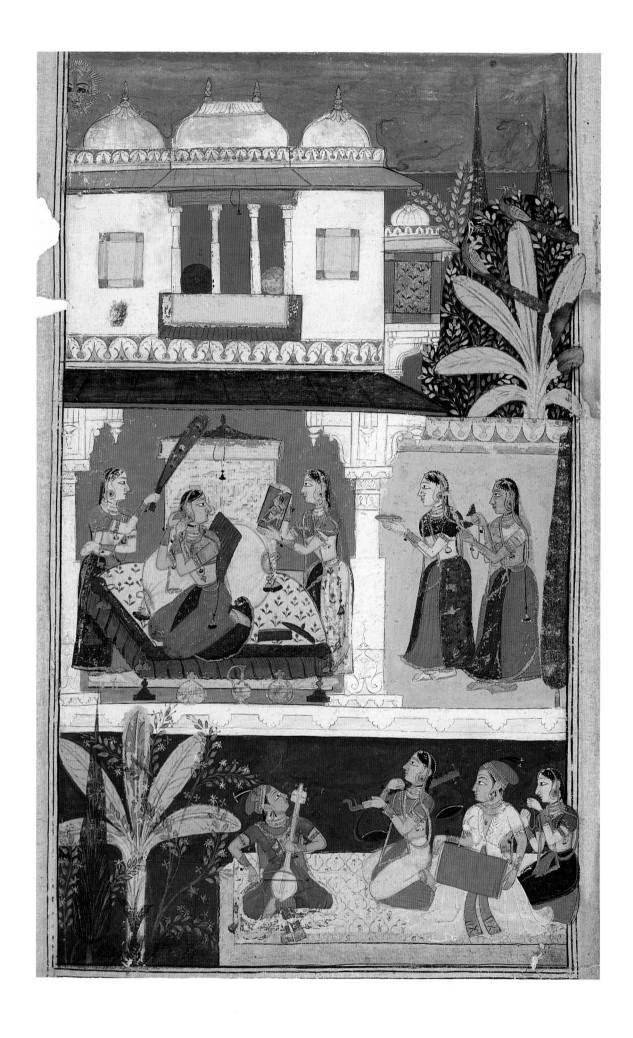

162 Artist unknown

The mature unrestrained heroine

Page from a *Rasikapriya* series
Rajasthan, Mewar
Circa 1660–90
Opaque watercolor and gold on paper
Image 8¾ x 6¼ in. (22.2 x 15.7 cm)
Sheet 9¼ x 6¾ in. (23.5 x 17.2 cm)
Gift of Mr. and Mrs. Paul E. Manheim, 69.125.1

The *Madhya Adhira Nayika* is the unrestrained heroine *(nayika)* in mid-youth who expresses her anger. She is supposed to lack self-possession, and so praise alternates with harsh criticism in the verse (in the top panel) as she berates Krishna:

Your body is like your father's [old], and your energy compares to that of your brother Balbir [you are as weak and drunk as he is]. Your face is like your mother's, and you have a similar lovable quality that is so appealing to me! Like the earth, you too are stable and immobile, but also like the wind, you can be fickle [impatient]. Like water,

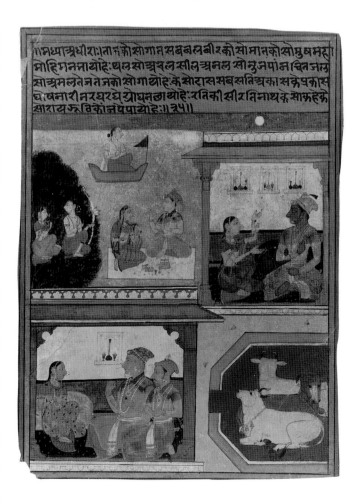

your heart is pure and your energy emanates like fire. As is true of the sky, your word and your status are known everywhere. Your love is like that of Rati [wife of Kama, lord of love] and your form like Kama's. Now tell me, o lord! Have I said anything untruthful? (Trans. V. N. Desai)

In a pavilion at the upper right, the heroine is seated with Krishna, gesturing as she compares his actions to those of his family and the gods, who are depicted in the scenes at the left. A pavilion at the lower left is occupied by Krishna's parents and his brother, Balarama, to whom the *nayika* traces certain of Krishna's traits, especially his tendency to become intoxicated. In the scene above, he is shown enjoying himself with a female companion. Kamadeva and Rati are shown crouching in the branches of a tree to the left of this couple. The male celestial above is visual reference to the sky, which is mentioned in the text. The lower right corner is occupied by three recumbent cows, suggesting the stability of the earth. Their bodies are all shown in profile view except for their heads, which are shown, progressively, in profile, in frontal view, and from the rear.

V. Desai explains that the Braj text, written in Devanagari script in the panel at the top of the page, is the title of the *Rasikapriya* verse (Ch. 3, v. 48) expressed in the form of similes (correspondence, 1992).

This page is one of three paintings from a dispersed *Rasikapriya* series in the Museum's collection (see cat. nos. 163 and 164). Pages from this series are also in the Government Museum, Udaipur; Prince of Wales Museum, Bombay; National Museum, New Delhi; Bharat Kala Bhavan, Banares. AGP

163 Artist unknown

The bewildered nayika

Page from a *Rasikapriya* series
Rajasthan, Mewar
Circa 1660–90
Opaque watercolor and gold on paper
Image 8⅞ x 6⁵⁄₁₆ in. (22.6 x 16 cm)
Sheet 9¼ x 6⅞ in. (23.5 x 17.5 cm)
Gift of Mr. and Mrs. Paul E. Manheim, 69.125.2

The text in the band at the top of the page describes the condition of the *Vichitra Vibhrama (Praudha) Nayika* (the bewildered heroine who remains slightly lost until she meets her beloved). The grammatical form clearly indicates that the verse is a conversation between two female attendants, as de-

picted in the lower left corner. The person who originally decided on the visual composition of the verse, most likely the creator of the first set of the Mewar *Rasikapriya* dating to circa 1630 on which this composition is clearly based, was highly literate and completely aware of subtle literary devices.

The Braj text, written in Devanagari script, in the panel at the top, explains the title of the *Rasikapriya* verse (Ch. 3, v. 4):

Krishna is delighted in his heart to see her slow charming gait. Her gentle smile, sensual *aura* and bodily fragrance are totally controlled by him. Seeing her bewildered condition, Krishna [the son of Nanda] feels like Kama himself thinking that indeed Brahma has mistakenly called Kama's arrows flowers, the real arrows are the feelings he generates. (Trans. V. N. Desai)

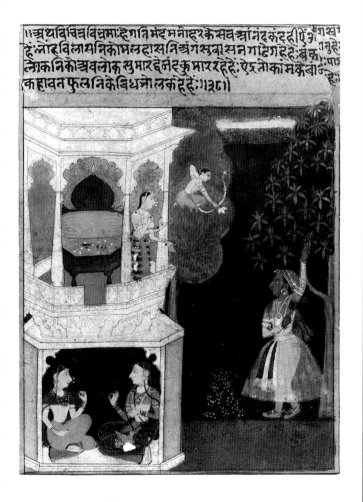

In the lower left of the painting, the two attendants mentioned in the text are shown conversing. Radha stands in the open pavilion above, looking down and gesturing toward Krishna. He stands beside a mango tree, with a branch of the tree in his left hand and his right hand pointing upward. High among the leaves of a nearby tree, Kamadeva is shown aiming his flowery arrow at Krishna.

For other pages in this series, see catalogue numbers 162 and 164. AGP

164 Artist unknown

The heroine whose desires are apparent

Page from a *Rasikapriya* series
Rajasthan, Mewar
Circa 1660–90
Opaque watercolor and gold on paper
Image 9 x 6⅜ in. (22.9 x 16.4 cm)
Sheet 9½ x 6¹⁵⁄₁₆ in. (24.2 x 17.7 cm)
Gift of Mr. and Mrs. Paul E. Manheim, 69.125.3

V. Desai explains that the Braj text, in Devanagari script, in the panel at the top relates to the title of the *Rasikapriya* verse (Ch. 3, v. 38):

The *Madhya Padurbhuta* type of *nayika* whose sensuous desires have become apparent. Today I happen to see one such *gopi* [who is so unique for her features that] she does not look like a daughter of an *ahira* [cowherd]. Her bodily charm is such that it is not found in others, and having seen her once you want to see her always. With one of her winks [full of amorous glances], the whole of the charm of the three worlds could be showered. Who could be the husband of such a beauty, the moon [Kalanidhi] or Kama, the god of love, or Krishna? (Trans. S. P. Tewari, with V. N. Desai)

The depiction of Radha in the upper left pavilion is of an adorned female, surrounded with all the paraphernalia of lovemaking—betel, flowers, etc. In the central scene she approaches Krishna with a saluting Kamadeva in tow, who carries a flower arrow. Radha refers to him with a gesture of her left hand, perhaps indicating him as a possible husband. The prominent moon refers to the second possible husband of Radha mentioned in the text.

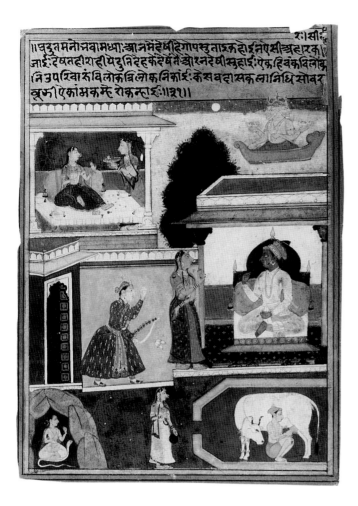

In the actual verse, a *gopi* or *sakhi* is describing the resplendent *gopi* she saw who was more charming than any other she had seen, a *gopi* and yet unlike a *gopi,* whose one powerful amorous glance was of more value than a vision of the splendors of the three worlds. She speculates that one so like the moon must desire union with Krishna. The fact that this *gopi,* Radha, is quite extraordinary is shown by the reactions of the three figures in the lowest register. The ephemeral Radha seems to be off somewhere to the right, for all three stare in that direction with beatific transfixed expressions. The *gopika,* probably the narrator in this verse, has let her milk vessel slip from her hip, where it is usually carried; the *gopa* is not at all attentive to his task of milking; the brahmin in his cave gazes intently, and even the *naga* (serpent) is pointed in that direction.

The introduction of these secondary figures, such as the *gopa* and the brahmin, is an allusion to Radha's *alaukikatva,* or quality of being not of the world. Radha is compared to the *lokas,* or realms, one of which, the *Satya-loka,* the highest realm, is represented by the deity Brahma, who is depicted holding the manuscript of the Vedas in a carriage at the top of the page. Inscribed on the Vedas held by Brahma is the phrase *shri saji,* the meaning of which is not clear but perhaps represents Brahma's invocation at the beginning of a verse.

For two additional pages from the same series, see catalogue numbers 162 and 163. AGP

165 Artist unknown

Episode surrounding the birth of Krishna

Page from a dispersed *Bhagavata Purana* series
Rajasthan, Mewar
Late 17th–early 18th century
Opaque watercolor on paper
Image 8⅞ x 14⅝ in. (22.5 x 37.2 cm)
Sheet 10⅛ x 15¹⁵⁄₁₆ in. (25.75 x 40.4 cm)
Gift of Emily M. Goldman, 1991.180.10

Vasudeva and Devaki are seen in the prison house of Kamsa, Devaki's brother. Vasudeva is seated with his feet and hands in shackles, while Devaki lies on the bed with the newly born Krishna. Kamsa had been forewarned by a heavenly voice that his sister's eighth child would kill him. In an attempt to avoid his destiny, he has imprisoned his sister and her husband, and killed each of their children at birth. When the eighth child, Krishna, is born, Vasudeva manages to steal out of the prison at night carrying his newborn son. He makes his way to Vrindavan and exchanges his child with the newly born daughter of Yashoda, the wife of the king of Vrindavan. He then returns to the prison and places the baby girl next to his sleeping wife.

The next day, Kamsa learns that his sister has given birth to another child. He rushes to the prison in order to hurl the infant to the ground, little realizing that she is none other than the goddess Durga. Flying up into the sky as she manifests her many-armed form, she taunts Kamsa that the child destined to kill him has already been born.

The two episodes depicted here appear in the *Bhagavata Purana* (Tenth Canto, Ch. 4, vv. 7–12).

The text on the verso has no relation to the scene depicted on the recto. AGP

Exhibition "Indian Miniatures from Mughal and Rajput," School of Visual Arts Gallery, New York, 1972.

Literature Parke Bernet 1964, lot no. 48 (listed as Pahari School).

Provenance Paul E. Manheim, New York; Jay C. Leff, New York; Nasli M. Heeramaneck, New York.

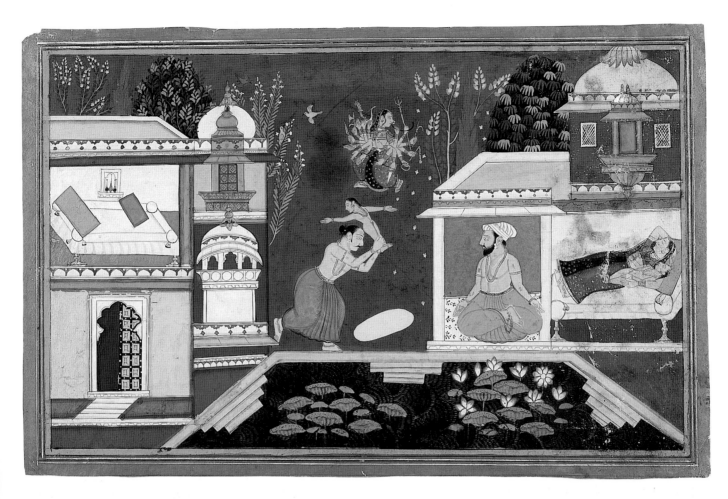

ll गीतगोविंदरो यत्रा पधषा चंचलकुंउला राधिकासघिप्रतेकूद्धे ॥वाकुवतीकीसिहे ॥ चंचलद्वाते श्रीभम्वा ॥ नराकुंउलांगलिकरे ॥ ललितहेके गोललीला
 संवदेकरेऊ नारभशाकतिभेषला ॥ अलीकरेऊगन ॥ स्वोते निभ्बा ॥ नलीरागतिकरे बंचले ॥ चंचलकुराउल ललितकपीला कुरुवारि तरसनज्झ धौनगति
लीला ॥ ५ ॥ काषि॰

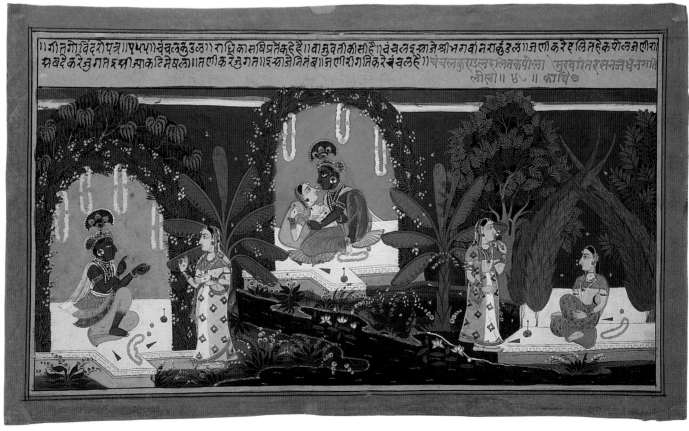

212

166 Artist unknown

Quivering earrings

Page from a *Gita Govinda* series
Rajasthan, Mewar
1714
Opaque watercolor and gold on paper
Image 7⅛ x 15⁵⁄₁₆ in. (18.1 x 38.9 cm)
Sheet 10 x 17 in. (25.4 x 43.2 cm)
Gift of Cynthia Hazen Polsky, 77.138

At the right, the heroine, Radha, sits alone in a bower at night. She is turned to face her *sakhi,* and her eyebrows are knit in suspicion as she crosses one leg over the other. She is elaborately dressed in a gold ankle-length skirt patterned with a red floral motif, an orange choli, and a transparent red veil bordered with a gold band. She wears armbands, a necklace, bracelets, anklets, a nose ring, and hair ornament. Accoutrements are placed around her in preparation for the arrival of Krishna. Above her, the intersecting arched boughs of cypress trees create the sensual space for lovemaking.

Radha's suspicion is aroused as she imagines her adored Krishna with another woman. Just such a scene is depicted at the center, where Krishna and a female companion occupy a bower decorated with three pendant garlands, in which they are isolated by a symbolic red background and thick arched creeping vines. The woman wears a bright yellow choli, an orange transparent scarf bordered with gold, and an orange skirt with pleats highlighted in red.

At the left Krishna is again represented, here seated alone on a dais in a bower surrounded by dense thickets. His costume consists of a narrow scarf draped around his shoulders, a white band around his waist, and a yellow dhoti with three tiers of folds at the hips in orange, pink, and lime green. A fan of peacock plumes is fastened to the top of his crown. With her hands raised in a gesture of conversing, Radha's *sakhi* stands to the right of Krishna's bower.

Radha imagining Krishna with another woman is the subject of the Sanskrit text (Fourteenth Song, v. 16) in the yellow band at the top, written in a Hindi dialect in black ink in Devanagari script (Miller 1977, p. 99):

Quivering earrings graze her cheeks;
Her belt sounds with her hips' rolling motion.
Some young voluptuous beauty
Revels with the enemy of Madhu.

The lush vegetation and the river flowing through the landscape reiterate the theme of sensuality. Details rich in evocative overtones convey the sound of the movement of jewelry mentioned in the text; white blossoms are sprinkled throughout the bowers and landscape. Fully opened lotuses

in the river bend toward the lovers. The decorative treatment of the foliage, textile patterns, vibrant coloring, and the mannered depiction of the figures are typical of late Mewar style as represented in this series. The figures are typically stylized with stiff disproportionate poses and gestures, the heads are large, the hands are awkwardly drawn, and the repetitive, unindividualized facial types do not convey emotion. Only the costumes of the figures offer variety, and while these are not finely delineated, trees and vegetation are more carefully worked in standardized overlays of leaves on solid green ground.

Both this painting and another page in our collection (cat. no. 167) are part of a *Gita Govinda* series that can be dated to 1714 on the basis of a colophon (Vatsyayan 1987, pp. 227–28). Vatsyayan suggests that the series was completed in three phases; the first set, now located in the Government Museum, Udaipur, consists of one hundred paintings and depicts the First through Ninth Songs and is "more closely faithful to the verbal text" than the other sets (ibid., p. 2). The second set, to which we attribute our page, is associated with the 1714 colophon (ibid., p. 228). Sets two and three are not as cohesive, vigorous, or sensitively rendered as the first set (ibid., pp. 136–37). Other pages have been published by Bautze 1990, p. 225, and Bautze 1991, cat. nos. 82–83, which are referred to as "the missing one hundred pages of this series" (p. 196, n. 6).

Other pages from this series are located in the National Museum, New Delhi; Art Institute of Chicago; Newark Museum; and various private collections. AGP

Literature Wiener 1971, cover illustration; Poster 1987, col. pl. p. 26.

167 Artist unknown

Kama and Rati witness the reunion of Krishna and Radha

Page from a *Gita Govinda* series
Rajasthan, Mewar
1714
Opaque watercolor and gold on paper
Image 8⅞ x 15⅝ in. (22.3 x 39.7 cm)
Sheet 10 x 16¹⁵⁄₁₆ in. (25.3 x 43.1 cm)
Promised gift of Anthony Manheim, L71.23.2

Bowers with floral creepers and hanging garlands are the setting for the continuing narrative of the Mewar *Gita Govinda.* At the left, Krishna is seated in a bower isolated

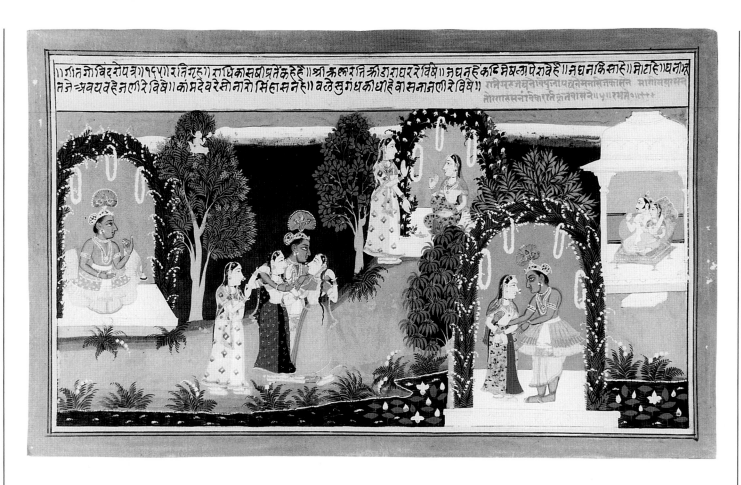

against a red background surrounded by dense arched vines whose tips are outlined in white. He wears a white scarf around his waist, a three-tiered orange, red, and pink girdle patterned with gold, and a yellow dhoti whose pleated border is outlined in red. He is ornamented with jewelry and a plumed crown.

In the center, Krishna dallies with two *gopis,* while Radha's companion watches. Their transparent scarves gently curve around them and the folds of their skirts are softly outlined.

The green forest path on which Krishna and the *gopis* play leads to a hill where Radha's companion comes to speak to Radha, who, like Krishna at the left, is seated alone in a bower surrounded by dense flowered branches and three pendant garlands. A gold incense burner by Radha's feet may represent the close relationship of scent and sensuality.

In the next scene, Krishna and Radha are reunited, and Krishna asks for Radha's forgiveness. An even more lush bower in a river bordered by lotuses surrounds them.

The two figures at the extreme right observing the reunion scene, possibly the divine couple Kama and Rati, are seated on a gold throne in a pavilion designated in the text as the "abode of Rati" and "the golden throne of Love [Kama]."

The Sanskrit verse is written at the top in red ink and repeated on the reverse, and the two lines of text in black ink, in a Hindi dialect, describe the scene:

Her broad hips are a temple of passion holding Love's golden throne;
He lays a girdle of gemstones there to mark the gate of triumph.
In woods behind a sandbank on the Jumna river,
Mura's foe makes love in triumph now. (Miller 1977, p. 101)

For another page from this series, see catalogue number 166. AGP

168 Artist unknown

Page from a dispersed Panchakhyana series

Rajasthan, Mewar
Circa 1720–40
Opaque watercolor on paper
Image 9⅝ x 15¾ in. (24.4 x 40.1 cm)
Sheet 10⅜ x 16½ in. (26.3 x 41.7 cm)
Anonymous gift, 81.192.8

Recto, at top, in Devanagari script: *A page from* Panchakhyana. *(122) Then a lion said: "My heart will not turn against him." Then Damanaka said: "Whoever the king likes earns the Fortune, he may be his brother, his own son, or his own kin, it is not of importance. [But] the ladies have a song that means: what is the use of gold that hurts the ears."* (Trans. S. P. Tewari)

Shown on a hillside at the right, the animals of the wild join in this fable scene. Figures engaged in discourse fill the rest of the scene.

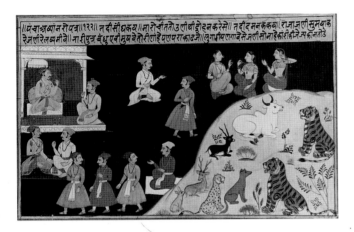

The title *Panchakhyana,* or *Panchakhyanaka,* denotes the stories of *Panchatantra,* allegorical stories much like *Aesop's Fables* (see Edgerton 1924). S. P. Tewari has noted (personal communication, 1991) that sometime in the twelfth century the title *Panchakhyana* was adopted for the work by Purnabhadra. This version of the text became very popular in western and central India. It is also known that Akbar commissioned at least one illustrated version of these tales. Besides the version of the text that was followed by the painter of our page, many versions of the *Panchatantra* were also translated into medieval and modern vernaculars (ibid., vol. 2, pp. 1 et seq. and 27 et seq.), as attested by the text in Rajasthani dialect at the top of our painting, which formed part of a now dispersed *Panchakhyana* series of the *Panchatantra* stories. AGP

Provenance Christie's 1977, lot. no. 140.

169 Artist unknown

Embracing couple

Rajasthan, Mewar
Circa 1725–30
Opaque watercolor, gold, and silver on paper
Image 9 11/16 x 5½ in. (24.7 x 14 cm)
Sheet 11 3/8 x 8 3/16 in. (28.9 x 20.8 cm)
Anonymous gift, 80.277.14

Obverse, at top, in broad yellow band, in Devanagari script: *Asananama. The lady's back is on the bed and he grasps her waist . . . and they are enjoying the pleasure of love-making.*

A bearded prince and his lover are shown in sexual embrace on a canopied bed on a royal terrace. Her left arm is raised and she holds a metal cup in her hand. The faces of the figures and their jewelry are carefully rendered, while their naked bodies are stiffly drawn. Their clothing and his dagger are on a footed table at the left. Silver vessels on the carpets surround the dais. This scene is probably from a sexual manual, such as the *Kama Sutra.*

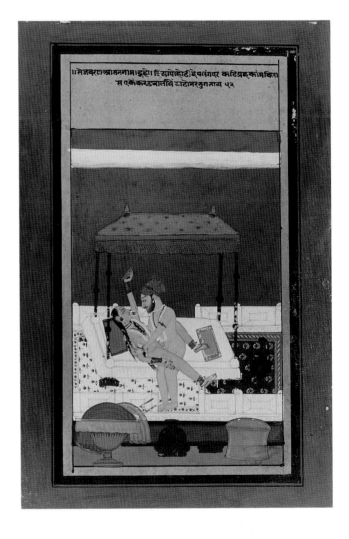

Erotic painting of this type was not uncommon in India in the eighteenth century and later. The embracing couples in many of the *Ragamalas* illustrated in this volume have underlying themes of a sexual or erotic nature or are laden with sexual symbolism. Poems such as the *Rasikapriya* or the

Gita Govinda, whose illustrations also comprise many of the paintings reproduced here, are largely concerned with such subject matter. Given that paintings were kept for private contemplation (rather than mounted as decoration in public rooms), we should not be surprised that such subject matter proliferated. AGP

170 Artist unknown

Fragment of a Jain Vijnaptipatra

Rajasthan, Mewar School, probably Udaipur
Circa 1725–50
Opaque watercolor on paper
Image (each rectangular element) 3⅝ x 3³⁄₁₆ in. (9.2 x 8.1 cm)
Sheet 12½ x 8⅝ in. (31.75 x 21.9 cm)
Anonymous gift, 73.175.10

The *Vijnaptipatra* was a formal invitation sent by Jain communities to monks inviting them, especially in the rainy season, to reside with the community and discover and share their knowledge. Many eighteenth-century examples have survived, which were painted primarily in Rajasthan and Gujarat (for four related examples, see Rosen 1986, cat. nos. 26, 68e, 69a, 69b).

This highly ornate fragment of the top of a long *Vijnaptipatra* is composed in a compartmentalized format. Six aligned rectangles representing six of the eight auspicious symbols of the Jain (*ashtamangala*) are embellished with stylized niches that contain, reading down from upper left: a red swastika (*svastika*) with orange flowers and dark green leaves that radiate from the center on a green background; a garlanded lotus vase (*kalasha*) with piercing eyes at the neck of the vessel on a gray background; a silver complex Jain swastika (*nandyavarta*) on a red background. Reading down from upper right, the niches contain: a red lotus on a silver background; a red and gray "throne of distinction" supporting a parasol (*bhadrasana*); a mirror (*darpana*) surrounded by flowers, rendered in a standardized form that reflects a bust portrait of a female. The two symbols missing from this fragment are the powder vase (*vardhamanaka*) and the pair of fish (*matsyaugma*). In any Jain series, including *Kalpasutras,* these eight symbols would be represented.

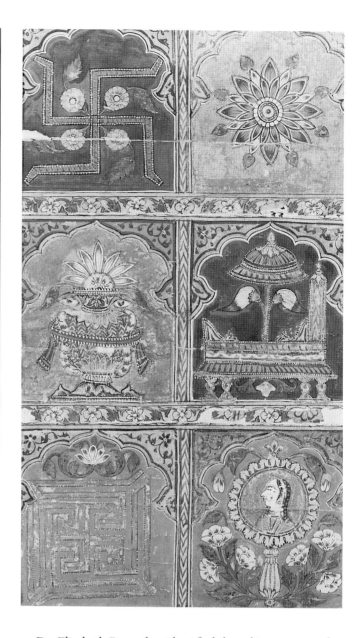

Dr. Elizabeth Rosen has identified the subject matter of the fragment and has suggested the dating based on a comparison with the border decoration of a dated example painted in 1725 at Sirohi in Southern Rajasthan, now in the National Museum, New Delhi. She also observes that the red lotus is not the usual motif represented among the *ashtamangala;* a *shrivatsa* would have been the common symbol in the group of eight auspicious symbols (personal communication).

The ornamentation and architectural setting within each compartment, as well as the decorative borders separating them, and especially the physiognomy of the female shown in profile, compare in style and palette to a Mewar-style painting from a *Chandana Malayagiri Varta* dated to 1745 in the Museum's collection (cat. no. 150), here ascribed to Marwar/Jodhpur. The style also compares with other documented pieces in the Spencer Collection at the New York Public Library. AGP

171 Artist unknown

Maharaja Pratap Singh II of Mewar hunting boar

Rajasthan, Mewar
Circa 1750–75
Opaque watercolor, gold, and silver on paper
Image 9 x 12 in. (22.85 x 30.5 cm)
Sheet 9¾ x 13⁵⁄₁₆ in. (24.8 x 33.8 cm)
Anonymous gift, 80.180.2

INSCRIPTIONS
Verso, at top left, in black ink, in Devanagari script: *Maharaja Shri Pratap Singhaji;* repeated at top right, in Urdu script.

Maharaja Pratap Singh II (r. 1752–55) on horseback accompanied by two dogs chases three wild boars. A sparse landscape is suggested by a few tufts of vegetation along the ground line and a solid light green background. The raja wears a long red jama with a striped pajama, red waistband, and gold sash, and is opulently arrayed with a black-plumed gold turban, earrings, bracelets, and rings, a quiver of arrows, long sword, black shield, and a *katar* with a blue jade handle in the shape of a horse. His brown mount is richly outfitted with a girdle of bells, silver plume, gold bridle, and string of pearls. The dogs are dressed with ornamented collars. There are silver and red borders.

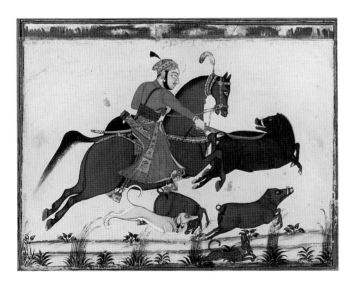

The figure's pose on the horse is awkward, as if he is standing astride the animal, while the actions of the horse, dogs, and boars are more naturalistically rendered. AGP
Literature Poster 1987, pp. 44–45, col. pl.

172 Artist unknown

The goddess Matangi

Rajasthan, Mewar
Circa 1760
Opaque watercolor, gold, and silver on paper
Image 10½ x 15⁷⁄₈ in. (26.7 x 40.3 cm)
Sheet 11¼ x 16½ in. (28.6 x 41.9 cm)
Anonymous gift, 84.201.9

INSCRIPTIONS
Recto, at top, in Braj, in black ink, in Devanagari script: *The fair, two-armed form of Shri Matangi ji. In one hand, the head of Mahesha, in [the other] hand, Mahesha's sword. . . . [You are] blazing on your subjects, who bow to you.* (Trans. S. Mitra); left, over image of goddess, in black ink, in Devanagari script: *Matangi.*

The inscription identifies the two-armed goddess as Matangi, the fierce form of Durga. In the center, she is represented in her usual configuration, multiarmed and riding a tiger. She wears a dark blue skirt, green choli, and brown veil, and is heavily bejeweled and crowned. The tiger is shown in an alert position, mouth slightly open, tail raised. The body is rendered in orange with black streaks and outlined in white. Silver chains decorate its neck. Six figures, with hands raised in supplication, stand in two rows at the right. Five of these are haloed, an indication of their divine status. The sixth may represent a ruler of Mewar, who possibly commissioned the painting. The figure of the goddess is repeated at the left, standing on the prostrate body of her counterpart, Shiva, a raised sword in one hand and a severed head in the other. Both goddesses have orange decorations on their foreheads that extend to their cheeks.

Many paintings reflect patronage of Shaivite rulers in Mewar. In a painting of Amar Singh II (r. 1698–1710) of Mewar (Welch and Beach 1965, pp. 72–73), the haloed ruler is shown with a crescent moon, a common attribute of Shiva and his consort goddesses. The ruler as a form of the supreme god on earth might have assumed all these attributes to glorify his image. The same halo and crescent moon adorn the central goddess in this painting. The ruler's sovereign and divine authority is probably suggested by the attendance of a multitude of gods in the worship of Matangi, his favorite goddess.

The subject of Matangi, a tantric form of *shakti,* representing the "Elephant Power" as associated with the Mahishasura myth, is not common in Rajasthani painting. For two comparable examples showing the Goddess Durga, see S. C. Welch 1973, p. 31, no. 10, from the James Ivory Collection; and Christie's 1980, lot no. 175. The painting is topped by a wide band of bright yellow, bearing the inscription. Black and dark red borders alternately outline the painting. AGP

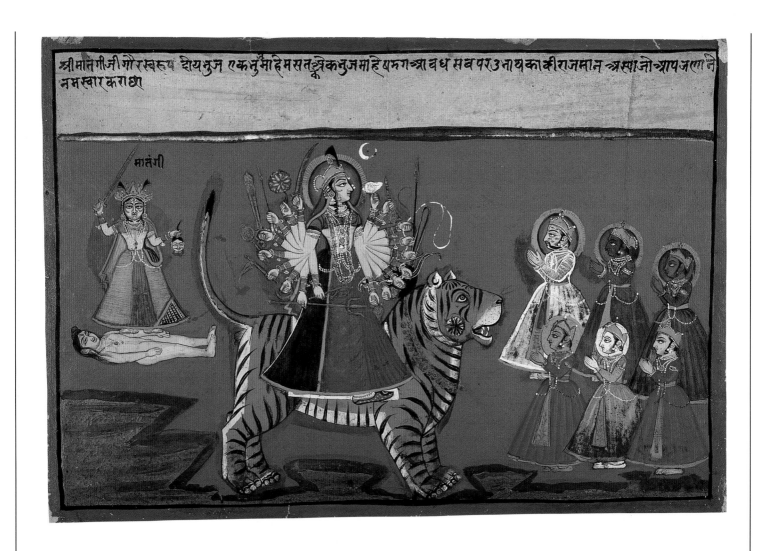

173 Artist unknown

Portrait of a stallion

Central Rajasthan, Ajmer (Sawar or Issarda)
Mid-19th century
Opaque watercolor, silver, and gold on paper
Sheet 11⅛ x 8 in. (28.25 x 20.3 cm)
The Brooklyn Museum, by exchange, 38.17

A majestic black-and-white stallion depicted as an idealized portrait is shown in profile facing the viewer's right. The stallion is caparisoned with a green, yellow, and red bridle with red tassels and a silver bell, green, yellow, and red girdle, red reins, and a magenta cloth over a red saddle on a green saddle-cloth dotted with red-and-white rosettes. His mane is plaited and finished with gold bells and long scarlet bands. The tip of his tail is dyed scarlet. The horse is set against a flat yellow ground with only a suggestion of such landscape elements as the grass below his hooves and the blue and white clouds across the top.

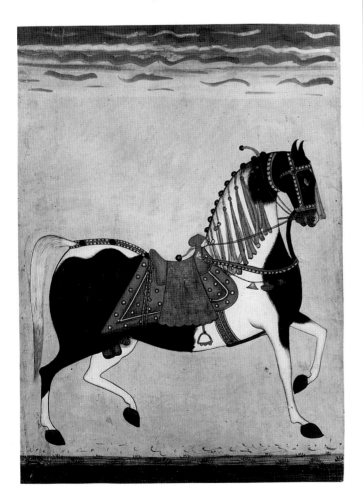

In contrast to the stylized simplicity or pictorial economy that characterizes the background, the subject is rendered in exquisite detail. His body has been modeled convincingly with the use of hatched lines in gray on white, most noticeably at the edges of the form contained by a black outline. The interplay of natural light on the horse's sleek coat is suggested with minute white hatched details on the curved black areas. The application of gold and silver has been limited to realistic accents for the metal bells, stirrup, and bit, another indication of the artist's interest in portraying the animal's nobility.

This painting was originally thought to come from Jaipur, but has recently been reattributed to the Ajmer area of Central Rajasthan on the basis of its stylistic rendering (Andrew Topsfield, personal communication). The artist used a ledger page that has dates on the reverse, on which basis the dating has been revised from the late eighteenth century to the mid-nineteenth. AGP

Literature Eastman 1934, cat. no. 66.

Provenance Nasli M. Heeramaneck, New York.

174 Artist unknown

Seated princess with attendant and lion

Rajasthan, Sawar (Ajmer)
Circa 1750
Opaque watercolor on paper
Sheet 8¹⁵⁄₁₆ x 5⁹⁄₁₆ in. (22.7 x 14.3 cm)
Gift of Martha M. Green, 1991.181.4

The princess, seated on a chair, and her female attendant, fanning her with a peacock feather fan, are depicted without fully colored costumes, although the attendant wears an unusually elaborate headdress. A recumbent lion occupies the area below the two women. There is a willow tree to the left and two flowering trees to the right. Washes of green, yellow, mauve, and red highlight the drawing of the figures and their costumes.

The attenuated figures and superimposed elements that indicate recession into space, as well as their unnatural juxtaposition, associate this study with the style of painting of Sawar, a *thikana* of Ajmer. This type of painting is charac-

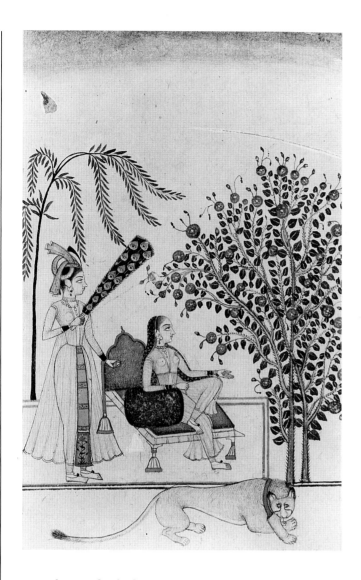

The standing figure at left carries an object, perhaps a scroll, over his shoulder. The text on the verso suggests that he has come to deliver a message to the seated figure, whom we tentatively identify as a ruler. The tilak marks on the foreheads of both figures establish their identity as Shaivite devotees. The seated figure wears a floral-patterned, full-length mauve garment, an orange and gold sash, a blue caplike hat with red and white dots, and several items of jewelry. The ruddy raja holds a *katar* in one hand and a shield in the other. The treatment of the hand and fingers is cursory and awkward. A large black aureole with an orange border, partially concealed by a yellow, pink, and green parasol, indicates his regal status. He sits on a green and black carpet and leans against a large, almost spherical, yellow bolster.

The white complexion of the messenger is relatively stark in comparison with that of the ruler. He is dressed in a dark green jacket with a long tail, red-orange trousers gathered at the bottom in tight creases, and an unusual dark blue hat with a trailing protecting neck piece of geometric design. An unusual feature is his hair, which falls loosely to his shoulders instead of the customary knot or concealment under the turban. The crossed eyes of the figures are also puzzling.

The figures are set against a plain orange field. The bold colors and stylized treatment of their physiognomy and costumes, as well as the setting, are typical features of Sirohi painting, and further enhance the frozen action of the messenger's reception. The scene is bordered with a series of red and yellow lines, into which the messenger's parcel and feet protrude.

terized as "unfinished," i.e., "painted directly on the paper without preparing a burnished surface" (Sharma 1974, cat. no. 75, pl. 73), or as having an "incomplete look" (Archer and Binney 1968, p. 47, fig. 34). AGP

175 Artist unknown

Fragment of a page from a Markandeya Purana series

Southern Rajasthan (Sirohi or Devgarh)
Circa 1630
Opaque watercolor and gold on paper
Sheet 4⅞ x 4¹¹/₁₆ in. (12.4 x 11.9 cm)
Anonymous gift, 1990.185.3

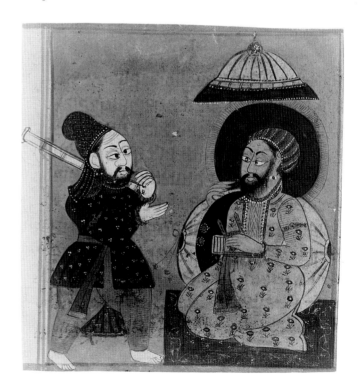

On the basis of its stylized representation of figures and choice of bold colors, this fragment has been tentatively attributed to Southern Rajasthan. This scene of a Shaivite devotee greeting a messenger is probably a fragment of a larger painting. Since the page has been cut down, only a fragment of the Sanskrit text on the verso remains to reveal some understanding of the scene. A similar page from Sirohi, now in the Cleveland Museum of Art (Leach 1986, pp. 254–55, fig. 94, recto and verso), has not been ascribed, but the Sanskrit text on the verso identifies its location in a *Markandeya Purana* series, and the stylistic and compositional similarities shared by both suggest that they are from the same set. The messenger of our page and the demon of the Cleveland folio wear trousers with similarly decorated hemlines and coats with comparable textile patterns, and the goddess in the Cleveland page wears the same unusual headdress as the Brooklyn messenger. The physiognomy of the figures, and especially the hands and their positioning, are also closely related, and the protrusion of details—the scroll and lion's tail—into the borders is a common feature of the two folios. In addition, the Devanagari texts on the verso of both pages share a common style of epigraphy and verse divisions.

The fragment of Sanskrit text in Devanagari script on the verso is incomplete because the page has been cut down. The remaining portion of the verse reads:

. . .The verse is sweet words. (65) The messenger said: The goddess and the demon . . . Came here to meet you. (66) Without any hindrance. . . . Please listen to what he said. (67) In three worlds, my . . . each separately. (68) The jewels that are famous in the three worlds . . . burning. (69) The objects that arose from the churning of the ocean of milk include the Horse, the Jewel, Knowledge [luster?]. . . .The other things [distributed] among the gods, heavenly minstrels, and serpents. Holding jewels . . . the goddess. We will consider in the world. . . . Also the highly powerful *shula* [javelin]. The lady with frivolous glances . . . jewel . . . from the receipt of. . . . Thus discussing intellectually, my. . . .Then, he went to the Devi Gambhira. The frightening phallus. . . . Here not released by you. In the three worlds. . . . (Trans. S. Mitra)

For two folios from a stylistically comparable *Devi Mahatmya* set, see Pal 1978, cat. no. 22, which dates to 1675–1700. AGP

176 Artist unknown

Nata Ragini

Western or Southern Rajasthan
Circa 1675
Opaque watercolor and gold on paper
Image 9¾ x 6⁷⁄₁₆ in. (24.8 x 16.4 cm)
Sheet 12³⁄₈ x 8⁷⁄₈ in. (31.4 x 22.6 cm)
Anonymous gift, 84.201.5

Nata Ragini typically shows a prince on horseback engaged in combat. In this animated scene, the royal figure is represented as a warrior riding a rearing, wide-eyed, white horse. The prince has decapitated one foot soldier (seen in the foreground), and his sword is held aloft as he prepares to strike another soldier standing ready for battle. The figures stand out against a barren field of rich yellow, bordered by a high, arched horizon marked with stylized mauve-colored rocks striated with green grass, and four foliated gold-and-green trees. The pattern of mauve-and-green rocks and foliated trees is echoed in the foreground along a swelling slate gray river highlighted by silver lines.

The costumes of the figures are rendered in copious detail. The prince wears a long gold jama embellished with green-and-orange flowers and belted at the waist by a gray sash. His gold and orange turban complements the colors of his jama. He is armed with a *katar*, tucked into his sash, a bow, and a sheath of arrows. His orange-and-purple-clad leg is firmly positioned in his stirrup, his purple shoe pointing toward his next victim. The stallion is also embellished with gold and orange accoutrements, including a striped saddle blanket, a headdress with feathers, and tasseled ornaments that coordinate with the prince's garments.

The foot soldier is dressed in a brick red short jama open to the waist and a sash with golden ties that match the striped golden brocade on his chest. His dark pajamas are short, revealing his bare feet in a wide stance, braced for attack. His right arm, raised above his gold turban, holds a straight sword; his outstretched left arm holds a blue concave shield. The slain soldier is dressed in a brown jama with a matching sash, golden tassels, and short orange pajamas that expose his bare feet. A sword lies in the hand beneath the slain body. Blood flows from the neck on the grassy bank of the river, and the severed head lies above the body marked by a purple-red pool of blood.

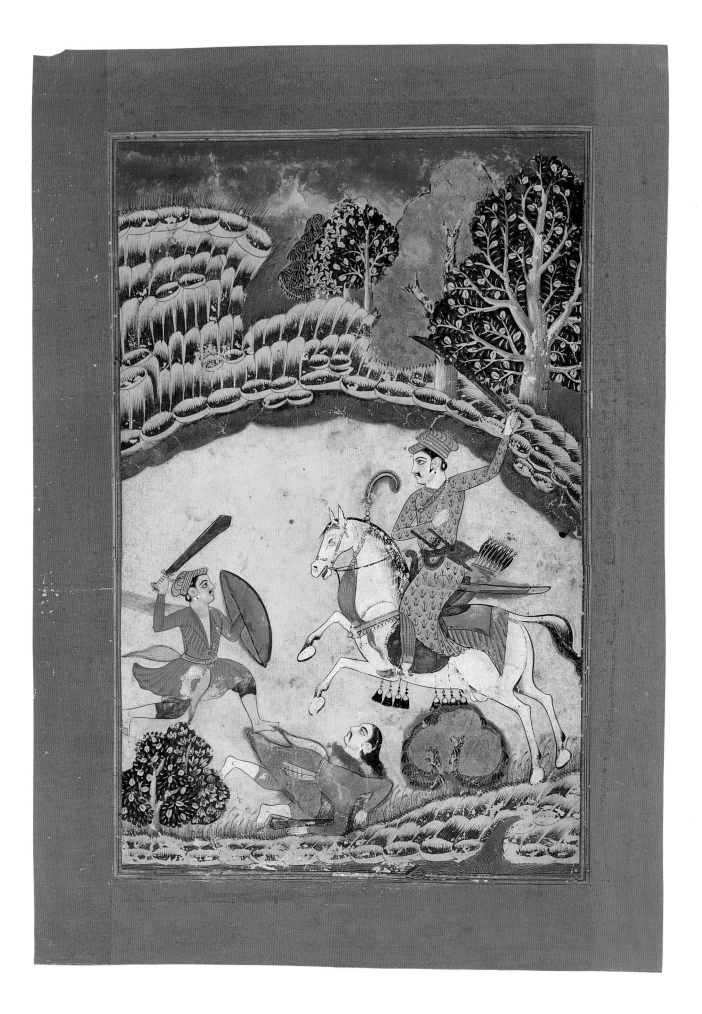

Although no other page from this series has been identified, the brushwork of the overpainted pastel color and the peculiar palette may be associated with various Western or Southern Rajasthani schools of painting. However, the figure type and squared facial shape are unusual for Rajasthan and seem to be based on a Mughal prototype. AGP

Literature Lerner 1974, cat. no. 14.

Provenance Jeffrey Paley, New York.

177 Artist unknown

Gauri Ragini

Rajasthan, Sirohi
Circa 1690
Opaque watercolor and gold on paper
Image 7¾ x 6¼ in. (19.7 x 15.9 cm)
Sheet 10¼ x 7⅝ in. (26.1 x 19.4 cm)
Anonymous gift, 84.201.6

INSCRIPTION

Recto, at top, in black ink, in Devanagari script: *Gauri Ragini. A beloved woman, who holds flower garlands in her lap as a token of her memories [surati], wears an inhibiting girdle made of bells, is dressed in neat and clean garments, has a godlike complexion, and is a storehouse of love.* (Trans. S. P. Tewari)

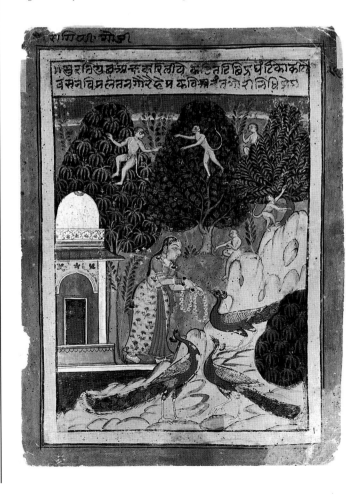

A woman dressed in a bright orange bodice and a patterned yellow skirt with transparent red scarf stands on the terrace of a pavilion in an imaginary garden. She offers garlands to peacocks that are gathered around her on a rocky outcrop animated by monkeys sporting among the rocks and trees.

The image depicted here differs from the usual version of *Gauri Ragini,* in which a beautiful, fair woman, separated from her beloved, is shown with garlands. The text inscribed above the painting corresponds to the more common depiction of Gauri, but the artist has not followed the text. Our heroine appears to offer her garlands to peacocks, a significant detail not mentioned in the text. Peacocks are more frequently associated with *Kakubha Ragini,* but are also present in some depictions of *Gauri Ragini* (see Ebeling 1973, p. 258).

For a comparable Sirohi *Ragamala* page in the Paul F. Walter Collection, identified as *Vasanta Raga,* Sirohi, 1675–1700, see Pal 1978, no. 21. The two pages appear to be by the same artist and from the same series, especially in the arrangement of the three trees in the landscape and the female figures. Several other contemporary Sirohi *Ragamala* series are cited by Ebeling (1973, p. 182), but these do not relate directly to the Brooklyn page. AGP

Literature Lerner 1974, cat. no. 15.

Provenance Jeffrey Paley, New York.

178 Artist unknown

Nanda requests a horoscope for Krishna

Page from a *Bhagavata Purana* series
Rajasthan, probably Sirohi
Circa 1725
Opaque watercolor and gold on paper
Image 6¼ x 7¾ in. (15.9 x 19.7 cm)
Sheet 9⅛ x 10½ in. (23.2 x 26.8 cm)
Anonymous gift, 78.260.5

INSCRIPTION

Upper left, inner border, in Braj, in black ink, in Devanagari script: *The sage Gargacharya makes the birth chart of Krishna, son of Nanda and Yashoda. (7).*

This page from a dispersed *Bhagavata Purana* series shows Nanda seated with the infant Krishna on his lap, gesturing to the sage Garga seated at the right (Ch. 10, v. 8.11–20, where the sage Garga casts Krishna's natal horoscope). Three women are seated to Nanda's left; the one in the middle, painted white, is Yashoda, Krishna's mother. All the figures are seated on orange cushions or rugs. A colorful appliqué textile is draped above them. The background is yellow. The

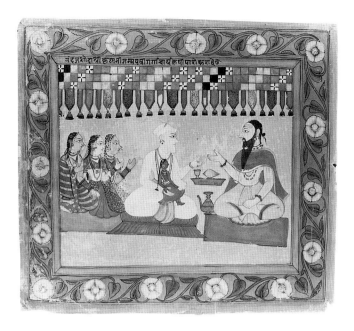

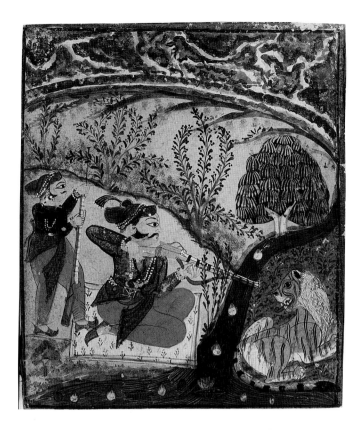

painting is surrounded by an orange border with yellow and mauve flowers.

Other paintings from this series are located in the collections of Paul. F. Walter, New York, and Doris Wiener, New York. AGP

Literature Gutman 1982, p. 171.

179 Artist unknown

Hunt scene

Southeast Rajasthan
Circa 1850s
Opaque watercolor on paper
Image 8⅜ x 7 in. (21.3 x 17.8 cm)
Sheet 8⅝ x 7⅜ in. (21.9 x 18.7 cm)
Frank Sherman Benson Fund, 67.131

A nobleman crouches on a white mat taking aim with his rifle at a tiger sitting amid flowers on an embankment across a stream. An attendant stands to the left loading a second rifle. The two figures have similar facial types, accentuated with long drooping mustaches and dramatic sideburns. Both are dressed in matching orange trousers, short green jamas, gray sashes, red slippers, strands of pearls, and red turbans, though the nobleman is indicated by a black plume and more richly textured headdress. Red horns for gunpowder, red purses, and red daggers are attached at their waists, a feature set unusually high in the attendant's body. The concentrated gaze of the tiger matches the intent stare of the hunter. The blue sky is streaked with lines of white, yellow, and red.

The composition is divided by the gray stream with lotus buds and leaves. The ground under the tiger is green and foliated. The ground area of the hunters is pink with divisions created by green borderlines and trees. The green color dabbed over the pink ground gives rudimentary definition to the land mass. This system of dabbing paint onto paper is often seen in larger, more finished Kota hunting scenes. AGP

Provenance E. Shapiro, New York.

180 Artist unknown

Section of a border with polo players

Western Rajasthan, or Gujarat
First quarter of the 17th century
Opaque watercolor and gold on paper
Image 3 x 9½ in. (7.6 x 24.1 cm)
Sheet 6½ x 12¾ in. (16.5 x 32.2 cm)
Gift of Martha M. Green, 1991.181.5

Set inside a floral border, three polo players on horseback are depicted on a yellow ground. The two horsemen at the

left are actively involved in the competition, while the third, at the right, seems to be observing the action. His horse wears a pendant fan-shaped decoration, and its tail extends into the right border. This L-shaped fragment, a section of a border from an unidentified manuscript, has been set into a second border, decorated with creeping vines and flowers.

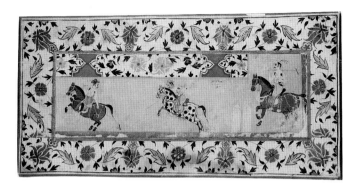

The assured thin outline of the figures betrays a familiarity with seventeenth-century Mughal technique, and the short transparent jama and flat turban are typical of the Mughal style. However, the bright opaque pigments and the flat two-dimensionality convey a "folk" quality that is frequently evident in Rajasthani painting of the period. In contrast, the outer border is characteristic of a later date. The silver and gold elements of the flower border are standardized in form and may have been transferred by stencils.

For two fragments depicting polo players from the same border, see Lerner 1974, cat. no. 4; and Metropolitan Museum of Art 1976, acc. no. 1975.6 (no page number is given). AGP

Provenance Paul E. Manheim, New York.

181 Artist unknown

Balarama pulling Hastinapur toward the Ganges

Page from a *Bhagavata Dashamaskanda* series
Western Rajasthan, or Gujarat
Mid-17th century
Opaque watercolor, gold, and silver on paper
Image 6⁹⁄₁₆ x 6¹³⁄₁₆ in. (16.7 x 17.3 cm)
Sheet 7⁵⁄₁₆ x 12³⁄₈ in. (18.6 x 31.5 cm)
Gift of Terence McInerney, 78.144

INSCRIPTIONS

In Braj, in Devanagari script

At top, left: *Balarama, having taken his plough, began to pull Hastinapur into the Ganges. All the Kauravas came and offered homage to him;* at top, center: *The Kauravas beseech Rama not to drag Hastinapur into the Ganges;* in right border: *Tenth Book with commentary. 26.* (Trans. E.F. Bryant)

At upper right, Balarama, Krishna's brother, crowned and dressed in a printed yellow dhoti and orange striped scarf, drags the city of Hastinapur (City of Elephants, the capital of ancient and modern India) toward the water with his plow. At the left, King Duryodhana sits on his throne, an attendant kneeling before him. The couple in the center are Sambha and Lakshmana. Below them, a citizen of Hastinapur offers praise to Balarama. The scene refers to an episode of the tenth chapter of the *Bhagavata Purana,* in which Duryodhana, the Kaurava king of Hastinapur, announces that he is looking for suitors for his lovely daughter Lakshmana. Sambha, son of Krishna of the Yadu dynasty, goes to Hastinapur and is so smitten by Lakshmana that he kidnaps her and carries her away. The heroes of Hastinapur pursue the couple and eventually overcome Sambha by sheer force of numbers, despite his heroic resistance. They carry the couple back to the city and hold Sambha hostage. Krishna's brother Balarama arrives to negotiate in the hopes of easing tensions between the Kaurava and the Yadu families of Sambha and Lakshmana, but Duryodhana's men are offensive to him. The angered Balarama retaliates by plunging his plow into the ground and dragging the city of Hastinapur toward the river Ganges. The people of Hastinapur, unwilling to have their city submerged, plead for his forgiveness, and Balarama is appeased. All the figures are outlined in red, and the tree and pond are emphasized by silver borders. Jeweled ornaments are indicated in gold.

The stiff treatment of the figures and their garments relates to other contemporaneous pages. Isolated elements, such as the foliated jama, make their appearance in the Shah Jahan period (r. 1628–58). However, Khandalavala (1950,

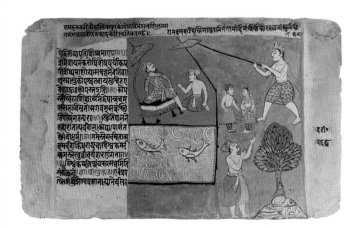

p. 17 and fig. 8) cites a leaf from a *Bhagavata Dashamaskanda* in the Jodhpur Library, dated 1610, with similar stylistic conventions as an example of the entry of Mughal elements into the Gujarat sphere. Until a systematic review of Hindu manuscripts painted in Gujarat in the seventeenth century is carried out, our knowledge in this area remains speculative. AGP

Provenance Christie's 1977, lot 114, pl. 30; Christie's 1978, lot 104.

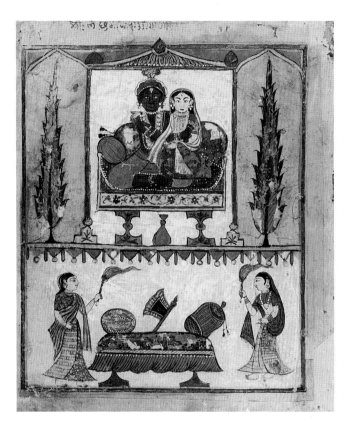

182 Artist unknown

Lakshmi Narayana

Frontispiece from a *Bhagavata Purana* manuscript
Rajasthani style, Gujarat
Circa 1625–50
Opaque watercolor, gold, and silver on paper
Image 8⅝ x 7⁵⁄₁₆ in. (21.9 x 18.6 cm)
Sheet 10¼ x 8¾ in. (26 x 22.2 cm)
Promised gift of Mr. and Mrs. Paul E. Manheim, L69.26.5

INSCRIPTION
In top border, in Sanskrit: *Shri Lakshmi Naraynji.*

In the upper register of the page, the crowned and heavily bejeweled blue God Vishnu is shown seated on a throne with his beloved Lakshmi in an undecorated pavilion flanked by two cypress trees situated in mauve niches. The couple leans against bolsters, one of which is marked by a pair of black tassels. In the scene below, two female attendants with fly whisks stand on either side of a bed covered with a green, yellow, and red spread on which there are two decorated pillows and a fan. The room is plain except for a decorative valance that consists of alternating blue and ocher triangular pennants.

When the album to which this page belonged was still intact, Hermann Goetz was able to study its contents. There were originally seventy leaves in the series, and, according to Goetz (1953, p. 3), this page, depicting Lakshmi Narayana in the Vaikuntha heaven, began the set, following the invocatory leaves.

As demonstrated in other paintings from the set, there is little evidence of any Mughal influence, and the series has been tentatively attributed to Gujarat on the basis of style. The album is now widely dispersed. For other pages in this series, see S.C. Welch 1973, pp. 38–39, cat. no. 15; Pal 1978, cat. no. 9; Kramrisch 1986, cat. nos. 39 (for the page depicting Ganesha and Sarasvati), 40, and 41. AGP

Literature Goetz 1953, pl. 1; Spink 1971, cat. no. 52.
Provenance Tula Ram, Delhi.

183 Artist unknown

Battle scenes from a Bhagavata Purana series

Western Rajasthan or Gujarat (?)
Circa 1650
Opaque watercolor and gold on thin paper
Sheet 4¾ x 8⅝ in. (12 x 21.7 cm)
Gift of Dr. and Mrs. Kenneth X. Robbins, 78.203

INSCRIPTIONS
In black ink, in Devanagari script
Recto, at upper left: *Balabhadrane;* at right margin: *Banasura.*
Verso, at upper left: Illegible; at upper right: Illegible; at middle left: *Ganapati;* at middle right: *Pradyumna;* at lower left: *Shambu;* at lower right: *Dhumralochana.*

The recto of the page shows a violent battle scene of Banasura in combat with four-armed Balabhadra of the Vrishis, identified by a caption to the right of his head. The pennant staff provides a convenient divider for the scene, separating the demons with horned heads at the right from Balabhadra's soldiers at the left. The demon Banasura carries an arsenal of bows and arrows in his ten hands and drives a horse-drawn chariot into this tumult.

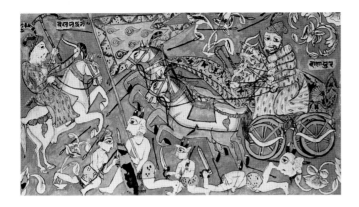

The verso shows a vertical composition of a two-armed bearded figure on a horse, a six-headed, six-armed figure on a peacock (probably a form of Karttikeya), the elephant-headed Ganapati on a rat, Shambhu and Pradyumna on horses, the demon Dhumralochana, and a crane, each identified by a label above his head. Both scenes are freely com-

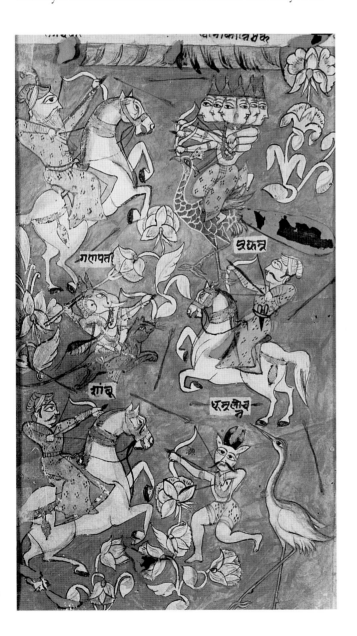

posed on a monochromatic red background on which scattered large flowers and arrows heighten the play of combat.

The folkish style of this series is typical of the developing attraction to Hindu themes in Western India, particularly in Gujarat. The closest stylistic comparison appears in leaves from the Tula Ram *Bhagavata Purana* series of circa 1625, in which figures are arranged as if floating on the page and the decorative elements, like the flowers in our pages, are an important motif (see Goetz 1952, pp. 1–16; Welch and Beach 1965, p. 118, cat. no. 15; Kramrisch 1986, cat. nos. 39–42; and one page in The Brooklyn Museum, cat. no. 182). J. Mittal also suggests comparison to a page from an unpublished Gujarati *Rukmini Haran* or *Usha Aniruddha* series, circa 1680, in the Jagdish and Kamla Mittal Museum, Hyderabad (personal communication, 1981).

For another leaf from this series, see catalogue number 184. AGP

184 Artist unknown

Battle scene from a Bhagavata Purana series

Western Rajasthan or Gujarat (?)
Circa 1625–50
Opaque watercolor and gold on thin paper
Sheet 4¾ x 8¾ in. (12 x 21.9 cm)
Gift of Dr. and Mrs. Kenneth X. Robbins, 81.298

INSCRIPTIONS
In black ink, in Devanagari script
Verso, at upper left: *Jadavadamanava (Yadava Damanava)*; at upper right: . . . *choniphoja [?]*.

Both sides of this leaf depict battle scenes with figures mounted on horses, camels, or elephants. On the recto, arrows pierce the air, surrounding those engaged in combat, as well as those already slain. A red background silhouettes the figures. On the verso, a warrior stabs the elephant that tramples him.

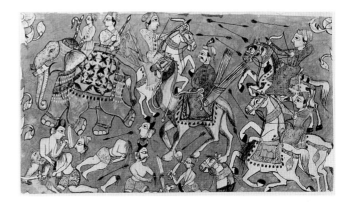

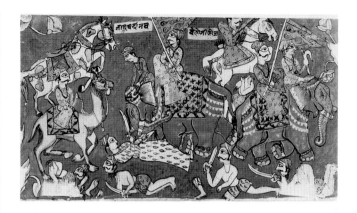

The modeling of the figures, indicated by washes of darker tones within the outlines, seems to be a peculiar stylistic feature of these leaves. The overlapping of the three equestrian soldiers at the right on the recto seems realistic for the period, although other elements of the painting conform to the iconography and style of the mid-seventeenth century. To date there has been no extensive study of similar *Bhagavata* series or related manuscripts for Western Rajasthan or Gujarat.

For another leaf from the same series, see catalogue number 183. AGP

185 Artist unknown

Holy men and courtiers assemble before a prince

Southern Rajasthan or Gujarat
Late 17th century
Opaque watercolor and gold on paper
Image 3⅝ x 7⅝ in. (9.2 x 19.4 cm)
Sheet 4⅛ x 9⅞ in. (10.5 x 25.1 cm)
Anonymous gift, 81.192.1

The side of the leaf reproduced here, from an unidentified manuscript, depicts a prince seated on a throne in the center of the composition. A chauri bearer stands behind him; four seated male figures and a standing attendant face him at the right. A woman sits in a pavilion at the left, accompa-

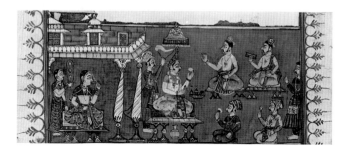

nied by a female attendant with a peacock fan. The background is a monochromatic red. There is a green border at the top with repeated floriate decoration. Side borders consist of a repeated stylized branch design, as seen in Jain manuscript pages from this region and date.

The other side shows the same prince and an entourage of six male attendants leaving a palace, which is depicted at the right. The background is a monochromatic lavender. The borders are the same as shown on the reverse of the leaf.

No other leaves from this manuscript have been identified. AGP

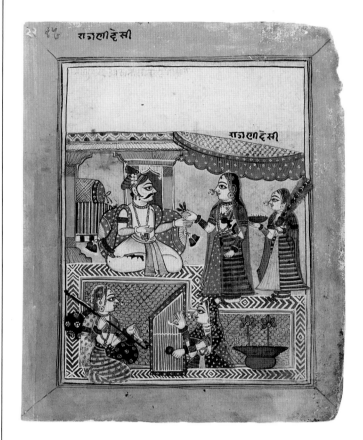

186 Artist unknown

Desi Ragini

Southern Rajasthan or Gujarat
First half of 18th century
Opaque watercolor, gold, and silver on paper
Image 7 x 5⅜ in. (17.6 x 13.7 cm)
Sheet 9 x 7⁷⁄₁₆ in. (22.8 x 18.9 cm)
Gift of Alan Kirschbaum, 80.268.2

INSCRIPTIONS

Recto, in outer margin, upper left, in black ink, in Devanagari script: *Ragini Desi;* in unpainted band at top of illustration, in pale red ink, in Devanagari script: *Ragini Desi vastrani savara Gauri;* near upper right margin: *Ragani Desi.*

A prince seated in a palace is served pan (betel) while he is entertained by two female musicians seated on a bright orange rug with blue chevron-patterned borders as they play the vina and the harp. There are multiple yellow and orange borders.

The iconography corresponds to *Raga Shri* (see Ebeling 1973, pp. 238–39.) The juxtaposition of colors and lively textile patterns that animate the composition are typical of Gujarat or Southern Rajasthan.

The extended text on the verso describes *Kamoda Ragini* (or *Ragani Kamodani*), which is usually depicted as a lone heroine in a bower. Thus, this text does not refer to the image depicted on the recto. For a representation of *Kamoda Ragini,* see catalogue number 124. AGP

187 Artist unknown

Cosmic diagram

Western India, Gujarat, or Rajasthan, Jodhpur
18th century
Opaque watercolor on cotton
35½ x 36 in. (90.2 x 91.5 cm)
The Brooklyn Museum Collection, X899.1

This large-scale painting on cotton is a Jain schematic map of the cosmos. Cosmic diagrams representing the worlds of man and the gods were used by the Jains to demonstrate the various levels of worldly and spiritual experience that one must traverse in the journey toward enlightenment. This diagram represents the world of man (*Manushya-loka*), shown as a series of rings around the realm of the enlightened, represented as a human navel at the center of the painting. Encircling the *Manushya-loka* is a red wall surmounted by variegated, petal-shaped components, which symbolize the mountain range whose name, *Manushottara,* translates as "beyond human kind." In each corner of the painting, beyond this boundary, there is a pavilion flanked by cypress trees in which a female devotee pays homage to a seated crowned male. These four sites mark the cardinal points of the compass with their corresponding entrances to the middle world.

Inside the *Manushya-loka* there are three island-continents (*dvipas*) separated by oceanic rings. The outer *dvipas* represent the earthly realm where humans, including those who will gain enlightenment (Tirthankaras), are born. Two pavilions with seated figures are shown in each of the outer *dvipas.* These coupled figures represent the inhabitants of the region. Trees, stylized mountain forms, and rivers, many of them labeled, represent the natural world. *Tirthas,* or holy sites, are indicated by dots and are located where two rivers

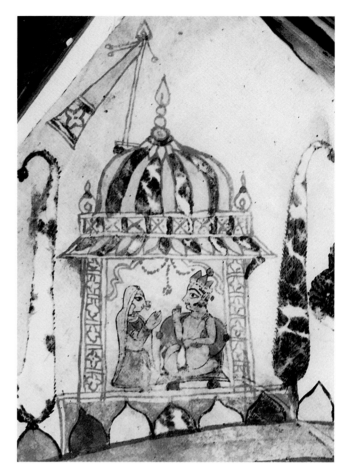

Detail of catalogue number 187.

run parallel. Rivers, indicated in blue on the diagram, are revered throughout India as places where one can cross over to another realm. The word *tirtha* refers to a crossing over, and the Tirthankara, an enlightened teacher, is one who has crossed over. The Jain cosmic diagram gives form to the concept of crossing over and provides direction by showing the progression of the soul toward the central goal.

According to Jain cosmology, thirty-two *dvipas* constitute the *Manushya-loka,* but this rendering limits itself to the two and a half continents (*Adhai-dvipa*) where humans are born. The third-innermost continent, *Jambhu-dvipa,* has Mount Meru at its center. This is the continent of the gods, the realm of enlightenment. Surrounding *Jambhu-dvipa* is the Salt Ocean, *Lavana-samudra,* in which swimming men and fish represent the souls who transmigrate from one *dvipa* to another in order to reach enlightenment. Water vessels mark the cardinal points in *Lavana-samudra* and control the flow of water.

Mount Meru is indicated by a large yellow circle with a smaller circle at the center representing the trunk of the *Jambhu* tree. The similarity in shape and color between

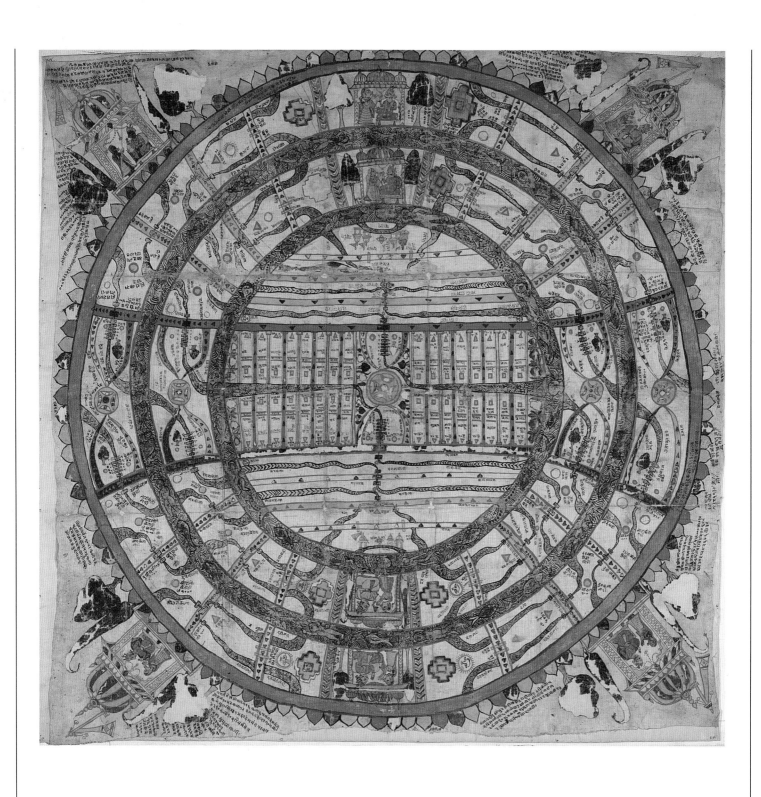

230

Mount Meru and the smaller *tirthas* of the outer *dvipas* indicates not only the sacredness of each crossing place, but also the essential connection between universal realms. Sacred mountain ranges, indicated on the rectangular ladderlike strip that runs horizontally across *Jambhu-dvipa,* lead up to Mount Meru. The Vaskara (Elephant-Tusk) Mountains arch away from Mount Meru and spread in all four directions. The dense grove (*Bhadrasala*) encircles Mount Meru's base and is here represented by several stylized trees. (Ann Norton has helped identify many of the elements of this diagram; personal communication, 1979).

The predominant colors—red, blue, and yellow—on an unpainted ground and the architecture of the shrines surrounded by cypress trees are all indications of a Rajput style, but cosmic diagrams such as this were produced throughout Rajasthan and Gujarat. The rounded forms of the figures suggest that our diagram dates to the eighteenth century. The use of couples marking the directional entrances to *Manushya-loka,* instead of Tirthankaras, may indicate an eighteenth-century development.

Two representations of the *Manushya-loka* dating to the fifteenth century are reproduced in Schwartzberg 1992, p. 368, fig. 16.24; and Doshi 1985, p. 14, fig. 4.　AGP

Literature Los Angeles 1950, fig. 82.

188　Artist unknown

Diagram of the universe (Kshetrasamasa)

Rajasthan or Gujarat
18th century
Opaque watercolor on cotton
25⅜ x 25⅜ in. (64.5 x 64.5 cm)
The Brooklyn Museum Collection, X899.2

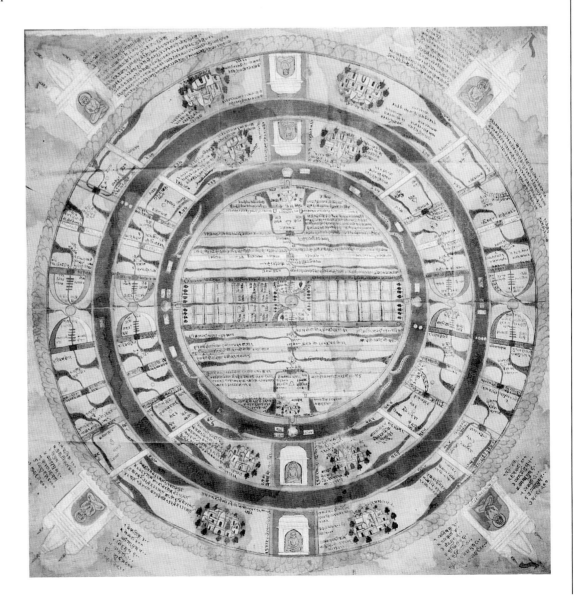

This Jain cosmic diagram consists of three concentric circles set within a square format. A white, three-towered Jain temple set in each corner houses a seated Tirthankara painted in yellow. A yellow band of clouds outlined in red frames the edge of the outer circle. The two outer circles, separated by a blue band of water, contain two smaller pavilions, each with a seated Tirthankara. Symbols representing cities, water, and various stylized patterns decorate the remaining areas. (See Kirfel 1920, pl. 3, for a similar diagram of sixteenth-century date now in the Virginia Museum of Fine Arts, Richmond.)

This painting of the middle world (*Madhya-loka*) of Jain cosmology is similar to a larger, more elaborate one also in the Museum's collection (see cat. no. 187). The two outermost rings, which represent the island continents of the middle world, are occupied by human beings and are also the realms where Tirthankaras can be born. Each realm consists of oceans, rivers, lakes, and mountains, which are described in the canonical texts. Mount Meru is indicated at the center of the innermost circle of the diagram. It represents the highest goal for all mortals and is the place where the bathing ceremony of each Tirthankara occurred.

The *jati-mantra,* referring to the bathing ceremony, is applicable to nearly all ritual occasions of Jains, who consider each Tirthankara's birth as a significant event, whereby he attains the state of *kevalin* (set free from matter) and is thus destined to become a *siddha* (one who has attained perfection). This moment is represented in the central core of the diagram.

Gods, while they exist in Jain cosmology, have not yet reached *moksha* and so are portrayed symbolically paying homage at shrines of Tirthankaras, indicated here in the four corners.

Painted diagrams of these realms have been considered efficacious as *yantra* (images of worshipful contemplation) for Jain devotees. The composition type may have originated in the early twelfth century and likely was based on an even earlier tradition (see Ramachandran 1934, Appendix; and John 1931). AGP

189 Artist unknown

Kaumari

Western India or Gujarat
Late 18th century
Opaque watercolor, gold, and silver on paper
Image 3⅝ x 4⁹⁄₁₆ in. (9.2 x 11.6 cm)
Sheet 4⁷⁄₁₆ x 6¹¹⁄₁₆ in. (11.3 x 17 cm)
Anonymous gift, 80.277.16

INSCRIPTION

In upper left margin, in Braj, in black ink, in Devanagari script: *Kaumari mounted [on her] peacock. 6.*

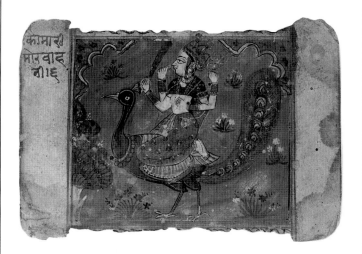

This page from an unidentified manuscript depicts the four-armed Kaumari, the *matrika* and *shakti* (female counterpart) of the Hindu god Kumara, seated on her *vahana,* in this case a peacock. As Kumara's *shakti,* she carries the same weapons and rides the same *vahana* as he does. There is a tree at the left, and clusters of flowers are scattered about the solid red background. There are wide undecorated borders at either side. AGP

Punjab Hills

190 Artist unknown

Portrait of a prince

Punjab Hills, Arki (Baghal)
Circa 1700–1710
Opaque watercolor on paper
Image 4¾ x 6⅞ in. (12.1 x 17.5 cm)
Sheet 5⅝ x 7⅝ in. (14.3 x 20 cm)
Anonymous gift, 80.71.2

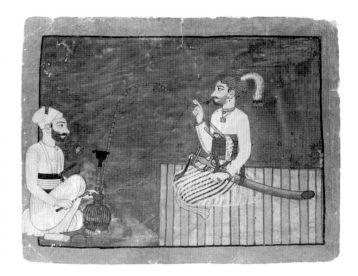

An unidentified, bearded prince, seated at the right on a striped rug, smokes a hookah, which is attended by a man seated at the left. The depiction of various objects in the painting—the globular hookah, the exaggerated proportions of the curved sword worn by the prince, his distinctive turban with long, curved feather plume, the simple rug shown from a different perspective—and the figures' long noses, eyes, beards, and facial features of both men, as well as their costumes, square amulet rings, and bracelets suggest comparison to a group of late-seventeenth-century portraits painted in Arki. Portraits associated with Rana Prithi Chand of Arki (r. 1670–1727) now in the collections of Raja Rajinder Singh and the San Diego Museum of Art (formerly Edwin Binney, 3rd) are noted for a similarly distinctive style (W.G. Archer 1973, vol. 2, pp. 3, 4, nos. 3 and 6).

Arki was a state closely tied politically and by marriage to neighboring Bilaspur. Arki paintings in the Prithi Chand period often demonstrate a similar treatment of sitters and other stylistic characteristics of the more widely known Bilaspur paintings of the time. Contemporaneous royal por-traits from other Pahari states, particularly Basohli, Mankot, and Nurpur (see cat. no. 243), also show the sitter with face in profile, the ubiquitous hookah, turbans clasped with long feathers, and even the same bird's-eye perspective of the rug. This portrait not only shows the more peculiar facial type but also reveals a less carefully executed drawing and painting technique recognized in several Arki paintings, among them a set of *Ragamala* paintings and a portrait of Rana Prithi Chand smoking a hookah (ibid., nos. 2 and 3).

Although there is no inscription to identify the sitters in our page, the attribution to Arki was first suggested by Catherine Glynn, who compared it to a third Arki painting in the Edwin Binney, 3rd Collection (now San Diego Museum of Art) entitled *Prince and Lady,* of circa 1700–1710 (ibid., p. 4, no. 6). AGP

191 Artist unknown

Siddha Lakshmi with Kali

Page number 34 from a Devi series

Punjab Hills, Basohli

Circa 1660–70

Opaque watercolor, gold, silver, and peacock blue-green beetle-wing cases on paper

Image 7⅛ x 6¹¹⁄₁₆ in. (18 x 17 cm)

Sheet 8⅝ x 8⅜ in. (22.1 x 21.4 cm)

Gift of Mr. and Mrs. Robert L. Poster in honor of Dr. Bertram H. Schaffner, 84.142

INSCRIPTIONS

Recto, upper portion of right margin, in black ink, in Sanskrit, in Takri script: *Siddha Lakshmi with Kali;* left margin: *34.*

Verso, in black ink, in Sanskrit, in Devanagari script: *One should [let one] meditate thus in the lotus of his heart on Siddha Lakshmi, goddess of remembrance, Bhadrakali [all epithets of Siddha Lakshmi] who is young, with a face resembling the rising moon and crown bedecked with crescent moon. Whose priceless graceful form is clad in a yellow dress, seated on an eightfold [cosmic] lotus, accompanied by Kali, drinking drafts of liquor.* (Trans. S. Mitra)

Shimmering and radiant against a rich sienna background, the blessed goddess Lakshmi, as Bhadrakali, is seated on a large open lotus. Exquisitely dressed in a gold sari and lotus crown with ornaments detailed with applied beetle-wing cases, and with a rayed silver halo, she holds a gold fluted vessel to her lips in one hand and the stem of a lotus bud in the other. Dark-skinned Kali, with gaping mouth, fangs, and the attributes of Shiva (crescent moon and the third eye on the forehead) stands on a strip of grass at the left holding a wine beaker, dressed in a full, bright orange skirt detailed with stylized gold flowers. The pedestal of the lotus on which the goddess sits rises out of a pond decorated with an overall pattern of tiny lotus petals from which two large lotus petals sprout. The sky is indicated by a narrow band of cloud at the top of the page. There is a wide red border with silver rules marking an inner border. (For another Basohli tantric figure, represented with a closed lotus bud, a bottle,

and a similar fluted drinking vessel, see a painting of Shiva as Vikral Bhairava in the Jagdish and Kamla Mittal Museum of Indian Art, Hyderabad, published in Goswamy 1986b, p. 195.)

In Indian iconography, Lakshmi always has a golden yellow skin color, as does the Devi in this painting. The lotus, associated always with Lakshmi and never with Kali (the terrifying form), figures prominently here with the principal figure seated on a lotus, holding a lotus stalk in her right hand, and wearing a crown decorated with lotuses. Tastefully dressed in formal attire of a full skirt, choli, and scarf, she is Siddha Lakshmi here, the silver halo indicating her attainment of perfection. Kali is always depicted in Indian sculpture and painting as partially dressed and sometimes barebreasted, as is the case with the attendant here.

Although the subject is clearly related to a Shaivite theme, the introduction of such details as the lotus crown, golden garment, and lotus seat may reflect a new interest in Vaishnava religious attributes. Recent scholarship (W.G. Archer 1973, vol. 1, p. 20) has brought to light the rise of Vaishnava cults in Basohli during the mid-seventeenth century under Raja Sangram Pal (r. 1635–c. 1673).

Other pages of this once large series illustrating the tantric manifestations of the great goddess often show her savoring the potent liquor she demands for nourishment, as here, or trampling the corpses of those she has vanquished (Enhbom 1985, p. 185). Many of the paintings from the same series have been discussed and reproduced. Two paintings are in the Government Museum and Art Gallery, Chandigarh, and one is in the collection of the National Museum, New Delhi (W.G. Archer 1973, vol. 1, pp. 33–34, vol. 2, pl. 16, nos. 1[i]–[iii]). Four of six leaves acquired in 1918 by the Lahore Museum have also been published (Aijazzudin 1977, pp. 3–4, pls. 6 and 7). Single unpublished examples are in the Museum of Fine Arts, Boston, and the Los Angeles County Museum of Art. For a related leaf in the Sri Pratap Singh Museum, Srinagar, see Goswamy 1986b, p. 268.

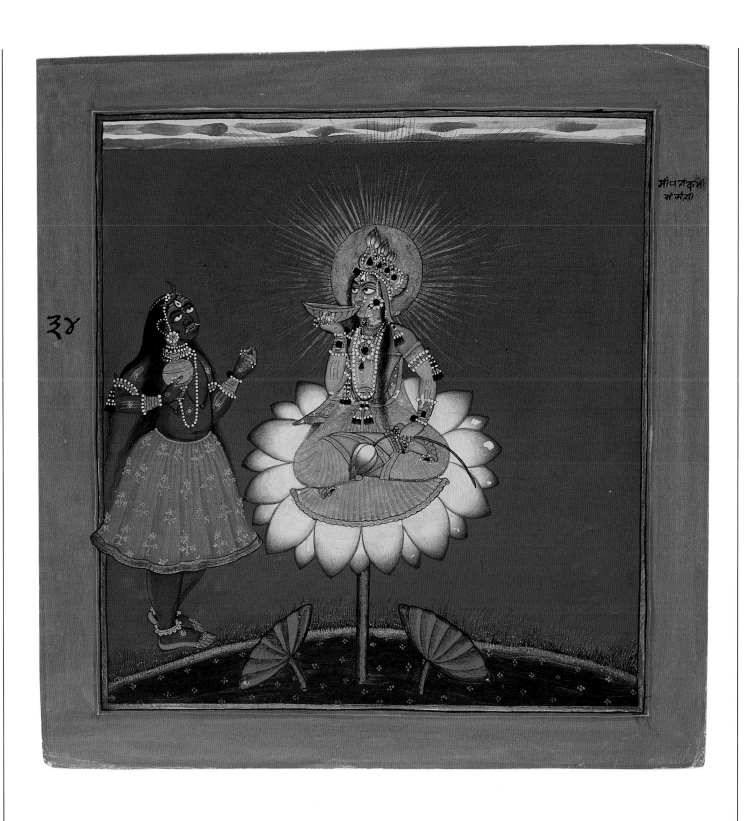

Our page is one of a group acquired by an American traveling in Amritsar in 1922, which came to light in 1979 and was subsequently dispersed. For other published pages from this group in private collections, see Kramrisch 1981, cat. no. P-47 (Dr. Alvin O. Bellak Collection, Philadelphia); Polsky and McInerney 1982, p. 28 and cover; Lerner 1984, pp. 158–63; Ehnbom 1985, pp. 182–85; Kramrisch 1986, cat. nos. 98 and 99; Goswamy and Fischer 1992, pp. 44–45, cat. no. 12. Single unpublished examples are in the Dr. Alvin O. Bellak Collection, Philadelphia; Museum of Fine Arts, Boston; Freer Gallery of Art, Washington, D.C.; Los Angeles County Museum of Art; and San Diego Museum of Art (formerly Colllection of Edwin Binney, 3rd).

Goswamy and Fischer 1992 (pp. 31, 36–45) attribute this series on stylistic grounds to the same artist as the Early *Rasamanjari* series, which they date circa 1660–70 and assign to an unnamed Nurpur artist. The authors locate the two series, which have conventionally been attributed to Basohli, in Nurpur, because the paintings were owned by a Basohli family and because a slightly later *Rasamanjari* series (circa 1694) has a colophon that mentions that the work was commissioned for Raja Kripal Pal of Basohli from the artist Devidasa (op. cit.). Goswamy and Fischer see the stylistic connections between the two *Rasamanjari* series, but claim there is evidence that Devidasa "came across the river to Basohli," i.e., from Nurpur (ibid., p. 31).

Now that there is evidence of earlier painting at other centers than Basohli, namely Kangra (see Introduction), the suggestion that the Devi series may have been painted at a center other than Basohli must be considered. In this catalogue, we note the possibility of a Nurpur attribution, but we cite the conventional Basohli attribution since the evidence in favor of Nurpur cannot yet be fully documented.

For a description of the chemical analysis of the wing cases of the indigenous beetle used in Basohli paintings (*Cetonia aurata,* Coleoptera), see Tandon 1975, pp. 112–15. AGP

Literature Pal 1983, p. 278, col. pl. 4, identified as Basohli, circa 1650–75; Poster 1987, p. 24, col. pl.

192 Artist unknown

Vishnu on Garuda

Punjab Hills, Basohli or Nurpur
Circa 1725 or earlier
Opaque watercolor, silver, and gold on paper
Image 7⁵⁄₁₆ x 4⁷⁄₈ in. (18.6 x 12.4 cm)
Sheet 8¹¹⁄₁₆ x 5¾ in. (22.05 x 14.6 cm)
Gift of the Ernest Erickson Foundation, Inc., 86.227.140

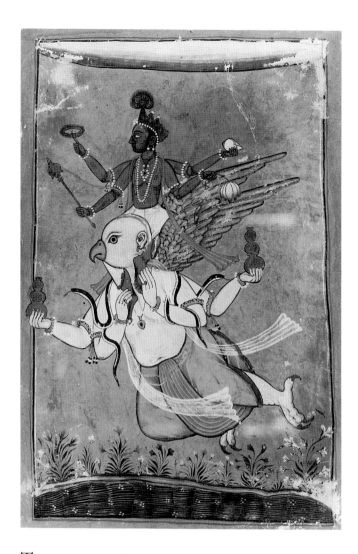

The blue god Vishnu rides on his four-armed eagle mount Garuda. Crowned with the traditional diadem surmounted by a peacock feather, he is four-armed and holds a conch, a lotus flower, a mace, and a discus (*chakra*), his divine attributes. Garuda has two snakes draped over his shoulders and forearms and holds three stacked pots in each of his outstretched upper hands. Both Vishnu and Garuda are adorned with tilak marks and jewelry emphasized by raised surfaces and pendant pompons. The piercing yellow of Vishnu's dhoti and Garuda's hands, the green of Garuda's wings, and the red of his dhoti contribute to the brightness associated with Hill painting of Basohli and Nurpur.

The figures are set against a monochromatic yellow-green background. A strip of water filled with repeated white four-dot petals and horizontal lines bordered by polychrome flowers occupies the foreground. A narrow band of blue with a white cloud line is at the top of the page, which is surrounded by simple black-and-red borders.

The colors and dynamic presentation of the deities are typical of Basohli or Nurpur paintings from the first quarter of the eighteenth century. The exact provenance of the painting is not known, but it demonstrates certain stylistic and iconographic characteristics that can be associated with either Basohli or Nurpur, which were centers of Vaishnava patronage. AGP

Literature Poster 1987, cat. no. 129.

193 Artist unknown

Leaf from a dispersed Bhagavata Purana series

Punjab Hills, Basohli
Circa 1760–65
Opaque watercolor and gold on paper
Image 9³⁄₁₆ x 13³⁄₁₆ in. (23.5 x 33.5 cm)
Sheet 11⁷⁄₈ x 15⁷⁄₈ in. (30.2 x 40.3 cm)
Anonymous gift, 82.227.2

Leaning on his staff at the right, Krishna observes the seven expressionless poisoned cowherds and four motionless cattle arrayed in a single flat plane across a lifeless landscape. At the top, a band of blue and a wide expanse of yellow streaked with red, blue, and gold, and a band of stylized clouds indicate the sky; gray waters are shown in the foreground.

This narrative scene from the *Bhagavata Purana* (Bk. 10, Ch. 15, vv. 48–50) illustrates the episode among Krishna's deeds in which he miraculously restores to life his boyhood friends, the cowherds, and their cows, here shown dying from drinking the dark brown poisoned waters of the Yamuna.

There were many *Bhagavata Purana* sets painted in the Punjab Hill states. This leaf is from the so-called fifth *Bhagavata Purana* series (W. G. Archer 1973, vol. 1, pp. 49–51, vol. 2, Basohli, no. 22 [i–xii]). Archer points to the sparse and open compositions as indicative of the transitional phase of Guler-Basohli style painting, reflecting the influence of Mughal painting of the 1750s.

The text on the verso identifies the book and verse depicted. AGP

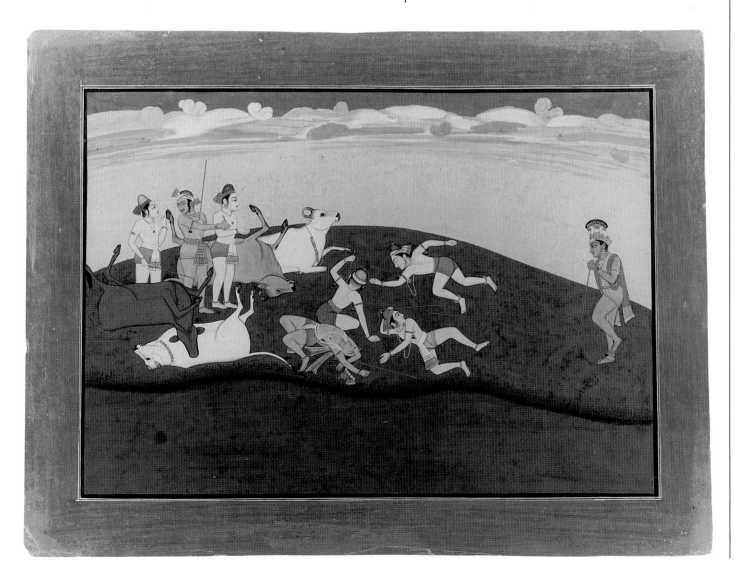

194 Artist unknown

Balarama kills the Ass-Demon

Scene from a dispersed *Bhagavata Purana* series
Punjab Hills, Bilaspur
Circa 1725
Opaque watercolor and silver on paper
Sheet 8³⁄₁₆ x 11 in. (20.75 x 27.95 cm)
Gift of the Ernest Erickson Foundation, Inc., 86.227.166

The exploits of Krishna, the cowherd, and Balarama, his brother, in the idyllic forest of Vrindavan are narrated in the tenth chapter of the *Bhagavata Purana,* a later scripture that has been a popular subject of Pahari paintings. Some of their miraculous trials revolve around their combat with a variety of demons, each sent by their evil uncle Kamsa, the king referred to in the text on the reverse. This page depicts a sequence of three events in the narrative of the demon Dhenuka, who, in the form of an ass, is killed by Krishna and Balarama, assisted by a cowherd.

The Sanskrit text on the verso, written in Devanagari script, reads:

Thus having listened to the narration of his friends, with an intention of promoting their welfare, the Lord, accompanied by the cowherds, went to the palm grove with a smile. Arriving, the Almighty caught hold of his [the ass demon's] hind legs in a hasty motion. Being killed, the wicked [Ass-Demon] gave out a cry of the sound *ka* from his heart to the king in whose refuge he was, and having been hurled by the Lord with one hand, emitted grass as well as his last breath in front of the king. Verse 5 [?]

The action flows clockwise from the middle ground at the right, where the Ass-Demon is pictured grazing. In the right foreground on the bank of a river, Balarama and a cowherd watch as the animal, now in the center, runs away. Finally, in the left foreground, Balarama, Krishna, and the cowherd bend over the dying ass, which lies on the ground near a tree. Trees occupy most of the middle ground. Behind them at the top, the gods in heaven observe the scene. Varied shades of blue predominate, in addition to green, as well as silver (which has oxidized) for the water of the river. There is no border.

Eight pages from this series are in the Museum für Volkerkunde, Berlin (Waldschmidt 1929, pp. 197–211, pls. LI–LIII, where they are dated to the middle of the seventeenth century and attributed to the school of Jammu).

Others from the series have been published by Davidson 1968, cat. no. 141; S. C. Welch 1973, pp. 76–77, cat. no. 43; W.G. Archer 1976, cat. no. 35; and Ehnbom 1985, p. 214, cat. no. 106. Two unpublished pages are in the Arthur M. Sackler Museum, Harvard University.

For another page from this same series, see catalogue number 195. AGP

Literature Poster 1987, cat. no. 130.

195 Artist unknown

Krishna and Balarama on their way to Mathura

Scene from a dispersed *Bhagavata Purana* series
Punjab Hills, Bilaspur
Circa 1725
Opaque watercolor and gold on paper
Image 8 x 10⁵⁄₈ in. (20.3 x 27 cm)
Sheet 9½ x 12 in. (24.5 x 30.5 cm)
Gift of Mr. and Mrs. Paul E. Manheim, 69.125.4

INSCRIPTION
Verso, at center, near lower edge, in black ink, in Devanagari script: *77.*

In this scene from the same Bilaspur *Bhagavata Purana* discussed in catalogue number 194, Krishna, Balarama, and the cowherds of Vrindavan are shown on the banks of the Yamuna River on their way to Mathura. At the left are seated three holy men with ritual offerings, while in the foreground others bathe in the river before worshiping the Devi.

The Sanskrit text on the verso in Devanagari script reads:

The cowherds became amused [inquisitive?]. Accompanied by [cowherds] they [Balarama and Krishna] went to Ambikavan. To the Lord. . . . They worshiped the Devi who is the mistress of Ambikavan with great devotion.

Although experts dispute the dating of this series, it clearly demonstrates W.G. Archer's designation (1987, p. 60) of the early Bilaspur works. The contrast of the subdued palette with the colorful orange and yellow costumes, the treatment of the entwined trees and other landscape elements, as well as the figural style, have been cited by other authors as a synthesis of Mughal and contemporaneous Pahari conventions (Archer and Binney 1968, p. 86, and Leach 1986, p. 267).

The attention to such details as the fur of the Ass-Demon in catalogue number 194 and the foliage of the trees in this scene—thought to stem from Mughal influence in Bilaspur pictures of this date—is common to all the paintings in this series, which is considered to be one of the finest examples of the Bilaspur style. AGP

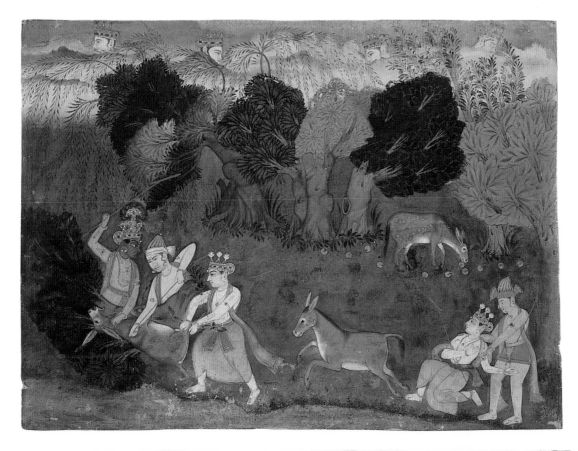

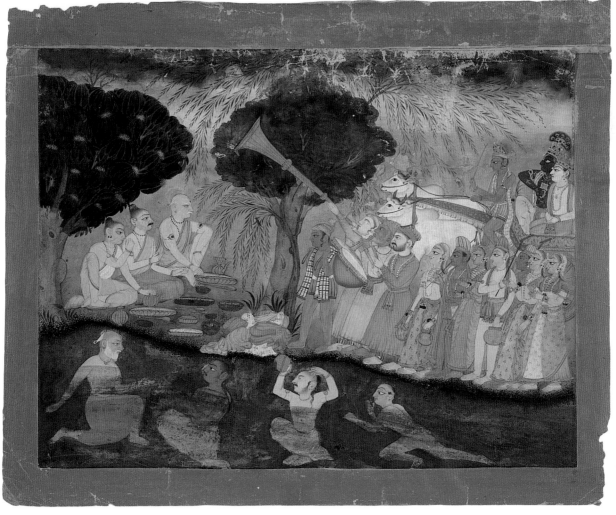

196 Artist unknown

Portrait of Raja Ajmer Chand of Kahlur

Punjab Hills, Bilaspur
Circa 1730
Opaque watercolor and gold on paper
Image 5⁵⁄₁₆ x 3⅝ in. (13.5 x 9.3 cm)
Sheet 6⅞ x 5⅝ in. (17.5 x 14.4 cm)
Promised gift of Anthony A. Manheim, L69.26.8

INSCRIPTION

Recto, in lower border, in black ink, in Devanagari script: *We [painters] have come under your protection. May God keep you safe and prosperous.* (Trans. B. N. Goswamy)

The mustached figure of Raja Ajmer Chand stands in typical Bilaspur pose against a solid green ground, his feet and skirt protruding into the borders. He is dressed in an ankle-length jama patterned with red-and-gold flowers on a white ground, a striped sash and turban with a long feather and pearled aigrette. He holds a *firman* in his left hand, has a *katar* (dagger) in his sash, and wears Vaishnava tilak marks on his face, forehead, and neck. Further ornamentation consists of a jeweled pendant, necklace, earrings, bracelet, and finger rings.

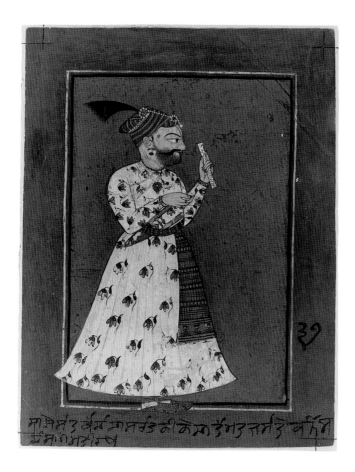

A similar pose and composition are repeated in another portrait of Ajmer Chand, now in the Raja Anand Chand Collection, Bilaspur (W.G. Archer 1973, vol. 1, p. 235, vol. 2, p. 177, no. 20). Archer also notes (ibid.) several other portrayals of this same ruler collected by Anand Chand for his history of Bilaspur.

Ajmer Chand reigned for more than forty turbulent, war-ravaged years (1692–1741) in Kahlur (Bilaspur). He was devoted to temple worship and ritual and was noted for several Vaishnava illuminated texts he commissioned, including a *Vishnu Avatara* (see cat. no. 197). AGP

Provenance Paul E. Manheim, New York.

197 Artist unknown

Varaha (The Boar Incarnation of Vishnu)

Punjab Hills, Bilaspur
Circa 1730–40
Opaque watercolor and gold on paper
Image 8⅜ x 6³⁄₁₆ in. (21.3 x 15.7 cm)
Sheet 10½ x 8⅛ in. (26.7 x 20.65 cm)
The Brooklyn Museum, by exchange, 41.1026

INSCRIPTION

Verso, in top red margin, in white pigment, in Takri script: *Wondrous Vishnu, wondrous Varaha.*

Vishnu is here represented as the awesome boar-headed incarnation Varaha, whose two principal feats are represented in this strident pose: trampling over the demon Hiranyaksha, and balancing the earth, depicted in the form of a simplified mountain with a walled citadel surrounded by trees, on his snout and tusks. He is crowned and bejeweled. His four hands hold his usual attributes: a scepter and a lotus in the lower hands and a wheel and a conch in the upper ones.

The striking colors that contrast boldly with a dark green background, the conformation of blossoming trees flanking Varaha, and the band of clouds at the top of the scene are typical Bilaspur conventions depicted in the known pages from a dispersed *Vishnu Avatara* series to which our page belongs. Other pages are located in the Cleveland Museum of Art (Leach 1986, p. 269); Seattle Art Museum; San Diego Museum of Art, formerly Collection of Edwin Binney, 3rd (W. G. Archer and Binney 1968, pp. 96–97); and possibly a sheet in the Museum of Fine Arts, Boston, which Leach suggests may be from a different but contemporaneous *avatara* series. (For a list of extant pages, see Leach 1986, p. 269.) Leach also discusses (ibid.) the popularity of the *avatara* subject in Bilaspur during this period, as evidenced by the number of extant contemporaneous pages. AGP

Literature Leach 1986, p. 269.

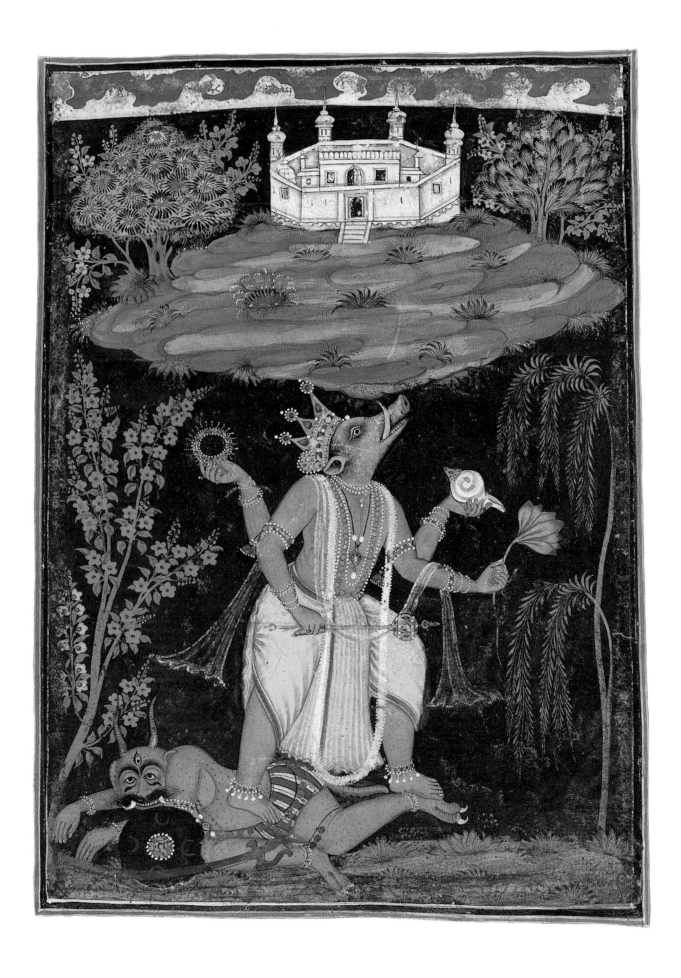

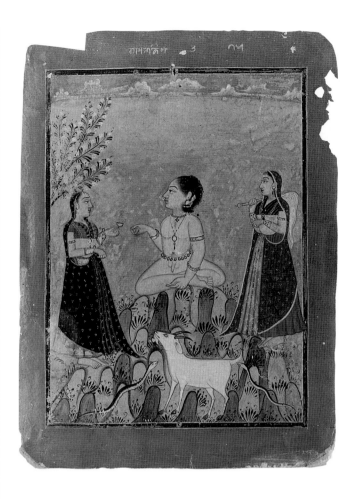

198 Artist unknown

Malkos Raga

Page from a dispersed *Ragamala* series
Punjab Hills, Bilaspur
Circa 1735–40
Opaque watercolor on paper
Image 6⅜ x 4¾ in. (16.2 x 12 cm)
Sheet 8 x 6 in. (20.1 x 15.3 cm)
Promised gift of Anthony A. Manheim, L69.26.4

INSCRIPTION

Recto, in top border, center, in Takri script: *Raga Malkosa.*

The designation of musical modes in the Hill States differs from the Rajasthani *Ragamala* tradition. The primary distinction is the addition of forty-nine *putras* (basically sons of the *ragas* and *raginis)* that describe—in addition to the common designations for seasons, times of day, and the varieties of love—the sounds of nature as related to the activities and animals of the household.

The Pahari *Ragamala* tradition follows the system of Mesakarna, who wrote a treatise on the subject in which he defines the *Malkosa* as the sound of a goat (Ebeling 1973,

pp. 64–66, 72, 272); according to stanzas in the *Ragamala,* the goat "sings" the relevant melodies. The central figure in this miniature is identified as *Malkosa* by the goat in the foreground as well as by the pale bluish green color, *Malkosa's* family color, in the distance. Depicted seated, as within the Rajasthani tradition, *Malkosa* is shown as a beardless adolescent, possibly a prince, attended by two women. He is nude except for a jeweled waistband, a jeweled pendant, necklaces, earrings, bracelets, and finger rings. His attendants wear ankle-length skirts, bodices, and veils. The one at the left offers him a dish, and the other carries a white fly whisk over her shoulder. These elongated figures epitomize the Bilaspur figural type. Similarly, a small detail like the up-turned sole of the prince closely resembles the drawing of the foot of a seated female in a Bilaspur *Patamanjari Ragini* of circa 1740 (W.G. Archer 1973, vol. 2, Kahlur, no. 33[ii]).

The stylized mountain is rendered in alternating dark and light forms with natural details of grass and weeds. It has been noted that the top of a mountain range, decorated with a flowering tree, is the favorite site for meditation, worship, and religious devotion (Waldschmidt and Waldschmidt 1967, Part I, p. 52). Two serpents in the foreground, a flowering branch at the left, and the clouds in the band of sky complete the scene. A similar miniature from a Pahari series (Basohli-Bilaspur, circa 1750) in the Museum für Indische Kunst, Berlin, is described in Waldschmidt and Waldschmidt 1967, Part I, pp. 150–52, fig. 56.

On the reverse, a somewhat crudely rendered sketch in ink on paper depicts the deity Krishna dancing on the snake demon Kaliya. A female figure at the right holds her hands in *anjali mudra.* Both figures hold lotuses. AGP

Provenance Paul E. Manheim, New York.

199 Artist unknown

Bhaskara Ragaputra

Page from a dispersed *Ragamala* series
Punjab Hills, Bilaspur
Circa 1750
Opaque watercolor and gold on paper
Image 7⅞ x 6¹⁄₁₆ in. (20 x 15.4 cm)
Sheet 10¼ x 8⅜ in. (26.1 x 21.3 cm)
A. Augustus Healy and Frank L. Babbott Funds, 36.244

INSCRIPTION

Recto, in top border, in white pigment, in Takri script: *Bhasakgn[?]putra.*

This mid-eighteenth-century *Ragamala* page from Bilaspur shows a woman milking a cow and a man holding the leash

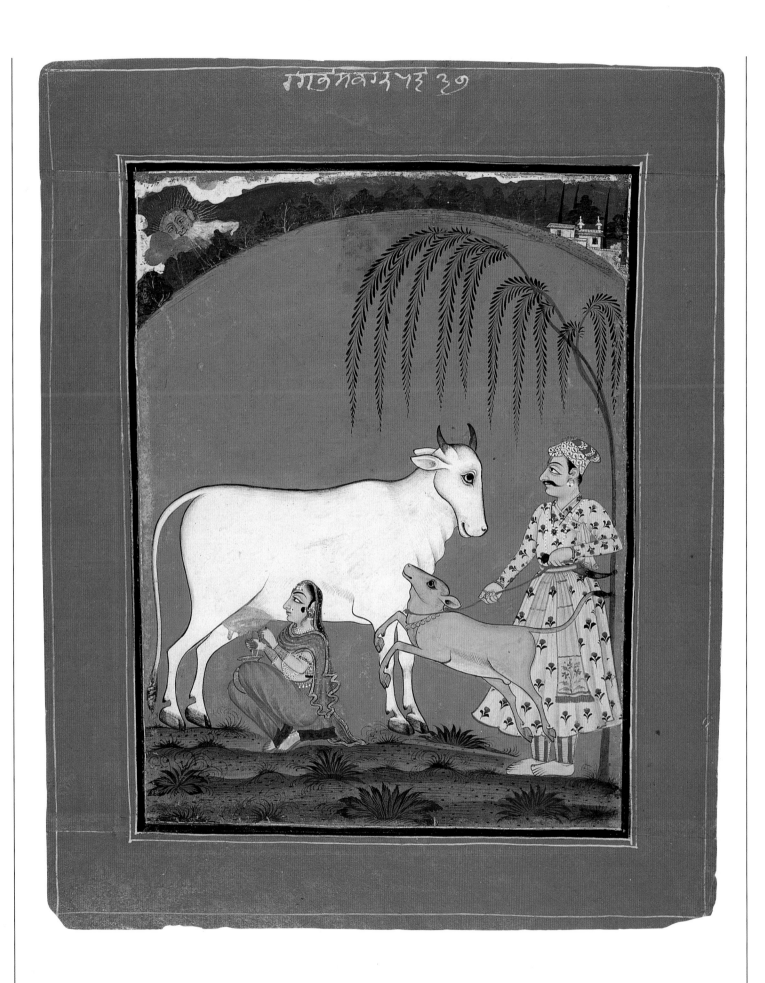

of a calf. This image belongs to *Bhaskara,* a musical mode known only in the Hill States. The word *Bhaskara* (Sun) is synonymous with the Rajasthani *Vibhasa Ragini,* which, in the Rajasthani tradition, represents lovers united at dawn (Waldschmidt and Waldschmidt 1975, p. 188) and is defined musically by Mesakarna as the sound of "milking" (Ebeling 1973, p. 74). Milking cows early in the morning is a typical Indian practice. Here the early morning sun is emblematically depicted at the upper left, rising on the eastern horizon.

A Bilaspur *Ragamala* series now in the Museum für Indische Kunst, Berlin, painted during the same century, includes a similar composition, identified as *Bhaskara Putra* (Waldschmidt and Waldschmidt 1975, p. 188, and idem 1967, fig. 29). As with the seventy-seven paintings in the Berlin series (W.G. Archer 1973, vol. 1, p. 237, and vol. 2, Kahlur [Bilaspur], no. 32[i–iii]), our page conforms in its static composition to a second, later group of Bilaspur *Ragamala* paintings, the style of which is "noted for the use of cleanly modelled forms, suave precise design and sharply phrased faces" (idem, vol. 1, p. 237). The Berlin set has traditionally been connected with Bilaspur by the family of the Thakur Ishwari Singh Chandela of Bilaspur, who was the former owner (ibid.). Other isolated Bilaspur *Ragamala* pages of the same date are located in the Victoria & Albert Museum, London, among them one from the Rothenstein collection, similar in size to ours; George P. Bickford Collection, Cleveland (Czuma 1975, cat. no. 113); and elsewhere. Our page was originally identified as *Bhasva-Gupta Raga,* probably owing to a misreading of the inscription.

A drawing for a Pahari *Bhaskar Putra* of *Hindola Raga* showing a woman milking a cow and a man holding a calf is reproduced in Ebeling 1973, p. 276, no. 312; for a second drawing with a couple seated inside a sunburst, without cow and calf, see ibid., p. 274, no. 306. AGP

Provenance Ananda K. Coomaraswamy, Boston.

200 Artist unknown

Krishna and Radha

Punjab Hills, Chamba
Circa 1690–1710
Opaque watercolor with embossed gold on paper
Sheet 10⅛ x 7 in. (25.8 x 17.8 cm)
Purchase, The Brooklyn Museum, by exchange, 37.122

Krishna and Radha are seated cross-legged with their heads turned to each other. Krishna embraces the goddess, whose dotted sari is wrapped around her waist and brought up to cover her hair. He holds a full-blown lotus in his right hand and a flute in the left. Radha offers betel to Krishna with her right hand, an amorous gesture, and holds the stem of a lotus in her left. The architectural framework surrounding the couple, Krishna's crown, and the jewelry of both figures are embossed with gold or raised white dots. The background is a vibrant yellow.

Although the painting lacks the beetle-wing decoration present in early Basohli paintings, it seems nevertheless Basohli-inspired in other details, such as the five-peaked crown surmounted by three lotuses and the Vaishnava *tripundra* marks on the divinity's body. The painting has been reattributed on stylistic grounds to the Chamba school in the period of 1690–1710, which is associated with the style of the "Nurpur" *Rasamanjari* series of circa 1710 (W.G. Archer 1973, vol. 1, pp. 390–97) and with several earlier Nurpur portraits because of the similar treatment of dress (with pleated skirts), the drawing and color (especially the placement of the figures against a yellow background), and the distinctive facial features, especially the eyes, which resemble the shape of a lotus leaf rather than the almond shape prevalent in contemporaneous Basohli works.

A closely related painting in the Cleveland Museum of Art (Leach 1986, fig. 134) depicts the Nurpur ruler Mandhata (r. 1661 [or 1667]–1700). Before the painting was acquired by the Cleveland Museum, the portrayed figure was identified as Vishvamitra, a Brahmin sage who figures prominently in the *Ramayana,* and the work was dated to 1730 (Kramrisch 1981, p. 233 and col. pl.). Leach (ibid., pp. 306–7) has not only reidentified the sitter as Raja Mandhata, but she has also suggested that on stylistic grounds the painting should be dated to the period of his reign.

Although Leach also proposes that the Cleveland portrait and our painting are closely comparable, it should be noted that her discussion of the Cleveland portrait does not indicate the presence of the embossed technique, a feature also absent from other portraits of the mustached raja (W. G. Archer 1973, vol. 1, p. 391, vol. 2, pls. 5 and 6, all of which show the figure in profile but appear to depict a slightly more shaded chin). The figures in the Nurpur portraits cited by Archer are depicted in painted floriate niches rather than in the raised ones of the Brooklyn page. Archer also notes the Nurpur artists' predilection for mauve, a color that is not evident in our page. For earlier literature on the page, see French 1931, pls. I and II; Coomaraswamy 1916, pl. XXX, labeled Jammu; Coomaraswamy 1926, pls. XCII–XCVII; Ghose 1929, pp. 6ff.

It is possible that this painting was intended as an isolated, perhaps votive, piece, or it may have been intended as a component of architectural decoration. The unusual feature of raised stamped detail occurs in very few early Pahari paintings of Krishna or Vaishnava themes.

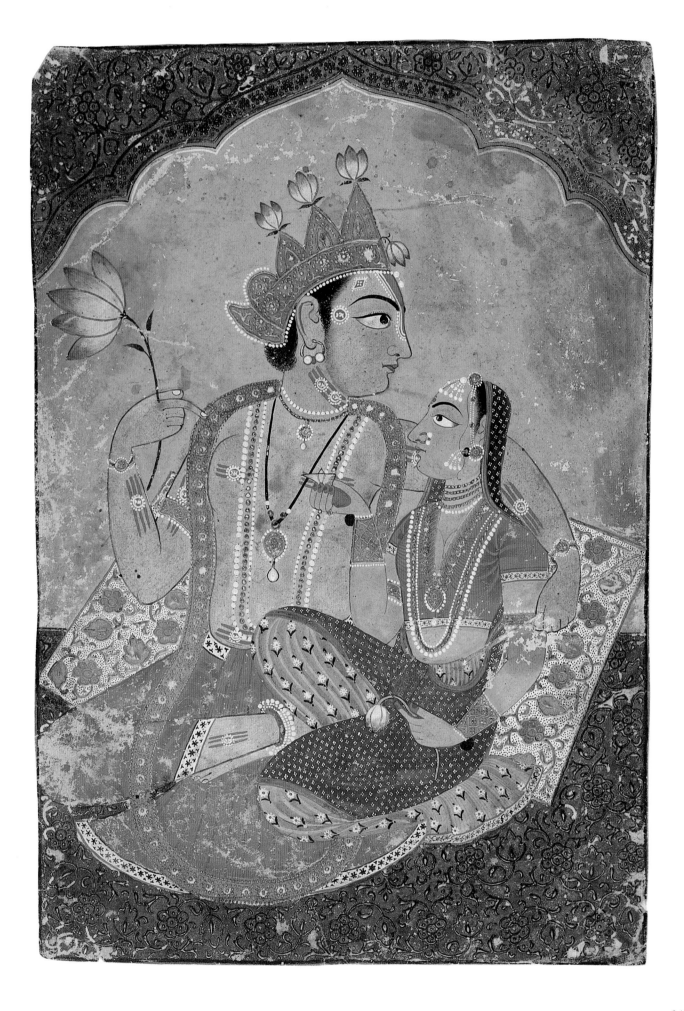

Examples of the embossed technique of raised and stamped ornament include a narrative scene from a *Ramayana* series of circa 1700 attributed by S. C. Welch as "Kulu with Bilaspur influence" (1973, cat. no. 37), in which the crowns, garland, bells, and other jewelry are shown in relief; a painting of the Great Goddess Durga seated on a lion (Kramrisch 1986, cat. no. 101); and the Vaishnava Saints Bhagwanji and Narainji (circa 1690) in the Government Museum and Art Gallery, Chandigarh (Goswamy and Fischer 1992, cat. no. 54, pp. 133 and 140). However, Goswamy and Fischer's description of the technique as repoussé metal sheet skillfully applied to paper differs from the technique of embossing in our page.

The painting has been executed on an old *bahi* (account) page, as indicated by the text on the reverse, in black ink, in Devanagari script. AGP

Literature Heeramaneck 1935–36, cat. no. 67; Spink 1971, fig. 88; Leach 1986, fig. 134C.

Provenance Ananda K. Coomaraswamy (?).

201 Artist unknown

Balarama diverting the course of the Yamuna River with his plough

Punjab Hills, Chamba
Circa 1760–65
Opaque watercolor and gold on paper
Image 5½ x 9⁵⁄₁₆ in. (14 x 23.65 cm)
Sheet 7⁵⁄₁₆ x 11³⁄₁₆ in. (18.6 x 28.4 cm)
A. Augustus Healy and Frank L. Babbott Funds, 36.250

Balarama, the principal figure in this illustration of divine power, lunges with a long plough in his extended right hand and holds an upright club in his left. The scene refers to an episode in the *Bhagavata Purana* in which Balarama, Krishna's brother, diverts the course of the Yamuna River. "Balarama spent two months in Brindavan, discoursing with Krishna by day and dancing with the milkmaids at night. One night when Balarama wished to bathe, he called to the Yamuna River to come to him; when the river paid no heed to his command, he angrily drew her toward him with his plough" (Coomaraswamy 1926, p. 60). The bright orange hue of Balarama's plough and mace, their position, and, above all, the unique placement of Balarama's limbs and the fluttering ends of his dhoti and scarf, all suggest that a miracle is taking place.

Seated at the right under the kadamba tree, Krishna plays his ever-present flute, attended by a female, possibly Radha, who offers betel leaf (pan). The viewer cannot ascertain whether Krishna or the woman has even recognized

Balarama's miraculous achievement. Their somewhat aloof position is alleviated by the swirling waves of the river that surrounds the rocks and the trees with flowering branches that bend in the direction of Balarama's action.

Both the palette, particularly the mustard yellow and purple-brown reserved for the coloration of the river, and the physiognomical details of the figures are distinctive Chamba conventions.

Two miniatures with similar scenes are in the Museum of Fine Arts, Boston (Coomaraswamy 1926, p. 166, acc. nos. 17.2555 and 17.2608). AGP

Literature Roberts 1937, pp. 113–26; Spink 1971, cat. no. 67.

Provenance Ananda K. Coomaraswamy, Boston.

202 Artist unknown

Durga slaying the Buffalo Demon, Raktabij, and Kali lapping up the demon's blood

Punjab Hills, Chamba
1800–1825
Opaque watercolor on paper
Image 9⁵⁄₈ x 13½ in. (24.5 x 34.3 cm)
Sheet 11⅛ x 15 in. (28.3 x 38.1 cm)
Gift of Ananda K. Coomaraswamy, 36.245

The combined episodes of Durga's attack on the demon and Kali's lapping up his blood are here presented in a single highly energized composition. A great orange-red monster with a human body, bird's claws, buffalo horns, white tusks, and a ferocious expression appears at the right. Astride her tiger vehicle, the multi-armed, crowned goddess Durga pierces the demon and attacks with her numerous weapons, while the black goddess Kali extends her long tongue to lap up the blood shed by the demon before it touches the ground and coagulates into new demons (*asuras*). Some of the blood emerging from the demon is transformed into numerous tiny Raktabij demons, who continue the battle.

The violent scenes of bloody battle express the dynamic energy of Durga. These two episodes are related in the *Devi Mahatmya* text of the *Markandeya Purana,* in which the goddess destroys various forms of demons, but multiple episodes incorporated in the same miniature is unusual. The *Bhayanaka rasa,* or the terrible sentiment, is predominant in this scene. Depiction of Devi in her frightening form of Kali engaged in devouring the streaming blood and the tiny demons emerging from the downpour successfully convey the intended terror.

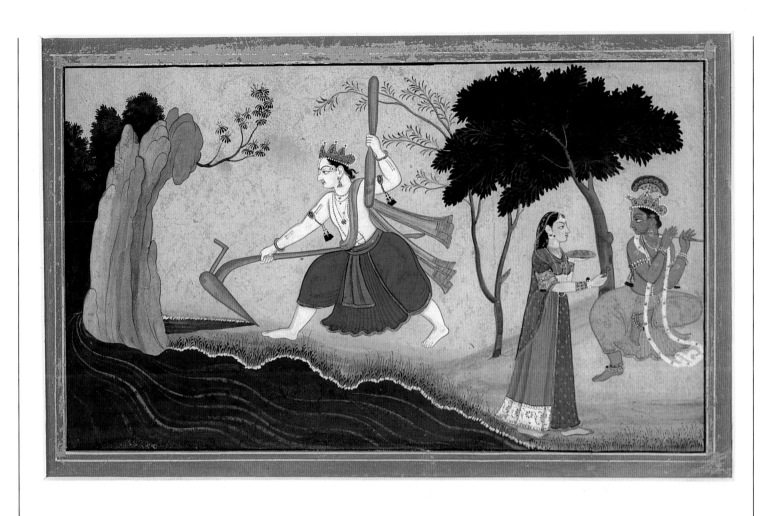

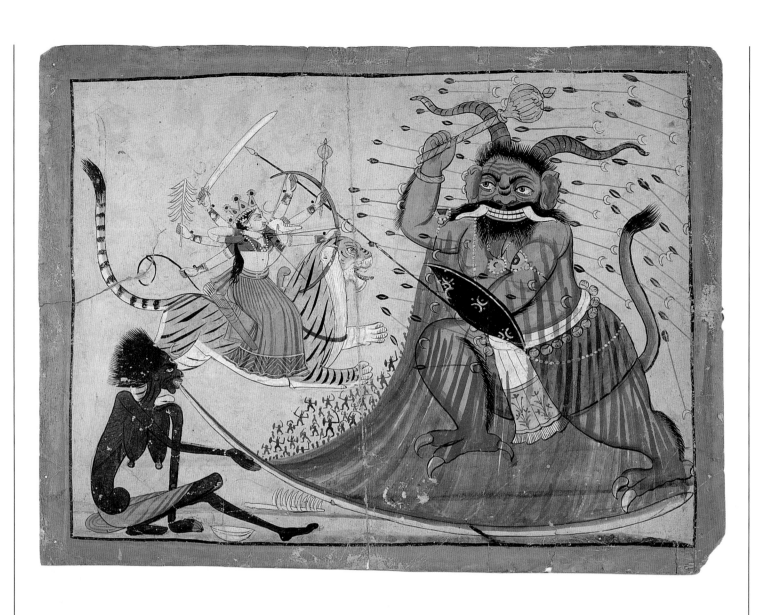

This independent leaf is not associated with any known *Devi Mahatmya* manuscript from the Hills but is here attributed to Chamba, which was noted for a predominantly red and yellow palette and produced many illustrated *Devi Mahatmya* manuscripts. These stylistic characteristics appear in more refined renderings of this subject in the *Devi Mahatmya* produced in Guler, circa 1740–81 (Aijazuddin 1977, cat. no. 48).

For a similar subject also from the Punjab Hills, in Guler or Kangra style, see Goswamy 1986b, p. 196, cat. no. 152. The date is less certain, but early nineteenth century is probable. AGP

203 Artist unknown

Page from a Naishadha-charita of Shri Harsha series

Punjab Hills, Chamba
Circa 1800–1825
Opaque watercolor and gold on paper
Image 9⅝ x 14 in. (24.5 x 35.5 cm)
Sheet 11⅝ x 15⅝ in. (29.5 x 39.6 cm)
Anonymous gift, 81.192.9

INSCRIPTION
Verso, at top center, in black ink, in Devanagari script: *31.*

In the wilderness setting, the figure of the hero Nala is repeated three times. At the right, he beseeches his antagonist, King Rituparna, who is seated on a horse-drawn cart with two attendants; at upper left, he shakes a tree; in the lower left corner, he stands next to the felled tree. The scene is not identified by any inscription but may represent the epi-

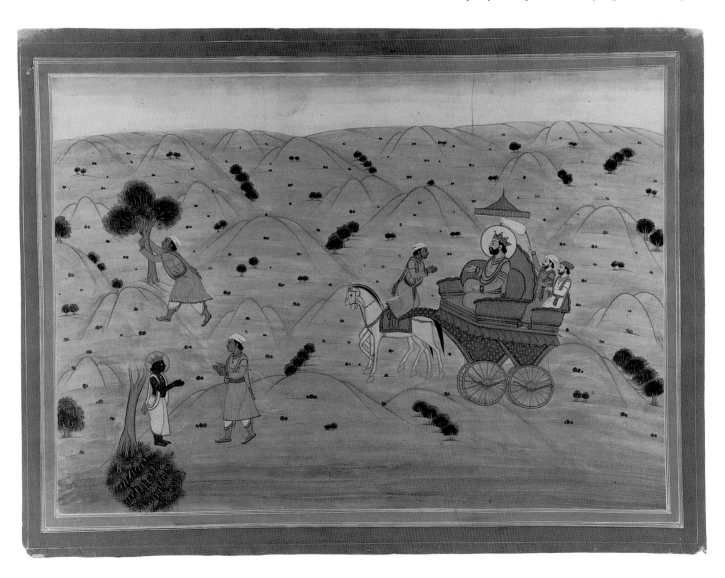

sode in which Nala shows Rituparna his skill at numbers by counting all the leaves of the forests.

Forty-eight drawings for a *Nala-Damayanti* series painted at Kangra about 1800, many of which are located in the Museum of Fine Arts, Boston, have been published by Eastman (1959), who identifies them as illustrations of the *Naishadha-charita* of Shri Harsha. Our painting belongs to a somewhat later, less ambitiously conceived series from which another painting has been published (see Dallapiccola 1978, p. 57, cat. no. 45, for which a specific Pahari school is not suggested). AGP

204 Artist unknown

Baj Bahadur of Kumaon (?)

Punjab Hills, Garhwal (?)
Circa 1750
Opaque watercolor and gold on paper
Image 10 x 6¾ in. (25.4 x 17.1 cm)
Sheet 12⅜ x 8⁷⁄₁₆ in. (31.4 x 21.4 cm)
Anonymous gift, 73.175.9

INSCRIPTION

In upper left of painting, in Takri script: *Raja Vaj Vahadur of Kumaun [?]*. (Trans. G. Sidhu)

Against a green background, with a band of clouds and blue sky at the top, a figure identified as Baj Bahadur rides a fully caparisoned brown horse. This unusual painting does not conform to the standard Pahari equestrian portrait, which often shows the rider with a falcon. Certain features, such as the figure isolated against an empty green background, demonstrate a strong connection to Mughal seventeenth-century portraiture, where this portrait tradition emanated, whereas the palette, empty landscape, distinctive manner of painting the band of sky and clouds at the top, and form of the horse do conform to a Pahari style.

This painting was originally identified as a Mughal portrait, until the inscription was first recognized by Glynn and Skelton (personal communications, 1978), as the Takri script of the Punjab Hills. Because of its geographic proximity to the plains, Bilaspur was suggested as the place of origin, since the earliest examples of painting associated with the state dated from the reign of Raja Dip Chand (1650–67), and its artists were recipients of seventeenth-century

Mughal and Rajasthani influences. The subject in this portrait has not yet been firmly identified. Various readings of the inscription have been suggested, but we now read it as "Kamaun da raja vaj vahadur." Kamaun is here interpreted as Kumaon, a state east of the Punjab Hills that remained a Rajput state until its defeat by the Gurkhas in 1790, except for a brief period (1744–45) when it was overrun by the Mughals. Based on the inscription, the painting may be ascribed to Kumaon, to which no published paintings have yet been attributed, with the conclusion that the sitter was one of its rulers, although no Raja Vaj Vahadur is listed in period records. (We are grateful to Gursharan Sidhu for reading the inscription and sharing his research on Kumaon's history.)

Stylistically, the painting relates to those produced at Garhwal, a state in close proximity to Kumaon. Archer cites the history of wars between Garhwal and Kumaon during the reigns of Garhwal rulers Prithi Shah (c. 1635–c. 1665), Medini Shah (c. 1665–84), and Fateh Shah (c. 1684–1716). The Garhwal court had alliances with the Mughals, and Archer notes that circa 1660 they "frequented Delhi" and retained the Mughal artists Sham Das and his son Har Das (W.G. Archer 1973, vol. 1, p. 98). Seen in relation to Mughal portraits of the reign of Emperor Aurangzeb (1658–1707), late-seventeenth-century Pahari portraits from several states, notably Bilaspur and Guler, reveal sensitivity to the features of the figure, which is often shown with face and feet in profile. The costumes and accoutrements, such as the short dagger (*katar*), are similar to those in Aurangzeb portraits, and the jeweled ornaments, particularly the dropped pearl earring seen here, are also evident in a circa 1660 portrait of Raja Dip Chand of Bilaspur listening to musicians (W.G. Archer 1973, vol. 2, p. 169). A portrait of a Bilaspur raja worshiping Krishna attributed to 1680–1700, in the Jagdish and Kamla Mittal Museum of Indian Art, Hyderabad (Desai 1986, cat. no. 80), is discussed as a Mughalized Pahari portrait because of its "subdued" character and delicate ornateness, qualities not unlike those present in our equestrian figure. The horse's form and trappings also appear in a depiction of a horse in a narrative scene from a folkish *Bhagavata Purana* series of circa 1670–80, attributed to Bilaspur (Archer, op. cit., fig. 5[i]). In addition to the delicate details, the muted green wash of the background, blue sky, and high horizon continue a Mughal convention favored by artists in Bilaspur and Mandi (see Glynn 1983, p. 56). AGP

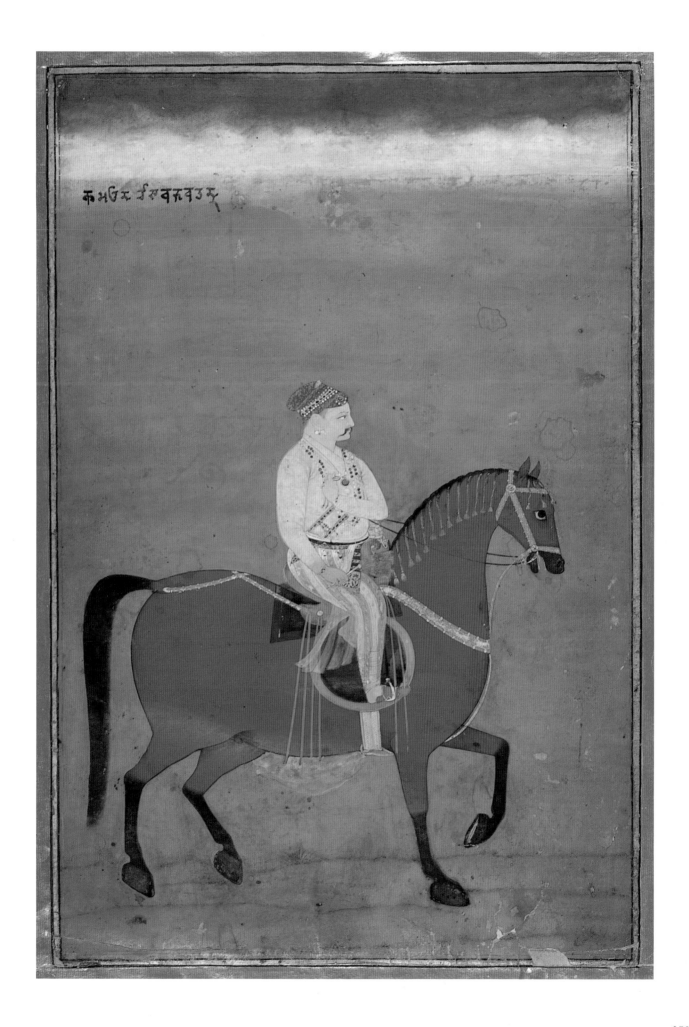

205 Artist unknown

Page from a Rukmini Haran series

Punjab Hills, Garhwal or Nurpur
Circa 1760–1800
Opaque watercolor on paper
Image 7⅛ x 10¹/₁₆ in. (18.1 x 25.6 cm)
Sheet 8⅜ x 11⅜ in. (21.3 x 28.9 cm)
Gift of the Ernest Erickson Foundation, Inc., 86.227.202

INSCRIPTIONS
Recto, in top margin, in black ink, in Takri script, center: *Rukma of Kurabapura*; right: *Shishupala, King of Chedi.*

The theme of Rukmini's marriage to Krishna is often depicted in Pahari paintings. This leaf from a dispersed *Rukmini Haran* series depicts an interior scene in which Rukma, brother of Rukmini, urges his father to marry Rukmini to Shishupal, who is king of Chedi. Rukma is shown in an agitated mood. Several companions support his pleas with the king. The principal theme of the tale is the marriage of Krishna and Rukmini. Rukmini had been engaged to marry Shishupal but is abducted by Krishna and becomes his wife.

This page belongs to a set of twelve paintings from a *Rukmini Haran* series attributed to Garhwal or Nurpur on the basis of style and the palette of red, brownish pink, and

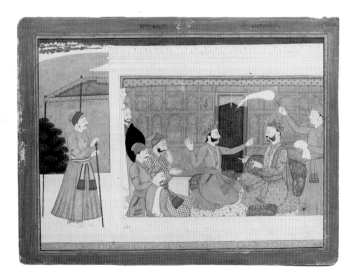

mauve (W. G. Archer 1973, vol. 2, p. 400). That this set of Nurpur paintings once belonged to the Garhwal royal collection may be due to the close relations between the ruling families of the two states in the first half of the nineteenth century. Ohri, who has discussed this series in relation to a Chamba school version of this subject in the Bhuri Singh Museum, Chamba, views the Garhwal school group as nineteenth-century copies of the Chamba series (Ohri 1975, p. 188, fig. 72). The compositions of the two scenes are essentially identical except for minor details and the different rendering of the faces, indicating that they may have been taken from the same stencil *(charba)* drawings. This view is also confirmed by Lal, who has published the Garhwal set, to which our leaf belongs, and attributed the painting to Mola Ram (1968, p. 90). Both Lal and Ohri place the drawings for the original *Rukmini Haran* series at Guler, the school credited with the development of later Pahari painting and the blending of lyricism, naturalism, and harmonious composition and colors. Ohri, who contends that artists at Garhwal copied this and other Chamba paintings, considers the quality of the Garhwal copies to be inferior as well. Lal indicates that this series once belonged to the Garhwal royal collection and notes the close relations between the ruling families of the two states in the first half of the nineteenth century.

Other leaves from this series are in the San Diego Museum of Art (formerly Collection of Edwin Binney, 3rd); William Theo Brown and Paul Wonner Collection, San Francisco; and Dr. Frederick Baekeland Collection, New York. AGP

Literature Lal 1968, pl. XXV; Poster 1986, cat. no. 131.

Provenance Balak Ram Sah of Srinagar, Garhwal; Mukandi Lal Collection.

206 Artist unknown

The Brahmin Sudama and Rukmini in a palace

Page from the Sudama episode of a *Rukmini Haran* series
Punjab Hills, Garhwal (?)
Circa 1800 or later
Opaque watercolor on paper
Image 8⁵/₁₆ x 10¹⁵/₁₆ in. (21.1 x 27.8 cm)
Sheet 8¹³/₁₆ x 11⁷/₁₆ in. (22.4 x 29.1 cm)
Anonymous gift, 80.277.17

This scene (after an earlier Garhwal painting) depicts the sage Sudama arriving at Rukmini's abode to tell her of Krishna's return and intent to elope with her. Sudama, dressed in yellow and lavender, stands in the courtyard of a white marble palace conversing with Rukmini, who sits in a tower balcony. His right hand is raised with index finger outstretched, indicating that he is relaying a message. Rukmini holds her veil in front of her face, a gesture of modesty. At the left, a seated maidservant in a mauve bodice and skirt holds a fly whisk. In the distance at upper left, small figures of a man and a woman converse on a roof terrace. Beyond the pink and white courtyard wall is a row of leafy trees interspersed with cypresses. The background is blue with a streak of white and a narrow band of darker blue.

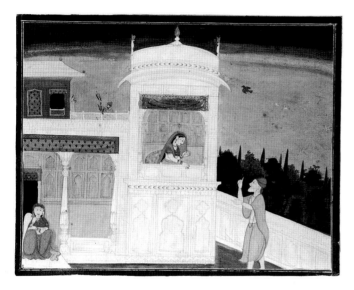

Three very similar compositions, with red backgrounds (more typical of Guler), have been published. One, in the Victoria & Albert Museum, London, is cited by W. G. Archer (1973, vol. 2, p. 83, Garhwal, no. 12) as Garhwal, 1775–85. A second painting, in the Bhuri Singh Museum, Chamba, is ascribed to a Master of the First Generation after Nainsukh by Goswamy and Fischer (1992, p. 345, cat. no. 147). A third version is in the Los Angeles County Museum of Art (Canby 1983, cat. no. 33). Considering the minor variations in such details as costume and architecture among the versions of this episode, the most striking difference between our page and the Bhuri Singh page, for example, is in the treatment of the background: in our page the sky is painted in several shades of blue, whereas the Bhuri Singh version has a bright red background. The figures in our page are considerably less sensitively drawn, with a stiffer line and an awkward presentation of the figures, as, for example, the maid who, though supposedly asleep, has her eyes wide open. AGP

207 Artist unknown

Ganesha

Punjab Hills, Guler
Circa 1775–1800
Opaque watercolor on paper
Image 6⁷⁄₁₆ x 9⁷⁄₁₆ in. (16.35 x 24 cm)
Sheet 8³⁄₁₆ x 11⁵⁄₁₆ in. (20.8 x 28.8 cm)
Gift of Ananda K. Coomaraswamy, 36.242

The isolated figure of Ganesha, the elephant-headed god, suggests that this page was intended as a frontispiece for a narrative manuscript. Ganesha would be invoked on ritual occasions in order to ensure their auspicious completion. Here, the god is seated on a lotus pedestal in the center of a marble terrace with trees at either side and a hill beyond. The figure of Ganesha is painted orange shaded with red-brown. Seated cross-legged (in *padmasana*), he wears a white dhoti, a seven-pointed jeweled crown, a pair of long necklaces, armlets, and bracelets. He has the crescent moon and third eye of Shiva, and three of his four hands hold attributes: the goad, the axe, and a ball of sweets. The fourth hand is shown in the gesture of granting gifts (*varada mudra*). The white terrace is enclosed by a pierced railing. A narrow dark blue border surrounded by a flecked pink border completes the design.

Goswamy (personal communication) has attributed this painting to the Guler artist Nainsukh. Neither the artist nor the subject of the series of this isolated painting has been conclusively identified. AGP

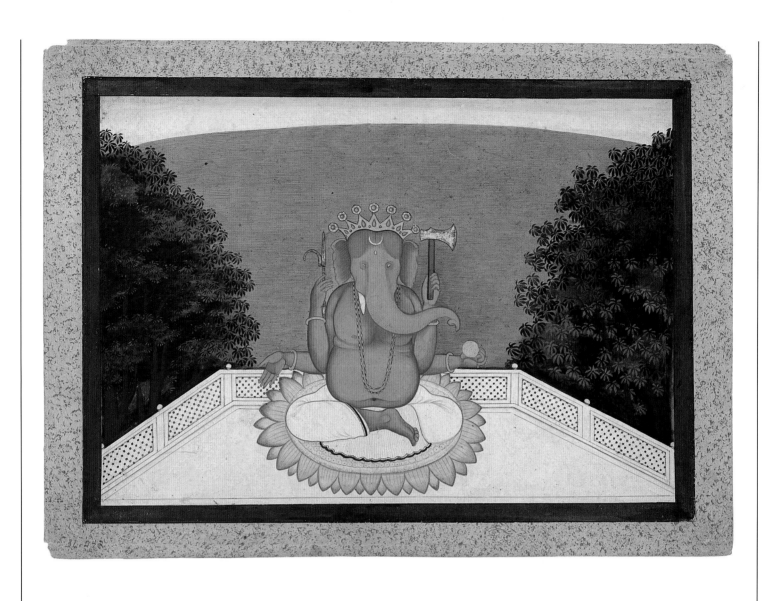

208 Artist unknown

Mahasura attacks the Devi

Page from a dispersed *Devi Mahatmya* series
Punjab Hills, Guler
Circa 1770–80
Image 6¾ x 10½ in. (17 x 26.8 cm)
Sheet 7⅞ x 11⅝ in. (20 x 29.5 cm)
Anonymous gift, 85.220.2

INSCRIPTIONS

Recto, at top in yellow margin, in Devanagari script: *13.*
Verso, in ink, in Devanagari script: *Beholding the descending [missile]. Devi released her missile, which, becoming hundred fold, brought Mahasura to subjugation.* (Trans. S. Mitra)

Like the Chamba folk painting of Durga attacking the demon Raktabij discussed above (cat. no. 202), this battle scene depicts the multi-armed goddess on her lion mount at the left as she battles the zoomorphic demon Mahasura, shown in three consecutive positions at the right. The goddess brandishes various weapons in her sixteen arms and is accompanied by five *ganas*. The scene is set in a barren landscape, indicated by a yellow wash, highlighted by rocks and clumps of brush. There is a high curved horizon line.

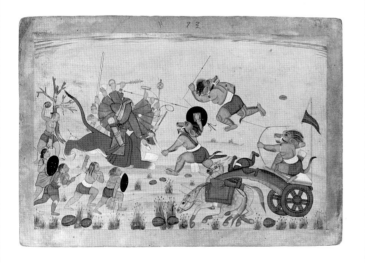

On the basis of provenance, the series to which this page and another in the Museum's collection belong (see cat. no. 209) was first ascribed to Guler of circa 1745 (W.G. Archer 1973, vol. 1, p. 150). However, the subsequent discovery of a colophon bearing the date V.S. 1838 [A.D. 1781] on a page from a *Devi Mahatmya* manuscript, a section of which is in the Lahore Museum (Aijazuddin 1977, pp. 19–33), has led scholars to reconsider the dating of our pages.

Although the colophon does not provide a firm date for the execution of the pages, it does enable us to define the characteristic parameters of the Guler style. Aijazuddin notes that the *Devi Mahatmya* series in the Lahore Museum may have actually been painted circa 1740–50, copying an earlier set, and inscribed later (1977, cat. no. 41 [i-xxxiv], especially no. xxvii). There is also an unfinished early Guler series of the same style, palette, and format in the Museum of Fine Arts, Boston (Coomaraswamy 1926, pp. 127–32, pl. 62).

Other *Devi Mahatmya* pages related to our paintings, dated variously to 1750–60, are reproduced in Lee 1960, cat. no. 54; W. G. Archer and Binney 1968, pl. 86; Wiener 1974, cat. no. 76; and Pal 1978, cat. no. 62. AGP
Provenance C. Bharany, New Delhi.

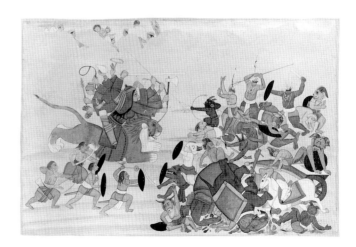

209 Artist unknown

The Devi defeats Mahasura

Page from a dispersed *Devi Mahatmya* series
Punjab Hills, Guler
Circa 1770–80
Opaque watercolor and gold on paper
Image 6⅝ x 10⅜ in. (16.8 x 26.5 cm)
Sheet 6¾ x 10⁹⁄₁₆ in. (17.3 x 26.8 cm)
Gift of Kaywin Lehman Smith, 84.205

INSCRIPTION

Verso, in black ink, in Devanagari script: *Devi accompanied by the spirits fought fiercely with the great* asura. *As the gods worshiped her, showers of flowers came down from the heavens.* (Trans. S. Mitra)

This more highly finished page from the same series illustrating the feats of the Devi in overwhelming the demon (see cat. no. 208) shows the armed goddess astride a lion in the act of vanquishing Mahasura's army of demons. There

are at least two other contemporary *Markandeya Purana* series that exhibit elements of this style, namely, the fluid naturalism, fine drawing, and bright hues interpolated into a subdued palette, presented here with washes of green and blue over a yellow ground, bright orange, red, green, and blue costumes, and other details accentuated with gold. The artist has carefully defined the facial expressions and gestures of the wounded and defeated demons, especially the orange and yellow demons squashed beneath one of the toppled elephants, one component contributing to the success of the intricate composition. AGP

210 Artist unknown

Leaf from a dispersed Hamir Hath series

Punjab Hills, Guler
1800–1810
Opaque watercolor and gold on paper
Image 8³⁄₁₆ x 12¼ in. (20.8 x 31.1 cm)
Sheet 9⅝ x 13⅞ in. (24.45 x 35.3 cm)
The Brooklyn Museum, acquired by exchange, 36.233

Two scenes from the *Hamir Hath* narrative are depicted here. In the lower corner, Mahima speaks to a bearded sentry at the gate in the palace wall, which runs diagonally across the lower part of the painting. In the upper portion of the painting, Mahima stands in the palace courtyard, his hands held in supplication before a pavilion in which Hamir Deb is holding court. Seated on a low dais, with his back to Mahima, he turns his head around and extends one arm as if in greeting. An attendant, hidden almost totally by a column, holds a peacock-feather whisk above him. Seated along the sides of the room on a red flowered carpet with green borders are the king's attendants, outfitted with

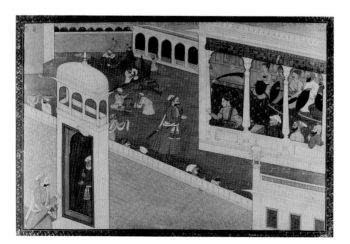

shields and swords. In the courtyard that fills the upper left section of the scene, workmen are busy dismantling a gold shrine, weighing the pieces, and carrying them away in baskets.

Despite such Kangra stylistic elements as the angled palace setting and finely detailed figures, Archer discusses his reasons for his attribution to Guler of the *Hamir Hath* series at length. He records two Pahari *Hamir Hath* sets painted at Mandi and at Guler between the years 1800 and 1810 (W. G. Archer 1973, vol. 1, pp. 360–62, 162, vol. 2, Mandi, no. 42, and Guler, no. 56). Our page, with its angular composition and carefully rendered portraits, is typical of paintings at Guler in its high period (1790–1805), during the reign of Sansar Chand of Kangra. Archer describes this time as a turbulent era in which the *Hamir Hath* adventures must have been chosen to reflect that ruler's downfall, and thus would not have been painted at Kangra (ibid., vol. 1, p. 362). Our page is closer in style to the pages Archer attributes to Guler (1800–1805) rather than to the later Mandi set (1808). Stylistically, this painting is related to a *Maha Lakshmi* series, produced in Guler in the decade 1760–70 (ibid., Guler, p. 159).

Other examples from the same series are in the Museum of Fine Arts, Boston (Coomaraswamy 1926, p. 117, pl. LV). For a drawing from the series in the Museum's collection, see Appendix no. D73. AGP

211 Artist unknown

Shiva and Parvati riding on Shiva's mount, Nandi

Punjab Hills, Guler
Circa 1800
Opaque watercolor and gold on paper
Image 5⅞ x 4¼ in. (14.9 x 11 cm)
Sheet 6¼ x 4¹¹⁄₁₆ in. (16 x 11.9 cm)
Promised gift of Mr. and Mrs. Paul E. Manheim, L69.12.2

Shiva and Parvati on Shiva's bull, Nandi, have been rendered in a simple line drawing. Shiva is provided with his customary attributes: the serpent around his neck, the third eye, and the crescent moon on his forehead. He is wrapped in a leopard skin, and a long pale-pink shawl is draped over his shoulders. His hair is tied into a *kapardin mukuta.* In his right hand he holds a green and orange flag attached to the ubiquitous trident. His left arm supports Parvati, who wears a long pleated purple skirt and a short orange choli. The hem of her skirt is accentuated with a floral-patterned gold band. She wears a green belt, a simple white necklace, two

bracelets, and a semitransparent gold scarf that covers her head and crosses over her right shoulder. In her raised left hand she holds a water vessel, matched in her right hand by a raised cup, suggesting a domestic theme for the scene. Her toes and palms have been dyed with henna. The gray and white Brahmin bull has an orange strap around his neck and, across his back, a large orange saddlecloth trimmed with a green border and decorated with an intricate curvilinear red pattern.

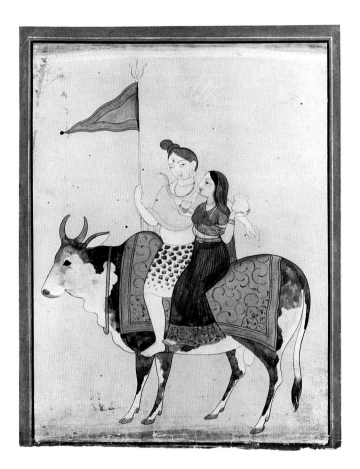

The position of Shiva and Parvati on Nandi is somewhat peculiar. Shiva's torso twists awkwardly from the profile position of his lower body into a three-quarter view. The background is yellow with a green wash at the bottom indicating the ground; a white and blue band at the top indicates the sky and clouds. The scene is outlined by black and white lines set against a red border. AGP

212 Artist unknown

Rama kicking a demon

Page from the "Shangri *Ramayana*"
Punjab Hills, Jammu
Circa 1700–1710
Opaque watercolor, silver, and gold on paper
Image 7½ x 12½ in. (19 x 31.75 cm)
Sheet 8⅝ x 13⅞ in. (21.95 x 35.3 cm)
Ella C. Woodward Memorial Fund, 70.145.2

INSCRIPTIONS
Verso, at upper left, in black ink, in Sanskrit, in Takri script: *Shri Kishkindha;* at middle left, in black ink, in Takri script: *25.*

This wilderness scene, from the fourth part of the *Ramayana* (*Kishkindha kanda,* named for the Kishkindha cave that was the homeland of the monkey army), shows the hero Rama kicking a demon whose eyes are closed and long legs and arms are outstretched. The onlookers at the left include Rama's brother Lakshmana, the monkey king Sugriva, and two monkeys. The figures are placed above a striped ocher and yellow ground line delineated with tufts of grass.

The Shangri *Ramayana,* named for the state where it was part of the ancestral collection of the ruling family, has been described as one of the earliest examples of Kulu painting. The series, discovered in 1956, included more than two hundred seventy leaves. The largest holdings, more than one hundred fifty pages, are now in the National Museum of India, New Delhi, and the Bharat Kala Bhavan, Banaras Hindu University (for the latter, see *Chhavi-2,* pp. 247–51, figs. 540–43). For a detailed discussion of the set and a complete bibliography of its scholarly consideration, see W. G. Archer 1973, vol. 1, Kulu, pp. 325–29, vol. 2, pp. 238–43.

Goswamy and Fischer have argued with some persuasiveness (1992, pp. 76–81) that the Kulu attribution commonly given to the Shangri series is mistaken. They suggest that the pages in Style I and Style II were painted at the court of Bahu, a once-influential capital of the state of Jammu. This new attribution is based on the similarities between Styles I and II and the style of a small group of early-eighteenth-century portraits of Bahu rulers. They maintain that in this period, this style of painting was produced in the Basohli area (in the western group of Pahari states), but not as far east as Kulu (ibid., p. 76). While the connection they propose between these pages and the state of Jammu is at least more convincing than the argument in favor of a Kulu attribution, their proposal of an attribution to Bahu, a

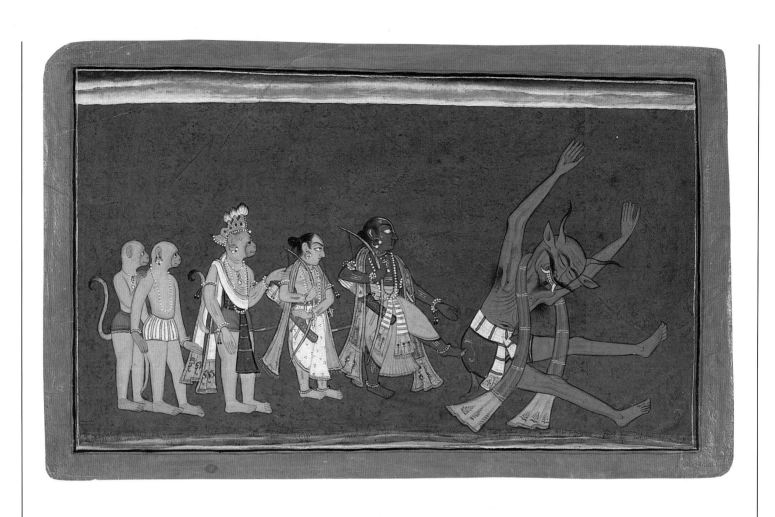

sometime capital of a satellite state of Jammu, and at times merely a provincial fortress a few miles from the town of Jammu, is more tenuous. Until additional evidence and/or arguments are adduced in favor of the Bahu attribution, this writer would simply prefer to ascribe these folios to the state of Jammu.

Goswamy and Fischer also suggest that Styles I and II are the work of the same hand. In accordance with previous theories, they attribute the pages in Styles III and IV to a different hand or hands, in fact suggesting that the Style IV pages were executed at, or by artists from, Mandi or Bilaspur. On the assumption that a coherent manuscript was executed in one place, we have assumed that, wherever the artists may have originated, the pages of Styles III and IV were executed together with those of Styles I and II and thus ascribe the entire series to Jammu.

Our page represents the naïvely exuberant and hieratic Style III of the series. The square-shaped heads of the monkeys and figures in this painting and the presentation of a row of figures on one plane set against a solid green or yellow background with high horizon of white and blue stripes are distinctive features of Style III. Bilaspur-type figures, pale yellow background, and inscribed borders are features of Style IV.

Other leaves representing Rama and Lakshmana with their monkey cohorts in the forest are discussed and reproduced in W. G. Archer 1976, pp. 90–93, cat. nos. 49 and 50; Ehnbom 1985, p. 198, cat. no. 97; and Kramrisch 1986, cat. no. 106, from the Alvin O. Bellak Collection, Philadelphia. Unpublished pages are in the collections of Mrs. W. G. Archer, London; Paul F. Walter, New York; Vinod Kanoria, Patna; Mrs. Nasli Heeramaneck, New Haven; San Diego Museum of Art (formerly Collection of Edwin Binney, 3rd); British Museum and Victoria & Albert Museum, London; Los Angeles County Museum of Art; and Pan-Asian Collection, now dispersed. AGP

Provenance Raja Raghbir of Shangri, Kulu Valley.

213 Artist unknown

Vali and Sugriva fighting

Page from the "Shangri *Ramayana*"
Punjab Hills, Jammu
Circa 1700–1710
Opaque watercolor on paper
Image 6¹⁵⁄₁₆ x 11¹⁄₁₆ in. (17.6 x 28.1 cm)
Sheet 8 x 12¼ in. (20.3 x 31.1 cm)
Gift of Mr. and Mrs. H. Peter Findlay, 77.201.1

INSCRIPTIONS
Verso, upper left, in black ink, in Sanskrit, in Takri script: *Shri Kishkindha;* middle left, in black ink, in Takri script: *34.*

A second scene of monkeys from the same series illustrated in catalogue number 212, also painted in Style III but by another artist in lighter tones, shows, at the left, the broth-

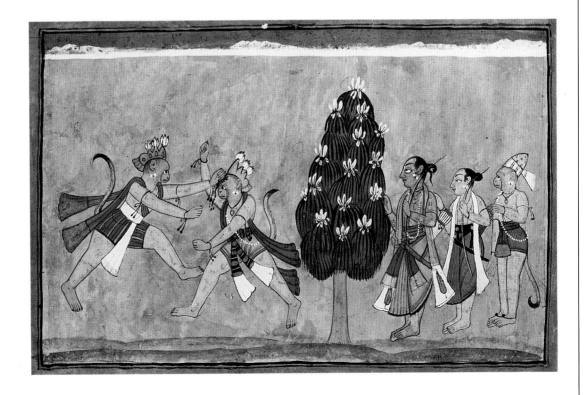

ers Vali and Sugriva, the two monkey kings, wrestling in a clearing in front of Kishkindha. Rama, Lakshmana, and Hanuman look on from behind a tree at the right. The brothers' dispute, which arose when Vali abducted Sugriva's wife, ends when Rama pierces Vali's heart with his golden arrow. Except for a solitary tree, the landscape is indicated only by a light green background and a dark green wash at the lower edge to denote a ground line. A thin blue band with white at the top indicates the sky and clouds. There is a red border with black rules. AGP

Provenance Raja Raghbir of Shangri, Kulu Valley.

214 Artist unknown

Vishvarupa, the cosmic form of Krishna

Punjab Hills, Jammu (?)
Circa 1820
Opaque watercolor and gold on paper
Image 2¹⁵⁄₁₆ x 5½ in. (7.45 x 14 cm)
Sheet 3¾ x 6⅛ in. (9.5 x 15.5 cm)
Anonymous gift, 79.186.1

This minute and carefully executed painting depicts the momentous episode in the *Bhagavad Gita (Mahabharata)* when Krishna reveals his cosmic form as Vishvarupa to Arjuna. A crowned Arjuna, shown in profile, stands at the left, clad in a pale violet jama, yellow shawl, and green waistband. He has a long mustache and sideburns; his hands are joined in supplication. The cosmic manifestation of Krishna is depicted as multi-headed, his sixteen arms fanning outward from his body, and his spread-eagled legs in the form of mountain peaks representing the entire universe. The two figures are isolated against a plain orange background, within yellow borders.

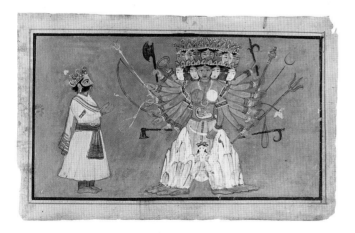

The attribution of this leaf to Jammu is based on the examination of figural stylizations and facial features in a late-eighteenth-century series painted at Jammu (W.G. Archer 1975, p. 95a, b). Krishna's revelation as Vishvarupa is also represented in a painting from Bikaner considered to be circa early eighteenth century, which has been extolled by Goswamy (1986, p. 217):

. . .the grandeur of the theme, the immanent, absolute, all-pervasive form of godhead, has stimulated some great work in the visual arts. In this context, the painters frequently take their inspiration from those incandescent, wonderfully eloquent passages in the *Bhagavad Gita* in which Krishna reveals to Arjuna his cosmic form. To the many doubts of the great Pandava hero, Krishna provides a variety of answers and, in the course of his "song," in words that contain "both metaphysics and ethics . . . the science of reality and the art of union with reality," Krishna speaks of himself as the Supreme Spirit. Humbly begging Krishna to reveal to him this divine aspect, Arjuna is granted a vision. "Behold now," Krishna says, "the entire universe with everything moving and not moving here, standing together in my body." Arjuna sees that majestic vision and is shaken, but then speaks of it in ecstatic words. . . .

AGP

215 Artist unknown

First night in exile

Page from a dispersed *Ramayana* series
Punjab Hills, Kangra
Circa 1775–80
Opaque watercolor on paper
Image 7⅞ x 12⅛ in. (20 x 31.3 cm)
Sheet 9⅝ x 13⅞ in. (24.45 x 35.25 cm)
Gift of Kaywin Lehman Smith, 80.181

The thin washes of grayed tones describe a night scene that illustrates an episode in the *Ayodhya kanda,* Part Two of the *Ramayana.* Guhaka, a friend of Rama and king of the Nishadas, a forest-dwelling people, converses with Lakshmana (Rama's brother), who guards the sleeping couple, Rama and Sita. They have just crossed the river Ganga beyond the border of Koshala into exile. The figure seated by a chariot on the left can be identified as Sumantra, Rama's charioteer. At the lower right, Guhaka's servants are shown carrying food and drink. (The scene has been identified by Dr. Barbara Stoler Miller.)

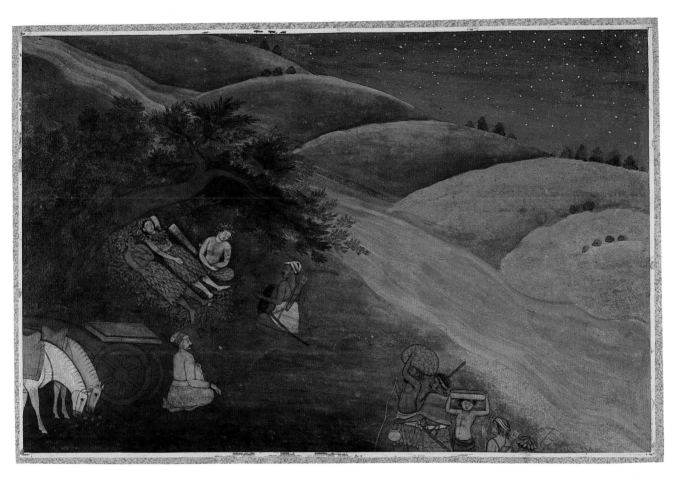

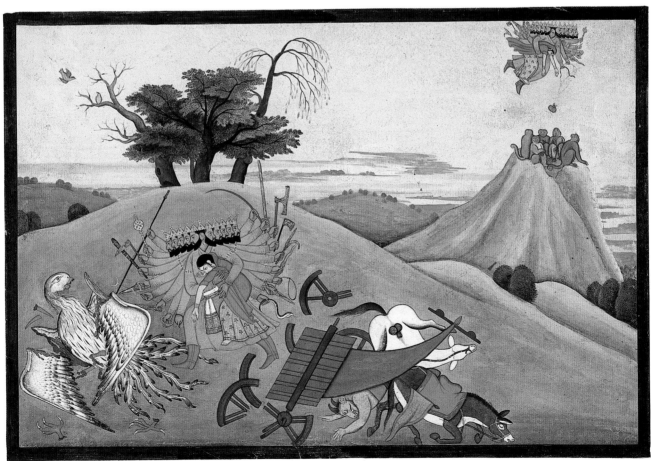

263

The river divides the pictures diagonally and, as in another Kangra painting from the same set, catalogue number 216, the landscape elements reiterate the figural composition. Here the line of the riverbank and an overhanging tree frame the figures in a triangular arrangement.

The Kangra *Ramayana* series is traditionally associated in style and date with other illustrated series, the *Bhagavata Purana* and the *Gita Govinda* (see W.G. Archer 1973, vol. 1, pp. 291–93). These three great series show the Kangra style at its height, reflecting the patronage of Raja Sansar Chand (r. 1775–1823). Archer suggests that the sets may have been commissioned to celebrate Sansar Chand's own wedding, which took place in 1781 (ibid., pp. 284–95). Since Sansar Chand was a devout Vaishnavite, illustrations of the Krishna themes in the *Bhagavata Purana* and *Ramayana* series would have been appropriate (ibid., p. 293).

The *Ramayana* series is identified stylistically by compositions emphasized by strong diagonals and meticulously detailed scenes with strong emotional impact. Archer suggests that there may have been three or more master artists engaged to work on this large series, which consists of more than one hundred pages. Goswamy and Fischer propose that the set be attributed to the second generation of descendants of Manaku and Nainsukh (Goswamy and Fischer 1992, pp. 313 and 340). Archer describes an unknown artist of the Kangra *Bhagavata Purana* series as the "master of the moonlight," who endowed the night scenes "with flowery lushness and eerie pallor," and suggests that he was one of the artists active in the production of the *Gita Govinda* (W.G. Archer 1973, vol. 1, p. 295). The stylistic qualities of the master are evident in our night scene.

For other illustrations from this series, see W. G. Archer 1976, pp. 72–77, cat. nos. 40–42; Pal 1976, cat. no. 6; Pal 1978, cat. nos. 67a and b; Ehnbom 1985, pp. 234–37, cat. nos. 116–18; Kramrisch 1986, cat. no. 120.

For another page from the series in our collection, see catalogue number 216. AGP

Literature *Archives of Asian Art* 1982, p. 85, fig. 4; Poster 1987, p. 18, col. pl.

216 Artist unknown

The abduction of Sita

Page from a dispersed *Ramayana* series
Punjab Hills, Kangra
Circa 1775–80
Opaque watercolor, silver, and gold on paper
Image 8 x 12¹⁄₁₆ in. (20.3 x 30.65 cm)
Sheet 9¾ x 14 in. (24.8 x 35.7 cm)
Anonymous gift, 78.256.3

The second page in our collection illustrating the Kangra *Ramayana* depicts Ravana's abduction of Sita, told in Book 3 of the *Aranya kanda*. In this poignant composition, violent action is depicted with both exacting realism and symbolic detail. The ten-headed demon Ravana, king of Lanka, crowned and armed with weapons, has severed the wings and body of the giant vulture Jatayu, who tried to rescue Sita, and has abducted the momentarily helpless heroine. In the foreground, the two horses and demon-charioteer lie crushed beneath his ruined chariot. In the upper right, Ravana, in flight, holds Sita under his arm; she lets fall an orange parcel (containing her jewelry), a clue that leads to her discovery by Hanuman's troops, here represented by five monkeys seated on a mountain peak. The landscape setting is prophetically cold and desolate: a single flourishing tree framed by two starkly barren trees depicted at the left echo the powerlessness of Sita's protectors. A thick dark blue line borders the painting with a speckled pink outer border.

Another representation of Sita's abduction, painted at Nurpur, circa 1720–30, is cited by W. G. Archer 1973, vol. 1, p. 396; vol. 2, p. 310.

For discussion of this Kangra *Ramayana* series, see catalogue number 215, which is the work of another master artist. AGP

Literature Poster 1987, pp. 32–33, col. pl.

217 Artist unknown

Utka Nayika

Punjab Hills, Kangra
Late 18th century
Opaque watercolor on paper
Image 7¼ x 4⅞ in. (18.4 x 12.4 cm)
Sheet 9¹³⁄₁₆ x 7⁹⁄₁₆ in. (24.95 x 19.2)
A. Augustus Healy and Frank L. Babbott Funds, 36.241

This small unfinished painting illustrates *Utka Nayika,* the heroine in Hindu love poetry who yearns for her lover. She is seated, in accordance with tradition, on a bed of leaves in a lonely grove at night. There are rocks and water in the foreground. A jackal passes by at the left, turning toward the heroine. Most of the background has been washed in; the sky is a deep blue flecked with white dots; the trees, a deep green with purplish brown trunks; the ground a little lighter green. The water is purplish gray and the rocks, a dotted light gray.

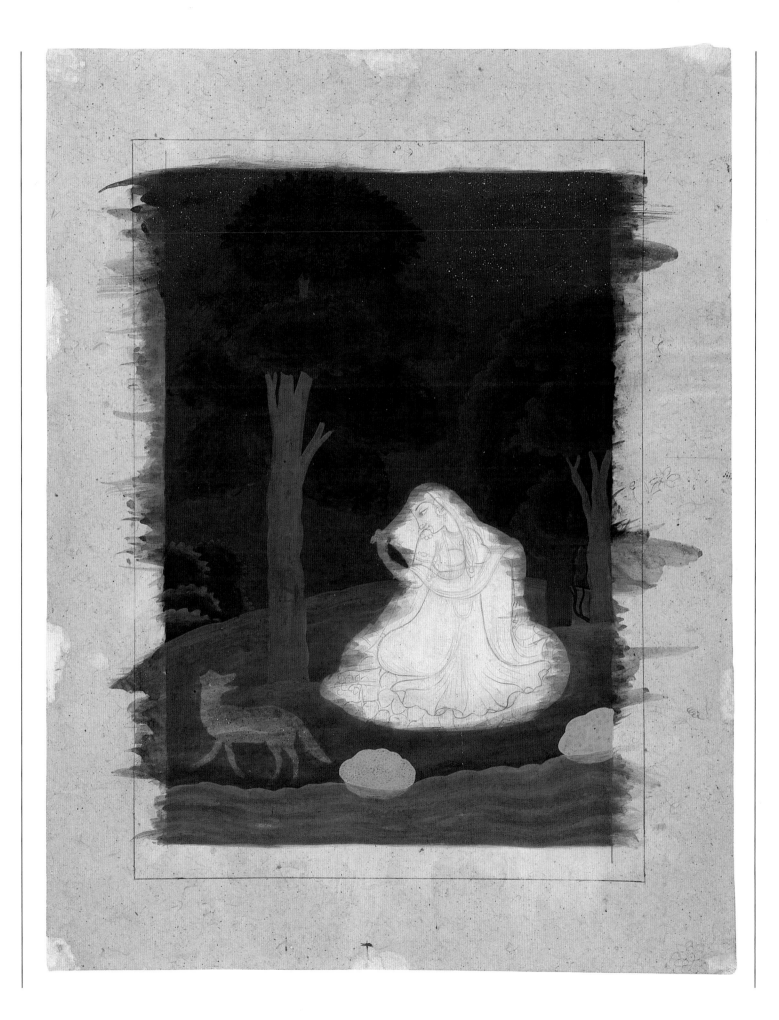

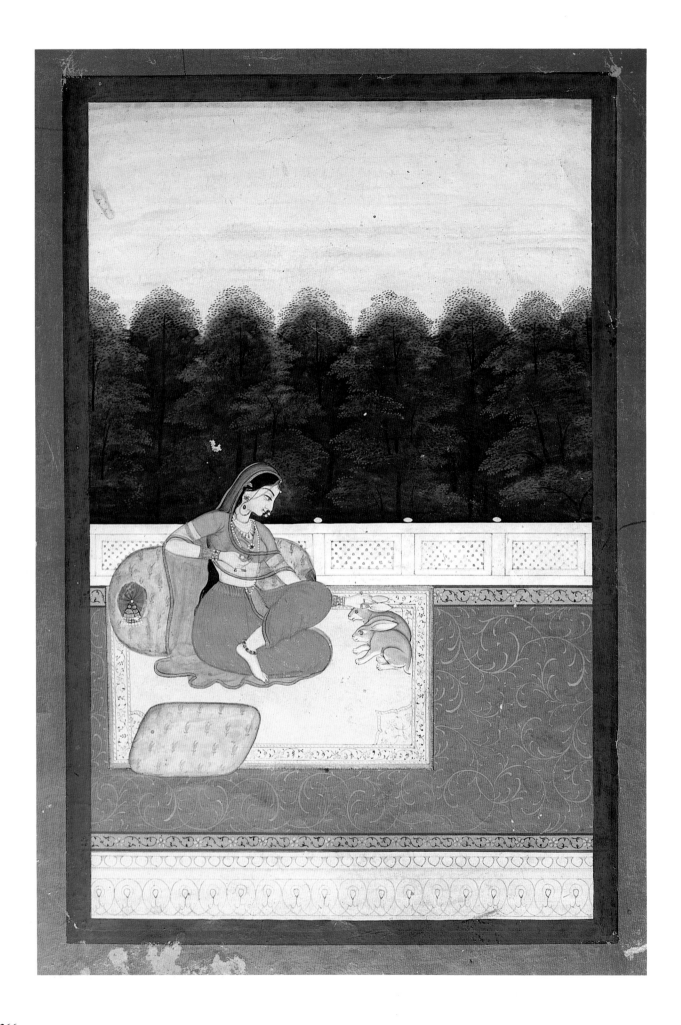

A.K. Coomaraswamy (1926, p. 14) has translated an appropriate passage of the *Rasikapriya* that suggests the subject of this painting:

(The nayika reflects.)
"Or has he clean forgotten? or has something misled him? or does he rove astray and cannot find the path?
Or is he afraid of something, O Keseva? or has he met any one? or has he fallen in love with some amorous woman?
Or is he coming along the road? or has he already arrived? howsoever it be, surely my Giver-of-Bliss will come!"
When Nand's son came not, she wondered for which of these reasons he delayed.

For an almost identical scene, also unfinished, see Coomaraswamy 1926, p. 182 (acc. no. 17.2613) and pl. XCIX. AGP

Literature Los Angeles 1950, cat. no. 131.

218 Artist unknown

Dhanashri Ragini

Punjab Hills, Kangra
Circa 1790 or later
Opaque watercolor and gold on paper
Image 8 x 5⅛ in. (20.4 x 13 cm)
Sheet 10 x 6¹⁵/₁₆ in. (25.4 x 17.7 cm)
Anonymous gift, 80.277.9

INSCRIPTION
Verso, at top, in red ink, in Devanagari script: *Dhanasri ragini of Malkos.*

A beautiful woman seated on a yellow carpet rests against a large rose-colored bolster and plays with two rabbits in front of her. A large red carpet with green borders covers the terrace. Beyond, a grove of trees is depicted under a white sky with pink and blue washes subtly applied.

Kangra painting in the period of Sansar Chand (r. 1775–1823) is noted for the poetic treatment of romantic subjects, especially those taken from the traditional repertory. In Rajasthan, *Dhanashri Ragini* commonly represents a woman painting a portrait, but some Pahari versions depict a woman with two hares (Ebeling 1973, p. 280, fig. 327; Waldschmidt and Waldschmidt 1975, vol. 2, p. 550, fig. 38) and categorize the *raga* as a wife of Malkosa, a variety of love in separation or loss. According to the sixteenth-century classification of *ragas* by Mesakarna, *Dhanashri Ragini* is linked with the sound of a hare, which explains the presence of the hares here (Ebeling, op. cit., p. 72). The painting exemplifies the characteristic Kangra style with open landscape setting, the woman's facial features and physiognomy, as well as the rich and bright color palette.

Archer (1973, vol. 1, p. 40, fig. 5[iii]) discusses a much earlier depiction of a woman with her pet rabbits, which he identifies as a rendering of the lonely *nayika,* the heroine who desperately longs for her lover, related possibly to a Hill *Ragamala* subject, *Suhi (Suhavi) Ragini* (a lady feeding a rabbit). The inscription on the verso of our painting corrects Archer's suggestion.

For comparable paintings, see W.G. Archer 1973, vol. 2, Kangra, nos. 37–40. AGP

Provenance Jeffrey Paley, New York.

219 Artist unknown

Manini Nayika

Punjab Hills, Kangra
Circa 1790
Opaque watercolor and gold on paper
Image 7¾ x 4¹³/₁₆ in. (19.5 x 12.3 cm)
Sheet 10¾ x 7½ in. (28 x 19.2 cm)
Promised gift of Anthony A. Manheim, L71.23.1

INSCRIPTION
Recto, in right margin, in black ink, in Takri script: *Budhi, budhi, budhi. . . .*

An elderly woman is seen comforting a young distraught *nayika* crouched on a terrace, who stares listlessly at the ground as she lowers her head in resignation, hunches her shoulders, and folds her arms in her lap. Her posture with left leg extended expresses her discomfort and anguish. Her translucent white sari edged with gold is wrapped loosely around her tan choli; rose pajamas cling to her body. Gold jewelry and emerald pendants in the form of earrings, neck-laces, rings, armbands, and anklets adorn her. She is sup-ported by a mauve bolster, and there is a pale yellow carpet beneath her. The elderly woman looks with concern at her anguished companion, gesturing during her sympathetic speech. The opaque forms of her garments, a voluminous yellow shawl drawn over her head and a deep purple sari, contrast with the translucent gauze clothing of the *nayika.* In the distance there is a pastoral landscape with a lake with two small empty boats at the right and a series of low-lying mountains with pastel pink peaks, forest green meadows, trees, and a distant marble palace.

The theme of love in separation is reiterated in such Indian poetry as the *Sat Sai* of Bihari Lal (circa 1650) and various *Nayaka-Nayika.* The dejected heroine sitting uncom-fortably on a terrace is obviously not comforted by the words of the aged companion who tries to console her. The *Manini Nayika* is a form of *nayika* that conveys the heroine's anger, here emphasized by her lowered head (Randhawa 1962, p. 170).

In spite of its damaged surface, the painting conveys the deep emotions of the figures, who are viewed through the arched frame of a window in a palace setting. The presence of the older figure giving comfort, the expressive rendering of the figures, and the distant landscape composition are typical of Kangra versions of the *Sat Sai* and relate to leaves of a dispersed *Sat Sai,* a *nayika* series in oval borders painted at Kangra (Randhawa 1962, p. 170, and idem, 1966, p. 39, fig. 14). AGP

Provenance Paul E. Manheim, New York.

220 Artist unknown

Ganesha and two attendants

Punjab Hills, Kangra
Circa 1790–1825
Opaque watercolor and gold on paper
Image 5¾ x 8¾ in. (15.6 x 22.3 cm)
Sheet 6⅛ x 8¹⁵⁄₁₆ in. (15.6 x 22.7 cm)
Gift of the Ernest Erickson Foundation, Inc., 86.227.178

The elephant-headed god Ganesha, four-armed and crowned, is seated in a pavilion on an octagonal gold throne

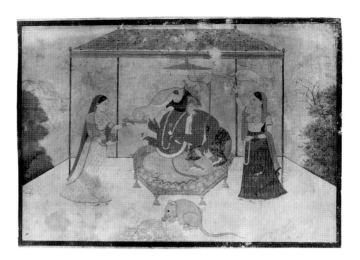

under a gold parasol fringed with strings of pearls. His jew-eled armbands, bracelets, and necklaces contrast with his or-ange body. His elephant head and trunk are beautifully rendered in a muted palette of pink and gray. He holds his attributes, the tusk, axe, and rosary, while his fourth hand delicately encases a sweet. He raises his noble head and ex-tends his sinuous trunk to the plate of sweetmeats, and curves his trunk around a ball of rice. The female attendant at the left who offers these sweets holds a gold jar in her other hand. At the right, a second female attendant wields a fly whisk. Ganesha is accompanied by a mouse, his vehicle, shown in the foreground. The ensemble of jeweled objects —the canopy, throne, and vessel—is decorated with the same pattern, enhancing the exquisite rendering. The manuscript from which this sheet derives has not yet been identified.

The painting surface is badly abraded, possibly the result of exposure to dust that afflicts the first page of a manu-script. Nevertheless, the refinements of Kangra style are emi-nently demonstrated here.

For another example of an invocational frontispiece, see catalogue number 207. AGP

221 Artist unknown

Krishna and Radha under a tree in a storm

Punjab Hills, Kangra
Circa 1790–first quarter of the 19th century
Opaque watercolor and gold on paper
Image 8⅜ x 6¼ in. (22.3 x 15.7 cm)
Sheet 9 x 6¾ in. (22.8 x 17.2 cm)
Ella C. Woodward Memorial Fund, 70.145.1

The lord Krishna, an incarnation of Vishnu, lives as a cow-herd with his beloved Radha. Here a storm is coming, and

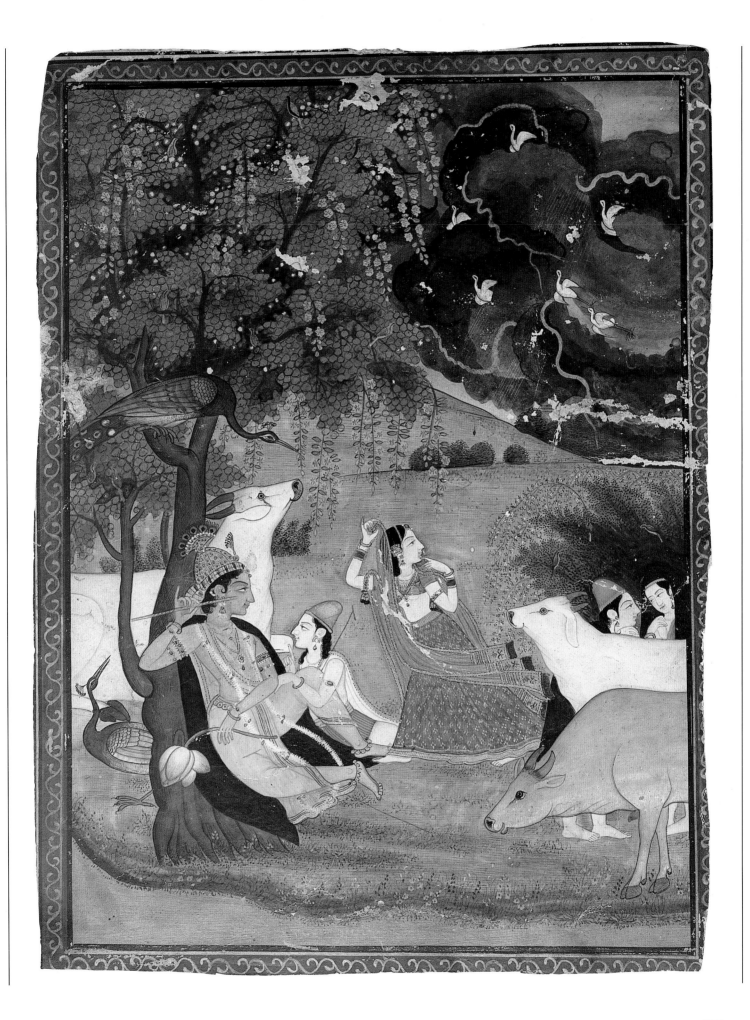

269

Radha and the herdsmen run for shelter to Krishna, who sits calmly under a tree, holding his flute and a lotus stalk. He, and one of the cowherds at the right, wear long black capes. Radha is seen in the center dressed in a mauve skirt and orange scarf, and adorned with jewelry. A peacock perches in a branch of the tree above Krishna and another stands behind him. Dark thunderclouds and bolts of lightning disturb a flock of cranes in the distance.

In poetry and song, peacocks announce the advent of the rainy season. The monsoon, awaited eagerly in India after a long dry year, is considered particularly romantic. Storm clouds are emblematic of passion—dark and dangerous, but bringing new life. The theme of romance is echoed by the intertwined vines and flowering creepers in the tree, a portent of the union of the eternal lovers and a popular theme in Indian lyrical poetry and painting. AGP

Literature Archives of Asian Art 1971–72, p. 92, fig. 4; Spink 1971, cat. no. 99, described as "Radha fleeing to Krishna."

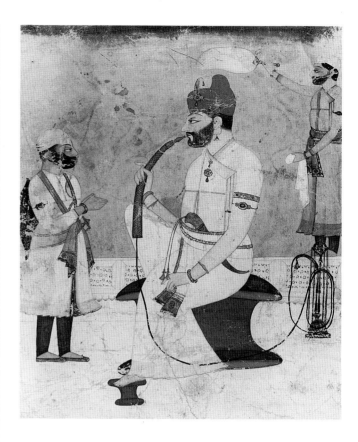

222 Artist unknown

Portrait of Raja Sansar Chand of Kangra

Punjab Hills, Kangra
Circa 1800–1810
Opaque watercolor and gold on paper
Sheet 8¾ x 7¼ in. (22.2 x 18.4 cm)
Gift of Ananda K. Coomaraswamy, 36.243

Raja Sansar Chand (r. 1775–1823), smoking a large hookah, is seated on a red stool on a white terrace. He is dressed in a long white jama, a red peaked turban, and various jeweled ornaments. A curved sword is tucked under the white sash at his waist. His right knee is raised and his left foot rests on a small footstool. A courtier, represented as a much smaller figure, stands in front of him wearing a sword and shield, his hands held before him in supplication. At the right, an attendant waves a yak-tail fly whisk above the raja. The background consists of a light blue sky.

The angular style of many of the Sansar Chand portraits can be traced to Sikh influence in Kangra. Sansar Chand is known to have established political ties with his former rival Maharaja Ranjit Singh, the Sikh ruler of Lahore, after his downfall in 1805. Subsequently the Sikhs came to Sansar Chand's aid, recovering the Kangra fort from the Gurkhas, after which Sansar Chand and other Hill State rulers became subjects of and tributaries to Ranjit Singh. Sikh influence is visible in early-nineteenth-century Kangra portraiture in the enlargement of heads and alterations to costume, as well as an increased tendency toward abstraction of the human form.

Coomaraswamy mentions the diaries of Moorcroft (1841), who refers to a portrait gallery that Sansar Chand visualized, which would have represented all the Hill State rulers. Usha Bhatia informs us that a full series of such portraits from the collection of M.S. Randhawa is now in the Chandigarh Museum (personal communication, 1990).

Sansar Chand's reign and his portraits are discussed more fully, and with many illustrations, in Randhawa 1961, pp. 1–30; Desai 1986, pp. 112–16; and W. G. Archer 1973, vol. 1, p. 255, and vol. 2, Kangra, nos. 9–24. An inscribed portrait showing the bearded Raja Sansar Chand seated on a large cane seat, holding the stem of a hookah and wearing the clan turban, is published in Coomaraswamy 1926, pl. 123, fig. DXCVI and in Khandalavala 1958, p. 152, no. 296. AGP

Provenance Ananda K. Coomaraswamy, Boston.

223 Artist unkown

Khandita Nayika

Punjab Hills, Kangra or Garhwal
Circa 1800–1820
Opaque watercolor and gold on paper
Image 7⅞ x 4⅝ in. (20 x 11.75 cm)
Sheet 10⅜ x 7½ in. (26.4 x 19 cm)
A. Augustus Healy and Frank L. Babbott Funds, 36.251

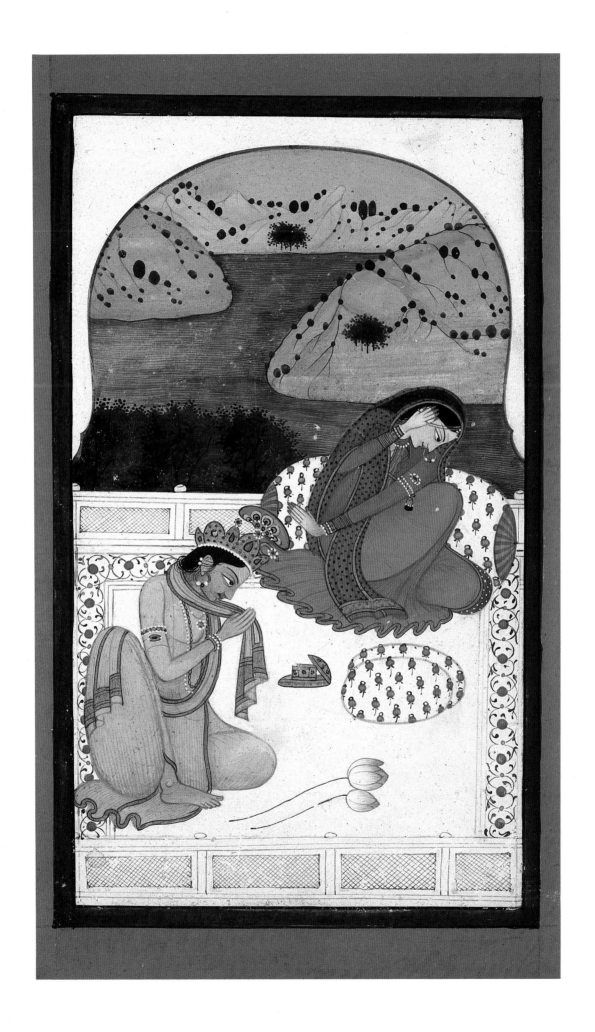

The scene shows a female seated on a terrace, her head bowed and one arm spurning her lover. He is seated at the lower left, his hands held in supplication, his head lowered humbly. Since his body is blue and he wears the five-pointed crown surmounted by a peacock crest, he is easily identified as Krishna; the female, therefore, is Radha. The scene is framed by a large white arch through which trees, a lake, and pinkish hills dotted with green specks of shrubbery are visible, and in the distance, a blue sky.

Previously described as a scene from the *Gita Govinda* (W.G. Archer 1957, pl. 25), this poignant study is now identified as one of the eight *nayikas,* or heroines. *Khandita Nayika* is described as a female "whose lord has spent the night away from home; when he returns in the morning, she reproaches him bitterly" (Coomaraswamy 1916, vol. 1, p. 43). AGP

Literature Coomaraswamy 1914, p. 112, pl. 4; W. G. Archer 1957, pl. 25.

Provenance Ananda K. Coomaraswamy, Boston.

224 Artist unknown

Proshita-patika Nayika

Punjab Hills, Kangra or Garhwal
Circa 1800–1820
Opaque watercolor on paper
Image 9⅜ x 5½ in. (23.8 x 14 cm)
Sheet 9⅝ x 5¹³⁄₁₆ in. (24.4 x 14.75 cm)
A. Augustus Healy and Frank L. Babbott Funds, 36.252

A woman is seated in a palace, her bowed posture and lowered head conveying her anxiety. A female attendant stands to the left offering comfort. The composition is enhanced by the stark white towers of the palace, which set off the purple and pink costumes of the women.

The poignant theme of a woman separated from her lover occurs so frequently in Indian poetry and painting that it is given a special category. The subject of this work was origi-

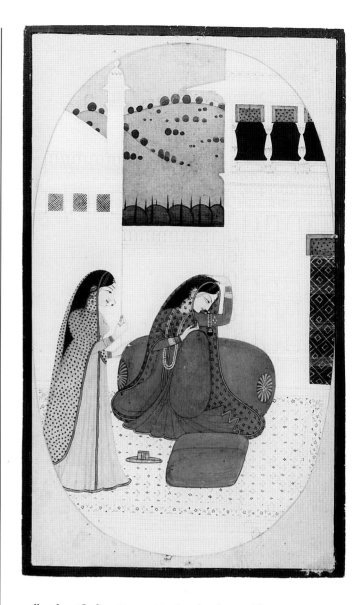

nally identified as *Manini Nayika,* the devoted heroine (Coomaraswamy 1916, pl. 74a, and Khandalavala 1958, no. 220). Our reattribution to *Proshita-patika Nayika*—the heroine whose husband is absent—may be more accurate; it had actually been considered by Coomaraswamy, who noted it on the mount of the painting. AGP

Literature Coomaraswamy 1916, vol. 2, pl. 74a; idem 1926, pl. 5, fig. 10; Khandalavala 1958, p. 173, no. 220.

Provenance Ananda K. Coomaraswamy, Boston.

225 Artist unknown

Battle between Lava and Rama's brother Shatrughna, near the hermitage of Valmiki

Page from a dispersed *Ramayana* series
Punjab Hills, Kangra
Circa 1820
Opaque watercolor and gold on paper
Image 10¾ x 14⅜ in. (27.3 x 36.7 cm)
Sheet 13¼ x 17¼ in. (33.7 x 43.8 cm)
Gift of Mr. and Mrs. Ed Wiener, 75.203.2

INSCRIPTIONS

Recto, in white pigment, in Devanagari script, top left: *Valmiki;* top center: *Sita;* top right: *Kusha;* lower left: *Lava;* lower center: *Shatrughna;* lower right, on the horse blanket: *Shyamakarna.*

Two scenes from the *Uttara kanda* chapters of the *Ramayana* after Sita's rescue are represented here. The scene in the lower center of the painting shows Rama's brother Shatrughna in a chariot making a triumphant tour with the sacrificial horse (labeled *Shyamakarna,* "dark eared") destined for Rama's horse sacrifice. When he reaches Valmiki's hermitage on the banks of the river Sarayu, Sita and Rama's twin sons, Kusha and Lava, will challenge the horse. At the left, the crowned diminutive figure of Lava is shown on the ground, being revived after his encounter with his uncle. At the left in the upper register, the sage Valmiki with disciples and Sita sit before a hut with young ascetics; at the right, Kusha approaches the hermitage with a load of sacrificial firewood and Kusha grass on his shoulder. The power of Valmiki's message is symbolically represented by the peaceful coexistence of the tiger and deer, animals that are natural enemies. The style, composition, and large format of this *Ramayana* set posit a Sansar Chand–period attribution.

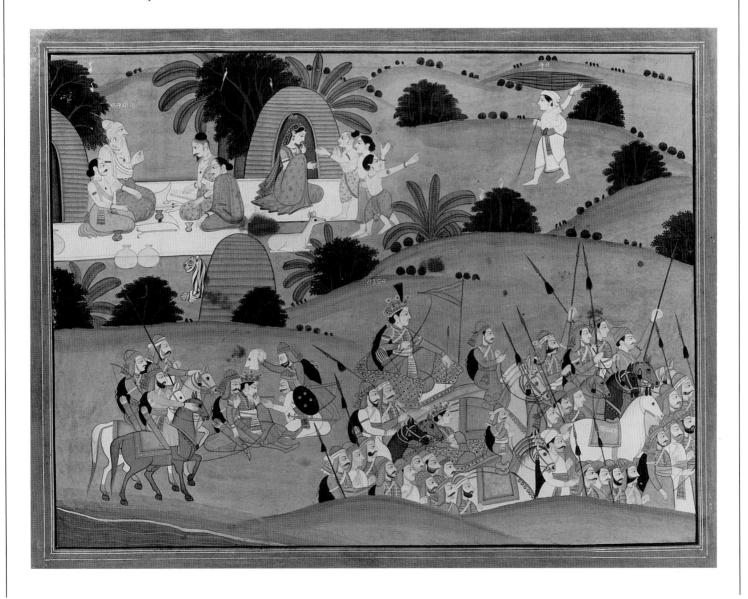

The Sanskrit text, on the verso in black ink in Devanagari script, reads:

And Shatrughna, overcome with compassion, raised Lava by the hand and ordered his attendants: Sprinkle this boy, who resembles Rama, with clean water. (42) The attendants immediately showered him with water. After he was revived, they placed him on the chariot and departed as he kept making inquiries. (43) Thus ends the thirtieth chapter, the Horse Sacrifice, containing the Kusha and Lava episode that describes the war between Lava and Shatrughna.

Janamejaya said: When Lava caught hold of the steed, such a fierce fight took place. Where had Kusha gone and why had he not told Sita? (1)

The sacred Kusha episode in its entirety is known to Jaimini, who said, O King, listen to my narration of the great adventures of Kusha. (2) Hearing this, both men and women become free of all sins.

From there, the sacrificial horse moved onward. As the great chariot left with Lava, (3) the young hermits whose faces were obscured by tears went to Sita. O Sita, some king's horse was caught forcibly by your son, Lava (4) who fought against his grand army. Having defeated the great army, the boy became very tired (5), and then his bow was shattered by some valiant warrior and he was taken to the capital. (6) Hearing their words, Janaki [Sita] transformed herself into a painted image of a heavenly damsel, like a maiden frightened by a flash of lightning or a rich man being confronted by a plunderer. (7) O King, listening to the events of the forest which came like a bolt from the blue, Sita fainted under the overwhelming effects of grief.

Gaining consciousness, she said, O Rama, I am truthful to you in thoughts, act, and speech; and by virtue of that truth my son Lava is well-versed in warfare. (8) But the lonely boy was shot down by your sinful commanders.

Speaking as thus, in a sweet voice, (9) the grieving lady cried bitterly. (10) Lava you left without asking me and were felled to the bed of arrows. Arrows should never hit your moonlike face. (11) Lava, who is intelligent and whose diet includes only fruits, roots, and tubers, had his body scarred with arrows. (12)

Why did your commanders hurt that boy? How could the hands of these cruel and sinful men act in that way? (13) And at this very moment neither father Valmiki nor mighty Kusha is present. To whom shall I relate the occurrence of such a great fight? (14)

O Janamejaya, thus Janaki kept lamenting; meanwhile, Kusha emerged from the forest carrying the load of sacrificial firewood and Kusha grass. (15)

While coming, Kusha encountered several bad omens, causing anxiety to his heart. (16) Deer were running to my right and left, letting out alarming sounds. Tears came to my eyes and my heart ached. Pondering thus, Kusha arrived at the entrance of the hermitage. (17) How is it that Lava is not coming to greet me? In the morning I prevented him from going with me. (18) Is he angry about that? Maybe not. By whom was Lava taken prisoner? Thinking as thus, the courageous one. . . . (Trans. S. Mitra)

For a depiction of Valmiki's hermitage in an earlier Kangra *Ramayana,* see Pal 1978, cat. no. 67a. AGP

226 Artist unknown

Krishna gazes longingly at Radha

Page from the "Lumbagraon *Gita Govinda*" series
Punjab Hills, Kangra
Circa 1820–25
Opaque watercolor and gold on paper
Image 9½ x 12⅝ in. (24.1 x 32.1 cm)
Sheet 11⅛ x 14⅜ in. (28.25 x 36.5 cm)
Designated Purchase Fund, 72.43

In the light of the Milky Way, from a bed of flowers and leaves behind a tree, Krishna gazes upon Radha, who is attired in green, symbolically leaning toward his love as his messenger appeals to her. The lovers' imminent reunion is suggested in the visual motifs of pairs of birds and flowering vines entwined around the trees of the forest. The uncertain future caused by the lovers' separation is one of the traditional aspects of sexual passion used to investigate the spiritual imagery of Part Five of the *Gita Govinda.*

The "Lumbagraon *Gita Govinda*," named for the ancestral collection of the Maharaja of Lumbagraon, is the third of three important Pahari *Gita Govinda* series: two painted at Kangra (the first, circa 1780) and one at Basohli (W. G. Archer 1973, vol. 1, pp. 307–8). The series, noted for the lush flowering trees of the forest setting and the use of bright and sometimes slightly discordant colors, is now dispersed. Pages are located in the Baron and Baroness Bachofen von Echt Collection, London; Alvin O. Bellak Collection, Philadelphia (Kramrisch 1986, cat. no. 128); San Diego Museum of Art, formerly Collection of Edwin Binney, 3rd (Archer and Binney 1968, pp. 120–21); Pan-Asian Collection, now dispersed; formerly William Ehrenfeld Collection (Ehnbom 1985, p. 250, cat. nos. 125 and 126); and Paul F. Walter Collection, New York (Pal 1978, p. 204), among others. Ehnbom suggests that there were probably not many more than forty leaves in this series (op. cit.).

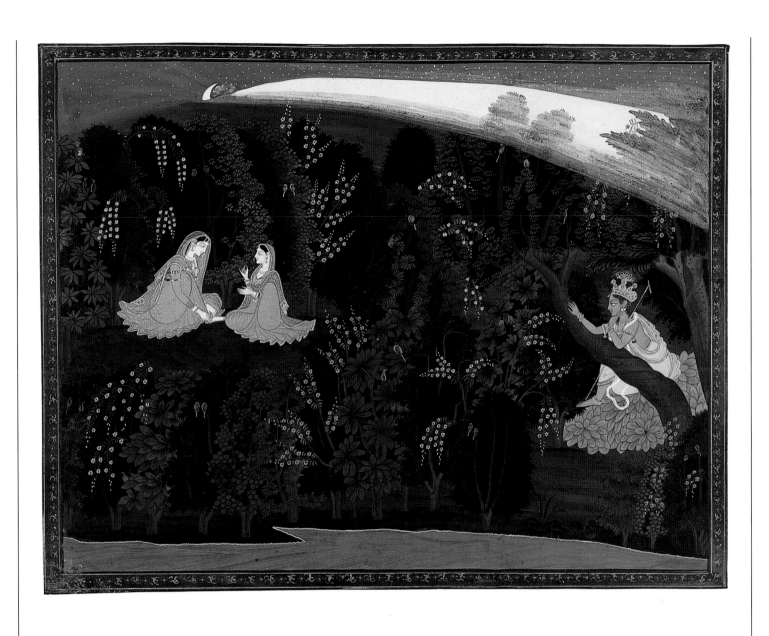

The Sanskrit text in Devanagari script on the verso, which refers to another page in the series, reads:

She, who has cast her wishful eyes at Govinda [the lord of cowherds], rejoicing and melodiously ringing her anklets, entered the grove. Afterward, she, who has denounced her lineage and incurred sin by the act of digression from the path of her lineage, became all the more beautiful with the manifested marks [of nails and teeth] like the moon risen on the horizon of Vrindavana with streams of his rays and resembling the sandal paste marks on the face of the lady of the horizon. (Trans. S. Mitra)

AGP

Literature Poster 1987, pp. 20–21, col. pl.

Provenance Maharaja Dhrub Dev Chand of Lumbagraon, Kangra.

227 Artist unknown

Shiva and Parvati

Punjab Hills, Kangra
Circa 1820–25
Opaque watercolor and gold on paper
Image 8⅜ x 7 in. (22 x 18 cm)
Sheet 8⅞ x 7⅞ in. (22.6 x 20.4 cm)
Gift of Martha M. Green, 1991.181.8

An enthroned Shiva and Parvati, with a corpse lying before them, are attended by four deities and two angels. The ash-covered Shiva is identified by his customary attributes, the third eye, the piled coiffure (*kapardin mukuta*), and the snakes wrapped around his neck, arms, and waist. He holds a trident in his raised upper right hand and a long sword in his lower left hand, perhaps in anticipation of a forthcoming ceremony or rite, or in celebration of the victory over and demise of the figure lying before him. He wears a leopard skin, which includes the beast's head and front paws, and jewelry made predominantly of gold and red *rudraksha* beads, but also including a garland of severed human heads. His consort, Parvati, is depicted in a deep red tone with black hair falling loosely over her shoulders. She is dressed in a gold-patterned skirt, a green choli, and a matching scarf tied so that it appears as a fan-shaped apron. She, too, has the third eye and is adorned with strands of pearls and several pieces of gold and pearl jewelry. She holds a variety of objects in her four hands: a bow, a rosary of pearls, an arrow, and an elephant goad. Both figures sit on lotus leaves and lean against pillows. The enormous gilded throne is decorated in geometric and organic patterns of purple, olive, and white.

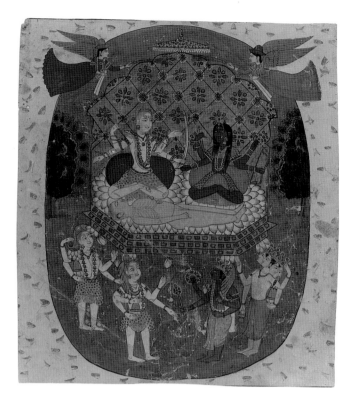

Below, Vishnu and Brahma stand with two other attendant divinities. Similar in form to Shiva but with long plumes and lotuses attached to their hair, they lack the lithe elegance of the enthroned Shiva figure. Vishnu is shown in his customary dark color wearing his auspicious yellow garment. A long yellow plume with a lotus is attached to his pointed crown, and he holds a variety of pearl-and-gem-encrusted gold attributes. Brahma is depicted with four heads under a single crown surmounted by a lotus. Dressed in a deep mauve dhoti and jewelry, he holds a gold vessel in one hand and a book in another. Each of these four divine figures has a gold bell-shaped object suspended from an arm-band or bracelet, and extends another hand with which to cup lotus leaves. At the top of the scene, two attendant angels (*vidyadharas*) wave green fly whisks with one hand and hold white cloths in the other. Their red and violet costumes, particularly the tall rimmed hats, suggest possible European influence.

The scene is set within a green landscape with several trees flanking the enthroned figures. Four yellow birds (one is abraded) occupy branches of the darker trees. The paint has been loosely applied in the larger areas of the composition so that the brushstrokes are apparent, an unusual feature in Indian paintings. The oval-shaped image is framed with an ivory-colored border that is decorated with gray fish heads and tails. This detail might suggest the cosmic waters.

A more precise interpretation of this painting has so far not been possible owing to the lack of any inscriptions. AGP

Provenance Paul E. Manheim, New York.

228 Artist unknown

Man meditating in a garden setting

Punjab Hills, Kangra
Circa 1820–40
Opaque watercolor on paper
Image 8⅜ x 5⁹⁄₁₆ in. (21.3 x 14.2 cm)
Sheet 10¾ x 7⅞ in. (27.3 x 20 cm)
Anonymous gift, 80.277.10

Unlike the conventional court portrait showing the sitter in a relaxed pose leaning against a bolster and smoking a hookah, this figure sits in meditation pose on a spotted animal skin spread on a bed. He wears a yellow jama and scarf and the caste headdress (*kulharia*).

This portrait of an unidentified sitter is part of a wide-ranging group of portraits of Pahari rulers and noblemen, especially of the period of Raja Sansar Chand (r. 1775–1823). AGP

Provenance Jeffrey Paley, New York.

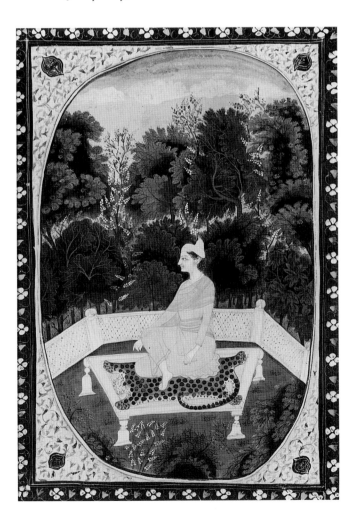

229 Artist unknown

Unidentified scene

Punjab Hills, Kangra
Circa 1825
Opaque watercolor and gold on paper
Image 9 x 12⁵⁄₁₆ in. (23 x 31.3 cm)
Sheet 10⅝ 14 in. (27 x 35.5 cm)
Anonymous gift, 79.187.3

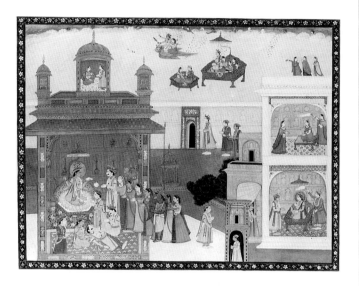

This uninscribed scene shows several episodes of an unidentified narrative. At lower left, a crowned male has fainted before the enthroned deity Vishnu and is being attended to by male and female figures. Above, celestials toss flowers from their heavenly chariots. Although this scene has not yet been identified, it may relate stylistically and iconographically to a leaf from an illustrated series of myths now in a private collection (Kramrisch 1986, cat. no. 127). AGP

230 Artist unknown

Pragamyashyatiyaka

Punjab Hills, Kangra
Circa 1825
Opaque watercolor, gold, and silver on paper
Image 8½ x 6 in. (21.6 x 15.2 cm)
Sheet 11½ x 8⅝ in. (29 x 21.8 cm)
Gift of Emily M. Goldman, 1991.180.12

INSCRIPTION
Recto, at top of outer border, in black ink, in Devanagari script:
Pragamyashyatiyaka 71.

Pragamyashyatiyaka is the heroine who awaits the return of
her lover. She sits confidently in a pavilion with an atten-
dant, pondering her mixed emotions of joy and anxiousness.
An augury of the crows and doves on a neighboring struc-
ture signifies someone's return. The two figures wear long
dresses decorated with gold-patterned or striped veils and
an elaborate assortment of pearl, ruby, and sapphire jewelry.
The delicate line drawing suggesting the folds of the ladies'
robes is particularly fine. The various textiles—the red car-
pet on the terrace and the fabrics of the garments, pillows,
and screens—are intricately patterned in geometric and
floral designs highlighted with gold.

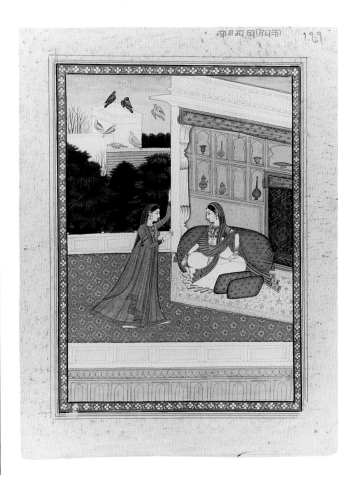

The pavilion architecture includes a column with lotus
decoration and niches filled with gold and silver vessels. A
tenebrous sylvan area separates the pavilion and the struc-
ture upon which the birds perch. Although a certain sense
of depth is suggested by superimposing objects on objects,
the perspective of the architecture is somewhat less than
convincing. The scene is framed with a smoky blue border
decorated with white and yellow flowers and several orange
stripes. The image is mounted on a beige paper with orange
marking to suggest the veins of stone or marble.

The text on the verso in black ink in Devanagari script
reads:

Hearing the news of the return of her lover, joy spread all
over the courtyard as well as the heroine. She asks the *ali*
[female companion]: "Tell me, who told you this? My
tears of happiness are flowing, and why is he apart when
he is so close to my heart? Seals [signs] of his love are so
deep on my body that my veil, even if fully extended, is
unable to cover them." (Trans. S. Mitra)

The painting may be part of a series, such as the Bihari
Sat Sai or *Rasikapriya.* AGP
Provenance Paul E. Manheim, New York.

231 Artist unknown

Kriya Vidagdha

Punjab Hills, Kangra
Circa 1825
Opaque watercolor and gold on paper
Image 8⅝ x 5¾ in. (21.3 x 14.5 cm)
Sheet 11½ x 8½ in. (28.9 x 21.7 cm)
Gift of Emily M. Goldman, 1991.180.13

INSCRIPTIONS
In black ink, in Devanagari script
Recto, in top margin, in Sanskrit: *The heroine well versed in love.*
Verso, at top center: *46.*

Kriya Vidagdha is the *nayika* who is well versed in love, here
represented by Radha, shown seated and accompanied by
her five attendants. They lean against patterned pillows un-
der an orange canopy. The treatment of the portico and ter-
race resembles the architecture of catalogue number 230.
Krishna, who gazes at the heroine from behind the court-
yard wall, appears in his ubiquitous dark color, yellow robes,
and pointed crown with a fan-shaped peacock plume.
Krishna and Radha appear to bow in recognition of one an-
other. With the exception of the woman seated in front of
the shaded window, who appears somewhat distracted by

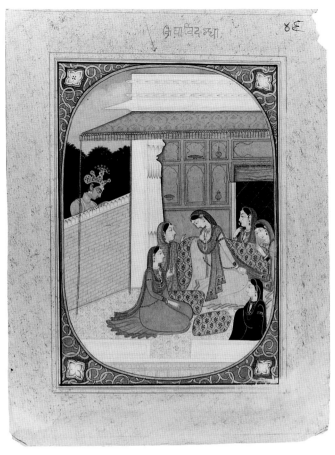

Krishna's presence, the attendants concentrate their attentions on Radha. The sky has been depicted with auspicious pink clouds.

The text on the verso in black ink, in Devanagari script, reads:

She, who surpasses Rati [Kama's wife] in beauty, is seated amid her superiors. The approaching lover [Krishna] excels Manobhava [Kama] in his charming grace. He desires to drink with his eyes the nectar of her beauty, which has no equal among women. She, on the other hand, envisions in her heart his graceful image, which is far superior to that of the husband of Rati (72). (Trans. S. Mitra)

The number 46 following the inscription refers to the verse number.

The oval format with lotus decorations in the four corners occurs in several Pahari sets, as in a *Sat Sai* series (Randhawa 1962, p. 152, pl. III; idem, 1966). AGP

Provenance Paul E. Manheim, New York.

232 Artist unknown

Arjuna's penance

Scene from a *Mahabharata* series
Punjab Hills, Kangra
Circa 1825–40
Opaque watercolor and gold on paper
Image 13½ x 18¾ in. (34.8 x 47.4 cm)
Sheet 15⁷⁄₁₆ x 20½ in. (39.2 x 52 cm)
Anonymous gift, 81.192.10

A series of episodes from the *Mahabharata* focusing on the Pandava hero, Arjuna, is depicted here in an unusually large format. The events take place in a mountainous setting under a pale blue sky. The narration starts at the upper right corner, where a group of pilgrims in a variety of headdresses, turbans, leaf caps, and piled coiffures assemble before the mountains. The mountain peaks are shaded with a thin application of gold.

At the right, a temple with a relatively large gray *Shivalingam* stands before a flowering tree. In front of the temple, an imposing figure (Arjuna) in helmet and chain mail sits cross-legged on a dried plantain leaf. His left hand rests on his thigh while his right is placed inside a small red bag, possibly containing rosary beads, which he may be counting as a part of his penance. His index finger protrudes from one corner of the bag, supporting its weight. Arjuna has a violet complexion and is dressed in gold armor and a gold helmet decorated with an orange band of cloth with gray stripes and fluttering gray ends. The armor has a wide gray band as well as an orange sash. He wears a pale mauve dhoti with gold dots and a blue border, loosely folded so as to cover his legs and feet. His weapons are placed on the ground before him: a black shield with gold decorations, a gorgeous bow, a sword with a highly decorated gold hilt, and its gray scabbard.

The group assembled beside Arjuna includes two women with elaborate ornamentation and three men wearing different types of hats. This group stands amid trees and shrubbery and is more readily visible compared to their former positioning in the mountains, where only their heads and shoulders are predominant. The long-haired man wearing the leaf cap is dressed in a skirt, also made of leaves, and a mauve scarf. His hands are folded across his chest and he looks away from Arjuna. Other male figures, ascetics, are depicted wearing leopard or tiger skins.

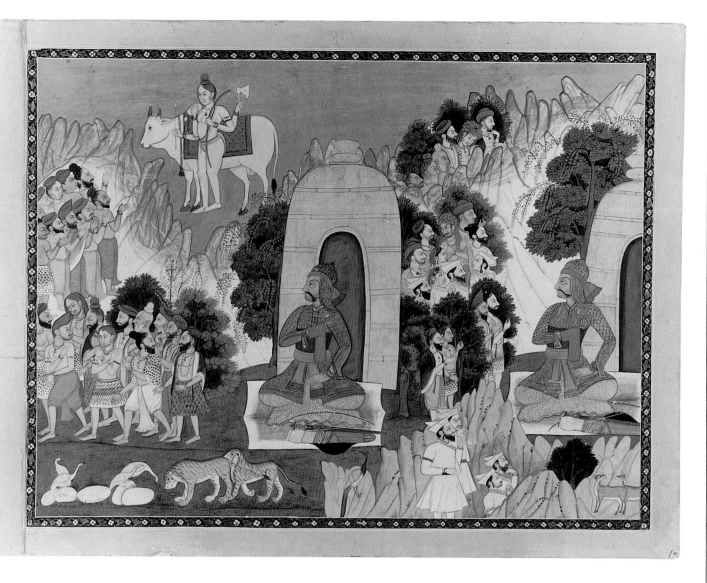

In the lower right, again in a mountainous setting, two antelopes are visible, while four men dressed in pale yellow-and-white frockcoats and tight trousers leave the scene, apparently after having visited Arjuna. The rocks are painted pink with tufts of green grass and weeds. A solitary peacock sits on a boulder.

In the center, Arjuna appears again, shown in the same seated meditation position, though the design of his armor has changed. He is looking at the group of departing ascetics to his right, some of whom have turned their heads in acknowledgment of him. One is dressed in a leaf skirt, others wear white and crimson dhotis as well as leopard- and tiger-skin wraps.

In the upper left, the men are seen again, standing amid snow-capped mountains, their arms folded in supplication to the heavens where Shiva stands with his bull, Nandi. Apart from the snakes he wears as earrings and as a waist-band or loincloth, the pearl necklace with gold pendant, gold bracelets, and the jeweled gold armlets, Shiva is nude.

In three of his four hands he holds an axe, an arrow, and a bow; the remaining hand rests on the hump of Nandi, who has a crimson-colored carpet with green borders spread across his back and a bell suspended from a gold rope around his neck. Shiva has his usual attributes of the third eye and *kapardin mukuta* but not the crescent moon. It would appear that the ascetics are reporting Arjuna's rigorous penance to the god, testifying their witness.

At the lower edge of the painting there is a stream, represented by a streak of gray, and its banks, strewn with white stones and green grass. Four cranes sit on the boulders, while two tigers stand on the grass, perhaps preparing to drink water from the stream. The peaceful coexistence of these delicate and carnivorous animals may be attributed to the outcome of Arjuna's strong penance and meditation; that is, the change in these wild creatures represents an outward manifestation of his labor. The theme of environmental change as a result of a hero's deep meditation is a favorite of Indian poets. Various shades of green are used in this painting to represent the trees, foliage, shrubbery, and grasses.

Usha Bhatia (personal communication, 1991) has informed us that this page is from a series painted at Kangra for the Nadaun family. Two paintings from the same series, in the San Diego Museum of Art (formerly Collection of Edwin Binney, 3rd, acq. no. I 927, acquired Sotheby's 1973a, lot 188; and acq. no. I 983, acquired Sotheby's 1974, lot 127), show similar treatment and format for the depiction of Arjuna, the figures, mountains, thatched hut surmounted by *amalaka shila,* and animals, all representing Sikh influence at Kangra in the period of Sansar Chand. See also W. G. Archer 1973, vol. 1, pp. 304–5, Kangra, no. 61, for a leaf in the Gahlin Collection, London.　AGP

233　Attributed to Bhagvan

Harsha Hambira Kalyana Raga

Punjab Hills, Kulu
Circa 1795 or earlier
Opaque watercolor and gold on paper
Image 8¹¹⁄₁₆ x 5⅞ in. (22.1 x 15 cm)
Sheet 9⁷⁄₁₆ x 6⅝ in. (24 x 16.8 cm)
Anonymous gift, 80.277.8

INSCRIPTION

Verso

In black ink, in Braj, in Devanagari script: *. . . like the moon . . . holding a blue lotus in his hand/For pleasure, prosperity [or beauty], liberation, and appeasing a woman whose heart has been broken/This is* Harshahambira Kalyana Raga, *always pleasing and sung by the notes resembling the sounds of a deer.* (Trans. S. Mitra)

A couple is seated on a bed set against a blue-black background. The fair-skinned, bearded prince is wearing a pale yellow jama, a sash, and a turban of the same color decorated with a jeweled ornament and rows of red dots. The woman wears a pale mauve dress and a dark violet veil with white dots. Their garments fan out under them. Both figures wear earrings, bracelets, armlets, necklaces of gold and pearls, and red tilaks on their foreheads. He holds her in his arms as she shyly turns away, eschewing direct eye contact. The bed is covered with a white spread edged with red ruffles; a portion of the underlying red and gold bed linen is exposed.

The painting has been attributed on the basis of style to the artist Bhagvan. Between 1790 and 1800, four series of pictures are inscribed with his name: a *Bhagavata Purana* dated to 1794 (Khandalavala 1958, cat. no. 108); a *Madhu Malati* dated to 1799 (Mittal 1956–57, pp. 90–95); a *Ragamala* series, circa 1790–1800 (W. G. Archer 1976, pp. 106–7, and Kramrisch 1986, cat. no. 107); and a *Rasa Panchadhyayi* series of the same period (W. G. Archer 1973,

vol. 1, p. 340). Mittal establishes the characteristics of Bhagvan's style on the basis of the 1799 series. Comparison with two leaves from this series in The Brooklyn Museum (cat. nos. 234 and 235) reveals that this *raga* page is painted with greater technical proficiency in both the portrayal of the figures and their interrelations. It also exhibits some of the features of Bhagvan's style as enumerated by Mittal: the treatment of costume and drapery, carmine outlines overpainting the black. W. G. Archer describes a depiction of *Angada Raga* listing additional Bhagvan features, such as the typical four-dot pattern in the woman's costume, the shape of the turban, the stylized folds of drapery, eyelashes indicated beyond the tear duct silhouetted against the nose, and especially the juxtaposition of cool and hotter colors and a marked simplicity of setting (1976, p. 106, cat. no. 57). Another characteristic of the artist (not present in our painting) is a fish-scale motif used in architectural decoration (ibid.). The *Ragamala* page is approximately the same size as our page and similar in style.

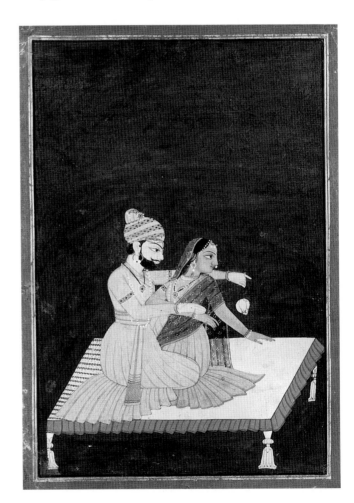

The subject of our page is quite rare and appears to be a combination of two *ragas:* Harsha and Kalyana. Ebeling describes two paintings of the *Harsha Raga* (1973, p. 289, fig. 361 [P3], and p. 290, fig. 365, designated as Bilaspur, eighteenth century), and two of *Kalyana Raga* (1973, pp. 166 and 240, figs. 13 and 36, p. 131, fig. C53). Harsha is the *ragaputra* of Bhairava and Kalyana is the *ragaputra* of Megha. In these depictions, a couple is similarly shown in amorous association on a bed.

In his treatise *Ragamala* (A.D. 1570), Mesakarna, a sixteenth-century court priest from Rewa, compiled a system of six *ragas,* each with five *raginis* (wives) and eight *ragaputras* (sons), from older, unidentified sources (Ebeling, op. cit., pp. 28, 64, 272). The actual designation of *putra* (son) occurs first in the Mesakarna system. He described each mode as a personality of divine or aristocratic character, and also compared each mode with the voice of an animal or the sound of a human activity. These two aspects of the *raga* are included in the text on the reverse of our page. Mesakarna's system was used primarily by the Pahari painters of Kulu, Basohli, Bilaspur, Garhwal, and Kangra as their exclusive system for *Ragamalas.*

Ragaputra Harsha is described in verse 21 (ibid., p. 72) as a fair-skinned man with lovely face, hands like a lotus, (blue) garment, pearl necklace, moving about vigorously and talking. Except for the last detail, the description corresponds to the Brooklyn painting. In verse 82 (ibid., p. 76), *Ragaputra Kalyana* is described as a lord in white garments and pearl necklace, seated on a splendid lion throne under a royal umbrella, fanned with a whisk, and chewing betel. In the Brooklyn painting, the prince is seated on a bed, perhaps chewing betel.

It seems that Mesakarna's iconographic description of both *ragas,* Harsha and Kalyana, applies to the prince in this painting relatively well, though not in every detail. The inclusion of the name Hambira into the *raga* needs further discussion. In the modern North Indian musical tradition, *Hambira Raga* sometimes combines with *Kalyana Raga* to form a separate *raga: Hambirakalyana.* The combination of different *ragas* is a common tradition in Indian classical music. AGP/SM

Literature Lerner 1974, cat. no. 36.

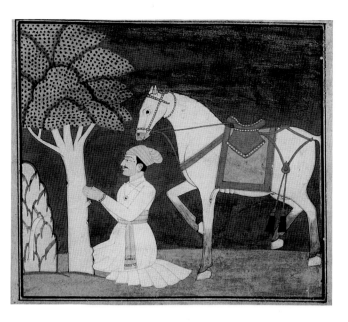

234 Attributed to Bhagvan

Illustration from a Madhu-Malati series

Punjab Hills, Kulu
Circa 1799
Opaque watercolor and gold on paper
Image 5 x 5½ in. (12.7 x 14 cm)
Sheet 6½ x 8⅝ in. (16.4 x 21.9 cm)
Gift of Martha M. Green, 1991.181.6

In this page depicting a scene from the *Madhu-Malati,* a male figure is shown kneeling in prayer before a tree. His horse is behind him, and a snake appears out of a mound at the left of the tree. The man is dressed in a white garment, the lower portion of which has been pleated to resemble the petals of a lotus blossom. The folds are finely delineated in red. He wears a yellow saṣh and a yellow turban, as well as necklaces, bracelets, a pendant, and an earring accentuated with gold. An unusual detail is the three-quarter view of his face, a feature generally represented in profile. His horse wears a red and green blanket over which is a red saddle complemented by red reins and bridle and a small, coiled snake attached to the blanket. The figures are situated on a band of green in an empty field of brown-ocher. The treatment of the mound and tree is extremely stylized, presenting them as patterned components of the composition. The scene is bordered on all four sides with bands of yellow, black, and red.

The text in Takri script on the reverse has not been translated.

For another sheet from the same manuscript, see catalogue number 235. AGP

Provenance Paul E. Manheim, New York.

235 Attributed to Bhagvan

Illustration from a Madhu-Malati series

Punjab Hills, Kulu
Circa 1799
Opaque watercolor and gold on paper
Image 5 x 6 in. (12.3 x 15.2 cm)
Sheet 6½ x 8⅛ in. (16.6 x 20.7 cm)
Promised gift of Anthony A. Manheim, L69.26.12

In another scene from the same manuscript as catalogue number 234, a teacher and his three pupils, one of whom is a woman, are involved in a teaching session that takes place in an area framed by three scarlet columns. The teacher is seated at the right, one leg under him, the other raised, a posture also assumed by the students who sit facing him. The teacher, dressed in a white dhoti, brown scarf, and a simple mauve turban, has tilak marks on his body. Before him is a slate with a salutation and vowels written in Devanagari script. He points his index finger in the direction of a male student, apparently asking him a question. That student, dressed in a yellow jama with a red sash and jeweled turban, folds his hands in supplication while answering the question. The gestures of the two other students are varied. The bearded student, seated in the middle, is dressed in brown. The female student, sitting at the left, wears a pale mauve skirt, blue choli, and red veil with white dots. She wears elaborate ornaments: nose ring, wide bracelets, earrings, and strands of pearl necklaces. All four figures wear gold ornaments embossed with gemstones and pearls. Architectural details include the fish-scale motif, typical of the Kulu artist Bhagvan. The painting is bordered first with black and then with a chocolate brown color.

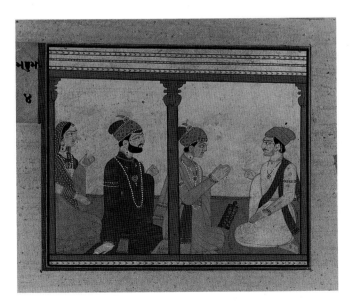

This painting deals with the romance of Madhu and Malati, who fell in love while attending the same school. Thus, the woman may be identified as Malati; however, it is unclear which of the two men is Madhu.

The text on the reverse, in an elaborate script, includes one line that glorifies knowledge: "What is the use of an unblemished lineage if a man is devoid of knowledge?"

AGP

Provenance Paul E. Manheim, New York.

236 Artist unknown

Courtiers' escapades

Leaf from an unidentified narrative series
Punjab Hills, Mandi
Circa 1670
Opaque watercolor and color washes on paper
Sheet 8⅝ x 11¾ in. (21.9 x 29.85 cm)
Gift of Dr. and Mrs. Kenneth X. Robbins, 81.317

INSCRIPTIONS
Verso, three lines, in black ink, in Takri script: illegible.

On paper overleaf, at center, in blue ink: Mandi library stamp; in black ink within stamp, in Takri script: illegible numeral; in black ink above stamp, in Takri script: *108.*

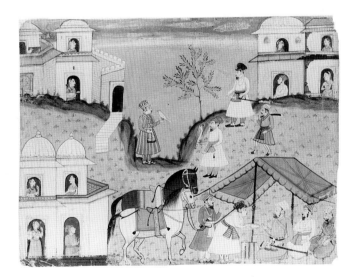

In the center midground four courtiers stand on a hillside, perhaps on a hunt, since two of the figures hold predatory birds. They are observed by men who appear at the windows or niches of palaces in the lower left and upper corners of the scene. In the lower right, a nobleman and two attendants are seated under a canopy. Facing this group is a man leading two caparisoned horses and another who presents an unidentifiable object on a tray. The figures are contrasted against a pale green wash spotted with darker tufts of grass

and a distant background of a jagged mauve hillside. There is no border.

W.G. Archer has published a remarkably similar painting from the series, now in the San Diego Museum of Art (formerly Collection of Edwin Binney, 3rd), which depicts several courtiers and a raja seated beneath a canopy with a hillside scene beyond (1973, vol. 2, p. 170. no. 5 [i]). He has compared other leaves from the series to Aurangzeb-period Mughal portraits, noting the conventions of costume and the small size of the figures, Mughal conventions that seem to be evident in our painting. Aurangzeb-period narrative painting is evoked as a possible source for this scene, especially in the depiction of more than one event in a single composition. In his discussion of this manuscript, Archer has suggested the possibility that a Mughal artist from Delhi could have established a particular local style at Bilaspur. Archer points out certain conventions that he considers to be Bilaspuri: the juxtaposition of the favorite red, reddish brown, orange, green, and brown colors, the "dwindling" of the lower limbs of the figures, and the use of brick construction, among others.

In addition to the stylized compositions and other conventions seen in the leaves of the set, one may also note the occasional appearance of lines of preliminary drawing, which show through color washes. In this page, the paint on the faces of the figures at the lower right, for example, has flaked off, leaving only the preparatory underdrawing. In one of the paintings in the Archer collection (W.G. Archer 1976, cat. no. 35), the underdrawing of a standing male figure is also evident. This figure is meant to have been the object of the standing male figure's outstretched arm, instead of a tree, which Archer indicated in his commentary.

Although Archer makes a convincing argument for a Bilaspur attribution, one can also argue for an attribution to Mandi on stylistic grounds. The predilection for striped costumes and turbans, the stylized arrangement of figures in a formalized garden, and the presence of the pale green background, as shown in another painting (Colnaghi 1978, cat. no. 59), are all seen in Mandi paintings. The palette, although possibly derived from Deccani painting, now becomes a convention in the north and is frequently seen in Mandi paintings. Mandi and Bilaspur were evidently on friendly terms throughout this period, whereas there was little interaction except by way of direct warfare between Mandi and the other Hill States. The style does not reflect much of the so-called style of Basohli, which was the chief center of culture from 1660 to 1700 in the Punjab Hills.

An important aspect of late-seventeenth-century painting in the Hill States that remains to be adequately explored is such documentation as the presence of library or owner's seals. One such seal is found on the reverse of this painting. Neglect of this facet of connoisseurship has led previous writers on the subject to attribute paintings from this manuscript solely on the basis of style—which in this case, with its several Mughal-inspired attributes, could be misleading. An inscription on the reverse and some writing on the paper overleaf attached to the painting have not yet been read and translated, but the seal on the overleaf has been identified by Dr. Catherine Glynn as a Mandi seal (personal communication, 1983). According to Glynn, who has gathered evidence of Mandi painting as early as the sixteenth century, this suggests a Mandi provenance (Colnaghi 1978, cat. no. 59); there is a particularly strong parallel in a large painting from a set previously called Bilaspur or Bikaner, circa 1670–80 (see Glynn 1983, pp. 21–64).

Pages from this series located in other collections, among them the Archer Collection, London; San Diego Museum of Art (formerly Collection of Edwin Binney, 3rd); Ralph and Catherine Benkaim, Beverly Hills; and Victoria & Albert Museum, London, have been identified as Bilaspuri paintings and dated to circa 1670–80 (Archer 1973, vol. 1, p. 231, and vol. 2, p. 170, and idem 1976, pp. 36–39); as well as catalogues of Maggs Brothers, London; Arthur Tooth & Sons, Ltd., London [1975, cat. no. 61], and various London auction catalogues). AGP

Literature Tooth 1975, cat. no. 65.

237 Artist unknown

Ravana challenges Rama's army

Punjab Hills, Mandi
Circa 1750
Opaque watercolor on paper
Image 4⅜ x 6½ in. (11.1 x 16.3 cm)
Sheet 6⅛ x 7¾ in. (15.5 x 19.5 cm)
Gift of Dr. Bertram H. Schaffner, 1994.11.1

INSCRIPTION
Overleaf: Mandi library seal.

The scene of the conflict between Ravana, the bloodied, multi-armed Shaivite shown at the left with three amputated hands, confronted by two crowned figures with bows and arrows, swords and shields, a crowned monkey guard (Hanuman) with a mace, and an ascetic, suggests a Shaivite-

Vaishnavite encounter. The central figure stretches his bow vertically into the upper border; his feet do not touch the ground, making it seem as if he were suspended from above. Kulu influence is evident in the masklike face of the monkey, the pointed crowns of the two warriors, the light green background, and the orange borders.

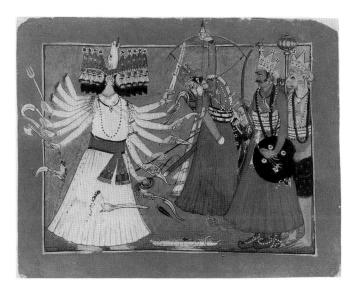

The significance of a *Ramayana* scene painted at Mandi in the reign of the ardent Shaivite Raja Shamsher Sen (r. 1727–81) may reflect the period's warring conflict with Kulu, when Raja Jai Singh, a great devotee of Rama, went to Ayodhya and never returned to Kulu (Archer 1973, vol. 1, p. 321). Raja Shamsher Sen of Mandi is portrayed in numerous idiosyncratic pictures, stylistic elements of which are evident here in the composition of the figures on a single plane, the protrusion of elements into the borders, the presence of Shaivite tilak marks, and the long pleated jamas with wide sashes (ibid., p. 358). Although Shamsher Sen is reported to have shown less interest in proving his strength through battle than his predecessors, the battle scenes of the *Ramayana* continued to be a popular subject in Mandi. AGP

238 Artist unknown

Queen Vantu with a hookah attended by a maid

Punjab Hills, Mandi
Circa 1750–80
Opaque watercolor on paper
Image 9⅛ x 6¾ in. (23.4 x 17 cm)
Sheet 10⁵⁄₁₆ x 7¼ in. (26.2 x 18.4 cm)
Promised gift of Mr. and Mrs. Paul E. Manheim, L69.26.6

INSCRIPTION
Verso, in black ink, in Devanagari script: *Rani Vantu.*

The imposing figure of Rani Vantu holds the nozzle of a glass bell-shaped hookah as she turns toward her attendant, who holds the bowl. The rani wears a pale yellow gown trimmed with an orange border, a midnight blue *orhani* with floral pattern, and red slippers. Her jewelry includes several beaded necklaces, a large orange pendant, gold bangles and bracelets, finger rings, earrings, and a large cumbersome nose ring. Her barefoot attendant wears a mauve sari and is adorned with a pearl necklace, earrings, and a nose ring. Both figures bear the tilak on their foreheads. The rani appears in a confident pose in which her face and feet point in opposite directions. Her gown protrudes into the border at the lower left. Additional features of the Mandi convention include the tufted grass, the plain background, and the band of dark blue above, indicating the sky. The picture is bordered with a red band.

Rani Vantu probably represents the wife of Raja Shiva Jawala Sen of Mandi (r. 1719–22) and the daughter of Mian Abhai Chand, the Rana of Hatli. Shiva Jawala Sen, who died at a young age, was succeeded by his infant son Shamsher Sen (r. 1727–81). From 1727 until her death in circa 1740, the queen mother ruled the state as regent, assisted by the

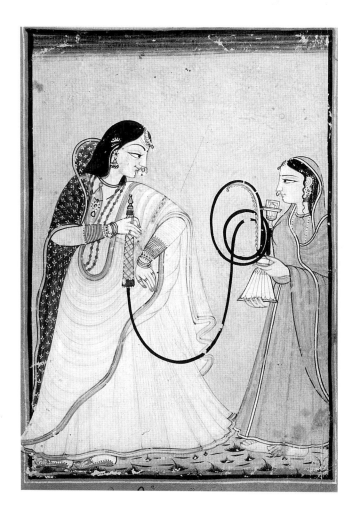

octogenarian Prime Minister Mian Jappu. The portrait suggests the relatively powerful position she must have held in state politics, for at the time of its execution artists would not ordinarily have had access to ladies' quarters; queens, princesses, and concubines were kept in seclusion. It is possible that this miniature is the same as that cited by W. G. Archer 1973, vol. 1, p. 359, vol. 2, p. 271.

Glass hookahs dating from the late eighteenth century, some of which were produced in Europe, have been documented by Skelton 1982, pp. 124–25. AGP

239 Artist unknown

Kaliyadamana

Punjab Hills, Mandi
Circa 1760–70
Opaque watercolor on paper
Image 9 x 5¾ in. (23 x 14.7 cm)
Sheet 10⅜ x 7⅛ in. (26.3 x 17.9 cm)
Anonymous gift, 80.277.7

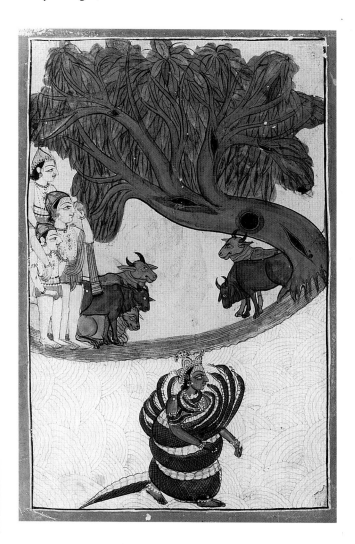

In this modest painting, the traditional ferocity of the struggle between Krishna and the serpent demon Kaliya is reduced to a rendering of Krishna standing passively on the riverbed, wrapped in the coils of the multicephalous brown and yellow serpent demon. Three *gopas,* two of whom hold their fingers to their faces in a gesture expressing surprise, and five cows stand on the shore above and do not look directly at the action. The branches of a tree fan out over the scene like a huge parasol.

The figures relate to paintings produced during the reign of Raja Shamsher Sen (r. 1727–81) (see cat. no. 237 and other comparable pages reproduced in Archer 1973, vol. 2, cat. nos. 33–35). The palette, vertical tilak marks, and the profile facial types are typical of later Mandi paintings. Since Krishna's usual yellow costume is hidden by the coils of the snake, the artist has transferred the bright color to the background of the painting and, according to the myth of Kaliya, to the dress of the *gopas.* The cows are depicted in different shades of black as a result of the demon's poisonous bite.

The inscription on the verso in black ink, in Takri script, is illegible. AGP

Literature M. Lerner 1974, cat. no. 35.
Provenance Jeffrey Paley, New York.

240 Artist unknown

Vasaka Sajja Nayika

Punjab Hills, Mankot
Circa 1690
Opaque watercolor on paper
Sheet 6¹⁵⁄₁₆ x 6¾ in. (17.7 x 17.15 cm)
The Brooklyn Museum Collection, X623.2

Here, romantic love is treated with compelling immediacy. A *sakhi* (female companion or confidante) prepares sandalwood paste to cool the heroine's feverish longing for the absent lover. The placement of figures at oblique angles, the abstract shape of objects in the bedchamber, and the intensity of colors, particularly when juxtaposed against the bright red background, produce a disturbing rhythm.

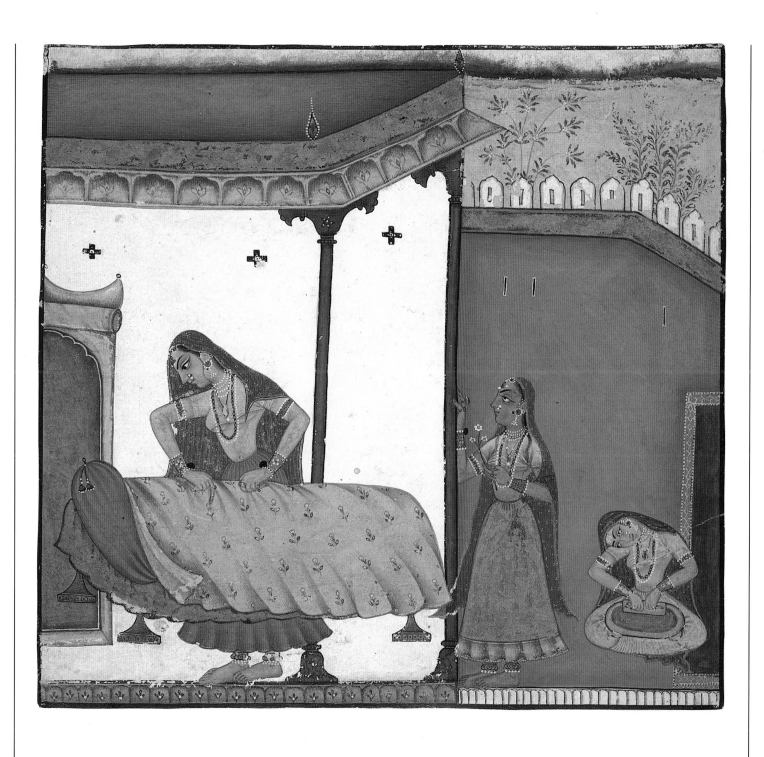

This isolated page representing the *Vasaka Sajja Nayika,* painted by an unnamed artist, compares stylistically to pages attributed by Goswamy and Fischer to the so-called Master at the court of Mankot (1992, pp. 96–99). The physiognomy of women with strands of hair delineated on their cheeks, high taut breasts, costumes with differentiated scarves (*orhanis*), and their particular jewelry, especially pearl pendant earrings, all match the details noted in depictions of female subjects described by Goswamy and Fischer (ibid., p. 108). Our page, published here for the first time, may be attributed to an artist of this workshop. AGP

241 Artist unknown

Rama and Lakshmana confer with Sugriva about the search for Sita

Scene from a dispersed *Ramayana* series
Punjab Hills, Mankot
Circa 1700–1710
Opaque watercolor and gold on paper
Image 6⅜ x 10½ in. (16.2 x 26.7 cm)
Sheet 7⅞ x 12 in. (20 x 30.5 cm)
Gift of Mr. and Mrs. Robert L. Poster, 85.220.1

Sugriva, the king of Kishkindha, sits at the center with Rama and Lakshmana, having dispersed his monkey and bear troops in all directions in search of the abducted Sita. To symbolize this action, monkey ministers, monkey troops, and a bear are depicted in the four corners of the composition. A tree bends over the central group like a royal parasol. The idiosyncratic series attributed to Mankot, to which this sheet belongs, is noted for the treatment of outcroppings, shading of rocks, trees, and other vegetation, hieratic figures shown in three-quarter poses, the predilection for ornamental crowns and jewelry, and the stylized clouds painted in a band above a high horizon. The painting is surrounded by a red border.

Ehnbom has compared this Mankot *Ramayana* series to several devotional sets of the early eighteenth century, noting that the "style here is less concerned with minute detail than those of Basohli and Kulu, deriving its dramatic force from curving rhythms and starkly placed figures" (1985, p. 208).

For other leaves from the Mankot *Ramayana* series, see W. G. Archer 1976, pp. 122–25, cat. nos. 65 and 66; Pal 1976, cat. no. 4; idem 1978, p. 160, cat. no. 55; Tandan 1982, pp. 96–97, fig. 77, pl. 38; Ehnbom 1985, p. 208, cat. nos. 102 and 103.

For a second contemporaneous *Ramayana* series attributed to Mankot, see W. G. Archer 1973, vol. 1, p. 376, vol. 2, p. 289. AGP

Provenance C. L. Bharany, New Delhi.

242 Artist unknown

Portrait of a prince, perhaps Mahipat Dev of Mankot

Punjab Hills, Mankot
Circa 1720
Opaque watercolor, gold, and beetle wings on paper
Image 7¼ x 8 in. (18.5 x 20.4 cm)
Sheet 7⅞ x 9¼ in. (20 x 23.5 cm)
Gift of the Oriental Art Council, 1990.73

In this uninscribed portrait, a bearded prince is shown seated with two female companions in a pavilion. The prince bears a strong resemblance to Mahipat Dev, a Mankot ruler of the late seventeenth century (r. circa 1650–90). W. G. Archer reproduces several portraits of Mahipat Dev (1973, vol. 2, pls. 8, 9, 14, 35) in which the prince wears a headdress with a similar black plume. However, these portraits are generally bolder in their economy of means, favoring broad planes or stripes of color with a more restrained use of floral patterns than is seen here.

This painting closely resembles portraits produced in Basohli. Elements of that style found here include an abundance of floral ornamentation, the use of beetle-wing cases to represent emeralds, and the buildup of white paint to render pearls. While other Pahari schools experimented with such methods of depicting these jewels, the technique appears to have been the invention, or at least a signature trait, of artists from the Basohli/Nurpur area. No documented Mankot portrait contains beetle wings.

A striking feature of this portrait is the placement of the figures within an architectural frame. A portrait of Mahipat Dev at prayer (Goswamy and Fischer 1992, cat. no. 37) and one of Medini Pal of Basohli (W. G. Archer 1973, Basohli, pl. 17) locate the sitters within similar pavilions. The device of placing segments of narration within architectural struc-

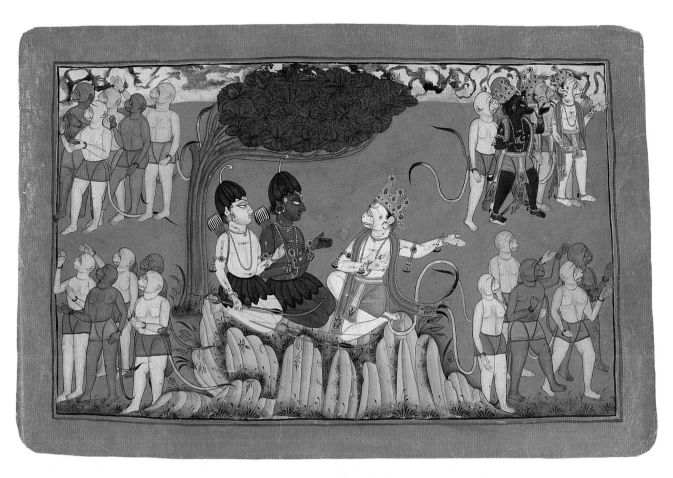

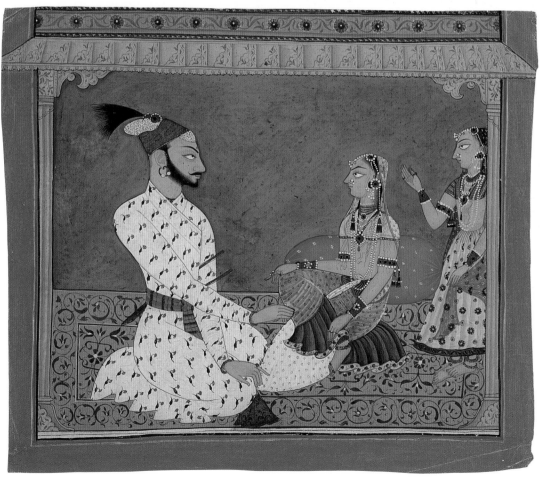

289

tures can be traced back to the early Basohli *Rasamanjaris,* and several Pahari states adopted the Mughal tradition of framing half-length or bust-length portraits within a window. However, portraits of full-length seated figures within architectural frames are rare for the area.

The highly ornamental frame depicted here bears a striking resemblance to the type of architecture seen in the *Rasamanjari* set painted for Raja Kripal Pal of Basohli in 1694–95. However, the physiognomy of the female attendants does not correspond to that of the female figures in the Kripal Pal *Rasamanjari.* The head and facial structure of female figures changes frequently in Basohli painting and probably corresponds to generational changes at the workshop. As a rule, however, the women of early Basohli painting have very small heads with flat, sloping brows. By contrast, the attendants in our portrait have large, rounded heads, with strong, almost masculine profiles. Their facial type corresponds far more closely to the Mankot type, as seen in the three Mankot *Bhagavata Purana* sets of the early eighteenth century. (See W. G. Archer 1973, vol. 1, p. 376, no. 25, for a series in horizontal format; p. 377, no. 26, for a series in vertical format; and p. 379, no. 36, for another series in vertical format.) Their earrings, with the triple fringe of pearls, also appear in several Mankot paintings of that period.

Strong ties were created between Basohli and Mankot when Mahipat Dev's daughter was married to Kripal Pal. The new bond thus forged between the two courts in the second half of the seventeenth century must have been of great political significance: record of the wedding survives, whereas little information about Mankot's history exists. Archer notes (ibid., p. 369) that the daughter became Kripal Pal's favorite rani. Given this diplomatic and familial bond, it is possible that Mahipat Dev could have been portrayed by a Basohli artist. However, the painting shows a svelte prince, and we know from inscribed portraits that Mahipat Dev became far heavier as he reached middle age. By the time of his daughter's wedding, Mahipat Dev was probably quite fat. If the portrait dates from Mahipat Dev's lifetime, then it would have been made when the prince was still young. The heads and costumes of the female figures, which correspond to those found in the early-eighteenth-century Mankot *Bhagavata Puranas,* suggest that the portrait was painted after the death of the prince, when the figure and facial features would have been copied from portraits made during his youth.

It is appropriate that the Mankot prince responsible for the alliance between Basohli and Mankot should be portrayed in a manner that combines the styles of each state. The use of Basohli decorative details, together with the presence of Mankot-style female figures, shows that the two states engaged, at least temporarily, in an exchange of artistic concepts. In its mixed style the portrait refers, perhaps unconsciously, to the diplomatic achievement of the subject.

Goswamy and Fischer (1992, pp. 96–99) attribute the earliest, horizontal *Bhagavata Purana* and several portraits to an unknown artist whom they call the Master at the Court of Mankot (active circa 1670–1700). Among the portraits are two of Mahipat Dev (ibid., cat. nos. 36 and 37), both now in the Government Museum and Art Gallery, Chandigarh. The images of Mahipat Dev cited by Goswamy and Fischer are similar in physiognomy to that in our example, and, as noted above, the portrait of Mahipat Dev at prayer makes use of a similar architectural framework. The female figures in our portrait correspond to those found in the horizontal *Bhagavata Purana.* However, our page is not as minimalist as most Master of Mankot portraits and seems to place greater emphasis on the trappings of royalty, thereby obscuring the sensitive rendering of the ruler's individual features. Because the female figures would also seem to correspond to those of the later, vertical *Bhagavata Puranas,* the portrait appears to date slightly later than the paintings ascribed to the Master at the Court of Mankot.

Few portraits from Basohli or Mankot show a ruler accompanied by women. One portrait in the Chandigarh Museum's Mankot Raj Collection (W. G. Archer 1973, Mankot, pl. 16) shows Raja Kripal Pal of Basohli attended by two very small female figures. Our portrait also includes two women, but one, of approximately the same size as the prince, is obviously a companion rather than a servant. She sits with him, supported by a bolster, and he reaches out to her in a gesture of affection. Although artists of other Hill States, especially Jammu, Guler, and Chamba, would later portray specific rajas with their ranis or consorts, none of these familial portraits has been recorded for either Basohli or Mankot.

Although our painting is obviously intended to depict a specific prince, it may also serve as an illustration of *Vinoda Raga,* which Ebeling describes as "a man in white amusing himself with betel and friends" (1973, p. 74). Examples of *Vinoda Raga* paintings from Mankot and Bilaspur (W. G. Archer 1973, Bilaspur pls. 28, 31[ii], 32[i], 33[i], Mankot, pl. 28) show that one Pahari interpretation of the theme called for the man to be seated within a pavilion or under a canopy, cavorting with two women. If the portrait were to serve a second purpose illustrating a romantic theme, then the prominent role played here by the women would be more appropriate. JMC

243 Artist unknown

Portrait of Raja Amar Singh of Patiala

Punjab Hills, Nurpur School (?)
Circa 1830
Opaque watercolor and gold on paper
Image 7½ x 4¹³⁄₁₆ in. (19.2 x 12.3 cm)
Sheet 10¹¹⁄₁₆ x 7⁹⁄₁₆ in. (27.6 x 19.5 cm)
Gift of Emily M. Goldman, 1991.180.7

INSCRIPTIONS

Verso, at upper center, in black ink, in Devanagari script: illegible; at middle center, in black ink, in Urdu (?): illegible; at lower center, in blue ink, in Devanagari script: *Raja Amar Singh of Patiala.*

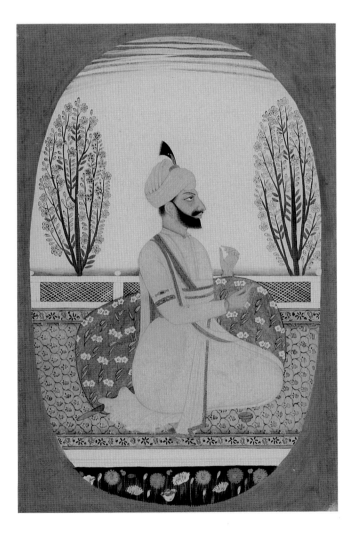

The raja, painted in intricate detail, is depicted seated on a terrace in a garden, staring contemplatively into the distance. His dark beard and mustache and the red at the corner of his eye are painted in an intricate series of fine lines. He wears a yellow gown fastened with a prominent gold button at the neck and a long gold-trimmed waistband. Additional decoration includes two pearl-and-gem-encrusted armbands, two thin gold bracelets, a thin gold finger ring,

and a sanguine and gold sash across his chest to secure his sword. The yellow turban, loosely folded around the raja's head, is secured with a black plume set in a gold and jeweled ornament. There is some overpainting at the top of the turban. On the floor, near his leg, is a small gold vessel. The position of his right hand suggests that he may have removed some substance, perhaps fruit or betel, from the small object. He leans against a large gold pillow, embroidered with white flowers and green stems. A gold sword lies between his body and the pillow.

The terrace is covered with an elaborately decorated orange carpet bordered in mauve and olive. A variety of orange, pink, and white flowers occupy the foreground of the scene. Beyond the white fence there are two tall trees with deep green leaves, mauve blossoms outlined in red, and grayish brown branches. A thin band composed of green and yellow lines suggests the receding field. The sky is indicated by a white field and several bands of brown, blue, and purple toward the top of the image. The border surrounding the oval is a powdery steel blue. Sometime after its production, the page was mounted on a pieced backing of brown paper.

The sharp, thin outlines, bright colors, and decorative patterning of this portrait are typical of the painting style practiced in the Punjab states in the second quarter of the nineteenth century. As the Sikhs rose to power and eventually unified the Punjab in this period, Pahari artists were commissioned to produce portraits to the exclusion of most other subjects. The convention of placing the sitter on a railed terrace backed by stylized trees is found in many Sikh portraits. Although our painting resembles these works, it does not contain the dramatic contrasts of dark and light and of juxtaposed primary colors found in Sikh portraits of the mid-nineteenth century. It probably dates to a transitional period, when the more lyrical Kangra-based styles were giving way to the brighter, more graphic style of the Sikh courts. The loosely tied, high turban worn by the ruler is similar to those found in Kangra and Nurpur portraits of the 1820s and 1830s, and contrasts sharply with the various turban styles found in later portraits.

The subject of our painting, although identified on the verso as Raja Amar Singh of Patiala, remains uncertain. W. G. Archer mentions an Amar Singh of circa 1825 who was a prince of Kotla, a small state near Nurpur (1973, vol. 1, p. 315). The style of our painting is close to that of Nurpur, but a portrait of Amar Singh of Kotla published by Archer (1966, fig. 8) bears no striking resemblance to the prince in our portrait. Patiala, a state in the southeastern Punjab Plains, was a prominent commercial and military center from Mughal times but was not known for its artistic output.

For another portrait of a Patiala ruler in the Brooklyn collection, a drawing in the Company School style, see Appendix D82. AGP

Provenance Paul E. Manheim, New York.

Other Schools



COMPANY SCHOOL

244 Artist unknown

An English lady

Delhi, Company School
Circa 1820–30
Opaque watercolor on ivory
5 x 4 in. (12.7 x 10.2 cm)
Gift of Terence McInerney, 80.182.1

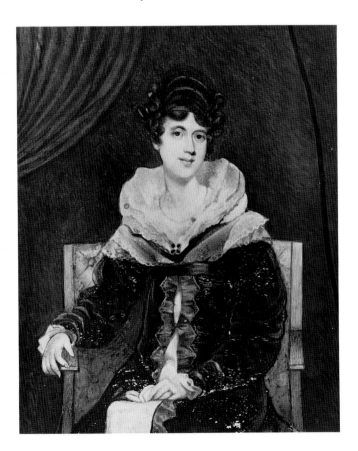

An oval-faced Englishwoman is coiffed and clothed according to the fashion of the 1820s. Over a white muslin dress with a raised, puffy collar, she wears a dark green velvet pelisse with satin trim and gold bands at the wrists. Her chestnut brown hair is adorned with green satin ribbons that end

in bows on either side of her head. Her skin is pale with pink highlights. She is seated in a red brocaded chair with wooden arms against a plain brown ground with a blue curtain in the upper left corner.

The practice of painting miniature portraits on ivory was introduced to India in the late eighteenth century by the British artists John Smart and Ozias Humphrey. By the first quarter of the nineteenth century another British painter, George Chinnery, had eclipsed these pioneers "in the taste of their patrons" (see M. and W. G. Archer 1955, p. 10). Because of the high prices British artists charged for portraits, Indian painters were soon pressed into service by British patrons. In 1839, Emily Eden, the sister of the Governor-General and a resident of Delhi, wrote, "I have had two Delhi miniature painters here, translating two of my sketches into ivory. . . . Azim, the best painter, is almost

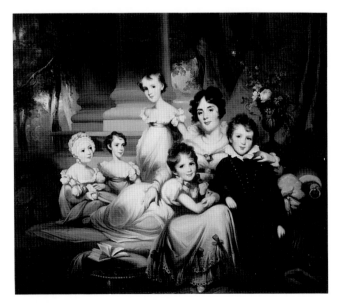

Figure 5

George Chinnery (English, 1774–1854)

Lady Harriet Paget with five of her children

India, Calcutta, c. 1807–20
Oil on canvas
The Hongkong and Shanghai Banking Corporation Limited

a genius except that he knows no perspective, so he can only copy" (ibid., pp. 68–69). The Museum's portrait exhibits many traits one associates with the style of Chinnery: the painterly rendering of the drapery, the soft treatment of the flesh, and the shading on the face and neck of the sitter. However, such details as the lady's gray, crablike right hand, the unsuccessful foreshortening of the arms of the chair, and the somewhat wooden handling of the folds of the sleeves suggest that this portrait is the work of an anonymous Indian artist. The resemblance of the sitter in the miniature to Mrs. Paget in a group portrait of the Paget family by Chinnery, now in the collection of the Hong Kong and Shanghai Banking Corporation (fig. 5), supports the attribution of this work to an Indian copying an English master. SRC

245 Artist unknown

A gentleman

Delhi, Company School
Circa 1820–30
Opaque watercolor on ivory
4⅞ x 3 in. (12.4 x 7.6 cm)
Gift of Terence McInerney, 80.182.2

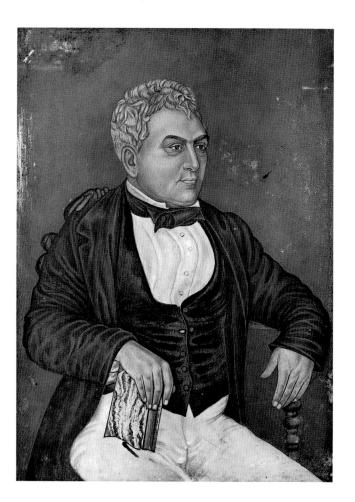

Viewed in a three-quarter pose against a plain dark gray ground, the European gentleman portrayed here is seated in a barely visible wooden chair, on the arms of which he rests both elbows. He wears white pants and a white shirt, a blue vest, and a slate gray tie and coat. His right hand holds a book with a marbled cover and red spine propped up on his knee.

This painting is certainly an attempt to adhere to the European style of portraiture, and may well be a copy of a portrait by an English artist. One is tempted to see it as an adaptation of the famous portrait of Sir Henry Russell, Chief Justice of Bengal, painted by George Chinnery in Calcutta in 1807 (see M. Archer 1979, p. 365). Although, unlike the original portrait of the Chief Justice, the figure is seen in a three-quarter view without the wig and robes of his station and against a plain background, his set jaw and straight nose, the position of the book and hands, all recall the original, which still hangs in the Judges' Library and Lounge, High Court, Calcutta. SRC

246 Artist unknown

Botanical study of a lily

Company School, Calcutta
Circa 1800
Watercolor on laid English paper
Sheet 21⅜ x 15³⁄₁₆ in. (54.3 x 38.5 cm)
Purchased with funds given by Willard G. Clark, 88.96

A green stalk of a lily with numerous perpendicular shoots and yellow-white buds and stamens has been depicted in a painstakingly detailed technique on English laid paper with unidentified watermark. Commissioned by the English officer Major James Nathaniel Rind when he was stationed in the 18th Native Infantry at Calcutta from 1789 to 1801, this drawing is part of an album of tropical flora drawn by an anonymous artist. (For three comparable botanical studies commissioned by Rind, see S. C. Welch 1978, cat. nos. 11–13.) They belong to the period when such people as Chief Justice Sir Elijah and Mary, Lady Impey, were collecting natural-history drawings in Calcutta.

The artist of this study of a lily was a contemporary of such renowned artists of the time as Zayn-al-din, Bhawani Das, and Ram Das. According to Dr. M. Archer, the entire Rind album was executed by one artist, whose identity remains unknown (personal communication, 1987). AGP

Literature Kyburg 1988, cat. nos. 17–21.

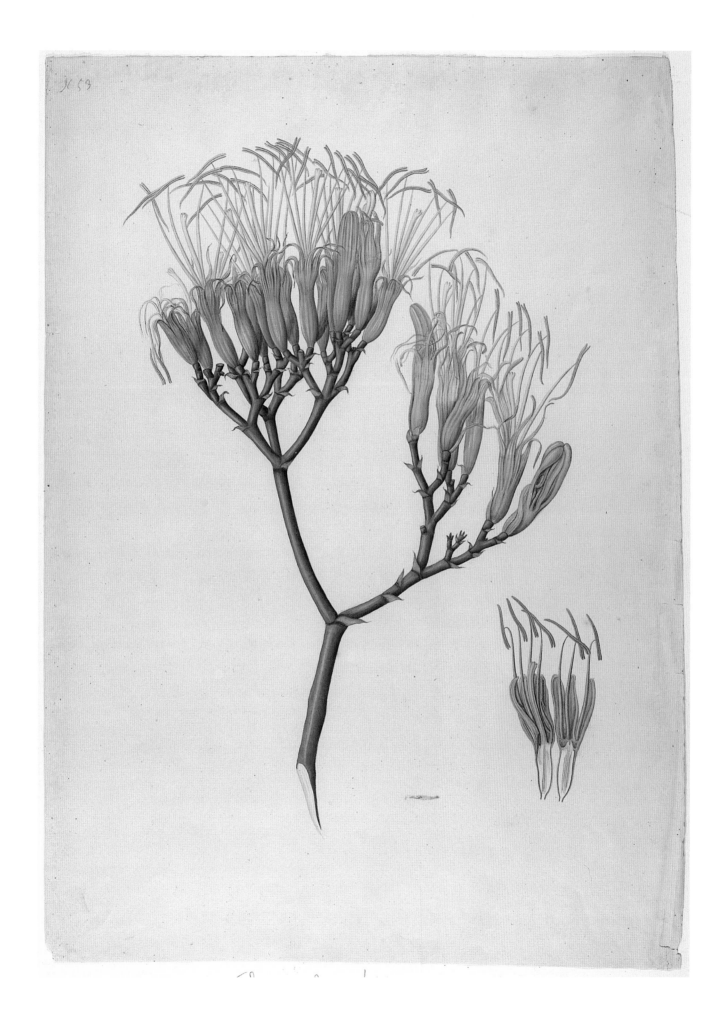

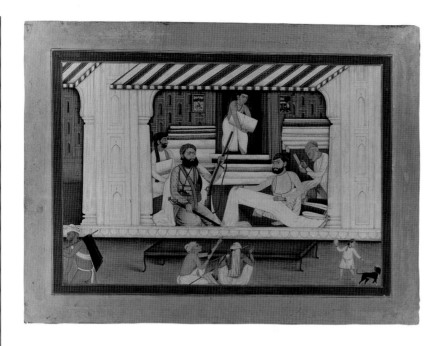

247 Basarat, son of Dutta

Cloth merchant's shop

Company School, Lahore
Circa 1850
Opaque watercolor and gold on paper
Image 7⅛ x 11¾ in. (18.1 x 29.8 cm)
Sheet 10⅝ x 14⅝ in. (27.2 x 37.2 cm)
Gift of Mr. and Mrs. Robert L. Poster, 1991.246

INSCRIPTION

In lower margin, in red pigment, in Urdu, in nastaliq script: *From the pen of Basarat, son of Dutta.* (Trans. R. Skelton)

The central scene of activity is a textile merchant's establishment framed within an archway in the front wall of the shop with red-and-white awnings above and a platform below. While his assistants work in the background, a merchant seated at the right displays a bolt of white fabric to a seated man at the left. The prospective customer is depicted in greater detail and in a more European style than the other figures. Facing front, he kneels on a mat and carries a rifle and a long sword, as well as a pistol tucked into the front of his belt. His garments are depicted in a much subtler manner than those of the proprietor and his staff, and his face shows a depth of character that appears to be the result of direct observation of a specific individual.

By contrast, the other occupants of the shop are not individualized. They go about their duties, surrounded by stacked bolts of cloth. A round-faced, bearded figure—an assistant or a waiting customer—sits quietly behind the figure at the left. A bare-chested, clean-shaven youth with ti-lak marks on his arms and face enters through the rear door,

carrying a folded parcel. Behind the merchant, a man writes in Persian on a white page.

Two miniature paintings hanging on the back wall of the shop on either side of a central door depict an incarnation of Devi riding on a fish, and the holy family of Shiva camped in the wilderness. Both works are consistent with Punjab Hills painting styles and subjects of the early or mid-nineteenth century.

Outside, two Hindu ascetics sit on the ground facing the shop. Both have small sticks from which they have hung their belongings. One smokes a pipe and appears to be begging for alms from the merchants and their customer. In the lower left corner, another holy man walks away. In the lower right corner, a boy holds a ball he will throw to a black dog. There is a blue inner border, marked by red and white rules, and a light pink outer border.

The faces of those inside the shop and of the figures outside are more stylized than that of the central figure and resemble physiognomic types seen in later Pahari paintings from Kangra, Garhwal, and Chamba. The British influence is apparent, however, in the use of three-quarter views for the faces of the two figures and the introduction of shadows in the foreground.

The secular content of the painting is of the type often requested by British patrons, but the formal, three-quarter turn of the major figure, with weapons so proudly displayed, reveals the influence of British portrait traditions while contrasting sharply with both the form and content of the rest of the painting.

For a similar page, perhaps from the same series, see Fussmann 1992, pp. 148–49, cat. no. 70. AGP

Provenance Sotheby's 1985, lot no. 371.

248 Artist unknown

Kichaka and Bhimasena

Leaf from a dispersed *Mahabharata* series
South India, Karnataka (Mysore)
1670
Opaque watercolor and gold on paper
Image 4¼ x 4¹⁵⁄₁₆ in. (10.8 x 12.55 cm)
Sheet 8 x 19³⁄₁₆ in. (20.3 x 48.75 cm)
Gift of Cynthia Hazen Polsky, 80.278.2

INSCRIPTIONS

Recto, in black ink, in Devanagari script, in upper left margin: *Viram 26;* in upper right margin: *Ram 26;* in lower margin, below image: *Sairandhri Kichaka Bhimasena.*

The *Mahabharata,* one of the most famous Sanskrit epics, relates the story of the dynastic rivalry between the Pandavas and the Kauravas. Here we see Bhima fighting with Kichaka while Draupadi, in disguise as Sairandhri, looks on, all identified in the margin below the image. The physiognomy of

beak-shaped noses, long round eyes, and emphatic profiles of the figures is consistent with the style of this series.

The exuberant style identifies the painting as an example of later South Indian painting, based on Vijayanagar-period figural style (1336–1565). This distinctive Karnataka style is common in the wall paintings that decorated monuments and temples, but few works of the period on paper or palm leaf survive. The paintings from a dated *Mahabharata* series are consistent with the earlier tradition in that they all exaggerate the stocky figures by means of modeling and highlighting with fresh colors and gold leaf within heavily calligraphic contours emphasized by patterns and shading.

According to Jagdish Mittal, a colophon states that the series was painted by the scribe Govind Sharma, son of Ratnaker, in 1670 (V.S. 1592), possibly during the reign of Devaraja Wodeyar (r. 1659–73), which would place the work in the region of Seringapatam in present-day Mysore, the capital of the Wodeyar Dynasty (Mittal in S.C. Welch 1985, p. 54).

Other leaves from this series are located in the Salar Jung Museum, Hyderabad (unpublished); the Jagdish and Kamla

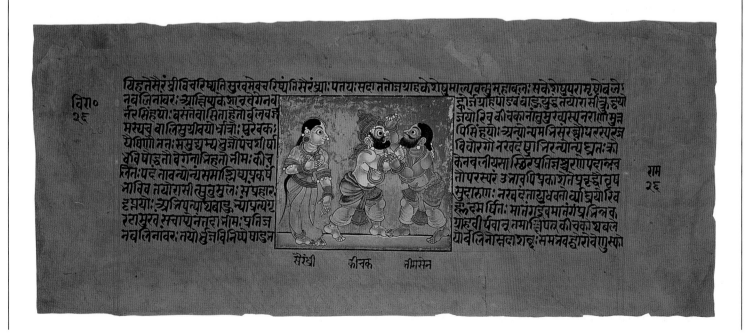

Mittal Museum of Indian Art, Hyderabad (S. C. Welch, op. cit., cat. no. 21a–b); the National Museum, New Delhi (Mittal 1969, pl. 5); (formerly) the George P. Bickford Collection, Cleveland (Czuma 1975, cat. no. 124); the Freer Gallery of Art, Washington, D.C. (Murray 1979, cat. no. 83); and the Ehrenfeld Collection, San Francisco (Ehnbom 1985, p. 100, cat. no. 43). AGP

Nandi, the bull. On either side, standing beneath separate arches with their hands in *anjali mudra,* are six saints: Appar, Sambandar, and Hayagriva at the left and Bringi, Sundara, and Manikavachakar at the right. (All figures have been identified by Vidya Dehejia, personal communication, 1989.) Throughout the painting, the orange and navy background is punctuated by small clusters of white dots.

For a related painting, see Mittal 1985, pp. 41–61. AGP

250 Artist unknown

Durga killing the buffalo demon

South India, Tanjore
19th century
Opaque watercolor embellished with applied gold and lacquer strips
Image 15⅝ x 12¼ in. (39 x 31 cm)
Gift of Dr. Bertram H. Schaffner, 1993.106.2

In the nineteenth century, the Durga and Krishna themes became very popular in the paintings of Tanjore and Mysore. Elaborately inlaid with gold and colored glass, such works have a certain decorative value while lacking the sensitive execution of the miniature paintings of Rajasthan. Here, the

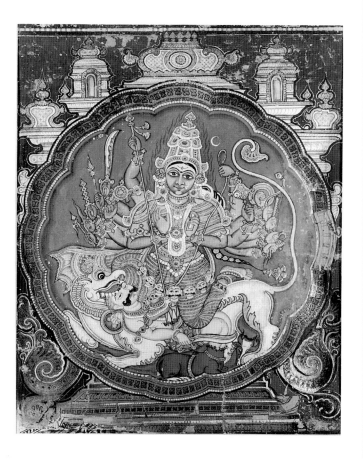

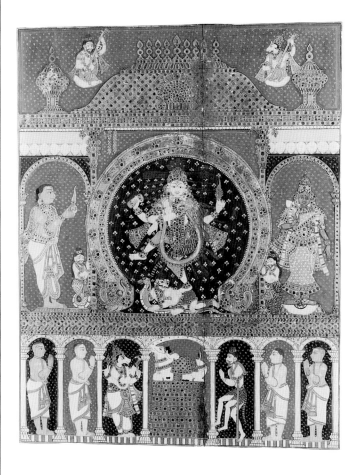

249 Artist unknown

Shiva Nataraja with saints

South India, Andhra Pradesh
Mid-18th century
Tempera, color, and gold on cloth, mounted on wood
Sheet 32 x 25½ in. (81.3 x 64.3 cm)
Anonymous gift, 1989.52

Shiva dances on the dwarf demon Apasmara beneath a flaming makara arch. He is flanked by the large figures of Patanjali on the left and Vyaghra Pada on the right. Smaller Nagarajas flank the arch on either side. Two small figures are seated on clouds above the golden dome of the shrine. To the left is the bearded sage Narada, and to the left is the animal-headed Tumburu. Directly below Shiva is his mount,

spectacle of Durga in her universal form is emphasized by the crenellated roundel framing the multi-armed goddess on her *yali*-mount as she pierces the torso of the demon, here a vanquished male figure laid out beneath her. The painting has been further stylized by the suggestion of a bronze icon mount with a mannered ornamental architectural pedestal and palace turrets that embellish the scene. AGP

251 Artist unknown

Krishna counsels the Pandava leaders

Page from a *Mahabharata* series
South India, probably Karnataka
Circa 1830–50
Opaque watercolor on paper
Image 10½ x 15¾ in. (26.7 x 40 cm)
Sheet 11 x 16¼ in. (28 x 41.3 cm)
Gift of Doris and Ed Weiner, 75.203.4

At center left, the blue god Krishna sits on a dais. He is crowned and four-armed, holding an unidentified object in his upper left hand and gesturing with his upper right. Three seated male figures to the right repeat his right-hand

gesture. A male warrior with long sword and shield approaches at the far left and an imposing blue figure, who may represent Krishna's cosmic manifestation, appears at the rear right. A striped curtain is draped across the top, the pattern of which is repeated on the decoration of the dais, suggesting the furnishings of a stage set.

A genre of folk paintings, generally ascribed to the nineteenth century, were intended as visual props for village storytellers reciting such *puranas* and epics as the *Mahabharata*. The *Mahabharata* scene represented here is one of the group of so-called Paithan paintings.

The characteristic picture plane, formulaic arrangement of figures, color, and flat linear style were developed for the Paithan epic scenes. The blocks of alternating flat opaque colors outlined in black create a rhythm accentuated by the figures' round "staring" black eyes, a characteristic noted by Kramrisch in her discussion of three episodes from the *Mahabharata* in a contemporaneous Paithan series (1986, p. 189 and cat. nos. 134–36).

For a *Mahabharata* painting comparable in composition and arrangement of figures, possibly by the same hand, as well as a similarity in ornamentation of costumes and architecture, see Dallapiccola 1982, pp. 86–87, fig. 84, a scene depicting Krishna at the camp of the Pandavas where he met the noble Yudhishthira (in the J. Vollmer Collection, Freiburg). AGP

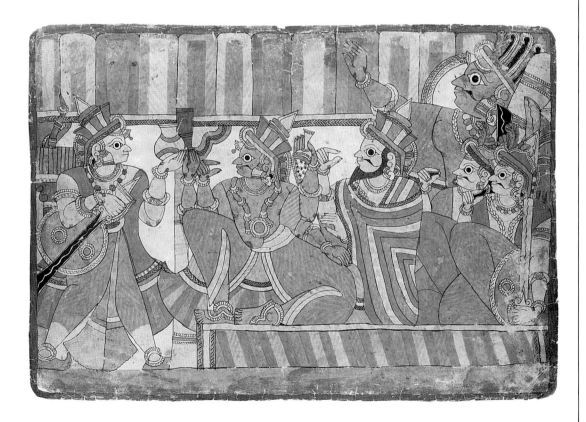

252 Artist unknown

Two leaves from an unidentified manuscript

Eastern India, Orissa
19th century (?)
Ink on palm leaves
Each leaf 1¾ x 11 in. (4.4 x 28 cm)
Gift of Dr. and Mrs. Kenneth X. Robbins, 79.188.1–.2

INSCRIPTIONS
In black ink, in Devanagari script
79.118.1
Recto, from left: *19, 20, 21.*
Verso, from left: *22, 23, 24.*
79.188.2
Recto, above left image: *Vakiraha;* from left: *31, 32, 33.*
Verso, from left: *34, 35, 36.*

These double-sided leaves with incised Sanskrit text depict in Orissan style of extremely fine quality pairs of lovers gracefully embracing in erotic poses. The figures are adorned with jewelry and hair ornaments and occupy elaborately furnished pavilions with various accoutrements of their love play. There is no color. Each couple is identified with a numeral. The rendering of architecture and landscape elements compares to three nineteenth-century Orissan palm leaf manuscripts in the Rietberg Museum, Zurich (Fischer, Mahapatra, and Pathy 1980, figs. 547–53).

For two examples from the same manuscript, see Wiener, n.d., cat. no. 18, where they are published as seventeenth century.

For comparable Orissan leaves, see Rawson 1973, no. 93, for two examples from a related manuscript identified as folios from a *Gita Govinda,* circa 1600; and Losty 1982, p. 137. According to Losty (1982, p. 113), "all known palm-leaf manuscripts from Orissa are of a comparatively late date and use the palmyra, on which the text is incised with a stylus in the southern Indian manner, and then inked." AGP

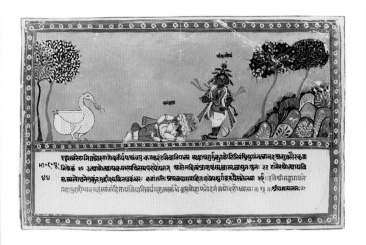

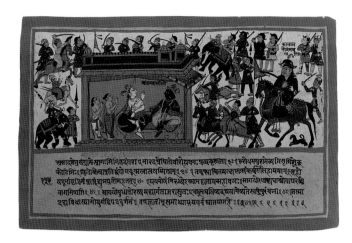

253 Artist unknown

Brahma worships Krishna

Page from a dispersed *Bhagavata Purana* series
Eastern India, Orissa
Circa 1800
Opaque watercolor on paper
Image 8 x 13⅝ in. (20.3 x 34.7 cm)
Sheet 9⅜ x 15 in. (24.1 x 38.2 cm)
Gift of Doris and Ed Weiner, 75.203.2

INSCRIPTIONS

In black ink, in Devanagari script
In image, above erect figure: *Krishna;* above prostrate figure: *Brahma;* in text band below image, at left: *66.*

The four-headed divinity Brahma, dressed in a red dhoti, prostrates himself before a smiling Krishna. The blue god wears a yellow dhoti, red patterned scarves, and a long white garland. His peacock-feather crown has several tiers of green feathers highlighted with yellow. At the left, Brahma's vehicle, the swan, whose feathers are defined with gray soft ridges, stands with a red flamelike form emanating from its beak. There are stylized trees with sinuous red trunks at either side and a cluster of multicolored rocks at the far right. The colorful figures, trees, and rocks, outlined in black, contrast with the monochromatic blue background. The border consists of repeated white flowers on a light blue ground ruled with red and yellow lines. Four lines of text closing the thirteenth chapter of the first half of the *Bhagavata Purana* are written in black ink in the panel below the image.

The linear style of the figures and the bright palette typify Eastern Indian painting during the late eighteenth century.

For other pages from this series, see Wiener 1974, cat. no. 71, identified as *The Infant Krishna Frees the Sons of Kuvera;* Lerner 1974, cat. no. 46; and Christie's 1978, lot no. 91.

AGP

254 Artist unknown

Kalayavana surrounds Mathura

Page from a dispersed *Bhagavata Purana* series
Eastern India, Orissa
Circa 1800
Opaque watercolors on paper
Image 5¹⁄₁₆ x 13⅜ in. (12.9 x 34 cm)
Sheet 9½ x 14¾ in. (24.2 x 37.5)
Anonymous gift, 1990.185.1

INSCRIPTIONS

Recto, in image, at top right, in black ink, in Devanagari script: *Kalayavana surrounds Mathura;* in pavilion: *Shri Rama Krishna. . . .;* in text panel, at left, in red pigment, in Devanagari script: *154.*

The episode of the king of Magadha attacking the Yadavas, whom Krishna protects, is depicted here. Balarama and Krishna are seated on a throne in a pavilion in which two Vaishnava devotees stand at the left. The action centers around the exterior of the orange-red pavilion, where an army wields swords, blades, and muskets. An equestrian figure, identified as Kalayavana, the "dark foreigner" and enemy of Krishna, dressed in black coat and plumed hat, approaches at the right. In the panel below the scene, the Sanskrit text in black ink, in Devanagari script, which continues on the verso, refers to the tenth chapter of the *Bhagavata Purana.*

The pages from this series can be identified by a white ground with the figures arranged in horizontal registers, and by distinctive trees and foliage (not present in this page). The series is freely drawn and compares to works of the period from Sirohi, southern Rajasthan, and Nepal in palette, format, and size.

For other pages from the same series, see Fischer, Mahapatra, and Pathy 1980, fig. 538; Goswamy and Dallapiccola 1982, pl. 64; Bautze 1992, cat. nos. 10–12.

AGP

255 Artist unknown

Krishna conquers the serpent Kaliya

Page from a dispersed *Bhagavata Purana*
Eastern India, Orissa
Circa 1775
Opaque watercolor and gold on paper
Image 5½ x 13½ in. (14.1 x 34.3 cm)
Sheet 9¾ x 14⅝ in. (24.8 x 37.2 cm)
Gift of Elvira and Gursharan Sidhu, 1993.199

INSCRIPTION

Recto, in image, to left of center, in black ink, in Devanagari script:
Nanda/Yashoda/the Gopis; to left of center, in black ink, in Devanagari script: .
. . *Shri Krishna* [sports upon?] *Kaliya. . . . These are the naga chiefs.*

Krishna dances on the conquered serpent demon Kaliya
while the *gopis* and nagas stand in gestures of reverence, wit-
nessing the miraculous deed. The upper section of the paint-
ing is reserved for the image of Krishna and his followers,
who are depicted against a white background. The center of

the painting is occupied by the dancing god at the right and
a large, decorative tree at the left. The figure of Krishna
dances on the multiple hoods of the black snake while blow-
ing a horn. The tail of the snake serves as a frame for the
figure of the god.

Two registers of figures at the left represent the cow-
herding population of Mathura, with Krishna's adoptive
parents, Nanda and Yashoda, standing closest to the god.
Multicolored cows gather around the *gopis* at the bottom of
the page. At the right, the lower register represents a variety
of naga types, and the upper register contains unidentified
figures including a drummer and a woman who is scattering
petals.

The lower section of the painting contains a passage in
Sanskrit, in Devanagari script, from the *Bhagavata Purana.*
The text is written on unprimed paper. The entire painting
is surrounded by a red border with red inner ruling.

This painting is similar in style, size, and format to cata-
logue number 254 and may come from the same manu-
script. However, the handwriting of the Devanagari texts
and inscriptions differ, and on this page, the text does not
continue on the verso. AGP

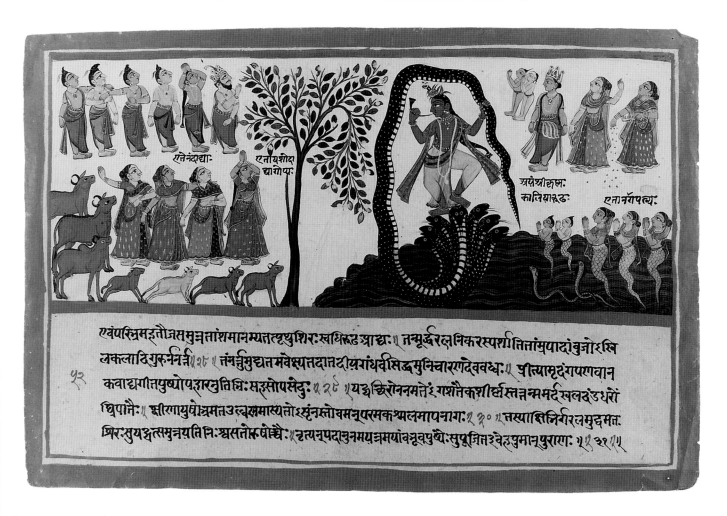

Appendix

Indian Drawings in The Brooklyn Museum

JOAN M. CUMMINS

Every Indian workshop that produced miniature paintings also produced drawings, many of which were made as preliminary sketches for paintings. Because most drawings were considered to be works in progress or rough studies, patrons of Indian painting rarely expressed interest in these unfinished works. For this reason, very few drawings have been found in royal collections (S.C. Welch 1976, p. 14), and until recently, relatively little attention has been paid to Indian drawings by scholars or collectors.

Indian drawings survive primarily because they were kept by painting workshops and by families of artists who passed them down through the generations. These drawings served as records of past work and as examples of draftsmanship for study by apprentice painters. Unfinished paintings and even fragmentary sheets of scratch paper were saved if they contained one fine sketch.

Many drawings are unfinished miniature paintings that were abandoned at various stages in the painting process. As such, they provide a valuable explanation of how the Indian artist composed and prepared a painting. Miniatures were often created by a team, with the most skilled and experienced artist delineating a composition, which would be finished by a colorist or team of colorists. One unfinished painting from Kangra (cat. no. 217) shows the coloring in progress and suggests that backgrounds and minor figures were completed before any color was applied to the central figure. Perhaps work on this painting was interrupted as the first colorist passed the piece on to a more skilled colorist who was to finish the figure.

The master draftsman maintained control over the finishing of the painting by leaving instructions for the colorists. Notations, either written (as seen in the Sirohi *Malkosa Raga* drawing D52) or in spots of paint (visible in several of the Museum's drawings, among them D39, D43, D47, and D55), indicate the colors to be used throughout the composition or in particularly important segments. Other drawings are carefully shaded and detailed even though this extra effort would be hidden beneath the opaque colors of the finished painting. By adding modeling and detail to the outline, the master could indicate to the others the sort of subtleties and mood he hoped to express in the painting.

A master draftsman's work might be copied several times for coloring by others. Pouncing was the most common mode of transferring a composition and is still practiced today. The original drawing is covered with a thin, translucent page, often of deer skin, and tiny holes are pricked through the two sheets along the outlines. The thin sheet is then lifted off and placed on a clean page, and charcoal dust is poured onto it, passing through the holes to produce a dotted outline identical to the original. Careful examination reveals the tiny pounce marks in several of the drawings in the collection; in one of the Museum's drawings (D17), the marks are particularly visible. The translucent page was used to keep the original drawing clean, but workshops often skipped this step and sifted the charcoal through the original drawing. This would explain why some of the drawings (notably D1, D20, D26, D28, and D30) are extremely dirty or dark. The pouncing process was used to transfer entire compositions as well as individual figures or other details that were then worked into new scenes.

Copying was the primary means by which young apprentices learned to paint and draw. By repeatedly tracing the works of the masters, the student's hand and eye memorized important forms and figures. One drawing in the collection (D10) illustrates the importance of the Mughal tradition to Rajasthani artists at Bikaner. Here, a Bikaner artist has carefully copied a Mughal *darbar* scene in order to gain a better understanding of Mughal style and techniques. Probably a number of the drawings in the collection were made as educational exercises, which may explain why they were left unpainted. Although many may be copies from, or preliminary sketches for, known images in other collections, none of the Museum's drawings have so far been linked to finished paintings.

All the drawings in The Brooklyn Museum's collection are on paper. The finest paper was reserved for the Mughal imperial court and was often imported from Persia. Paper of varying degrees of roughness was made in India from combi-

nations of jute, linen, silk, and bamboo fibers. To create a stronger surface for painting, numerous pages were glued together; occasionally, particularly in the Punjab Hill schools, scraps from past sketches and old ledgers were used as backing for a clean page (Pal and Glynn 1976, p. 5), which was burnished to create a smooth drawing surface. In the Punjab Hills school at Kangra, the page was often painted white before any drawing was made (S.C. Welch 1976, p. 15). The image was usually drawn in a black, carbon-based ink with a thin squirrel's-tail brush, or sometimes with a stylus. Lead pencil was not used by Indian painters until the early nineteenth century (Purinton and Newman 1986, p. 108). The Museum's collection includes two drawings from this later period in which lead pencil was used: a Pahari sketch (D56) and a Western-style portrait study of a maharaja (D82).

When the artist drew an image that was to be painted, he generally began by sketching on the page in a thin or lightly colored ink. Even the most rudimentary outlines are remarkably precise, set down on the page in clean, confident lines unlike the loose freehand drawings of many Western artists. A number of planning sketches were made prior to drawing on the painting surface. The practice drawing (*hastalekha*) was usually made on a rough scrap of paper. (All traditional Indian terms for the painting processes are from Sivaramamurti 1978.) The Museum's collection includes a number of these scratch pages, some containing finished, fully colored and shaded studies interspersed with scribbled notes and thumbnail sketches (see D27, D32, and D81).

After a preliminary sketch (*sutrapatarekha*) had been made on the painting surface, some workshops would prime the page with a thin coat of primer, usually a lead or kaolin white, which was burnished to create a smooth painting surface. Many Rajput schools did not use a white ground for painting, but the Mughal-influenced schools, such as Kangra, Bikaner, and Jaipur, seem to have preferred it (Johnson 1972, p. 141). The first sketch, occasionally in orange (as in the Kangra drawing D75), can be seen faintly through the white priming layer. The final composition (*subhavartirekha*) was drawn in black or sepia ink on the new surface, often with alterations to the first sketch. In the *Illustration from a* Hamir Hath *series* (D73) one can see numerous differences between the orange and black compositions. Often corrections were made to a preliminary drawing by blocking out sections with opaque white paint and then redrawing the image. The patches of bright white correction paint seen under the figure of Krishna in D19 would have been invisible in the finished painting.

As preparations for painting, the final drawings were refined to varying degrees. Some are merely outlines, some are enhanced by thin washes of ink or color; some outlines are bold and thick while others are needle sharp, allowing for greater elaboration. The means of refining final drawings seems to have differed from workshop to workshop and often corresponds to the painting style of the area. The

Vishnudharmottara, a seventh-century text on painting techniques, notes that the great masters most valued the line drawing, and other early texts state that the ideal figure is one evoked in a small number of flowing, continuous lines (Sivaramamurti 1978, p. 28). This tradition of expressive outlines and an economy of means is apparent in Indian drawing and painting as early as the Ajanta cave murals of the fifth century A.D. and continues into the Rajput styles that are sometimes described as indigenous or folk. The drawings from Sirohi (D49, D52, and D53), with their bold lines of varying thickness and their spare, static compositions, have a graphic quality that gives them the appearance of finished works. The drawings from Nagaur (D48) and Mysore (D80) and those in the Kishangarh folk style (D28 and D30) are similarly flat and easy to read. The drawing from Deogarh (D23) uses a more fluid line, which gives a softer, more expressive quality to the image. In the paintings of all these schools it is often the outline, repainted over the colors, that provides the painting with complex volumes and textures.

The Mughal style, which essentially introduced Persian and European traditions to the Indian, did not rely as heavily on outline or on line in general. Typically, the schools that look to the Mughal tradition used a uniformly thinner, lighter outline and gave volume to their images with shading. The unfinished paintings of these schools, with their subtle variations of tone and their carefully rendered details, are more refined by Western standards. Bikaner artists in particular took special pains to "finish" a drawing even though it was intended for painting (see D4 and D5). Other Rajasthani schools and some Deccani workshops produced similarly shaded and detailed drawings, although within a single school the degree of refinement may vary from drawing to drawing.

Some of the Pahari schools show the apparently Mughal-inspired tendency toward the use of tone and away from the heavy line, as, for example, in the work of an artist at Guler who carefully shaded the faces of the figures in a drawing for an illustration to the *Bhagavata Purana* (D67). Although shading is not evident in every drawing from Guler (D64, D66, D68, and D69), they all move away from the strong, expressive calligraphic line, seen in drawings from Sirohi and Deogarh, in favor of a thin, rudimentary outline. Other Pahari schools at Kangra and Chamba show a similar tendency toward a thin line (D57 and D73). Although line plays a part in the paintings of all of these schools, it tends to be very delicate and is subordinate to hue and tone.

The artists of the schools most influenced by the Mughal tradition were probably looking at the finished, monochromatic wash paintings on unprimed paper that Mughal artists produced for their emperor (cat. nos. 39, 41, and 43). These paintings are often described as drawings because they contain elements that are simply an outline with little shading. Unlike the bulk of Indian drawing, however, they

were considered finished pieces, made for the patron's delectation and framed with ornate colored borders. In these portrait drawings, the faces are fully rendered in subtle tonal washes with a single dark outline along the profile. The bodies and clothing of the figures are more sketchy, with occasional areas of shading. The Mughal tendency to call attention to specific areas of the composition through varied degrees of refinement contrasts with the more linear "indigenous" Rajput preference for spreading the focus over the entire surface of the drawing in a flat pattern. Lines, where they appear in Mughal drawings, tend to be uniform in width, and the expressive content of the image seems to come from the forms created by the lines and not from the lines themselves.

A small number of finished drawings produced by Rajput artists seem to have been inspired by Mughal drawings. The Museum's collection includes three lightly colored drawings (D25 from Jaipur, D27 from Kishangarh, and D31 from Kota), which appear to be finished works rather than preliminary sketches. All three are portraits. Like the Mughal drawings, they emphasize the face, delicately highlighting jewelry, and merely suggesting the body and its surroundings. These drawings may have been studies for more formal portraits, but they are so exquisitely finished, with touches of gold and finely burnished colors, that it seems likely that they had some value beyond that of a mere exercise.

The Brooklyn Museum has collected Indian drawings since the 1930s, when Dr. Ananda K. Coomaraswamy supervised the acquisition of a number of Rajput drawings, most of them from Kangra. Coomaraswamy was an innovator in the study of Indian painting and was the first scholar to devote volumes entirely to Indian drawings (Coomaraswamy 1910 and 1912). If one compares the first of the Coomaraswamy acquisitions, a *Rasamandala* from Kangra (D76), with a 1980 acquisition, an unusual South Indian drawing of the same subject (D80), one can see how connoisseurship of drawings changed over the years. Early collectors favored the sweet, lyrical images of Kangra and related schools, which were among the first non-Mughal styles to be celebrated by Coomaraswamy.

The history of the Museum's collection generally mirrors the history of Western connoisseurship, and although the Museum would continue to collect drawings in the Kangra style, in later years it would expand its interests to the more abstracted, indigenous styles, including that of the South Indian *Rasamandala*. After the 1930s, the Museum was slow to acquire more drawings, until the late seventies, when the family of Paul F. Walter donated a large collection of drawings from states throughout Rajasthan, the Deccan, and the Punjab Hills. A second large group of drawings was donated to the Museum in 1981 by Dr. and Mrs. Robert Dickes. Other important acquisitions include a portrait of a Jaipur prince of circa 1799 (D25), donated by J. Aron, and the Mughal drawings donated by the Ernest Erickson Foundation, Inc. (cat. nos. 41 and 43).

DECCAN

D1 Ladies drinking

Deccan, Golconda, circa 1670

Ink, pounced along outline for transfer

Full sheet 5⅞ x 4¼ in. (15 x 11 cm)

Gift of Marilyn W. Grounds, 80.261.31

D2 Vibhasa Ragini

Deccan, Hyderabad, circa 1800

Ink, pounced along outline for transfer

Full sheet 9¼ x 4¾ in. (23.5 x 12.1 cm)

Gift of Marilyn W. Grounds, 80.261.43

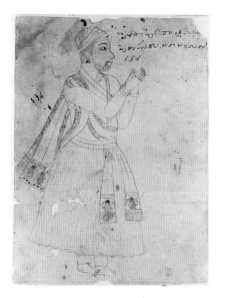

D3 Portrait inscribed "Javaji-Nada Gaulji"

Deccan, Shorapur, circa 1700 or earlier

Ink and color on paper

Full sheet 8⅛ x 6¹/₁₆ in. (20.8 x 15.5 cm)

Gift of Marilyn W. Grounds, 80.261.29

RAJASTHAN

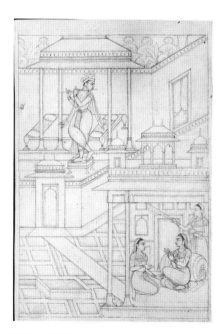

D4 Krishna serenades Radha

Rajasthan, Bikaner, circa 1650

Ink on paper

Full sheet 9¹/₁₆ x 6 in. (23.1 x 15.3 cm)

Image 8⅜ x 5¾ in. (21.5 x 14.6 cm)

Gift of Mr. and Mrs. H. Peter Findlay, 77.201.2

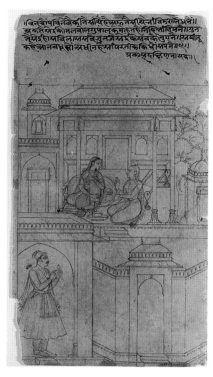

D5 Prakasha Dakshina Nayaka

Rajasthan, Bikaner, circa 1650

Ink on paper

Full sheet 10⁹/₁₆ x 5⅞ in. (26.9 x 15.1 cm)

Gift of Marilyn W. Grounds, 79.260.9

D6 Lion hunt

Rajasthan, Bikaner, circa 1680

Ink and color on paper, pounced for transfer

Full sheet 9½ x 16⅝ in. (24.1 x 42.4 cm)

The Brooklyn Museum, 36.844

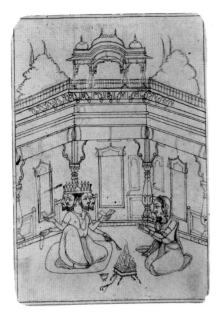

D7 *Khambavati Ragini*
School of Muraudin?
Rajasthan, Bikaner, circa 1700
Ink on paper
Full sheet 7 1/16 x 4 3/4 in. (18 x 12.3 cm)
Image: 6 7/8 x 4 5/8 in. (17.3 x 11.7 cm)
Gift of Marilyn W. Grounds, 80.261.34

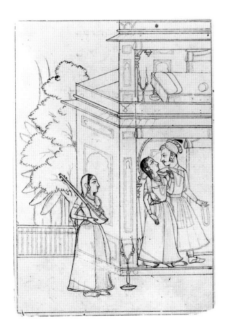

D8 *Marva Ragini Malkosa*
Rajasthan, Bikaner, circa 1725
Ink and color on paper
Full sheet 7 x 4 3/4 in. (17.7 x 12.2 cm)
Gift of Marilyn W. Grounds, 80.261.7

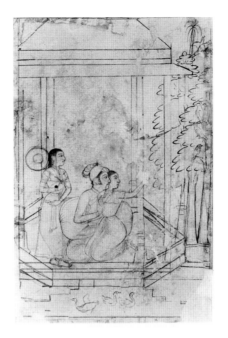

D9 *Nayaka-Nayika*
Rajasthan, Bikaner, circa 1725
Black and sepia ink on paper
Full sheet 9 1/8 x 6 in. (23.2 x 15.1 cm)
Gift of Marilyn W. Grounds, 79.260.5

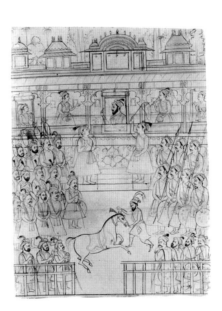

D10 *Copy of a Shah Jahan Darbar scene*
Rajasthan, Bikaner, early 19th-century copy of an earlier Mughal painting
Ink and washes of color on paper
Full sheet 13 x 9 5/8 in. (33 x 24.5 cm)
Gift of Marilyn W. Grounds, 79.260.7

D11 *Bilavala Ragini*
Rajasthan, Bundi or Kota, circa 1675
Ink and color on paper
Full sheet 9 1/2 x 5 7/8 in. (24.1 x 15 cm)
Image 7 11/16 x 4 3/8 in. (19.5 x 11.2 cm)
Gift of Marilyn W. Grounds, 79.260.8

D12 *Gaunda Ragini*
Rajasthan, Bundi, circa 1680
Ink and color on paper
Full sheet 9 3/16 x 5 3/4 in. (23.3 x 14.6 cm)
Image 8 x 4 3/8 in. (20.3 x 11.1 cm)
Gift of Marilyn W. Grounds, 80.261.3

D13 *Dipaka Raga*

Rajasthan, Bundi, circa 1680
Ink and color on paper
Full sheet 9⁵⁄₁₆ x 5⅛ in. (23.6 x 13 cm)
Image 7⅞ x 4⁵⁄₁₆ in. (20 x 11 cm)
Gift of Marilyn W. Grounds, 80.261.35

D14 *Elephant with toppling mahouts*

Rajasthan, Bundi, mid-18th century
Ink and color on paper
Full sheet 12⅛ x 15⅝ in. (30.7 x 39.4 cm)
Gift of Dr. and Mrs. Robert Dickes, 81.188.1

D15 *King meeting demon warriors*

Rajasthan, Bundi, circa 1760
Ink and color on paper, pounced for transfer
Full sheet 6⁵⁄₁₆ x 8⅛ in. (16.1 x 20.7 cm)
Gift of Marilyn W. Grounds, 80.261.8

D16 *Bhairavi Ragini*

Rajasthan, Bundi, circa 1760
Ink on paper
Full sheet 8½ x 6½ in. (21.5 x 16.5 cm)
Image 8⅛ x 6⅛ in. (20.7 x 15.5 cm)
Gift of Marilyn W. Grounds, 80.261.6

D17 *Raja on a balcony viewing a lady at her toilette*

Rajasthan, Bundi, circa 1770
Ink with orange highlights on paper, pounced for transfer
Full sheet 11⅜ x 8 in. (29 x 20.3 cm)
Image 10½ x 7½ in. (27 x 19.1 cm)
Gift of Marilyn W. Grounds, 80.261.22

D18 *Ladies at a well aiding a traveler*

Rajasthan, Bundi, circa 1770
Ink on paper
Full sheet 12⅝ x 9¾ in. (32 x 25 cm)
Gift of Marilyn W. Grounds, 80.261.23

D19 Gajendra Moksha
Rajasthan, Bundi, circa 1775
Ink on paper, pounced for transfer
Full sheet 12⅜ x 8⅜ in. (31.5 x 21.5 cm)
Gift of Marilyn W. Grounds, 80.261.5

D20 European girl feeding a parrot
Rajasthan, Bundi or Kota, circa 1780
Ink on paper, pounced for transfer
Full sheet 8⅝ x 6¾ in. (22.2 x 17.1 cm)
Gift of Marilyn W. Grounds, 80.261.40

D21 Two ascetics before a Shri Nathaji shrine
Rajasthan, Bundi, circa 1780
Ink and color on paper
Full sheet 19½ x 6¼ in. (49.5 x 15.8 cm)
Gift of Dr. and Mrs. Robert Dickes, 81.188.7

D22 Lady and confidante
Rajasthan, Bundi, circa 1780
Ink on paper
Full sheet 21⅛ x 11⅛ in. (53.3 x 28.3 cm)
Gift of Dr. and Mrs. Robert Dickes, 81.188.4

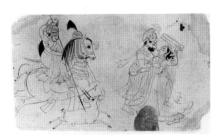

D23 Raja hunting/Raja making love
Rajasthan, Deogarh, circa 1825
Ink on paper
Full sheet 5½ x 9¼ in. (13.7 x 23.9 cm)
Gift of Marilyn W. Grounds, 80.261.13

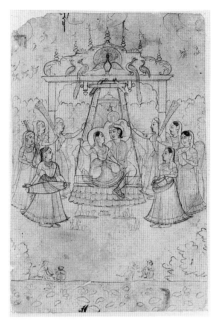

D24 Radha and Krishna on a peacock swing

Rajasthan, Bikaner artist at Jaipur (?), circa 1800 or earlier

Ink on paper

Full sheet 6⅞ x 4½ in. (17.5 x 11.4 cm)

Gift of Marilyn W. Grounds, 79.260.3

D25 A prince, perhaps Raja Pratap Singh of Jaipur, with his beloved

Rajasthan, Jaipur, circa 1800

Ink and color with gold on paper

Full sheet 6 x 8¹¹⁄₁₆ in. (15.3 x 22.2 cm)

Gift of Jack Aron, 76.65

D26 Raja in a garden pavilion entertained by female musicians

Rajasthan, Jodhpur, circa 1830

Ink and color on paper, pounced for transfer

Full sheet 13⅝ x 20¼ in. (34.5 x 51.4 cm)

Gift of Marilyn W. Grounds, 80.261.44

D27 Portrait of a nobleman

Rajasthan, Kishangarh, circa 1780

Drawing with color and gold on paper

Full sheet 4⅞ x 3¼ in. (12.3 x 8.2 cm)

Gift of Marilyn W. Grounds, 80.261.42

D28 Cow with her young

Rajasthan, Kishangarh Folk Style, circa 1820

Ink on paper, pounced for transfer

Full sheet 19½ x 21⅝ in. (49.5 x 55 cm)

Gift of Marilyn W. Grounds, 79.260.4

D29 Ramayana scene

Rajasthan, Kishangarh Folk Style, circa 1850

Ink on paper, pounced for transfer

Full sheet 8⅜ x 12 in. (21.4 x 30.2 cm)

Gift of Marilyn W. Grounds, 80.261.25

D30 Ramayana scene

Rajasthan, Kishangarh Folk Style, circa 1850

Ink on paper, pounced for transfer

Full sheet 8⅜ x 12 in (21.4 x 30.2 cm)

Gift of Marilyn W. Grounds, 80.261.26

D31 Bejeweled maharaja

Rajasthan, Kota, circa 1740–50

Ink and color on paper

Full sheet 8½ x 5⅛ in. (21.5 x 13 cm)

Gift of Marilyn W. Grounds, 80.261.19

D32 Tiger portrait and hunt scene

Rajasthan, Kota, mid-18th century

Ink and color on paper

Full sheet 9⅝ x 21⅝ in. (24.4 x 55 cm)

Gift of Dr. and Mrs. Robert Dickes, 81.188.2

D33 Elephants fighting

Rajasthan, Kota, mid-18th century

Ink on paper

Full sheet 21¼ x 18⅜ in. (54 x 46.5 cm)

Gift of Dr. and Mrs. Robert Dickes, 81.188.3

D34 Figure studies

Rajasthan, Kota, circa 1750

Ink on paper, pounced for transfer

Full sheet 5 x 5⅞ in. (13 x 14.7 cm)

Gift of Marilyn W. Grounds, 80.261.20

D35 Elephant in chains

Rajasthan, Kota, circa 1780

Red and black ink on paper

Full sheet 7¾ x 12 in. (19.7 x 30.5 cm)

Gift of Marilyn W. Grounds, 80.261.37

D36 Artist sketching

Rajasthan, Kota, circa 1800

Ink with white outline on paper

Full sheet 5⅜ x 3½ in. (13.7 x 9 cm)

Gift of Marilyn W. Grounds, 80.261.21

D37 *Lion hunt*
Rajasthan, Kota or Uniara, circa 1800
Ink and color on paper
Full sheet 9⅝ x 6⅞ in. (24.3 x 17.5 cm)
Gift of Marilyn W. Grounds, 79.260.10

D38 *Preliminary sketch of an elephant hunt*
Rajasthan, Kota, early 19th century
Ink on paper
Full sheet 9 x 21½ in. (23 x 54.4 cm)
Gift of Dr. and Mrs. Robert Dickes, 81.188.6

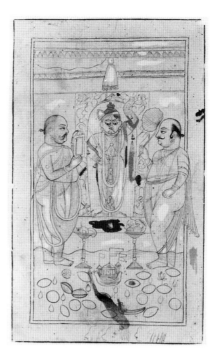

D39 *Shri Nathaji and devotees*
Rajasthan, Kota, circa 1810
Ink and color on paper, pounced for transfer
Full sheet 9⅜ x 5¹¹⁄₁₆ in. (23.9 x 14.5 cm)
Image 8¼ x 4½ in. (20.8 x 11.25 cm)
Gift of Marilyn W. Grounds, 80.261.30

D40 *Worship of Shri Nathaji*
Rajasthan, Kota, circa 1820
Ink and color on paper
Full sheet 10½ x 8¾ in. (26.8 x 22.7 cm)
Gift of Marilyn W. Grounds, 79.260.6

D41 *Ram Singh II hunting tigers*
Rajasthan, Kota, circa 1825–50
Ink and ocher on paper
Full sheet 16½ x 21 in. (42 x 53.3 cm)
Gift of Dr. and Mrs. Robert Dickes, 81.188.5

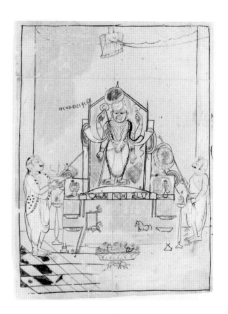

D42 *Worship of Shri Nathaji*
(Verso *Two sketches: An Artist; A Nautch Girl*)
Rajasthan, Kota or Nathadwara, circa 1825–50
Ink and color on paper
Full sheet 13⅜ x 9¾ in. (33.8 x 24.6 cm)
Gift of Marilyn W. Grounds, 80.261.17

D43 *Ram Singh II of Kotah and his son Chattar Singh hunting wild boar*
Rajasthan, Kota, circa 1840
Sepia ink and color on tinted paper
Full sheet 9¾ x 12 in. (24.5 x 30.5 cm)
Gift of Marilyn W. Grounds, 80.261.10

D44 *Rama, Lakshmana, and Hanuman worshiping Shiva and Durga*
Rajasthan, Kota, circa 1850
Ink and color on paper
Full sheet 10⅝ x 8⅜ in. (27 x 21 cm)
Gift of Marilyn W. Grounds, 80.261.12

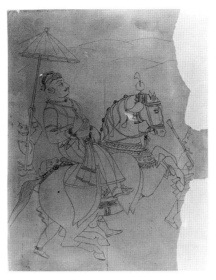

D45 *Equestrian portrait of Ram Singh II of Kota*
Rajasthan, Kota, circa 1850
Ink and color on paper
Full sheet 10⅝ x 8⅜ in. (27 x 21 cm)
Gift of Dr. Ananda Coomaraswamy, 36.246

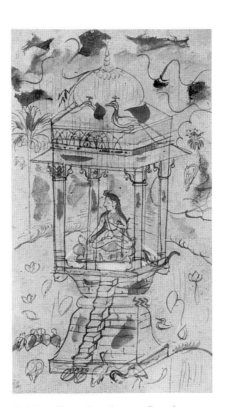

D46 *Gaundmalar or Ganda Malhara Ragini*
Rajasthan, Kota, circa 1850
Ink and color on paper
Full sheet 9⅛ x 5⅛ in. (23.3 x 13.3 cm)
Gift of Marilyn W. Grounds, 80.261.18

D47 *Palace scene*
Rajasthan, Kota, circa 1850
Sepia ink and color on paper
Full sheet 14¾ x 10½ in. (37.5 x 26.8 cm)
Gift of Marilyn W. Grounds, 80.261.39

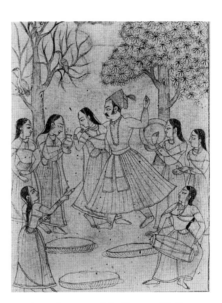

D48 *Raja and ladies at Holi festival*
Rajasthan, Nagaur, circa 1725
Ink with color, pounced for transfer
Full sheet 7³⁄₁₆ x 5⅜ in. (18.4 x 13.6 cm)
Gift of Marilyn W. Grounds, 80.261.28

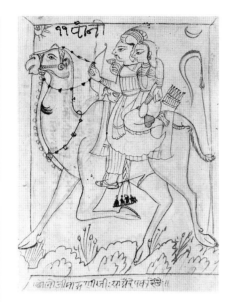

D49 *Maru Ragini (Dhola and Maru riding on a camel)*
Rajasthan, Sirohi, circa 1750
Ink on paper
Full sheet 6⅛ x 4⅝ in. (15.5 x 11.6 cm)
Gift of Marilyn W. Grounds, 79.260.2

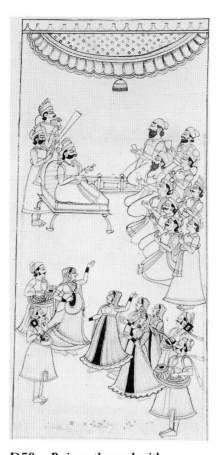

D50 *Raja enthroned with courtiers, musicians, and nautch girls in attendance*
Rajasthan, possibly Sirohi, circa 1750
Ink with gray wash on paper
Full sheet 17¼ x 8⅞ in. (43.7 x 22.5 cm)
Image 17¹⁄₁₆ x 7¹³⁄₁₆ in. (43.5 x 20 cm)
Gift of Marilyn W. Grounds, 80.261.27

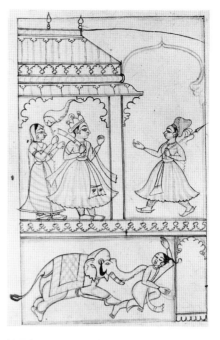

D51 *Kanada Ragini*
Southern Rajasthan, Sirohi, circa 1750–1800
Ink on paper
Full sheet 9¾ x 6⅜ in. (24.8 x 16.2 cm)
Gift of Marilyn W. Grounds, 80.261.9

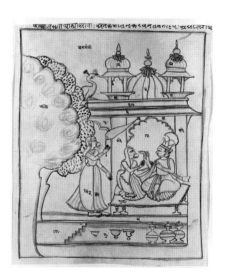

D52 *Malkosa Raga*
Rajasthan, Sirohi, circa 1750–1800
Ink and color on paper
Full sheet 9⁵⁄₁₆ x 7⅝ in. (23.5 x 19.5 cm)
Image 8¾ x 7 in. (22.2 x 17.8 cm)
Anonymous gift, 80.277.12

D53 *Ragini Madhu Madhavi*

Rajasthan, Sirohi, circa 1775

Ink on paper

Full sheet 12⁷⁄₈ x 8⁵⁄₈ in. (32.7 x 21.9 cm)

Image 11¾ x 7½ in. (29.4 x 19 cm)

Gift of Marilyn W. Grounds, 79.260.1

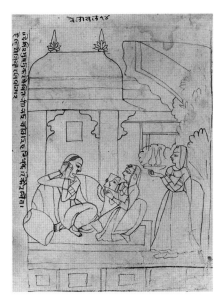

D54 *Vilavala Ragini*

Rajasthan, Sirohi, circa 1800

Ink on paper

Full sheet 7⁵⁄₈ x 5¾ in. (19.5 x 14.5 cm)

Image 7 x 5 in. (17.8 x 12.7 cm)

Gift of Marilyn W. Grounds, 79.260.11

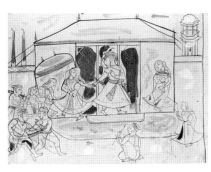

D55 *Raja Ram Singh II of Kotah and Ramkishan Singh of Udaipur*

(Verso *Raja and lady in front of a pavilion*)

Rajasthan, Udaipur, circa 1850

Ink and color on paper

Full sheet 10¼ x 14½ in. (26.2 x 37.1 cm)

Gift of Marilyn W. Grounds, 80.261.33

D56 *Krishna and the gopis tease an old man*

Punjab Hills, circa 1790–1800

Pencil with orange outlines on paper

Full sheet 10⅛ x 12¼ in. (26 x 31 cm)

Image 6⁷⁄₈ x 10⅛ in. (17.5 x 26 cm)

Gift of Marilyn W. Grounds, 80.261.4

D57 *Battle scene*

Scene from a Ramayana *series*

Punjab Hills, Chamba, circa 1735

Ink on paper

Full sheet 7¾ x 11¼ in. (19.7 x 28.8 cm)

Image 6⁵⁄₈ x 10⅛ in. (16.7 x 25.5 cm)

Gift of Marilyn W. Grounds, 80.261.24

D58 *Sugriva annointed by his forces*

Scene from a Ramayana *series*

Punjab Hills, Chamba, circa 1735

Ink on paper

Full sheet 7⁷⁄₈ x 10⁷⁄₈ in. (20 x 27.6 cm)

Gift of Dr. and Mrs. Robert Dickes, 81.188.8

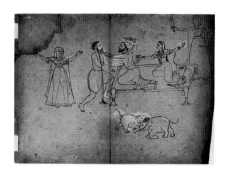

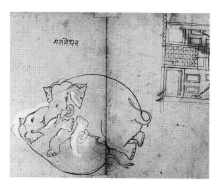

D59 *A violent argument in the bedchamber*

(Verso *Elephants copulating [*"*Gaja methan*"*]*)
Punjab Hills, Chamba, first half of the 18th century
Ink with corrections in red and white
Full sheet 9½ x 11¾ in. (24 x 30 cm)
Gift of Dr. Bertram H. Schaffner, 85.283.2

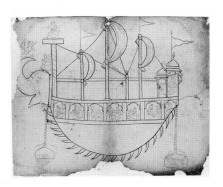

D60 *A fanciful boat*

Punjab Hills?, Chamba?, 19th century
Ink and charcoal on paper
Full sheet 8⅝ x 11⅝ in. (21.9 x 30.8 cm)
Gift of Dr. and Mrs. Robert Dickes, 81.188.10

D61 *The gods beg Devi to intervene*

Scene from a Devi Mahatmya *series*
Punjab Hills, Guler, 1740–60
Ink on paper
Full sheet 6¾ x 9 in. (17.2 x 22.8 cm)
Anonymous gift, 1991.128.3

D62 *Chanda and Munda before Parvati*

Scene from a Devi Mahatmya *series*
Punjab Hills, Guler, 1740–60
Ink on paper
Full sheet 6½ x 7½ in. (16.4 x 19 cm)
Anonymous gift, 1991.128.4

D63 *The demons gather around Sumbha while the gods gather around Indra*

Scene from a Devi Mahatmya *series*
Punjab Hills, Guler, 1740–60
Ink on paper
Full sheet 6¾ x 9 3/16 in. (17.2 x 23.5 cm)
Anonymous gift, 1991.128.5

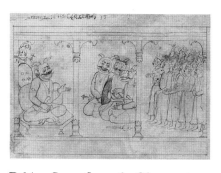

D64 *Scene from the Bhagavata Purana*

Punjab Hills, Guler, circa 1760
Ink on paper
Full sheet 8½ x 11½ in. (21.6 x 29.3 cm)
Image 6⅞ x 10¾ in. (17.4 x 27.3 cm)
Gift of Marilyn W. Grounds, 80.261.32

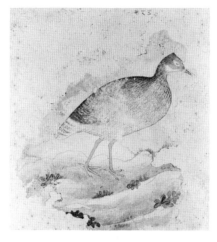

D65 *A bird, perhaps a grouse*
Punjab Hills, Guler, circa 1760
Ink and color on paper
Full sheet 5¾ x 5½ in. (15 x 14.4 cm)
Gift of Marilyn W. Grounds, 80.261.38

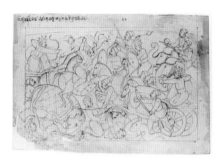

D66 *Battle scene*
Scene from a Bhagavata Purana *series*
Punjab Hills, Guler, circa 1760–70
Ink on paper
Full sheet 8⅝ x 12¾ in. (21.9 x 32.3 cm)
Image 7 x 11⅛ in. (17.8 x 28.1 cm)
Gift of Dr. and Mrs. Robert Dickes,
81.188.9

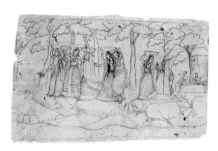

D67 *Krishna and Balarama*
exact a toll
Scene from a Bhagavata Purana *series*
Punjab Hills, Guler, circa 1800
Ink and color on paper
Full sheet 6½ x 10⅜ in. (16.5 x 26.5 cm)
Gift of Marilyn W. Grounds, 80.261.16

D68 *Portrait of Ali Bahadur*
Peshvi Dikhani
Punjab Hills, Guler, circa 1825
Ink on paper
Full sheet 5 x 5½ in. (12.7 x 14 cm)
Gift of Marilyn W. Grounds, 80.261.14

D69 *Portrait of Takuh*
Halkanah Dikhani
Punjab Hills, Guler, circa 1825
Ink on paper
Full sheet 4¼ x 5½ in. (10.7 x 14.2 cm)
Gift of Marilyn W. Grounds, 80.261.15

D70 *Three figures*
Punjab Hills, possibly Jammu or Mandi,
circa 1750
Ink and color on paper
Full sheet 3¾ x 8¼ in. (9.5 x 21 cm)
Gift of Mr. and Mrs. J. Gordon
Douglas III, 83.234.1

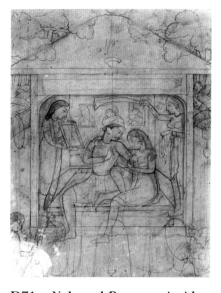

D71 *Nala and Damayanti with*
attendants
Punjab Hills, Kangra, late 18th century
Ink on paper
Full sheet 6⅞ x 5⅜ in. (17.5 x 13.4 cm)
Gift of Dr. Ananda Coomaraswamy,
36.248

D72 *Illustration of unidentified*
love poem
Punjab Hills, Kangra, 18th century
Ink on paper
Full sheet 11 x 8½ in. (27.8 x 21.6 cm)
By exchange, 36.843

D73 *Sultan Alau'd Din encamped at the siege of Ranthambhor*

Illustration from a Hamir Hath *series*

Punjab Hills, Kangra, late 18th–early 19th century

Ink on paper

Full sheet 10 x 13⅜ in. (25.5 x 34.1 cm)

Image 7¾ x 11⅛ in. (19.7 x 28.3 cm)

A. Augustus Healy and Frank L. Babbott Funds, 36.254

D74 *Lovers parting at dawn*

Punjab Hills, Kangra, circa 1800

Ink on paper

Full sheet 4¼ x 5½ in. (10.7 x 14.2 cm)

Gift of Marilyn W. Grounds, 80.261.11

D75 *Krishna and Radha seated in a pavilion*

Punjab Hills, Kangra, circa 1800

Ink on paper

Full sheet 12⅝ x 9⅜ in. (32.1 x 24.5 cm)

Gift of Dr. Ananda Coomaraswamy, 36.247

D76 *Rasamandala*

Punjab Hills, Kangra, 1810–20

Ink and light washes of color on paper

Full sheet 10½ x 11⅛ in. (26.7 x 28.5 cm)

By exchange, 36.234

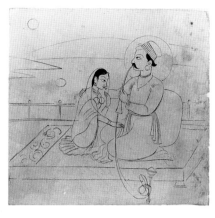

D77 *A prince holding a hookah embraces his lady*

Punjab Hills, possibly Kulu, 1700 or earlier

Ink on paper

Full sheet 6¾ x 7¼ in. (17 x 18.5 cm)

Gift of Marilyn W. Grounds, 80.261.36

D78 *Radha at her toilette*

Punjab Hills, Kulu, circa 1725

Ink and color on paper

Full sheet 8⅛ x 5¾ in. (21 x 14.8 cm)

Gift of Marilyn W. Grounds, 80.261.2

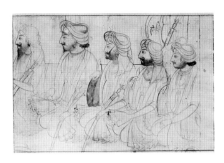

D79 *Portraits of Dhian, Gulab, Ranbir, Sohan, and Udham Singh*
Punjab Hills, Sikh School, circa 1820
Ink with white wash on paper
Full sheet 4½ x 7¼ in. (11.3 x 18.3 cm)
Image 4⁷⁄₁₆ x 6⅜ in. (11.2 x 16.1 cm)
Gift of Marilyn W. Grounds, 80.261.41

SOUTH INDIA

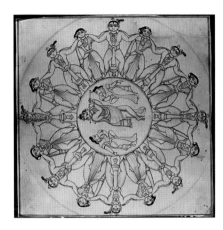

D80 *Rasamandala*
South India, Mysore (?), late 19th century
Ink on paper
Full sheet 9 x 8¾ in. (22.9 x 22.3 cm)
Gift of Mrs. Cynthia Hazen Polsky, 80.278.3

COMPANY SCHOOL

D81 *Study of a youth*
Rajasthan, Kota?, European style, circa 1800
Ink and color on paper
Full sheet 5⅞ x 6¼ in. (15 x 15.8 cm)
Anonymous gift, 1990.185.4

D82 *Portrait of the Maharaja of Patiala*
Punjab Hills, European style, late 19th century
Pencil, ink, and color on paper
Full sheet 6½ x 9 in. (16.4 x 22.8 cm)
Image 3½ x 4½ in. (8.9 x 11.4 cm)
Gift of Marilyn W. Grounds, 80.261.1

Bibliography

AIJAZUDDIN 1977
Aijazuddin, F.S. *Pahari Paintings and Sikh Portraits in the Lahore Museum.* London/New York: Sotheby Parke Bernet, 1977.

AKBAR-NAMA
Abu'l-Faz'l. *Akbar-nama.* Translated by H. Beveridge. 3 vols. Calcutta, 1897–1921. Reprint. Delhi: Ess Publications, 1973.

ALI 1968
Ali, M. Athar. *The Mughal Nobility under Aurangzeb.* Bombay: Asia Publishing House, 1968.

ALI 1985
Ali, M. Athar. *The Apparatus of Empire,* Delhi: Oxford University Press, 1985.

AMAR 1975
Amar, Gopilal. "Architecture." In *Jaina Art and Architecture,* edited by A. Ghosh, vol. 3, pp. 494–533. New Delhi: Bharatiya Jnanpith, 1975.

ANDHARE 1972
Andhare, Shridhar. "A Dated Amber Ragamala and the Problem of Provenance of the Eighteenth Century Jaipuri Paintings." *Lalit Kalā,* no. 15 (1972), pp. 47–50.

ANDHARE 1987
Andhare, Shridhar. *Chronology of Mewar Paintings.* Delhi: Agam Kala Prakashan, 1987.

ARABESQUES
Arabesques et jardins de Paradis. Paris: Editions de la Réunion des Musées Nationaux, 1989.

ARCHER, M. 1979
Indian and British Portraiture 1770–1825. London: Sotheby Parke Bernet, 1979.

ARCHER, M. AND W.G. 1955
Archer, Mildred, and W.G. Archer. *Indian Painting for the British 1770–1880.* London: Oxford University Press, 1955.

ARCHER, M. AND W.G. 1963
Indian Miniatures from the Collection of Mildred and W.G. Archer, London. Introduction by Sherman E. Lee. Washington, D.C.: Smithsonian Institution, 1963.

ARCHER, W.G. 1952
Archer, W.G. *Indian Painting in the Punjab Hills.* Victoria & Albert Museum, Museum Monograph no. 3. London: H.M. Stationery Office, 1952.

ARCHER, W.G. 1957
Archer, W.G. *The Loves of Krishna.* London: Allen & Unwin, 1957.

ARCHER, W.G. 1959
Archer, W.G. *Indian Painting in Bundi and Kotah.* Victoria & Albert Museum, Museum Monograph no. 13. London: H.M. Stationery Office, 1959.

ARCHER, W.G. 1960
Archer, W.G. *Indian Miniatures.* Greenwich, Conn.: New York Graphic Society, 1960.

ARCHER, W.G. 1973
Archer, W.G. *Indian Paintings from the Punjab Hills: A Survey and History of Pahari Painting.* Foreword by Sherman E. Lee. 2 vols. London/New York: Sotheby Parke Bernet, 1973.

ARCHER, W.G. 1976
Archer, W.G. *Visions of Courtly India: The Archer Collection of Pahari Miniatures.* Washington, D.C.: International Exhibitions Foundation, 1976.

ARCHER, W.G., AND BINNEY 1968
Rajput Miniatures from the Collection of Edwin Binney, 3rd. Introduction by W.G. Archer. Catalogue entries by Edwin Binney, 3rd. Exhibition catalogue. Portland, Oreg.: Portland Art Museum, 1968.

ARCHIVES OF ASIAN ART 1971–72
"Recent Acquisitions." *Archives of Asian Art,* vol. 25 (1971–72), p. 92.

ART NEWS 1964
H.L.F. [Henry La Farge]. "The Prophet in India." *Art News,* vol. 62, no. 10 (February 1964), pp. 28–29, 67. (Review of an exhibition at Asia House, New York, January 15–March 25, 1964.)

ARTS COUNCIL OF GREAT BRITAIN 1982
In the Image of Man. Exhibition catalogue. London: Arts Council of Great Britain, 1982.

ASHRAF 1963
Ashraf, Muhammad. "Golconda." *Marg,* vol. 16, no. 2 (March 1963), pp. 40–42.

ASHTON 1947–48
Ashton, Leigh, ed. *The Art of India and Pakistan.* Commemorative catalogue of the exhibition held at the Royal Academy of Arts, London, 1947–48. London: Faber and Faber, 1950.

BABUR-NAMA
SEE Beveridge, A.S. 1921

BAHADUR 1972
Bahadur, K.P., trans. *The Rasikapriya of Keshavadasa.* Delhi, Patna, and Varanasi: Motilal Banarasidass, 1972.

BARRETT AND GRAY 1963
Barrett, Douglas, and Basil Gray. *Painting of India.* Geneva: Editions d'Art Albert Skira, 1963.

BAUTZE 1985
Bautze, Joachim. "Portraits of Bhao Singh Hara." *Berliner Indologische Studien,* vol. 1 (1985), pp. 107–22.

BAUTZE 1986
Bautze, Joachim. "Portraits of Rao Ratan and Madho Singh Hara." *Berliner Indologische Studien,* vol. 2 (1986), pp. 87–106.

BAUTZE 1987a
Bautze, Joachim. *Drei "Bundi"-Ragamalas. Ein Beitrag zur Geschichte der rajputischen Wandmalerei.* Stuttgart: Franz Steiner Verlag, 1987.

BAUTZE 1987b
Bautze, J. *Indian Miniature Paintings: c. 1590–c. 1850.* Exhibition catalogue. Amsterdam: Galerie Saundarya Lahari, 1987.

BAUTZE 1987c
Bautze, Joachim. "Zur Darstellung der Hauptgottheiten Kotas in der Malerei der zweiten Hälfte des 18. Jahrhunderts und der ersten Hälfte des 19. Jahrhunderts." *Berliner Indologische Studien,* vol. 3 (1987), pp. 253–78.

BAUTZE 1987d
Bautze, Joachim. Review of *Indian Miniature Paintings and Drawings* [*The Cleveland Museum of Art Catalogue of Oriental Art*] by Linda York Leach. *Tribus: Jahrbuch des Linden-Museums,* no. 36 (December 1987), pp. 172–74.

BAUTZE 1988–89
Bautze, Joachim. "Portraitmalerei unter Maharao Ram Singh von Kota." *Artibus Asiae,* vol. 49, nos. 3–4 (1988–89), pp. 316–50.

BAUTZE 1990a
Bautze, Joachim. "Ikonographie und Datierung der späteren Jagdszenen und Portraits Bundis." *Tribus: Jahrbuch des Linden-Museums,* no. 39 (December 1990), pp. 87–112.

BAUTZE 1990b
Bautze, Joachim. "Porträtmalerei unter Maharao Raja Ram Singh von Bundi." In *Das Bildnis in der Kunst des Orients,* edited by Martin Kraatz, Jürg Meyer zur Capellen, and Dietrich Sekel. Stuttgart: Franz Steiner Verlag, 1990.

BAUTZE 1990c
Bautze, Joachim. "The Ajmer Darbar of 1832 and Kota Painting." *South Asian Studies,* vol. 6 (1990), pp. 71–91.

BAUTZE 1991
Bautze, Joachim. *Lotosmond und Löwenritt. Indische Miniaturmalerei.* Exhibition catalogue. Stuttgart: Linden-Museum, 1991.

BEACH 1974
Beach, Milo Cleveland. *Rajput Paintings at Bundi and Kota.* Ascona: Artibus Asiae, 1974.

BEACH 1978
Beach, Milo Cleveland. *The Grand Mogul: Imperial Painting in India, 1600–1660.* With contributions by Stuart Cary Welch and Glenn D. Lowry. Exhibition catalogue. Williamstown, Mass.: Sterling and Francine Clark Art Institute, 1978.

BEACH 1981
Beach, Milo Cleveland. *The Imperial Image: Paintings for the Mughal Court.* Exhibition catalogue. Washington, D.C.: Freer Gallery of Art, 1981.

BEACH 1982
Beach, Milo Cleveland. "The Mughal Painter Daswanth." *Ars Orientalis,* vol. 13 (1982), pp. 121–33.

BEACH 1987
Beach, Milo Cleveland. *Early Mughal Painting.* Cambridge: Harvard University Press, 1987.

BEACH 1992
Beach, Milo Cleveland. *Mughal and Rajput Painting.* Vol. 3, pt. 1 of *The New Cambridge History of India.* Cambridge: Cambridge University Press, 1992.

BEHROUZ 1984
Behrouz, Sarvatiyan. *Layli va Majnun.* Tehran: Tuss Press, 1984.

BEVERIDGE, A.S. 1921
Beveridge, Annette Susanna, trans. *The "Babur-nama" in English.* 2 vols. Luzac, 1921. Reprint. New Delhi: Oriental Books Reprint Corporation, 1970.

BEVERIDGE, H.
SEE *Akbar-nama.*

BEVERIDGE 1979
SEE *Maäthir-ul-Umara.*

BHAGAVATA PURANA
The Bhagavata Purana. Translated by G.V. Tagare. Delhi, Varanasi, and Patna: Motilal Banarsidass, 1976.

BICKFORD COLLECTION
SEE Czuma 1975.

BINNEY 1972
Binney, Edwin, 3rd. "Later Mughal Painting." In *Aspects of Indian Art,* edited by Pratapaditya Pal, pp. 118–23. Leiden: Brill, 1972.

BINNEY 1973
Binney, Edwin, 3rd. *Indian Miniature Painting: From the Collection of Edwin Binney, 3rd.* I, *The Mughal and Deccani Schools.* Exhibition catalogue. Portland, Oreg.: Portland Art Museum, 1973.

BINNEY 1979
Binney, Edwin, 3rd. *Turkish Treasures from the Collection of Edwin Binney, 3rd.* Exhibition catalogue. Portland, Oreg.: Portland Art Museum, 1979.

BRAND AND LOWRY 1985
Brand, Michael, and Glenn D. Lowry. *Akbar's India: Art from the Mughal City of Victory.* Exhibition catalogue. New York: Asia Society, 1985.

BROWN, P. 1918
Brown, Percy. *Indian Painting.* Heritage of India Series. Calcutta: The Association Press, 1918.

BROWN, P. 1924
Brown, Percy. *Indian Painting under the Mughals* A.D. *1550 to* A.D. *1750.* Oxford: Clarendon Press, 1924. Reprint. New York: Hacker Art Books, 1975.

BROWN, W.N. 1933
Brown, W. Norman. *The Story of Kalaka.* Washington, D.C.: Smithsonian Institution, Freer Gallery of Art, 1933.

BROWN, W.N. 1934
Brown, W. Norman. *A Descriptive and Illustrated Catalogue of Miniature Paintings of the Jaina Kalpasutra as Executed in the Early Western Style.* Washington, D.C.: Smithsonian Institution, Freer Gallery of Art, 1934.

BROWN, W.N. 1947
Brown, W. Norman. "A Painting of a Jain Pilgrimage." In *Art and Thought, Issued in Honor of Dr. Ananda K. Coomaraswamy,* edited by K. Bharatha Iyer, pp. 69–72. London: Luzac, 1947.

CANBY 1981
Canby, Sheila R. "The Life and Work of the Painter Riza." Ph.D. diss., Harvard University, 1981.

CANBY 1983
Canby, Sheila. *Indian Paintings from the Los Angeles County Museum of Art.* Exhibition catalogue. San Francisco: The Art Museum Association of America, 1983.

CHANDRA, M. 1949a
Chandra, Moti. *Jain Miniature Paintings from Western India.* Ahmedabad: S. Manilal Nawab, 1949.

CHANDRA, M. 1949b
Chandra, Moti. *The Technique of Mughal Painting.* Lucknow: U.P. Historical Society, Provincial Museum, 1949.

CHANDRA, M. 1951
Chandra, Moti. "Portraits of Ibrahim Adil Shah II." *Marg,* vol. 5, no. 1 (1951), pp. 22–28.

CHANDRA, M. 1957
Chandra, Moti. *Mewar Painting in the Seventeenth Century.* New Delhi: Lalit Kala Akademi, 1957.

CHANDRA, M. 1970
Chandra, Moti. *Studies in Early Indian Painting.* New York: Asia Publishing House, 1970.

CHANDRA, P. 1960
Chandra, Pramod. "Ustād Sālivāhana and the Development of Popular Mughal Art." *Lalit Kalā,* no. 8 (October 1960), pp. 25–46.

CHANDRA, P. 1971
Chandra, Pramod. "Indian Painting." In *Indian Miniature Painting: The Collection of Earnest C. and Jane Werner Watson.* Exhibition catalogue. Madison, Wis.: Elvehjem Art Center/University of Wisconsin Press, 1971.

CHANDRA, P. 1976
Tūtī-Nāmā: Tales of a Parrot. Complete Colour Facsimile Edition in Original Size of the Manuscript in the Possession of the Cleveland Museum of Art. Vol. 1, *Commentarium: The Tūtī-Nāmā Manuscript of the Cleveland Museum of Art and the Origins of Mughal Painting.* Text by Pramod Chandra. Foreword by Sherman E. Lee. Vol. 2, *Facsimile.* Graz: Akademische Druck-u. Verlagsanstalt, 1976.

CHANDRA, P. 1989
Chandra, Pramod. "The Brooklyn Museum Folios of the *Hamza-nama.*" *Orientations* (July 1989), pp. 39–45.

CHESTER BEATTY
Arnold, Thomas W. *The Library of A. Chester Beatty: A Catalogue of the Indian Miniatures.* Revised and edited by J.V.S. Wilkinson. 3 vols. Oxford and London: privately printed, 1936.

CHHAVI 1971
Chhavi: Golden Jubilee Volume. Edited by Anand Krishna. Banares: Bharat Kala Bhavan, 1971.

CHHAVI–2
Chhavi–2: Rai Krishnadasa Felicitation Volume. Edited by Anand Krishna. Banares: Bharat Kala Bhavan, 1981.

CHRISTIE'S 1977
Fine Islamic and Indian Manuscripts and Miniatures. Sale. Christie's, London. May 5, 1977.

CHRISTIE'S 1978
Important Indian Miniatures and Paintings. Sale. Christie's, New York. May 25, 1978.

CHRISTIE'S 1980a
Important Islamic and Indian Manuscripts and Miniatures. Sale. Christie's, London. April 24, 1980.

CHRISTIE'S 1980b
Important Islamic and Indian Manuscripts and Miniatures. Sale. Christie's, London. October 16, 1980.

CLARKE 1921
Clarke, C. Stanley. *Indian Drawings: Twelve Mughal Paintings of the School of Humayun.* London: Victoria & Albert Museum, 1921.

COLNAGHI 1978
Indian Painting: Mughal and Rajput and a Sultanate Manuscript. Exhibition catalogue. London: P. & D. Colnaghi, 1978.

COMSTOCK 1925
Comstock, Helen. "The Romance of Amir Hamza." *International Studio,* vol. 80, no. 333 (February 1925), pp. 349–57.

COOMARASWAMY 1910
Coomaraswamy, Ananda K. *Indian Drawings: First Series, Chiefly Mughal.* London: The India Society, 1910.

COOMARASWAMY 1912
Coomaraswamy, Ananda K. *Indian Drawings, Second Series, Chiefly Rajput.* London: The India Society, 1912.

COOMARASWAMY 1914
Coomaraswamy, Ananda K. "The Eight Nayikas." *Journal of Indian Art and Industry,* vol. 16, no. 124 (1914), pp. 99–112.

COOMARASWAMY 1916
Coomaraswamy, Ananda K. *Rajput Painting.* 2 vols. London: Oxford University Press, 1916.

COOMARASWAMY 1926
Coomaraswamy, Ananda K. *Catalogue of the Indian Collections in the Museum of Fine Arts, Boston.* Part 5, *Rajput Painting.* Boston: Museum of Fine Arts, 1926.

COOMARASWAMY 1930
Coomaraswamy, A. K. *Catalogue of the Indian Collections in the Museum of Fine Arts, Boston.* Part 6, *Mughal Painting.* Boston: Museum of Fine Arts, 1930.

CORONATION DARBAR 1911
Loan Exhibition of Antiquities. Coronation Darbar 1911. Catalogue of Exhibits. Calcutta: Museum of Archaeology, 1911.

CULIN 1913–14
Culin, Stewart. Report on a Collection Trip to Japan, China, India, and Europe. October 1913–May 25, 1914. The Brooklyn Museum Archives, New York.

CULIN 1924
Culin, Stewart. "Illustrations of the Romance of Amir Hamzah." *The Brooklyn Museum Quarterly,* vol. 11, no. 3 (July 1924), pp. 138–43.

CZUMA 1975
Czuma, Stanislaw. *Indian Art from the George P. Bickford Collection.* Introduction by W.G. Archer. Exhibition catalogue. Cleveland: Cleveland Museum of Art, 1975.

DALLAPICCOLA 1978
Dallapiccola, A.L. *Princesses et courtisanes, à travers les miniatures indiennes.* Exhibition catalogue. Paris: Galerie Marco Polo, 1978.

DAS 1978
Das, Asok Kumar. *Mughal Painting during Jahangir's Time.* Calcutta: Asiatic Society, 1978.

DAVIDSON 1968
Davidson, J. Leroy. *Art of the Indian Sub-Continent from Los Angeles Collections.* Exhibition catalogue. Los Angeles: U.C.L.A. Art Council Art Galleries, 1968.

DESAI 1984
Desai, V.N. "Connoisseur's Delights. Early Rasikapriya Paintings in India." Ph.D. diss., University of Michigan, Ann Arbor, 1984.

DESAI 1985
Desai, Vishakha. *Life at Court: Art for India's Rulers: 16th–19th Centuries.* Exhibition catalogue. Boston: Museum of Fine Arts, 1985.

DICKINSON AND KHANDALAVALA 1959
Dickinson, Eric, and Karl Khandalavala. *Kishangarh Painting.* New Delhi: Lalit Kala Akademi, 1959.

DICKSON AND WELCH 1981
Dickson, Martin Bernard, and Stuart Cary Welch. *The Houghton Shahnameh.* 2 vols. Cambridge: Fogg Art Museum, 1981.

DIMAND 1929
Dimand, M.S. *Dated Specimens of Mohammedan Art in the Metropolitan Museum of Art.* Part II, *Manuscripts and Miniature Paintings.* New York: Metropolitan Museum of Art, 1929.

DIMAND 1933
Dimand, M.S. *A Guide to an Exhibition of Islamic Miniature Painting and Book Illumination.* Exhibition catalogue. New York: Metropolitan Museum of Art, 1933.

DIMAND 1967
Dimand, M.S. *Indian Miniature Paintings.* New York: Crown Publishers, 1967.

DIMAND n.d.
Dimand, M.S. *Indian Miniature Painting.* Milan, n.d.

DOSHI 1983
Doshi, Saryu. "The Iconic Narrative in Jain Painting." *Marg,* vol. 36, no. 3 (1983), pp. 22–93.

DOSHI 1985
Doshi, Saryu, *Masterpieces of Jain Painting.* Bombay: Marg Publications, 1985.

DYE 1980
Dye, Joseph M., III. "The Chronology and Stylistic Development of Seventeenth Century Malwa Painting." Ph.D. diss., Institute of Fine Arts, New York University, 1980.

EASTMAN 1934
Eastman, Alvan Clark. *Exhibition of Early Indian Sculptures, Paintings, Bronzes, and Textiles formed by Nasli M. Heeramaneck.* Exhibition catalogue. New York: Heeramaneck Galleries, 1934.

EASTMAN 1959
Eastman, Alvan Clark. *The Nala-Damayanti Drawings.* Boston: Museum of Fine Arts, 1959.

EBELING 1973
Ebeling, Klaus. *Ragamala Painting.* Basel/Paris/New Delhi: Ravi Kumar, 1973.

EDGERTON 1924
Edgerton, Franklin. *The Panchatantra Reconstructed.* 2 vols. New Haven: American Oriental Society, 1924.

EHNBOM 1984
Ehnbom, Daniel J. "An Analysis and Reconstruction of the Dispersed *Bhagavata Purana* from the *Caurapañcāsika* Group." Ph.D. diss., University of Chicago, 1984.

EHNBOM 1985
Ehnbom, Daniel J. *Indian Miniatures: The Ehrenfeld Collection.* Exhibition catalogue. New York: Hudson Hills, 1985.

EHNBOM AND TOPSFIELD 1987
Ehnbom, Daniel, and Andrew Topsfield. *Indian Miniature Painting.* Sale catalogue. London: Spink and Son, 1987.

ETTINGHAUSEN 1961
Ettinghausen, Richard. *Paintings of the Sultans and Emperors of India in American Collections.* New Delhi: Lalit Kala Akademi, 1961.

FALK 1976
Falk, Toby S. *Persian and Mughal Art.* Exhibition catalogue. London: P. & D. Colnaghi, 1976.

FALK AND M. ARCHER 1981
Falk, Toby S., and Mildred Archer. *Indian Miniatures in the India Office Library.* London: Sotheby Parke Bernet, 1981.

FALK, SMART, AND SKELTON 1978
SEE Colnaghi 1978.

FARIDANY-AKHAVAN 1989
Faridany-Akhavan, Zahra. "The Problems of the Mughal Manuscripts of the Hamza-Nama: 1562–77. A Reconstruction." Ph.D. diss., Harvard University, 1989.

FINDLY 1981
Findly, Ellison Banks. *From the Courts of India: Indian Miniatures in the Collection of the Worcester Art Museum.* Exhibition catalogue. Worcester, Mass.: Worcester Art Museum, 1981.

FISCHER, MAHAPATRA, AND PATHY 1980
Fischer, Eberhard, Sitakant Mahapatra, and Dinananth Pathy. *Orissa: Kunst und Kultur in Nordost-Indien.* Zurich: Museum Rietberg, 1980.

FRAAD AND ETTINGHAUSEN 1971
Fraad, Irma L., and Richard Ettinghausen. "Sultanate Painting in Persian Style, Primarily from the First Half of the Fifteenth Century: A Preliminary Study." In *Chhavi: Golden Jubilee Volume,* pp. 48–66. Banares: Bharat Kala Bhavan, 1971.

FRENCH 1931
French, J.C. *Himalayan Art.* London: Oxford University Press, 1931.

FUSSMANN 1992
Mythos und Leben: Indische Miniaturen aus der Sammlung Klaus und Barbara Fussmann. Exhibition catalogue. Berlin: Museum für Indische Kunst, 1992.

GAHLIN 1991
Gahlin, Sven. *The Courts of India. Indian Miniatures from the Collection of the Fondation Custodia, Paris.* Exhibition catalogue. Paris: Fondation Custodia, 1991.

GALERIE MARCO POLO 1977
Ragamala: Exposition Mars 1977. Exhibition catalogue. Paris: Galerie Marco Polo, 1977.

GANGOLY 1934–35
Gangoly, O.C. *Rāgas and Rāginīs.* 2 vols. Bombay: Nalanda Publications, 1934–35.

GASCOIGNE 1971
Gascoigne, Bamber. *The Great Moghuls.* New York: Harper and Row, 1971. Reprint. London: Jonathan Cape, 1990.

GETTY 1962
Getty, Alice, *The Gods of Northern Buddhism. Their History, Iconography and Progressive Evolution through the Northern Buddhist Countries.* Rutland, Vt./Tokyo: C.E. Tuttle, 1962.

GHOSE 1929
Ghose, Ajit. "The Basohli School of Rajput Painting." *Rupam,* no. 37 (January 1929), pp. 6–17.

GITTINGER 1982
Gittinger, Mattiebelle. *Master Dyers to the World.* Exhibition catalogue. Washington, D.C.: The Textile Museum, 1982.

GLÜCK 1925
Glück, Heinrich. *Die Indischen Miniaturen des Haemzae-Romanes im Österreichischen Museum für Kunst und Industrie im Wien und anderen Sammlungen.* Zurich: Amalthea-Verlag, 1925.

GLYNN 1983
Glynn, Catherine. "Early Painting in Mandi." *Artibus Asiae,* vol. 44, no. 1 (1983), pp. 21–64.

GOETZ 1930
Goetz, Hermann. *Bilderatlas zur Kulturgeschichte Indien in der Grossmoghulzeit.* Berlin: D. Reimer, 1930.

GOETZ 1947
Goetz, Hermann. "Indian Painting in the Muslim Period: A Revised Historical Outline." *Journal of the Indian Society of Oriental Art,* vol. 15 (1947), pp. 19–41.

GOETZ 1950
Goetz, Hermann. *The Art and Architecture of Bikaner State.* Oxford: B. Cassirer, 1950.

GOETZ 1952
Goetz, Hermann. "A New Key to Early Rajput and Indo-Muslim Painting: A Unique *Bhagavata Purana* Album from Southwest Marwar." *Roopa-Lehka,* vol. 23, nos. 1–2 (1952), pp. 1–16.

GOSWAMY 1975
Goswamy, B.N. *Pahari Paintings of the Nala-Damayanti Theme in the Collection of Dr. Karan Singh.* New Delhi: National Museum, 1975.

GOSWAMY 1986
Goswamy, B.N. *Essence of Indian Art.* Exhibition catalogue. San Francisco: Asian Art Museum, 1986.

GOSWAMY 1988
Goswamy, B.N. *A Jainesque Sultanate Shah-nama.* Zurich: Museum Rietberg, 1988.

GOSWAMY AND DALLAPICCOLA 1982
Goswamy, B.N., and A.L. Dallapiccola. *Krishna, The Divine Lover.* Boston: David R. Godine, 1982.

GOSWAMY AND FISCHER 1987
Goswamy, B.N., and Eberhard Fischer. *Wonders of a Golden Age: Painting at the Court of the Great Mughals.* Exhibition catalogue. Zurich: Museum Rietberg, 1987.

GOSWAMY AND FISCHER 1992
Goswamy, B.N., and Eberhard Fischer. *Pahari Masters: Court Painters of Northern India.* Zurich: Artibus Asiae Publishers/ Museum Rietberg, 1992.

GRAY 1949
Gray, Basil. *Rajput Painting.* New York: Pitman, 1949.

GRUBE 1972
Grube, Ernst J. *Islamic Paintings from the 11th to the 18th Century in the Collection of Hans P. Kraus.* New York: H.P. Kraus, 1972.

GUTMAN 1982
Gutman, J.M. *Through Indian Eyes.* Exhibition catalogue. New York: International Center for Photography, 1982.

HAMZA-NAMA
Hamza-nama. Vol. 1, *Die Blätter aus dem Museum für Angewandte Kunst in Wien.* Vol. 2, *Die Blätter aus dem Victoria & Albert Museum, London.* Graz: Akademische druck-u. Verlagsanstalt, 1982.

HEERAMANECK 1935
Heeramaneck, Nasli M. *Loan Exhibition of Early Indian Sculpture, Paintings and Bronzes.* Introduction by Ananda Coomaraswamy. Catalogue by Nasli M. Heeramaneck. Exhibition catalogue. (College Art Association of America, 1935.) New York: The Galleria, 1936.

HEERAMANECK COLLECTION 1966
The Arts of India and Nepal: The Nasli and Alice Heeramaneck Collection. Exhibition catalogue. Boston: Museum of Fine Arts, 1966.

HUTCHINS 1980
Hutchins, Francis G. *Young Krishna.* West Franklin, N.H.: Amarta Press, 1980.

JOHN 1931
John, Helen. "Trisastisalakapurusacarita." *Gackwado Oriental Series,* 1931, no. 51 and no. 77.

JOHNSON 1972
Johnson, B.B. "A Preliminary Study on the Technique of Indian Miniature Painting." In *Aspects of Indian Art,* edited by Pratapaditya Pal, pp. 139–46. Leiden: E.J. Brill, 1972.

KATZ 1963
Katz, Lois. *Asian Art: From the Collections of Ernest Erickson and the Erickson Foundation, Inc.* Exhibition catalogue. Brooklyn: The Brooklyn Museum, 1963.

KEIR COLLECTION
SEE Robinson 1976.

KHANDALAVALA 1950
Khandalavala, Karl. "Leaves from Rajasthan." *Marg,* vol. 4, no. 3 (1950), pp. 2–24, 49–56.

KHANDALAVALA 1953–54
Khandalavala, Karl. "A Gita Govinda Series in the Prince of Wales Museum." *The Prince of Wales Museum Bulletin,* no. 4 (1953–54), pp. 1–18.

KHANDALAVALA 1958
Khandalavala, Karl. *Pahari Miniature Painting.* Bombay: New Book Company, 1958.

KHANDALAVALA 1982
Khandalavala, Karl. "Krishna in the Visual Arts.: In *Krishna, the Divine Lover,* edited by A.L. Dallapiccola, pp. 171–83. Boston: David R. Godine, 1982.

KHANDALAVALA 1983
Khandalavala, Karl. "The Heritage of Islamic Art in India." In *An Age of Splendour: Islamic Art in India,* edited by Karl Khandalavala and Saryu Doshi, pp. 2–31. Bombay: Marg Publications, 1983.

KHANDALAVALA AND M. CHANDRA 1962
Khandalavala, Karl, and Moti Chandra. "An Illustrated Kalpasutra Painted at Jaunpur in A.D. 1465." *Lalit Kalā,* no. 12 (October 1962), pp. 9–15.

KHANDALAVALA AND M. CHANDRA 1969
Khandalavala, Karl J., and Moti Chandra. *New Documents of Indian Painting: A Reappraisal.* Bombay: Prince of Wales Museum of Western India, 1969.

KHANDALAVALA, CHANDRA, AND CHANDRA 1960
Khandalavala, Karl, Moti Chandra, and Pramod Chandra. *Miniature Painting: A Catalogue of the Exhibition of the Sri Motichand Khajanchi Collection Held by the Lalit Kala Akademi.* New Delhi: Lalit Kala Akademi, 1960.

KHANDALAVALA AND MITTAL 1969
Khandalavala, Karl, and Jagdish Mittal. "An Early Akbari Illustrated Manuscript of Tilasm and Zodiac." *Lalit Kala,* no. 14 (1969), pp. 9–20.

KHANDALAVALA AND MITTAL 1974
Khandalavala, Karl, and Jagdish Mittal. "The Bhagavata Mss from Palam and Issarda: A Consideration in Style." *Lalit Kalā,* no. 16 (1974), pp. 28–32.

KIRFEL 1920
Kirfel, Willibald. *Die Kosmographie der Inder.* Bonn: Schroeder, 1920.

KRAMRISCH 1937
Kramrisch, Stella. *A Survey of Painting in the Deccan.* London: The India Society, 1937.

KRAMRISCH 1975
Kramrisch, Stella. "Jaina Painting of Western India." In *Aspects of Jaina Art and Architecture,* edited by U.P. Shah and M.A. Dhaky, pp. 385–404. Ahmedabad: Gujarat State Committee for the Celebration of 2500th Anniversary of Bhagavan Mahavira Nirvana, 1975.

KRAMRISCH 1981
Kramrisch, Stella. *Manifestations of Shiva.* Exhibition catalogue. Philadelphia: Philadelphia Museum of Art, 1981.

KRAMRISCH 1986
Kramrisch, Stella. *Painted Delight: Indian Paintings from Philadelphia Collections.* Exhibition catalogue. Philadelphia: Philadelphia Museum of Art, 1986.

KRISHNA, A. 1963
Krishna, Anand. *Malwa Painting.* Varanasi: Bharat Kala Bhavan, 1963.

KRISHNA, N. 1985
Krishna, Naval. "Bikaneri Miniature Painting Workshops of Ruknuddin Ibrahim and Nathu." *Lalit Kalā,* no. 21 (1985), pp. 23–27.

KRISHNADASA
Krishnadasa, Rai. *Mughal Miniatures.* New Delhi: Lalit Kalā Akademi, 1955.

KÜHNEL 1922
Kühnel, Ernst, *Miniaturmalerei im islamischen Orient.* Berlin: Bruno Cassirer, 1922.

KÜHNEL AND GOETZ 1926
Kühnel, Ernst, and Hermann Goetz. *Indian Book Painting from Jahangir's Album in the State Library in Berlin.* London: Kegan Paul, Trench, Trubner, 1926.

KYBURG 1988
Kyburg, Ltd. Catalogue (untitled). London, 1988.

LAL 1968
Lal, Mukandi. *Garhwal Painting.* New Delhi: Publications Division, Ministry of Information & Broadcasting, 1968.

LEACH 1986
Leach, Linda York. *Indian Miniature Paintings and Drawings: The Cleveland Museum of Art Catalogue of Oriental Art: Part One.* Cleveland: Cleveland Museum of Art/Indiana University Press, 1986.

LEACH 1991
Leach, Linda York. *Mughal and Other Indian Paintings from the Chester Beatty Library.* Dublin: Scorpion Publishing, forthcoming.

LEE 1960
Lee, Sherman E. *Rajput Painting.* Exhibition catalogue. New York: Asia Society, 1960.

LENTZ AND LOWRY 1989
Lentz, Thomas W., and Glenn D. Lowry. *Timur and the Princely Vision: Persian Art and Culture in the Fifteenth Century.* Exhibition Catalogue. Los Angeles: Los Angeles County Museum of Art, 1989.

LERNER 1974
Lerner, Martin. *Indian Miniatures from the Jeffrey Paley Collection.* Exhibition catalogue. New York: Metropolitan Museum of Art, 1974.

LERNER 1984
Lerner, Martin. *The Flame and the Lotus: Indian and Southeast Asian Art from the Kronos Collection.* Exhibition catalogue. New York: Metropolitan Museum of Art/Harry N. Abrams, 1984.

LEWIS 1969
Lewis, R.E. *Indian Paintings and Drawings.* Exhibition brochure. San Francisco: R.E. Lewis, 1969.

LOS ANGELES 1950
The Art of Greater India 3000 B.C.–1800 A.D. Exhibition catalogue. Los Angeles: Los Angeles County Museum of Art, 1950.

LOSTY 1982
Losty, Jeremiah P. *The Art of the Book in India.* Exhibition catalogue. London: The British Library, 1982.

LOSTY 1986
Losty, J.P. *Indian Book Painting.* London: The British Library, 1986.

LOWRY 1988
Lowry, Glenn D., with Susan Nemazee. *A Jeweler's Eye. Islamic Arts of the Book from the Vever Collection.* Exhibition catalogue. Washington, D.C.: Smithsonian Institution, 1988.

LOWRY AND BEACH 1989
Lowry, G.D., and M.C. Beach. *An Annotated Checklist of the Vever Collection.* Washington, D.C.: Smithsonian Institution Press, 1989.

MAATHIR-UL-UMARA
Maäthir-ul-Umarā: Being Biographies of the Muhammaden and Hindu Officers of the Timerid Sovereigns of India, from 1500 to about 1780 A.D. By Shah Navaz Khan and His Son Abdul Havy. Translated by H. Beveridge. Revised, annotated, and compiled by Baini Prashad. 2 vols. Calcutta, 1911–14. 2nd ed. Patna: Janaki Prakasham, 1979.

MAGGS 1924
Maggs Bros. Ltd., London. *Bulletin.* 1924.

MAGGS 1966
Maggs Bros. Ltd., London. *Oriental Miniatures & Illumination.* Bulletin No. 10, September 1966.

MAGGS 1971
Maggs Bros. Ltd., London. *Oriental Miniatures and Illumination.* Bulletin No. 19, June 1971.

MAGGS 1978
Maggs Bros. Ltd., London. *Oriental Miniatures and Illumination.* Bulletin No. 28, February 1978.

MAJUMDAR 1936
Majumdar, R.C. *The Maratha Supremacy.* Bombay: Bharatiya Vidya Bhavan, 1936.

MARG 1983
An Age of Splendour: Islamic Art in India. Edited by Karl Khandalavala. Bombay: Marg Publications, 1983.

MARKEL 1988
Markel, Stephen. "Drowning in Love's Passion: Illustrations of the Romance of Sohni and Mahinwal." In *A Pot-Pourri of Indian Art,* edited by Pratapaditya Pal, pp. 99–114. Bombay: Marg Publications, 1988.

MARTIN 1968
Martin, F.R. *The Miniature Painting and Painters of Persia, India, and Turkey from the 8th to the 18th Century.* 2 vols. London: B. Quaritch, 1912. Reprint. 1 vol. London: Holland Press, 1968.

McINERNEY 1983
McInerney, Terence. *Indian Drawings.* Exhibition catalogue. London: Arts Council of Great Britain, 1983.

McINERNEY 1991
McInerney, Terence. "Manohar." In *Master Artists of the Imperial*

Mughal Courts, edited by Pratapaditya Pal, pp. 54–68. Bombay: Marg Publications, 1991.

McNEAR 1974
McNear, Ann. *Persian and Indian Miniatures from the Collection of Everett and Ann McNear.* Exhibition catalogue. Chicago: Art Institute of Chicago, 1974.

MEHTA
Mehta, Nanalal Chamanlal. *Studies in Indian Painting: A Survey of Some New Material Ranging from the Commencement of the VIIth Century to Circa 1870.* Bombay: D.B. Taraprevala, 1926.

MELIKIAN-CHIRVANI 1969
Melikian-Chirvani, A.S. "L'Ecole de Shiraz et les origines de la miniature moghole." In *Paintings from Islamic Lands,* edited by R. Pinder-Wilson, pp. 124–42. Oxford: Bruno Cassirer, 1969.

MEMOIRS OF JAHĀNGĪR
SEE Rogers and Beveridge 1968.

MEREDITH-OWEN
Meredith-Owen, G.M. "Hamza b. Abd al-Muttalib." *Encyclopaedia of Islam* (Leiden, 1971), vol. 3, pp. 132–34.

MILLER 1971
Miller, Barbara Stoler. *Phantasies of a Love-Thief: The Caurapancasika Attributed to Bilhana.* New York: Columbia University Press, 1971.

MISHRA 1964
Mishra, Vishwanathprasad. *Rashikapriya na Priyaprasad Tilak.* Varanasi: Kalyandes & Brothers, 1964.

MITTAL 1956–57
Mittal, Jagdish. "An Illustrated Manuscript of Madhu-Malati and Other Paintings from Kulu." *Lalit Kalā,* nos. 3–4 (April 1956–March 1957), pp. 90–95.

MITTAL 1963a
Mittal, Jagdish. "Paintings of the Hyderabad School." *Marg,* vol. 16, no. 2 (March 1963), pp. 43–56.

MITTAL 1963b
Mittal, Jagdish. "Deccani Painting at the Samasthans of Wanparthy, Gadwal and Shorapur." *Marg,* vol. 16, no. 2 (March 1963), pp. 58–62.

MITTAL 1969
Mittal, Jagdish. *Andhra Paintings of the Ramayana.* Hyderabad: Lalit Kala Akademi, 1969.

MITTAL 1985
Mittal, Jagdish. "An Illustrated Deccani Manuscript from Rajahmundry: A Hitherto Unknown Center of Painting in Deccan." *Mitteilungen aus dem Museum für Völkerkunde, Hamburg,* vol. 15 (1985), pp. 41–61.

MMA 1976
Notable Acquisitions. New York: The Metropolitan Museum of Art, 1976.

MOOKERJEE 1966
Mookerjee, Ajit. *Tantra Art: Its Philosophy and Physics.* New Delhi: Ravi Kumar, 1966.

MOORCROFT 1841
Moorcroft, W., and G. Trebeck. *Travels in the Himalayan Provinces of Hindustan and the Panjab; in Ladakh and Kashmir; in Peshawar, Kabul, Kunduz and Bokhara, 1819–1825.* London, 1841.

MURRAY 1979
Murray, Julia. *A Decade of Discovery: Selected Acquisitions 1970–1980.* Washington, D.C.: Freer Gallery of Art, 1979.

OHRI 1975
Ohri, V.C. "Some Problems of Garhwal Painting—A Brief Discussion." In *The Arts of Himachal,* edited by V.C. Ohri, pp. 188–98. Simla, Himachal Pradesh: Simla State Museum, 1975.

OHRI 1991
Ohri, V.C. *On the Origins of Pahari Painting: Some Notes and a Discussion.* Simla, Himachal Pradesh: Indian Institute of Advanced Study, 1991.

OKADA 1992
Okada, Amina. *Indian Miniatures of the Mughal Court.* New York: Harry N. Abrams, 1992.

PAL 1967
Pal, Pratapaditya. *Ragamala Paintings in the Museum of Fine Arts, Boston.* Exhibition catalogue. Boston: Museum of Fine Arts, 1967.

PAL 1972
Pal, Pratapaditya, editor. *Aspects of Indian Art.* Leiden: E.J. Brill, 1972.

PAL 1976
Pal, Pratapaditya. *The Flute and the Brush: Indian Paintings from the William Theo Brown and Paul Wonner Collection.* Exhibition catalogue. Newport Beach, Calif.: Newport Harbor Art Museum, 1976.

PAL 1978
Pal, Pratapaditya. *The Classical Tradition in Rajput Painting, from the Paul F. Walter Collection.* Exhibition catalogue. New York: Pierpont Morgan Library, 1978.

PAL 1983
Pal, Pratapaditya. *Court Paintings of India: 16th–19th Centuries.* New York: Navin Kumar, 1983.

PAL AND GLYNN 1976
Pal, Pratapaditya, and Catherine Glynn. *The Sensuous Line: Indian Drawings from the Paul F. Walter Collection.* Exhibition catalogue. Los Angeles: Los Angeles County Museum of Art, 1976.

PAL AND MEECH 1988
Pal, Pratapaditya, and Julia Meech-Pekarik. *Buddhist Book Illuminations.* Hurstpierpoint, Eng.: Ravi Kumar, 1988.

PARKE BERNET 1944
Indian and Other Miniatures . . . : The Private Collection of the Painter Sarkis Katchadourian. Sale. Parke Bernet Galleries, New York. January 28, 1944.

PARKE BERNET 1964
Indian Sculptures, Paintings, Bronzes. Ancient Art of the Near and Far East. From the Collection of the Heeramaneck Galleries. Sale. Parke Bernet Galleries, New York. October 14, 1964.

PARKE BERNET 1969
Near & Far Eastern Art. Sale. Parke Bernet Galleries, New York. May 10, 1969.

POLSKY COLLECTION 1982
Polsky, Cynthia, and Terence McInerney. *Indian Paintings from the Polsky Collection.* Exhibition catalogue. Princeton: The Art Museum, Princeton University, 1982.

POSTER 1987
Poster, Amy G. "Indian and Southeast Asian Art." In *The Collector's Eye: The Ernest Erickson Collections at The Brooklyn Museum,* edited by Linda S. Ferber, pp. 145–86. Exhibition catalogue. Brooklyn: The Brooklyn Museum, 1987.

PURINTON AND NEWMAN
Purinton, Nancy, and Richard Newman. "A Technical Analysis of Indian Painting Materials." In *Pride of the Princes: Indian Art of the Mughal Era in the Cincinnati Art Museum,* by Ellen Smart and Daniel S. Walker, pp. 107–13. Cincinnati: Cincinnati Art Museum, 1985.

RAJ 1990
Bayly, C.A., ed. *The Raj: India and the British 1600–1947.*
Exhibition catalogue. London: National Portrait Gallery, 1990.

RAMACHANDRAN 1934
Ramachandran, T.N. *Tiruparuptikunram and Its Temples.* Madras:
Government Press, 1934.

RANDHAWA 1961
Randhawa, M.S. "Maharaja Sansar Chand: The Patron of Kangra
Painting." *Roopa-Lehka,* vol. 32, no. 2 (1961), pp. 1–30.

RANDHAWA 1962
Randhawa, M.S. *Kangra Painting on Love.* New Delhi: National
Museum, 1962.

RANDHAWA 1966
Randhawa, M.S. *Kangra Paintings of the Bihari Sat Sai.* New Delhi:
National Museum, 1966.

RANDHAWA AND GALBRAITH 1968
Randhawa, Mohinder Singh, and John Kenneth Galbraith. *Indian
Painting: The Scene, Themes and Legends.* Boston: Houghton Mifflin,
1968.

RAWSON 1973
Rawson, Philip. *The Art of Tantra.* Greenwich, Conn.: New York
Graphic Society, 1973.

REIFF 1959
Reiff, R. *Indian Miniatures: The Rajput Painters.* Rutland, Vt.: C.E.
Tuttle Co., 1959.

RIJKSPRENTENKABINET 1978
Miniaturen uit India: De Verzameling van Dr. P. Formijne. Amsterdam:
Rijksprentenkabinet, 1978.

ROBERTS 1937
Roberts, Laurance P. "Indian Miniatures." *Brooklyn Museum
Quarterly* vol. 24, no. 3 (July 1937), pp. 112–25.

ROBINSON 1976
Robinson, B.W., ed. *Islamic Painting and the Arts of the Book.*
London: Faber and Faber, 1976.

ROGERS 1981
Rogers, J.M. *Exhibition Handlist: Princely Paintings from Mughal India.*
London: The British Museum, 1981.

ROGERS AND BEVERIDGE 1968
The Tūzuk-i Jahāngīrī, or Memoirs of Jahangir. Translated by
Alexander Rogers. Edited by Henry Beveridge. Delhi: Munshiram
Manoharlal, 1968. 3rd edition, 1978.

ROSEN 1986
Rosen, Elizabeth S. *The World of Jainism: Indian Manuscripts from the
Spencer Collection.* Exhibition catalogue. New York: The New York
Public Library, 1986.

SARDA 1911
Sarda, Har Bilas. *Ajmer: Historical and Descriptive.* Ajmer: Scottish
Mission Industries Company, 1911.

SCHIMMEL 1975
Schimmel, Annemarie. *Mystical Dimensions of Islam.* Chapel Hill,
N.C.: University of North Carolina Press, 1975.

SCHWARTZBERG 1978
Schwartzberg, Joseph E., ed. *A Historical Atlas of South Asia.*
Chicago: University of Chicago Press, 1978.

SCHWARTZBERG 1992
Schwartzberg, Joseph E. "Geographical Mapping." In *Cartography
in the Traditional Islamic and South Asian Societies,* edited by J.B.
Harley and David Woodward, vol. 2, bk. 1, pp. 388–493.
Chicago: University of Chicago Press, 1992.

SEYLLER 1985
Seyller, John. "Model and Copy: The Illustration of Three
Razmnama Manuscripts." *Archives of Asian Art,* vol. 38 (September
1985), pp. 37–66.

SEYLLER 1987
Seyller, John. "Scribal Notes on Mughal Manuscript Illustrations."
Artibus Asiae, vol. 48, nos. 3–4 (1987), pp. 247–77.

SEYLLER 1992
Seyller, John. "Overpainting in the Cleveland Tūtināma." *Artibus
Asiae,* vol. 52, nos. 3–4 (1992), pp. 283–327.

SHAH, C.J. 1932
Shah, C.J. *Jainism in North India, 800 B.C.–A.D. 526.* London:
Longmans, 1932.

SHAH, U.P. 1976
Shah, U.P. *More Documents of Jaina Paintings and Gujarati Paintings
of Sixteenth and Later Centuries.* Ahmedabad: L.D. Institute of
Indology, 1976.

SHARMA 1974
Sharma, O.P. *Indian Miniature Painting.* Brussels: Bibliothèque
Royale Albert I^er, 1974.

SHIVESHKAR 1967
Shiveshkar, Leela. *The Pictures of the Chaurapancasika: A Sanskrit Love
Lyric.* New Delhi: National Museum, 1967.

SIVARAMAMURTI 1968
Sivaramamurti, C. *South Indian Paintings.* New Delhi: National
Museum, 1968.

SIVARAMAMURTI 1978
Sivaramamurti, C. *The Painter in Ancient India.* New Delhi: Abhinav
Productions, 1978.

SKELTON 1959
Skelton, Robert. "The Ni'mat nama: A Landmark in Malwa
Painting." *Marg,* vol. 12, no. 3 (1959), pp. 44–50.

SKELTON 1961
Skelton, Robert. *Indian Miniatures from the XVth to XIXth Centuries.*
Exhibition catalogue. Venice: Neri Pozza Editore, 1961.

SKELTON 1972
Skelton, Robert. "A Decorative Motif in Mughal Art." In *Aspects
of Indian Art,* edited by Pratapaditya Pal, pp. 147–52. Leiden:
E.J. Brill, 1972.

SKELTON 1976
Skelton, Robert. "Indian Painting of the Mughal Period." In
Islamic Painting and the Arts of the Book: The Keir Collection, edited by
B.W. Robinson, pp. 233–74. London: Faber and Faber, 1976.

SKELTON 1981
Skelton, Robert. "Shaykh Phūl and the Origins of Bundi
Painting." In *Chhavi–2: Rai Krishnadasa Felicitation Volume,*
pp. 123–29. Banares: Bharat Kala Bhavan, 1981.

SKELTON 1982
Skelton, Robert. *The Indian Heritage: Court Life and Arts under
Mughal Rule.* Exhibition catalogue. London: Victoria & Albert
Museum, 1982.

SKELTON 1987
Skelton, Robert, et al., eds. *Facets of Indian Art: A Symposium Held at
the Victoria and Albert Museum.* New Delhi: Heritage Publishers,
1987.

SMART AND WALKER 1985
Smart, Ellen S., and Daniel S. Walker. *Pride of the Princes: Indian Art
of the Mughal Era in the Cincinnati Art Museum.* Cincinnati:
Cincinnati Art Museum, 1985.

SOTHEBY'S 1921
Persian, Indo-Persian and Indian Miniatures, Manuscripts and Works of Art. Sale. Sotheby, Wilkinson & Hodge, London. October 24–25, 1921.

SOTHEBY'S 1963
Western and Oriental Manuscripts and Miniatures. Sale. Sotheby & Co., London. June 10, 1963.

SOTHEBY'S 1966
Western and Oriental Manuscripts and Miniatures. Sale. Sotheby & Co., London. December 12, 1966.

SOTHEBY'S 1968
Persian, Turkish and Arabic Manuscripts, Miniatures from the Collection Formed by Sir Thomas Phillips (1792–1872). Sale. Sotheby & Co., London. November 26, 1968.

SOTHEBY'S 1969
Highly Important Oriental Manuscripts and Miniatures. Sale. Sotheby & Co., London. December 1, 1969.

SOTHEBY'S 1970a
Highly Important Oriental Manuscripts and Miniatures. Sale. Sotheby & Co., London. December 7, 1970.

SOTHEBY'S 1970b
Oriental Manuscripts and Miniatures. Sale. Sotheby & Co., London. December 9, 1970.

SOTHEBY'S 1972
Fine Indian and Persian Miniatures. . . . Sale. Sotheby & Co., London. December 12, 1972.

SOTHEBY'S 1973a
Important Mughal Miniatures. Sale. Sotheby & Co., London. March 26, 1973.

SOTHEBY'S 1973b
Fine Oriental Miniatures and Manuscripts. Sale. Sotheby & Co., London, December 11, 1973.

SOTHEBY'S 1974
Oriental Miniatures and Manuscripts. Sale. Sotheby & Co., London. April 23, 1974.

SOTHEBY'S 1977a
Important Oriental Manuscripts and Miniatures: The Property of the Hagop Kevorkian Fund. Sale. Sotheby Parke Bernet & Co., London. May 2, 1977.

SOTHEBY'S 1977b
Fine Oriental Miniatures and Manuscripts. Sale. Sotheby Parke Bernet & Co., London. October 10, 1977.

SOTHEBY'S 1978a
Important Oriental Manuscripts and Miniatures: The Property of the Hagop Kevorkian Fund. Sale. Sotheby Parke Bernet & Co., London. April 3, 1978.

SOTHEBY'S 1978b
Fine Oriental Miniature Manuscripts and Qajar Paintings. Sale. Sotheby Parke Bernet & Co., London. April 4, 1978.

SOTHEBY'S 1985
Indian, Tibetan, Nepalese, Thai, Khmer and Javanese Art. Sale. Sotheby's, New York. September 20–21, 1985.

SOTHEBY'S 1989
Indian, Himalayan and Southeast Asian Art. Sale. Sotheby's, New York. March 29, 1989.

SOTHEBY'S 1990
Indian, Himalayan and Southeast Asian Art. Sale. Sotheby's, New York. October 6, 1990.

SOTHEBY'S 1991
Indian, Himalayan and Southeast Asian Art. Sale. Sotheby's, New York. October 28, 1991.

SOTHEBY'S 1992
The Bachofen von Echt Collection: Indian Miniatures. Sale. Sotheby's, London. April 29, 1992.

SOUCEK 1985
Soucek, P.P. "Ali Heravi." In *Encyclopaedia Iranica,* vol. 1, pp. 864–65. London: Routledge and Kegan Paul, 1985.

SPINK 1971
Spink, Walter M. *Krishnamandala.* Exhibition catalogue. Ann Arbor: University of Michigan, 1971.

SPINK AND SONS 1987
SEE Ehnbom and Topsfield 1987.

STCHOUKINE 1929
Stchoukine, Ivan. *La Peinture Indienne à l'Epoque des Grands Moghols.* Paris: Librairie Ernest Leroux, 1929.

TANDAN 1982
Tandan, Raj Kumar. *Indian Miniature Painting: 16th through 19th Centuries.* Bangalore: Natesan Publishers, 1982.

TANDON 1975
Tandon, B.N. "Brilliant Green Enamel Looking Material in the Basohli Paintings: A Scientific Study." In *Arts of Himachal,* edited by V.C. Ohri, pp. 112–15. Simla: State Museum, 1975.

TE NIJENHUIS 1976
Te Nijenhuis, E. *The Ragas of Somanatha.* Leiden: [Brill], 1976.

TITLEY 1977
Titley, Nora M. *Miniatures from Persian Manuscripts: A Catalogue and Subject Index of Paintings from Persia, India and Turkey in the British Library and British Museum.* London: British Museum, 1977.

TOD 1829–32
Tod, James. *Annals and Antiquities of Rajast'han, or the Central and Western Rajpoot States of India.* 2 vols. London, 1829–32. 2d ed. Edited with an introduction and notes by William Crooke. 3 vols. London: Humphrey Milford/Oxford University Press, 1920. Reprint. 2 vols. New Delhi: Motilal Banarsidass, 1971. Reprint. 2 vols. New Delhi: M.N. Publishers, 1978.

TOOTH 1975
Indian Paintings from the 17th to 19th Centuries. Exhibition catalogue. London: Arthur Tooth and Sons, 1975.

TOPSFIELD 1980
Topsfield, Andrew. *Paintings from Rajasthan in the National Gallery of Victoria.* Exhibition catalogue. Melbourne: National Gallery of Victoria, 1980.

TOPSFIELD 1981
Topsfield, Andrew. "Sahibdin's *Gita Govinda* Illustrations." In *Chhavi–2: Rai Krishnadasa Felicitation Volume.,* pp. 231–38. Banares: Bharat Kala Bhavan, 1981.

TOPSFIELD 1984
Topsfield, Andrew. *An Introduction to Indian Court Painting.* London: Victoria & Albert Museum, 1984.

TOPSFIELD 1990a
Topsfield, Andrew. "A Dispersed Gita Govinda Series in the Mewar-Deccani Style." In *Makaranda: Essays in Honour of Dr. James C. Harle,* edited by Claudine Bautze-Pichon, pp. 215–26. New Delhi: Satguru Publications, 1990.

TOPSFIELD 1990b
Topsfield, Andrew. *The City Palace Museum Udaipur.* Ahmedabad: Mapin Publishing Pvt., 1990.

TOPSFIELD AND BEACH 1990
Topsfield, Andrew, and Milo Cleveland Beach. *Indian Paintings from the Collection of Howard Hodgkin.* New York: Thames and Hudson, 1990.

TŪTĪ–NAMA
SEE Chandra, P. 1976.

UNESCO 1951
UNESCO, *Art in Asia and the West.* Exhibition catalogue. San Francisco: San Francisco Museum of Art, Civic Center, 1951.

VAN HASSELT 1974
Van Hasselt, Carlos. *Acquisitions récentes de toutes époques. Fondation Custodia, Collection Fritz Lugt.* Paris: Institut Neerlandais, 1974.

VATSYAYAN 1987
Vatsyayan, Kapila. *Mewari Gita-Govinda.* New Delhi: National Museum, 1987.

VICTORIA & ALBERT MUSEUM 1990
Arts of India: 1550–1900. Edited by John Guy and Deborah Swallow. London: Victoria & Albert Museum, 1990.

WALDSCHMIDT 1929
Waldschmidt, Ernst. "Illustrations de la Krishna-Lila." *Revue des Arts Asiatiques,* vol. 6, no. 4 (1929–30), pp. 197–211.

WALDSCHMIDT AND WALDSCHMIDT 1967
Waldschmidt, Ernst, and Rose Leonore Waldschmidt. *Miniatures of Musical Inspiration in the Collection of the Berlin Museum of Indian Art: Pictures from the Western Himalaya Promontory.* Wiesbaden: O. Harrassowitz, 1967.

WALDSCHMIDT AND WALDSCHMIDT 1975
Waldschmidt, Ernst, and Rose Leonore Waldschmidt. *Miniatures of Musical Inspiration in the Collection of the Berlin Museum of Indian Art.* Part 2, *Ragamala Miniatures from Northern India and the Deccan.* Berlin: Museum für Indische Kunst, 1975.

WEIMANN 1983
Weimann, Christopher. "Techniques of Marbling in Early Indian Paintings." *Fine Print* (October 1983), pp. 135–37.

WELCH, A. 1973
Welch, Anthony. *Shah 'Abbas and the Arts of Isfahan.* Exhibition catalogue. New York: The Asia Society, 1973.

WELCH, A., AND WELCH, S.C.
Welch, Anthony, and Stuart Cary Welch. *Arts of the Islamic Book: The Collection of Prince Sadruddin Aga Khan.* Exhibition catalogue. Ithaca, N.Y.: Cornell University Press/The Asia Society, 1982.

WELCH, S.C. 1964
Welch, Stuart Cary. *Art of Mughal India.* Exhibition catalogue. New York: The Asia Society, 1964.

WELCH, S.C. 1973
Welch, Stuart Cary. *A Flower from Every Meadow.* With contributions by Mark Zebrowski. Exhibition catalogue. New York: The Asia Society, 1973.

WELCH, S.C. 1976
Welch, Stuart Cary. *Indian Drawings and Painted Sketches: 16th through 19th Centuries.* Exhibition catalogue. New York: The Asia Society, 1976.

WELCH, S.C. 1978
Welch, Stuart Cary. *Room for Wonder: Indian Painting during the British Period 1760–1880.* Exhibition catalogue. New York: American Federation of Arts, 1978.

WELCH, S.C. 1985
Welch, Stuart Cary. *India. Art and Culture 1300–1900.* Exhibition catalogue. New York: The Metropolitan Museum of Art, 1985.

WELCH, S.C. 1987
Welch, Stuart Cary, Annemarie Schimmel, Marie L. Swietochowski, and Wheeler M. Thackston. *The Emperor's Album: Images of Mughal India.* New York: The Metropolitan Museum of Art/Harry N. Abrams, 1987.

WELCH, S.C., AND BEACH 1965
Welch, Stuart Cary, and Milo Cleveland Beach. *Gods, Thrones, and Peacocks. Northern Indian Paintings from Two Traditions: Fifteenth to Nineteenth Centuries.* Exhibition catalogue. New York: Asia House Gallery, 1965.

WIENER 1970
Indian Paintings. Exhibition catalogue. New York: Doris Wiener Gallery, 1970.

WIENER 1971
Indian Painting. Exhibition catalogue. New York: Doris Wiener Gallery, 1971.

WIENER 1973
Indian Miniature Paintings. Exhibition catalogue. New York: Doris Wiener Gallery, 1973.

WIENER 1974
Indian Miniature Paintings. Exhibition catalogue. New York: Doris Wiener Gallery, 1974.

WORSWICK AND EMBREE 1976
Worswick, Clark, and Ainslie Embree. *The Last Empire: Photography in British India, 1855–1911.* Exhibition catalogue. Millerton, N.Y.: Aperture, 1976.

ZEBROWSKI 1983
Zebrowski, Mark. *Deccani Painting.* Berkeley: University of California Press, 1983.

Glossary

'Abbasid Middle Eastern dynasty of caliphs ruling out of Baghdad A.D. 750–1258

Adhai-dvipa continents in the Jain cosmos where humans are born

Afrasiyab King of Turan who leads a campaign against Iran in the *Shah-nama*

Aghasura serpent demon slain by Krishna in the *Bhagavata Purana*

Ahalya mother of Chirakarin and wife of Gautama in the *Mahabharata/Razm-nama*

ahira cowherd

Akbar-nama chronicle of the emperor Akbar's reign, written in Persian by Abu'l-Faz'l in the late sixteenth to early seventeenth century

Akrura Krishna's messenger in the *Bhagavata Purana*

Akvan demon subdued by Rustam in the *Shah-nama*

alaukikatva "quality of otherworldliness"; heavenly, superhuman

ali female companion

amalaka shila ribbed, melon-shaped architectural component used as a finial on North Indian temple towers

Amaru-shataka "The Hundred Verses of Amaru"; a collection of romantic and erotic poems by King Amaru

Amr hero who penetrates the fortress of Zummurud Shah by disguising himself as a physician in the *Hamza-nama*

angavastar white scarf worn by Hindu holy men

Aniruddha grandson of Krishna and lover of Usha

anjali mudra gesture of respect, greeting, or adoration; the hands are raised slightly with palms together

Anwar-i Suhaili "The Lights of the Canopus"; a late-fifteenth-century Persian adaptation, by Husain ibn' Ali Va'iz, of the *Panchatantra*, a fifth-century collection of fables in Sanskrit

Aranya kanda the chapter of the *Ramayana* that takes place in the forest (*aranya*) where Rama lives in exile

arati Hindu ritual of devotion

Arghan demon ally of Zummurud Shah in the *Hamza-nama*

Arjuna one of the Pandava brothers in the *Mahabharata;* the recipient of Krishna's counsel in the *Bhagavad Gita*

ashtamangala the eight auspicious symbols of Jainism, consisting of the mirror, the throne of distinction, the powder vase, the full water vessel, the pair of fish, the *shrivatsa* symbol, the *nandyavarta* symbol, and the *svastika;* all of unknown origin, these symbols appear frequently in Jain art

asura demon

aura perceived atmosphere surrounding an individual

Avadhi Sanskritic language of Uttar Pradesh written in Arabic script

avatara incarnation, usually of the god Vishnu; Krishna is the most celebrated avatara of Vishnu

Ayodhya kanda the chapter of the *Ramayana* that takes place in the vicinity of Ayodhya, the birthplace of Rama

bahi court record, or account

Balabhadra four-armed ruler of the Vrishi tribe in the *Bhagavata Purana*

Balagopala-stuti "Eulogy for the Young Lord of Cowherds"; tales of Krishna's life among the cowherds of Vrindavan

Balakrishnaji image of the infant Krishna crawling with a butter ball in one hand

Balarama white-skinned elder brother of Krishna; an incarnation of Vishnu

Banasura king of Shonitapura in the *Bhagavata Purana*

banta metal casket for ritual offerings

Baramasa "The Twelve Months"; text describing the romantic attributes of each month of the year

Bhadrakali "Blessed Dark One"; form of the Goddess Kali

Bhadrasala dense grove surrounding the base of the sacred Mount Meru in Jain representations of the cosmos

bhadrasana (*bhaddasana*); throne of distinction; one of the eight auspicious symbols (*ashtamangala*) of Jainism

Bhagavad Gita Krishna's counsel to the Pandava prince Arjuna in the *Mahabharata;* one of the most important philosophical texts of Hinduism

Bhagavata Dashamaskanda tenth book of the *Bhagavata Purana,* occasionally treated as a separate text

Bhagavata Purana "The Ancient Story of the Blessed One"; the most prominent and frequently depicted Sanskrit chronicle of Vishnu, the loving Preserver, and of eight of his incarnations; text dates to circa A.D. 900

bhang hashish

Bhima (Bhimasena); second Pandava brother in the *Mahabharata*

Bismillah "In the Name of Allah"; opening phrase of all but one chapter of the *Qur'an*

Bizhan romantic hero and lover of Manizhah, daughter of Afrasiyab, in the *Shah-nama*

Brahma multiheaded Hindu god of creation

Brahman (Brahmin); Hindu caste of priests

Braj local variant of Sanskrit; the source of modern Hindi and other North Indian dialects

Buddhist relating to Buddhism, a religion founded in the sixth century B.C. in India

Chaitra Sanskrit name for the month running from mid-March through mid-April

chakra discus

Chanda demon in the *Devi Mahatmya;* also, the romantic heroine of the *Chandayana*

Chandana Malayagiri Varta Jain text describing the adventures of King Chandana and Queen Malayagiri

Chandayana romance of Laurak and Chanda, also called the *Laur Chanda,* composed in Avadhi by Mulla Da'ud in 1389

charba pounced (pierced) stencil, used for copying outlines of paintings

chauguno "four-fold pain"; unfortunate side effect of the passionate longing suffered by Indian heroines when separated from their lovers

Chaurapanchasika "The Fifty Stanzas of Secret Love"; a poem in Sanskrit by Bilhana (circa 1100), describing the forbidden love for a princess experienced by a poet on the eve of his execution

chauri fly whisk

Chirakarin hero in the *Mahabharata/Razm-nama* who is ordered by his father to kill his mother but delays the action until his father changes his mind

choli short, tight-fitting bodice worn by women

darbar king's public audience

darpana *(dappana);* mirror; one of the eight auspicious symbols (*ashtamangala*) of Jainism

Devaki Krishna's mother

Devanagari script of classical Sanskrit and modern-day Hindi

Devananda Brahman woman who carried the embryo of Mahavira prior to its transfer to the womb of Trishala in the *Kalpasutra*

Devata Hindu deity

Devi The Supreme Goddess; all goddesses are manifestations of Devi

Devi Mahatmya section of the *Markandeya Purana* celebrating the deeds of the Goddess Devi in her many manifestations

Dhenuka demon in the *Bhagavata Purana* who takes the form of an ass and is subsequently killed by Krishna and Balarama

Dhola romantic heroine and lover of Maru in Rajasthani folk literature

dhoti man's garment, tied around the waist and pulled up between the legs

Dhumralochana The "Dark-eyed One"; demon in the *Bhagavata Purana*

dipa oil lamp

div demon

Divan collection of poems

Draupadi wife shared by the five Pandava brothers in the *Mahabharata*

Durga the most prominent warrior form of Devi, created by the gods for the purpose of conquering demons

Duryodhana eldest of the Kaurava brothers in the *Mahabharata;* king of Hastinapur whose daughter, Lakshmana, is kidnapped by Sambha in the *Bhagavata Purana*

Dussera (Dasahara); one of the most important annual Hindu festivals

dvipa island-continent of the Jain cosmos

fakir "pauper"; Sufi mendicant

Fatiha the opening chapter of the *Qur'an,* often used in prayer

Fereidoun Persian king in the *Shah-nama*

firangi long sword

firman mandate; order; represented as a scroll

Foroud son of Siyavush in the *Shah-nama*

Gajendra Moksha "Release of the Lord of Elephants"; Vishnu as the savior of the drowning elephant

Gambhira "The Profound One"; form of Devi in the *Markandeya Purana*

gana devotee or spirit-attendant of Shiva, often a dwarf or grotesque figure

Ganapati Ganesha

Ganesha "Lord of the Ganas"; elephant-headed son of Shiva; as Overcomer of Obstacles, Ganesha is invoked at the beginning of Hindu texts and prior to any major undertaking such as a journey

Gardabhilla magician-king of Ujjain who is conquered by Kalaka after the abduction of the nun Sarasvati in the *Kalakacharya-katha*

Garga (Gargacharya); sage who casts Krishna's natal horoscope in the *Bhagavata Purana*

Garuda man-eagle vehicle of the Hindu god Vishnu and a killer of snakes

Gautama father of Chirakarin and jealous husband of Ahalya in the *Mahabharata/Razm-nama*

Ghanashyama "Dark Like a Cloud"; Krishna

Gita Govinda "Song of the Herdsman"; Sanskrit poem by the twelfth-century East Indian poet Jayadeva, describing the love of Krishna and Radha

Giv Iranian hero in the *Shah-nama*

gopa cowherd

Gopala "Lord of the Cowherds"; Krishna

gopi cowherd woman; milkmaid

Govinda "Chief Herdsman"; Krishna

Guhaka king of the forest-dwelling Nishadas and ally of Rama in the *Ramayana*

Gunakara priest and mentor of Kalaka in the *Kalakacharya-katha*

gur sword case

Hamir Deb excessively proud protagonist of the *Hamir Hath*

Hamir Hath "The Pride of Hamir"; Hindi ballad about the downfall of a ruler besieged in his fortress

Hamza-nama alternative name for the *Qissa-i Amir Hamza*

Hanuman monkey lieutenant of Rama who aids in the rescue of Sita in the *Ramayana*

Hari Krishna or Vishnu

Harinegameshin antelope-headed divinity who transports the embryonic Mahavira to the womb of Queen Trishala in the *Kalpasutra*

hashiya illuminated border of a manuscript

hastalekha "hand drawing"; a rough, practice sketch made on scratch paper

hasya rasa comic sentiment; SEE *rasa*

Hejirah (Hegira, Hijra); "Emigration"; the departure of the Prophet Muhammad from Mecca to Medina in A.D. 622; the beginning of the Moslem era, indicated in dates as A.H. (*anno Hejirae*)

Hindi modern language of Northern and Central India

hindola elaborate swing

Hindu relating to Hinduism, the multifaceted, indigenous religion of India

Hiranyaksha "Golden-Eyed One"; demon defeated by Varaha

hookah water pipe

howdah seat on the back of an elephant

Hum hero who seeks vengeance for the death of his brother in the *Shah-nama*

Imam Moslem religious leader; also, the prayer reader in a mosque

Indra multi-eyed king of the Hindu gods

Iskandar-nama Persian history of the life of Alexander the Great

Islamic relating to Islam, the strictly monotheistic religion first promoted in seventh-century Arabia by the Prophet Muhammad and present in India from the ninth century or earlier

Jaimini narrator in the *Ramayana*

Jain relating to Jainism, an austere religion originating in the sixth century B.C. in India, teaching liberation of the soul by right knowledge, right faith, and right conduct

jama long tunic or overgarment

Jambu-dvipa central area of the Jain cosmos; home of enlightened beings; India

Janaki another name for Sita, the heroine of the *Ramayana*

Janamejaya narrator in the *Ramayana*

Jatayu vulture appointed to guard Sita in the *Ramayana;* he is killed by the demon king Ravana during the abduction of Sita

jati-mantra Jain bathing ceremony

jhari water jar used in Hindu worship

jina Jain saint

Jogamaya (Yogamaya); goddess who disguises herself as the baby Krishna to fool the evil Kamsa in the *Bhagavata Purana*

Kabus evil king of Turan who is defeated by Rustam in the *Shah-nama*

kachcha mode of wearing the dhoti with the hem tucked into the waistband

Kalaka one of three similarly named saints, heroes of the *Kalakacharya-katha*

Kalakacharya-katha Jain epic detailing events in the lives of three saints, each called Kalaka; generally presented as an appendix to the *Kalpasutra*

Kalanidhi "Sixteen-Part Treasure"; the moon

kalasha (kalsha); vase- or urn-shaped vessel; one of the eight auspicious symbols (*ashtamangala*) of Jainism

Kalayavana "Dark Foreigner"; enemy of Krishna in the *Bhagavata Purana*

kalgi plume worn in a headdress

Kali "The Dark One"; a horrifying, bloodthirsty emanation of Devi

Kaliya multiheaded serpent demon subdued by Krishna in the *Bhagavata Purana*

Kaliyadamana episode in the *Bhagavata Purana* in which Krishna defeats the serpent demon Kaliya

Kalpasutra "The Book of the Ritual"; Jain text celebrating the exemplary life of Jina Mahavira, the twenty-fourth Tirthankara; ascribed to the sage Bhadrabahu (circa 300 B.C.)

Kalumkari painted or printed cotton textile

Kama (Kamadeva); Hindu god of love and lust, often similar in appearance and behavior to Cupid; also called Manobhava

Kama Sutra "Scripture of Desire"; fourth-century Sanskrit text by Vatsyayana describing the art of lovemaking

Kamsa evil king who attempts (in vain) to avoid a predestined death at the hands of Krishna in the *Bhagavata Purana*

kapardin mukuta "crown of locks"; matted tresses piled up to form a headdress; a characteristic of religious ascetics and especially of the god Shiva

Kartik month running from mid-October through mid-November

Karttikeya (Skanda, Kumara); younger son of Shiva, known for his youth and for his valor in battle

karuna compassion

katar short, double-bladed dagger

Kaumari wife of Kumara

Kauravas "Sons of Kuru"; one of the warring factions in the *Mahabharata*

kayastha Hindu caste of professional scribes

kevalin Jain term for the state of being set free from material existence; similar to *nirvana*

Khamsa "Quintet"; series of poems; among the numerous *Khamsas* written by Persian authors, perhaps the most famous is the one completed in 1188 by the Persian poet Ilyas ibn Yusuf Nizami

Kichaka general defeated by Bhima in the *Mahabharata*

kinnara heavenly being, often a musician, sometimes portrayed with the face of an animal

Kishkindha kanda chapter of the *Ramayana* in which the action is located in the vicinity of Kishkindha, the capital of the monkeys

Krishna blue-skinned incarnation of Vishnu, celebrated in the *Bhagavata Purana* and other Hindu texts as a mischievous infant, a passionate lover, a valiant warrior, and a spiritual advisor; alternate names for the various forms and roles of Krishna include: Balakrishnaji, Gopala, Govinda, Hari, Madanmohanji, Shri Nathaji, Shyama, and Vishvarupa

Krishna-Lila description of Krishna's dalliance with the cowherders of Vrindavan

Kshatriya Hindu caste of warriors and kings

Kshetrasamasa Jain diagram of the cosmos

Kuh-i nur (Koh-i-noor); famous diamond once owned by Hindu and Persian rulers, surrendered to the British crown in 1849 on the annexation of the Punjab

kula staff worn wrapped in a turban by Persians of the early Safavid period

kulharia headdress identifying the class of the wearer

Kumara Karttikeya, younger son of Shiva

Kusha one of Rama's twin sons in the *Ramayana*

Kuvera demon conquered by Krishna in the *Bhagavata Purana*

Lakshmana Rama's most loyal brother, who follows him into exile in the *Ramayana*; also, daughter of Duryodhana and beloved of Sambha in the *Bhagavata Purana*

Lakshmi goddess of prosperity and well-being; a consort of Vishnu

Lakshmi Narayana Vishnu and his consort Lakshmi shown together in an affectionate pose

Laurak romantic hero of the *Chandayana*

Lava one of Rama's twin sons in the *Ramayana*

Lavana-samudra "The Salty Sea"; ocean surrounding the central continent in the Jain cosmos

Layla romantic heroine and lover of Majnun

Layla va Majnun romantic poem included in the *Khamsa* ("Quintet") of the Persian poet Nizami (d. 1209), concerning the youth Majnun and his beloved Layla, a girl from a rival tribe

loka level of the cosmos; the world

Lulu heroic spy who rescues Sa'id-i Farrukh Nizhad in the *Hamza-nama*

Madanmohanji "One who is stupefied by intoxicant"; metal image of Krishna playing the flute, located in Nathadwara shrine

Madhu romantic hero and lover of Malati

Madhu-Malati Sanskrit drama by Bhavabhuti (early eighth century) about the romance between the princess Malati and Madhu, the commoner son of the prime minister; the best-known version was written in Hindi in the sixteenth century by Majhan

Madhya-loka "Middle Land"; the area in the Jain cosmos populated by both mortal and enlightened men

Mahabharata "The Great Descendants of Bharata"; important Sanskrit war epic describing the rivalry between the heroic Pandavas and Kauravas

Mahadev "Great God"; Shiva

Maha Lakshmi text extolling the feats of the goddess Lakshmi

Maharaja Indian ruler; superior to raja

Mahasura "Great Demon"

Mahavira "Great Hero"; twenty-fourth Tirthankara, a model of the righteous ascetic life and victory over the material world, whose deeds are related in the *Kalpasutra*

Mahesha "Great Lord"; Shiva

Mahima character in the *Hamir Hath*

Mahinwal romantic hero and the lover of Sohni

Mahishasura demon who took the form of a bull and was defeated by Durga

mahout elephant driver

Majnun "Crazy Man"; the romantic hero and lover of Layla in *Layla va Majnun*

Malati romantic heroine and lover of Madhu

Manigriva demi-god freed from captivity by the infant Krishna in the *Bhagavata Purana*

Manizhah romantic heroine, lover of Bizhan, and daughter of Afrasiyab, in the *Shah-nama*

Manobhava Kama, the god of love

Manushya-loka "Land of Men"; area of the Jain cosmos where unenlightened humans live

Markandeya Purana moral text recited by the sage Markandeya, a section of which (the *Devi Mahatmya*) describes the feats of Devi

Maru romantic hero and lover of Dhola

Matangi demon-slaying goddess

matrika "little mother"; a Hindu female deity, usually the female emanation of a male god

matsyaugma pair of fish; one of the eight auspicious symbols (*ashtamangala*) of Jainism

moksha release from the world of material and emotional concerns; the goal of several Indian religions

morchal fan of peacock feathers

mudra symbolic hand gesture

Muhammad the Prophet of Islam

Munda demon in the *Devi Mahatmya*

Mura demon killed by Krishna in the *Bhagavata Purana*

Mushtika demon killed by Krishna in the *Bhagavata Purana*

Musmahil surgeon persona adopted by Amr as a means of gaining access to an enemy fortress in the *Hamza-Nama*

Nafahat al-Uns "The Breaths of Familiarity"; a collection of poems by the Sufi poet Jami (d. 1492)

nafs base aspect of the human soul, mortified by Sufi ascetics in the quest for spiritual strength

Nagadevata serpent god

Nagaraja king of the serpents

nagini female serpent

Naishadha-charita "The Story of the Prince of Nishadhas"; Sanskrit poem by Shri Harsha (twelfth century) describing the romance of Nala and Damayanti

Nala romantic hero, the husband of Damayanti

Nala-Damayanti romantic adventure story about the hero Nala and his beloved Damayanti, recounted in several Hindu texts, including the *Naishadha-charita* of Shri Harsha and the *Mahabharata*

Nalakubara demi-god freed from captivity by the infant Krishna in the *Bhagavata Purana*

Nanda foster father of Krishna

Nandi bull vehicle of Shiva

nandyavarta (*nandiyavatta*); complex, *svastika*-like symbol; one of the eight auspicious symbols (*ashtamangala*) of Jainism

Narada sage known for his lyre playing

naskhi a Persian script

nastaliq a Persian script

Nataraja "King of the Dance"; Shiva

nautch dance; dancing girl

Nayaka-Nayika text describing the various types of romantic heroes and heroines

nayika romantic heroine, a type of ideal lover categorized in *Nayaka-Nayika* texts

Ni'mat-nama "Book of Delicacies"; illustrated collection of recipes, in Persian, created for a Mandu sultan in the early sixteenth century

nirvana state of nothingness; the spiritual goal of Hinduism and Buddhism

Nishadas tribe of forest dwellers in the *Ramayana;* the tribe of Nala

orhani thin scarf, usually worn over the head and shoulders

Oriya language of Orissa

padmasana "lotus sitting"; yogic position in which one sits cross-legged with the soles of the feet facing up

Padshah-nama one of several contemporary court chronicles of the Mughal emperor Shah Jahan (1592–1666)

Pahari "of the Hills"; generic term referring especially to paintings originating in the Punjab Hills

pan betel leaf, often combined with spices; a mild intoxicant and savory delicacy chewed like tobacco

Panchakhyana (*Panchakhyanaka*) collection of Sanskrit allegorical fables of the fifth century, similar to *Aesop's Fables*

Pandavas "Sons of Pandu"; one of the warring factions in the *Mahabharata*

Parsva (Parshva); twenty-third Jain Tirthankara

Parvati wife of the Hindu god Shiva

Paryushana rainy season

patka sash worn around the waist by noblemen

Pausha Sanskrit name for the month that runs from mid-December through mid-January

peshkar official title of a steward

peshvaj ankle-length transparent overgarment

pichhvai painted cotton temple banner

Pradyumna grandson of Krishna

Prakriti variant of Sanskrit, based on local dialects

prana breath; life-giving principle that runs through the body

purana sacred text describing the deeds of the gods and the appropriate means of paying homage to them

Putana demoness killed by the baby Krishna

putra son; term used for a subgroup of musical modes; see *raga*

Qissa-i Amir Hamza Persian epic adventure story of Amir Hamza, a ninth-century folk hero who came to be identified with the uncle of the Moslem Prophet Muhammad

Qur'an (*Koran*); the sacred book of Islam, containing the revelations conveyed by God to the Prophet Muhammad over a period of twenty-two years; canonical text consisting of 114 chapters established in the mid-seventh century under the rule of the Caliph Othman

Radha married lover of Krishna; their forbidden love is celebrated in several texts, including the *Gita Govinda*

raga classical melody personified as a male, commonly one of six in a *Ragamala,* presiding over six female melodies called *raginis,* and often a number of *ragaputras* (sons), or even *ragaputris* (daughters or wives of sons)

Ragamala "garland of *ragas* (musical modes)"; series of thirty-six or more illustrations inspired by classical melodies, each personifying a characteristic of love or heroic behavior

ragaputra subcategory of a type of *raga*

ragini feminine mode in a *Ragamala*

raja ruler

Raktabij demon conquered by goddesses in the *Devi Mahatmya*

Rama hero of the *Ramayana;* an incarnation of Vishnu

Ramayana "The Story of Rama"; epic relating the deeds of Rama, his exile in the forest, and the quest to recover his abducted wife, Sita; the Sanskrit version, probably dating between 500 and 300 B.C. and traditionally attributed to the sage Valmiki, is often reinterpreted by local poets and dramatists

rani queen or princess

rao prince

rasa specific emotional response evoked by a work of art; the primary criterion for aesthetic appreciation in the Indian tradition

Rasamandala image of Krishna dancing in a circle with the *gopis*

Rasamanjari "Posy of Delights"; poem in Sanskrit by Bhanu Datta (fourteenth century) categorizing types of lovers according to age, experience, situation, and traits

Rasa Panchdhyayi "Five Chapters of Delight"; a section of the *Bhagavata Purana*

Rasikapriya "The Lover's Breviary"; a poem in Hindi by Keshavadasa (late sixteenth century), analyzing the stages of love through analogy with incidents involving Radha and Krishna

Rati wife of Kama

Ravana ten-headed, multiarmed demon-king of Lanka who abducts Sita in the *Ramayana;* devotee of the god Shiva

Razm-nama "The Book of War"; Persian translation by Nakib Khan of the Sanskrit *Mahabharata* commissioned by Akbar in 1582

Rituparna evil king in the story of Nala and Damayanti

Rohini Balarama's mother

roti flat bread

rudraksha prayer bead made from a variety of seed pod, worn primarily by Hindu holy men

Rukma brother of Rukmini in the *Rukmini Haran*

Rukmini romantic heroine, the principal wife of Krishna

Rukmini Haran "The Rape of Rukmini"; story of Krishna's abduction of Rukmini, who is engaged to another man

Rustam Persian epic hero whose deeds are detailed in several texts, including the *Shah-nama*

sadhu Hindu holy man, usually a wandering ascetic

Safavid Persian dynasty of the sixteenth through eighteenth centuries

Sahi generic term for foreigner, usually indicating Central Asians who appear in the *Kalpasutra* and *Kalakacharya-katha*

Sa'id-i Farrukh Nizhad heroic prince in the *Hamza-nama*

Sairandhri servant-girl identity assumed by Draupadi when in disguise in the *Mahabharata*

sakhi woman's confidante or companion

Salim father of Majnun

Samachari third part of the *Kalakacharya-katha* containing the rules for monks during the rainy season

samavasarana first preaching of Mahavira, the twenty-fourth Jain Tirthankara

Sambha son of Krishna and abductor of the princess Lakshmana in the *Bhagavata Purana*

Samgitadamodara record of a conference of musicians, compiled by Pratap Singh of Jaipur (1779–1804)

Samvat short for the era Vikram Samvat, generally used in northern India, reckoned from 57 B.C.; the era by which many Indian manuscripts are dated

Sangha monastic order

Sanghar-i Balkhi hero who rescues Sa'id-i Farrukh Nizhad in the *Hamza-nama*

Sanskrit classical, Indo-European language of Indian literature; the root of many modern Indian languages

Sarasvati Hindu goddess of knowledge; the Jain nun who is abducted by Gardabhilla and saved by Kalaka in the *Kalakacharya-katha*

sari wrapped and draped garment worn by Indian women

Sat Sai "The Seven Centuries"; long series of Hindi verses celebrating the love of Krishna and Radha, by Bihari Lal (circa 1650)

Satya-loka "Realm of Truth"; highest spiritual level in Hinduism, represented by the god Brahma

Shah-nama "Book of Kings"; Persian national epic recounting the history of Persia's earliest rulers up to the conquest of the Arabs, completed by the poet Firdawsi in A.D. 1010

Shaivite (Shaiva); relating to the worship of the Hindu god Shiva; a worshiper of Shiva

Shaka Central Asian or Scythian

Shakra chief of the sixty-four Jain leaders; comparable to Indra in the Hindu pantheon

shakti female aspect of a god, representing his physical energy

shalagrama black pebble symbolizing Vishnu

Shambhu character in the *Bhagavata Purana*

Shams-i Tabriz Islamic saint

Shanti Parvan "Chapter of Peace"; book twelve of the *Mahabharata*

Shatrughna one of Rama's brothers in the *Ramayana*

Shiite Moslem sect; the dominant political force in Iran in the sixteenth century

shikhara curvilinear tower found on many North Indian temples

Shishupal ruler of Chedi in the *Rukmini Haran*

Shiva one of the major gods of the Hindu pantheon; described as The Destroyer; the embodiment of several extremes: The Great Ascetic and practitioner of Yoga; a ferocious slayer of demons; the devoted husband of Parvati; also called Mahadeva

Shivalingam sacred phallic emblem of Shiva

Shri "wondrous, glorious, most exalted"; an Indic honorific; Lakshmi, the goddess of prosperity and good fortune

Shri Nathaji Krishna, specifically the image worshiped in Nathadwara, a Vaishnava pilgrimage center in Rajasthan

shrivatsa (sirivaccha); cruciform symbol representing a curl of hair; one of the eight auspicious symbols (*ashtamangala*) of Jainism

shula missile, especially a javelin

Shumbha demon in the *Devi Mahatmya*

Shvetambara "clothed in white"; Jain monastic order

Shyama "Dark One"; Krishna

Shyamakarna "Dark-Eared One"; horse intended for sacrifice in the *Ramayana*

siddha perfected person

Siddha Lakshmi form of the goddess Lakshmi associated with knowledge

Sikh relating to Sikhism, a religion originating in northern India

Sita wife of Rama; abducted by the demon Ravana in the *Ramayana*

Siyavush son of King Kayus and student of Rustam in the *Shah-nama*

Sohni romantic folk heroine who drowns while trying to cross the river to meet her lover Mahinwal

suba petty kingdom

subedar petty feudatory

subhavartirekha "drawing situated in beauty"; final drawing applied to the page prior to painting

Sudama sage who serves as messenger for Krishna and Rukmini in the *Rukmini Haran*

Sufi generic term relating to Moslem mysticism

Sugriva king of the monkeys and Rama's ally in the *Ramayana*

Sumantra Rama's charioteer in the *Ramayana*

surati object of great enjoyment or delight

sutrapatarekha "measuring drawing"; preliminary sketch made on the painting surface prior to priming

svastika (sotthiya); four-armed, spiral symbol; one of the eight auspicious symbols (*ashtamangala*) of Jainism

swami Hindu wise man

Takri cursive form of Devanagari script used in parts of the Punjab Hills

tanpura stringed instrument

Tantric relating to Tantra, a later form of Hinduism or Buddhism promoting secret, alternative means of attaining spiritual and magical goals

Tayus character in the *Hamza-nama*

Telugu South Indian language

Thakur official title of a baronet

thikana Rajput fief or barony

tikka hair ornament

tilak marks painted on the face and body by Hindus to indicate their religious affiliation

Tilasm and Zodiac Islamic text on astrology, botanical cures, and incantations

Timurid dynasty founded by Timur (Tamerlane; 1338–1405); ruled in Iran and Central Asia in the fourteenth and fifteenth centuries

tirtha "crossing place"; sacred site, usually at the banks of a river

Tirthankara "one who has crossed over"; one of the twenty-four Jain saints who have crossed out of the cycle of reincarnation

tripundra "three lines"; Vaishnava tilak marks

Trishala surrogate mother of Mahavira in the *Kalpasutra*

tughra calligraphic emblem; official signature of the Ottoman sultans

tulasi holy basil

Tuti-nama "Tales of a Parrot"; series of tales told by a parrot to a woman whose husband is away; Persian version, based on the Sanskrit *Shukasaptati,* completed by Ziya ad-Din Nakshabi in 1330

Umrao of Chin character in the *Hamza-nama*

Urdu language of Pakistan and of parts of northern India

Usha Aniruddha story of romance between the heroine Usha and Krishna's grandson Aniruddha

Uttara kanda last (*uttara*) chapter of the *Ramayana*

Uttardha second half of the tenth book of the *Bhagavata Purana*

vahana animal vehicle of a deity

Vaikuntha Darshana "Vision of Vishnu"; representation of a dream of the Bikaner ruler Karan Singh (r. 1631–74)

Vaishnavite (Vaishnava); relating to the worship of the Hindu god Vishnu; a worshiper of Vishnu

Vali monkey king, the brother of Sugriva, killed by Rama in the *Ramayana*

Valmiki sage and author of the *Ramayana*

varada mudra symbolic gesture of granting wishes; the palm faces out with fingers pointing down

Varaha boar incarnation of Vishnu; responsible for saving the earth from drowning in an ocean of chaos

vardhamanaka (*vaddhamanaga*); powder vase; one of the eight auspicious symbols (*ashtamangala*) of Jainism

Vasudeva Krishna's father

Vasuki serpent who shelters Vasudeva and the infant Krishna as they cross the Yamuna in the *Bhagavata Purana*

Vasupujya twelfth Jain Tirthankara

Veda early Hindu collection of hymns in proto-Sanskrit, dating from approximately 1000 B.C.

vidyadhara celestial being representing knowledge

vijnaptipatra "carrier of knowledge"; formal invitation to an exchange of ideas, sent to monks by Jain communities

Vikral Bhairava ferocious and victorious form of Shiva in his role as demon-slayer

Vikram Samvat (V.S.); "Valorous Year"; the era (beginning with the reign of Vikramaditya, circa 57 B.C.) by which many Indian manuscripts are dated

vina stringed musical instrument

Vishnu one of the major gods of the Hindu pantheon; the Benevolent Preserver, who descends in a series of incarnations to defend the earth

Vishnu Avatara text describing the incarnations of the Hindu deity Vishnu

Vishnudharmottara Hindu text on artistic techniques, dating from the fifth to ninth century

Vishvamitra sage in the *Ramayana*

Vishvarupa cosmic, all-encompassing form of Krishna, as revealed to Arjuna in the *Bhagavad Gita*

Vrishvasura demon killed by Krishna in the *Bhagavata Purana*

yali auspicious lionlike creature

yantra diagram with sacred significance or power

Yashoda adoptive mother of Krishna

yogi practitioner of Yoga, a spiritual discipline

yogini female yogi; a Tantric goddess

Yudhishthira eldest Pandava brother in the *Mahabharata*

Yusuf u Zulaykha romantic poem by the fifteenth-century Sufi poet Jami, based on a story in the Old Testament and the *Qur'an* in which Potiphar's wife (Zulaykha) becomes infatuated with Joseph (Yusuf)

zennana harem

Zummurud Shah giant and enemy of Amir Hamza in the *Hamza-nama*

Index

Page numbers in *italics* refer to illustrations.